Photography

A Cultural History

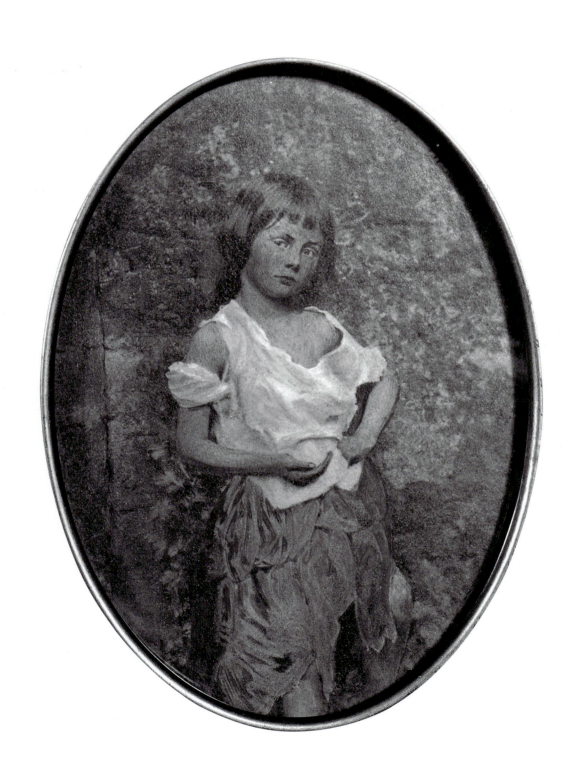

Photography
A Cultural History

Mary Warner Marien
Syracuse University, Syracuse, New York

Prentice Hall, Inc.,

 Published 2002 by Prentice Hall, Inc.
A Division of Pearson Education
Upper Saddle River, New Jersey 07458

ISBN 0-13-019856-0

10 9 8 7 6 5 4 3 2

 This book was designed and produced by
Laurence King Publishing Ltd, London
www.laurenceking.co.uk

Every effort has been made to contact the copyright holders,
but should there be any errors or omissions, Laurence
King Publishing Ltd would be pleased to insert the
appropriate acknowledgement in any subsequent printing
of this publication.

Senior Managing Editor: Richard Mason
Development Editor: Damian Thompson
Picture Editor: Susan Bolsom
Picture Researchers: Bridget Arora, Martin Baldessari,
 Emma Brown, Mary-Jane Gibson, Carrie Haines,
 Debra Nagao, Lily Sellar
Interior Designers: Cara Gallardo, Tim Higgins and
 Ian Hunt Design
Cover Designer: Price Watkins

Typeset by Marie Doherty

Printed in China

Front cover: Gertrude Käsebier, *Portrait—Miss N. (Evelyn
Nesbitt)*, 1902. Platinum print. National Gallery of Canada/
Musée des Beaux-Arts du Canada, Ottawa.

Back cover: Nadar & Adrien Tournachon, *Pierrot the
Photographer*, 1854–55. Paper print. Musée Carnavalet, Paris.

Frontispiece: Lewis Carroll, *Alice Liddell as "The Beggar Maid,"*
c. 1859. Hand-colored albumen print. Sotheby's Picture
Library, London.

CONTENTS

PICTURE CREDITS

Laurence King Publishing has endeavored to contact all copyright owners. Any corrections or omissions will be noted for any future edition. Grateful thanks for their help go to: Janice Madhu of the George Eastman House, NY; Jacqueline Burns of the J. Paul Getty Museum, Los Angeles; Maria Umali of the Gilman Paper Company; Pat Fundom of Hallmark Cards Inc., Kansas City; Akiko Shiozawa in Tokyo. Collections are given in captions next to illustrations. The following abbreviation has been used: LOC/P&P (Library of Congress, Washington D.C./Prints & Photographs Division). Sources for illustrations not supplied by museums or collections, additional information, and copyright credits are given below.

1 Rapho, Paris; 2 Courtesy Andrea Rosen Gallery, NY, in representation of Estate of Felix Gonzalez-Torres. © Estate of Felix Gonzalez-Torres. Photo by Peter Muscato; 3 © Associated Press/Ted S. Warren; 1.0 © Ville de Chalon-sur-Saône, France. Musée Nicéphore Niépce; 1.1 Collection of Ambrosiana Library, Milan. All Rights Reserved/Index, Florence; 1.2 Photo Bibliothèque Nationale de France, Paris; 1.9, 1.15, 1.17, 1.18 Science & Society Picture Library, London; 1.19 With thanks to Douglas Nickel; 2.0 With thanks to Alison Doane; 2.6 Courtesy Hans P. Kraus, Jr., NY; 2.7, 2.9 Science & Society Picture Library, London; 2.14 V & A Picture Library, London; 2.27, 2.28 Courtesy John Wood, McNeese State University, Louisiana; 2.32 Conaculta-INAH-SINAFAO-Fototeca Nacional, Mexico City; 2.33 Courtesy the Director, National Army Museum, London; 2.34 Research Library, Getty Research Institute, Los Angeles;

2.39, 2.54, 2.55 Photo Bibliothèque Nationale de France, Paris; 2.41 Courtesy George Eastman House, NY. Museum Purchase: Charina Foundation Purchase Fund; 2.47 DG-40-80 Floyd and Marion Rinhart Collection. Ohio State University Libraries. Used by permission; 2.49 With thanks to William Welling, NY; 2.53 With thanks to Peter Palmquist; 2.56 Courtesy Strong Museum, Rochester, NY © 2002; 2.57 © National Portrait Gallery, Smithsonian Institution/Art Resource, NY; 2.59 Courtesy Library of Congress, Washington D.C. Prints & Photographs Division LC-USA7-10881; 2.60 Museum of Fine Arts, Boston. Gift of Richard Parker in memory of Herman Parker 1994.124 © 2001 Museum of Fine Arts, Boston, All Rights Reserved; 2.61 Metropolitan Museum, NY. Gift of I.N.P. Stokes and the Hawes family; 3.0 © Photothèque des Musées de la Ville de Paris/cliché Ladet; 3.2 LOC/P&P. LC-USZ62; 3.4, 3.5, 3.28, 3.29, 3.30, 3.32, 3.34, 3.37, 3.44, 3.51, 3.77, 3.83, 3.89, 3.91, 3.96, 3.99, 3.102, 3.105 V & A Picture Library, London; 3.9, 3.49, 3.50, 3.94 3.53 Photo RMN, Paris; 3.14 © National Portrait Gallery, Smithsonian Institution/Art Resource, NY; 3.15 LOC/P&P LC-USZ62-114481; 3.16 LOC/P&P LC-USZ62-76355; 3.17 LOC/P&P # 301949; 3.19 LOC/P&P LC-USZ62; 3.20 LOC/P&P LC-B8171-557; 3.21 LOC/P&P LC-B8171-7798; 3.25 With thanks to G.Léyris; 3.26 Illustrated London News; 3.27 Photo Bibliothèque Nationale de France, Paris; 3.31 Courtesy Library of Congress; 3.45 © Christie's Images Ltd 2002; 3.46 Courtesy the Director, National Army Museum, London; 3.47 Collection Centre Canadien d'Architecture/Canadian Centre for Architecture, Montréal

PH1980:0048:04:010; National Museum of American Art, Smithsonian Institution, bequest of Sara Carr Upton/Scala, Florence; 3.55 LOC/P&P C-USZ62-22284; 3.56·National Archives, Washington, D.C. 77-KS-1-15; 3.57, 3.72 Courtesy George Eastman House, NY; 3.58 LOC/P&P LC-USZ62-50848; 3.62, 3.65 © National Anthropological Archives, Smithsonian Institution # 4042; 3.64 LOC/P&P LC-USZ62; 3.66 © Smithsonian Institution; 3.67 National Archives, Washington, D.C. 77-HQ-264-809; 3.69 LOC/P&P LC-BH821-6803; 3.71 Bibliothèque de l'Institut de France, Paris/Photo RMN, Paris/Le Mage; 3.76 © Bibliothèque Centrale M.N.H.N. Paris; 3.86 © Scottish National Photography Collection, Scottish National Portrait Gallery, Edinburgh; 3.88 With thanks to G.Léyris; 3.95 Félix Nadar/Archives Photographiques © Centres des Monuments Nationaux, Paris; 3.100 Science & Society Picture Library, London; 3.106 Sotheby's Picture Library, London; 3.107 © Christie's Images Ltd 2002; 3.108 Rheinisches Bildarchiv, Cologne; 4.0 LOC/P&P LC-USZ62-64301; 4.5, 4.40, 4.44 V & A Picture Library, London; 4.6 Dayton Art Institute, Dayton, Ohio 1984.58. Gift of Mrs Lillian T. Snider; 4.7, 4.8, 4.10, 4.12, 4.13, 4.58 Courtesy Library of Congress; 4.15 ArtSeal Services; 4.18 LOC/P&P LC-USZ62-76355; 4.19 Museum of Modern Art, NY. Purchase. Copy Print © 2001 Museum of Modern Art, NY; 4.21 Museum of Modern Art, NY. Gift of Mrs Hermine M. Turner. Copy print © 2001 Museum of Modern Art, NY; 4.22 LOC/P&P LC-USZ62-79452. Reprinted with permission of Joanna T. Steichen; 4.23 Museum of Modern Art, NY. Gift of the photographer,

Preface

Although I have been captivated by photography since childhood, the thought that I might teach and write about a subject that was a fervent personal interest of mine never occurred to me until 1984. In that year, Professor David Tatham, then Chair of the Fine Arts Department at Syracuse University, persuaded me to try a one-semester course. I have been teaching graduate and undergraduate courses in the history of photography and writing about the subject ever since.

Despite the impressive increase in college photography courses during the last decades of the twentieth century, autodidacts such as myself make up the bulk of photohistorians. Like many others, I became a photographic historian in my parents' living room, while looking at copies of *Life* magazine. As a group, we revel in our passionate preferences. If I thought I could get away with it, I would have filled this book with my favorite pictures, such as those that French photographer Robert Doisneau made of Paris in the 1950s and 1960s. I have not yet found a way to show Doisneau's work in my undergraduate survey, nor have I included him here, even though, in a portrait pinned above

my desk, a broadly grinning Doisneau points directly at me, prompting me to keep on trying (Fig. 1).

In writing this book, I have tried to survey photography's history in such a way that readers can gauge the medium's manifold developments, and appreciate the historical and cultural contexts in which photographers lived and worked. Some readers may long for a comprehensive taxonomy of photography, a unified field with movements and ideas carefully delineated like kingdoms, phyla, orders, and species. Indeed, this sort of categorization is a practical if sometimes blunt instrument with which to create order and highlight dominant ideas and visual approaches. Yet it is crucial to remember that people living in a particular era do not synchronize their thoughts. They interpret, refine, resist, oppose, or ignore the prevalent attitudes of their time. Years of teaching have brought home to me the dangers of homogenizing subtly distinctive viewpoints or creating periods so watertight that they leave no residue in the next chapter. The Victorians did not simultaneously pull out their pocket watches on the stroke of New Year's Eve and agree that the epoch of

heroic landscape photography in the American West should end promptly then and there.

My students have taught me that, contrary to conventional wisdom, they do not dislike history, but are instead hungry for it. Consequently, I have tried to sketch the political and economic events, such as wars and depressions, that shaped the circumstances in which photography was practiced, while paying special attention to the particular ideas generated by and about photography in each period. The Focus boxes in this book contain much of this material.

The short history of photography gives it a special excitement, and it is still possible to discover historically significant images at tag sales and regional museums. In the last few decades, the scope of photographic history has widened to encompass fresh materials and new analytic tools that promise the emergence of a vital interdisciplinary field. Although photography is a Western discovery, students are rightly curious about its manifestations in the wider world. To serve that interest, I have both incorporated recent research into non-Western photographers and Western visions of the non-Western world as they were directed towards science, anthropology, journalism, and art.

Yet I am mindful that comprehensive histories of photography in India and China, those countries that make up more than one-third of the world's population, have yet to be written. Moreover, the photographic archives of business and industry have scarcely been mined, and the history of advertising photography, which has shaped the modern experience internationally, remains mostly unwritten.

Influential photographers have often led long lives traversing eras during which many changes took place. For example, Alfred Stieglitz (1864–1946) was born one year before the American Civil War ended, and he died one year after World War II. Having taught an introductory course, I realized that newcomers to the field appreciate an overview of individual careers such as that of Stieglitz, even if this requires occasionally disrupting the chronological order of the presentation. Hence I have included a number of Portrait

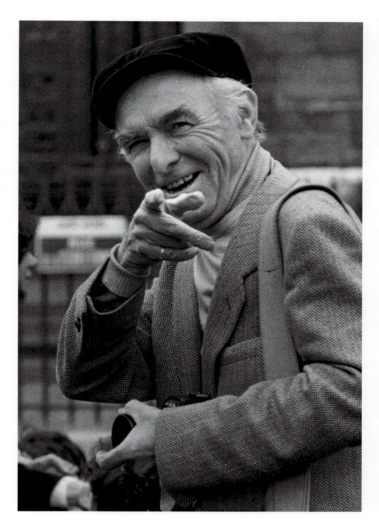

1
GERARD MONICO,
Robert Doisneau, 1986.

boxes that concentrate the mind on certain influential photographers.

I have discovered in the classroom that today's students are puzzled by the lengthy struggle waged through the nineteenth and twentieth centuries to have photography accepted as an art form. I have narrated that contest, not simply as a large-scale attempt to achieve parity with painting, but as it relates to wider social issues, such as the ascent of a professional, moneyed middle class and the rise of consumer culture.

Globalization has encouraged a convergence and blurring of photographic genres: photojournalists show their work in art galleries; artists create new magazines to foster social change; practitioners from developing countries depict indigenous motifs from a postmodern perspective. The computer, invented, as its name suggests, to facilitate computations, has instead spun a communications web that has been investigated and refined by photographers from many fields. Along with my

student-colleagues, I am intrigued by emerging technologies, and I have concluded this survey with an investigation of digital photography at the beginning of the new millennium.

ACKNOWLEDGMENTS

Many people generously gave me time and advice during the preparation of this text. A. P. Balachandran, Geoff Batchen, Vladimir Birgus, Sarah Brock, Blanka Chocholova, Jana Colacino, Sabeena Gadihoke, Bissy Genova, Holly Jennings (Harry N. Abrams), Catherine Ann Johnson, Ulrich Keller, Laura Levin, Frank Macomber, Elizabeth Anne McCauley, Michael More, Doug Nickel, Phil Ono, Ram Rahman, Gina Rodríguez, Larry Schaaf, and Mira Shin all offered valuable information and good counsel.

I also wish to thank the following reviewers who made such useful contributions to the development of my manuscript: Wendy Brill-Wynkoop, College of the Canyons; George Dimock, University of North Carolina at Greensboro; Peter Bacon Hales, University of Chicago, Illinois; Dan Higgins, University of Vermont; David L. Jacobs, University of Houston; Miles Orvell, Temple University; James Paster, Sam Houston State University; and Al Wildey, University of Idaho.

While still an undergraduate, Diana Perez ably took on research and translation tasks. In the Syracuse University Library, Ed Gokey was an impeccable researcher, and the ever patient and resourceful Randy Bond readily shared not only his knowledge of World War II and photography but also answered all manner of questions.

At George Eastman House in Rochester, New York, Becky Simmons helped me learn about the illustrated photo-graphic book, as did Roy Flukinger and David Coleman at the Harry Ransom Humanities Research Center, University of Texas at Austin. Throughout the book, I checked dates against the George Eastman House Database, maintained by Andrew Eskind and Del Zogg.

At Laurence King Publishing Ltd., Lee Ripley Greenfield patiently persuaded me that I could write this book. I was fortunate in having in Damian Thompson a steadfast development editor. I was equally fortunate in having in Richard Mason an experienced managing editor who guided all aspects of the editorial process, picture research, design, and scheduling with immense dexterity.

My thanks go to Michael Bird for copyediting and cutting the text, and for skilfully polishing my prose. Sue Bolsom and her team of picture researchers tirelessly pursued images and creatively suggested alternatives where necessary. Designers Tim Higgins and Ian Hunt have fashioned handsome and dramatic pages that do full justice to their subject.

On the homefront, I am indebted to my spouse and live-in editor, Michael Marien, for his intelligent and careful editing of the manuscript. My greatest obligation, however, is to those legions of people whom I have never met. This book, and the ongoing course of researching and writing photography's history, owe to an international community of photographers, scholars, and critics whose efforts are expanding our field. Without their research, I could not have written this volume. It is to them, the denizens of the footnotes, that I humbly dedicate this book.

MARY WARNER MARIEN
Syracuse University, Syracuse, New York
May 2002

Introduction

One of photography's oldest dreams lay as if stranded on the floor (Fig. 2), snubbed by the museum crowd who refused to be taken in by it, and skirted by schoolchildren who guessed that it was a trick to lure them into trouble. The neatly stacked pile that sophisticates and students shunned, as if it was a nest of ugly bugs, was made up of identical photographs of rain-fattened clouds taken by Felix Gonzalez-Torres (1957–1996). The Cuban-born artist was indifferent to the orthodox purity of art media and eager to explore the poetics of the mundane. In the past he had put photographs of an elegantly rumpled

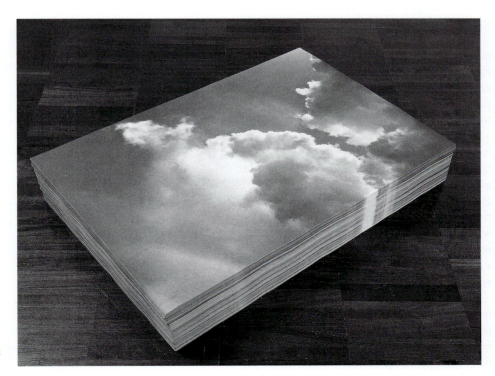

2
FELIX GONZALEZ-TORRES, *Untitled (Aparición)*, 1991. Offset print on paper.

bed on public billboards to encourage interpretations, or invited gallery visitors to open and consume shinily-wrapped candies that he had spilled onto thick carpets.

Had some of his cloud pictures found their way onto the waiting school bus, the watchful security staff were instructed not to notify the police but instead to summon the curator, who might then replace the missing items with exactly the same number that had been taken. While Gonzalez-Torres mocked the belief that art should be precious by his use of cheap materials, and by giving away his work, he nevertheless had exacting standards for how high his pile of cloud pictures should be at all times.

About a decade after photography was disclosed to the world in 1839, commentators began to ponder how to gather and distribute information cheaply or freely through camerawork. Ever since, the potential for the wide dissemination of photographs through photographic reproductions has thrilled and perplexed social pundits. Inexhaustibly free, a work of art and of science, ephemeral and permanent, neglected but controlled, Gonzalez-Torres's stacked images condensed an enduring dialogue about the dream of free access to the world of visual experience. They also summarized what the photographer and critic Allan Sekula called the "goofy inconsistency" of assertions made about the medium.[1]

By 1850, photography was deeply at odds with itself. It was conjectured to be variously an art, a danger to art, a science, a revolutionary means of education, a mindless machine, and a threat to social order. For some, photography augured a modern, bloodless class revolution achievable through the democratic dissemination of knowledge hitherto available only to the well-to-do. Others envisioned a monstrous social degeneration in which the middle class, sated with visual fantasies of reality, would repudiate accepted values and become a breed of narcissistic, self-justifying voyeurs.

Advocates of photography's potential tended to ignore the ways in which the photograph was not an objective view but a series of choices concerning selection of subject, angle of view, and degree of staging, as well as subsequent manipulations that adjusted tones and cut away or erased sections of the print. Then, as now, photography was often considered a universal language, uninflected by culture or personality. In the nineteenth century, commentators speculated that the new medium's neutrality would increase opportunities for people who had little schooling.

No doubt many nineteenth-century campaigns for visual and verbal literacy had as their aim the moral improvement and political pacification of the huge influx of urban workers. In other words, photography was quickly enmeshed in the intricate nineteenth-century dialogue about modernization and its social effects. At the same time, it was also framed through the big ideas of Western thought: seeing and knowing; nature and culture; originality and knowledge; reality and illusion.

The history of photography is as endlessly surprising as the emergence of a butterfly from a wrinkled chrysalis. Who could have predicted that so soon after photography's invention, the French photographer Hippolyte Bayard would trifle with realist representations and create pictures in which statues appear to float or be ready to step out of their niches (see Fig. 2.10)? And how did a late nineteenth-century amateur photographer and non-practicing doctor, Peter Henry Emerson, convincingly make the case that photography should be considered an art?

In order to understand photography, I believe we have to approach it as more than clusters of canonical images and contraptions. The far-reaching social dialogue about photography did not fluctuate at the same speed as technological invention, nor in reaction to a few pictures. Instead, people responded to the *idea* of photography. For Lady Elizabeth Eastlake, writing in 1857, photography portended a proliferation of images that fed what she called the "craving or rather necessity for cheap, prompt, and correct facts," but which was antithetical to progress in the finer things, such as art.[2] Henry James's famous 1890 short story "The Real Thing" pointed out that mass media encouraged the general public's "perversity—an innate preference for the represented subject over the real one."[3]

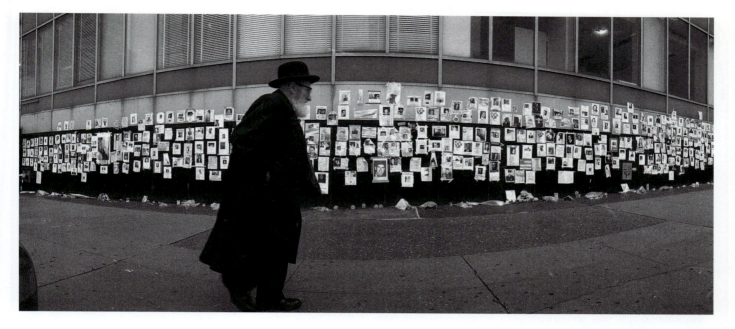

3
TED S. WARREN, *After the Attacks, New York, September 2001.*

On Thursday, September 20, 2001, an old man walks past photos of individuals missing since the devastating attacks on the World Trade Center on September 11. The images were pasted onto walls outside the NYU Medical Center in Lower Manhattan.

Writing on photography in 1927, the otherwise perceptive German critic Siegfried Kracauer lambasted "the blizzard of photographs," especially in the illustrated magazines and newspapers, calling it a "secretion of the capitalist mode of production" that swept away the dams of memory and annihilated meaning.[4]

More recently, historian Daniel Boorstin warned in 1961 that we are threatened by a "new peculiarly American menace. It is not the menace of class war, of ideology, of poverty, of disease, of illiteracy, of demagoguery, or of tyranny, though these now plague most of the world. It is the menace of unreality."[5] The state of photography emerged as a central intellectual concern in the late 1970s and the 1980s, when the medium came to symbolize both the mass media and the experience of mediated reality. Sounding the alarm, art critic Thomas Lawson ominously declared that "the camera, in all its manifestations, is our god, dispensing what we mistakenly take to be truth."[6]

In the early twentieth century, the piquant blend of psychology and desire that erupted in Surrealist art unexpect-edly vaulted from the gallery to the illustrated newspaper, where momentary collisions of fact and symbol, subsequently called "grab shots," have dominated the place "above the fold" ever since. In the aftermath of September 11, 2001, we came to see that an affecting symbolism was wrung from family photographs arrayed as impromptu posters of the missing, memorials to those who were lost, and as declarations of patriotism (Fig. 3). Vernacular images were transformed into mass media.

Our time is characterized by such mergers. Art, photojournalism, social documentary, and scientific imaging are converging, blurring traditional boundaries and energizing photographic practice. Photojournalists routinely show their work in art galleries, and artists launch magazines to circulate photographs that depict the modern world and encourage social change. When the critic John Berger wrote that "the relation between what we see and what we know is never settled,"[7] he pinpointed the underlying, unresolved tension that animates photography and keeps it engaging new audiences. Always fascinating, photography continues both to reflect and shape our world.

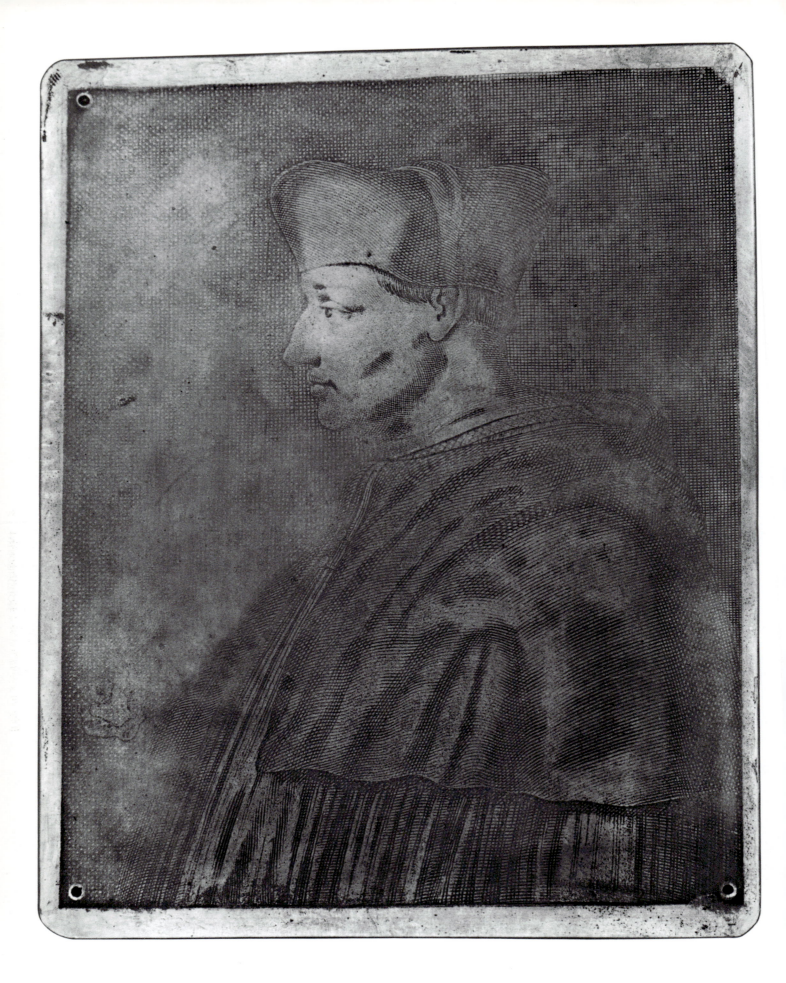

The Origins of Photography (to 1839)

**1.0
JOSEPH NICÉPHORE
NIÉPCE,** *Cardinal
d'Amboise,* **1826.
Heliograph on pewter
plate (reproduction of
an engraving). Musée
Nicéphore Niépce,
Chalon-sur-Saône,
France.**

A seventeenth-century
image of Cardinal
d'Amboise was one of
the most popular and
commercially successful
engravings in France.
Niépce copied the
image onto a pewter
plate by photographic
means as an experiment
to show that the process
would make it possible
to print multiple copies,
although he never
seems to have done so.

Photography was presented to the world on August 19, 1839, at a joint meeting of the Academy of Science and the Academy of Fine Arts in Paris. Claiming a sore throat, Louis-Jacques-Mandé Daguerre (1787–1851), the specified inventor, did not make the initial presentation. He left the demonstration and technical discussion to François Arago (1786–1853), a scientist and member of the Chamber of Deputies, the lower house of the French government. For his accomplishment, Daguerre was awarded a lifelong pension from the French government. The only requirement placed upon him was that he fully reveal his method, which he did in his booklet *Historique et description du procédé du Daguerréotype et du Diorama* (*History and Description of the Process of the Daguerreotype and the Diorama*) (1839). The text was quickly translated into many languages and published around the world.

Tradition still casts Daguerre as the originator of photography, a consensus initiated by François Arago almost two centuries ago. Yet the history of the development of photography is a more complicated tale, involving partial successes, missed opportunities, good fortune, and false starts. It centers on basic questions about how the elements of history, especially the history of technology, are reckoned and ordered. The oft-repeated story of the presentation of photography in 1839 says little about the precursors of the medium, the specific course of invention, the social environment in which the medium was conceived, and about others who contributed to Daguerre's work or who formulated different photographic processes.

The basic ingredients of photography—a light-tight box, lenses, and light-sensitive substances—had been known for hundreds of years before they were combined. If the invention of photography had depended solely on the availability of materials, it might have been a late Renaissance invention. Indeed, all but the light-sensitive material was present in a technique for astronomical observation that used some European cathedrals like cameras. Beginning in the sixteenth century, the dark interiors of churches such as Santa Maria del Fiore in Florence, Italy, and Saint-Sulpice in Paris, France, were punctuated with a small hole in the roof, which worked like a lens to focus an image of

the sun on the floor below, where its movements were measured and used to establish the modern calendar. Ironically, these gauges verified Galileo's theory that the sun, not the earth, was the center of our universe, an idea repudiated by the Catholic Church.[1] With the cathedral serving as a camera, a light-sensitive material might have been found in silver. Silversmithing was an advanced art in the Renaissance, and the perception that silver darkens when exposed to light was an ancient commonplace. If someone ever tried placing a polished silver plate on the floor of the cathedral, however, to see whether it would register the sun's image, the record of that experiment has not survived.

Before the end of the eighteenth century, imagining the photographic process seems to have been difficult. Unlike other transformational technologies, such as air travel and automobiles, photography was not foreseen in the centuries before it was invented. Looking back on what was widely perceived as the medium's abrupt appearance, American essayist and medical doctor Oliver Wendell Holmes (1809–1894) remarked that "in all the prophecies of dreaming enthusiasts, in all the random guesses of the future conquests over matter, we do not remember any prediction of such an inconceivable wonder No Century of Inventions includes this among its possibilities."[2] In utopian and speculative fiction written prior to 1800, only the 1760 novel *Giphantie*, by French writer Charles François Tiphaigne de la Roche (1723–1774), anticipated something like the detailed transcription of the observable world that would occur with photography. In *Giphantie*, a narrator visits the hollow of the earth's center where a group of spirits creates highly illusionistic paintings. A canvas is smeared with a mysterious viscous material and placed before a desired scene. Like a mirror, it records every color and detail. After an hour's drying time in a dark place, the picture becomes permanent. Arguably, *Giphantie* anticipated the use of light-sensitive chemicals, but the story did not involve a light-tight box, lenses—or a human operator.

Although it seems that the invention of photography should be related to the start of the Industrial Revolution, its connection to the technical, social, and political changes that accompanied the initial mechanization of production during the late eighteenth and early nineteenth century in Europe is not easy to establish. The desire for reliable visual reproductions has been linked to the needs of expanding commerce and industry, and the wish of the emerging middle class for realistic portraits. But around 1800, when the first documentable experiments attempted to record the visible world by means of light-sensitive materials, these trends were not clearly discernible to contemporaries. It is as if photography was invented twice: once during a period of largely concealed and scattered technological development, from the turn of the eighteenth century to 1839; and again, in the decades after disclosure, when it would be ceaselessly reinvented by the social uses to which it was put and the cultural dialogue surrounding it. A similar lag between invention and social use occurred with the fax machine, which had working prototypes in the 1920s, but which did not come into widespread use until the late twentieth century, when business and science demands for quick, global transmissions increased.

BEFORE PHOTOGRAPHY

Describing the late eighteenth century, historian Eric Hobsbawm persuasively depicted a world that was largely rural, in which there was no urban, mass culture pressing for realistic, multiple images.[3] Even in Britain, where industrialism was most advanced, the stream of reports, novels, and documents describing the Industrial Revolution did not appear until the 1830s and 1840s. In the early nineteenth century, the visual arts were dominated by Neoclassical idealism and Romantic expression. Naturalistic depiction of reality was occasionally pursued, for example, in the German landscape painting called Biedermeier, or British watercolors such as those of John Sell Cotman (1782–1842), although this trend did not yet seem influential. While the British artist John Constable (1776–1837) struggled to render his observations of the changing

light effects of sun and clouds in the rural landscape, his successful contemporary Joseph Mallord William Turner (1775–1851) produced fantastical medleys of color unfettered by mere depiction. Similarly, during the 1820s, French artist Eugène Delacroix (1798–1863) was fascinated with expressionistic color and theatrical lighting effects, and was less interested in realism. By the mid-1830s, when many painters became more concerned with the appearance of mundane reality, as in the work of the Barbizon School of artists such as Théodore Rousseau (1812–1867), photography had been invented by several people.

The invention of photography—or photographies, since several different image-making methods were created—did not depend directly on the impetus of a particular visual tradition, or even a demonstrable social need. Instead, the climate of congenial attitudes toward material progress, research, and innovation encouraged its conception. Around 1800, western European countries began to define government's role as fostering economic development through the expansion of industry and commerce. Social progress was understood to flow from the intellectual freedom of individuals seeking to solve scientific problems that would lead to practical applications. Those with the most to gain from this attitude toward change were the educated classes, as well as entrepreneurs, manufacturers, and enlightened landlords—people making up a growing middle class whose status was based on their achievements and earnings.[4]

The primary elements of the photographic process began to be linked and experimented with in an era when practical, commercially feasible applications of scientific experiments were encouraged by national policy and cultural values. Independent entrepreneurs and business people started to believe that their investments in research might be rewarded. Much of the history of early experiments in photography shows cultural attitudes prompting resourceful individuals to resolve technical puzzles. Not every inventor sought financial gain and acclaim, but each of the originators whose stories we know believed in tinkering with devices and testing formu-

las. In 1839, when the medium was disclosed, the industrializing world was ready to apply it to portraiture, record-keeping, political persuasion, academic investigation, and travel accounts. But around 1800, when scattered inventors began attempting to record optical reality by chemical and optical means, that cultural readiness for photography's later uses is not apparent.

TECHNOLOGICAL AND ARTISTIC FOREBEARS

Because our culture places great value on the imaginative art of the past, it is sometimes forgotten that one of the most common uses for visual depictions in the centuries before photography was to copy the observable world and to communicate visual information in an uninflected manner. Routine commissions for landscapes and portraits did not generally call for the artist's personal interpretation. Similarly, engravers and etchers, who produced multiple images from drawings cut into a wooden or metal plate, were expected faithfully to copy historic monuments, machines and devices, animals and botanical specimens, and even works of art.

Contraptions to help artists produce images had existed for centuries. Machines designed to render perspective, the illusion of three-dimensional space on a flat surface, began to be built during the Renaissance.[5] In the early sixteenth century, Leonardo da Vinci (1452–1519) depicted one in use (Fig. 1.1). A piece of netting with a series of regular, open rectangular shapes was

**1.1 (right)
LEONARDO DA VINCI,** *Draughtsman Using a Transparent Plane to Draw an Armillary Sphere,* **c. 1510. Drawing. Biblioteca Ambrosiana, Codice Atlantico 1 r, Milan, Italy.**

The artist's eye is placed at a set distance from the panel of glass located before an object to be traced. One eye is covered or closed, and the head may be fixed so that it cannot move. The object, in this case an astronomical model called an armillary sphere, is traced on the glass, and then copied on to drawing paper.

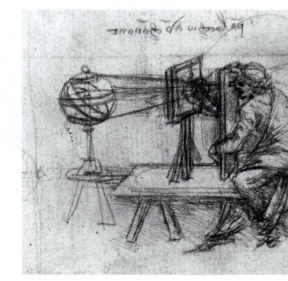

placed in front of a subject, and the artist copied the subject as it appeared in each rectangle on to drawing paper that had been prepared with similar, but scaled-down rectangles. The net was particularly useful in foreshortening, that is, contracting the image of an object or human figure so as to create the appearance of perspective. A variant of the technique, employing graph paper, is used today.

The PANTOGRAPH, familiar since the seventeenth century, and still available as a drafting tool and as a child's toy, helped artists copy, enlarge, or reduce drawings. French engraver Gilles-Louis Chrétien (1754–1811) adapted the pantograph to engraving in 1786, calling his invention the PHYSIONOTRACE (Fig. 1.2). The physionotrace mechanized a technique for making profiles (Fig. 1.3) that can be traced back to the time of Louis XIV (1638–1715; r. 1643–1715). Not only did the physionotrace permit users to make multiple copies but color could also be applied.[6] SILHOUETTES, or

**1.2 (left)
ARTIST UNKNOWN,** *Gilles-Louis Chrétien's Physionotrace.* **Drawing, c. 1786. Bibliothèque Nationale de France, Paris.**

Chrétien adapted the pantograph's tracing procedures to portraiture. In the upper section of the device, the artist viewed the sitter through an eyepiece, moving it to trace the profile. A stylus in the lower frame tracked the eyepiece movements exactly, registering them in ink on paper. The portrait was transferred to a copper plate, etched, and used to make multiple images.

**1.3
ARTIST UNKNOWN,** *Gilbert Motier, Marquis de La Fayette, 1895;* (below image) *D'après le physionotrace de Quenedey.* **Aquatint, colored, after physionotrace drawing. Marquis de Lafayette Print Collection. David Bishop Skillman Library. Lafayette College Library, Easton, Pennsylvania.**

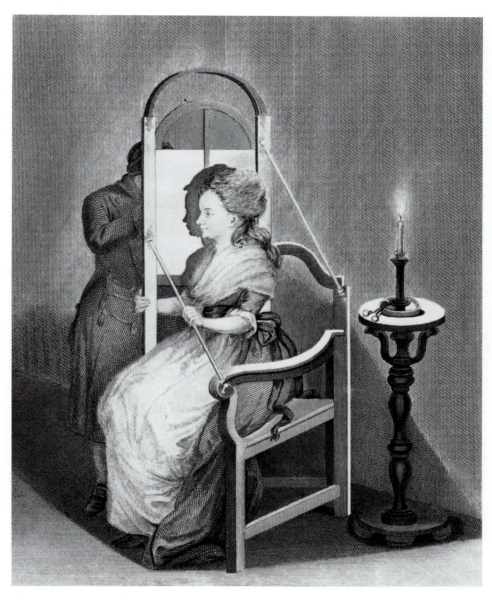

The Swiss scientist J. K. Lavater was a major proponent of the silhouette form. The shadow cast by sunlight or a candle was traced on to paper. The image was filled in with ink, or used as a template to cut a silhouette from black paper. The silhouette's popularity drew on the increasingly widespread conception that human character could be read through the study of facial features.

shadow portraits, were part entertainment and part artistic venture. Silhouette makers primarily served the bourgeoisie, but they also sold profile portraits on the streets and at parties. Some dextrously cut dark paper while observing a subject standing in profile; others used a candle to project the outline of a subject's head on to a sheet of paper (Figs. 1.4, 1.5).

The public acceptance of the silhouette, usually a single image, and the physionotrace, which produced multiple, engraved images, accompanied the growth of the middle classes in eighteenth-century Europe, and their taste for likenesses rendered without the idealization and ornament flaunted in aristocratic portraits. A seemingly neutral descriptive approach to portraits in all media began to distinguish middle-class likenesses from those created for the upper classes. In addition to being quicker than painting, and certainly less expensive, the silhouette and the physionotrace responded to the middle-class view of itself as a distinct social group. Such portraits exemplified a sense of individualism and accomplishment among professionals and business people, expressed not simply through the ownership of portraits, but through a preference for likenesses that accentuated such personal features as the shape of the nose and the slant of the forehead. Treatises on physiognomy, the study of physical features to deduce human character, appealed to a middle class seeking new ways, beyond pedigree, to understand temperament and personal achievement. As they evolved, mechanical aids to drawing became more exact, emphasizing outlines and contours, rather than shading, or

1.6
GEORG BRANDER,
Table Camera Obscura,
1769. Engraving.
Gernsheim Collection.
Harry Ransom Human-
ities Research Center,
University of Texas
at Austin.

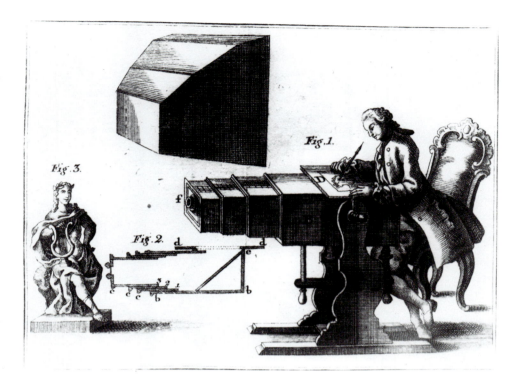

atmospheric effects, or personal inter-
pretation. A similar idea of a neutral
representation found favor in the sci-
ences, especially biology, botany, and
geology, which sought methods to con-
vey visual data objectively.

The drawing aid with the most direct
effect on photography was the CAMERA
OBSCURA, literally, a "dark room."
Actually, the camera obscura was origi-
nally a darkened, room-size chamber, in
which a tiny opening in one wall acted
like a lens, focusing an upside-down
image of the scene outside on to the
opposite wall. Over time, the room-sized
chamber was made smaller and por-
table (Fig. 1.6). It was equipped with
lenses, and constructed with an internal
mirror so that the upside-down image
was righted and could be traced on a
piece of paper placed on a translucent
glass plate installed in the top of the
device. Like other machines to aid draw-
ing, the camera obscura did not encour-
age imagination or personal style, and
usually produced stiff, formal images
(Fig. 1.7). It could help artists to trace the
outlines of shapes, but it obviously could
not copy the religious, historical, or
mythological scenes that were central
to art production until the nineteenth
century.

An even more transportable and
lightweight aid to drawing was patented
in 1806 by British scientist William
Hyde Wollaston (1766–1828). Simple, if
somewhat awkward to use, the CAMERA
LUCIDA, or light room, consisted of a
rod to which was affixed a glass prism
having two silvered sides that reflected
the scene at which it was aimed. A per-
son wishing to draw a scene would
attach the camera lucida to a drawing
table and adjust the prism so as to
reflect an image directly into the eye.
Looking down, the user then moved the
prism slightly to create the illusion of
the scene existing on the drawing paper.

1.7
THOMAS SANDBY,
*Windsor from the
Goswells,* 1770. Camera
obscura drawing.
The Royal Collection.
© 2002 Her Majesty
Queen Elizabeth II.

English artist Thomas
Sandby (1721–1798)
used a camera obscura
to create this view on
four pieces of paper
overlapped to present a
wide panorama. In
his expert hands, the
strength of the device is
apparent, especially in
the proper perspective
accorded the concen-
trated buildings in
the distance. Since the
camera obscura involves
tracing an image, it is
inadequate in rendering
atmospheric effects
such as cloudiness.

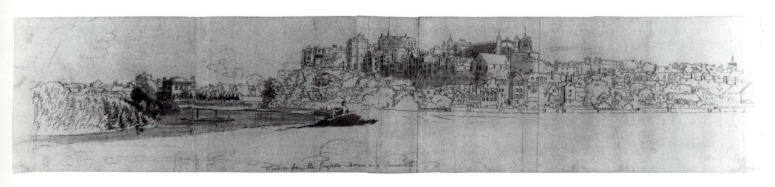

**1.8 (right)
CORNELIUS VARLEY,
*Artist Sketching with a
Wollaston Camera
Lucida*, 1830. Engraving.
Gernsheim Collection.
Harry Ransom Humanities Research Center,
University of Texas
at Austin.**

The British watercolor
artist Cornelius Varley
(1781–1873) not only
used the camera lucida,
but also came up with
his own improvement
in 1811, called Varley's
Graphic Telescope. This
employed a cylindrical
telescope to create the
illusion that the image
of a scene existed on a
sheet of drawing paper.

The would-be artist could then trace the outlines of the scene directly on to the drawing paper, while looking up occasionally to check the actual scene. The camera lucida was useful to travelers who wanted to record topographic or architectural views (Figs. 1.8, 1.9).

There were, in sum, two general categories of drawing aids. The first, like the camera lucida, helped artists produce a single image. The second, like the physionotrace, yielded multiple copies. The development of these devices in the years prior to photography indicates different needs, not a concerted social demand. For example, landscape artists used drawing devices to make a visual record as part of the preparation for a painting. Travelers employed these tools to render mementos of a scene. In either case, the user did not ordinarily intend to make multiple copies of the image, like copy-artists, engravers, and printers. Similarly, when photography was invented by a number of individuals, some created systems that produced unique single images, and others fashioned techniques that could make multiple copies.

Single-original vs. multiple

THE INVENTION OF "PHOTOGRAPHIES"

The history of the first photographs has been made to fit into the widely accepted notion that invention is regular and progressive, with each experiment building in an orderly, successful way, on the achievements of the past. However, none of photography's pioneers reported making headway in that fashion. Even limiting the standard history of the medium's inception to a few celebrated European efforts in the late eighteenth and early nineteenth centuries, so as to then imply a link to the Industrial Revolution, has not produced a neat chronology of inventions. The camera has been seen as an image-making machine swiftly spewing out pictures as mechanized looms produced cloth for a new market. But the swift camera started to take shape only after 1855, through the combined effect of technological changes, the development of networks for the production and consumption of images, and the emergence of a mass market public. The first

Drawn by C. Varley for G. Dollond, with the Camera Lucida.

photographs were much closer to preindustrial craft production, in which single, unique objects were made by hand.

FLORENCE AND THE QUESTION OF SIMULTANEOUS INVENTION

French artist and cartographer Antoine Hércules Romuald Florence (1804–1879) traveled through the interior of Brazil with German naturalist Baron Georg von Lansdorff (1774–1852) to record the area's peoples and natural settings. After the expedition he settled in a remote part of the province of São Paulo, where he painted views and portraits. In 1830, while trying to publish a book on animal sounds, he became frustrated by the lack of nearby printing shops, and invented his own printing technique, which he called *poligraphie*, meaning "multiple writing." Soon after, Florence conceived photography after noticing that certain fabrics faded when exposed to light. According to Boris Kossoy, Florence was successful because he was removed from centers of scientific learning, and had to think unconventionally.[7] With the aid of the local

druggist, Florence experimented with the camera obscura to see if he could make its images permanent. Unsuccessful, he investigated the printmaking potential of glass plates that were covered with a dark mixture of gum arabic and soot. Like an engraver, he scratched designs into the plates, and then placed them on paper that had been made light-sensitive through a treatment with silver chloride, which darkens in the presence of light. The paper's light-sensitivity could be halted by the application of an ammonia solution, which stopped the darkening action.

Florence's diaries show precise drawings of small cameras and of printing frames that used sunlight to print an image. In 1832, he began using the term *photographie* for his process, deriving it from the Greek words for light and writing.[8] He used his photographic technique to produce diplomas, tags, and labels, but appears not to have fared well in reproducing camera images. When Daguerre's photography was announced in 1839, Florence realized that his humble efforts could not compete, and he directed his energies toward other aspects of the printing business.[9] Writing to newspapers in São Paulo and Rio de Janeiro, he modestly declared that he would not "dispute anyone's discovery ... because two people can have the same idea."[10]

The notion of simultaneous invention—that two or more people can develop the same concept at about the same time—was mentioned by Florence and by another of photography's pioneers, William Henry Fox Talbot (1800–1877), whose experiments are discussed later in the chapter.[11] Simultaneous invention makes it difficult to construct a linear chronology of photography and suggests, moreover, that there may have been other successful yet unknown attempts to invent photography. If Florence, living in a remote area, could originate a way to reproduce labels using a light-sensitive silver compound, others elsewhere in the world may have had similar partial success. It is probable that, while the work of individuals like Florence will become better known, the precise history of photography's invention will never be fully ascertained.

1.9
WILLIAM HENRY FOX TALBOT, *Camera Lucida Drawing of the Terrace at the Villa Medici,* **October 5, 1833. Drawing. National Museum of Photography, Film and Television, Bradford, England.**

Talbot's hesitant sketch may indicate the frustration he felt while using the camera lucida. Ineffective hand renderings such as this one prompted him to conceive a method of photography.

Villa Melzi

5th Oct.r 1833

THE PROBLEM OF PERMANENCE: WEDGWOOD AND DAVY

Many histories of photography trace the development of European photography through the research of Thomas Wedgwood (1771–1805) and Humphry Davy (1778–1829), both of whom—unlike Florence—were in touch with up-to-date scientific inquiry. Wedgwood, son of Josiah Wedgwood (1730–1795), the British amateur scientist and pottery manufacturer who helped popularize Neoclassicism with his designs, attended meetings of the Lunar Society, a distinguished group that included physician-scientist Erasmus Darwin (1731–1802), inventor James Watt (1736–1819), and the political theorist and scientist Joseph Priestley (1733–1804). The group kept abreast of scientific discoveries in Europe and America, and deliberately sought practical applications for new findings. Thomas Wedgwood's special interest was the new, or French, chemistry developed by Antoine-Laurent Lavoisier (1743–1794), who mandated repeated testing of hypotheses in the laboratory, a practice he helped to establish as the standard for the field. The new chemists were animated by the sense that they were discovering the world afresh.

An enthusiasm for science, especially the new chemistry, prompted Thomas Wedgwood and his friend Humphry Davy, then a humble apothecary's apprentice, to experiment with light-sensitive materials. They sought to fix the image of an object's shadow cast on paper or leather that had been made light-sensitive by immersion in a silver nitrate solution, and they also attempted to capture images formed in a camera obscura. In addition, they tried to copy paintings on glass, by letting light pass through the glass on to light-sensitive paper. Unknown to them, silver nitrate was not sufficiently light-sensitive to hold the camera obscura images. The more direct approach, shadow images of objects and paintings on glass, did leave a photographic imprint, although it was not permanent, since the silver nitrate continued to react to light until the surface darkened. In his 1802 report on their work, Davy announced that "nothing but a method of preventing the unshaded part of the delineation from being coloured by exposure to the day is wanting, to render the process as useful as it is elegant."[12] Wedgwood's serious illness prevented further joint experiments, and Davy moved on in other scientific directions, eventually becoming the president of the Royal Society.

Although Wedgwood and Davy's experiments in fixing a light-induced image were less successful than the later efforts of Florence, their publication in the influential *Journals of the Royal Institution of Great Britain* (1802) meant that they could be consulted by scientists and later historians of photography (Florence's contribution was not recognized until 1970). Even so, their work did not become a stepping stone for subsequent successful attempts to stabilize an image through photochemical reactions. In that sense, it was as isolated as that of Florence in Brazil.

THE "SUN WRITING" OF NIÉPCE

Another precursor of photography was the "sun writing" developed in France by Joseph Nicéphore Niépce (1765–1833). Born to a family of people who had worked for French royalty, Niépce received a fine education, and he came of age with high expectations. The French Revolution beginning in 1789 altered his prospects, and, from the seclusion of a country estate, he sought ways of making a living. With his brother Claude, he spent years perfecting an internal combustion engine intended to power riverboats. Dubbed the *pyréolophore*, this engine was intended to rival the new onboard steam engine, by burning vegetable oil or other similar substances; it received a French patent in 1807. Like many would-be entrepreneurs who saw the development of new machines and processes as the source of prosperity, Niépce turned his attention to the potential of the lithographic process.

— LITHOGRAPHY, a technique for reproducing images, uses drawings on a flat surface, usually a smooth stone (ancient Greek: *lithos*), rather than a metal or wood recessed surface, as in engraving and etching. It was perfected in 1798 by the German actor and writer Alois Senefelder (1771–1834). For communicating information, the lithograph had several advantages. It could yield quite a

large number of prints and it could render tones and shadows more subtly than etching and engraving, which got their effects of light and dark from the closeness of individual lines scratched into the surface of the plate. Lithography appealed to painters, who could work directly on the lithographic stone without having laboriously to cut lines into the surface. But it also intrigued early nineteenth-century entrepreneurs, who saw in lithography a process that could surpass existing methods for illustration. In the early 1800s, lithography aroused the kind of get-rich-quick excitement generated in small computer and software companies in the late twentieth century.

Lacking the ability to draw on the lithographic stone, Niépce began to experiment with ways to produce an image through the action of light upon photosensitive materials. His early efforts, begun in 1816, involved the use of paper made light-sensitive by the application of a silver chloride solution. After exposing the photosensitive paper in a camera obscura, he experienced some of the very same problems as Wedgwood and Davy. The image was too indistinct, and the action of the light could not be thoroughly stopped. Moreover, the tones of the image were reversed: dark became light, and light became dark, to create what was later known as a NEGATIVE. Niépce tried, without success, to use the negative as it is used today, that is, printing it to create a POSITIVE image, in which the tones are re-reversed and thereby corrected. He also failed to alter the reversed dark and light areas through chemical means.

Undaunted, Niépce continued to try out various light-sensitive materials. He does not seem to have known about the experiments of Wedgwood and Davy; nor, like them, did he encounter many past investigations of such materials. An obscure 1727 paper on the effects of light on silver nitrate by German scientist Johann Heinrich Schulze (1687–1744) might have been difficult to locate, but experiments with light-sensitive materials conducted by Swedish chemist Carl Wilhelm Scheele (1742–1786), published in 1777, and the work of Swiss librarian and botanist Jean Senebier (1742–1809), published in

1782, would have been available to a researcher living in an academic and intellectual capital such as early nineteenth-century Paris. The discovery by British scientist John Herschel (1792–1871), published in 1819, that hyposulphite of soda dissolved silver chloride, thereby stopping its reaction to light, also seems to have been unknown to Niépce, although he did receive advice about photosensitive materials from French chemist Louis-Nicolas Vauquelin (1763–1829). Niépce's approach to photography was thus largely independent of the research of others.[13]

Beginning in 1822, Niépce shifted his interests to copying engravings by means of the action of light. To do so, he saturated an engraving with oil to make it more transparent. He then placed it on a pewter plate that had been coated with bitumen of Judea, a substance known to harden when exposed to light. After light exposure, the areas beneath dark parts of the engraving, the lines, remained soft, while those beneath the light parts of the engraving, the spaces between the lines, hardened. The plate was rinsed with lavender oil, washing away the soft areas. What remained was an engraving plate, whose grooved areas Niépce had further etched with acid, and then printed (Fig. 1.0).

Finding this procedure more encouraging than his experiment with silver chloride, Niépce put a similarly prepared plate in a camera obscura and exposed it in a window at his estate, Le Gras, near Chalon-sur-Saône. After about eight hours, he removed the plate and washed it, rinsing away those soluble areas of the plate where the bitumen of Judea had received less light. The resulting plate contained a poor but visible negative of the scene outside the window where the camera obscura had been placed. The image itself was reversed laterally, that is, left to right. Niépce then took the plate and exposed it to iodine fumes. The iodine did not fully reverse the tones, but created greater contrasts.[14] In effect, Niépce made what is now called a DIRECT POSITIVE image, one which, as the name implies, produces a photograph without a separate negative. Because there was no negative from which to print copies, the image could not be reproduced. Though not completely stable, Niépce's

View from the Window at Gras (c. 1826) is considered to be the world's first permanent photograph (Fig. 1.10).

In 1827, Niépce brought examples of his process, called heliography, from the Greek words for sun and writing, to London, where he was visiting his brother Claude, who still hoped to get financial backing for the combustion engine to power riverboats. Claude's ill-health and the increasing financial strains on the family prompted Niépce to seek funding for his photographic process. He managed to get the attention and support of Francis Bauer (1758–1840), a Fellow of the Royal Society, for whom he prepared a short "Notice sur l'héliographie" ("Notice on Heliography") (December 8, 1827), describing the process in general terms. His failure to generate interest in the process may have been due to Niépce's cautious concealment of his exact technique. Before returning to France in February 1828, Niépce left many heliographs of engravings and the *View from the Window at Gras* with Francis Bauer.

THE COLLABORATION OF NIÉPCE AND DAGUERRE

While traveling through Paris on his journey to Britain, Niépce met with Daguerre, at that time known as a painter, designer of stage sets, and co-proprietor of the Diorama, a distinctive kind of theater that presented realistic special effects to thrill audiences (Fig. 1.11). To plan his stage illusions, especially the impression of deeply recessed theatrical space, Daguerre employed the camera obscura. He also made some ineffectual attempts to capture photochemically the images produced by the camera obscura.

Daguerre and Niépce were introduced by Charles Chevalier (1804–1859), a Parisian maker of optical instruments and devices such as the camera obscura, with whom both men did business. After his disappointing trip to England, coupled with the death of his brother Claude in February 1828, Niépce redoubled his efforts to find a photochemical method to obtain

1.10
JOSEPH NICÉPHORE NIÉPCE, *View from the Window at Gras*, c. 1826. Heliograph. Gernsheim Collection. Harry Ransom Humanities Research Center, University of Texas at Austin.

Rediscovered in 1952 by photographic historians Alison Gernsheim and Helmut Gernsheim, the image still obscurely shows—on the left—an upper story of the Niépce residence that served as a pigeon house and, in the center, a slanted roof of a barn. Because the picture was exposed for about eight hours while the sun changed position, sunlight appears to be shining on the roof and both ends of the buildings.

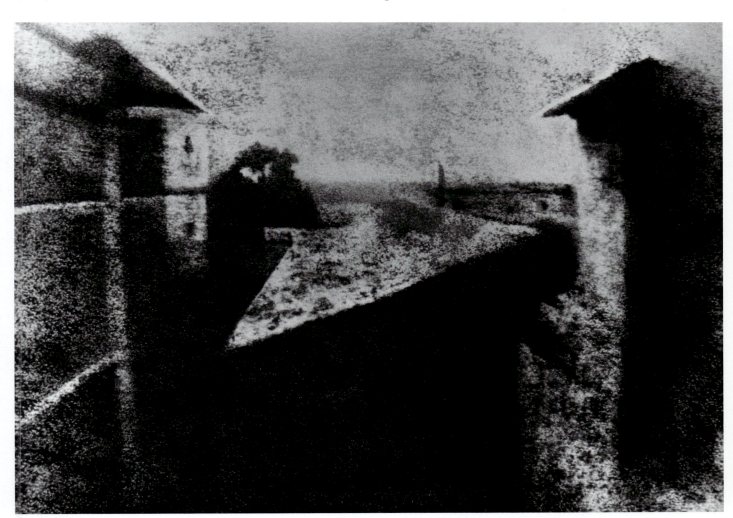

permanent camera obscura images. Niépce moved from using pewter plates to highly polished silver plates, and to copper plates covered with silver. He continued to use bitumen of Judea, which yielded better picture quality when employed on a silver backing.

Niépce had decided to work with Daguerre to improve the photographic process, even though, as the photographic historians Alison and Helmut Gernsheim concluded, Daguerre could not produce a successful photograph to show Niépce. In a contract signed by both on December 14, 1829, Daguerre promised to give Niépce an improved camera obscura, and Niépce agreed to show Daguerre the means by which he was able to capture camera obscura images, which he did at his estate. Daguerre later admitted that the camera obscura he gave to Niépce was ineffective in producing clearer images. When Niépce died suddenly in 1833, Daguerre took up his research.

DAGUERRE AND THE LATENT IMAGE

Daguerre's personal circumstances were very different than Niépce's. Born into a petit-bourgeois family, he lacked much formal education. Nevertheless, his out-going personality and drive to succeed contrasted with Niépce's docile yet mistrustful attitude toward others. Daguerre was poised to take advantage of social forces in the 1830s. In France, the hold of upper-class landowning interests remained strong, but was challenged by the growing power of middle-class commercial and industrial development. Business people, bureaucrats, and managers were part of an emerging elite based not on birth but on intelligence and hard work. Daguerre's humble beginnings and rise to prominence as a co-owner of the Diorama in Paris and, subsequently, in London made him something of a class hero.

By 1835, Daguerre's experiments with Niépce's materials—silver plates, silver-plated copper plates, and iodine—led to his concentrating on the creation of a LATENT IMAGE, that is, an image that had been registered on the silver surface of a plate, but which was not yet visible. Like Niépce, who treated *View from the Window* with iodine fumes, Daguerre realized that treatments after exposure could bring out the image more effectively. Where Niépce started with a visible image, and intensified the tones using iodine fumes to give the picture greater contrast, Daguerre found that

**1.11
LOUIS-JACQUES-MANDÉ DAGUERRE,** *Landscape with Gothic Ruins and Figures,* **1821. Brown ink and wash drawing. George Eastman House, Rochester, New York.**

Daguerre's watercolor of the mists and shadows in a ruined Gothic church gives a sense of the dramatic style of the Diorama's entertainment. Through carefully planned shifting lighting, transparent paintings on thin fabric, and sound effects, audiences were given the impression of being in a ruin, on an alpine hill, or near a waterfall.

1.12
LOUIS-JACQUES-MANDÉ DAGUERRE, *Still Life* (Interior of a cabinet of curiosities), 1837. Daguerreotype. Société Française de Photographie, Paris.

In what may be the oldest surviving daguerreotype, Daguerre carefully arranged plaster casts, a wicker-wrapped bottle, and a framed print to show the remarkable ability of the new medium. Ranging from black to white, with many tones in between, the daguerreotype also demonstrated the ability to render different surface textures clearly.

there was a latent image on the exposed silver plate, which could be treated with mercury fumes, further developing the picture, and making it visible. Soon after, in 1837, he discovered that a solution of common table salt dissolved in hot water would stop the light-sensitive material from continuing to react (Fig. 1.12).

In the end, Daguerre's photographic process was simple enough that he, like Niépce before him, began to worry about someone stealing it, and robbing him of both his place in history and his long-sought financial reward. To make a DAGUERREOTYPE, a copper sheet plated with silver was given a high polish. The plate, as it was called, was placed with the silver side down over a closed box containing iodine. The iodine fumes fused with the silver to create silver iodide, which is light-sensitive. The plate was then fitted into a camera obscura adapted for it and exposed to light. Exposure times varied, but the earliest daguerreotypes took about four to five minutes (Fig. 1.13), as recorded in one of the reports sent to the French Chamber of Deputies. The plate, with its latent image, was then put in a special box and exposed to mercury fumes,

which blended with the silver to produce a visible image. The still light-reactive image was thoroughly washed with a sodium chloride (table salt) solution, which stopped the response to light, and then carefully rinsed with plain water.

With his success, Daguerre renegotiated the contract he had made with Niépce, which was held by Niépce's son, Isidore (1805–1868). In 1837, Daguerre demanded and received the right to call himself the inventor of the process, and to have the process bear his name. Isidore Niépce secured his father's legacy by getting Daguerre to agree that accounts of both photographic processes would be published together. Additionally, Daguerre and Isidore Niépce arranged to market the processes by subscription, that is, by selling shares to the public. An initial attempt in 1838 to convince the public to buy shares in the new business failed. Paradoxically, Daguerre's reputation for creating optical illusions at the Diorama seems to have made the public suspicious of his methods. For a second attempt in late 1838, Daguerre prepared a broadsheet describing his research and that of Niépce. He subtly promoted his own process, while paying sentimental,

**1.13
LOUIS-JACQUES-
MANDÉ DAGUERRE,**
*View of the Boulevard
du Temple,* c. 1839.
**Daguerreotype.
Bayerisches
Nationalmuseum,
Munich, Germany.**

Early daguerreotypes
made city streets seem
deserted, because
carriages and pedestri-
ans moved too quickly
to be registered on the
daguerreotype plate.
The man on the corner
with his foot raised has
probably stopped to
spend some time having
his shoes polished,
hence his image and
that of the bootblack
were recorded.

faintly belittling attention to Niépce's
early efforts. The broadsheet boasted
that the daguerreotype required only
three to thirty minutes outdoor exposure
to light, and speculated on future uses.
Daguerre considered that the daguerreo-
type would be used by the "leisured
class," making renderings of country
houses, and providing the means to
"form collections of all kinds." "The
little work it entails," he concluded, "will
greatly please ladies."[15]

At about the same time, Daguerre
attempted to persuade prominent scien-
tists and artists to endorse his photo-
graphic process. When the astronomer
and politician François Arago saw the
daguerreotype, he soon set about secur-
ing French government assistance for
the process. Government support for
science and invention was an important
feature of French intellectual life.[16] With
the sponsorship of a member of the
French Academy of Science, and the
approval of the Academy, a French citi-
zen could approach the relevant govern-
ment department for funds. Arago, a
liberal and progressive member of the

Chamber of Deputies, had already spon-
sored bills for the development of the
railroad and the telegraph. While he
may have seen in Daguerre's process a
counterpart of his own attempts to
measure the intensity of light, he also
recognized that the ingredients of the
daguerreotype process were sufficiently
simple and easily available that the pro-
cedure could be quickly copied. Since
copyright would not readily secure
rights to the process, Arago cleverly
suggested that the government provide
Daguerre and Isidore Niépce with pen-
sions, and that the new process be
magnanimously given to the world by
France.

On January 7, 1839, Arago made a
statement to the French Academy of
Science describing the process in the
most general terms, and emphasizing
the originality of Daguerre's inven-
tion. The day before, H. Gaucheraud, a
journalist writing for the *Gazette de
France*, previewed the new process,
suggesting that the fine detail of the
daguerreotype would not substantially
challenge drawing and painting,

because the appearance of the daguerreotype was much closer to the look of engravings, and of mezzotints, a printing process able to produce a greater range of tones than etchings and engravings.[17]

RESPONSES TO THE ANNOUNCEMENT OF THE DAGUERREOTYPE

News of Daguerre's invention was quickly broadcast, and caught the attention of those who recalled related experiments and those who were working on similar photographic processes. Francis Bauer, to whom Niépce had given some heliographs, quickly organized a British exhibit of these works, in an effort to publicize his acquaintance's earlier accomplishments. In a March 1839 paper on photography, John Herschel recalled that a book by Elizabeth Fulhame, *View to a New Art of Dying* [sic] *and Painting* (1794), proposed capturing and retaining images on cloth through the interaction of light and certain metals.[18] The historian of photography Pierre G. Harmant has revealed that, from 1839 on, twenty-four persons claimed to have invented photography.[19] Among them was Hippolyte Bayard (1801–1887), who attempted to deduce Daguerre's process before the specific information was released to the public.

BAYARD'S DIRECT POSITIVE PROCESS

Bayard, a minor official in the French Ministry of Finance with no scientific training, responded to the 1839 announcement of Daguerre's method by making photographic experiments. He aimed at making a direct positive print, such as that produced by Niépce and

1.14
HIPPOLYTE BAYARD,
Self-Portrait as a Drowned Man, 1840. Direct paper positive. Société Française de Photographie, Paris.

Playing on the Romantic notion of the misunderstood artist who commits suicide, Bayard penned a note on the back of this photograph, suggesting that he ended his life in penniless despair. Noting the darkness of his hands and face, Bayard added that these indicated decomposition, since no-one even came to the morgue to claim his body![20]

Daguerre, which he and others considered to be a simpler and more elegant process than theirs. Bayard completely darkened light-sensitive paper that had been soaked in sodium chloride by exposing it to light. He then took the blackened paper and soaked it again, this time in a solution of potassium iodide. When this paper was placed in a camera obscura and exposed, the light bleached the paper according to its intensity. Like the daguerreotype, Bayard's unnamed process produced a single, unique print that could not be used as a negative to make multiple copies.

Hoping to share Daguerre's success, Bayard showed his images to Arago, who was disconcerted by the prospect of another inventor. Doubtless aware of such famous challenges to discovery as the struggle between British scientist Joseph Priestley and French scientist A.-L. Lavoisier for the discovery of oxygen, Arago secured some small funds to enable Bayard to continue his experiments, but asked him not to announce his findings. Although Bayard exhibited about thirty of his direct positive prints on July 14, 1839, lack of official recognition prevented him from achieving Daguerre's celebrity. Using his direct positive process, Bayard created a comic yet critical response to his nation's neglect of his work. In an image he titled *Self-Portrait as a Drowned Man*, Bayard photographed himself feigning death by suicide (Fig. 1.14). Although Bayard's melodramatic pretense did not earn him the honor he desired, he did not drown himself, but went on to make further photographs, some of which, like his *Self-Portrait*, teased the viewer into thinking about what could be represented in photography, and what could not (see p. 32; Fig. 2.10).

HERSCHEL'S "PHOTOGRAPHIC SPECIMENS"

In Britain, meanwhile, John Herschel, like many scientists, became intrigued with the recent announcement of the daguerreotype, even though the precise formula and materials had not been divulged. Two decades before, in 1819, Herschel had explored the properties of a chemical called hyposulphite of soda, discovering that it would dissolve silver salts. "HYPO" (now the term for sodium

thiosulfate), used today in the development process of black-and-white photography, got its nickname from Herschel's nineteenth-century work. Another of Herschel's early photographic experiments was his 1831 exploration of the light reactions of platinum salts.

A few weeks after Daguerre's announcement, Herschel began to try his luck with photography. In his notebook for January 29, 1839, he wrote: "Expts [experiments] tried within the last few days since hearing of Daguerre's *secret* & that Fox Talbot has also got something of same kind."[21] On the very next day, with no understanding of Daguerre's process, but a wealth of knowledge about light-sensitive chemicals and lenses, Herschel succeeded in fixing a camera image and conceived of making prints from a negative image. On February 7, 1839, he showed some of his images at the Royal Society. Writing to his friend and colleague Talbot a few days later, he referred to his "photographic specimens" (Fig. 1.15), thus coining the word "photographic", which quickly evolved into photography, the general term for the medium. (The term *photographie* employed by Florence may have been used earlier, but his work was unknown in Europe.)

Herschel's photographic investigations continued into the 1840s. He experimented with the possibilities of color photography, using vegetable dyes; he also used iron salts to create a process he dubbed CYANOTYPE that produced an image in which the dominant tones were deep Prussian blue and white (Fig. 1.16). Herschel was one of the first to voice the democratic potential of photography: of the cyanotype he wrote that every person might be a printer and a publisher.[22] While it never became a major form of photography, the simplicity and low cost of the cyanotype made it a commercial success in the 1840s, and a favorite at the end of the nineteenth century for amateurs and scientists working in the field. Until the advent of digital image processing, it was widely used to produce blueprints for architects and builders.

TALBOT'S PHOTOGENIC DRAWING

"Change rules supreme in the affairs of men," reflected Herschel's friend and

1.15 (below)
JOHN HERSCHEL, *William Herschel's Telescope Seen Through the Window at Slough,* **February 10, 1839. Silver-based negative. National Museum of Photography, Film and Television, Bradford, England.**

The results of early photographic experiments were often faint. Few of these indistinct images have survived. One of Herschel's earliest images, this silver-based photograph depicts through a window the telescope used by his famous father, the astronomer William Herschel.

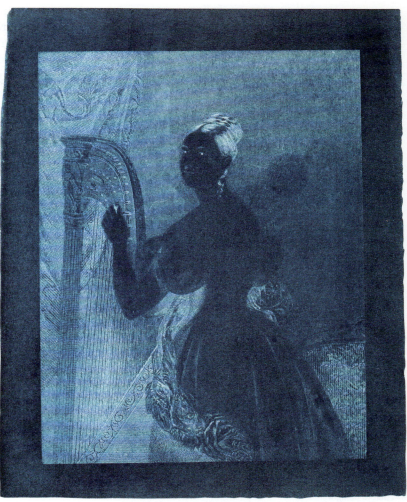

1.16
JOHN HERSCHEL, *Untitled* (from an engraving of a woman with a harp), 1842. Cyanotype. Museum of the History of Science, Oxford, England.

scientific colleague Talbot, upon hearing about the daguerreotype. Talbot had conceived fixing light-induced images as early as 1833, and had also had some success the following year, well before Daguerre achieved provable results. Musing intently, Talbot reflected that, "after having devoted much labour and attention to the perfecting of this invention, and having now brought it, as I think, to a point in which it deserved the notice of the scientific world, — that exactly at the moment that I was then engaged in drawing up an account of it, to be presented to the Royal Society, the same invention should be announced in France."[23] As historian Gail Buckland observed, "Talbot was staggered."[24] He had no way of knowing whether his method was the same as that developed by Daguerre, but he sensed the prospect of losing his claim to be the first to capture a camera image.

Talbot, a multi-talented British scientist, classical scholar, and linguist, was educated at Cambridge University and lived at the family estate of Lacock

Abbey. He dated his photographic efforts to 1833, when he got disappointing results using a camera lucida as an aid to drawing scenes near Lake Como in Italy. "After various fruitless attempts I laid aside the instrument and came to the conclusion that its use required a previous knowledge of drawing which unfortunately I did not possess," he recalled. "I then thought of trying again a method which I had tried many years before," he continued: "This method was, to take a *camera obscura* and to throw the image of the objects on a piece of paper in its focus — fairy pictures, creations of a movement, and destined as rapidly to fade away. It was during these thoughts that the idea occurred to me — how charming it would be if it were possible to cause these natural images to imprint themselves durably, and remain fixed upon the paper."[25]

By 1834, Talbot had experimented with two methods of fixing a photochemically induced image. The least-known was similar to that concocted

by Florence. While staying in Geneva, Switzerland, Talbot prepared glass plates by darkening them with candle smoke, and varnishing the surface so that the soot would stay in place. He then drew or wrote on the plates with a tool that cut through the black coating, and placed them over paper that had been made light-sensitive. When exposed to light, the lines of drawing or writing were transferred to the paper. He suggested that the technique could be used by friends to share letters and images.[26]

In addition, Talbot formulated a method of sensitizing paper similar to the procedure of Wedgwood and Davy, although he later claimed not to have read their 1802 published results. Aware of the light sensitivity of silver compounds, Talbot discovered that the strength of a solution of ordinary table salt (sodium chloride) in water was key to making images and then stopping the action of light. He first soaked paper in a weak solution, and allowed it to dry. He then applied a solution of silver nitrate, which reacted with the sodium chloride to form light-sensitive silver chloride. He did not put the sensitized paper in a camera obscura, but placed an object to be copied, such as a leaf, lace, or fern frond directly on the paper, sometimes flattened it down with a piece of glass to make greater contact with the paper, and then exposed the sandwiched object to light. When the object was removed, a pale rendering of its shape remained on the paper. Depending on the strength of the sunlight to which it was exposed, from ten minutes to thirty minutes were necessary to make a print. The area sur-

rounding the image darkened due to exposure to light.

After the object was removed from the paper, Talbot had to prevent the light area from darkening in response to further exposure. He tried various chemicals to inhibit the continuing action of light upon the paper, among them potassium iodide, and a strong solution of table salt. Because of the use of table salt, both in sensitizing the paper and in fixing its image, the process would eventually be called a salt print. Talbot referred to his work as "PHOTOGENIC DRAWING," that is light-caused drawing, or "sciagraphy," that is shadow writing (Fig. 1.17). Prints such as these are still made today, and they are often called shadowgraphs or photograms.

Although he jotted a reminder message in his notebook for May 1834, telling himself to "Patent Photogenic Drawing," Talbot did not do so.[27] Since each sheet of paper used in his technique had to be separately processed, the results were uneven and labor-intensive. Perhaps Talbot was waiting until he could perfect the reliability and consistence of photogenic drawing. He continued to experiment, and in 1835, he managed to make a picture after exposing sensitized paper in a small camera (Fig. 1.18). In February of that year, Talbot noted that his photogenic drawings might be used to yield what he called a second drawing. In other words, he conceived of the photogenic drawing not simply as an end in itself, but also as a negative from which positive prints might be made, although he did not actually use the term or print from one of his early photogenic drawings.

In 1841, after improving the capability of photogenic drawings to make multiple copies, Talbot would patent a photographic process he called the CALOTYPE. The name derived from *kalos*, the Greek word for beauty. Like the daguerreotype, it made use of the latent image, the invisible picture on the negative that had to be further developed after exposure in the camera. Unlike the daguerreotype, with its single, unique picture, the calotype produced a negative, from which many prints could be made. Thus the calotype would become the basis for modern photographic reproduction. But in the mid-1830s, before the announcement of the

1.17
WILLIAM HENRY FOX TALBOT, *Leaf with Serrated Edge,* **c. 1839.** Photogenic drawing negative. National Museum of Photography, Film and Television, Bradford, England.

In Talbot's photogenic drawing process, a negative image was produced. The leaf was placed on light-sensitized paper and exposed to the sun. Where the light could reach it directly, the paper turned dark. Where the leaf hindered light from exposing the paper, a pale silhouette, complete with well-rendered veins, was left on the paper. The technique became the basis for multiple photographic prints.

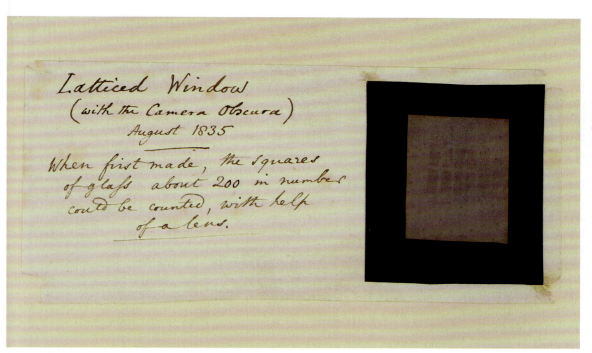

Of this photograph of a Gothic window at his estate, Talbot wrote that "When first made, the squares of glass about 200 in number could be counted, with help of a lens."

daguerreotype, Talbot was losing interest in his photographic experiments. He returned to his classical studies for more than three years, until Daguerre's announcement spurred him to demonstrate not only that his method was original, but also that it had generated photographs before 1839.

THE POLITICS OF INVENTION

Talbot read about Daguerre's image-making process within days of the January 7, 1839 announcement, and quickly moved to make his own work known. He wrote to Arago, claiming prior invention, and prepared a paper giving "Some Account of the Art of Photogenic Drawing, or, the Process by which Natural Objects May be Made to Delineate Themselves without the Aid of the Artist's Pencil," which he read at the Royal Society on January 31, 1839. The first exhibit of his photogenic drawings took place as part of the regular Friday evening lecture of the Royal Institution on January 25, 1839. Scientist Michael Faraday (1791–1867) spoke about Daguerre's invention, and then urged the audience to examine a display of Talbot's work. *The Literary Gazette* (Saturday, February 2, 1839) recorded that the purpose of the exhibition was to establish Talbot's claim to original invention, should he be challenged

by Daguerre. The journal went on to exclaim that "No human hand has hitherto traced such lines as these drawings displayed; and what man may hereafter do, now that Dame Nature has become his drawing mistress, it is impossible to predict."[28] *The Magazine of Science, and School of Arts* copied Talbot's photogenic drawings in ink for the cover of their April 27, 1839 edition (Fig. 1.19).

While photography itself had not been predicted, many of the nineteenth-century uses of photography were soon foreseen after its disclosure in 1839. Arago, for instance, thought that it could aid archeological research and restoration, and also be employed as a kind of objective retina (*rétine physique*) that would assist scientists in studying the properties of light.[29] He thought it might be used to record the art painted and incised on the walls of ancient Egyptian buildings, a task begun in the nineteenth century, yet still far from complete at the beginning of the twenty-first century.

In his arguments for making the daguerreotype a French gift to the world, Arago also anticipated the mistrust and wrangling that would follow the near-simultaneous announcements of two competing photographic processes. Talbot, for example, was very wary of showing the French his process. Writing to Herschel in February 1839, he suggested "that it might be best not to

disclose at present the washing out process, the retransfer, & c. until brought to a state more worthy of publication, inasmuch as the Parisians would hardly be able to discover it immediately if it is not part of Daguerre's process, & I wish to show them that we could do something here which they could not imitate as yet."[30]

In France, Arago hastened to establish Daguerre as the exclusive inventor of photography. He saw to it that Talbot and Herschel, along with other well-known scientists, were boldly invited to Paris to see the daguerreotype and, presumably, to witness its exceptional rendering ability. Talbot refused, but asked Herschel, who was already planning a visit there, to view Daguerre's work. "I shall be glad to hear from you, what you think of them," he wrote: "Whatever their merit, which no doubt is very great, I think that in one respect our English method must have the advantage." "To obtain a second copy of the same view," Talbot continued, "Daguerre must return to the same locality & set up his instrument a second time; for he cannot copy from his metallic plate, being opaque."[31]

When Herschel saw Daguerre's pictures, he reported back to Talbot that "it is hardly saying too much to call them miraculous." The daguerreotypes, he wrote, "surpass anything I could have conceived as within the bounds of reasonable expectation … Every gradation of light & shade is given with a softness & fidelity which sets all painting at an immeasurable distance." Herschel also added that the exposure time needed for Daguerre's process was very short.[32] In effect, Talbot's respected colleague and friend was compelled to acknowledge the visual superiority of the daguerreotype, a difference in quality so great that it seemed to trivialize Talbot's objection that the daguerreotype could not make multiple copies.

When Daguerre's Diorama burned to the ground in March 1839, Arago strengthened his efforts to award him a pension and to claim the invention of photography for France. He wrote to the minister of the interior hinting that various nations had made Daguerre tempting offers, which the inventor refused. Arago also arranged a display of daguerreotypes for the Chamber of Deputies, and showed the process to the Chamber of Peers. In addition, he orchestrated the major themes of various formal reports presented to these two chambers. In the Chamber of Deputies, Arago stressed the potential scientific importance of Daguerre's invention to the science of photometry (measuring the properties of light) and astronomy. His friend and scientific colleague Joseph Louis Gay-Lussac (1778–1850) reiterated the notion in the Chamber of Peers. Both attempted to raise national pride and rouse a rivalry with England by pressing the need to make photography a French cultural achievement. Arago and Gay-Lussac stirred memories of the contest between British and French linguists to translate the Rosetta Stone, which led to the modern understanding of Egyptian hieroglyphics, and they alluded to the dispute between France and England as to the origin of the Gothic style in architecture. At a time when memories of the Napoleonic Wars between the two countries were still fresh, clear claim to the invention of photography would be read as evidence of national superiority.

In this effort to make Daguerre the sole inventor, reports on his process made to the Chamber of Deputies, Chamber of Peers, and the French Academy of Science distanced his achievement from that of Niépce. Arago insisted that the daguerreotype was "entièrement neuf" (entirely new), and that Daguerre's work of genius was threatened by the efforts of would-be geniuses.[33] From January to August 1839, when the process had its first public demonstration, Daguerre's reputation as an original intellect steadily grew. During that period, no details of his process were revealed, enveloping the daguerreotype and its inventor in irresistible mystery. Indeed, although he was required to produce a booklet describing the daguerreotype process in detail, Daguerre never revealed exactly how he developed it, but allowed tales of fortuitous accidents and miraculous visual events to fill in the blanks. In the end, Daguerre and Isidore Niépce secured government pensions, with Daguerre receiving the larger share.

The excitement following the first public demonstration of Daguerre's process, at the joint meeting of the

1.19
ARTIST UNKNOWN,
*The Magazine of
Science, and School of
Arts,* **1839. Photogenic
drawings on magazine
cover, new series, vol. 1,
no. 4, April 27, 1839.**

Samples of Talbot's
photogenic drawings
could not be printed in
magazines or news-
papers, but had to
be copied by hand in
ink and engraved.

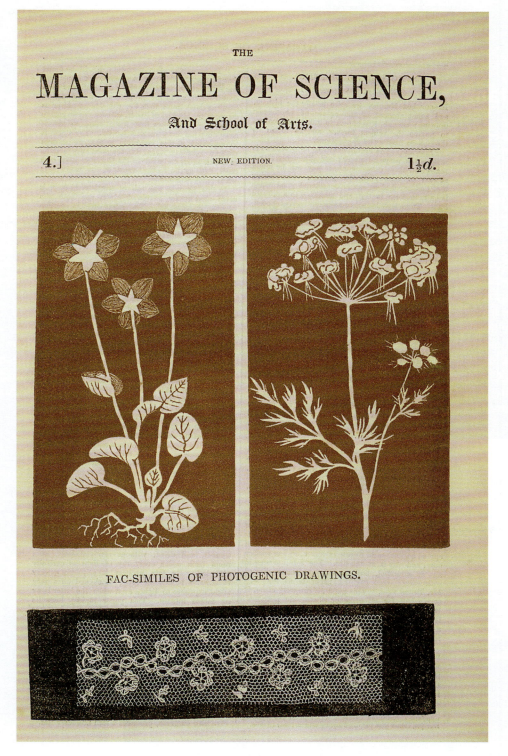

Academy of Science and the Academy of Fine Arts in Paris on August 19, 1839, was captured by Marc-Antoine Gaudin (1804–1880), a maker of optical instruments:

We all felt an extraordinary emotion and unknown sensations which made us madly gay … Everyone wanted to copy the view offered by his window, and very happy was he who at first attempt obtained a silhouette of roofs against the sky: he was in ecstasies over the stove-pipes; he did not cease to count the tiles on the roofs and the bricks of the chimneys; he was astonished to see the cement between each brick; in a word, the poorest picture caused him unutterable joy, inasmuch as the process was then new and appeared deservedly marvellous.[34]

In January 1839, there was not one, but several photographies. Some had failed or were destined to be forgotten. Some, like Daguerre's process, produced single images; others, like Talbot's, were potentially capable of

FOCUS
The Stranger

A mythic inventor of photography arrived late on the scene during the 1850s. Accounts of photography's history, published in journals aimed at a general audience, recounted the appearance of "the Stranger," a bedraggled man who enters the Paris shop of optical instrument-maker Charles Chevalier in January 1826. The Stranger wants to purchase a camera obscura, but his poverty prevents him from buying the best instrument. The Stranger recounts his attempts to fix the images in a camera obscura, and shows Chevalier some photographs. As he is about to depart the shop, the Stranger leaves a vial of a secret brown liquid with Chevalier, telling him that it is the substance that produces photographs. The Stranger does not leave instructions for its use, and when he does not return to the shop, Chevalier asks Daguerre to try the brown liquid. Daguerre has no success, but his attempts use up the mysterious substance.

As the story of the Stranger moved from source to source, it grew in complexity. The Stranger became poorer, and his physical needs became more urgent. Conjectures were added. Why did the Stranger not return to Chevalier's shop? Did he end his days in a charity hospital, shivering with cold and hunger? Did he plunge himself into the Seine, discouraged that Daguerre, not he, had got credit for photography? For a person of genius, the later stories concluded, life's disappointments are sharper than for the rest of us.

Like Hippolyte Bayard's self-portrait of himself as a drowned man (see Fig. 1.14), the story of the Stranger was infused with notions of doomed Romantic genius. Indeed, it has been speculated that Bayard's disheartening experience in gaining acceptance for his photographic process may be the origin of the story (Fig. 1.20).

L'inconnu montrant une épreuve photographique à M. Charles Chevalier. Dessin de M. Gustave Janet.

1.20
ARTIST UNKNOWN, "The Stranger," from Francis Wey, *Comment le soleil est devenu peintre: histoire du daguerréotype et de la photographie.* Musée des Familles, June 1853. Wood engraving. Widener Library, Harvard University, Cambridge, Massachusetts.

making multiple prints. The quality of those images produced on metal and paper differed as well. The daguerreotype rendered a startlingly detailed picture on a mirror-like silver surface. The paper processes produced images that were less distinct, with large contrasting areas of dark and light. Because the paper absorbed the light-sensitive chemicals, the result often looked like a monochrome watercolor, sunk into the paper's fabric. The daguerreotype, by comparison, seemed to have lifelike three-dimensional qualities. It yielded a wide range of gray tones, where the paper processes, depending on the type and purity of chemical used, included tawny orange, gray-violet, and sepia-brown.

PHILOSOPHY AND PRACTICE: NATURE'S AUTOMATIC WRITING

The pioneers of photography portrayed it as a way to generate pictures independent of the physical talent and mental effort of the camera operator. Talbot, Daguerre, and Niépce all shied away from explaining photography as an invention that makes images through human agency. Each insisted that photography originated in nature and was disclosed by nature. Talbot wrote that photography depicts its images "by optical and chemical means alone"; the image is "impressed by Nature's hand." Daguerre put it this way: "the DAGUERREOTYPE is not an instrument which serves to draw nature; but a chemical and physical process which gives her the power to reproduce herself." Niépce defined his accomplishment as "spontaneous reproduction, by the action of light." The initial legal agreement, drawn by Niépce and Daguerre, spoke of Niépce's attempts "to fix the images which nature offers, without the assistance of a draughtsman."[35] Of course, photography's inventors observed the medium's verisimilitude and its reliable visual reproduction, but they stressed its apparent spontaneity: "auto-graphy," nature's automatic writing. These modest, even self-effacing descriptions would trouble photography for generations in its attempts to legitimize itself as a fine art medium.

Beginning with the earliest written accounts, photography was described in different terms than the machines, instruments, and processes of the Industrial Revolution. By situating photography in nature and in natural history, rather than in human history, its pioneers distanced the medium from the history of other innovations. For example, the words "invention" and "discovery" were (and still are) used interchangeably of photography, while other technological achievements are usually called inventions. It would be bizarre to think of the railroad or the telegraph, for example, as discovered; but photography, considered as a natural phenomenon, much like magnetism, has been understood to be discovered, then applied to human use.

In this way the medium was integrated with Western notions of empiricism, especially its core belief that knowledge should be based on disinterested observation, not personal opinion. The shared cultural imagining of photography—that is, the idea of photography, not its practical applications—emphasized photography as a natural *and* neutral vision. The camera image was thought to be like the picture on the retina of the human eye, confirming an eighteenth-century proposition that the retinal image is completely independent of the subject's thoughts and feelings. Photography's neutral vision was conceived not only as a boon to science, but as a socially symbolic anticipation of a future in which the world could be better known by more people—a means to democratize knowledge. But that very concept of democratic neutrality or objectivity would also soon create a backlash that denigrated the individual photographer's ability to be a discerning interpreter of ideas.

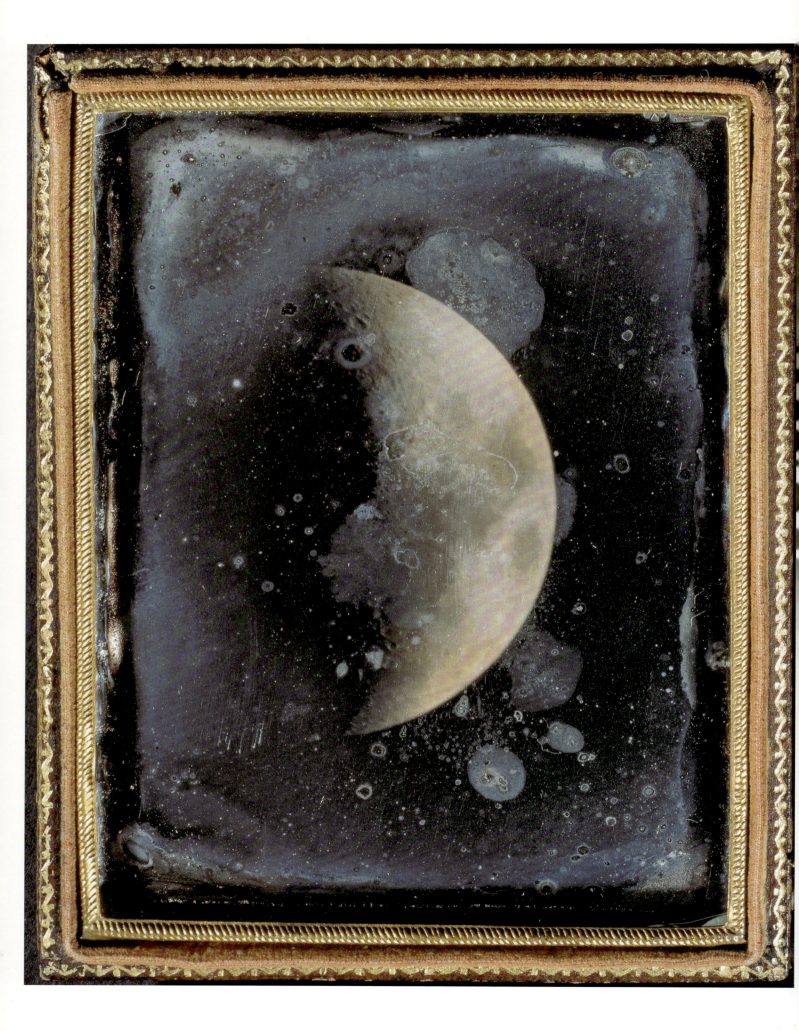

The Second Invention of Photography (1839–1854)

During the months following Daguerre and Arago's first presentation in 1839, photography and its potential were energetically discussed in Britain, Europe, Russia, and the United States, as well as some parts of Asia and Latin America (Fig. 2.1). But the basic outlines of photography's practical uses and social meanings—its second invention—took more than a decade to emerge.

THE SECOND INVENTION

One of the earliest indications of the conversion of photography from an invention to an active agent in the social world was the patenting of both the calotype and the daguerreotype processes. In the summer of 1839, Daguerre was quietly working with an agent in Britain to patent his process there, and to assign the manufacture of his camera and supplies to a French firm run by Alphonse Giroux (active 1840s). Daguerre received the patent, restricting the making of daguerreotypes in Britain to those who paid to do so. Similarly, Talbot patented the calotype process in 1841, although he only charged commercial photographers to use it. In part, the patenting of

the daguerreotype and the calotype was motivated by nationalistic competition, but it also indicated the transformation of photography from an invention to a property with commercial promise.

Daguerre's instruction manual arrived in the United States in September 1839, but news of the invention had come months earlier. In April 1839, when few people had seen a photograph, *The New Yorker* was sufficiently confident in the medium's future to extol both Daguerre's contrivance and Talbot's photogenic drawing. The article humorously proposed that photography would conquer the other arts: "The Dagueroscope and the Photogenic revolution are to keep you all down, ye painters, engravers, and, alas!, the harmless race, the sketchers."[1] On a more serious note, the article discussed photography as a modern innovation, situating it among the "phastasmagoria of inventions [that] passes rapidly before us."[2] The commentator, who had never seen a daguerreotype, nonetheless praised it as "more like some marvel of a fairy tale or delusion of necromancy than a practical reality."[3]

In the 1840s, as photography began to proliferate as a craft, a fledgling

**2.0
GEORGE PHILLIPS BOND & JOHN ADAMS WHIPPLE,**
Moon, c. 1851.
Daguerreotype. Harvard College Observatory, Cambridge, Massachusetts.

The Great Refractor telescope was thought to be the largest in the world at the time that daguerreotype portraitist Whipple and astronomer Bond amazed their colleagues with views that clearly captured the lined and cratered surface of the moon. The technical achievement of their moon photographs was recognized at the Crystal Palace Exhibition in London in 1851 (see p. 29).

Théodore Maurisset's
(1803–1868) lithograph
La Daguerréotypomanie
("Daguerreotypomania")
is a fantasy on the future
of the daguerreotype. It
foretells the effects of
mass-produced photo-
graphs, the appearance
of aerial photography,
and the demise of
engravers, who are
invited to rent gallows
near the center of the
picture, on which to end
their useless lives.

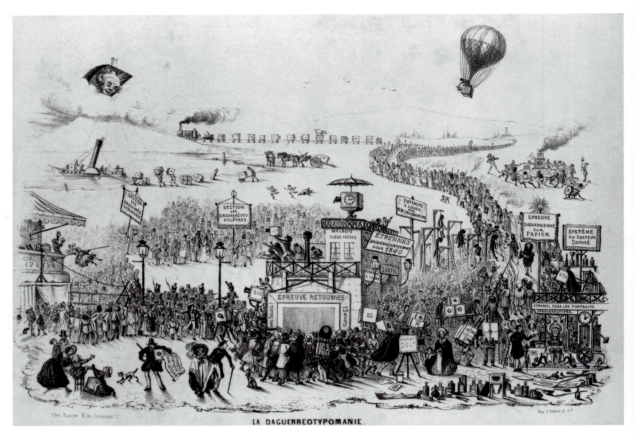

LA DAGUERREOTYPOMANIE.

industry, a means of record-keeping, and an aspiring artform, it also became a topic in newspapers, magazines, and other areas of public debate, where it was regularly called an "art-science." The term recognized that photographic images were not only generated by a mix of science and art, but also applied in both activities. The ambiguous character of photography in its early years was fostered by the equally uncertain definitions of art and science. Art could mean a skill or a craft, as well as specific media like painting, sculpture, and engraving. Science referred to areas of knowledge like biology and geology, and also to techniques for making experiments and observations, like objective scrutiny and recording.[4] To many observers, photography seemed a science wedded to a craft, fundamentally dependent on the photographer's knowledge of chemistry and willingness to experiment. Images that appear primarily aesthetic might result from scientific inquiry.

The Austrian scientist Anton Georg Martin (1812–1882) studied photography soon after it was announced, and used it to picture an ordinary farmyard in winter (Fig. 2.2). Martin's aim, indicated by a note on the back of the image,

was to experiment with exposure time, light, and equipment.[5] Those who took up the new medium found themselves refitting traditional visual arts subjects, like landscape, to photography's capabilities. The blending of custom and camerawork is evident in French photographer Alexandre Clausel's (1802–1884) *Landscape near Troyes*, in which a transitory moment is anchored within a carefully chosen point of view whose symmetry and balance derive from the rules of artistic composition (Fig. 2.3).

Writing in *The Athenaeum*, an anonymous author expressed the absence of a distinct category for photography. Describing a meeting of the Calotype Club in London, which was founded in 1847, the writer noted that the members had "associated together for the purpose of pursuing their experiments in this art-science (we scarcely know the word fittest completely to designate it)."[6] The art-science label survived into the 1850s. In an early issue of *La Lumière*, France's first photographic magazine, Francis Wey announced that the journal would be "neutral ground" for photography, which inherently embraced both science and art.[7] There is little evidence that this categorization was unsettling; instead, the term art-science seemed produc-

tively vague, expressing an interplay between the humanities and the sciences, and the broad interests of people who took up the new medium. Images like those produced by William Henry Fox Talbot's friend, the botanist and scientific illustrator Anna Atkins, could be

simultaneously aesthetically pleasing and scientific, without any perceived contradiction (see Fig. 2.14).

Although the daguerreotype was primarily adopted when exact renderings in portraiture and in science were desired, and the calotype used when

softer effects and multiple copies were wanted, no rigid conventions governed their use. Thus, despite the daguerreotype's superior detail and sharp focus, the calotype's ability to make multiple copies, and to be retouched on the negative, made it useful to scientists as well. Similarly, the daguerreotype could occasionally be made to approximate landscape painting, as Alexandre Clausel convincingly did through his well-balanced composition and attentive use of many middle-gray tones that evoke the look of multiple thin layers of paint. Especially in the early years of its second invention, photography was flexible and experimental, neither a sharply delimited art form, nor quite the product of science.

Reactions to early photography ranged from the exuberant to the cautious. American poet and short-story writer Edgar Allan Poe (1809–1849), the subject of a haunting 1849 portrait (Fig. 2.4), wrote three articles on photography for popular magazines in 1840. Describing the daguerreotype's "most miraculous beauty," Poe opined that "all language must fall short of conveying

2.4
PHOTOGRAPHER UNKNOWN, *Edgar Allan Poe*, 1849. Daguerreotype. The J. Paul Getty Museum, Los Angeles, California.

American poet and fiction writer Edgar Allan Poe is shown in a daguerreotype portrait made just days after a suicide attempt.

any just idea of the truth ... but the closest scrutiny of the photogenic drawing discloses only a more absolute truth, a more perfect identity of aspect with the thing represented." He urged readers to imagine a "positively perfect mirror" that "is *infinitely* more accurate in its representation than any painting by human hands."[8]

Despite *The New Yorker* magazine's playful 1839 foreboding that photography would stifle art, few painters saw early photography as a threat. When John Jabez Edwin Mayall (1810–1901), an American photographer working in London, proposed that the daguerreotype was capable of illustrating history, an editorial response in an 1847 issue of *The Athenaeum* corrected him: "At best, he [Mayall] can only hope to get a mere naturalist's rendering. Ideality is unattainable,—and imagination supplanted by the presence of fact."[9] Nevertheless, Mayall went on to document history— or at least a photographic version of it. His mammoth plate daguerreotype, one of fourteen made of *The Crystal Palace at Hyde Park, London*, depicted the interior of Joseph Paxton's (1801–1865) remarkable large metal and glass structure that housed the Great Exhibition of the Works of Industry of All Nations in 1851 (Fig. 2.5).

Because the photograph was commonly conceived as nature delineating nature, some found it lacking in imagination. *The New Yorker*'s anonymous commentator was convinced that "Nature is only become handmaid to Art, not her mistress." "Painters need not despair; their labours will be as much in request as ever, but in a higher field: the finer qualities of taste and invention will be called into action more powerfully: and the mechanical process will be only abridged and rendered more perfect."[10]

Many of photography's modern applications emerged in the 1840s and early 1850s, together with an equally enduring dialogue about visual representation and multiple imaging. The medium's expansion was inextricably associated with world-shaping forces. Industrial capitalism created a middle class of professionals, such as scientists, who began to use photography in their work. The rapid growth of cities facilitated the exchange of ideas among

FOCUS
Iron, Glass, and Photography

The Great Exhibition, dubbed the Crystal Palace Exhibition by the press, opened in London in May 1851. This early world's fair brimmed with excitement for technological progress and material prosperity. It boasted Britain's lead in industrial production and promoted the idea that modern mass manufacturing and engineering could be applied in the cause of economic and social betterment. For example, a model, modular house for the working class was on display.[11] Observers noted the resemblance of Joseph Paxton's building to a glass house, the space used by photographers, and associated both structures with social advancement (Fig. 2.5).

Included in the Crystal Palace displays were cameras, other photographic equipment, and photographs. Commercial portraits and landscape photographs were shown with photographic equipment, while art photography was displayed in the Fine Arts Court. Roughly the same number of daguerreotypes and calotypes were shown.[12]

The connections between technological progress, social advancement, modern architecture, and the new medium of photography also occurred in France, where Hector Horeau (1801–1872), an architect, egyptologist, and publisher of prints based on early photographs, was an avid proponent of glass and iron building construction. His philosophy for public works emphasized education and communication for the working class, an idea also expressed by proponents of photography. Ironically, Horeau had successfully competed in the contest to design the Crystal Palace, only to be replaced a month later by Paxton.

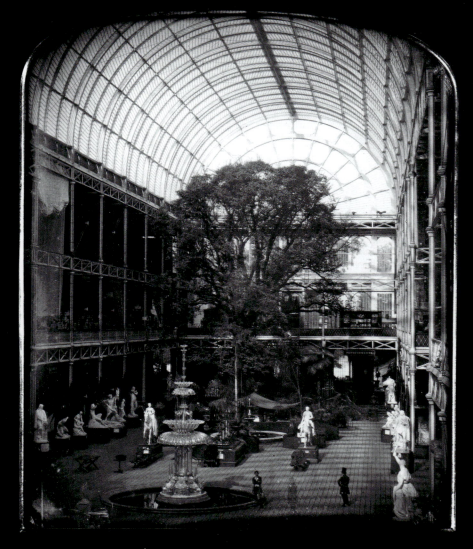

2.5
J. J. MAYALL, *The Crystal Palace at Hyde Park, London*, 1851. Daguerreotype. The J. Paul Getty Museum, Los Angeles, California.

people interested in the medium of photography, and the shift of populations from the countryside to the cities accentuated the desire for observable personal identity, fueling the market for photographic portraits. Whereas in small towns and villages, people were usually known to their neighbors, in the burgeoning cities strangers gawked at strangers, sizing them up in an instant. In this milieu of unstable social identity, photography offered sitters a chance to fix an outward appearance for all time.

As the medium's capacities grew during its first dozen years, photography also provided a way to enact a public personality through which sitters might be known and remembered. While urban populations increased, rural peoples, traditional occupations, and unpolluted landscapes emerged as sentimental and nostalgic subjects in the visual arts, and, ultimately, in photography. Meanwhile, the expansion of Western powers into Asia, Africa, and Latin America provided fresh vistas to be photographed, and a persuasive

visual means to rationalize foreign adventurism. The new image-making method altered the way in which people related to visual media. By the mid-1850s, photography, which had initially seemed a wondrous phenomenon, had become a routine part of Western life.

TALBOT AND *THE PENCIL OF NATURE*

While Daguerre took little part in the development of photography after 1839, Talbot continued his efforts. His 1839 account of photogenic drawing conceived the photographic image as a kind of "*natural magic*"[13] with potential for both science and art. He went on to explore both these aspects.

In 1835 Talbot had produced what may be the world's first photomicrograph, that is, a photograph of a magnified small object. Talbot believed that photography would "be especially useful for naturalists since one can copy the most difficult things, for instance crystallizations and minute parts of plants, with a great deal of ease,"[14] but he was

2.6
WILLIAM HENRY FOX TALBOT, *The Open Door*, 1844, plate 5 from *The Pencil of Nature*, 1844–46. Salt print from a calotype negative.

Describing this image, Talbot wrote that the seventeenth-century Dutch school of painting had already commended scenes from everyday life, and he suggested that photographers could use the camera to create similarly evocative views.

2.7
WILLIAM HENRY FOX TALBOT, *Articles of China*, plate 3 from *The Pencil of Nature*, 1844–46. Calotype. Fox Talbot Collection. National Museum of Photography, Film and Television, Bradford, England.

Images in *The Pencil of Nature* inventoried books, glassware, and china, demonstrating photography's ability to present neutral information in pictorial form, and its potential as evidence.

also interested in its art applications. He considered *The Open Door* (Fig. 2.6), in which he emulated seventeenth-century Dutch painting of scenes from everyday life, an example "of the early beginnings of a new art."[15] Larry Schaaf has observed that it draws on the doorway as a traditional symbol of the passage between life and light, and death and darkness.[16]

The Open Door was included as plate 5 in Talbot's book *The Pencil of Nature*, which he published in six sections, between 1844 and 1846. One of the first books illustrated with actual photographs rather than engraved versions, *The Pencil of Nature* contained twenty-four calotype images. Since the calotype process created a negative, from which positive prints could be made, actual calotypes were tipped in (pasted at the corners to the page). Each image was accompanied by an explanatory text. *The Pencil of Nature* demonstrated the breadth of Talbot's investigation into the applications of photography. Some images, such as *Articles of China*, showed photography's record-keeping

ability (Fig. 2.7), while others demonstrated how photography could variously depict biological specimens, architecture, and sculpture, and reproduce sketches and engravings. Talbot even suggested that in the future photographs might be taken in the dark, making possible secret surveillance.

Throughout the 1840s, Talbot mingled art, science, and what would eventually be called documentary photography, in such works as the series of haystack studies produced on his property. Early on, Talbot understood photography's ability to present a sequence of images, the meaning of which proceeded not just from one example, but from all of them and from their arrangement. As the French Impressionist Claude Monet (1840–1926) would do later in the nineteenth century, Talbot studied the effects of light, and delighted in the configuration of geometric shapes found in the natural and built environments. In *Hayrick with Porter*, a servant stands holding a broom surrounded by various garden implements (Fig. 2.8). The photograph

was a visual record of a time of day when the sun emphasized the complementary shapes of the haystack and the building behind it. The photograph also reveals Talbot's aesthetic awareness in its formal, alternating patterns of dark and light that begin in the immediate foreground of the picture. Perhaps its most intriguing aspect is the rendition of the sky. Technical faults in early photographic materials tended either to over-expose the sky or to make it appear mottled. Talbot coped with this flaw by making the sky visually interesting, giving it a ragged, angular shape that matched the buildings and the haystack.

**2.8
WILLIAM HENRY FOX
TALBOT,** *Hayrick with
Porter,* August 21, 1841.
Salt print from a calo-
type negative. Hans
P. Kraus, Jr., Collection,
New York.

This 1841 calotype is an
example from Talbot's
early series of images,
which included studies
of the effects of light on
the shape and shadows
of haystacks.

Talbot also pursued commercial experiments with photography. Exploiting the calotype's ability to furnish multiple prints, he founded a photographic studio and printing establishment in Reading, a town about forty miles west of London (Fig. 2.9). The business was part of the mid-century industrialization of photography; here Talbot produced *The Pencil of Nature* as well as other views for sale.

BAYARD: THE DOUBTING CAMERA

After Hippolyte Bayard produced his *Self-Portrait as a Drowned Man* (see Fig. 1.14), he continued to test the limits of photographic representation, exploring ways in which it could be misleading or unsettling (Fig. 2.10). Some contemporary viewers recognized Bayard's unusual approach; Francis Wey (1812–1882) wrote that Bayard's images united "the impression of reality with the fantasy of dreams."[17] Ultimately, Bayard took up both daguerreotype and calotype photography, in which he enjoyed professional success. In some photographs, he lingered on the textural richness and attractive shapes of such ordinary things as leaves, tools, stone, and straw. But a teasing sense continued to inform his work: what the eye sees, and what the photograph records, may not be trustworthy.

PHOTOGRAPHY AND THE SCIENCES

Though few early photographers were as multi-faceted in their interests as Talbot, as early as May of 1839 scientists had attempted to employ Talbot's photogenic drawings in their work.

THE MICROSCOPE AND THE TELESCOPE

After witnessing Daguerre's Paris presentation of his invention and studying directly with Daguerre, the Viennese physicist and mathematician Andreas Ritter von Ettingshausen (1796–1878) created startlingly detailed microscopic images (Fig. 2.11). Ettingshausen was a member of an informal circle of artists, mathematicians, and scientists who explored photography, but like many of its early users and advocates, he did not pursue it throughout his scientific

**2.9
PHOTOGRAPHER
UNKNOWN,** *Untitled*
(Panorama showing
Talbot's Reading estab-
lishment), c. 1845.
Calotype. National
Museum of Photo-
graphy, Film and
Television, Bradford,
England.

Talbot's Reading estab-
lishment produced
multiple copies of pho-
tographs in the glass-
house seen in the rear,
as well as outside in the
sunlight, as here. Talbot
can be seen on the far
right removing a lens
cap from a camera.

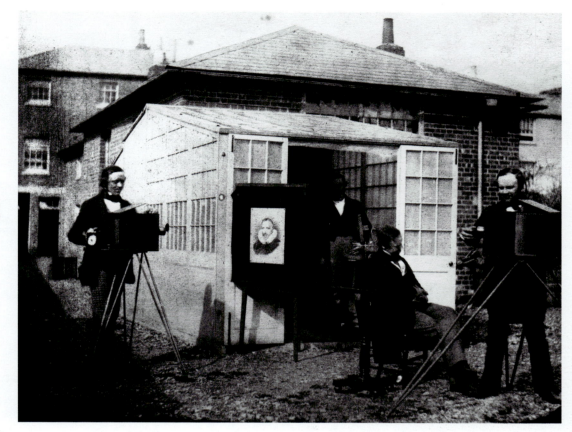

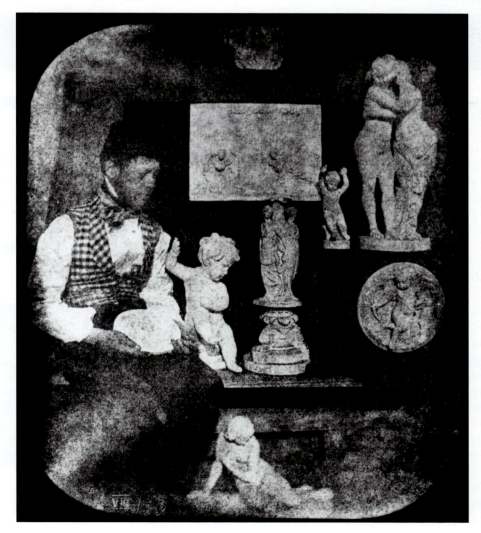

**2.10
HIPPOLYTE BAYARD,** *Self-
Portrait with Plaster Casts,*
1850. Gelatin silver print.
National Gallery of
Canada/Musée des Beaux-
Arts du Canada, Ottawa.

Unlike other early photogra-
phers, Bayard sometimes
jested with the idea that the
photograph was a mirror of
reality, as in this image of
apparently weightless,
gravity-defying plaster casts
of statues.

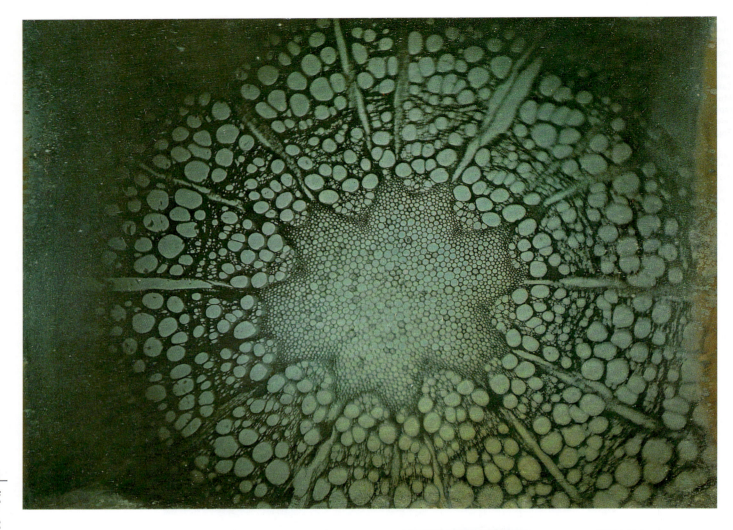

**2.11 (above)
ANDREAS RITTER VON ETTINGSHAUSEN,** *Section of Climatis,* **March 4, 1840. Daguerreotype. Ezra Mack, New York.**

This cross-section seemed to record the plant's cell structure. However, the lens magnifying the specimen in this early experiment distorted the cells' shape and size.

**2.12 (right)
LÉON FOUCAULT,** **Microscopic studies, plates 21, 22, 23, 24, from** Alfred Donné's *Cours de Microscopie,* **1845. Engravings from daguerreotypes. The J. Paul Getty Museum, Los Angeles, California.**

career. The scientist Léon Foucault (1819–1868), who would later do distinguished work on the speed of light, became involved with photography while still a medical student. He helped to produce eighty-six microscopic daguerreotypes, which were then engraved for the textbook *Cours de Microscopie* (1845), written by his mentor, the physicist Alfred Donné (1801–1878) (Fig. 2.12). Because the daguerrean process was a tricky, time-consuming way to make duplicates, during its early years the usual course for reproducing daguerreotypes in both scientific and artistic illustrations was to hand-copy the image on to an engraving plate.

Beginning in the early 1840s, several daguerreotype experiments reduced printed matter to a size so small that it had to be read with a microscope. This microform technique promised to condense rare books and manuscripts to easily transportable and storable size. Celestial photographs were also tried, although the dim light of distant stars, with the obvious exception of the sun,

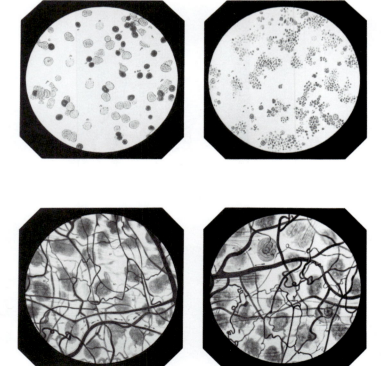

2.14
ANNA ATKINS, *Poppy*, c. 1852. Cyanotype. Victoria
& Albert Museum, London.

In the nineteenth century, several amateur women
scientists prepared botanical specimens for scien-
tific study. Beginning in 1843, Anna Atkins pub-
lished about a dozen copies of *British Algae:
Cyanotype Impressions*, which contained nearly 400
cyanotype pictures. She sent the book to friends
and researchers, such as William Henry Fox Talbot.

2.13
**WILHELM &
FRIEDRICH
LANGENHEIM,** *Seven
Daguerreotypes
Showing Eclipse of the
Sun*, May 26, 1854.
Daguerreotypes. Gilman
Paper Company
Collection, New York.

made clear and detailed photographs
difficult. Daguerre himself made a faint
image of the moon to prove the poten-
tial benefits of the medium to his spon-
sor, the astronomer and politician
François Arago. In 1845, with Arago's
encouragement, Foucault and another
French scientist, Hippolyte Fizeau, had
some success in photographing the sun
with sunspots. The result was published
as a lithograph in Arago's *Astronomie
populaire* (1858). In America George
Phillips Bond (1825–1865) and John
Adams Whipple (1822–1891) made
daguerreotype views of the moon (Fig.
2.0). Philadelphia photographers and
dealers in photographic equipment,
Wilhelm Langenheim (1807–1874) and
his brother Friedrich (1809–1879)
recorded eight phases of the solar
eclipse of 1854 (Fig. 2.13).

BIOLOGY

For more than a decade, scientific illus-
trator Anna Atkins (1799–1871) created
impeccable cyanotype impressions of
algae species and other specimens.
A member of the Botanical Society of
London and an accomplished book illus-
trator, Atkins used the technique devel-

oped by John Herschel to combine sci-
entific exactitude with aesthetic sensitiv-
ity to form and presentation (Fig. 2.14).
Similar work was done by Thereza
Llewelyn (1834–1926), whose photo-
genic rendering of a maidenhair fern
surrounds her portrait by her father
John Dillwyn Llewelyn (Fig. 2.15). He
had been introduced to photography
by his wife, Emma Thomasina Talbot
(William Henry Fox Talbot's first
cousin), and was typical of the amateur
photographers who experimented with
the technical and chemical aspects of
photography, while making a variety of
landscape images and family pictures.
Like many amateurs, he benefited from
meetings with others, and exchanges,
often by mail, of information and pho-
tographs from men and women with
similar interests. Another British ama-
teur, active in both scientific and artistic
photography, was George Shadbolt
(1819–1901). The country paths and
venerable trees in his *Watching the Newts*
(Fig. 2.16) are characteristic of British
amateur subject matter, which generally
ignored industrial and urban views in
favor of ancient buildings and tradi-
tional agricultural pursuits.

2.15
JOHN DILLWYN LLEWELYN, *Thereza,* c. 1853. Salted paper print. Gilman Paper Company Collection, New York.

An amateur scientist, Thereza Llewelyn was interested in botany and astronomy. This portrait was intended to show her at work and to indicate symbolically her accomplishments, through the presence of books, biological samples, and scientific instruments.

2.16
GEORGE SHADBOLT, *Watching the Newts,* c. mid-1850s. Salted paper print. George Eastman House, Rochester, New York.

Observing newts, small aquatic salamanders that cannot be seen in the photograph, seems like an odd subject for an image. But in the context of the amateur photography practiced by the middle and upper classes, it not only conveys the scientific interests of educated people but also their available leisure time to pursue hobbies such as biology and photography.

ANTHROPOLOGY AND MEDICINE

From the first, practitioners of anthropology and medicine saw in photography a good opportunity to generate historical and research archives. Robert Sommer, a German professor of psychiatry, proclaimed that photography should "replace the written record (or at least supplement it)," because the medium "is uncontaminated by the interpretive problems inherent in language."[18]

Hugh Welch Diamond (1806–1886), a British medical doctor and active amateur, photographed still lifes and took pictures of antiquarian interest. He also made photographs of mental patients (Fig. 2.17). He professed that mentally ill patients could look at photographs of themselves and better understand their afflictions. For Diamond, the photograph was a transparent medium that allowed the therapist and the patient accurately to interpret the language of nature. "The picture speaks for itself," he asserted.[19] Diamond maintained that "the Photographer secures with unerring accuracy the external phenomena of each passion, as the really certain indication of internal derangement, and exhibits to the eye the well known sympathy which exists between the diseased brain and the organs and features of the body."[20] Addressing the Royal Society in 1856, he stressed that photography's scientific objectivity would give it historical importance. "Photography," he concluded, "gives permanence to these remarkable cases … and makes them observable not only now but for ever."[21] Because these photographs were understood to be both effective therapeutic and educational instruments, patients were obliged to pose for them.

Dr. Diamond was one of the first photographers to experiment with the COLLODION PROCESS or wet-plate process, a new negative–positive process published by Frederick Scott Archer (1813–1857) in 1851. Although still time-consuming, the wet-plate process used glass, rather than paper, to support the light-sensitive material. It boasted a greater sensitivity and shorter exposure time than previous processes, including the albumen glass-plate negatives, devised in the late 1840s by Claude Félix Abel de St. Victor Niépce (1805–1870), a

relative of Joseph Nicéphore Niépce. The wet-plate process furnished multiple images that were free from the imprint of texture rendered by the paper negatives.

Most photographs of mental patients were intended for scientific study, but in rare instances they were used to raise money for the asylum. A French example, mounted individual daguerreotypes in a poster-like format, publicized a lottery to benefit patients (Fig. 2.18). Photography was also used during its first decade to describe, compare, and rank "racial" types. The notion of race was renewed in the late eighteenth and early nineteenth centuries, when it was used to describe innate qualities of nations and ethnicities, sometimes with the aim of arousing nationalistic feeling. With the rapid colonization of the non-Western world, human diversity was increasingly discussed and classified.

The French photographer E. Thiésson (active 1840s) produced annotated images of the residents of Sofala, a town in Mozambique (Fig. 2.19), and of the Botocudo people in Brazil. Thiésson omitted names and personal details in

2.17
HUGH WELCH DIAMOND, *Seated Woman with Bird,* c. 1855. Albumen print. The J. Paul Getty Museum, Los Angeles, California.

Most of Diamond's photographs were of women patients. He adapted the new medium to continue a series of engraved patient portraits, started by his predecessor, as superintendent of the Surrey County Lunatic Asylum.

2.18
PHOTOGRAPHER UNKNOWN, *Untitled* (Lottery announcement), 1852. The J. Paul Getty Museum,
Los Angeles, California.

The heading, "Galerie Historique," and the phrase, "au bénéfice des originaux," have ironic meanings. A
regular gallery presented portraits of famous individuals, not asylum inmates. The phrase "au bénéfice des
originaux" means both for the benefit of those pictured and for the benefit of eccentric or unusual people.[22]

2.19 (above)
E. THIÉSSON, *Native Woman of Sofala*, 1845. Daguerreotype.
Gift of Eastman Kodak Co. George Eastman House, Rochester, New York.

The side or profile view of non-Western subjects appeared first in early daguerreotypes. It became the standard visual technique for photographing non-Western peoples, and anticipated the so-called mug shot in police photography.

an attempt to accentuate the scientific objectivity of his photographs. He developed a specific visual vocabulary, posing his subjects from the side and from the front, and using a plain background. The appearance of neutrality and the distance of subjects from the camera were conventions that developed slowly and unevenly during photography's first decades, as ethnographers adopted a standard, "styleless" style to connote truth. In fact, many early images of non-Westerners employed the customs of middle-class portraiture, as in a subtle daguerreotype by the Philadelphia photographers Wilhelm and Friedrich Langenheim (Fig. 2.20). With its simple background, three-quarter profile, and the sitter's contemplative pose, the image wavers between anthropological record and formal portraiture.

Some medical evidence was collected in early photographs, yet highly detailed, sometimes hand-colored engravings continued to be used because they revealed fine points of anatomical structures more clearly than photographs.[23] Patients were photographed according to the conventions of portraiture, rather than to show only wounds and diseases. They seldom posed in clinical settings,

2.20 (below)
**WILHELM &
FRIEDRICH
LANGENHEIM**, *African
Youth*, 1848.
Daguerreotype. Peabody
Museum, Harvard
University, Cambridge,
Massachusetts.

FOCUS
Photography, Race, and Slavery

The Langenheim daguerreotype (see Fig. 2.20) was probably in the collection of the Swiss-born naturalist Louis Agassiz (1807–1873), who came to the United States in 1846. The founder of Harvard University's museum of comparative zoology, Agassiz was an avid proponent of photographic data and perhaps the best-known scientist in mid-nineteenth-century America.[24] His ethnological interests led him to authorize a Southern colleague to commission front, back, and side views of slaves from a North Carolina plantation in 1850. Agassiz hoped to provide visual evidence for his theory that the races were created separately at different times and in different parts of the world, an idea that slavery's proponents felt would

scientifically justify racial inequality. Agassiz's colleague hired J. T. Zealy (active 1850s), who ran photographic studios in Columbia, South Carolina, and Petersburg, Virginia, to make a series of fifteen daguerreotypes.

In two images of a slave named Jack, the key assumption of middle-class portraiture—that personal character was expressed through physical appearance—vies with the desire to record objectively a generic physical type (Figs. 2.21 and 2.22). Zealy's subjects were not identified by their African names, but their slave names and the names of the plantations on which they served. In the first picture, Jack is romantically lit, emphasizing facial features that make him appear noble, pensive, and

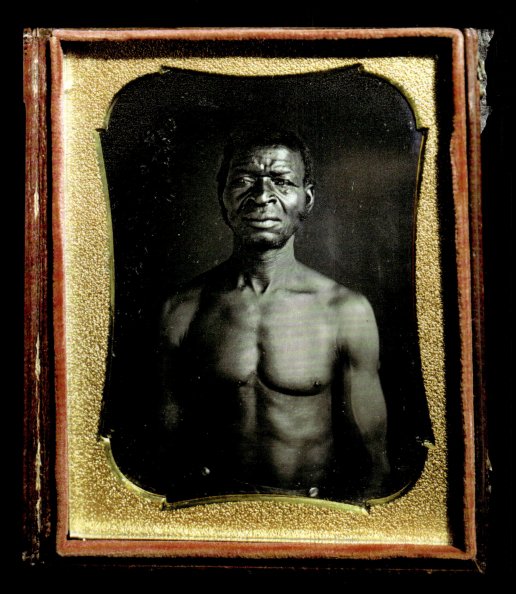

2.21
J. T. ZEALY, *Jack*, **1850s. Daguerreotype. Peabody Museum of Art, Archaeology & Ethnology, Harvard University, Cambridge, Massachusetts.**

ing. His eyes are fixed beyond the camera. But in
d, side view, his personality traits are dimin-
d the romantic side light of the first image is
ntensify anatomical features that would substan-
ssiz's thesis. Although the photographs were
compare and contrast physical types, no images
rably posed white men and women accompanied
uerreotypes.
ain purpose of Zealy's slave photographs was to
viewers of the truth of a racial theory. But they
questions about the authorship of images.
Agassiz commissioned them as part of his
, he was not there when the images were made.

A colleague communicated to the photographer what the
aim of the photographs was to be and labeled the final
prints, yet Zealy actually made the exposures. Obviously,
the subjects of these photographs had no say in their
representation.

Today, Zealy's name is appended to the images,
because in contemporary law and ethics photographers
are understood to be the originators of their work. But in
nineteenth-century terms, Zealy was, in this instance, an
operator, that is, a person who exposed and/or developed
photographs for those who conceived the pictures. The
images were sent to Agassiz; they were not Zealy's prop-
erty to keep, copy, or distribute.

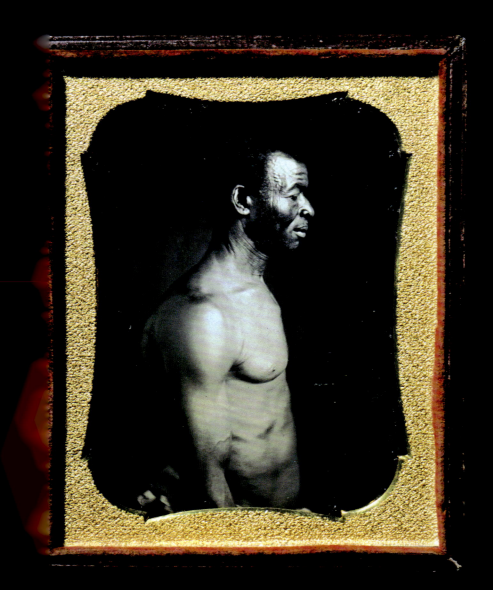

2.22
J. T. ZEALY, *Jack* **(from
the side), 1850s.
Daguerreotype. Peabody
Museum of Art,
Archaeology &
Ethnology, Harvard
University, Cambridge,
Massachusetts.**

but were pictured in surroundings such as those used for middle-class portraits, and their faces were usually identifiable (Fig. 2.23). Modern protocols for photographing illness—concealing personal identity and emphasizing symptoms—did not become prevalent until the later nineteenth century. In many respects, the patients in early medical photographs resembled the portraits that doctors took of themselves.[25] As the medical profession grew throughout the second half of the nineteenth century, however, largely due to the increasing use of antiseptics and anesthesia, so too did the rhetoric of therapy and medical education. This in turn fostered more revealing medical imaging that focused on wounds, marks, or dysfunctions. The explicitness of photographs picturing American Civil War casualties (see Fig. 3.20) far exceeded the decorum afforded patients a decade earlier.

Performing History?
The Dr. Morton Controversy

Where art conventions influenced early photographic practice, a contradictory blend of old ideas and new expectations was created. A series of daguerreotypes taken in Boston, Massachusetts, by the firm of Southworth and Hawes combined notions associated with older media, such as printmaking and painting, with emergent ideas about the purpose of photography. It was not clear for years whether these photographs showed the actual surgery in which ether was first used to relieve pain during an operation, or whether they reenacted the historical event (Fig. 2.24).

Dr. William T. G. Morton, the discoverer of ether who first used it in surgery, could not be identified in the pictures, nor could the original patient. The suggestion that these images were reenactments did not invalidate them, however. The *tableau vivant*, or living picture, was a popular entertainment in which people donned costumes to recreate historic scenes or famous works of art. Moreover, the visual arts traditionally sanctioned artists who were not present at historical events to depict those events, even to embellish such scenes. If the surgery scene employed artistic license, this would not make it a falsification calculated to deceive viewers. Also, the images may have been made either to commemorate the historical event, or as devices with which to petition Congress for an award to Dr. Morton.

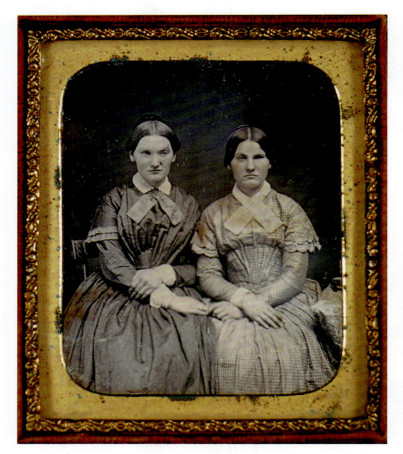

2.23
PHOTOGRAPHER UNKNOWN, *Untitled* **(Deformity about the left eye in two sisters), c. 1847. Daguerreotype. Burns Archive, New York.**

Early medical photographs showed patients in street clothes, posed as if for a formal portrait. This image shows two sisters with a deformity about the left eye, which in one sister has a more exposed eyeball and in the other is almost closed.

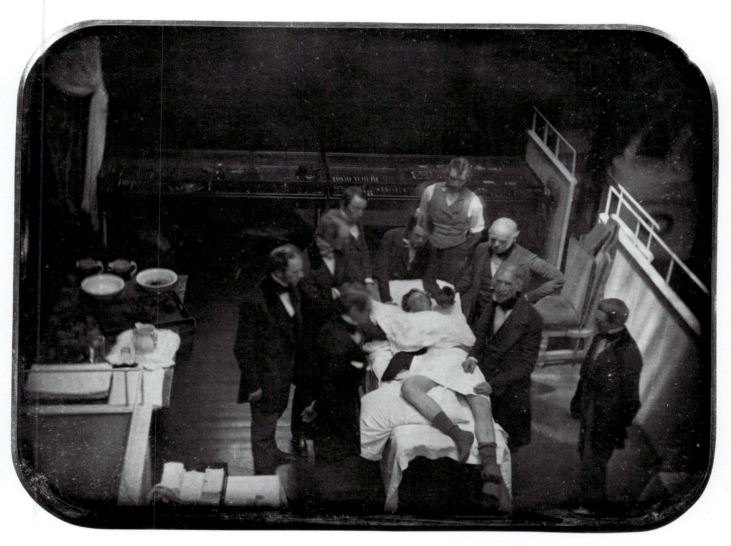

Certain viewers interpreted the presence of medical instruments in cases as evidence of an authentic operating room. Others also argued that, if the daguerreotypes were reenactments, they would have emulated the original surgery more closely, in which the patient probably sat in an operating chair. Skeptics also observed that participants appeared to be posing for the camera in a manner not possible during actual surgery. Some scholars observed that Dr. John Collins Warren, shown with his hands on the patient's draped leg, may have asked Southworth and Hawes to pose the scene so as to emulate Rembrandt's famous painting *The Anatomy Lesson of Dr. Tulp*.[26]

By modern hygiene standards, the surgeon and his colleagues, mostly in street clothes, and the patient, still in his stockings, do not seem prepared for surgery, but for photography. Moreover, the statue visible in the upper right-hand corner appears outlandish in an operating room. But medical historians

pointed out that, if the image recorded the pre-operation application of anesthesia in an anteroom, then the poses, garb, setting, and even that statue, would be plausible.

Eventually, another photograph was found that convincingly showed the subsequent post-operative scene, thus clearing up the mystery. A real surgery, though not the first use of anesthesia, had taken place before the camera of Southworth and Hawes. While the first surgery under ether was not photographed, in the public memory these later images came to stand for that momentous event. These daguerreotypes were thus at once commemorative, documentary, scientific, symbolic, and aesthetic. This rich multiplicity, a result of the mixing of science and art in early photography, did not persist long. The tensions between realism and symbolism were taken up again in the twentieth century in such art movements as surrealism and conceptual art, as well as in advertising.

**2.24
ALBERT SANDS
SOUTHWORTH &
JOSIAH JOHNSON
HAWES,** *Early
Operation Using Ether
for Anesthesia*, **1847.
Daguerreotype. The
J. Paul Getty Museum,
Los Angeles, California.**

Although photography was quickly associated with truthful experience, photographers also borrowed from the art tradition of commemorating historical events. Here an early, but not the first, use of anesthesia is registered both as a document of an actual operation and as a symbolic acclamation of a milestone in medicine. To modern eyes, however, the surgeons in street clothes and the general indifference to hygiene evident in the room do not indicate progress.

RECORDING EVENTS WITH THE CAMERA

Although both the calotype and the daguerreotype processes were too slow to record rapid action, early attempts were made to photograph public events on the spot. For example, Hermann Biow (1804–1850), a portrait photographer living in the German city of Hamburg, is credited with photographing the ruins of the great fire that devastated the city from May 5 to May 8, 1842 (Fig. 2.25). George N. Barnard, an American who would become famous for his American Civil War photographs (see Fig. 3.17), used the daguerrean process to record a lakeside granary fire in Oswego, New York (Fig. 2.26).

In Hamburg and Oswego, the photographers happened to be nearby when these dramatic scenes occurred, but had no preconceived plan to make, sell, or publish their daguerreotypes. By contrast, when historic happenings were anticipated, photographers could arrange to be present. In France, a remarkable pair of "before and after" daguerreotypes were made with the explicit intention of rushing them to publication as wood engravings. During the revolution of 1848, middle-class demands for greater political influence and the right to vote flared up into street conflicts that led to the abdication of King Louis-Philippe and the establishment of a provisional government, which declared a republic. A daguerreotypist named Eugène Thibault (active 1840–1870) was commissioned by the weekly Paris journal *L'Illustration* to photograph the barricades prior to and after a skirmish between the revolutionaries and French troops. The resulting images were published on July 1, 1848 (Figs. 2.27 and 2.28).

While painters and printmakers could enhance their images with sharply rendered scenes of gallantry and heroism, photographers were hard-pressed to express the full historical significance or emotional impact of events. The London photographer W. E. Kilburn (active 1846–1862) took daguerreotypes of a meeting of the Chartists, a loose coalition of working-class people seeking political and economic reforms, on April 10, 1848. But his static views fail to convey the exhilaration of the assembly and the speeches in defiance of the government (Fig. 2.29).

2.25
HERMANN BIOW,
Ruins of Hamburg Fire, 1842. Daguerreotype. Museum für Hamburgische Geschichte, Hamburg, Germany.

Biow was able to make forty-six daguerreotypes of the destruction. Often cited as the first efforts of photojournalism, the photographs were not originally intended for publication in a newspaper.

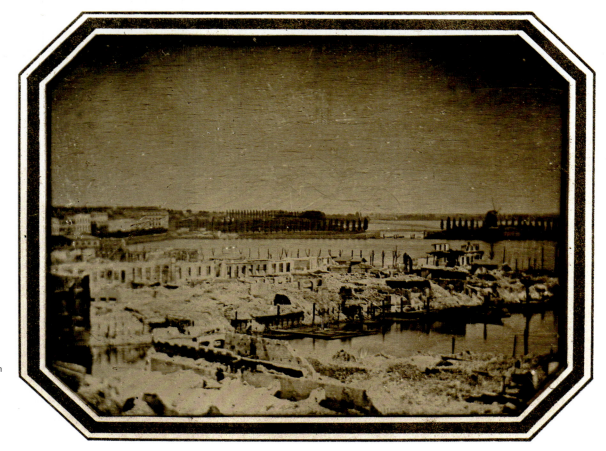

2.26
GEORGE N.
BARNARD, *Burning of Oswego Mills*, July 5, 1853. Daguerreotype. George Eastman House, Rochester, New York.

The inadequacy of the daguerreotype to render action is apparent. The fast-moving flames are indistinct, and the bodies of workers on the barge in the foreground are transparent like ghosts. Barnard later sold copies of this photograph to the public.

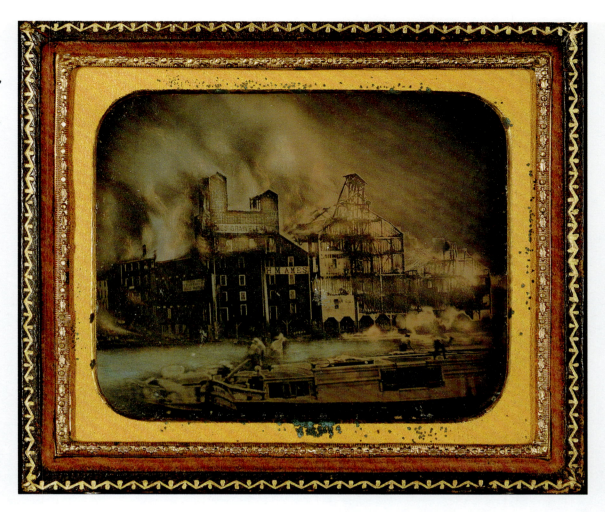

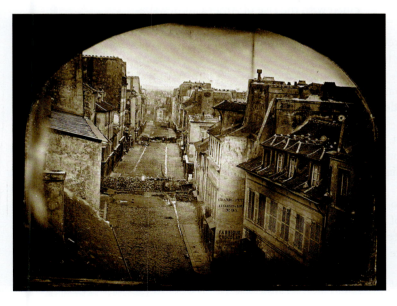

2.27
EUGÈNE THIBAULT, *The Revolution of 1848: Before the Attack*, 1848. Daguerreotype. Count Geofroy de Beauffort Collection.

2.28
EUGÈNE THIBAULT, *The Revolution of 1848: After the Attack*, 1848. Daguerreotype. Count Geofroy de Beauffort Collection.

In the foreground of figure 2.27, many cobblestones appear to be missing. They were often removed and stacked near the barricades to be thrown at the advancing troops.

2.29
W. E. KILBURN, *The Great Chartist Meeting on Kennington Common*, April 10, 1848. Daguerreotype. Royal Archives © 2002 Her Majesty Queen Elizabeth II.

Photographs of historical events sometimes failed to find a clear subject or theme with which to represent the occasion. Kilburn's image doesn't make the importance of the scene accessible to viewers.

WAR AND PHOTOGRAPHY

IMAGING WAR

Early photography also had difficulty in documenting the facts, causes, and the experience of conflict. Both the daguerreotype and the calotype required lengthy preparation of materials prior to exposure in the camera and a cumbersome development process; neither was able to register the rapid action of battle. In having to conceive the war photograph without scenes of active conflict, photographers probably relied on visual conventions established in other media, and on society's expectations of what war pictures should look like. War photographers had to cope with the lack of an established market or viewing space for their work, and the fact that, unlike painters and engravers, they were restricted to what happened in front of the lens. Artists in other media could concoct patriotic symbols and emotionally affecting scenes, but the war photographer was faced with transforming the real into the symbolic, and with finding

or staging heart-rending incidents. These and other perplexities surfaced in the first photographed wars.

The Mexican–American War coincided with the rise of American newspapers. Daily papers in cities benefited not only from new high-speed presses, but also from news carried across the nation by couriers and sometimes by telegraph. Public interest in the war accelerated the appearance of wood-engraving illustrations in newspapers, and increased the popularity of lithographs. But these images were not based on photographs, nor was there a call to make them more authentic by copying camerawork. In the long term, however, the war brought about a change in journalism that affected photography. For the first time, war correspondents dispatched from major American papers could send back reports that were rushed into print. Speedier reporting by war correspondents eroded the domination of the Washington, D.C. newspapers and the military as major sources of war information. The Mexican–American War

FOCUS
The Mexican-American War

In 1836, led by American residents, the Mexican province of Texas declared itself an independent republic. The separation was the final result of long-running quarrels between the two nations about land rights and financial reparations due Americans for property lost during civil unrest in Mexico in the 1830s. Peace negotiations were hampered by the American residents' campaign to have Texas annexed by the USA (Texas eventually achieved statehood on December 29, 1845). Relations between Mexico and the United States were further troubled by the escalating American desire to "manifest destiny" by acquiring more North American soil, including the Mexican territories of California and New Mexico. Further, the prospect of Texas's entry into the Union as a state in which slavery was legal intensified the national debate about the future of slavery. After skirmishes with Mexican troops early in 1846, the United States declared war. The war ended in 1848 with the treaty of Guadalupe Hildalgo, in which Mexico ceded extensive territories including most of what became Arizona, California, Colorado, Nevada, and New Mexico.

The fifty or so anonymous photographs remaining from the conflict—often called the first photographed war—show the faltering beginnings of a war photography largely cut off from battle scenes and troop movements. Some general tendencies are apparent: as happened in many subsequent conflicts, for example, photographs of soldiers were made either before they left for the war or in military encampments. Disruptions in trade and transportation caused shortages of photographic materials near the front, yet scarce supplies did not keep photographers from boasting their ability to make images. Photographers also made images of war heroes, along with a few landscapes and town views. One of the best-preserved examples is the daguerreotype of Brigadier General John Ellis Wool, accompanied by his staff, on a street in the Mexican town of Saltillo (Fig. 2.30). Because of the daguerreotype's long exposure time, the group had to pause to have a photograph taken. Still, some blurring occurred on the left side of the image.

2.30
PHOTOGRAPHER UNKNOWN, *General Wool and Staff, Calle Real, Saltillo, Mexico,* c. 1847. Daguerreotype. Amon Carter Museum, Fort Worth, Texas.

DEATH OF MAJOR RINGGOLD.
OF THE FLYING ARTILLERY.
AT THE BATTLE OF PALO-ALTO, (TEXAS) MAY 8TH 1846.

2.31
ARTIST UNKNOWN,
Death of Major Ringgold of the Flying Artillery, at the Battle of Palo-Alto (Texas), May 8, 1846,
1846. Lithograph. Amon Carter Museum, Fort Worth, Texas.

Painters and printmakers frequently embellished death scenes of major figures. Ringgold's white horse bows low so that a well-dressed, unruffled aide can catch the falling body of his mortally wounded master. Mindless of his wounds, Ringgold points toward heaven, as his wide-eyed mount, now burdened with an empty saddle (the traditional military symbol of death), seems about to weep.

also fostered an appetite for up-to-date news. Within a decade, communications systems were specifically devised to transport both images and text describing distant hostilities. In England, for example, topical images of the Crimean War (1854–56) would be displayed for viewing and sale (see pp. 86–91).

During and after the Mexican–American War, patriotic themes dominated the images produced for the press and the market. A popular hand-colored lithograph portraying the melodramatic death of Major Samuel Ringgold could not have been matched by the camera without overt staging (Fig. 2.31). Early war photographs, however, were not always innocent of manipulations. The amputation scene in an intriguing Mexican daguerreotype was probably staged for the camera. It shows a sergeant who has just been operated on, presumably by Dr. Pedro Van der Linden, Inspector General of Mexico's Military Medical Corps[27] (Fig. 2.32). Van der Linden, on the far right, is holding an amputated lower leg. Other participants point to the patient's stump, and someone has added a sign noting the place and date. It seems unlikely that

this image was made immediately after the operation, but rather reenacted later.[28] Historian Gina Rodríques Hernández believes that the group was arranged for the camera, because the participants appear too clean for battle-front surgery. Van der Linden recounted being interrupted by North American soldiers while performing an amputation. Thrusting out his bloody hands, he pleaded for humanitarian respect, and, as his story goes, the Americans not only retreated, but became his protectors and received his medical services.

A daguerreotypist accompanying the United States troops may have made the picture to commemorate the brief eruption of peace during combat.[29] Posed like a history painting, the image evokes the same sort of contradictions surrounding the Southworth and Hawes daguerreotypes of the first uses of surgical anesthesia (see Fig. 2.24).

BRITISH CONFLICTS IN ASIA

John McCosh (1805–1885; occasionally MacCosh) is the earliest war photographer whose name is known. He took photographs not of troops but of fellow officers in India, where he served as a

**2.32
PHOTOGRAPHER
UNKNOWN,**
Amputation,
Mexican–American War,
Cerro Gordo, 1847.
Daguerreotype. National
Institute of Anthro-
pology and History,
Mexico City, Mexico.

A damaged daguerreo-
type made in Mexico
pays homage to a brief
moment when the con-
flict was paused to allow
a doctor to perform a
grisly amputation. Proof
of the battlefield surgery
is evidenced by the
patient raising his
bloody stump, and by
the surgeon's presenta-
tion to the camera of the
severed limb.

surgeon with the East India Company during the Second Sikh War (1848–49), a conflict between the Sikh minority and the British. McCosh made calotype photographs as a hobby in the mid-1840s. In addition to portraits of military colleagues, McCosh also pho-tographed local people, emphasizing "racial" physical characteristics. During the Second Burma War (1852–53), between the Burmese and the British, McCosh produced large photographs, like his view within the city of Prome (Fig. 2.33).

**2.33
JOHN McCOSH,**
*Artillery in front of Stone
Dragons,* Prome, Burma,
1852. Calotype. National
Army Museum, Chelsea,
London.

Images such as John
McCosh's 1852 photo-
graph of British artillery
in front of the Stone
Dragons in the Burmese
city of Prome confidently
juxtapose non-Western
culture with symbols of
imperialist might.

EXPEDITIONARY AND TRAVEL PHOTOGRAPHY

The global expansion of European and American power spurred the growth of photographic practice. Despite its unwieldy equipment and technical limitations, photography was seen as an important tool for information gathering. Hershel had unsuccessfully suggested that photographic equipment be included in an 1839 British expedition to the Antarctic; then in 1842 American photographer Edward Anthony (1811–1888) accompanied a government survey of the northeast boundary of the United States and Canada.[30] None of Anthony's daguerreotypes survives, however. Despite modest success, the era's enthusiasm for exploration found a strong symbol in the camera. In 1846 *Art Union* called it "an indispensable accompaniment to all exploring expeditions," which would "greatly … abbreviate the toils and diminish the dangers of those who may follow" in the tracks of the explorer.[31]

EGYPT AND THE HOLY LAND

As early as 1839, François Arago had urged the use of the new medium of photography in copying the hieroglyphic inscriptions on ancient Egyptian buildings. He was envisioning a continuation of the extensive French documentation of ancient Egypt begun under Napoleon, but, although Egypt was one of the first sites to attract daguerrean photographers, they did not fulfill Arago's hope for a systematic visual survey of Egyptian antiquities. Instead, they composed views that responded to the European taste for picturesque ruins. The picturesque, meaning literally like a picture, was a broad aesthetic category in nineteenth-century thought. In general, it meant that a natural scene was composed in such a way that it stirred fine feelings or thoughts in the viewer, just as a painting or a sketch might do. By selecting such topics and designing scenes reminiscent of prints and paintings, photographers validated their efforts and won public acceptance.

2.34
HECTOR HOREAU, *Medinet Habu,* **plate 18 from** *Panorama d'Égypte et de Nubie,* **1841. Aquatint from daguerreotype by Joly de Lotbinière. Resource Collections of the Getty Center for the History of Art and the Humanities, Los Angeles, California.**

Because the daguerreotype was a unique image that did not produce a negative, it could only be copied by the daguerrean process. To produce copies, engraving and lithography were used. Views derived from daguerreotypes were sometimes printed (as here) using aquatint, an engraving process able to mimic the tonal range of daguerreotypes.

2.35
N. M. P. LEREBOURS,
Portail de Notre Dame de Paris (detail), plate 43 from *Excursions Daguerriennes,* 1840–44. Engraving after a daguerreotype. George Eastman House, Rochester, New York.

The photographic camera and operator, and a human subject on the left, were probably added to this view of Notre Dame, Paris, to provide both human interest and a sense of scale. This print is one of the earliest pictures to show a photographer at work.

Early photographers took advantage of the fact that several regions of the Middle East contained both ancient monuments and biblical sites. While on a Grand Tour of Greece, Egypt, and the Holy Land, the Swiss-born Canadian Pierre-Gustave Joly de Lotbinière (1798–1865) made daguerreotypes of Egyptian architecture. His work became the basis for the AQUATINTS issued by the architect and egyptologist Hector Horeau in *Panorama d'Égypte et de Nubie* (*Panorama of Egypt and Nubia*) (1841) (Fig. 2.34). Similarly, French publisher Noël Marie Paymal Lerebours (1807–1873) relied on daguerreotypes when he assembled a multi-volume work titled *Excursions Daguerriennes, representant les vues et les monuments les plus remarquables du globe* (*Daguerrian Excursions, Showing the World's Most Remarkable Views and Monuments*) (1840–44). Lerebours, who bought daguerreotypes and commissioned others for his publi-

cations, calculated that prospective buyers would not appreciate a straightforward transcription of daguerreotype views, so he adjusted harsh shadows and other elements to make his scenes more appealing to contemporary taste (Fig. 2.35).

Lerebours's *Excursions Daguerriennes* discounted the efforts of the many anonymous photographers who contributed daguerreotypes, and credited the publisher for conceptualizing, organizing, and printing the work. In the era of early photography, conceptualization was routinely prized over the actual taking and making of a photograph. In the portrait studio, for instance, the photographer might pose a client and arrange the lighting, while an assistant actually exposed and developed the image. For a long time, Scottish photographer David Octavius Hill was bestowed more distinction for the art direction of his pictures than his partner, Robert Adamson,

was given for the execution of them (see p. 72).

Among more than a hundred travel subjects included in *Excursions Daguerriennes* is a view of the Propylaea, or gateway to the Athenian Acropolis, taken by Lotbinière (Fig. 2.36). Greek photographers, too, photographed ancient remains, but daguerreotypes taken by Greeks of their homeland in the early 1840s do not survive.[32] A remarkable daguerreotype of a general view of the Acropolis from the hill of Philopappus was taken by Greek painter Philippos Margaritis (1810–1892)[33] (Fig. 2.37).

The Holy Land was another destination for many early photographers, and the site for one of the first planned attempts to use photography as persuasion. When working on a new edition of *Evidence of the Truth of the Christian Religion,* Alexander Keith (1791–1880) asked his son, the medical doctor George Skene Keith (1819–1910) of Edinburgh, to make daguerreotypes that would show the veracity of the Bible. An earlier edition contained drawings probably not done on the site,[34] but for the new edition, published in 1844, George Keith took about thirty daguerreotypes, eighteen of which were made into engravings for the book, in order to "convince the unprejudiced inquirer or the rational and sincere believer, that it is impossible that his faith be false."[35] Keith's images were accompanied by biblical quotations

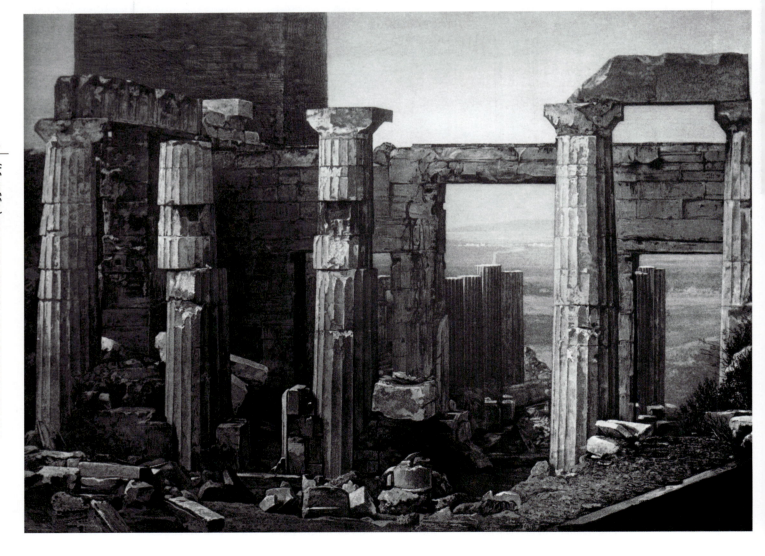

2.36
JOLY DE LOTBINIÈRE, *View of the Propylaea of the Acropolis, Athens, 1839, from Excursions Daguerriennes,*
1840–44. Engraving after a daguerreotype. George Eastman House, Rochester, New York.

The gateway, or Propylaea, of the Athenian Acropolis was a portal through which well-to-do Europeans longed to pass as part of their Classical education. This engraving after a daguerreotype has had a noticeable softening effect on the original image.

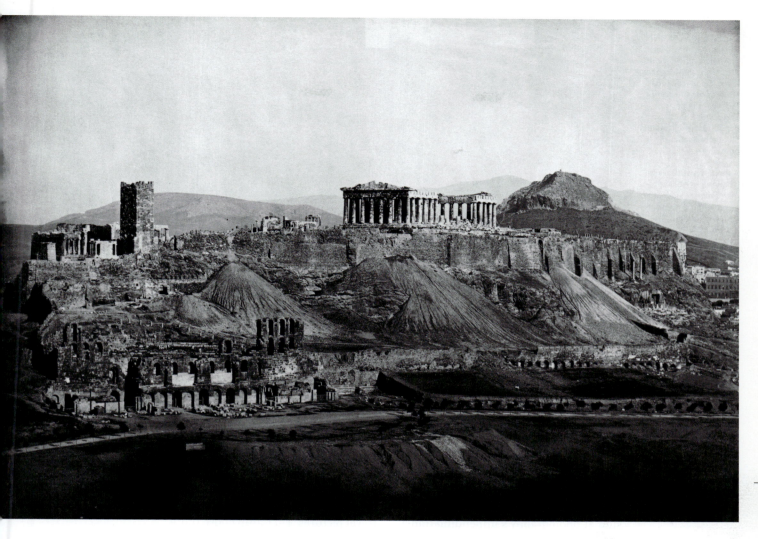

2.37
PHILIPPOS MARGARITIS, *Untitled* **(Acropolis: general view from the Hill of Philopappus, southwest), 1865.**
Daguerreotype. The J. Paul Getty Museum, Los Angeles, California.

This daguerreotype reveals more pronounced contrasts and greater detail than would an engraving after a daguerreotype (see Fig. 2.36). Margaritis learned the daguerreotype process from the traveling French photographer Philippe Perraud (1815–?).

(Fig. 2.38). Not all Western photographers focused exclusively on places and buildings important to Christian belief. Among nearly a hundred daguerreotypes made by the French nobleman Joseph-Philibert Girault de Prangey (1804–1892), an admirer and student of Islamic architecture, are images of such famous buildings as the Dome of the Rock (Fig. 2.39).

Different methods of producing light-sensitive paper for photographs were also employed by travelers. French writer, amateur egyptologist, and student of Arabic literature Maxime Du Camp (1822–1894) adapted the process for an extended trip with writer Gustave Flaubert (1821–1880) to Egypt, Nubia, and the Holy Land. Du Camp was com-

missioned by the French Ministry of Public Education to photograph Egypt's monuments. Flaubert, then largely unknown, held a commission from the Department of Agriculture to study crop production and trade. These commissions functioned like passports, allowing travelers to circumvent questions and delays.

After many struggles with the medium, Du Camp managed to make more than 200 paper negatives, 125 of which were printed, mounted on paper, and bound with an introduction. The photographs were printed by Louis Désiré Blanquart-Evrard (1802–1872), who perfected the calotype and also increased its yield. Blanquart-Evrard coated the light-sensitive paper with

2.38
DR. GEORGE SKENE KEITH, "Zion will be plowed as a field Jer. 26; Mic. 3:12," in Alexander Keith, *Evidence of the Truth of the Christian Religion*, 1847. Engraving from a daguerreotype. National Library of Scotland, Edinburgh.

Although it appears to be an objective recording of the scene, Keith's photograph emphasizes desolate infertility in a deliberate attempt to contrast the lushness of biblical Israel with the contemporary landscape.

whey and albumen, derived from milk and eggs, respectively. The coating allowed the so-called ALBUMEN PAPER to be prepared ahead of time, which quickly led to the commercialization of its production. With another entrepreneur, Blanquart-Evrard also operated a photographic printing factory, a further sign of photography's impending transition from a handicraft to an industrial product.

Unlike volumes that depended on engravings or aquatints based on daguerreotypes, Du Camp's *Egypt, Nubie, Palestine et Syrie* (*Egypt, Nubia, Palestine, and Syria*) (1852) contained reproductions of actual photographs, one of the first travel books to do so. Breaking with the newly established style of adjusting shadows and adding human figures to daguerreotype-based travel pictures, Du Camp chose more neutral views of ancient Egyptian art and architecture (Fig. 2.40). Having defined his goal as an accurate account of ancient Egyptian monuments,

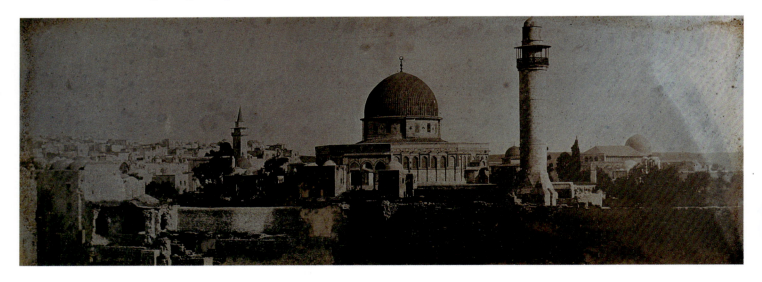

2.39
J. P. GIRAULT DE PRANGEY, *The Dome of the Rock and the Wailing Wall* (laterally reversed view), c. 1850. Daguerreotype. Bibliothèque Nationale de France, Paris.

Since Girault de Prangey was excluded from Islamic sacred buildings, many of his views are taken at a distance. His photograph of the Dome of the Rock, Jerusalem, shows the mosque and, in front of it, the Wailing Wall, sacred to Jews.

Du Camp made precise measurements of buildings as well as photographing them. He also recorded contemporary Arab culture, only to have most of these pictures rejected by his publisher, who thought they had no commercial value. Toward the end of his journey, Du Camp traded his photographic equipment for yards of embroidered fabric, and never resumed his photographic work.

Not every photographer in Egypt was as committed to scientific detachment and neutral description as Du Camp. John B. Greene (1832–1856), born in France of an American family, actively pursued the study of both photography and ancient cultures, becoming one of the earliest archeologists to use the new medium in his work. Some of his images parallel those of Du Camp in depicting ancient Egyptian architecture, sculpture, and inscriptions with legibility and precision; other works seem more like evocative watercolors than

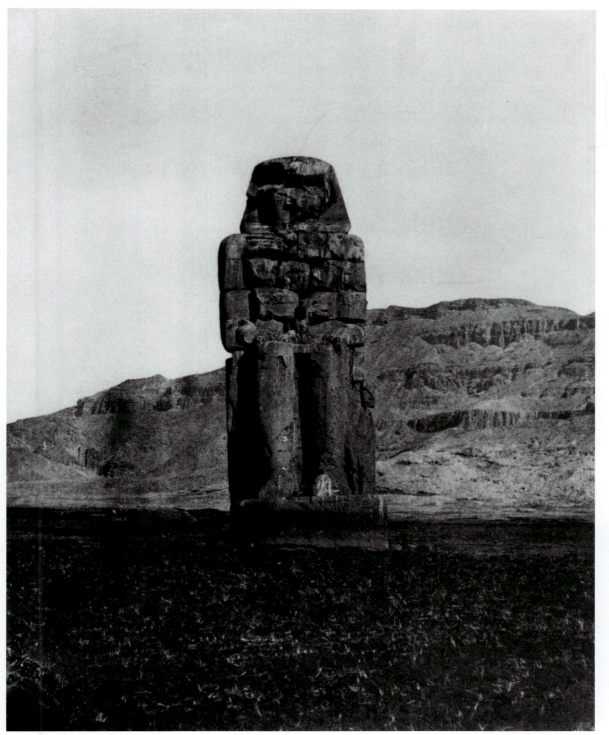

2.40
MAXIME DU CAMP,
Colossus of Memnon,
1850. Salt print from
paper negative.
Gernsheim Collection.
Harry Ransom
Humanities Research
Center, University of
Texas at Austin.

In his Egyptian views,
Du Camp chose points
of view that created a
sense of order, and con-
veyed a clear idea of the
monument. The human
figure standing in the
lap of the colossus may
seem comical, but was
probably asked to stand
there to give the viewer
a sense of scale.

systematic records (Fig. 2.41). More than ninety of Greene's Egyptian images were published by Blanquart-Evrard in *Le Nil: Paysage, explorations photographiques* (*The Nile: Landscape and Photographic Explorations*) (1854).

The idea of the photographic series, that is, of creating and arranging images in meaningful sequences, was increasingly adopted in historical, archeological, travel, scientific, medical, and even art photography. During the medium's earliest years, compilations of dissimilar and unrelated images, such as those found in Lerebours's *Excursions Daguerriennes* and Talbot's *The Pencil of Nature*, were prevalent. But as photography proliferated, the arrangements of related images were published more frequently. Photographic series expanded the notion of photography from that of an image-making process, to something akin to writing. Nineteenth-century albums and books containing interrelated pictures underscored the photographer's skill in building up what the twentieth century would know as the photographic essay. Slowly, commentators began to concede that some photography—series, aesthetic endeavors, and scientific improvements—involved intellectual exertion, a claim that would serve to distance professional and serious amateur photographers from itinerant and part-time practitioners.

THE HISTORIC MONUMENTS COMMISSION

In its historical and civic interest, as well as its convenient stillness and large masses, architecture was suited to photography. Moreover, as historian Janet Buerger observed, in the medium's early period, cityscapes were more popular in

2.41
JOHN B. GREENE,
The Banks of the Nile at Thebes, **1854. Salted paper print from a waxed paper negative. George Eastman House, Rochester, New York.**

Early photographic materials were so sensitive to the light of the sky that the upper regions of photographs tended to be overexposed. Consequently, some photographers selected angles that diminished the prominence of the sky. Others, such as Greene in this Egyptian scene, deliberately used the blankness to create a sense of emptiness.

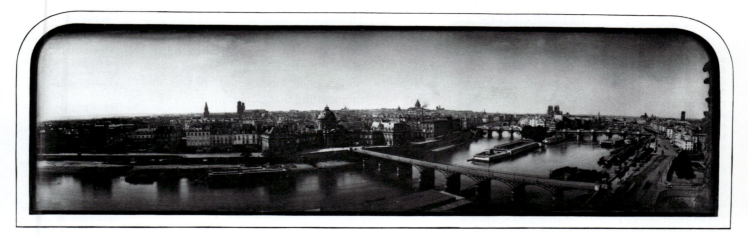

Many early photographers such as Martens devised new methods that extended the possibilities of the medium. To create some of his panoramas, Martens worked with long, thin, pliable daguerreotype plates and a specially built rotating camera called a Megaskop, which enabled him to record wide-angle views.

photography than in any previous art medium. The growth of urban areas during the mid-nineteenth century doubtless helped make the city an object of increased interest. Photographers often chose to picture the enduring monuments from the past with which the public customarily identified cities. For example, Frederick von Martens (1809–1875), a French photographer of German descent who made photographs for Lerebours, invented a rotating camera. His panoramic view of Paris sweeps down the Seine to the Cathedral of Notre Dame, which was enclosed in scaffolding for repairs (Fig. 2.42).

A grand series of architectural photographs was undertaken by the Historic Monuments Commission of the French Ministry of the Interior. Formed prior to the disclosure of photography to the world, the commission was charged with listing, surveying, and making recommendations for the historically correct restoration of French medieval and Gothic architecture. This task seemed urgent for several reasons. The aftermath of the French Revolution, the expansion of urban populations, and the industrial disruption of the countryside all nurtured a sense that the future would be markedly different from the past. In turn, this recognition of rapidly passing time heightened public appreciation of history and historical landmarks, many of which had been very seriously neglected or damaged. Moreover, French medieval and Gothic buildings were cherished symbols of cultural achievement, intensified by France's political and economic rivalry with Britain.

This politically charged atmosphere helped to revitalize the Historic Monuments Commission, which, by 1850, was considering whether to use photography in its architectural inventory. It might have been expected that the commission would choose the daguerreotype for its own purposes—a French invention that rendered a more detailed image than did the British calotype. Yet the commission rejected the daguerreotype's cold metallic tinge, in favor of the softer forms produced by the calotype. Further, a leading member of the commission complained that people of taste had not fully accepted the daguerreotype, because its mass of details was more distracting than artful. By contrast, the calotype's less sharply defined shapes and details, and evocative shadows more eloquently expressed nostalgia for the medieval past. The large size of the calotype was also an attractive feature, as was its ability to produce negatives from which multiple copies could be made.[36]

The photographic enterprise, which came to be known collectively as the Missions Héliographiques, employed several French photographers (Edouard Baldus, Hippolyte Bayard, Gustave Le Gray, Henri Le Secq, O. Mestral), the first of whom was Hippolyte Bayard, then vice-president of the recently founded professional association, the Société Héliographique. Like many early photographic organizations, it did not specialize in any one kind of photographic practice. It encouraged artistic, scientific, and technical discussions, and published a journal. Within this group, and others similar to it in Europe and America, scientists created what would be called artistic photographs, and artists freely experimented with the chemistry of photography.

Five members of the Société Héliographique were chosen by the Historic Monuments Commission, among them Edouard Baldus (1813–1889), who brought a remarkable inventiveness to the task. Typically, Missions Héliographiques photographers were assigned areas of France and particular monuments. Among Baldus's destinations was the church of Saint-Trophîme in Arles, a city in the south of France. In the adjacent medieval cloister, the self-styled "painter-photographer" Baldus cleverly devised an image-making process that went beyond the scope of his camera's vision. He created a large print of the *Cloister of Saint-Trophîme, Arles* (1851) by joining many negatives, and by retouching them where necessary (Fig. 2.43). In this effort, Baldus did not define the photograph as the pure product of a single camera exposure, but as a flexible basis for picture-making.

Throughout its subsequent history, photographers would juggle two notions, either aligning themselves with the idea of the inherently unique value of the unretouched negative and print, or maintaining that camerawork is, and should be, multifold, embracing not only the pure print but also all manipulations of the images.

Henri Le Secq (1818–1882), another of the Missions Héliographiques photographers, was also a painter and antiquarian. His undertakings for the Historic Monuments Commission often produced finely detailed registers of architecture and sculpture, as in the *Tour des Rois* (*Tower of Kings*) from the south tower of Rheims Cathedral, (1851) (Fig. 2.44). In his other work, Le Secq orchestrated images in which deep shadows mute detail and create such sharp contrasts that the photograph even approaches abstraction

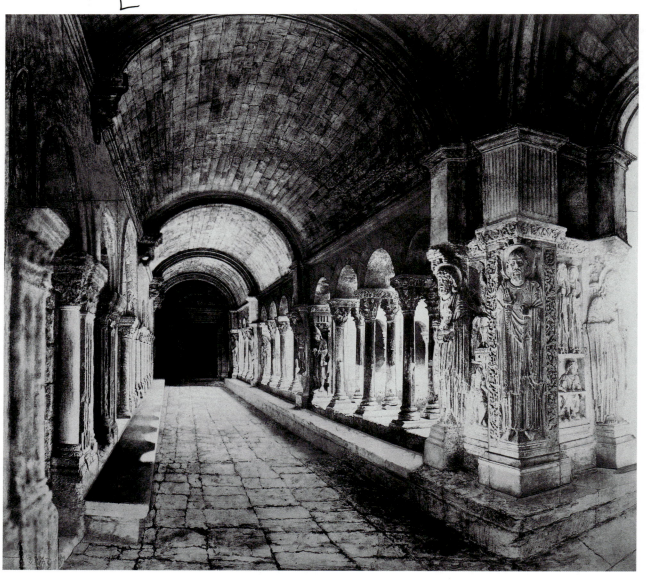

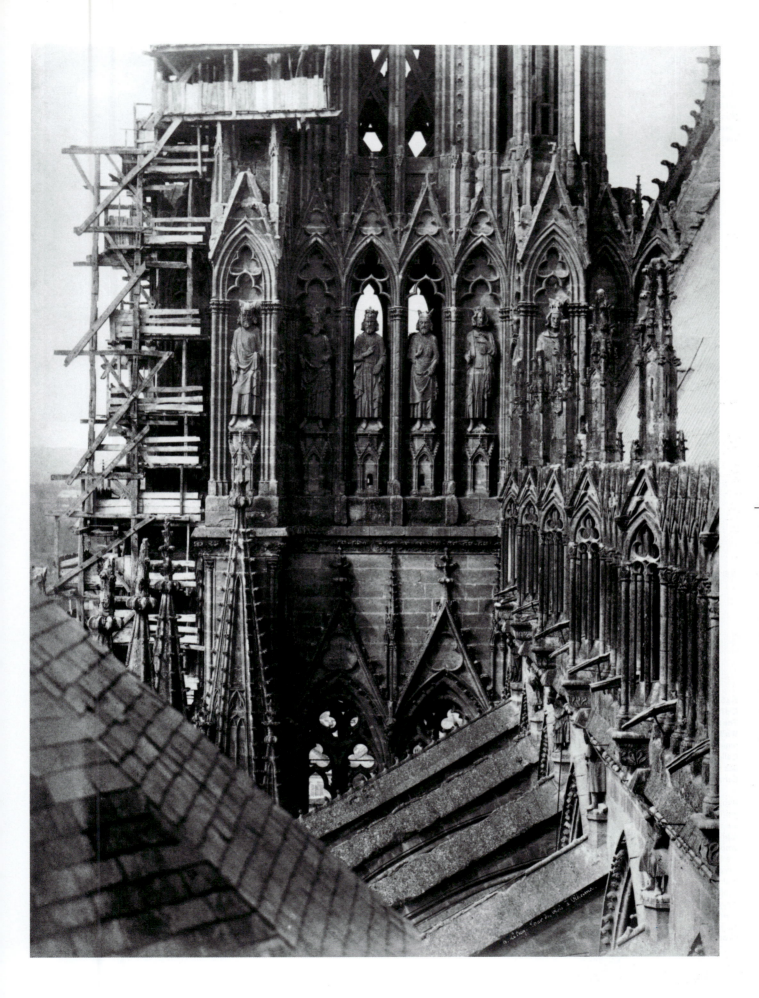

2.45
HENRI LE SECQ,
*Farmyard Scene, near
St. Leu-d'Esserent*, c.
1852. Cyanotype print
from paper negative.
Museum Purchase.
George Eastman House,
Rochester, New York.

THE SECOND INVENTION OF PHOTOGRAPHY (1839–1854)

(Fig. 2.45); he also made ingenious still-life photographs.

The subject-matter of the Historic Monuments Commission was taken up by other photographers without official appointments to the commission, notably Charles Nègre (1820–1880).

Nègre, a painter, progressed from daguerreotype to paper photography in the late 1840s. He made architectural photographs, and a unique series of street photographs, including images of organ grinders, rag pickers, and chimney sweeps (Fig. 2.46).

2.46
CHARLES NÈGRE,
*The Chimney Sweeps
Walking*, 1851. Salted
paper print. National
Gallery of Canada/Musée
des Beaux-Arts du
Canada, Ottawa.

Photographs of workers going about their chores are rare in early photography, and Nègres's are among the first. From the look of the chimney sweeps' feet, it appears that Nègre asked his subjects to stop momentarily in order to record their appearance. The background areas of the photograph have been retouched, to diminish the details of the buildings so as to emphasize the sweeps.

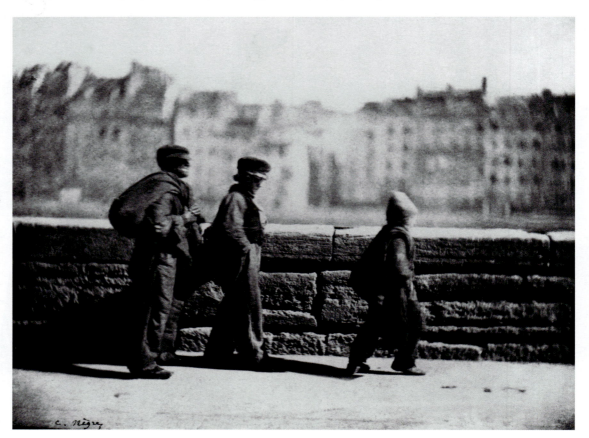

PORTRAITURE AND THE CAMERA

A wide range of photographic practice developed rapidly in the medium's early years. Yet neither landscape, nor still life, nor the variety of scientific practice acquired quite the aura of magic that the portrait photograph did. At first, Daguerre thought that portraits were impracticable, and the otherwise imaginative François Arago likewise declared that there was little hope that the technique could be used for portraiture. In the earliest daguerreotypes (Fig. 2.47), sitters tended to move or blink during the long exposure time required, blurring the images. It was some time, too, before the modern smile became an omnipresent convention. The chemistry making possible shorter exposure times improved swiftly, and devices to hold heads still were soon invented, bringing on a rush of daguerrean portraits (Fig. 2.48). The detailed, silver-surfaced daguerreotype was resolutely preferred to the more atmospheric calotype prints. American scientist, inventor, and artist

Samuel F. B. Morse (1791– 1872) was in Paris when Daguerre's invention was first announced. In exchange for an invitation to see how the telegraph worked, Daguerre showed Morse his photographic process in March 1839. Morse's interest in camera images, however, had predated that of Daguerre. About thirty years earlier, he had unsuccessfully attempted to fix images obtained in a camera obscura.

Once instructions for making the daguerreotype became available, Morse was among the first to make images. Although occasionally frustrated by the unpredictable medium, he produced an extraordinary image of members of the Yale University class of 1810, as they gathered in August 1840 for their thirtieth reunion (Fig. 2.49). The frame surrounding the collection of portraits measures only $3^1/_4$ by $4^1/_4$ inches, and each image is only $^1/_2$-inch square. It is not known if the images were somehow reduced in size from larger portraits, or whether the ingenious Morse used a special camera to make diminutive originals, which were then rephotographed.[39]

2.47
ROBERT CORNELIUS (attrib.), *Seated Couple*, c. 1840. Daguerreotype. Floyd & Marion Rinhart Collection, Ohio State University Libraries, Columbus, Ohio.

Early photographs required an exposure time of two minutes or more. The stern expressions and wide-open eyes of sitters sometimes resulted from their attempts to keep still and not blink.

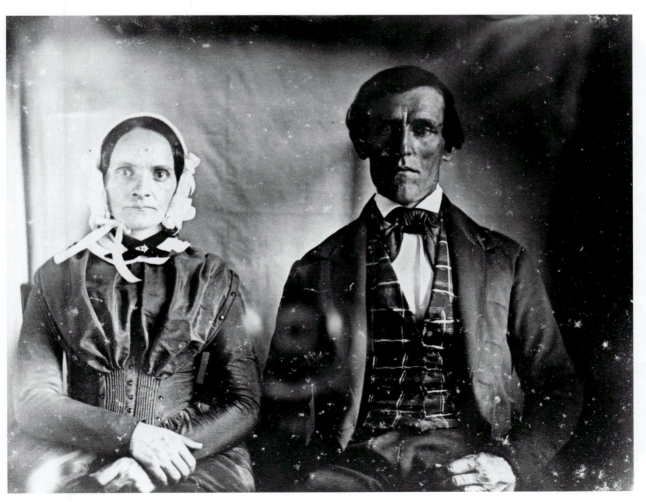

HONORÉ DAUMIER,
Nouveau procédé employé pour obtenir des poses gracieuses, c. 1856. Lithograph on paper. National Gallery of Canada/Musée des Beaux-Arts du Canada, Ottawa.

Cartoons spoofing the inconveniences of early portrait photography soon appeared. Many studios employed vise-like equipment, hidden by the sitter's hair and body in the final picture, to steady the head.

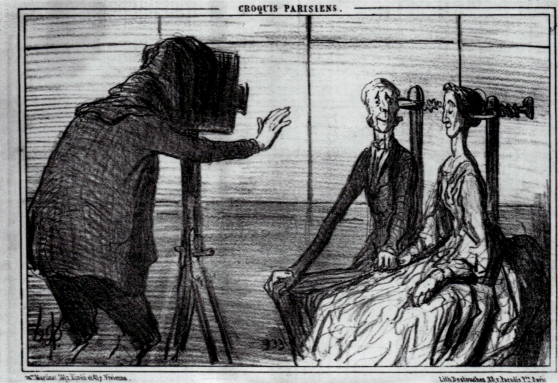

2.49 (below)
S. F. B. MORSE,
Graduates of Yale, Class of 1810, 1840. Daguerreotype.

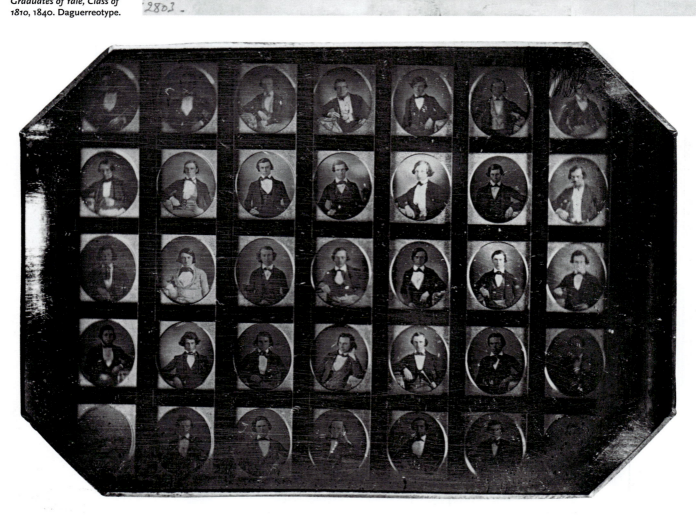

2.50
GEORGE
CRUIKSHANK,
*Photographic
Phenomena*, 1842.
Paper print. Gernsheim
Collection. Humanities
Research Center,
University of Texas at
Austin.

The earliest daguerreotype portraits are often rigidly frontal. The sitter sat beneath a skylight, while reflectors directed more light on selected features (Fig. 2.50). Given the discomfort involved, the *Daguerrean Journal* suggested that resolute indifference was "the best expression for a Daguerreo-type."[40] Subsequently, viewers could pore over daguerreotypes with magnifying lenses, marveling at the details of representation, especially the outlines of family resemblance and the contrast between youth and age.

In London, Richard Beard (1802–1885) opened a daguerreotype studio in March 1841, the first licensed public source for daguerreotypes in Britain. It was quickly followed by the studio of another licensee, the London firm of French entrepreneur Jean-François-Antoine Claudet (1797–1867). In 1851, Claudet enlarged his London offices, establishing what he called the "Temple to Photography," a studio decorated with painted portrait medallions of artists, scientists, and photographic pioneers. Claudet's attempt to claim for photography the status of both a science and an art would be variously repeated throughout the nineteenth century.

Claudet's portrait work quickly diversified: he added backdrops and studio props, and he grouped his sitters in aesthetically pleasing arrangements. His 1851 daguerreotype *The Geography Lesson* shows a man standing before a globe, and children with books, the central one of which shows a print of a classical building (Fig. 2.51). The image is a stereographic daguerreotype (see STEREOGRAPHY), produced by two cameras

PHOTOGRAPHIC PHENOMENA, OR THE NEW SCHOOL
OF PORTRAIT-PAINTING.

" Sit, cousin Percy ; sit, good cousin Hotspur !"—HENRY IV.
" My lords, be seated.'"—*Speech from the Throne*.

2.51
J. F. A. CLAUDET, *The
Geography Lesson*, 1851.
Stereoscopic daguerreo-type. Gernsheim
Collection. Harry
Ransom Humanities
Research Center,
University of Texas at
Austin.

Claudet specialized in
intricate arrangements
of his sitters. The image
being viewed by this
group might well be a
photograph produced
in engraved form by a
publisher such as
Lerebours.[41]

spaced to imitate human binocular vision. In a special viewer, the two stereographic images appeared to be a single three-dimensional scene. Though obviously posed, Claudet's scene is not far-fetched. Books like Lerebours's *Daguerrian Excursions* were used to teach geography to a generation of children.

In Berlin, Gustav Oehme (1817–1881), an optician who studied with Daguerre, set up a photography studio. He seems to have arranged the family in his 1847 group portrait to maximize the appearance of casual good-naturedness (Fig. 2.52). The necessity for clients to hold a pose is nevertheless evident on the right, where the girl is steadied by the woman next to her. Photographers and sitters abandoned rigid appearances as soon as technical improvements permitted: clients learned to appear joyful, studious, or reflective, and smiles and signs of congeniality swept through

photographic practice. In the literature of the time, the idea of enacting an emotion for the camera was not felt to conflict with the notion that photographs rendered truth to experience. The photographic studio emerged as a new social space in which sitters could compose and record an image of how they desired to appear for acquaintances, strangers, and posterity.

COLORING THE IMAGE

When the Russian daguerreotypist Aleksei Grekov (1779/80–1850s) titled his 1840 booklet, *A Painter without a Brush and Paint, Photographing Any Images, Portraits, Landscapes, etc., in Their True and Faithful Colour in a Few Minutes*, he was referring to the gray scale of the daguerreotype, not to hues on the color spectrum.[42] However, daguerreotypes were sometimes hand-tinted, to alleviate the gray tones that

2.52
GUSTAV OEHME,
Group Portrait in Oehme's Studio, Berlin, April 11, 1847. Daguerreotype. Robert Lebeck Collection. Rheinisches Bildarchiv, Cologne, Germany.

By the late 1840s, sitters preferred to appear casual and affectionate. Smiles began to replace the stern faces of the early 1840s.

2.53
PHOTOGRAPHER
UNKNOWN, *James
Warner Woolsey, Nevada
City, Miner, with Nugget
Weighing over Eight
Pounds*, 1849–50.
Daguerreotype. Mrs.
Philip Kendall Bekeart
Collection.

The hand-painted gold nugget conveys the sitter's good fortune during the California gold rush. His carefully curled locks and trim moustache also suggest that his luck has allowed him to afford a fine barber.

2.54 (below)
J. A. MOULIN, *Étude: Séduction*, c. 1852. Paper print. Bibliothèque Nationale de France, Paris.

Paris photographer Jacques-Antoine Moulin (c. 1800–c. 1869), who specialized in *académies*, was adept at contriving poses using suggestive drapery and exotic settings.

customers identified with illness and death.[43] French critic Francis Wey denounced the unrelenting gray of the daguerreotype portrait as "fried fish pasted on to metal plaques."[44] Some photographers attempted to create daguerreotypes that would be automatically colored by chemical reactions to light rays.

Color was not always a simple, realistic addition to a photograph. In a portrait of James Warner Woolsey, the gold nugget was subsequently wash-painted to achieve a symbolic quality (Fig. 2.53). The color was applied by an artist painting directly on to the daguerreotype, probably with a thin camel-hair brush. Soft pastel colors were often added to warm the skin tones in erotic daguerreotypes, the market for which expanded when stereographic daguerreotypes began to be produced. The creation of so-called *académies*, photographs of nudes and semi-nude women, professedly made for the use of artists, provided some daguerreotypists and calotypists with additional income, as did frankly erotic photographs (Fig. 2.54).

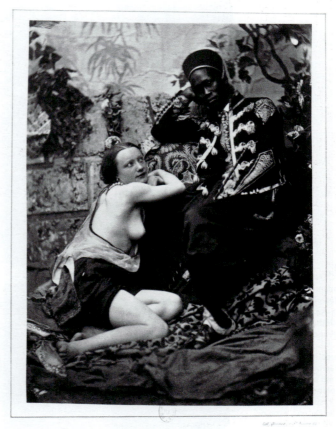

Etudes Photographiques

Pictured singly or in groups, the nude female figure substantially outnumbered male nudes (Fig. 2.55). The capability of the paper photograph to make multiple prints allowed the output of nude photographs to increase rapidly: as historian Elizabeth Anne McCauley has shown, despite some attempts at censorship, soft-core pornographic photographs were one of the first mass-market products.[45]

As materials became more widely available and reliable, photographic practice grew. An 1848 American article declared that "in our great cities, a daguerreotypist is to be found in almost every square; and there is scarcely a county in any state that has not one or more of these industrious individuals busy at work catching 'the shadow' ere the 'substance fade.'"[46] The idea of securing the shadow, or image, before the sitter deceased was not always possible; it sometimes meant commissioning images of dead people. The custom of

making a deathbed image, through making a death mask or painting, was democratized through photography and became a routine practice in the mid-nineteenth-century middle classes. Because of the high mortality rate for infants and children, they were the frequent subjects of such photographs, which were not, as today, considered ghoulish (Fig. 2.56). The post-mortem photograph became widespread in America and throughout Europe. Later, when most people had photographs of their family and friends, the practice decreased.

THE PHOTOGRAPHY STUDIO

A European observer remarked that "American daguerreotypists go to enormous expense for their rooms, which are most elegantly furnished … Everything is … united to distract the mind of the visitor from his cares and give to his countenance an expression of calm contentment."[47] In the biggest

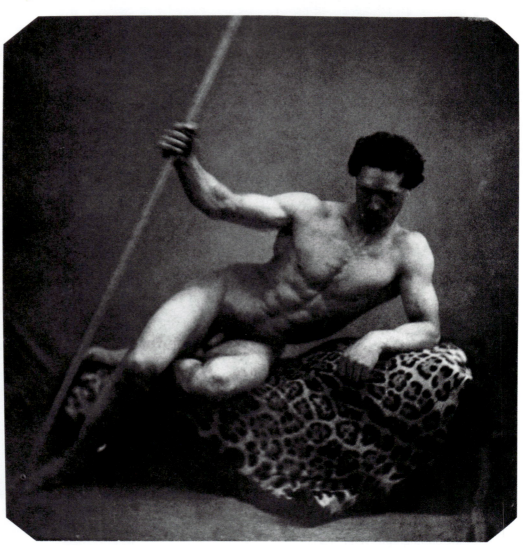

2.55
EUGÈNE DURIEU,
Académie de l'Album Delacroix réunissant,
1853–54. Paper print. Bibliothèque Nationale de France, Paris.

The painter Eugène Delacroix commissioned several photographic studies for his work, such as this male nude. Delacroix maintained that photography was too unimaginative to be a genuine art.

2.56
PHOTOGRAPHER UNKNOWN, *Father and Mother Holding a Dead Child*, c. 1850–1860s. Daguerreotype. Strong Museum, Rochester, New York.

Post-mortem photography flourished in photography's early decades, among clients who preferred to capture an image of a deceased loved one rather than have no photograph at all.

2.57
AUGUSTUS WASHINGTON, *John Brown*, c. 1846–47. Quarter-plate daguerreotype. National Portrait Gallery, Smithsonian Institution, Washington, D.C.

Washington may have met Brown through their mutual anti-slavery activities in New England. One of the earliest American photographers of African and Asian descent, Washington worked in Hartford, Connecticut, a stronghold of the abolitionist movement.

2.58
J. P. BALL, *Portrait of an Unidentified Man with High Collar and Plain Cravat*, n.d. Daguerreotype. George Eastman House, Rochester, New York.

Ball created a six-hundred-yard painted panorama based on his 1855 anti-slavery pamphlet, *Ball's Splendid Mammoth Pictorial Tour of the United States Comprising Views of the African Slave Trade; of Northern and Southern Cities, of Cotton and Sugar Plantations; of the Mississippi, Ohio and Susquehanna Rivers, Niagara Falls, etc.*

American cities, daguerrean studios began to rival part-time and itinerant photographers. The historian Alan Trachtenberg observed that "sitters were encouraged to will themselves into the desired self-expression," thereby creating "a role and a mask."[48] Salon owners might employ fashion and hair stylists, while less expensive venues too began to provide visual symbols of personal achievement and economic success for their portraits. Plain backgrounds were replaced by painted backdrops, such as garden scenes, and studio props such as columns, chairs, tables, rugs, books, sculptures, and flowers were added to express the sitter's interests, attitudes, or aspirations.

The shift from relatively unaffected pictures to images in which sitters used the new medium to enact an appearance gave photographers more leeway in which to design photographic representations. As one example, Augustus Washington's (1820/1821–1875) powerful portrait of American abolitionist John Brown depends on the orchestration of Brown's hands (Fig. 2.57). One is raised in the position of vow-making or challenge, while the other grasps a flag thought to be that of the Subterranean Pass Way, Brown's unrealized scheme for an organization such as the Underground Railroad, which assisted runaway slaves. Washington, the son of a former slave and an Asian woman, was an active abolitionist. He eventually emigrated to Liberia, the African country acquired by the American Colonization Society, which promoted the repatriation of freed slaves. Washington prospered in Africa, running several photographic studios, farming sugarcane, and serving in the Liberian Congress.

Like Washington, other African-American photographers catered to both white and black customers. At least fifty black daguerreotypists are known to have practiced in the United States during photography's first decade.[49] J. P. (James Presley) Ball (1825–1904), also an active abolitionist, began his career in Cincinnati, Ohio, and soon built the city's largest and most successful photographic practice (Fig. 2.58). During his long life, he worked in a variety of photographic processes and established studios in Montana, Washington, and, perhaps, in Hawaii, where he died.

CELEBRITY PHOTOGRAPHY

Numerous photographic studios attracted customers by exhibiting images of celebrities. Studios offered free daguerreotypes to celebrities from all walks of life in exchange for the right to exhibit their likenesses, and to reproduce them, mostly as engravings or lithographs. In the mid-1840s, John Plumbe (1809–1857), an American photographer who was born in Wales, devised a plan to mass-produce celebrity photographs by offering subscribers a daily portrait of the rich and famous.[50] Though this scheme failed, early photographers encouraged the public taste for celebrity likenesses. Realistic images of political figures helped to shift the public's perception of politics away from events and toward personalities. Lithographs based on photographs also featured well-known public people, as in a print showing Daniel Webster's 1850 address to the United States Senate. This was part of the fiery debate that led to the Compromise of 1850, which allowed slavery to continue in the states where it existed, but not in the newly acquired state of California. To create the lithograph, engraved versions of daguerreotype portraits were affixed to hand-drawn bodies, with the disturbing result that the senators' out-of-scale heads look like an arrangement of fruit (Fig. 2.59).

THE FIRM OF SOUTHWORTH AND HAWES

The Boston photographic establishment run by Albert Sands Southworth (1811–1894) and Josiah Johnson Hawes (1808–1901) exhibited large daguerreotypes of political and cultural celebrities, along with scenes of Boston's economic prosperity and historical heritage (Figs. 2.60 and 2.61). Southworth and Hawes specialized in large, that is, whole, plate daguerreotypes (usually 6½ inches wide by 8½ inches high) that cost about $15. At a time when commonplace daguerreotypes sold for about $2, and some were even advertised for as low as twenty-five cents,[51] Southworth and Hawes boasted that they did no cheap work.

The notion of the daguerreotypist as an artist was forcefully advanced by Albert Sands Southworth, in his self-portrait and in his writing (Fig. 2.62).

2.59 (above)
PHOTOGRAPHER
UNKNOWN, *Daniel Webster
Addressing the U.S. Senate in
the Great Debate on the
Compromise Measures of 1850,*
1850. Lithograph made from
daguerreotypes by Eliphalet
M. Brown. Library of Congress,
Washington, D.C.

The heads of the senators lis-
tening to Daniel Webster were
copied from daguerreotypes
made by Eliphalet Brown, who
later accompanied Commodore
Matthew C. Perry to Japan
(see p. 113).

2.60
JOSIAH JOHNSON HAWES,
McKay's Shipyard, East Boston,
c. 1855. Daguerreotype.
Museum of Fine Arts, Boston,
Massachusetts.

**2.61
ALBERT SANDS
SOUTHWORTH &
JOSIAH JOHNSON
HAWES,** *Harriet
Beecher Stowe*, c. 1850.
Quarter-plate
daguerreotype.
Metropolitan Museum,
New York.

Stowe's *Uncle Tom's
Cabin* was published in
installments in 1850, the
same year as this photo-
graph. Photographs of
well-known persons
were displayed in photo-
graphic studios to
encourage business.
Celebrities often were
offered free photo-
graphs in exchange for
permission to exhibit
their image.

He maintained that "the artist, even in photography, must go beyond discovery and the knowledge of facts. He must create and invent truths, and produce new developments of facts." Playing on the mid-nineteenth-century interest in character study, Southworth described the role of the photographer as catching "the whole character of the sitter … at first sight." Southworth affirmed that "Nature is not all to be represented as it is, but as it ought to be, and might possibly have been."[52]

THE CALOTYPE PORTRAIT: HILL AND ADAMSON

The absence of specialization in early photography produced remarkable hybrids. The work of David Octavius Hill (1802–1870) and Robert Adamson (1821–1848) in Scotland encompassed landscape, portraiture, and ethno- graphic recording. Hill was originally a landscape painter and lithographer, who was asked to create a commemorative painting showing the clergymen who participated in the 1843 independence

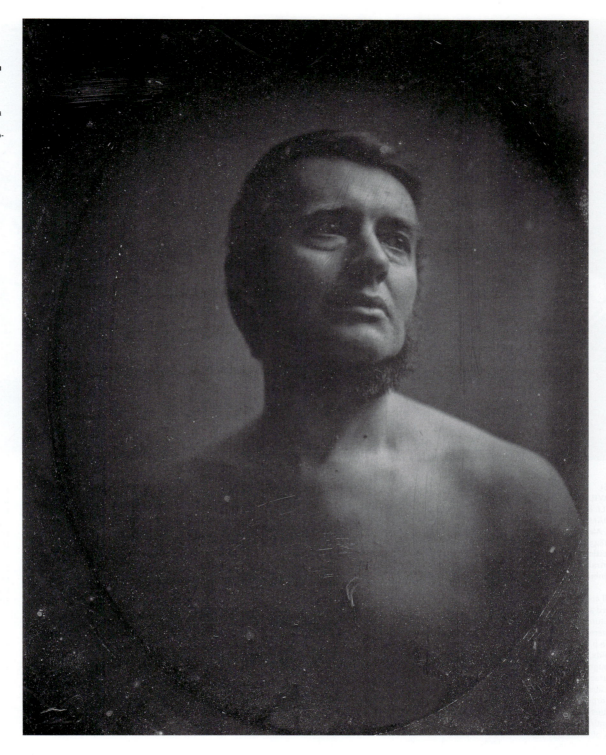

2.62
ALBERT SANDS SOUTHWORTH,
Self-Portrait, c. 1848.
Daguerreotype. Gilman
Paper Company
Collection, New York.

Southworth contrived a
dramatically lit picture,
with a delicate, rich pro-
gression of gray tones.
Back-lighted, as were
many of his clients,
Southworth showed
himself in the guise
of a thoughtful, long-
suffering, Romantic
painter.

movement that freed the Scottish
Church from the Church of England.
Daunted by the thought of sketching
the 400 people present, he turned to
Edinburgh photographer Robert
Adamson to photograph the partici-
pants. Trading on the traditional under-
standing of the commemorative
painting, Hill included portraits of per-
sons who were not present at the origi-
nal event in the work, finished twenty
years later, titled *The Signing of the
Deed of Demission*.[53] Like the print of

Daniel Webster speaking to the Senate
(see Fig. 2.59), the painting relinquished
perspective and enlarged the propor-
tions of the heads so that the faces
would show clearly. But with the calo-
types generated during their brief col-
laboration, Hill and Adamson were
more visually inventive.

They turned the calotype's formal
qualities to their advantage. Rather than
imitating the itemizing detail of the
daguerreotype, Hill and Adamson com-
posed within the softer forms resulting

2.63
DAVID OCTAVIUS HILL & ROBERT ADAMSON, *Dr. Alexander Keith,* c. 1843. Paper print. Scottish National Portrait Gallery, Edinburgh.

Hill and Adamson developed a style of male portraiture that emphasized Reverend Keith's (see also p. 52) head and hands, parts of the body thought to express inner character. Perhaps because their images incorporated aesthetic values also found in paintings, there were few objections to their non-naturalistic use of photography.

from the calotype's paper negative. Adapting artistic principles of light and shade (chiaroscuro), they orchestrated the surface with large areas of shadow, which suppressed fine detail. They posed sitters artfully, and used intense, unnaturalistic lighting to create theatrical effects (Fig. 2.63). Viewers compared Hill and Adamson's style to the light and shadow effects in Rembrandt's works, a resemblance that Talbot had also remarked in relation to his early work.[54] Hill was especially pleased with what others, particularly proponents of the daguerreotype, found inferior in the calotype process. He admitted that "The rough surface, and unequal texture throughout of the paper is the main cause of the Calotype failing in details, before the process of Daguerreotypy [sic]." Of calotypes, he wrote that "they look like the imperfect work of a man—and not the much diminished perfect work of God."[55]

The exposure time for Hill and Adamson's calotypes could be as long as one to two minutes. They photographed outdoors, usually in direct sunlight, often using monuments in Edinburgh's Greyfriars' churchyard as a backdrop.

They encouraged sitters to enrich their portraits with expressive props, such as books or drawing implements. In addition to their portrait work, Hill and Adamson made some of the earliest anthropological photographs in the nearby fishing village of Newhaven (Fig. 2.64), whose waning traditional way of life contrasted with that of industrializing Edinburgh. These and other prints by Hill and Adamson appealed to the yearning for simpler, pre-industrial times. They were sold singly or in albums, through booksellers and galleries, thus extending the market for photographs.

When the images were shown at the Royal Scottish Academy, Adamson was listed as executing the photographs, while Hill gave artistic direction. This information was perhaps intended to convince painters that photographs might be shown in their gallery. But it also indicates the split between conceptualization and implementation in early photography. For about a century after Hill's death in 1870, their collaborative work was largely credited to Hill's imagination as a painter, rather than to Adamson's technical virtuosity.[56]

2.64
DAVID OCTAVIUS HILL & ROBERT ADAMSON, *Mrs. Elizabeth Hall and Unknown Woman (Newhaven Fishwives),* c. 1845. Salted paper print. Scottish National Portrait Gallery, Edinburgh.

FOCUS
The First Police Pictures?

An exceptional early series of 220 photographic portraits of itinerant people was made by Swiss photographer and lithographer Carl Durheim (1810–1890) from 1852 to 1853. During a large-scale Swiss government operation, stateless, itinerant people were held in open confinement in the city of Bern, and forced to adopt a more settled life. They had been poor tradespeople who moved from town to town, subsisting as tinkers and grinders, or by making baskets (Fig. 2.65).

The images were intended to be transformed from paper photographs into lithographs and distributed to the police so they could identify any of the itinerants who strayed from Bern. Thinking that it would make identification easier, the photographer tried to show as much of the person's body as possible. Although police pictures did not become routine until the 1880s, occasional portraits of criminals were made in the late 1850s and 1860s. The slow development was caused by the absence of an accepted format with which to standardize them and of a network through which to circulate them.

2.65
CARL DURHEIM, *Katharina Josephine Wächter*, 1852–53. Salted paper print. Swiss Federal Archive, Bern.

THE REALITY EFFECT

Unlike painting and engraving, photography left relatively few visible traces of its manufacture. Compared with brushstrokes and a network of lines, the daguerreotype seemed like a smooth mirror that did not betray how it was made. As a result, the photograph was seen as an automatic recording device that required no interpretation. Increasingly, the photograph was believed to be what the average person would have seen standing in the same spot at the same time as the photographer. Stereoscopic daguerreotypes, such as *The Geography Lesson* (see Fig. 2.51), added the illusion of three-dimensionality. The fact that photographers such as Baldus (see p. 58) manipulated and retouched negatives did not significantly affect the public's belief in photographic truth. Neither did the increasing use of calculated poses and studio props in portrait photography.

Belief in the medium's objective reflection of reality was reinforced by photographers' efforts to intensify the appearance of truth. For example, while ornate backgrounds and symbolic objects continued to be used, some photographers returned to the plain backgrounds of the earliest daguerreotypes, and had the sitter look directly into the camera. This technique made the photograph seem unaffected. By using bust shots, facial features were enlarged, often to life size, giving the impression of a personal encounter, as if the viewer personally knew the sitter well enough to enter his or her private space.

With the increased "reality effect" came a lasting dilemma, detectable in many early photographs: the tension between visual intensity taken as truth and the larger, societal significance of a subject. This problem is evident in what may be the first daguerreotypes of Native Americans. During the 1840s, St. Louis photographer Thomas M. Easterly photographed the Sauk and the Fox, who were resettled by the U.S. government to the Nemaha Reservation in what is now the state of Kansas. His image of the chief Keokuk (Fig. 2.66) uses impressive detail, a simple backdrop, and restrained hand-coloring to connote immediacy and truthfulness. Yet this image was far from historically

comprehensive. At the time it was made, Keokuk had been appointed by United States Indian Affairs officials to replace a more rebellious leader. He and other Sauk and Fox companions were in St. Louis to give an entertainment performance of so-called war dances at a circus. Like the photograph of the 1848 Chartist meeting (see Fig. 2.29), Keokuk's portrait does not tell the full story. In public discussions and literature, the capacity of the photograph to seem whole and complete, while omitting relevant truths, was rarely addressed directly. Nevertheless, the conflicts in society's understanding of photography and the problems of truth-telling found some expression in mid-nineteenth-century literature.

PHOTOGRAPHY AND FICTION

In overwrought language and outlandish plots, popular fiction played on photography's visual veracity, suggesting that the medium could reach beneath the surface to penetrate the minds of sit-

2.66
THOMAS EASTERLY,
Keokuk, or the Watchful Fox, 1847. **Hand-colored quarter-plate daguerreotype. Missouri Historical Society, St. Louis, Missouri.**

Easterly's portrait of *Keokuk, or the Watchful Fox*, a chief of the Sauk and Fox, concentrated on the sitter's worn face and distinctive clothing. He relied on a plain, neutral background to accentuate the sitter's pensive look, while he highlighted the exotic elements of Native American apparel.

ters. It could thwart villains and make straight the path of true love. This good magic was complemented by stories of bad photographic magic, in which Svengali-like daguerreotypists spied on newlyweds and lured innocents from their families. In such stories, the mysterious and compelling powers of hypnotism and mesmerism (a variety of hypnotism thought to be induced by magnetic fields, in vogue during photography's early years) were merged with photography. Some sitters reported that they felt drawn to the camera's eye, or unnerved by the experience of being photographed, as if they were being scrutinized, or compelled to act like a marionette. In a daguerreotype of a hypnotism session, most of the participants appear unaware of the camera's presence, as though they are in what was termed a magnetic sleep (Fig. 2.67).

The best-known story about photography's double-life as a recorder of reality and a mysterious generator of insights into character is Nathaniel Hawthorne's *The House of the Seven Gables*. By 1851, when Hawthorne pub-lished the novel, public perception of photography's relationship to truth had emerged as a pivotal metaphor for knowledge and ignorance. The story's central character, Mr. Holgrave, is a daguerreotypist. His portraits have spe-cial powers, extending human sight into insight, and revealing what ordinary vision cannot bring into focus: the moral character of individuals.

The nineteenth-century trust in char-acter reading of facial features and human gestures, which predated the invention of photography, soon trans-ferred to photography. In *The House of the Seven Gables*, that faith was enhanced by the association of magic with daguer-rean realism. Belief in the extraordinary powers of photography was manifest in sitters' requests to photographers, such as the one that photographers use tokens of the dead, for example a scarf or hat, to summon forth the image of the departed one for a photograph.[57] Fiction gave voice to the way in which growing public confidence in photo-graphic representation was mixed with wariness about its power.

**2.67
JOHN ADAMS WHIPPLE,** *Hypnotism,* **c. 1845. Daguerreotype, no. 113. Gilman Paper Company Collection, New York.**

Hypnotism and photog-raphy were both associ-ated with magic and mystery in the public mind. John Adams Whipple was the Boston scientist who, with George Phillips Bond, successfully made daguerreotype views of the moon in about 1851 (see Fig. 2.0).

PHILOSOPHY AND PRACTICE: A THREAT TO ART?

Photography is arguably the most historically aware visual medium. The writing of its history began with the disclosure of the medium to the world in 1839, and persisted as a preoccupation throughout nineteenth-century photographic literature. Isidore Niépce, son of Joseph Nicéphore Niépce, attempted to assert his father's place in history with a slim 1841 volume called *Historique de la découverte improprement nommé daguerréotype* (*History of the Discovery Improperly Called Daguerreotype*). In the same year, Robert Hunt (1807–1887), a geologist and staunch advocate of photography from the first, published *A Popular Treatise on the Art of Photography*, which served to introduce the public to both photographic history and techniques.

Despite the historical interests of photography's proponents, subjects with no evident scientific, archival, artistic, or commercial value were neglected. Child laborers, for instance, are largely absent from early photography. Images of working men and women, except when stiffly posed with tools or clothed in quaint ethnic and regional costume, are also uncommon. Scenes of ordinary activities such as preparing food are exceedingly rare, unless these activities are performed in an exotic culture.

Photography's association with the broad technological changes taking place in the industrializing world was firmly fixed within the medium's first decade. Both its proponents and its critics likened photography to such major modern inventions as the steam engine and the telegraph. Writing in 1840 about Italian Renaissance art, British critic Francis Palgrave (1788–1861) produced a vituperative aside on modern inventions, including photography: "Steam-engine and furnace, the steel plate, the roller, the press, the Daguerreotype, the Voltaic battery, and the lens, are the antagonist principles of art."[58] By contrast, an unnamed commentator for an 1843 issue of the *Edinburgh Review* effused that photography "is indeed as great a step in the fine arts, as the steam-engine was in the mechanical arts ... and ... it will take the highest rank among the inventions of

the present age." Yet this writer urged his readers to make a clear distinction between the linear, cumulative development of science and technology, and what constitutes genuine advancement in art. Progress in art, the reviewer declared, was not endlessly incremental: "It would be hazardous to assert that Apelles and Zeuxis were surpassed by Reynolds and Lawrence, and still more so that Praxiteles and Phidias must have yielded the palm to Canova and Chantrey."[59]

As belief in the objectivity of photography took hold, the medium was belittled as a potential art form. Influential British critic John Ruskin (1819–1900) contradicted himself on the matter of the daguerreotype. Calling it a blessing in 1845, less than a year later he found it a matter of serious concern. Acknowledging the daguerreotype as "the most marvellous invention of the century," Ruskin worried about its effects on viewers' perceptions of art: "As regards art, I wish it had never been discovered, it will make the eye too fastidious to accept mere handling."[60]

Photography, for Ruskin, was so wedded to minute appearances that it could not express the personality and soul of the artist. His was a new twist on an old theme: after an October 1839 exhibition of daguerreotypes at the Academy of Arts in St. Petersburg, Russia, one reviewer reported that "the daguerreotype is a useless means of making portraits," because "mathematical verisimilitude and lifeless precision do not do justice to a portrait, for which one needs expression and life; these can only be conveyed by the animating strength of talent and thought of an individual — no machine can do this."[61] Similarly, Eugène Delacroix, who sometimes used photographs as aids for his work, called the camera a machine that makes pictures untrue to human perception. Where the mind filters and emphasizes, the machine does not. It cannot engage the world as the mind can, and its intractable verisimilitude prevented the dialogue of soul to soul that Delacroix deemed the central activity of art.[62]

Criticism of photography's mechanical simplicity merged easily with passionate contemporary reproach of the damaging social effects inherent in mass culture. In France, Flaubert

recoiled from what he called "a whorish century," filled with "fake materials, fake luxury, fake pride." Literary critic C.-A. Sainte-Beauve (1804–1869) decried the advent of industrial literature, which he thought was served up to satisfy base emotions, rather than edify.[63] In this intellectual atmosphere, photographic verisimilitude became a bludgeon in the hands of photography's critics. French critic Etienne-Jean Delécluze (1781–1863) saw photography as a science imposing its mode of dogged imitation on art.[64] Advocates of photography responded by suggesting that photography could improve public taste, particularly through art reproduction, which was attempted early in the 1840s[65] (Fig. 2.68).

The friction between photography's advocates and detractors may have spurred French photographer Gustave Le Gray (1820–1882) to outline a special aesthetic appreciation for photography, drawing on the principles of painting. A skilled photographic technician and chemist who worked for the Historic Monuments Commission, Le Gray advanced the idea that profuse photographic detail did not have artistic merit.

With critics such as Francis Wey and photographers such as Hill and Adamson, Le Gray advocated a theory of sacrifices, that is, of giving up particulars, and composing the picture surface either with sharply defined tonal areas, or through softness.[66] As early as 1853, the English painter and photographer William Newton (1785–1869) similarly advocated the development of an art photography that consciously worked against the glut of details produced by "chemical Photography." He proposed rendering a subject a little out of focus.[67] Le Gray's support of the new medium and his excitement about its possibilities are expressed in his treatises; where some critics considered that photography would lower public appreciation for art, he argued that it would advance taste by allowing the public to study the fullness of nature.[68]

In the *Forest of Fontainebleau* (c. 1851) (Fig. 2.69), Le Gray pictured a spot that was a favorite of the Barbizon School painters, such as Jean-Baptiste-Camille Corot (1796–1875) and Jean-François Millet (1814–1875), who sought new artistic subjects in the commonplace landscape of the village of Barbizon near

**2.68
PHOTOGRAPHER UNKNOWN,** *Ingres' Painting of Cherubini and his Muse,* 1841–42. Daguerreotype. The J. Paul Getty Museum, Los Angeles, California.

The use of photography for art reproduction was advocated from the first. Photographs of statues and buildings were generally more satisfactory than photographs of paintings, because early photographic chemicals were not sensitive to a full range of colors.

2.69
GUSTAVE LE GRAY,
Forest of Fontainebleau,
c. 1851. Daguerreotype.
The J. Paul Getty
Museum, Los Angeles,
California.

Le Gray was not inter-
ested in imitating paint-
ing, but became aware
of photography's poten-
tial as light work, that is,
as the major medium
for understanding the
effects of light on form.
The appearance of
bright patches of form-
dissolving light is simi-
lar to what the French
Impressionist painters
would achieve a decade
later.

Paris. Le Gray filled the frame with
impressions of filtered woodland light
and, in the monochromatic palette avail-
able to him, rendered the rich varieties
of green, from verdant lichen patches to
silvery leaves.

Le Gray's approach to photography
united science and art. He experimented
with techniques to render delicate gra-
dations of tone, and he invented his own
dry WAXED PAPER PROCESS, which kept
the paper sensitive for two weeks, and
allowed the photographer to develop it
up to a week after exposure. Le Gray's
famous seascapes reveal the range of his
resistance to the idea that photography
was merely an automatic recording of
scenes before the lens. He manipulated
the photograph in a number of ways.
He sometimes photographed dramatic
cloud formations separately from sea
views, merging the resulting two nega-
tives, and printing the sky and the sea
separately. To complete the picture, he
carefully retouched the horizon line
where the two negatives met. *Mediter-
ranean Sea at Sète* merged one negative

of the sea and one of the sky, creating a
dramatic image with blazing light in
the center of the picture (Fig. 2.70). Le
Gray's concern with the overall aesthetic
harmony of the print also led him to
retouch clouds, subtract figures, accen-
tuate horizontal or vertical elements,
and vignette scenes, that is, to darken
the edges of the print to emphasize the
center. The technique of printing more
than one negative to create a single pic-
ture, as Baldus had done in the cloister
of Saint-Trophîme in Arles (see Fig.
2.43), became known as COMBINATION
PRINTING. Like the out-of-focus photo-
graph and the photograph to which
paint has been added, combination
printing challenged the notion of pho-
tography as an unadulterated transcrip-
tion of optical reality.

The most profound changes arising
in the first fifteen years of photography
were less visible than the profusion of
images generated by the new medium
and the debate about its worth as art.
Faith in photography as an impartial
image-maker began to alter the human

relationship to memory. No prior medium fully presaged the common photograph's ability to externalize remembrance, or to produce images conceived of as genuinely akin to actual experience. The sense of a personal encounter, of being there, connected individual experience with national and scientific events. At the same time, what twentieth-century French philosopher Michel Foucault (1926–1984) called "compulsive visibility" began to play a much larger part in human affairs.[69] Societal, scientific, and even personal progress started to be understood as dependent on increased visibility of data in all fields of government and in intellectual inquiry.

As the notion that something might be photographed hardened into the expectation that it ought to be photographed, the public began to perceive a natural claim to see images of all sorts. By the mid-1850s, this perception gave impetus to the making and marketing of a great array of pictures, from individual portraits, scientific images, and the first efforts of photojournalism. The assumption that one would own a single photograph of oneself eventually yielded to the notion that one desired to own, or at least to see, many photographic images, including those of strangers and far-off events. During photography's first fifteen years, the stage was set for the intense commercialization and dissemination of photography, which in turn sharpened the question of photography as a fine art, while deepening its acceptance as a chronicler.

2.70
GUSTAVE LE GRAY,
Mediterranean Sea at Sète, 1856–59. Albumen silver print from two glass negatives. Gilman Paper Company, New York.

Printed from two separate glass negatives, Le Gray's seascape emphasizes the brilliant sheen of sun on water. The place where the two negatives were joined is barely perceptible along the horizon line.

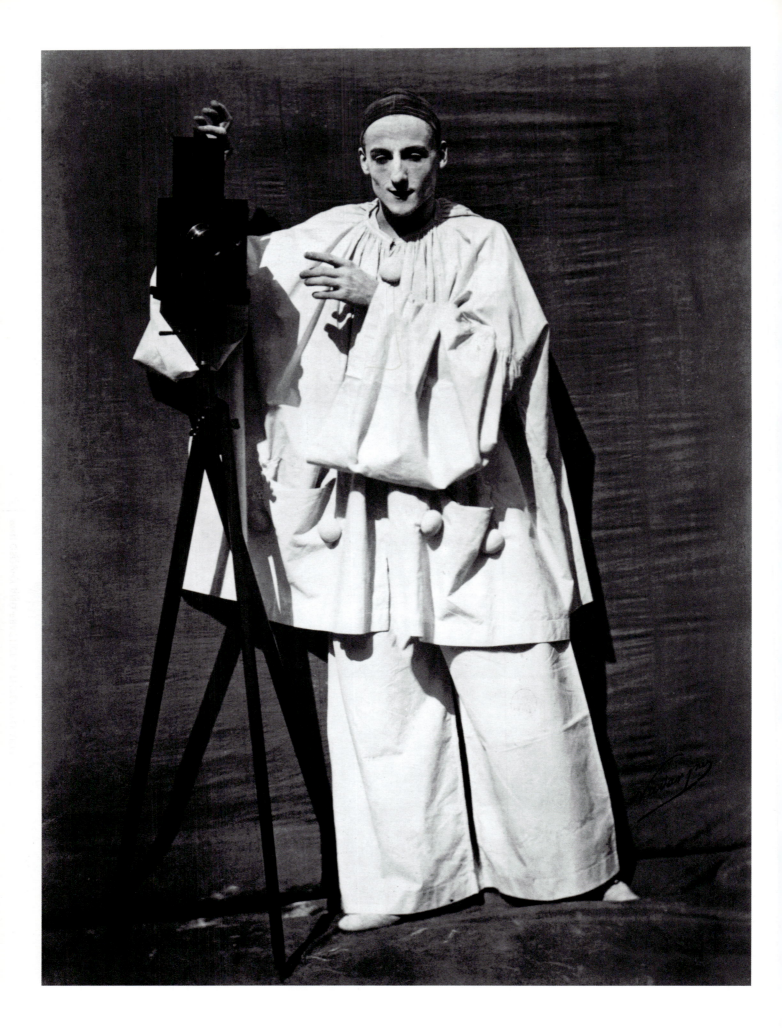

The Expanding Domain (1854–1880)

"It is now more than fifteen years ago that specimens of our new and mysterious art were first exhibited to our wondering gaze," recalled Lady Elizabeth Eastlake (1809–1893) in her 1857 review of photography. "Since then," she continued, "photography has become a household word and a household want; it is used alike by art and science, by love, business, and justice; it is found in the most sumptuous salon, and in the dingiest attic."[1] Photographic images were displayed in shop windows, and newspapers used photographic sources for their illustrations. At the same time, with the continued spread of photography, the development of new applications, and the intense commercialization of the medium in the late 1850s, amazement at its ability to capture appearances declined. As photography became more commonplace, the medium's societal and artistic impact was more frequently debated.

The rapid commercialization of photography sprang from the interaction of social needs and technical inventions. The convenience of the collodion, or wet plate, process, and the resulting availability of low-priced prints stimulated the market for portraits of family,

3.0
NADAR & ADRIEN TOURNACHON, *Pierrot the Photographer,* 1854–55. Paper print. Musée Carnavalet, Paris.

Cast as a photographer, the Pierrot was understood not as a clown but as a sensitive Romantic artist.

friends, and public figures. As the telegraph, railroad, steamship, and the clipper speeded up communications, commerce, and travel, the desire for portraits and views kept pace. For instance, in the months leading up to the American Civil War in 1861, the market for inexpensive portraits of people in the news grew at an unparalleled rate.[2] In Britain, the views of Egypt by British photographer Francis Frith (1822–1898) were anticipated keenly. At the same time, the growing market for low-priced photographs intensified the contrast between the so-called "cheap johns" who churned these out and those who hoped to elevate photography to the status of a fine art.

THE STEREOGRAPH

Chief among the low-priced photographs that burgeoned in the later nineteenth century was the stereograph. Stereographic photographs helped turn photography into an industry, by stoking the viewer's desire to see more of the world. The principle of the stereograph was known before the invention of photography, and applied to daguerreotypes (see Fig. 2.51). Stereographs became immensely popular from the mid-1850s

to the early twentieth century, with improvements in the technology of paper photography, and with the development of special cameras that used two lenses. During the 1840s, stereographic daguerreotypes had been made by joining images produced by two separate cameras, but the new stereographic camera produced two simultaneous images, photographed as if one were seen with the left eye and the other with the right (Fig. 3.1). Placed in a special viewer, the images recombined to give the illusion of receding space. Given their ease of production, photographers and publishers quickly sought ways of mass-producing and distributing stereographs. One of the largest nineteenth-century photographic supply houses and publishers of photographs, E. and H. T. Anthony & Co. in New York, was said to have stereographs of 50,000 different subjects, including views of Broadway traffic.[3] Producers of stereographs manufactured millions of images, and set up the distribution networks with which to market them (Fig. 3.2).

To twenty-first-century viewers, stereographs may seem airless, static, and artificial. But to nineteenth-century viewers, the stereograph was a quite unprecedented leap forward in realistic representation, which opened up great expectations. In a swooning 1859 essay on "The Stereoscope and the Stereograph," Oliver Wendell Holmes (see p. 2), the well-known Boston area physician, photographer, and writer on photography, noted that when looking at the image, "the mind feels its way into the very depths of the picture," awestruck at its inexhaustible detail.[4] Holmes had a knack for describing the physical feelings experienced when using the viewing instrument: "The shutting out of surrounding objects, and the concentration of the whole attention ... produce a dreamlike exaltation of the faculties, a kind of clairvoyance, in which we seem to leave the body behind us and sail away into one strange scene after another, like disembodied spirits."[5] Holmes thought the stereograph surpassed painting in its intense illusionism, and its potential to broadcast knowledge to a wide audience. It would become "the card of introduction to make all mankind acquaintances," and it would simulate the feeling of being present at natural wonders such as the Alps, and human marvels such as the pyramids. For Holmes, the stereograph was a watershed moment in the progress of human history:

Form is henceforth divorced from matter Give us a few negatives of things worth seeing There is only one Coliseum or Pantheon; but how many millions of poten-

3.1
PHOTOGRAPHER UNKNOWN, *Untitled* (Stereoscopes in use), c. 1860s. Stereograph. George Eastman House, Rochester, New York.

Stereographs were viewed in stereoscopes. Although viewers could exchange pictures, they could not simultaneously look through the device and see the three-dimensional effect.

3268 The Fresh View Agent soliciting.

**3.2
PHOTOGRAPHER
UNKNOWN,** *Looking
up Broadway from the
Corner of Broome Street,*
1868. Stereograph.
Albumen silver print,
1868–71. Library of
Congress, Washington,
D.C.

So-called instantaneous
views depicted bustling
city life, a favorite sub-
ject for the stereograph.
The technical character-
istics of stereographic
cameras allowed them
to fix activity without
blurring the action.

tial negatives have they shed—representa-
tives of billions of pictures …. Every conceiv-
able object of Nature and Art will soon scale
off its surface for us …. The time will come
when a man who wishes to see any object,
natural or artificial will go to the Imperial,
National, or City Stereographic Library and
call for its skin or form …. We do now dis-
tinctly propose the creation of a comprehen-
sive and systematic stereographic library,
where all men can find the special forms
they particularly desire to see as artists, or as
scholars, or as mechanics, or in any other
capacity.[6]

The growth of science and its orga-
nizing systems, particularly in such
areas of public interest as geology, geog-
raphy, biology, and ethnography, helped
to stimulate the stereograph market, as
did colonial expansion and global com-
merce. Behind the eagerness for stereo-
graphs was the ideal of democratic
access to information. "What an educa-
tional revolution is here, my country-
men," wrote a critic in an 1858 issue of
the British journal *The Athenaeum*.
"Why our Tommys and Harrys will
know the world's surface as well as a
circumnavigator …. What a stock of
knowledge our Tommys and Harrys will
begin life with! Perhaps in ten years or
so the question will be seriously dis-
cussed … whether it will be any use to

travel now that you can send out your
artist to bring home Egypt in his carpet-
bag to amuse the drawing room with."[7]
Stereography thus concocted a pleasing
combination of education and entertain-
ment that presaged what the late twenti-
eth century would call infotainment. In
the words of a French commentator,
photography increasingly seemed capa-
ble of "enlightening the masses so as to
elevate and amend them."[8]

Stereographs were produced and
marketed through a global network of
publishers and dealers. The public's
desire to collect stereos, as they were
called, created a boom and bust econ-
omy in the images as photographers
and publishers attempted to entice
the public with new subjects to view.
Sometimes a photographer or publisher
created a best-selling stereo or set of
stereo cards, at other times the images
moldered in warehouses while the com-
pany that issued them went bankrupt.
The vogue highlighted the issue of
images as property. When stereographs
were pirated from one publishing house
and published by another, civil penalties
were seldom applied and copyright laws
proved inadequate.

Demand led more photographers to
carry stereo cameras along with their
regular equipment. Moreover, ambitious

3.3
**ANDRÉ ADOLPHE
EUGÈNE DISDÉRI,**
*Princess Buonaparte
Gabrielli,* c. 1862. Uncut
carte-de-visite cards.
Gernsheim Collection.
Harry Ransom
Humanities Research
Center, University of
Texas at Austin.

Cartes-de-visite were
inexpensively produced
by the thousands.
Ordinary people traded
and collected images of
family and friends, as
well as pictures of peo-
ple they did not know.
The *carte* or card photo-
graph was used as pro-
motional material by
politicians and celebri-
ties. Inadvertently, the
cartes also promoted the
notion that the public
has the right to look at
the rich and famous.

photographers started to conceive the
image with reference to the stereo-
graph's ability to render depth. In land-
scape photography, for example, the
photographers picked or even composed
scenes in which an object such as a
fallen tree or wedge-patterns of dark and
light would lead the eye from the fore-
ground to the middle ground, and then
on to distant hills (see Fig. 3.60).

Portraits were seldom done in the
stereo format, because the illusion of
deep pictorial space would have been
distracting. But almost every other sub-
ject was conceivable as a stereograph.
The market swelled with sets of stereo-
graphs devoted to such themes as travel,
religion, urban vistas, and architecture.
Romance and courtship were depicted
by photographers who contrived stories
and used actors to perform scenes.
Pornographic stereos were available for
beholding in small, discreet viewing

devices. When photographers from the
North and the South went forth to pho-
tograph the American Civil War (1861–
1865), they often brought along a stereo-
graphic camera. Because these cameras
were lighter and more portable than the
standard view camera, photographers
sometimes used them to make images
that they did not intend to issue as
stereographs.

THE *CARTE-DE-VISITE*

Whereas the appeal of the stereograph is
easy to understand, the success of the
CARTE-DE-VISITE, or card photograph as
it was called in the United States, is less
obviously apparent. Perfected and
patented in 1854 by French photogra-
pher André Adolphe Eugène Disdéri
(1819–1889), the *carte-de-visite* was a
small portrait photograph originally
intended to be pasted to the back of a
regular visiting card (4 by 2½ inches)

(Fig. 3.3). Like the stereographic camera, the standard *carte-de-visite* camera had more than one lens. But whereas the stereo camera took two pictures at the same time, the *carte-de-visite* camera was constructed so that up to eight different images of the sitter could be exposed on one photographic plate.

The cheapness of the *carte-de-visite* portrait, resulting from its efficient means of production, partly explains its rapid acceptance. Many *cartes-de-visite* were full-length portraits, or bust-length shots, rather than close-up studies of the face. The distance from the camera, especially in the full-length portraits, eliminated the need and expense of careful lighting and time-consuming retouching. The success of the *carte-de-visite* also derived from the liberal use of fancy furniture and painted backdrops calculated to make the sitter appear rich. Like the later daguerreotypes, *cartes-de-visite* encouraged sitters to construct an image of self-satisfaction and financial prosperity. Some photographers even stocked lavish clothing, which they rented to sitters for the photographic moment.

The vogue for *carte-de-visite* photographs was, like that for stereographs, propelled by a collecting urge. People amassed *cartes* of famous people much as they accumulated stereos of notable natural wonders, placing them in plush albums. Such renowned figures as France's Napoleon III, President Abraham Lincoln in the United States, and members of Britain's royal family recognized the public's craving to possess their likenesses, and willingly posed for photographers. Speculation in *carte* subjects ran high, and over-production was common, resulting in an even more precarious market than that for the stereograph. The vogue lasted about ten years, having saturated the market with millions of images.[9]

PHOTOGRAPHIC SOCIETIES, PUBLICATIONS, AND EXCHANGE CLUBS

The expansion of photographic practice in the mid-nineteenth century promoted the growth of photographic associations. Photographers with divergent interests formed societies in order to promote the medium to the general public, hold exhibitions, trade technical information,

and publish newsletters or journals. Some groups, such as the Photographic Exchange Club in Britain, modeled themselves on organizations in the graphic arts, and traded images. The Photographic Society of London, founded in 1853, was quickly followed by city-based photographic societies throughout Britain. Its status was enhanced when Queen Victoria and Prince Albert became patrons. The society published the *Journal of the Photographic Society*, which later became the *Photographic Journal*. Other societies and journals helped to disseminate technical information and news of exhibits. The French Heliographic Society, which began in 1851, published the influential journal *La Lumière*. The group was succeeded by the French Photographic Society in 1855. The Photographic Society in Vienna, Austria, founded in 1861, was the first in the German-speaking world. Photographic clubs and publications sprang up throughout Europe, North and South America, and in colonial India and Asia.

In addition, private publishers set up such journals as *The Photographic Art Journal*, which was founded by Henry Hunt Snelling in 1851, and *Anthony's Photographic Journal*, published by E. and H. T. Anthony & Co. from 1870. The rise of the periodical press in the mid-nineteenth century, especially newspapers and journals that began to use photographically derived engravings, opened new markets. Two American weekly papers with readerships that promptly soared into the millions were *Frank Leslie's Illustrated Newspaper*, started in 1855, and *Harper's Weekly*, begun two years later. Each was dedicated to bringing the public visual accounts of current events.[10]

WAR AND PHOTOGRAPHY

Writing in *The Atlantic Monthly* for July 1859, Oliver Wendell Holmes forecast that "the next European war will send us stereographs of battles."[11] His prediction was darkly realized when the next major war, the American Civil War, erupted in the United States. On the eve of the conflict, there was widespread naiveté about the conduct of war and its effects on camerawork. John Draper (1811–1882),

editor of *The American Journal of Photography*, mused that "those who stay at home to take care of the women and children may know almost as much about a battle as the soldiers who see it, or fight it." He fancied that "there will be little danger … for the photographer [who] must be beyond the smell of gunpowder or his chemicals will not work."[12]

Photographs and photographers' accounts from previous conflicts, such as the Mexican–American War and the Second Burma War (see pp. 46–49), had not been widely circulated and the possibility that war photographs might be different from heroic war paintings and engravings was consequently not much discussed. Commentators mostly failed to take into account the technical inadequacy of photography to register the swift action of battle, which supplied one of the major visual art themes, or the likelihood that such disruptions as low light or a strong breeze could halt picture-taking at crucial moments. Few mentioned that photographic equipment was still cumbersome, or that plates had to be processed soon after exposure, forcing the photographer to hurry to a makeshift darkroom.

Despite high hopes for photography, sketch artists—often amateurs attached to military units in semi-official positions, or entrepreneurial individuals who sold their works to journals for reproduction as engravings—continued to produce the majority of war images that the public saw. Photographers recorded what they could: fortifications and landscapes, as well as troops and military leaders, before and after battle. What it lacked in spontaneity, photography began to make up for in quantity, both in the number of views taken and in their extensive circulation. Yet this proved to be a mixed blessing: seeing many images eventually reduced the impact of each of them, and considerably hindered the emergence of a single image as a symbol of the conflict and a rallying point. As photographs achieved a new degree of topicality, they were also liable to lose value as their immediate newsworthiness faded. Together with mass-produced stereographic photographs and *cartes-de-visite*, war photographs taught viewers a modern skill: how to ignore or forget images when confronted by too many.

During the nineteenth century, European countries were involved in many so-called "small wars," a term used by Major Charles Callwell to describe the conflicts associated with the expansion of colonial European powers in Asia, North Africa, India, and the Middle East.[13] Callwell saw these conflicts as inevitably "a heritage of extended Empire."[14] Britain was involved in about thirty such wars during the nineteenth century, almost two dozen of which were fought in India between the Indian Mutiny of 1857 and 1900. The presence of photographers at these colonial struggles strengthened the public perception of a link between photography's expansion and territorial conquest.

In February 1856, as peace negotiations after the Crimean War (1853–56) were being conducted, French photographer Eugène Durieu (1800–1874) (see Fig. 2.55) reported to the French Photographic Society that photography would conquer unknown territories as the victorious armies of France conquered land.[15] Indeed, photography became a formalized element in military organization: in 1856, a photographic section was formed as part of the Telegraphic School run for the Royal Engineers in Chatham, England; and in 1861, the French Minister of War ordered that one officer in every brigade be trained in photography.[16] By 1870, the camera was commonly used for many tasks, such as copying maps, teaching recruits, and recording experiments with weaponry.

THE CRIMEAN WAR

The conflict in the Crimea, a peninsula at the northern end of the Black Sea, sprang from a tangle of issues relating to European influence in the Ottoman Empire, and pitted Russia against Britain, France, Turkey, and Sardinia. The war required joint action and cooperation from the allies to plan strategy and to furnish supplies. Newspaper reports by William Howard Russell (1820–1907), published by the London *Times* late in 1854, revealed how mismanagement and disunity among Britain's allies produced severe hardships, food scarcities, and lack of medical care among the troops. In a dispatch written on November 25, 1854, Russell described torrential rains that flooded tents and chilled soldiers who lacked

PUNCH, OR THE LONDON CHARIVARI.

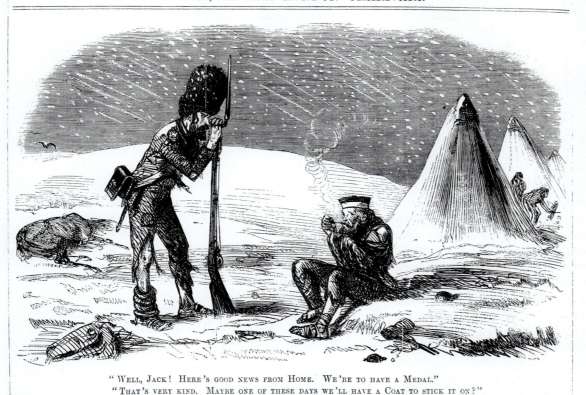

" Well, Jack ! Here's good news from Home. We're to have a Medal."
" That's very kind. Maybe one of these days we'll have a Coat to stick it on ? "

3.4
ARTIST UNKNOWN, "Well, Jack! Here's good news from home. We're to have a medal." "That's very kind. Maybe one of these days we'll have a coat to stick it on?" Printed cartoon. *Punch*, February 1855. Victoria & Albert Museum, London.

During the Crimean War (1853–56), journalists and cartoonists made the British public aware of the hardships faced by the troops because of bureaucratic bungling.

warm, waterproof clothing. The "wretched beggar who wanders the streets of London in the rain," wrote Russell, "leads the life of a prince compared with the British soldiers who are fighting out here for their country." "These are hard truths," Russell warned, "but the people of England must hear them."[17] Political cartoons denounced the situation of the soldiers (Fig. 3.4).

Early in the conflict the War Department ordered two ultimately unsuccessful photographic forays in an attempt to counteract newspaper accounts of the war. The next British efforts to photograph in the Crimea were undertaken separately by Roger Fenton (1819–1869) and James Robertson (1813–1888).

Roger Fenton

A well-known British amateur photographer, Roger Fenton helped to found the Photographic Society in 1853. An artist by inclination and a lawyer by training, he studied painting in France and learned the wax paper photographic process invented by Gustave Le Gray (see p. 78). In the fall of 1852, Fenton was off again, this time to Russia, where he photographed historic Russian architecture, as well as the construction of a bridge across the Dnieper River at Kiev, a structure commissioned by Czar Nicholas I (1796–1855; r. 1825–1855) from Fenton's friend and promoter of photography, British engineer Charles Vignoles (1793–1875).

By the mid-1850s, governments and publishers were speculating about the potential of war photographs. In Manchester, England, the firm of print publishers Thomas Agnew & Sons commissioned Fenton to make images in the Crimea, to which Agnew would retain the reproduction rights. Fenton eventually exhibited his Crimean War photographs in London, and in 1856 Agnew published 160 of Fenton's more than 300 photographs, which could be purchased singly or in handsome volumes. By this time peace negotiations were well underway, and the project proved to be less financially rewarding than the publisher had hoped. Along with some Crimean photographs by James Robertson, Fenton's unsold photographs and negatives of the war were auctioned at a discount in 1856.

One of Fenton's photographs, *The Valley of the Shadow of Death* aroused

FOCUS
The Valley of Death

Theirs not to make reply,
Theirs not to reason why
Theirs but to do and die.
Into the valley of Death
 Rode the six hundred.

Alfred, Lord Tennyson, "The Charge of the Light Brigade"

Even before it became immortalized in a famous poem and a famous photograph (Fig. 3.5), the area in the Crimea where so many British troops met their deaths was called "the valley of death."[18] The desolate lowland lived up to its name when, on October 25, 1854, Russian artillery in a strong position fired on a British cavalry brigade whose attack orders had been confused through the chain of command. The Light Brigade incurred heavy losses. Tennyson incorporated the line "Someone had blundered" from newspaper accounts of the incident. When Fenton's photograph was exhibited in 1855, the editor of the *Photographic Journal* in London wrote that the show was the "most remarkable and in certain respects the most interesting exhibition of photographs ever opened." The writer singled out

The Valley of the Shadow of Death "with its terrible gestions, not merely those awakened in the mem but actually brought materially before the eyes, by tographic reproduction of the cannon-balls lying strewd like moraines of a melted glacier through bottom of the valley."[19]

Fenton did not arrive in the Crimea until mon after the event and after Tennyson wrote the first of his poem. He was aware of the national sentim surrounding the "valley of death" when he left Bri The renown of his photograph of the site grew in sequent years, propelled by the Tennyson poem, t Christian symbolism of death and eternal life, an complex sentiments felt by the British about the v The charge of the Light Brigade, not a pivotal batt the war, became an enduring emblem of devotior duty during senseless conflicts.

3.5
ROGER FENTON, *The Valley of the Shadow of Death*, 1855. Paper
Victoria & Albert Museum, London.

**3.6
ROGER FENTON, A
Quiet Day at the Mortar
Battery, 1855. Salted
paper print. The J. Paul
Getty Museum, Los
Angeles, California.**

Fenton's photographs
did not depict the hard-
ships faced by the
troops in the field, nor
did they picture battle
scenes. For the most
part, his images contra-
dict reports in the
British press, by show-
ing that life in the
Crimea was dull and
uneventful.

strong feelings when it was shown, but most of Fenton's views were inoffensive. Although his letters from the front clearly show that he was frustrated by the war's mismanagement, and, like many others there, suffered from cholera, Fenton's photographs were less explicit (Fig. 3.6). Most did not make direct reference to the war's calamities: he did not depict fallen soldiers, the wreckage of battle, or the results of supply shortages that caused soldiers to loot civilian homes. Like war artists in the past, he made heroic images of military leaders, and his photographs of the soldiers showed them in no danger, often enjoying the same social activities they might at home.

Fenton's tact may have derived from the instructions to the first, failed, government-sponsored photographic party, which was to bring back visual evidence that newspaper accounts of the war exaggerated the disease and starvation endured by the troops. Moreover, Fenton's acquaintance with Queen Victoria (1819–1901; r. 1837–1901) during the first half 1854, when he created a flattering likeness of the monarch, photographed the royal children (Fig. 3.7), and instructed the royal couple in the rudiments of photography, may have

tempered his images.[20] Further, the worst privations occurred during the winter of 1854, when lack of supplies was exacerbated by severe cold and rampant cholera. Fenton visited the Crimea in 1855, when the previous winter's situation had to some extent been alleviated. Aware that the print publishing firm would be marketing the photographs and that there would be a public exhibition, Fenton may have assumed that few people would want to see or to buy images of suffering and carnage. Interestingly, the public and press did not raise issues of content—Fenton's photographs were praised by critics for their factual quality and superiority to words.

James Robertson

James Robertson was a British citizen working as chief engraver of the Imperial Mint in Constantinople, and an accomplished amateur landscape photographer, who made views in the Middle East. Early in the war he traveled to the area, taking some images about which little is known, then in 1855 he returned to the war zone. Robertson's trip may have been sponsored by print publishers looking for someone to carry on when Fenton left, or he may have set off on his own initiative. He made

3.7
ROGER FENTON, *The
Royal Family in
Buckingham Palace
Garden*, May 22, 1854.
Paper print. The Royal
Archives © 2002
Her Majesty Queen
Elizabeth II.

Queen Victoria was
aware of the power of
photography to form her
public image. Her more
formal portraits are
counterbalanced by
casual views and family
scenes.

approximately sixty images, including
the ruins of a redan, or fortification, at
Sebastopol, which had been secured
only after numerous bombardments
(Fig. 3.8). Robertson's photographs were
published by Thomas Agnew, who auc-
tioned the unsold photographs and neg-
atives along with Fenton's surplus
images. The public does not seem to
have remarked on the difference
between Robinson's more explicit
images and Fenton's tamer ones.

Fenton and Robertson are the best-
known photographers of the Crimean
War, because their work was published
in engraved interpretations in newspa-
pers and issued in multiple photo-
graphic prints. But there were other
photographers on the scene, including
Karl Baptist von Szatmari (1812–1887),
an amateur painter and photographer in
Bucharest, Romania. He used his social
connections to visit the opposing armies

of Turkey and Russia early in the con-
flict that led to the Crimean War.
Although all but one of his photographs
have perished, the range of subjects,
known from a show of his work at the
Paris Exposition of 1855, includes group
portraits and troop movements. Legend
has it that the young Russian novelist
Leo Tolstoi, who was in an artillery unit
at Sebastopol, made a number of pho-
tographs. Like other French photogra-
phers, the painter Colonel Jean-Charles
Langlois (1789–1870) arrived late in the
war. An accomplished war historian,
Langlois spent more than two decades
depicting France's battles in his large
circular painted panorama on the
Champs Elysées in Paris. He used his
Crimean photographs as a source for a
panoramic painting of fighting at the
city of Sebastopol and joined fourteen
photographs together to form a 360-
degree view (Fig. 3.9).[21]

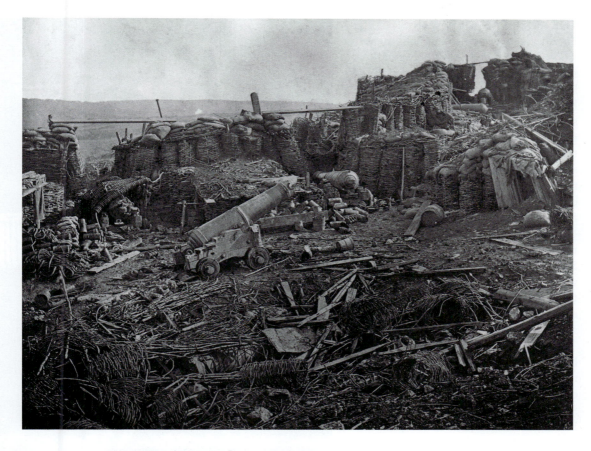

**3.8 (above)
JAMES ROBERTSON,**
Interior of the Redan,
June 1855. Salted paper
print. Gernsheim
Collection. Harry
Ransom Humanities
Research Center,
University of Texas at
Austin.

Unlike Roger Fenton,
James Robertson did
not shy away from
showing scenes of
destruction during the
Crimean War.

**3.9
CHARLES LANGLOIS,**
*A Section from the
Panorama of the
"Taking of Sebastopol,"*
plate 7, November, 1885.
Calotype. Musée
d'Orsay, Paris.

Langlois' Crimean War
photographs were
joined together to create
a 360-degree view of the
battlefield. The wide
scope of the display
intensified the sense of
being on the spot.

THE AMERICAN CIVIL WAR

For decades, economic and political tensions in the United States between the industrialized northern states and the largely agricultural southern states had been patched over by fragile concessions. One such agreement, the Compromise of 1850, admitted California to the Union as a free, that is, non-slave state, but allowed slavery to continue in the states where it existed, and mandated the return of fugitive slaves from free states. Abolitionist feeling in the North was roused by the provision that runaway slaves had to be returned to the South, and the immediate cause of the war, the secession from the Union by the state of South Carolina, was partly motivated by the dispute over fugitive slaves.

Fighting between North and South began with the shelling of Fort Sumter in South Carolina on April 12, 1861, and ended with the southern surrender at Appomattox, Virginia, on April 9, 1865. During the hostility, war correspondents, artists, and photographers furnished the public with plentiful news and images. Unlike in the Mexican–American War (see p. 47), Americans understood from the beginning that this conflict would be photographed extensively, and that actual photographs, and the engravings taken from them, would create a comprehensive visual chronicle—the first of its kind in American history.[22] The first pictures from the conflict were taken by southern photographers such as George S. Cook (1819–1902) the day after Fort Sumter fell. Born in Connecticut, Cook settled in the South in his twenties, but maintained his contacts with northern photographers, publishers, and suppliers, such as E. and H. T. Anthony & Co.[23]

When the division between North and South deepened, Cook centered his work on Confederate subjects. In February 1861, at the request of the northern photographer John Jabez Edwin Mayall (1810–1901) (see p. 28 and Fig. 2.5), Cook made a portrait of Major Robert Anderson, who commanded the Federal troops at Fort Sumter, in the mouth of Charleston Harbor (Fig. 3.10). In the succeeding months, as the quarrel between the North and the newly declared southern Confederacy focused on the continued presence of

Federal troops in the Fort, wood engravings of Cook's photograph were reproduced in the northern press, and *cartes-de-visite* made from the photograph were sold by the thousands. When Fort Sumter fell to southern forces, Cook made many photographs, including the lowering of the American flag. After the war, Cook amassed 10,000 Civil War photographs, largely by other photographers, which were later acquired by the Valentine Museum in Richmond, Virginia.

The Effect of the War on Photography

While only one photographer, Andrew J. Russell (1830–1902), was actually paid by the United States government, many quasi-official photographers from the North and South saw the conflict as an opportunity to expand their markets. Photographic portraits of such politicians as Abraham Lincoln were popular, as were images of military leaders. Families of soldiers going off to war desired pictures of their young men, who, in turn, wanted photographic keepsakes of their families. Photog-

3.10
GEORGE S. COOK,
Portrait of Major Robert Anderson, 1860–65.
Wet plate collodion.
Valentine Museum, Richmond, Virginia.

Such was the appetite to see images of newsmakers, that Cook's photograph of Major Robert Anderson, who commanded the Federal troops at Fort Sumter when it fell to Confederate forces, was quickly turned into wood engravings and circulated throughout the North.

**3.11
BERGSTRESSER
BROTHERS,**
*Bergstresser's
Photographic Studio,
3d Div., 5th Corp, Army
of the Potomac,*
c. 1862–64. Albumen
silver print. U.S. Army
Military History
Institute, Carlisle
Barracks, Carlisle,
Pennsylvania.

Photographers found
ready subjects in mili-
tary camps, where new-
found friendships were
celebrated by having a
photograph made. In
this photographic stu-
dio, the roof opened to
allow the sunlight in.

raphers such as the three Bergstresser brothers from Pennsylvania set up makeshift studios at military camps to provide photographs to soldiers (Fig. 3.11). An article in the *New York Tribune* for August 20, 1862 reported that the Bergstresser brothers had "followed the army for more than a year and taken, the Lord only knows how many thousand portraits. In one day, since they came here [to Fredericksburg] they took in one of their galleries, 160 odd pictures at $1.00 each (on which the net profit was probably ninety-five cents)."[24] The recently invented TINTYPE photographs, developed on thin sheets of iron, were particularly popular, cheap, and lightweight (Fig. 3.12). Photographs from the front lines were published in many formats, including the popular *carte-de-visite*. E. and H. T. Anthony & Co. issued more than a thousand pictures per day, sent in by semi-professional photographers and celebrities such as Mathew Brady (1823–1896).

Of the more than 1,400 photographers who made images of troops, military installations, and battle sites, most were from the North. Southern photographs are more scarce not simply because of the ravages of war, but also because of the severe shortages of photographic materials brought on by economic turmoil and military blockades.

Nevertheless, there are few differences among the subject categories

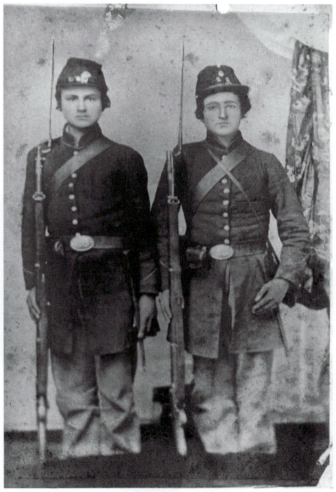

**3.12
PHOTOGRAPHER UNKNOWN,** *John and Nicholas Marien of Terre Haute, Indiana,* c. 1862–64. Tintype (original lost). Courtesy the author.

Tintypes were lightweight and more durable than daguerreotypes. An improved postal system could speed the images from the war zone to families at home.

PORTRAIT
Mathew Brady

Mathew Brady is best remembered for the battlefield photographs that his firm took during the American Civil War. But, as historian Mary Panzer noted, Brady's wartime photographs were dominated by representations of individuals and groups of soldiers.[25] Brady's emphasis on specific people reveals his philosophy that history is shaped by great persons, not abstract historical forces nor political controversies.

Brady's interest in portraiture began early in his professional life. Like many enterprising photographers of limited means, the young Brady undertook a number of different tasks that might offer a steady photographic practice. He began his career in New York City during the early 1840s, making cases for painted miniatures and jewelry, as well as daguerreotypes. By 1844, he had opened a daguerreotype studio and was winning awards for his images. He produced a series of portraits of criminals, which were made into wood engravings and published in the American edition of Marmaduke Sampson's *Rationale of Crime*.

By the late 1840s, celebrity photography had become his stock in trade. He produced unflinching portraits, including that of John C. Calhoun, the powerful South Carolina politician who opposed northern abolition movements (Fig. 3.13). This and other daguerreotypes of prominent Americans were transformed by Francis D'Avignon (1813–?) into lithographs (Fig. 3.14) and published in Brady's *The Gallery of Illustrious Americans* (1850). Produced during the debate that led to the Compromise of 1850, *The Gallery* struck a delicate balance by including images of opposing politicians.

Throughout the 1850s, Brady created portraits of distinguished American figures in law, government, business, society, and the arts, and exhibited them in his photographic studios (Fig. 3.15). Brady's images were sometimes used for personal publicity, being reproduced as inexpensive popular prints. Brady's status rose with the fame of his sitters, whose reputations increased in turn because their images bore his name and were displayed in his gallery. Before the outbreak of the Civil War in 1861, Brady had amassed over 10,000 photographs of celebri-

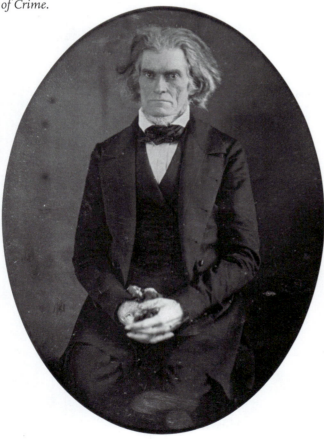

3.13
PHOTOGRAPHER UNKNOWN, *John C. Calhoun*, c. 1848–49. Daguerreotype. The Beinecke Rare Book and Manuscript Library, Yale University, New Haven, Connecticut.

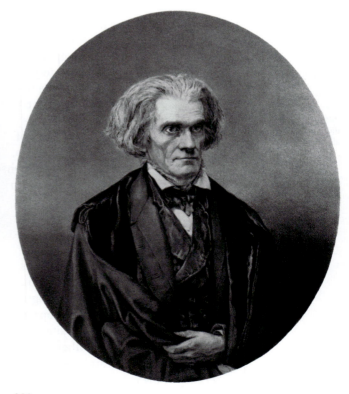

3.14
FRANCIS D'AVIGNON, *John C. Calhoun*, c. 1861. Lithograph. National Portrait Gallery, Smithsonian Institution, Washington, D.C.

ties, mostly Americans. Even United States presidents were not immune from the potential of photography.

Mathew Brady's famous photograph of Abraham Lincoln (1809–1865) was taken on the day in 1860 when he gave an address in New York at the Cooper Union (Fig. 3.16). Brady sold prints of the photograph, and it was reproduced in newspapers and magazines. Most people had never seen Lincoln, but rumors of his physical ugliness were rife during the presidential campaign. The Democrat opposition sang a song at rallies that ended "We beg and pray you—Don't, for God's sake, show his picture."[26] Brady distracted attention from Lincoln's gangliness by directing light to his face. He posed the future president in a statesmanlike attitude and took care that he curled his fingers (especially of his right hand), so that they would not appear overly long and large. Lincoln credited Brady for part of his success, remarking that "Brady and the Cooper Institute made me President."[27] By 1864, Brady and his firm had created more than thirty photographs of Lincoln, who himself sat for dozens of photographers.

Perhaps because of poor eyesight, Brady did not take most of the photographs that bore his name. Like David Octavius Hill (see p. 72 and Figs. 2.63 and 2.64) in Scotland, Brady conceptualized images, arranged the sitters, and oversaw the production of pictures. In his Civil War work, Brady stressed his conceptual and administrative capacity by frequently appearing in photographs with military leaders.

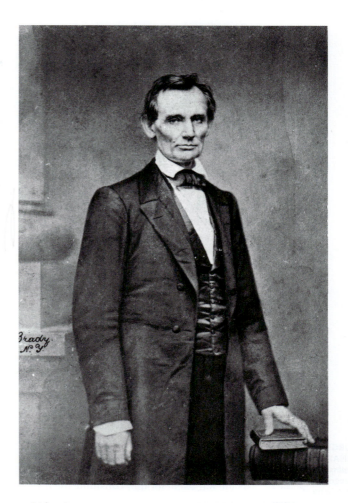

3.15
ALBERT BERGHAUS, *M. B. Brady's New Photographic Gallery, Corner of Broadway and Tenth Street, New York*, from *Frank Leslie's Illustrated Newspaper*, 1861. Wood engraving. Library of Congress, Washington, D.C.

3.16 (above)
MATHEW BRADY, *Abraham Lincoln*, 1860. Salted paper print (*carte-de-visite*). Library of Congress, Washington, D.C.

found in Civil War photographs. Whether of battlefields or individuals, Civil War photographs tend to be stiff and formal. Casual camaraderie among soldiers, like that pictured in Roger Fenton's work in the Crimea, was seldom recorded. Although African-American troops were photographed and occasional images were made of abused slaves, the Civil War did not engender a far-reaching photographic record of slavery and its aftermath.

The restraints and omissions in subject-matter, as well as the carefully balanced compositions, probably owe to the sense prevalent during the war that photography was a type of history writing, dedicated to recording the events, not investigating their tangled causes. The July 21, 1862 *New York Times* observed:

Mr. Brady deserves honorable recognition as having been the first to make Photography the Clio of war [in Greek myth, Clio is the muse of history] … His artists have accompanied the army on nearly all its marches, planting their sun batteries by the side of our Generals' more deathful ones, and 'taking' towns and cities, forts and redans, with much less noise and vastly more expedition. The result is a series of pictures christened "Incidents of War," and nearly as interesting as the war itself; for they constitute the history of it, and appeal directly to the great throbbing hearts of the North.[28]

Throughout the war, it was customary for major photographers to copyright their images, even though the photographs were frequently published by other firms or individuals. For example, George Barnard, who worked for Mathew Brady, copyrighted his work,

and later published *Photographic Views with Sherman's Campaigns* (1866), in which he recorded the well-organized destruction of the South's railroads. Northern troops lined up along the tracks, and on a signal simultaneously picked up one side of the railroad ties and tipped them over. The rails were then burned at high heat so that they twisted themselves into ruin[29] (Fig. 3.17).

Recognition of photographers who worked for other image-makers also became more common during the Civil War. Timothy O'Sullivan (1840–1882), who left Mathew Brady's studio in 1862 to work with Alexander Gardner (1831–1882), was given credit for his work in Gardner's publications. He made hundreds of war photographs, including *The Harvest of Death*, his most famous image, taken on the Gettysburg battlefield (Fig. 3.18). It was included in *Gardner's Photographic Sketch Book of the Civil War*, published in two volumes in 1865–66. As the war dragged on, photographs of battles and leading military officers were less sought after. The initial enthusiasm for the vast photographic record that could be made of the war was replaced by a sense of what could not be photographed.

The Civil War and Remembrance

After the Civil War, *Frank Leslie's Illustrated Newspaper* published images derived from photographs of prisoners in southern prisoner of war camps such as that at Andersonville, Georgia (Fig. 3.19). These photographs initiated one of the most lasting debates about the Civil War. While no one doubted the

**3.17
GEORGE N. BARNARD,** *Sherman's Hairpins,* **1864.** Stereograph, albumen print. Library of Congress, Washington, D.C.

During his campaign in the south, General Sherman ordered that the tracks of southern railroads be gathered and burned to prevent their being used again. The twisted rails were called "Sherman's hairpins."

3.19 (below)
PHOTOGRAPHER
UNKNOWN, *Frank Leslie's Illustrated Newspaper*, June 18, 1864. Woodblock print. Library of Congress, Washington, D.C.

3.18 (above)
ALEXANDER GARDNER, *The Harvest of Death, Gettysburg, Pennsylvania, July 1863*, from *Gardner's Photographic Sketchbook of the Civil War.* Stereoscope. Negative by Timothy O'Sullivan. Library of Congress, Washington, D.C.

In his *Photographic Sketch Book of the Civil War*, published after the conflict, Gardner told his readers that this photograph "conveys a useful moral: it shows the blank horror and reality of war, in opposition to the pageantry."[30] This statement may have been a veiled criticism of Mathew Brady, whose photographs favored ceremony and personalities.

truth of the soldiers' dire condition, its cause has been disputed. About 80,000 prisoners were held by both the North and the South, while prisoner of war exchanges stalled over such issues as whether black northern soldiers would be returned by the South. As the war dragged on, the North's blockades became more punitive, denying food and medical supplies to the South. The editors of *Harper's Weekly* wrote of the Confederates, "they do not [starve their prisoners] intentionally, perhaps, but that does not help the matter We are surely not obligated to tolerate the torture of Union prisoners because we wage the war so strictly that the rebels' supplies fail."[31] In northern newspapers, the poor condition of Union captives was contrasted with what was thought to be the decent and honorable condition of southern prisoners in northern detention centers. Little attention was paid to broadcasting the misery endured by southerners in prisons such as that at Elmira, New York.[32]

After the Civil War, and well into the twentieth century, the photographic books of the war were rumored to have been financial failures. It is true that Brady struggled for a decade to place his

PORTRAIT
Alexander Gardner

When Alexander Gardner emigrated from Scotland to the United States in 1856, he was already an accomplished photographer. His association with Brady, whom he may have met in London when both attended the Crystal Palace Exhibition in 1851 (see p. 29), proved to be beneficial to both photographers. Beginning in 1856, Gardner, an adept accountant and organizer, brought order and a modicum of financial stability to Brady's Washington gallery. With Brady, Gardner foresaw the potential market for photography brought about by the impending Civil War.

Brady's corps of photographers gained access to battlefields and fortifications through the efforts of one Allan Pinkerton (1819–1884), head of the presidential protective organization that became known as the Secret Service. Pinkerton, a Scot, arranged for Gardner and a contingent of photographers who worked with him to be given access to Union encampments, where the photographers carried on covert activities, for example photographing groups of soldiers in which spies were thought to dwell. These photographers also made copies of maps for the Secret Service, and pictures of feasible battlefields, and structures such as bridges, tunnels and railroad lines for the War Department.

Gardner and his subordinates made many of the photographs associated by the public with Mathew Brady. The battle at Antietam in Maryland, September 1862 resulted in shocking photographs of the dead (Fig. 3.20), eight of which were engraved and published by *Harper's Weekly* on October 18. On the occasion of their exhibition in New York City, the *New York Times* brooded on their effect: "Mr. Brady has done something to bring home to us the terrible reality and earnestness of war. If he has not brought bodies and laid them in our dooryards and along the streets, he has done something very like it."[33] After seeing the Antietam photographs, Oliver Wendell Holmes, who visited the battlefield soon after the conflict took place, similarly commented:

Let him who wishes to know what war is look at this series of illustrations. These wrecks of manhood thrown together in careless heaps or ranged in ghastly rows for burial were alive but yesterday It was so nearly like visiting the battlefield to look over these views, that all the emotions excited by the actual sight of the stained and sordid scene, strewed with rags and wrecks, came back to us, and we buried them in the recesses of our cabinet as we would have buried the mutilated remains of the dead they too vividly represented.[34]

When President Lincoln removed General George McClellan as head of the Union army, Alexander Gardner lost his favored position as "Photographer, Army of the Potomac." He then resigned from Brady's staff, but kept good, if competitive relations with his former employer. Both Gardner and Brady made images at the battle of Gettysburg in Pennsylvania, the Civil War's bloodiest engagement. Most of Gardner's views of Gettysburg feature death and destruction. It was on the Gettysburg battlefield that Gardner reconfigured a scene for the camera,

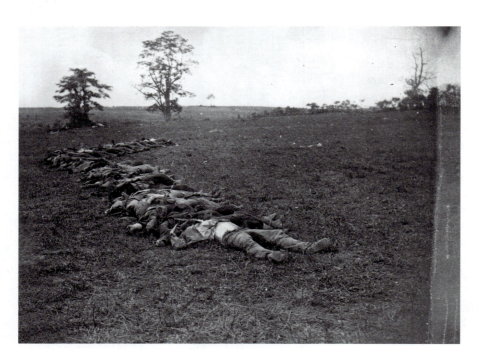

3.20
MATHEW BRADY,
Soldiers on the Battlefield, 1862.
Albumen silver print by Alexander Gardner.
Library of Congress, Washington, D.C.

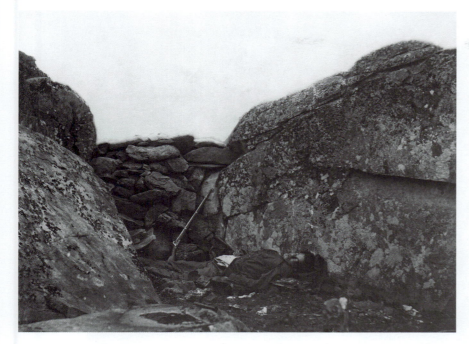

3.21
ALEXANDER
GARDNER, *Home of a
Rebel Sharpshooter,
Gettysburg,* from
*Alexander Gardner's
Photographic
Sketchbook of the Civil
War,* plate 41, July 1863.
Wet collodion print.
Library of Congress,
Washington, D.C.

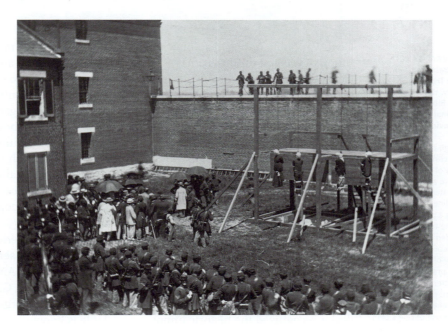

3.22
ALEXANDER
GARDNER, *Execution of
the Lincoln Conspirators,*
1865. From an original
glass negative. George
Eastman House,
Rochester, New York.

so as to intensify its visual and emotional effects. To make *Home of a Rebel Sharpshooter* (Fig. 3.21), he had the corpse moved to a stone wall, and supported the dead man's head on a knapsack so that it faced the camera.[35] The rifle leaning on the wall is a prop that Gardner carried with him. The fact that Gardner did not keep his arrangement of this scene a secret indicates that the public was willing to allow the photographer to construct a scene that was true in a larger sense than fidelity to visual fact. Soon after Gettysburg, Gardner was briefly captured by Confederate troops, but released after they had assured themselves that he was not a spy. Like the ability of southern photographer George S. Cook to obtain photographic supplies during the conflict, this suggests that photographers were regarded as neutral observers of war, not partisans.

Gardner's eye for the sensational is evident in the series of photographs he made of the conspirators who plotted the assassination of Lincoln. He photographed several of them after their arrest and published images of their execution (Fig. 3.22). Although the series from which this image comes seems like an innovative precursor of the photo-essays that would appear in twentieth-century magazines such as *Life,* it was probably made primarily for Secret Service records. Images derived from Gardner's photographs were published in *Harper's Weekly* (July 22, 1865), but the actual photographs did not sell well.

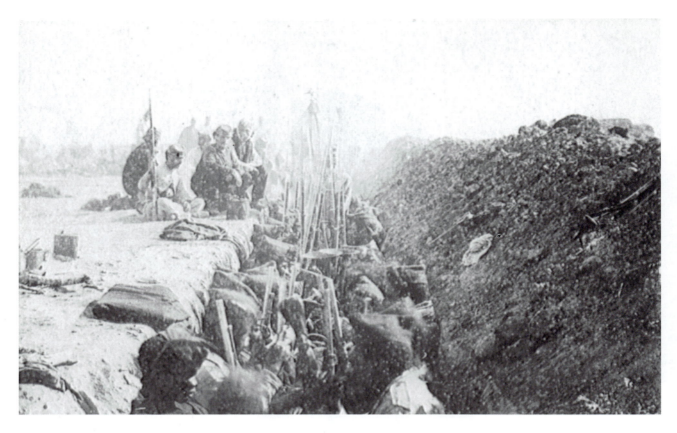

3.23
ESTEBAN GARCÍA,
First Battalion April 24
in the Trenches of
Tuyuty, 1866. Collodion
print. Biblioteca
Nacional de Uruguay,
Montevideo.

Though constrained by
the technical insuffi-
ciency of photography to
capture action, García
generated the feeling of
front-line activity by
taking a picture above
jostling troops in a
crowded trench. García
did record the horrific
sprawl of Paraguayan
dead, practicing the
unwritten, yet universal
custom of picturing far
more enemy corpses
than those of one's own
troops.

Civil War photographs in a public insti-
tution; it was not until 1875 that
Congress paid Brady for the title to his
prints and negatives. Current research
suggests that Gardner's book and
Barnard's volume, issued in small num-
bers, were both moderately profitable.

In 1869, both Brady and Gardner
petitioned Congress to purchase, and
hence preserve, their negatives. Both
proposals were rejected, partly because
the government was unsure how to
store large numbers of photographs.
About 90,000 of Gardner's glass-plate
negatives passed to a portrait photogra-
pher in Washington, D.C., who, in turn
sold them to a scrap glass dealer. The
dealer recognized the historic impor-
tance of the work and tried unsuccess-
fully to market the images; finally, the
glass and the silver in the emulsion
were salvaged, destroying the negatives.
Other sources, including the collection
of E. and H. T. Anthony & Co., who
distributed both Brady and Gardner
images, were ultimately obtained by the
United States Library of Congress.

THE WAR OF THE TRIPLE ALLIANCE, SOUTH AMERICA

The day after Christmas, 1864, 80,000
troops under the direction of Paraguay's
leader, Francisco Solano Lopez (1826?–

1870), invaded Brazil. In May 1865,
Brazil, Uruguay, and Argentina formed
a triple alliance to defeat the Lopez gov-
ernment. The conflict arose over dis-
putes about navigation routes and land
claims. Tens of thousands of troops
from the four countries were mobilized.
The war, which thundered on until
1870, was especially devastating for
Paraguay; some estimate that 80 percent
of the country's population died during
the hostilities.

As in the American Civil War, pho-
tographers were sent to the fronts. One
of the first Latin American war photog-
raphers, Esteban García (active 1860s),
from Uruguay, organized their efforts.
Little is known about García, but his
images were published by Bate & Co.,
a Montevideo studio financed by inves-
tors in the United States. The North
Americans were hoping to reproduce
what they mistakenly thought was the
substantial financial success of Brady's
American Civil War photographs.[36] Sold
in sets of ten, called *La Guerra Ilustrada*
(*The War, Illustrated*) (1866), the photo-
graphs show the troop formations and
battle preparations characteristic of
nineteenth-century war photographs
(Fig. 3.23). Like American Civil War
images, the daily personal experiences
of the combatants are virtually absent.

THE FRANCO-PRUSSIAN WAR AND THE PARIS COMMUNE

The Franco-Prussian War sprang from the political and economic rivalry between France, under Napoleon III (1808–1873; r. 1852–70), and Prussia, led by Otto von Bismarck (1815–1898), who orchestrated the confrontation. France declared war on July 10, 1870, only to experience repeated defeats that culminated in the decisive German victory at the Battle of Sedan (August 31–September 2, 1870), when Napoleon III was captured. A provisional government was declared in Paris, and in the winter of 1870 Prussian troops laid siege to the city. Passenger balloons, with such names as *Daguerre* and *Niépce*, attempted to carry communications from the beleaguered city. In the lore of war and photography, the extensive use of carrier pigeons has become legendary. Packaged in tiny containers and tied to tails of homing pigeons, over 100,000 messages of photographically reduced text passed between the city and French officials outside the siege line. The Prussians used falcons to chase and kill the French pigeons.[37] Despite the Parisians' efforts, the city fell after German bombardment.

Resentment at the royalist leanings of the postwar French government was especially keen in Paris. The move to disarm the National Guard, townsmen who fought the Germans and who supported an idea of a French republic, further angered Parisians. In mid-March, a group of anti-royalists and working-class activists declared themselves the "Paris Commune." Although the Commune lasted less than three months, it became an abiding emblem of a righteous people's revolution in France, and around the world. During so-called Bloody Week (May 21–May 28, 1871), when the French government repossessed the city, around 25,000 Parisians were killed, more than during the Reign of Terror in the French Revolution or the recent German siege[38] (Fig. 3.24).

During and after the Commune, photography was used to record events as well as to promote, explain, and rationalize political positions. The Communards posed for photographs before and after they tore down the Vendôme Column, erected by Napoleon Bonaparte (1769–1821; r. 1804–14, 1815), whose statue stood on top of it. The decree for the destruction of the column belittled it as "a monument of

3.24
PHOTOGRAPHER UNKNOWN, *Communards in their Coffins,* May 1871. Albumen print. Gernsheim Collection. Harry Ransom Humanities Research Center, University of Texas at Austin.

An unknown photographer captured the carnage with an image of numbered corpses slumped in their coffins. This photograph of dead Communards could be read by their supporters as a symbol of tragedy and by their enemies as a symbol of triumph.

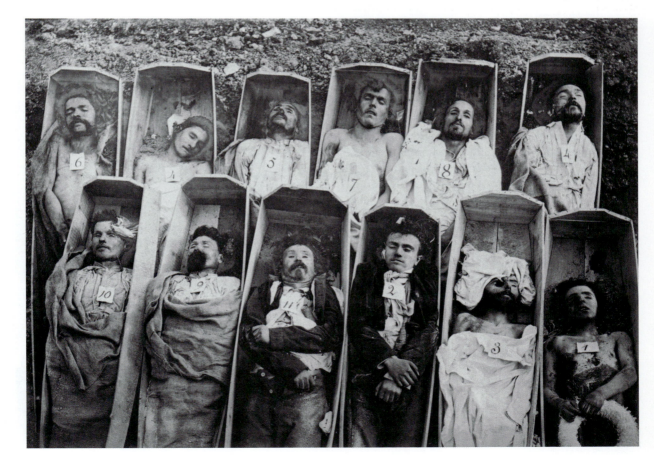

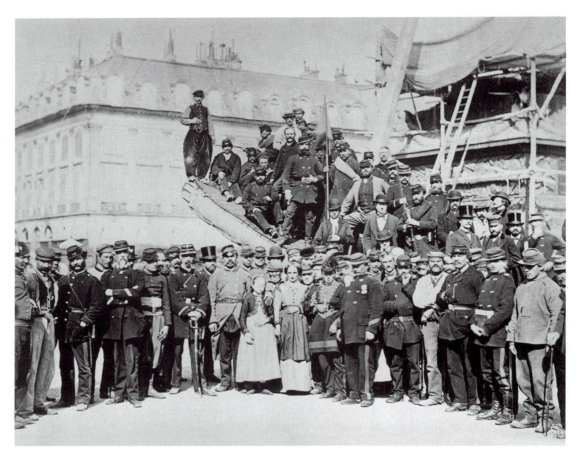

barbarianism, a symbol of brute force
and of false glory, a confirmation of mil-
itary rule contrary to the international
rights of man."[39] The Communards
posed for a number of photographs
while it was being pulled down (Fig.
3.25). Bruno Braquehais (1823–1875)
took 109 views of the Commune, which
were sold in a bound album called *Paris
during the Commune*. Ironically, pho-
tographs of the Communards were soon
used to identify and arrest them, when
the French government retook the city.

The activities of photographers in
Paris after the fall of the Commune
were the subject of a satirical illustration
in the *Illustrated London News* for June
24, 1871[40] (Fig. 3.26). It is difficult to
gauge completely the meaning of this
print. British criticism of French radical-
ism had run high since the French
Revolution of 1789; here, however, the
placement of the photographer, and his
disregard for the urgent task of the fire
fighters and the acute suffering of the
woman and child in the right fore-
ground, seem to criticize the neutrality
and intrusiveness of photography, and
the public's hankering for sensational
photographs. In other words, the
conflict-ridden modern attitude toward

the media, which criticizes that which it
craves, may have emerged in the late
nineteenth century.

After the Commune, the French pho-
tographer Eugène Appert (active 1870s)
made dramatic, deliberately contrived
photographs of the events. In his *Crimes
of the Commune* he included nine fabri-
cated prints of events that visually pre-
sented the French government's view of
the Communards. After obtaining por-

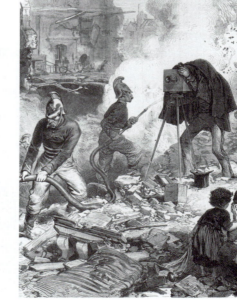

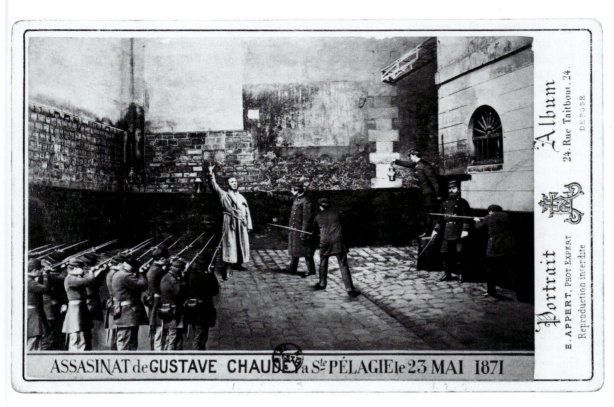

ASSASINAT de GUSTAVE CHAUDEY a Ste PÉLAGIE le 23 MAI 1871

In this image, Appert staged what he considered to be the hasty rush to judgment that caused the execution of Chaudey, a politician and former newspaper editor. Chaudey stands larger than life in the center, protesting his innocence and exclaiming, "Long live the Republic."

traits of the leaders of the Commune, Appert hired actors to enact historic scenes from the point of view of the anti-Commune forces. In the studio, he cut out the individual figures, pasted on them the heads of the Communards, then rephotographed the image. These composite photographs vary considerably in quality (Fig. 3.27).

"SMALL WARS," COLONIAL EXPANSION, AND PHOTOGRAPHY

The Crimean War, the American Civil War, the War of the Triple Alliance, and the Franco-Prussian War were conflicts which, for the most part, engaged national armies against each other. But most conflicts during the nineteenth century pitted troops from the great powers against non-European peoples. Military, commercial, and propagandistic uses of photography were exploited during these small wars and subsequent colonial expansion. The combat-related uses of photography, such as the duplication of maps, description of terrain, and depiction of armaments, became more routine. Photographers increasingly accompanied troops from the major powers, both to record military exploits and to picture foreign countries for audiences back home. In India, China, North Africa, Abyssinia (now Ethiopia), the Middle East, and Asia,

photographers were granted the right to photograph troops and the aftermath of battles. They also produced views of foreign lands that stressed the exotic look of the landscape, architecture, and people. In the 1850s and 1860s, dozens of Western photographers without military obligations relocated abroad and set up studios in countries where they hoped to make images for markets back home and for colonial settlers.

The landscape and architectural views produced by photographers attached to military expeditions and those made by commercial photographers are strikingly similar. Both tend to emphasize the unusual aspects of a landscape, an extraordinary temple or public building, or the remoteness of a site. In effect, the photographs, sold singly or in albums, promoted the notion of the photographer as a brave and resourceful explorer, akin to other expatriates, such as military personnel and entrepreneurs, who were living large at the edges of the world.

In the November 1859 edition of *The Photographic News*, an anonymous reviewer noted an exhibition of stereoscopic photographs published by the London firm of Negretti & Zambra. The writer observed that "as ... the camera became more common in Egypt and the Holy Land, the more adventurous

photographers turned their steps to more distant and less known countries. Even the jealously-guarded countries of China and Japan cannot shut out the camera."[41] Especially in places where intertwined Western political and economic interests expanded, photographers very quickly followed. In Asia, photography was first known primarily in port cities, but from the 1850s photographers began trekking to remote interior regions, photographing the residue of war, the wonders of the natural world, and indigenous art and architecture.

India

Arriving in India in 1863, British photographer Samuel Bourne (1834–1912) made three climbs high in the Himalayan wilds. Despite the physical obstacles and technical problems that beset his treks, Bourne excluded the hardships of the trail from his photographs, restricting difficulties to the long descriptive letters he wrote home to the *British Photographic Journal*. These helped to make Bourne the epitome of the heroic photographer abroad. He wrote that the mountain "scenery was not well adapted for pictures—at least for photography The character of the

Himalayan scenery in general is not picturesque."[42] Bourne carefully selected scenes and camera angles, ultimately depicting the Himalayas as a compliant and serene landscape, waiting to be recorded by the camera (Fig. 3.28). One photographic historian credits Bourne with initiating "an imperial picturesque," that is, an adaptation of European notions of pictorial organization and subject matter to the look of an exotic locale.[43]

After his journey to photograph the Crimean War, James Robertson traveled with photographer Félice Beato (c.1820s–c.1907) throughout the Middle East. Pictures of India were published under the name of Robertson and Beato or Robertson Beato et Cie, though it is possible that Robertson never actually visited the subcontinent.[44] Beato, however, was certainly in India making photographs, some of them staged, soon after the Indian Mutiny, which began with the 1857 uprising of Indian-born troops in the employ of the British East India Company, the private corporation that controlled trade in India, against the regular British Army (Fig. 3.29). Later called by Indians the First War of Independence, the uprising spurred the

3.28
SAMUEL BOURNE,
Valley and Snowy Peaks Seen from the Hamta Pass, Spiti Side, 1863–66. Albumen print from wet collodion negative. Victoria & Albert Museum, London.

In Bourne's view of the Hanta Pass, the mountains rise up in a harmonious half-circle nearly filling the corners of the plate, as loftier, snowier peaks dissolve into the distant sky. Despite his attention to overall symmetry, he did not sacrifice particulars for composition, but managed to integrate myriad details into the picture.

**3.29
FÉLICE A. BEATO
(attrib.),** *The Execution
of Mutineers in the
Indian Mutiny*, 1857.
Victoria & Albert
Museum, London.

During the Indian
Mutiny, or First War of
Independence, Beato
photographed from the
British perspective,
which included severe
punishments for the
rebels.

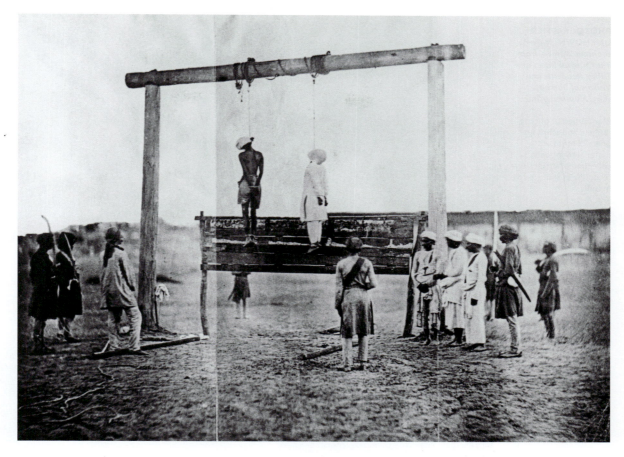

British to reorganize the army and restructure colonial rule.

Beato was not the first Western photographer in India. John Murray (1809–1898), a medical doctor who had worked for the East India Company, and who taught medicine in Agra, was also a photographer (Fig. 3.30). The East India Company itself had employed photographers to document Indian landscape and its antiquities since the mid-1850s.[45] Three brothers, Adolph (1829–1857), Hermann (1826–1882), and Robert (1833–1885) Schlagintweit, natural scientists and Alpine explorers, were com-

missioned by the Company to do biomagnetic measurement in India and the Himalayas. During their four-year stay, Robert made photographic renderings for their report of the scientific mission, and for Hermann's book *Travels in India and High Asia* (1869–1880). One measure of the presence of Western photographers in India is the formation of three photographic societies, in Bombay, Madras, and the province of Bengal from 1854 to 1856. Another indication of photography's capacity to replicate the British imperial view of India is found in a monthly publication, *The Indian*

**3.30
JOHN MURRAY,**
*Panorama of the West
Face of the Taj Mahal*,
c. 1850s–1860s.
Albumen print from
mixed-type paper
negatives. Victoria &
Albert Museum,
London.

3.31
PHOTOGRAPHER
UNKNOWN, *Nagar
Brahmin Women,* from
*The Oriental Races and
Tribes: Residents and
Visitors of Bombay,*
1863. Albumen print.

Many amateur photog-
raphers and ethnogra-
phers contributed
material to Johnson's
collection of images rep-
resenting ethnic groups
in India.

Amateur's Photographic Album
(1856–58), and in combinations of text
and pictures, such as the two-volume
*The Oriental Race and Tribes: Residents
and Visitors of Bombay* (1863–1866),
produced by William Johnson of the
Bombay Photographic Society[46]
(Fig. 3.31). As in China, Western pho-
tographers employed painters trained
in the art of the miniature to color
photographs.[47]

China

Félice Beato was with Anglo-French
troops in China in 1860, during the sec-
ond Opium War (1856–60) perhaps in
a semi-official capacity. At this period,
China had endured a decade of civil war

and economic instability, amidst
Western pressure to open the country to
commerce. The opium trade, hugely
profitable to the British, French, Dutch,
and Americans, flourished despite being
outlawed by the Chinese government.
After the first Opium War (1839–42),
negotiations with European powers and
the United States opened some ports to
trade, but hostilities reignited in 1856,
when Chinese officials searched a
British ship. In 1860 the Western allies
took the forts at Taku, near Tientsin, a
critical step in the advance on the capital
city of Beijing. Beato's sequential docu-
mentation of the China campaign may
be the first such conscientious series of
images. He methodically photographed

3.32
FÉLICE A. BEATO,
Interior of the Angle of North Fort on August 21 1860, 1860. Albumen print. Victoria & Albert Museum, London.

There is some evidence to suggest that Beato had corpses dragged into this scene and artfully arranged, a staging method he employed in some of his photographs of the Indian Mutiny.

taken in the American Civil War (see Figs. 3.18 and 3.20).

However vivid the devastation, Beato's photograph by itself did little to explain the condition of China and its relations with the West. After the signing of peace accords between the Chinese government and the Western powers, which Beato tried unsuccessfully to photograph, he managed to photograph Prince Kung, brother of the emperor, who negotiated with representatives of the West. Kung's image, and Beato's views of war and commerce, were sold both in Asia and Britain.[48]

Throughout Asia, the practice of photography directly followed the expansion of Western interests. Expatriates, traveling businessmen, tourists, and viewers in Europe and America provided a ready market for pictures. Photographers and publishers continually speculated about new views and markets, and began

the aftermath of the allies' efforts to capture the forts at Taku; the interior of one of the strongholds shows the unburied Chinese dead amidst the conquered fort (Fig. 3.32). The bold picturing of carnage predates the grisly photographs

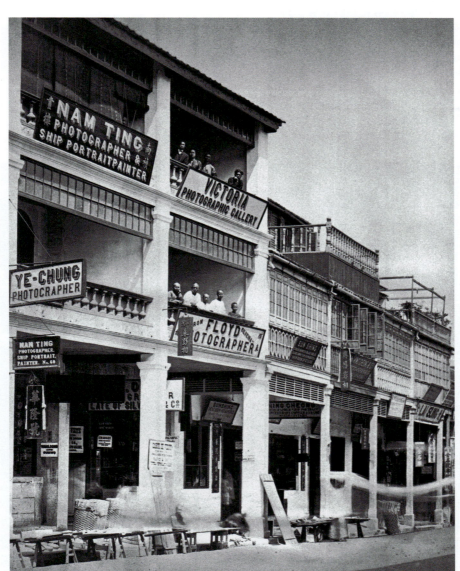

3.33
WILLIAM PRYOR FLOYD, *Photographers' Studios* (Floyd's studio among other studios, Queen's Road, Hong Kong), late 1860s–early 1870s. Albumen print. Gift of Mrs. W. F. Spinney, 1923. Peabody Essex Museum, Salem, Massachusetts.

Photography studios flourished in areas where colonial forces traded. Western photographers frequently hired Asian assistants, who soon set up their own rival businesses.

3.34
FÉLICE A. BEATO,
Panorama of Hong Kong, Showing the Fleet for the North China Expedition, March 18–27, 1860. Panorama consisting of six albumen silver prints from five wet collodion glass-plate negatives, each mounted on paper and joined by Japanese tape. Victoria & Albert Museum, London.

Western audiences preferred images of an exotic East, as well as pictures that showed the Western presence in Asia. In this view, Beato included Western mercantile and military ships, photographed from the roof of a British government building.

traveling abroad, or sending photographers abroad, to seek their fortunes (Fig. 3.33). In China, for instance, the photographic publishing firm of Negretti & Zambra issued a series of stereographic views which showed scenes in the southern city of Canton after it had been captured by the Western allies, and Beato crafted a panorama of the British Fleet in Hong Kong harbor (Fig. 3.34). Around the globe, photographs of international ports, wharves, and Western commercial buildings were regularly created. Stereotypical images of indigenous peoples and local scenes also became popular. Beginning in the late 1860s, Shanghai photographer L. F. Fisler (active 1866–1887) contrived studio settings of Chinese life for the camera (Fig. 3.35).

The American expatriate photographer Milton M. Miller (active 1850s–1870s) set up practice in the thriving city of Hong Kong, which had been deeded to the British in 1842. Miller acquired photographs of Beijing by Beato, which he marketed in addition to his portrait practice. Though active for only a few years in the 1860s, Miller worked in both Hong Kong and Canton, selling photographic prints and producing images of influential Chinese and foreign citizens, as well as occasional city views. The standards for middle-class portraiture, developed in the West, were adapted to the tastes of a new, well-to-do

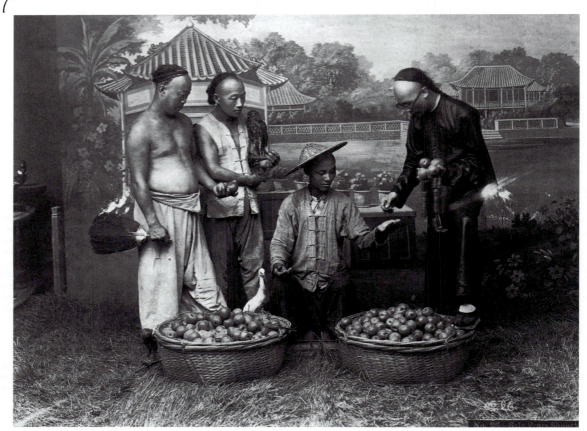

3.35
L. F. FISLER, *Selling Pears (Shanghai, China)*, 1870s. Paper print. Peabody Essex Museum, Salem, Massachusetts.

Chinese clientele. Lavish furnishing, placed in an enclosure marked off by a cloth backdrop, formed the setting for people who dressed in fine clothing and displayed artistic treasures. Miller's portraits, mostly of the Chinese upper and middle classes, and persons working for foreign traders, usually show the sitters directly facing the camera (Fig. 3.36). Rarely a hint of expression is evidenced on a sitter's face, but as a rule the camera kept its distance from the sitter.

When traveling around China, the Scottish photographer John Thomson

(1837–1921) observed this approach, which he satirized through the words of a fictional photographer, A-hung:

"You foreigners," says A-hung, "always wish to be taken off the straight or perpendicular. It is not so with our men of taste; they must look straight at the camera so as to show their friends at a distance that they have two eyes and two ears. They won't have shadows about their faces, because, you see, shadows form no part of the face. It isn't one's nose or any other feature; therefore it should not be there. The camera, you see, is defective … it won't recognize our laws of art."[49]

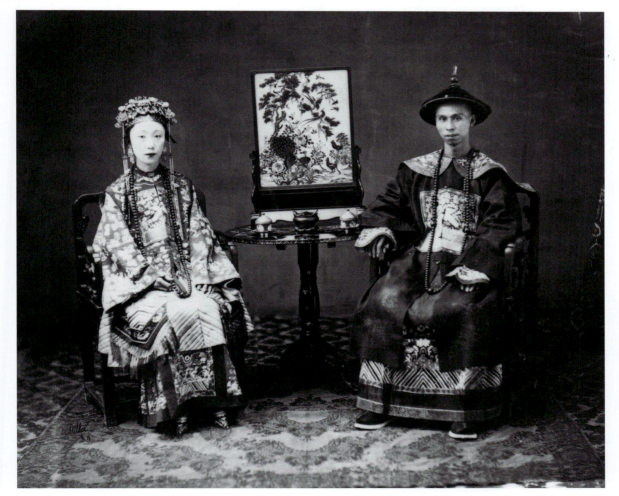

**3.36
MILTON M. MILLER,**
*Cantonese Mandarin
and His Wife*, 1861–64.
Paper print. Royal
Asiatic Society, London.

Miller adapted his photographic style to the requirements of his Eastern clients. He abstained from the use of dramatic lighting, nor did he take his pictures from unusual angles, as Western portraitists often did of their clients.

Especially in Chinese cities such as Hong Kong, which had established trade with foreigners, artists were employed to copy paintings of Chinese scenes for sale to Western business-people and travelers. These images, rendered in a more three-dimensional style than was used in traditional Chinese painting, dwelled on what seemed unusual and exotic to Western eyes. Such elements as rickshaws and sedan chairs, and pictures of workers and tradespeople in typical dress were also drafted into photographic practice. Chinese costume, particularly the bound feet of women (see Fig. 3.36), and Chinese punishments such as the cangue (Fig. 3.37), were frequent subjects. With the arrival of photography in China in the 1840s, some Chinese copy-painters turned to reproducing photographs in paint. In time, after training in the studios of foreigners or under the tutelage of Western missionaries, they

began making photographs. Hong Kong seems to have been a photographic training center for Chinese, who then set up practice in other cities.

Unlike many Chinese photographers, who used the medium to augment their painting income, the famed Chinese photographer Afong Lai (active 1860s–1880s), probably did camera-work full time. The quality of his work was noted in 1872 by Thomson, who wrote that "there is one China-man in Hong Kong, of the name Afong, who has exquisite taste, and produces work that would enable him to make a living even in London."[50] Lai advertised his up-to-date knowledge of photographic processes, as well as the resources of his well-stocked studio. He also published an album of prints taken after the typhoon that hit Hong Kong on September 22, 1874 (Fig. 3.38).

By the time he became acquainted with Lai's work, Thomson had spent

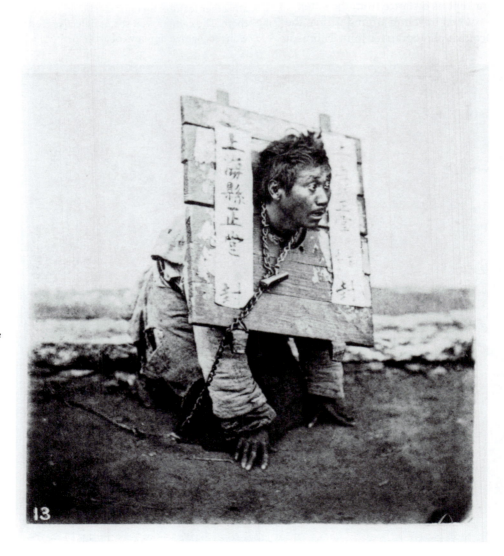

**3.37
JOHN THOMSON, *The Cangue*, 1871–72, from *China and its People*, 1874. Victoria & Albert Museum, London.**

The cangue was a Chinese punishment in which a wooden board was worn around the neck like a portable pillory. Photographs of Asian criminal punishments, especially beheadings, became a persistent theme in Western photography, beginning in the mid-nineteenth century.

several years traveling around Asia making photographs. His work pattern was to settle in an area for a while, make images, then strike out for new territory. He moved to Singapore in 1863, but made long photographic excursions over the next three years to India, Siam (now Thailand), and Cambodia. His first book, *The Antiquities of Cambodia*, was published in 1867. By 1868, he had resettled in Hong Kong. Thomson's images may stand alone aesthetically (Fig. 3.39), but they were integrated with geographic observation, and

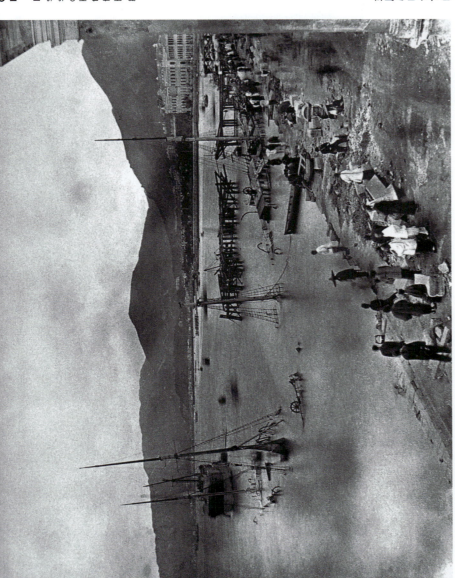

3.40
FELICE A. BEATO,
Mount Fuji, 1868. Paper
print. Old Japan
Collection, Surrey,
England.

Beato often photo-
graphed Mt. Fujiyama,
the highest and most
sacred mountain in
Japan, either highlight-
ing its reach through the
clouds or the way in
which it dominated the
surrounding country-
side.

ethnographic research in his texts and
lectures. Like other photographers
aware of viewers' tastes, he took pho-
tographs of Chinese laborers, punish-
ments (see Fig. 3.37), and street people.
Thomson published six books of text
and photographs on China, including
Illustrations of China and Its People
(1873–74), a four-volume work of 200
photographs produced in the COLLOTYPE
process, an advancement that allowed
images to be printed along with text.

Japan

The introduction of commercial photog-
raphy to Japan coincided with the mod-
ernization of the country, and yet it is

3.41
FELICE A. BEATO, *Beato's Artist*, c. 1868. Albumen
print. Courtesy Old Japan, Purley, Surrey, England.

The unnamed Japanese artist delicately colored prints
for Félice Beato. Japanese experience with art on paper,
such as the woodblock prints called *ukiyo-e* and the
hand-colored paper stencils called *kata-gama*, may
have prompted Japanese artists to begin to tint
photographs.

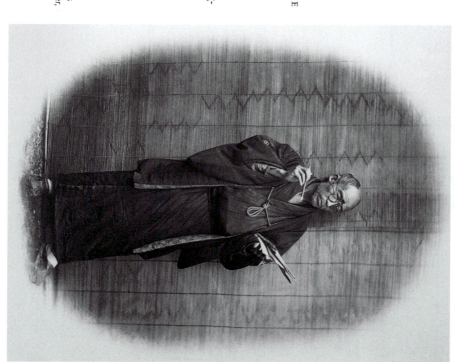

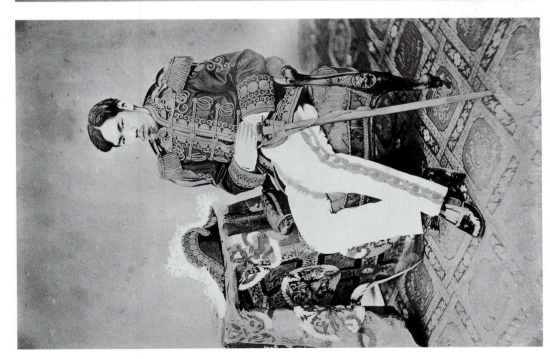

3-42
UCHIDA KYUICHI, *Mutsuhito, the Emperor Meiji*, c. 1872. Albumen print. Richard Gadd Collection. Monterey Museum of Art, Monterey, California.

3-43
UCHIDA KYUICHI, *Haru-ko, the Empress of Japan*, c. 1872. Albumen print. Richard Gadd Collection. Monterey Museum of Art, Monterey, California.

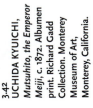

clientele of wealthy Japanese patrons, as well as foreigners. When Beato arrived in Japan from China, he probably saw the growing economic opportunity. The *London Illustrated News* for July 13, 1863, indicates that he had set up a studio in Yokohama. Despite the political conflict between pro- and anti-modernization supporters, Beato's views imaged a tranquil country, unchanged for centuries (Fig. 3.40). He also made images of what he called "native types," including hand-tinted, somewhat romantic images of the samurai, the Japanese warrior class whose privileges were repealed as Japan modernized its armaments and built a centrally controlled military.

Many of Beato's images were delicately hand-colored by Japanese artists (Fig. 3.41). Their contact with Western photographers was presumably one of the main ways in which the Japanese learned photography. In 1872, Uchida Kyuichi (1844–1875) made two photographs of Emperor Mutsuhito (1852–1912; r. 1867–1912) and the Empress

difficult to view this momentous change in the images produced during the later nineteenth century. In 1853 and 1854, Commodore Matthew C. Perry used shows of force to establish political and economic relations between the United States and Japan, and helped start the process of modernization in that largely feudal country. On his second mission, Perry brought along a daguerreotypist, Acting Master's Mate Eliphalet Brown (1816–1886), who made photographs while Perry negotiated with the Japanese for nearly five months. The daguerreotypes were published as wood engravings and lithographs in the official report of Perry's trip.[51]

Given widespread curiosity about Japan, which had been all but closed to foreigners, it was likely that Western, and, in time, Japanese photographers, would grasp the commercial potential for making views. From the late 1850s, a steady trickle of Western photographers entered Japan; by the early 1860s, Japanese professionals were serving a

These may be the first photographs of the emperor and empress, who oversaw the modernization of the country. The emperor here wears an adaptation of Western dress at the suggestion of advisors who noted that many Europeans liked to exchange *cartes-de-visite*, and would favor seeing him in contemporary clothing.[52] The empress is clothed in traditional garb, underscoring the symbolic association of women with a culture's traditional values.

3-44
FRANCIS FRITH, First
*Pylon View of the Great
Temple*, 1850s. Wet col-
lodion paper print.
Victoria & Albert
Museum, London.

Frith's view of the deeply
incised relief sculpture
on the outer gate of
Philae's temple of Isis is
characteristic of his
approach to Egyptian
artifacts. He liked to
include some local
people, not simply to
demonstrate the scale of
the sculpture, but also
to contrast the present
with the past, and to let
viewers glimpse con-
temporary Egypt.

Haru-Ko, who ruled over Japan as it
modernized (Figs. 3-42, 3-43). When
offered for sale, these images quickly
became popular;[52] they were withdrawn
from the market in 1873, however, when
the government decided that they repre-
sented an inappropriate commercializa-
tion of the monarchs. Photographs of
the emperor were not officially offered
for sale again until 1889.[53]

PHOTOGRAPHY IN THE
MIDDLE EAST

During the 1850s and 1860s, the popu-
larity of an extended trip to view ancient
sites around the Mediterranean, often
called the Grand Tour, stimulated the
market for views of Italy, Greece,
Palestine, and Egypt. The books, prints,
and stereographs produced by British
photographer Francis Frith (1822–1898)
were extremely popular. They intro-
duced a generation of British viewers to
the sights of Egypt and the Holy Land.

Frith's photographs in Egypt encom-
passed such well-known monuments as
the pyramids at Giza, and less familiar
works such as the buildings on Philae,
an island in the southern reaches of the
Nile near Aswan (Fig. 3-44). Frith was
also a publisher of photographic books,
and arranged his pictures of Egypt in
such volumes as *Egypt and Palestine
Photographed and Described by Francis
Frith* (1858–60). Like the photographs
themselves, Frith's books mix the
ancient and the modern; awestruck
descriptions of ancient architecture are
interspersed with amusing accounts of
recent travels. Frith also worked on an
1862 edition of the Bible, which con-
tained fifty-five of his Middle East pho-
tographs. Spurred, perhaps, by the
popularity of his books on Egypt and the
Holy Land, Frith and his assistants set
out in 1859 to photograph every city and
town in England, Scotland, Ireland, and
Wales, including historic monuments

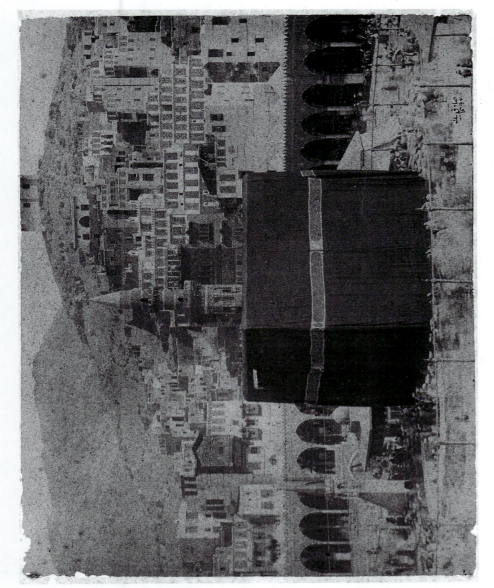

3.45
MUHAMMAD SADIQ,
The Holy City, c. 1880.
Albumen print.

While traveling on his official duties, Sadiq made the first known photographs of Islamic holy cities Medina and Mecca. Possibly because Sadiq was a devout Muslim, he encountered no cultural resistance to the making of these photographs.

and natural sites.[54] This encyclopedic urge, which struck many photographers and publishers, resulted in thousands of images that were sold singly on newsstands and similar venues.

While Frith photographed sites in the Middle East, Egyptian colonel and amateur photographer Muhammad Sadiq (sometimes Sadic Bey) (1832–1902) set out on a military mapping mission to explore Arabia. Although the exploration did not officially include photography, Sadiq was able to make the first known photographs of the holy city of Medina (Madinah), where the Prophet Muhammad was born. In 1880, Sadiq accompanied a cortege of pilgrims from Egypt to Mecca (Makkah), where he produced a panorama with the draped Ka'ba, or sacred structure, in the center (Fig. 3.45).

TOPOGRAPHICAL SURVEYS AND PHOTOGRAPHY

In the second half of the nineteenth century, the United States, Canada, and many European countries carried out numerous surveys of their own land,

colonies, and foreign territories. Surveys were organized for a variety of purposes, including providing clean water to European settlers, transcribing the geology of an area, scouting routes for railroads, and recording archeological or architectural sites. Often the surveys were carried out by military engineers, who had already recognized the value of photography for determining artillery range and reproducing maps and sketches.

Because the terrain encountered by the foreign surveyors and the photographers who accompanied them was little known, the surveys' sponsors could not thoroughly predetermine what would be photographed. Nevertheless, photographers observed subtle cultural guidelines when selecting, arranging, and framing their shots. For example, Christians associated photographs of the Middle East with the Bible, regardless of the initial intent or context of the image. Photographers were aware of the intellectual and emotional interaction viewers had with such photographs, and they understood its commercial potential. Consequently, they ignored contemporary conditions in places

FOCUS
The Abyssinian Campaign, or the Maqdala Expedition

It is sometimes difficult to distinguish survey photography from the photography done by major powers during military campaigns. For example, during the Maqdala expedition to Ethiopia, launched in 1867 by the British Government when Christian missionaries and other Europeans were taken hostage by the emperor, the Royal Engineers furnished Sir Robert Napier's troops with a team of photographers. They reportedly managed to make an astounding 15,000

images, despite the hazards of conflict and the difficulties of terrain.[55] As might be expected, the Maqdala expeditionary photographers made routine military photographs of leaders and troop formations. But they also created aesthetically attentive landscapes, including this view of the emperor's mountain fortress (Fig. 3.46), together with images of indigenous houses, and pictures of the Ethiopians in typical clothing or with interesting implements.

3.46
PHOTOGRAPHER UNKNOWN, *Maqdala* (Emperor Tēwodros's mountain fortress and capital), 1868. Paper print. Ogilby Trust and National Army Museum, London.

associated with the Bible, and stressed the very timelessness of the setting (Fig. 3.47).

Sergeant James McDonald, assigned by the British Royal Engineers to survey Jerusalem, and later the Sinai, photographed early Christian inscriptions and pilgrimage sites. His images of the Sinai Peninsula are composed almost as paintings (Fig. 3.48). As was typical of photographers traveling through the Middle East, McDonald regularly took ethnographic images.

DÉSIRÉ CHARNAY AND EXPEDITIONARY PHOTOGRAPHY

French photographer Désiré Charnay (1828–1915) received financial support for his photographs of pre-Columbian sites in Mexico, and locations associated with Spanish conquistador Hernán Cortés, from a branch of the French government (Fig. 3.49). Soon after returning to France, Charnay joined his country's 1863 expedition to Madagascar to extend French political and trade influence[57] (Fig. 3.50). When Charnay

**3.47
LOUIS DE CLERCQ,**
Eighth Station of the Cross: Jesus Consoles the Daughters of Jerusalem, from *Voyages en Orient: Les Stations de la Voie Douloureuse à Jerusalem (album 4),* 1859–60. Albumen print. **Collection Centre Canadien d'Architecture/Canadian Centre for Architecture, Montreal.**

While photographing castles built by crusaders in Syria and Palestine, French photographer Louis de Clercq (1836–1901) applied his spare, modernistic style to a photograph of The Way of the Cross, that is, the route of Jesus on the way to crucifixion.[56] His *Voyages en Orient 1859–1860* contained a separate album of these images.

3-49
DÉSIRÉ CHARNAY,
*Landscape with Tree
Planted by Hernán
Cortés, Mexico, 1856*.
Salted paper
negative. Musée
d'Orsay, Paris.

A tree reputed to have
been planted by Cortés
would have obvious
symbolism for European
audiences. Charnay's
attitude toward Mexico
was typical of the
European colonial out-
look. In his book *Cités et
ruines américaines
(American Cities and
Ruins)* (1862–63), he
wrote that "it was
France's duty to rouse
Mexico from its numb-
ness ..."[58]

returned to Mexico in 1864, he accompanied French troops who were sent to support Emperor Maximilian (1832–1867; r. 1864–67), who had been put on the throne by Napoleon III. After Maximilian was captured and executed by his rival Benito Juárez (1806–1872) in 1867, Charnay stayed in the United States for three years. He later ventured through South America, Java, and Australia, where his interest in writing about and photographing exotic landscapes, ancient ruins, and ethnographic types continued.

THE 49TH PARALLEL SURVEY

Photography of the shared northwestern border of the United States and Canada, running along the 49th parallel, was begun by an American survey team in 1857, and completed jointly with a British team of Royal Engineers from 1858 to 1861 (Fig. 3.51). Beginning in 1855, some members of the Royal Engineers had been given photographic training. Soon

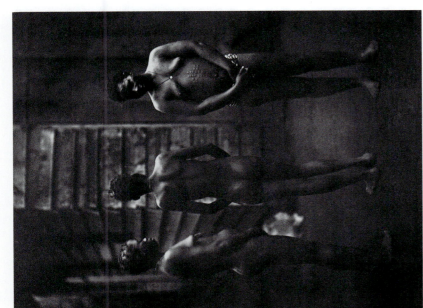

**3.50 (above)
DÉSIRÉ CHARNAY,
*A Mission in
Madagasgar: Marou,
Malgache*, 1863.
Albumen print from a
wet collodion negative. Private
Collection.**

Charnay used the rapidly accepted conventions for photographing non-Western peoples by comparing the bodies of three residents of Madagasgar.

**3.51
PHOTOGRAPHER
UNKNOWN (ROYAL
ENGINEERS),
*Cutting on the Forty-ninth Parallel, on the
Right Bank of the
Mooyie River Looking
West*, 1860–61.
Albumen print from
wet collodion negative. Victoria & Albert
Museum, London.**

In some of the earliest photographs of the Pacific Northwest region of North America, British photographers with an American survey team recorded the rough camps, the making of astronomical computations, and the laborious work of cutting a twenty-foot-wide slash through the forests from the Rocky Mountains to the Pacific coast.

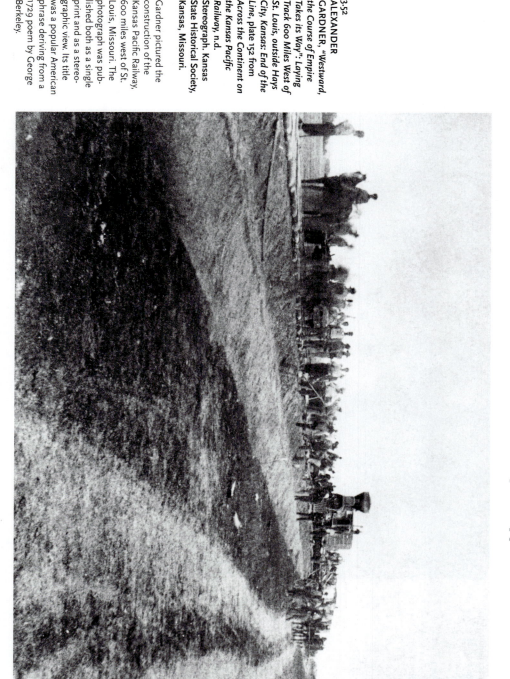

3.52
ALEXANDER GARDNER, "Westward, the Course of Empire Takes its Way": Laying Track 600 Miles West of St. Louis, outside Hays City, Kansas: End of the Line, plate 152 from Across the Continent on the Kansas Pacific Railway, n.d. Stereograph. Kansas State Historical Society, Kansas, Missouri.

Gardner pictured the construction of the Kansas Pacific Railway, 600 miles west of St. Louis, Missouri. The photograph was published both as a single print and as a stereographic view. Its title was a popular American phrase deriving from a 1729 poem by George Berkeley.

after, Sir John Burgoyne (1782–1871), inspector general of fortifications, originated a program of systematic training in photography under the direction of one Charles Thurston Thompson (1816–1868), official photographer to the South Kensington Museum (now the Victoria and Albert Museum in London). The photographer-engineers were charged "to send home periodical photographs of all works in progress, and to photograph and transmit to the War Department all drawings of all objects, either valuable in a professional point of view, or interesting as illustrative of history, ethnology, natural history, antiquities, etc."[59] As in most surveys, scientists accompanied engineers to the borderlands. They wrote about the fossils, plants, and animals they encountered. The final map-making and scientific report writing took place in Washington, D.C., though it was never finished because the American Civil War pressed other duties on many of the contributors.[60] The British photographers also joined expeditions in Palestine, the Sinai, China, India, Greece, and Panama.

GOVERNMENT SURVEYS IN THE UNITED STATES

In 1838, the United States Army Corps of Topographical Engineers became a separate branch of the military assigned to explore and map the undeveloped parts of the United States.[61] The Corps remained a military unit, capable of fighting, yet its work was directed toward the advancement of civilian enterprise and public works. After the Civil War, surveys of the American west covered vast regions. As the historian William Goetzmann observed, the Corps could perform scientific exploration, such as mapping unknown terrain, while also serving political and commercial ends, like scouting roads and railway passages for private entrepreneurs, which would, in turn, displace native peoples.[62] Similarly, photographs of the American west could be simultaneously scientific, commercial, political, and aesthetically pleasing.

In the expansive lands west of the Mississippi River, surveys mixed dispassionate scientific investigation with research on the commercial potential of natural resources. Attempts to map possi-

ble routes for a transcontinental railroad line were spurred by pressure from settlers, from business, and by gold and silver finds, such as the discovery of the Comstock lode in 1859, near Virginia City, Nevada. Government surveys often had an encyclopedic mission, attempting to construct orderly records of Native American life, geology, plants, and animals, as well as commercial potential. For instance, the huge *Pacific Railroad Reports* included whole volumes on zoology.[63]

Photography and the Transcontinental Railway

After years of speculation and surveying, the United States Congress in 1862 authorized the construction of a transcontinental railroad. Two years after the end of the Civil War, Alexander Gardner was appointed chief photographer to the eastern division of the Union Pacific Railway. Along with images made by photographers under his supervision, his photographs were published in an album titled *Across the Continent on the Kansas Pacific Railway (Route of the 35th Parallel)*, offered for sale in April, 1869. The album included scenes of small

town life, settlers' homes, Native Americans, and military installations, as well as his primary topic, the construction of the railroad. *Westward, the Course of Empire Takes Its Way* shows workers and pioneers laying track at the end of the line (Fig. 3.52). The title alludes to a famous mural painted by Emanuel Leutze for the United States Capitol in Washington, D.C., completed in 1862 (Fig. 3.53). Gardner was working for Brady in Washington as the painting was being executed, and reports of its progress appeared in newspapers along the east coast. The mural shows pioneers crossing the continent on horseback and in covered wagons; in applying the title to his static, posed photograph, Gardner may have hoped to associate the railroad with the sense of adventure and accomplishment depicted by Leutze.[64]

Andrew J. Russell (1830–1902), who had been the only officially assigned photographer in the American Civil War, was hired by the Union Pacific Railway to photograph the building of a northern route across the American west that competed with the proposed

3.53
EMANUEL LEUTZE,
Westward the Course of Empire Takes its Way (Westward Ho!), 1861.
Oil on canvas, 33 × 43 in. (84 × 110 cm). National Museum of American Art, Smithsonian Institution, Washington, D.C.

The small figure of a young man at the apex of the composition is triumphantly waving his arm to celebrate the pioneers' successful crossing of the Rocky Mountains.

3·55
TIMOTHY
O'SULLIVAN, *Pyramid and Tufa Domes, Pyramid Lake, Nevada,* 1878. Albumen print. Library of Congress, Washington, D.C.

O'Sullivan photographed members of the United States Geological Expedition of the 40th parallel clambering on the unusual rock formations in Pyramid Lake. But in this, his best known image of the area, he showed it undisturbed by the human presence. The far shore is only lightly suggested, while the bold diagonal composition suggests the tremendous volcanic forces that pushed up the domes.

3·54
ANDREW J. RUSSELL, *Meeting of the Rails, Promontory, Utah,* 1869. Albumen print. Union Pacific Historical Museum, Omaha, Nebraska.

Russell's photographs celebrated the engineering feats required to build a railroad across the rugged terrain of the western United States. His images of the meeting of the Union and Central Pacific railroads in Promontory, Utah on May 10, 1869 are part of the collective visual memory of Americans.

track of the Kansas Pacific, for which Alexander Gardner photographed. Russell's album *The Great West Illustrated in a Series of Photographic Views Across the Continent; Taken Along the Line of the Union Pacific Railroad* was published in 1869 (Fig. 3·54).

Timothy O'Sullivan and Survey Photography

The May 2, 1867 issue of the *New York Times* noted the departure of a "party of young men on an important surveying expedition to a section of the Rocky Mountains and the great basin westward."[65] The journey, sponsored by the U.S. Congress and carried out by the United States Engineers, was directed by scientist Clarence R. King (1842–1901). The surveying party was to follow part of the proposed route of the transcontinental railroad, and included T. H. O'Sullivan as the official photographer.

Like his colleague and friend Alexander Gardner, Timothy O'Sullivan journeyed through the American west after the Civil War. With King's survey, O'Sullivan made views of the strangely shaped lava domes that erupted from Pyramid Lake in Nevada (Fig. 3·55). While the survey wintered in Virginia

City, Nevada in 1868, O'Sullivan ventured several hundred feet underground into the Comstock mine, the most famous deposit of gold and silver in America (Fig. 3.56).

O'Sullivan was scarcely back in Washington, D.C., when he joined another survey. The Darién Survey Expedition of 1870 set out to explore the Isthmus of Darién (or Panama), led by Lieutenant-Commander Thomas O. Selfridge under the auspices of the Secretary of the Navy. The group also included sixty Marines, a show of force for the Panamanian people, who suspected that the proposed canal would endanger their way of life.[66] O'Sullivan found photographing in the jungle difficult because of the humidity, frequent rain, and the thick vegetation that allowed little light to penetrate. Nevertheless, he produced more than 200 stereo images and 100 glass plates.[67] Some of his pictures, like those done by Bourne in India (see Fig. 3.28), adapt the Panamanian landscape to Western tastes (Fig. 3.57).

O'Sullivan accompanied two other important American surveys: the 1871 United States Geographical Survey West of the 100th Meridian, commonly called the Wheeler Survey for its leader George Montague Wheeler (1842–1905); and an independent 1873 survey sponsored by Wheeler to photograph Native Americans and the ruins of a cliff-dwelling culture in the Canyon de Chelly, in what is now Arizona (Fig. 3.58). The trip's reputation was tarnished in the press for having allegedly abandoned two white guides, and resulted in the shooting deaths of several Native Americans. The photographs taken by O'Sullivan, however, depict none of the ill-feeling or tragedy of the journey, indicating that he, like many nineteenth-century photographers, understood that his documentary work was bound by his assignment and by commercial considerations.

3.56
TIMOTHY O'SULLIVAN,
A Miner at Work in the Comstock Mine, 1868. Paper print. National Archives, Washington, D.C.

In the Comstock mine, O'Sullivan made pictures with the aid of light created by igniting a magnesium wire. The intense light of the magnesium revealed the close quarters in which the miners worked.

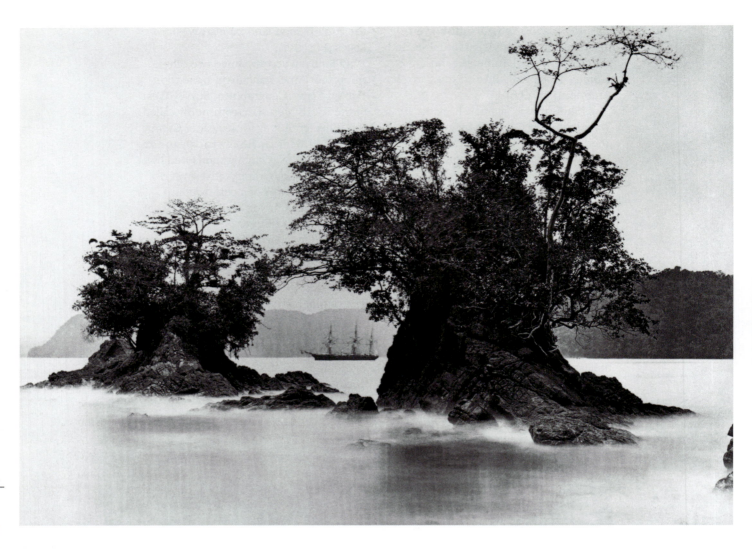

Preservation of the Wilderness: Yellowstone and Yosemite

Westward expansion and development in the United States were driven by political and economic motives, as well as spiritual yearnings for unity, which seemed to compromise the notion of the west as inviolable wilderness. There were two wests in American perception: the west of such natural resources as minerals, timber, and arable land; and the the west of ancient Native American peoples, vast geological wonders, and trackless wilderness. The Gold Rush era and subsequent closing of the western frontier threatened to do away with a central psychic dynamic in American life—the attitude that, in a pinch, one could head out west beyond the taint of human society and live simply. Settlement and enterprise appeared to endanger the unique American landscape, but the wilderness seemed hostile to robust economic development. The history of photographic imaging of the Yosemite Valley in California and the Yellowstone area of Wyoming demonstrates how closely intertwined were the notions of pure nature and civilized progress.

Carleton E. Watkins (1829–1916) was not the first person to photograph the dramatic scenery of the Yosemite Valley, but he was the best known and most influential. Another San Francisco photographer, Charles Leander Weed (1824–1903), had visited Yosemite in 1859. Watkins's early career brought him near Yosemite, to the vast Mariposa Estate, where he was commissioned to photograph the property's mining activities. The photographs were used to entice foreign investors with the estate's gold and mineral potential. In his early commercial photographs Watkins developed the practice of showing that human enterprise did not disturb the natural order (Fig. 3.59). He was one of the first American artists in any medium to construct a commercial sublime, that is, rendering nature's grandeur with subtle, unobtrusive traces of new economic ventures.

3.57
TIMOTHY O'SULLIVAN, *The Nipsic in Limón Bay, at High Tide,* **1871. Albumen print. George Eastman House, Rochester, New York.**

When United States forces entered Panama in 1870, surveying the area for a possible canal, local people were openly suspicious. None of this tension entered O'Sullivan's lyrical picture of the *Nipsic,* the command ship of the survey, framed between two clumps of trees growing on outcroppings in Limón Bay.

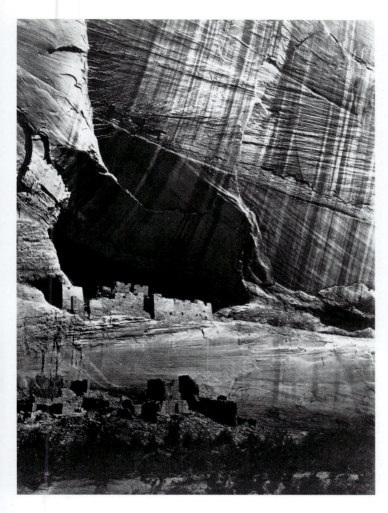

Watkins probably made his initial 1861 trip to Yosemite in the company of one of the Mariposa Estate's entrepreneurs. He returned to Yosemite in 1865 and 1866, under the informal auspices of the California State Geological Survey, whose members studied the geology, biology, and mineral potential of the region, as well as likely sites for roads. The Gold Rush years had quickened American and foreign interest in California. Watkins, alert to opportunity, if not always adept in business matters, began a series of photographs at Yosemite, whose scenic beauty was already attracting both a growing curiosity back east and a few intrepid tourists. Like O'Sullivan at Pyramid Lake, Watkins preferred to show Yosemite as an Eden of unsullied awe. The absence of people accentuated the area as a prime site in which to witness the processes of nature.

His stereograph *From the "Best General View," Mariposa Trail* (Fig. 3.60) typifies the soaring sublime that he contrived to express in the expansiveness of the valley and the height of its crags. Although more tourists were arriving in Yosemite by the mid-1860s, Watkins

3.59
CARLETON E. WATKINS, *Cape Horn, near Celilo*, 1867. Albumen silver print from glass negative. Gilman Paper Company Collection, New York.

3.58 (above)
TIMOTHY O'SULLIVAN, *Ancient Ruins in the Cañon de Chelly*, 1873. Albumen print. Library of Congress, Washington, D.C.

The cliff-dwellings in the Canyon de Chelly were built by the Anascizi people in pre-Columbian times. In the nineteenth century popular prints, paintings, and photographs of ancient Native American ruins helped to bolster the notion that these people were a dying culture.

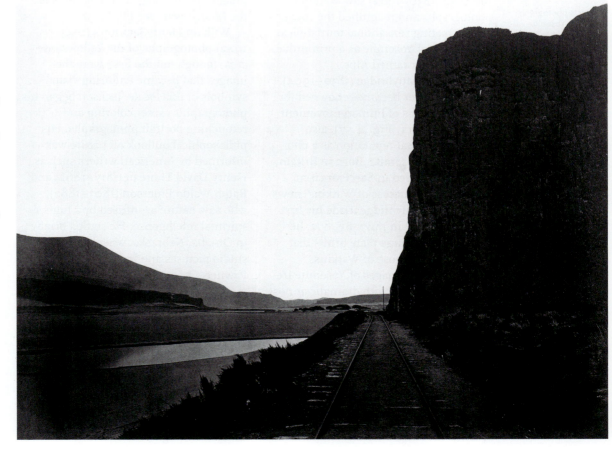

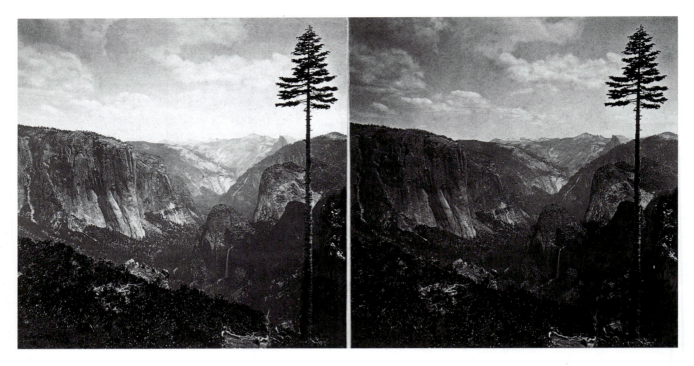

3.60
CARLETON E. WATKINS, *From the "Best General View," Mariposa Trail*, c. 1865–66, from Watkins' Pacific Coast stereo series, no. 1134. Albumen print. Center for Creative Photography, University of Arizona, Tucson, Arizona.

Watkins's photograph shows the Yosemite valley as it might have existed at the time of creation. The dark foreground area and the tall tree on the right help to inflate the three-dimensional effect of the stereograph by creating a sense of deep recessive space.

still took his photograph from a vantage point that eliminated all traces of the human presence, and dislocated the view from contemporary life. Moreover, the viewer is not situated in a particular spot, but invited to soar above the valley, a feeling that would have been made all the more intense in stereographic viewing. German-American painter Albert Bierstadt (1830–1902) saw Watkins's photographs and magnified the conventions, creating sensational tourist-pleasing images of Yosemite as a primordial, cotton-candy-swathed Alps.

Eadweard Muybridge (1830–1904), who would later become renowned for his photographs of human movement (see pp. 213, 215; Fig. 4.57), also gained a national reputation as a photographer of Yosemite. Born in Britain, Muybridge settled in San Francisco. Following the success of Watkins' views of the valley, Muybridge made his first trip to Yosemite in 1867. By 1872, he was producing large plate prints that competed with those of Watkins.

Muybridge's images of Yosemite frequently fill the sky with dramatic atmospheric effects. Even when he chose a point of view that would dangle the viewer over a precipice (Fig. 3.61), Muybridge did not imitate the hypnotic detail and airless clarity of Watkins's work. Muybridge sometimes printed cloud studies separately in the upper portion of his Yosemite scenes. He also relished moonlight effects, and invented

a device that minimized overexposure of the sky, and thereby allowed clouds to appear. In *Spirit of Tutohannula* (1867), he responded to the American association of ancient peoples with wilderness by having an individual enact the ghostly presence of the Native American chief said to have lived on the summit of El Capitán in Yosemite. It was good practice for his staged photographs of the Modoc War (see Fig. 3.65).

William Henry Jackson's (1843–1942) photographs of the Yellowstone area, though not the first, were the images that became enduring visual symbols of this locale. Jackson began his photographic career coloring and retouching portrait photographs. His philosophical outlook on nature was informed by American writers such as Henry David Thoreau (1817–1862) and Ralph Waldo Emerson (1803–1882), who saw nature as infused by a higher spiritual intelligence. He settled briefly in Omaha, Nebraska, where he made studio pictures and locale shots of the Pawnee, Otoe, and Omaha peoples living in the area. In the *Descriptive Catalogue of Photographs of American Indians by W. H. Jackson, Photographer of the Survey of 1877*, he spoke of Native Americans in terms that were becoming increasingly prevalent. He saw them as dwindling vestiges of a primitive time in America, who could only purchase survival by adopting the values of white Americans (Fig. 3.62).

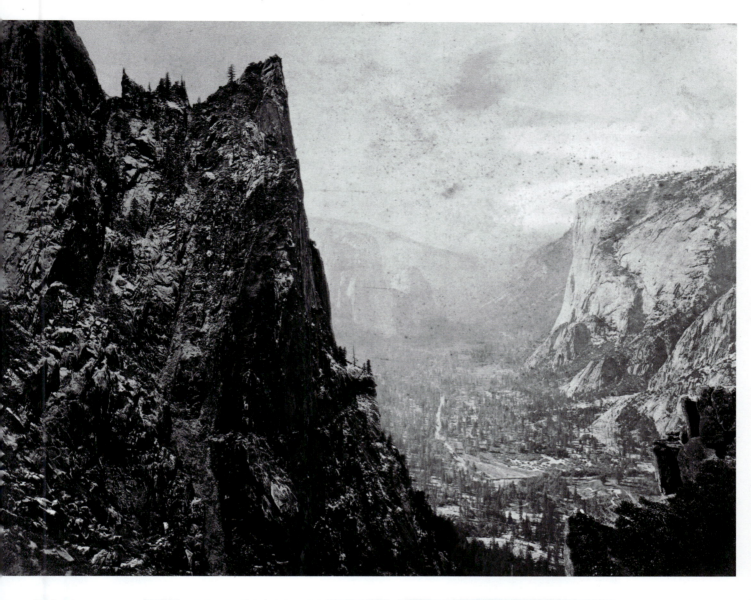

3.61 (above)
EADWEARD
MUYBRIDGE, *Valley of the Yosemite from Union Point*, c. 1872. Albumen print. The J. Paul Getty Museum, Los Angeles, California.

Muybridge has chosen a view through Yosemite Valley showing a mass of dark rock in the foreground that contrasts with distant mountains rendered barely visible in the haze. The sheer face of El Capitán rising 3,000 feet can be made out on the right.

3.62
WILLIAM HENRY JACKSON, *(Omaha) Indians Building Houses for the Tribe*, 1877. Albumen print. National Anthropological Archives, Smithsonian Institution, Washington, D.C.

Like several photographers of the west, Jackson worked for a government-sponsored survey. He joined the first official government and scientific survey of the Yellowstone area, directed by Ferdinand Vandeveer Hayden in 1871.[68] Previous explorations to Yellowstone, which would become the country's first official National Park, aroused public interest in the area's geological wonders, as did the prospect of a rail service for tourists. Aware of public curiosity about the area, Hayden brought with him the landscape painter Thomas Moran (1837–1926), who had made sketches for a recent article in *Scribner's* magazine on "The Wonders of Yellowstone." He also invited sons and protégés of such powerful Washington politicians and lobbyists as Massachusetts Senator Henry L. Dawes, the principal spokesperson in the campaign that resulted in Yellowstone being designated a National Park in 1872.[69] Along the way, Jackson made photographs of gold mining. But for his treatment of the Yellowstone geysers, such as *Mud Geyser in Action* (Fig. 3.63), he turned to retouching, embellishing the steamy emissions.

WAR AND THE PHOTOGRAPHY OF NATIVE AMERICANS

The movement westward brought about regular conflicts with Native Americans, who fought removal from their ancient homelands and consolidation with other, unrelated groups.

The Modoc War

In northern California and Oregon, longstanding tension between the Modoc people and white settlers escalated between 1872 and 1873. Unhappily moved by the U.S. government to the Klamath Reservation in Oregon, many Modocs returned to their ancestral homelands along the California–Oregon border. In November 1872, cavalry troops arrived to remove the Modocs from settler-claimed land. Eventually the Modocs hid in caverns and depressions found in the rugged lava beds south of Tule Lake, where the remainder of the campaign against them was fought.

The terrain of the lava beds was so unfamiliar to the U.S. military that the Corps of Engineers was called in to make a reconnaissance.[70] The photographer hired to record the topography and,

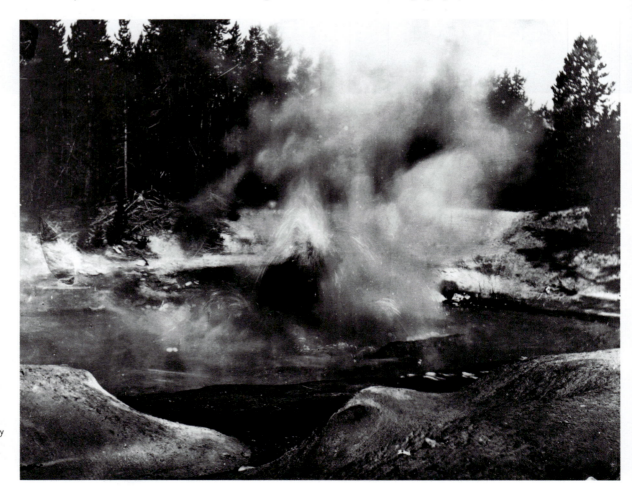

3.63
WILLIAM HENRY JACKSON, *264. Mud Geyser in Action,* **1871. Paper print. U.S. Geological Service, Denver, Colorado.**

Jackson recorded the wonders of the Yellowstone area of Wyoming, much as Watkins recorded the marvels of Yosemite. The images produced by both photographers helped in the effort to make both areas into National Parks.

perhaps, copy maps and sketches was Louis Heller (1839–1928). A German-born photographer who worked in California, he was the first to reach the war front. His images of Modoc prisoners were used on the cover of *Frank Leslie's Illustrated Newspaper* for July 12, 1873[71] (Fig. 3.64). At the time, Muybridge was a San Francisco photographer in the employ of Bradley and Rulofson, commercial photographers who sold images of California as well as current events. His photographs of the troops and the locale were sent to Washington to show

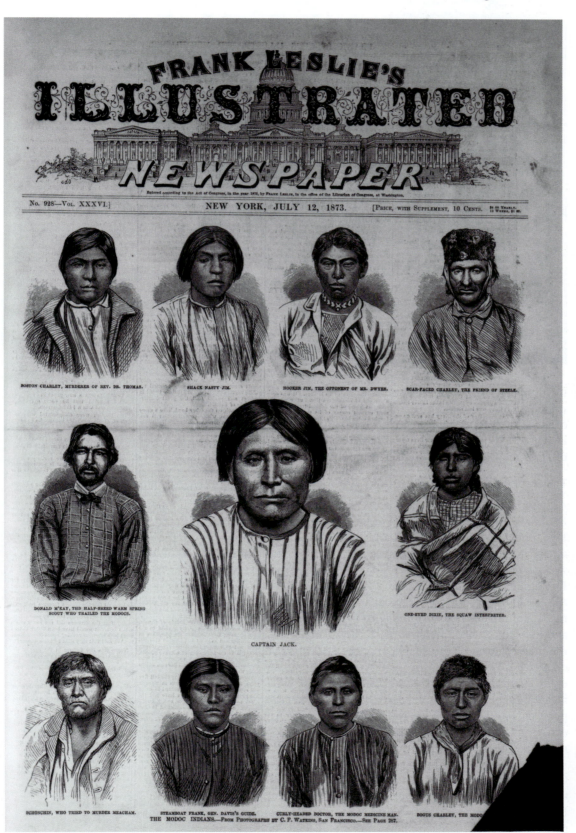

3.64
LOUIS HELLER,
Frank Leslie's Illustrated Newspaper, June 12, 1873. Woodblock print from a photograph by Louis Heller. Library of Congress, Washington, D.C.

The cover of the newspaper erroneously credited Heller's photographs of Modoc prisoners to Carleton Watkins. The note, in small print at the bottom of the page, tells readers that the images were derived from photographs, an increasingly common announcement that expressed the authenticity of the images.

3.65
EADWEARD
MUYBRIDGE, *A Modoc
Brave on the War Path*,
1872–73. Paper print.
National
Anthropological
Archives, Washington,
D.C.

Muybridge posed a
Native American scout
working for the U.S.
Army as an enemy
Modoc brave, although
he was not a Modoc.

the difficult circumstances in which the
military had been operating against the
Modoc (Fig. 3.65). These pictures were
also used to illustrate the June 21 issue
of *Harper's Weekly*.

The Fort Laramie Treaty

Although dozens of wars such as the
Modoc War were fought from 1850 to
1886, the preparation, conduct, and
aftermath of battles and skirmishes
were seldom reported by the camera.
Photographic portraits of Native
American leaders were sometimes
made, both in their own settlements,
and in towns where photographers
maintained studios. Newspaper articles
on the so-called Indian Wars were gen-
erally illustrated by artists' conceptions,
rather than photographically derived
pictures. From time to time, Native
American artists rendered the engage-
ments with paintings on animal hide.

A photograph taken by Alexander
Gardner in 1868 of the participants in
the peace talks and treaty negotiations at
Fort Laramie (Fig. 3.66) shows Civil War
general William Tecumseh Sherman

(third from the right of the U.S. delega-
tion), commander of the army's Divi-
sion of the Mississippi, which included
the Great Plains. Sherman took his Civil
War philosophy of "total war" and
applied it to relations with Native
Americans, for whom it meant the anni-
hilation of villages and supplies, as well
as battle.[72] The Treaty negotiated at Fort
Laramie in 1868 followed the war for
the contested Bozeman Trail, which
gave white settlers a passage westward.
It came after the most decisive Native
American victory in all of the western
wars.[73] Nevertheless, the May 1868 pho-
tograph visually reversed the temporary
fortunes of war. It depicted the beaten
white men in a physically superior posi-
tion, even though the treaty they were
negotiating was highly favorable to the
Native Americans.

Little Big Horn

The provisions of the 1868 Fort Laramie
treaty were violated by both sides, who
entered each other's territories. Survey
parties scouting a route for the Northern
Pacific Railroad entered Native Ameri-

**3.66
ALEXANDER
GARDNER,** *Untitled*
**(Commissioners,
General Sherman
among them, seated
with Indians), May 10,
1868. Paper print.
National Anthropo-
logical Archives,
Washington, D.C.**

In this image of the Fort
Laramie negotiations,
the U.S. delegates face
the camera, as if aware
of the historical record
they are making. The
Native Americans
mostly have their backs
to the camera or are in
shadow. Native
Americans would some-
times turn their backs to
the camera and cover
their heads so that the
shadow-catcher would
not capture their
spirits.[74]

**3.67
W. H. ILLINGSWORTH,** *Indian's Eye view of Custer Expedition Entering the Black
Hills,* **1874. Paper print. National Archives, Washington, D.C.**

Thinking that it would have great public interest, W. H. Illingsworth made fifty-five
photographs of General George Custer's expedition, including this "Indian's eye
view" of the group.

can territory, where they clashed with
warriors led by Sitting Bull. The discov-
ery of gold in the Black Hills of present-
day South Dakota motivated thousands
of white miners to invade the legendary
home of the Sioux gods.[75] In 1874
Colonel George Armstrong Custer (1839
–1876) led a reconnaissance force of
over 1,000 heavily armed troops. There
were about 100 wagons in his train,
some carrying equipment to be used
by the engineers, the geologist, and
other scientists who accompanied him.
A photographer, W. H. Illingsworth
(1842–1893), captured the expedition
entering the Black Hills (Fig. 3.67). After
several smaller battles, U.S. troops
under Custer were thoroughly defeated
at Little Big Horn in 1876. Custer's Last
Stand, as it came to be called, inflamed
the American public, whose support
for harsher treatment of the Native
Americans gathered strength during the
last decades of the nineteenth century.

PHOTOGRAPHY AND
SCIENCE

MEDICAL PHOTOGRAPHY

Because the American Civil War was
fought near towns and cities, there was
acute public awareness of battle injuries
and the needs of soldiers. The Sanitary

Apple Vender.—Boston Common.

**3.68
PHOTOGRAPHER
UNKNOWN,** *Patronize
the Disabled Soldier,*
from *American Views:
New Series,* c. 1866.
Stereograph. Bob Zeller
Collection, Pleasant
Garden, North Carolina.

After the American Civil
War, photographs of sol-
diers continued to be
made and circulated, in
part for patriotic rea-
sons and in part to show
how they fared after gov-
ernment service. Here
two veterans with war-
related disabilities sell
apples and lemonade on
Boston Common.

Commission was a charitable organiza-
tion of private citizens who came
together to do whatever the United
States government did not do for sol-
diers during the war. The commission,
modeled on the British equivalent that
was active during the Crimean War,
worked with the government to provide
food and medical supplies, ambulance
service, rehabilitation, and aid to depen-
dent families. To raise money, the
Sanitary Commission held fairs, which
included the sale of photographs of
landscapes and famous individuals.
Disabled soldiers were the subject of
postwar photographs (Fig. 3.68).

Throughout the war, Clara Barton
(1821–1912), the first woman clerk in
the United States Patent Office, orga-
nized relief efforts for wounded soldiers.
She managed to secure permission to be
on the front lines, where she ministered
to northern and southern soldiers. Like
many of Brady's sitters, she was a popu-
lar figure in American civic life, who
gave many public lectures (Fig. 3.69).

The number of amputations suffered
by Civil War soldiers shocked both doc-
tors and the general public. In the May
1863 issue of the *Atlantic Monthly,*
Oliver Wendell Holmes described how
photographs of able-bodied people walk-
ing on city streets might be observed in
order to devise effective and comfortable
artificial limbs.[76] Medical practitioners

and hospitals, meanwhile, commis-
sioned photographs of soldiers with
wounds (Fig. 3.70). During the war, the
Surgeon General founded the Army
Medical Museum in Washington, D.C.,
one of whose purposes was to collect
photographs of war injuries.[77] Over
1,000 pictures were collected in com-
pendiums of photographs and engrav-
ings based on photographs, including
the eight-volume *Photographs of Surgical
Cases and Specimens* (1866). Though
thwarted by shortages of paper and
printing supplies, Confederate doctors
also published a journal largely devoted
to battlefield medicine. The *Confederate
States Medical and Surgical Journal,*
issued from January 1864 to February
1865, printed a few photographically
derived woodcuts of injured soldiers.[78]

PHOTOMICROGRAPHY AND ASTRONOMICAL PHOTOGRAPHS

From the first, objects and organisms
made visible by microscopes and tele-
scopes were subjects of photography
(see Figs. 2.0, 2.12, 2.13, 2.14). Indeed,
photomicrography became a photo-
graphic specialty beginning in the
1850s.[79] For the French physician and
anatomist Jules-Bernard Luys (1828–
1897), photomicrography was an impor-
tant aid to scientific objectivity. In his
*L'Iconographie photographique des centres
nerveux* (*Photographic Iconography of*

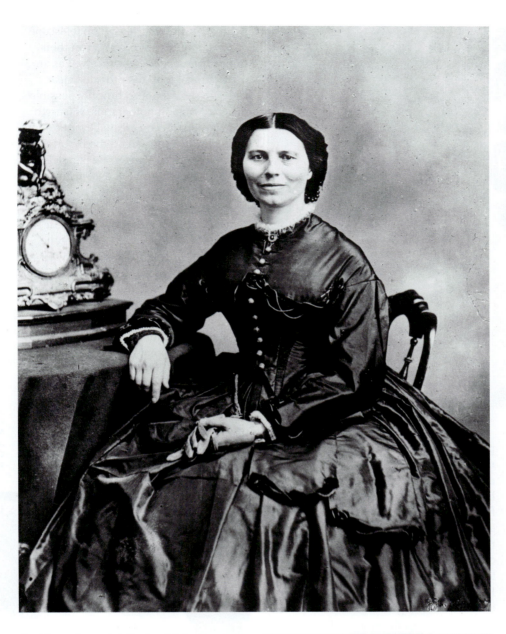

3.69
MATHEW BRADY,
Clara Barton, c. 1866.
**Albumen silver print.
Library of Congress,
Washington, D.C.**

In addition to his work
during the American
Civil War, Mathew Brady
was known for a
straightforward, yet inti-
mate portrait style,
which he developed for
pictures of American
celebrities, such as
American Red Cross
founder, Clara Barton.

133

the Nerve Centers) (1873), which was
issued with an atlas of photographs and
lithographs of neurological subjects,
Luys wrote that photography substituted
"the action of light for ... personality, in
order to obtain an image both imper-
sonal and accurate"[80] (Fig. 3.71).

From the late 1850s on, proposals to
miniaturize and store information in
photographs became more frequent.
The *American Journal of Photography* for
1858 recommended storing public docu-
ments on photographic negatives. With
its usual exuberance, *Photographic News*
opined that "the whole archives of a
nation might be packed away in a snuff-
box." Businesses were founded to pro-
duce microscopic photographs, either as
a means of record-keeping or for novel-
ties, such as penholders fitted with a
lens that magnified tiny calendars.[81]

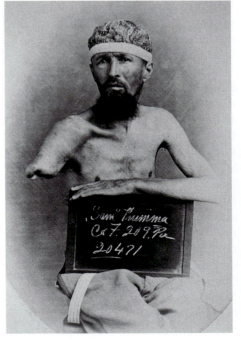

3.70
**PHOTOGRAPHER
UNKNOWN,** *Untitled*
**(Corporal Samuel
Thummam, wounded at
the battle of Petersberg),
1865. Burns Archive,
New York.**

Photographs of
wounded American Civil
War veterans were made
and circulated to teach-
ing hospitals for study
in an effort to improve
battlefield care, recovery,
and the quality of
prosthetics.

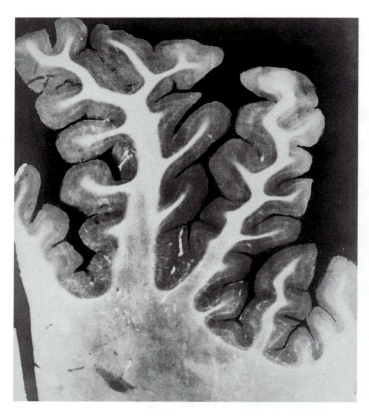

3.71
DR. JULES LUYS, *Four-Diameter Cross-Section of Segments of Cerebellum*, plate 68 from *L'Iconographie photographique des centres nerveux*, c. 1873. Albumen silver print. Bibliothèque de l'Institut de France, Paris.

Luys used photographs of the human nervous system to counter criticisms that the pictures in an earlier work, made by the lithography process, were more imaginative than accurate.

Despite much enthusiasm for its potential, telescopic photography did not proceed as rapidly as photomicrography. Astronomical photography was beset with technical problems resulting from low light, the movement of the earth, and the limitations of photosensitive materials, while the sun's brightness created its own difficulties. Nevertheless, many astronomers, such as John Herschel, saw the potential to create systematic recording of the sun and its features. Others, in the spirit of François Arago's original conjectures (see pp. 19–20), considered that photochemical reactions might be used to measure light rays.

Photographers continued to have difficulty creating clear images of the moon. Throughout the 1870s, American astronomer and photography advocate Lewis M. Rutherfurd (sometimes Rutherford) (1816–1892) circulated his 1865 photograph of the moon (Fig. 3.72). Working together, engineer James Nasmyth (1808–1890) and astronomer James Carpenter (1840–1899) created a unique series of astronomical pictures. Among the images in their 1874 publication *The Moon, Considered as a Planet, a World, and a Satellite*, were WOODBURYTYPE PRINTS of photographs of plaster models of the moon, constructed in accordance with

Nasmyth's drawings based on telescope observations. Far from fakery in their minds, the model was conceived as an instructional tool that provided clear, close-up details not technically possible in actual moon photographs. Nasmyth and Carpenter even created events, such as a volcanic eruption on the moon's surface (Fig. 3.73), and drew parallels between such natural phenomena as the creases on the surface of the moon, a human hand, and an apple[82] (Fig. 3.74).

The largest international effort in astronomical photography during the period took place in December 1874, when scientists from Germany, Britain, and France entered into a friendly competition to record the passing, or transit, of the planet Venus across the face of the sun.[83] The French team included the scientist and photographer Pierre-César Jules Janssen (1824–1907), who developed a revolver camera, in effect a gun fitted with a lens, to make sequential exposures on a daguerreotype plate (Fig. 3.75). Though outmoded for portrait and landscape photography, the daguerreotype was chosen by the French

3.72
LEWIS RUTHERFURD, *Moon*, March 4, 1865. Albumen silver print. George Eastman House, Rochester, New York.

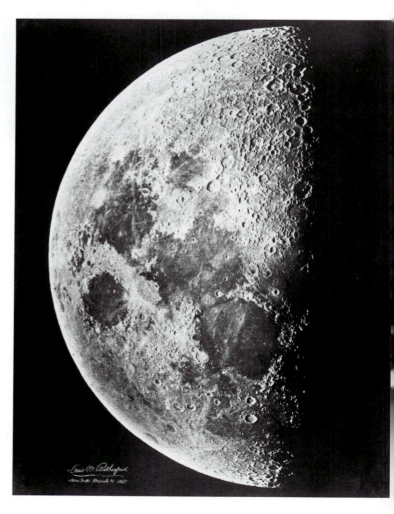

3.73 (above)
**JAMES NASMYTH &
JAMES CARPENTER,**
*Moon, Crater of
Vesuvius,* 1864. From
*The Moon, Considered
as a Planet, a World,
and a Satellite,* 1874.
Woodburytype. National
Gallery of Canada,
Musée des Beaux-Arts
du Canada, Ottawa.

In order to produce this
close-up image,
Nasmyth and Carpenter
built an elaborate model
of the moon, staged an
eruption of the volcano,
which had not been
observed from earth,
and photographed the
result.

team, in part because its metal plates
were not subject to breakage, as were
glass plates.

In the second half of the nineteenth
century, the public experience of pho-
tographs depicting human society and
the natural world increased. With that

expansion came an intensification of the
visual effects of images. The three-
dimensionality of stereographs is per-
haps the most prominent example, but
there are others. Photographers created
panoramic views, some of which mimic-
ked the span of human vision, others of

3.74
**JAMES NASMYTH &
JAMES CARPENTER,**
*Back of Hand, Wrinkled
Apple,* 1864, from *The
Moon, Considered as a
Planet, a World, and a
Satellite,* 1874.
Woodburytype. National
Gallery of Canada,
Musée des Beaux-Arts
du Canada, Ottawa.

The search for universal
laws in nature led
Nasmyth and Carpenter
to compare the wrin-
kling of the human hand
to that of an apple, and,
eventually, to the
processes that created
the furrowed surface of
the moon.

**3.75
PIERRE-CÉSAR JULES
JANSSEN,** *Transit of
Venus,* **1874.
Daguerreotype, partly
colored, full plate.
Société Française de
Photographie, Paris.**

Janssen used a gun-like
camera to photograph
the transit of Venus. The
outer ring of the photo-
graph is toothed into
48 segments, one for
each exposure. Venus
appears in each tooth as
a black dot. The large
circle in the center top
of the plate and the
notch in the lower right
were used to hold and
turn the plate in the
gun-camera.

**3.76
AIMÉ CIVIALE,** *Circular
Panorama Taken from
Bella Tolla (3030
metres),* **1866. Collotype,
printed by Jean-
Dominique Gustave
Aroca, 1882 or earlier.
Bibliothèque Centrale du
Musée National
d'Histoire Naturelle,
Paris.**

which attempted to reproduce a circular,
360-degree view. Throughout the nine-
teenth century, painted and photo-
graphed panoramas were used for
popular entertainment and education.
Whereas painted panoramas were ren-
dered on long canvas scrolls, photo-
graphic panoramas were constructed

from connected sequences of camera
images.

From 1859 to 1866, French geologist
Aimé Civiale (1821–1893) made a strik-
ing series of twenty-eight large photo-
graphic panoramas in the Italian,
French, Austrian, and Swiss Alps
(Fig. 3.76). Civiale did not conceive his

photographs to show how a human might perceive the scene, nor to render the beauty of the Alps. He wanted the panoramas to illustrate the tremendous geological uplift that originally formed the European mountain systems. Civiale developed a scientific aesthetic for his purposes, in which the large patterns of the mountains' geological development were emphasized and the myriad surface details were decreased. His work was shown in the exhibitions of the French Photographic Society for a decade, from 1859 to 1869.[84]

PHOTOGRAPHIC STUDIES OF HUMAN EXPRESSION

The notion that inner human character could be interpreted through facial expressions persisted throughout nineteenth-century portraiture in all visual media. In fact, as photographs became more generally available, they made readings of inner character more widespread, either through gallery displays such as Brady's, or through the personal sharing of images. Writing in the July 1863 issue of the *Atlantic Monthly*, Oliver Wendell Holmes envisaged a new human possibility called "photographic intimacy," a friendship established by the exchange of photographs, between two people who have never met. The relationship starts after the exchange of letters and views of scenery. It culminates in an exchange of photographic self-portraits carefully staged among personal objects, and the sharing of photographic pictures of loved ones. In time, Holmes wrote, photography would make the "outer and ... inner life a reality ... but for his voice, which you have never heard, you know ... [the photographic correspondent] better than hundreds who call him by name, as they meet him year after year."[85] The conviction that a clear correspondence existed between inner moods and outward appearances also informed scientific experiments on human gestures and facial expressions, such as the photographs of mental patients taken by Dr. Hugh Welch Diamond in the 1850s (see p. 37).

Duchenne de Boulogne

Outwardly, the explorations undertaken by the French doctor Guillaume Benjamin Duchenne de Boulogne (1806–1875) resemble Diamond's work. Duchenne was a physician at the Paris hospital La Salpêtrière, which treated people suffering from epilepsy, neurological problems, and insanity. Duchenne's *Mécanisme de la physionomie humaine* (*The Mechanism of Human Physiognomy*), published in 1862, was accompanied by an atlas of 84 photographs taken between 1852 and 1856 of human subjects whose facial muscles were stimulated by electric current (Fig. 3.77). With the technical advice of photographer Adrien Tournachon (1825–1903), brother of the famous Parisian photographer, Nadar (Gaspard Félix Tournachon; 1820–1910), Duchenne attempted to arouse through electrical stimulation the individual facial muscles that he considered to be involved in human expression. Most of his photographs were of people with mental retardation; 45 of the 84 images are of one older mentally retarded man.

To aid the camera's recording, swift and subtle muscular reactions were ignored in favor of more dramatic and visible ones. Duchenne took his subjects' emotional responses to be typical of all humans; the individual's personality and distinctive range of reactions did not interest him. Unlike Diamond's efforts, Duchenne's work was very

3·77
G. B. DUCHENNE DE BOULOGNE,
"Electrical contraction of the eyelids, the forehead with voluntary lowering of the jaw: terror," plate 63 from *Mécanisme de la physionomie humaine: ou analyse electro-physiologique de l'expression des passions,* 1876. Paper photograph tipped in book. Victoria & Albert Museum, London.

Duchenne used electrical currents to stimulate facial expressions. He seems to have had few intellectual or scientific reservations about stimulating the appearance of emotions artificially, rather than observing them as his subjects responded to people, things, or thoughts that provoked a response.

ICONO-PHOTOGRAPHIQUE

MÉCANISME DE LA PHYSIONOMIE HUMAINE

Pl. 9.

Duchenne (de Boulogne), phot.

specifically related to art as well as science. His *Mécanisme* contained plates in which works of art were compared with his photographic experiments, so as to show how art did not always show physiologically true depictions of human emotional responses. Photographic historian Nancy Roth found that, to his contemporaries, Duchenne's representations seemed too naturalistic for art: one critic wrote that "he's ... to be reproached for stripping art of its every ideal, reducing it to an anatomical realism every bit in keeping with the tenets of a certain modern school of art."[86] The nineteenth-century clash between two

3.78
G. B. DUCHENNE DE BOULOGNE (1; 2); **ANONYMOUS** (4; 5); **O. G. REJLANDER** (6; 7?), *Untitled*, from Charles Darwin's *The Expression of the Emotions*, before 1872. Heliotype.

Oscar Rejlander and Duchenne de Boulougne contributed photographs to Charles Darwin's study of *The Expression of the Emotions*. The fussy baby in figure 1 became a huge hit with the British public. Known as "Ginx Baby," it sold about 300,000 prints.

approaches to painting, represented by Gustave Courbet's (1819–1877) realism and the idealism of Jean-Auguste-Dominique Ingres (1780–1867), was specifically referenced by the commentator in relation to Duchenne's physiological photography.

Darwin

After he published *The Origin of Species* (1859) and *The Descent of Man* (1871), the British scientist Charles Darwin (1809–1882) completed a study that he had begun in 1838. *The Expression of the Emotions in Man and Animals* (1872) argued that the physical signs of emotional states were inherently the same in all humans, and that animals had emotions that they expressed in ways similar to people. The volume underscored

Darwin's hypothesis that humans were not a separately created species, but resulted from the processes of natural selection and evolution.

About 9,000 copies of the book sold in the first four months of publication, both because Darwin was a well-known, controversial author, and because the subject of emotional expression was popular at the time.[87] Darwin's introduction acknowledged his debt to the insights and photographs of emotion made by Duchenne de Boulogne. In fact, Duchenne lent Darwin photographs, which he published as part of his study. With some of Duchenne's images, Darwin asked the engraver who worked on the photographs to temper the wrinkles and to remove the instrument that directed an electrical stimulus to the subject's face. Along with illustrations provided by artists, Darwin also included photographs commissioned from the London photographer Oscar Rejlander (see Fig. 3.97), who personally acted out some of the emotional states before the camera. Believing that babies exhibited the purest, least acculturated signs of emotion, Darwin used photographs of babies made by Rejlander and Adolph Diedrich Kindermann (active 1860s–1870s) of Hamburg, Germany (Fig. 3.78). In all, five photographers provided images to Darwin.

Darwin investigated the means by which photographs might be inexpensively included in the text. This had proved difficult because the presses that printed text ran too fast to reproduce photographs and type at the same time, and because most photographs needed to be printed on special paper, not newsprint. But a technique known as HELIOTYPE, invented by the photographer Ernest Edwards (1837–1903) who made a portrait of Darwin in 1868, used printing press plates to reproduce photographs, and thus keep down the price of the book. The resulting images are not sharp and detailed, but they do sufficiently convey facial gestures.

Charcot

Like his teacher Duchenne de Boulogne, the French physician and neurologist Jean-Martin Charcot (1825–1893) worked at La Salpêtrière, where he drew upon photographs to

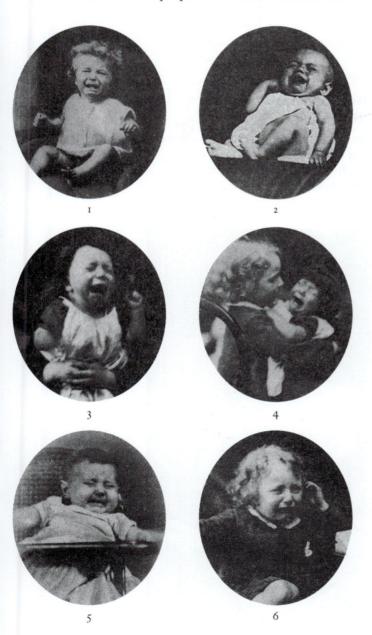

1 2

3 4

5 6

document his case studies, and was interested in the expression of emotion in art. In one sense, Charcot carried Duchenne's work to an extreme, making weekly public presentations of his patients, many of them female, to an audience of scientists and socialites.[88] Charcot's particular concern with hysteria attracted his most famous admirer, Sigmund Freud (1856–1939).

From 1877 to 1880 Charcot published *L'Iconographie photographique de La Salpêtrière* (*Photographic Iconography of the Salpêtrière Hospital*), a three-volume work that contained photographs of hysterics (Fig. 3.79). Collaborating with the clinician Désiré Magliore Bourneville (active 1870s), and assisted by Paul Régnard (active 1870s), an intern at La Salpêtrière, Charcot sought to photograph the physical expression of mental states. He chose subjects who were known throughout France to be able to respond well to hypnotic suggestion.[89] Like Diamond, Duchenne, and Darwin, Charcot's work and his photographs emphasized facial expression as an infallible indicator of psychological states. And like them, Charcot regarded himself as a neutral observer. Of his visual recording, he stated: "I stand here merely as a photographer, I write down what I see."[90]

3.79
PHOTOGRAPHER UNKNOWN, *Attitudes Passionelles*, plate 21 from Charcot's *L'Iconographie photographique de La Salpêtrière*, 1876. Paper print. Bibliothèque Interuniversitaire de Médecine, Université René Descartes, Paris.

Charcot not only photographed sitters acting out various symptoms of mental illness, he invited the public to his sanatorium on Tuesdays to see the performances. His subjects' exaggerated expressions and physical positions resemble poses assumed by actors in the theater, largely because they were called upon to act out their symptoms for the camera, not experience them afresh.

PHOTOGRAPHY AND THE SOCIAL SCIENCES

Photography participated in the production of evidence in many fields. Geology, biology, botany, medicine, astronomy, and chemistry used photography to collect and exhibit evidence. European efforts to establish comprehensive and systematic classifications of human beings were enhanced by the intense discussion of Charles Darwin's writings on evolution and the origins of the human species. Theories about the multiple origins of human beings, akin to that which motivated Louis Agassiz to commission photographic studies of slaves (see pp. 40–41) persisted, despite Darwin's insistence on a single human origin. Some commentators interpreted his writings to validate a natural hierarchy of development, from the lower to the higher races, based on visible difference in the anatomy, and on cultural characteristics.

ETHNOGRAPHIC STUDIES AND DISPLAY

Grand schemes to compare and contrast races and to photograph them were launched throughout the later nineteenth century. For instance, it was proposed that the Calcutta exhibition of

PHOTOGRAPHER UNKNOWN, *A Croat Couple from the Valley of the Serezan near Zagreb*, exhibited in the Western and Slav section of the *Moscow Ethnographic Exhibition*, 1867. Paper print. Royal Anthropological Institute, London.

In an effort to promote pan-Slavic unity, the *Moscow Ethnographic Exhibition* showed models of Slavic people, such as these in a fabricated natural setting, complete with local flowers.[93]

1869 should bring together "tribal" peoples from Asia, Polynesia, and Australasia, for purposes of examination and photography.[91] The scheme failed, but ethnographic studies and exhibitions, extensively illustrated by photographs, flourished throughout the 1860s and 1870s. German photographer Carl Dammann (active 1870s) issued an album of 600 small images titled *Ethnological Photographic Gallery of the Various Races of Man* in 1875.

In Russia, more systematic fieldwork aimed at describing physical types and local costumes began to use photography. The Russian Geographical Society issued special instructions for photographers who were attempting to create a scientific study of difference. Full face, profile, and full-length views of people were considered to be the most scientifically useful.[92] The *Moscow Ethnographic Exhibition* of 1867 displayed full-scale replicas of architectural interiors showing local implements and regional costume (Fig. 3.80).

3.81 (right)
PHOTOGRAPHER
UNKNOWN, *Brinjara
and Wife*, plate 161 from
The People of India,
1868. Paper print. Harry
Ransom Humanities
Research Center,
University of Texas,
Austin, Texas.

The People of India was
part of a large, though
informal, British effort
to collect statistical
data, study the history of
Indian civilization, and
appropriate the country
into "the laboratory of
mankind." They believed
that Indian society had
to develop into a mod-
ern one along the same
route taken by Britain.[94]

3.82 (below)
JOHN LAMPREY, *Front
and Profile Views of a
Malayan Male*, c.
1868–69. Carbon prints.
Royal Anthropological
Institute of Great Britain
and Ireland, London.

The People of India (1868–75) was an
eight-volume series of text and pho-
tographs. Begun in response to a casual
request for a souvenir album by the
British Governor General Charles John
Canning, it developed into a huge pro-
ject involving civilian and military pho-
tographers. The 468 tipped-in prints
generally show people identified by tribe
and caste, holding a tool or weapon
denoting their work and social position
(Fig. 3.81).

The lack of standardization in
anthropological photography led scien-
tists such as Thomas Henry Huxley
(1825–1925) and John Lamprey (active
1870s) to create systems by which
humans could be photographed for
observation and comparison. Huxley's
anthropometric poses were cumber-
some, but Lamprey's recommendations
in his 1869 journal article "On a Method
of Measuring the Human Form" became
influential (Fig. 3.82). Both Huxley and
Lamprey proposed that the scientific
study of race should be based on obser-
vations of the nude human body, so that
differences in skin color, hair texture,
physique, and the like would be

recorded. This strategy strengthened the belief that there were basic differences among humans, observable through distinctions in physical appearance.

So wrong

Orientalism

With the global expansion of Western political and economic interests in the mid-nineteenth century, photographers sought to highlight cultural differences. One of the most persistent such types of photograph showed women from the Middle East and Asia in sexually suggestive poses. The term "Orientalism," adopted by cultural critic Edward Said in a 1978 book of the same title, has come to mean the wholesale social labeling of non-Western peoples as passive, rather than active; childlike, rather than mature; feminine, rather than masculine; and timeless, that is, apart from the progress of Western history. More specifically, it describes the phenomenon of titillating sexual interest or intrusive observation of people from non-Western cultures, especially women.[95]

In Western literature, travel accounts, and art before the invention of photography, Middle Eastern women were contradictorily described as closeted in harems, swathed in thick clothing and veils, *and* as sexually aggressive. Images of the odalisque, the drowsily reclining naked or semi-nude female pictured in an intimate or exotic setting, were frequent in Western art. In photography, the mystery and unavailability of Middle Eastern women were enhanced by costume and pose (Fig. 3.83). Not all pictures of Middle Eastern women, however, were made to please foreign fantasies: Marie Lydie Cabannis Bonfils (1837–1918), wife of the photographer Félix Bonfils (1831–1885), is reputed to have made the photographs of women who came to the family's Beirut studio.[96] In India, legitimate photography of women in *purdah*, that is, seclusion, was done by British women, such as a certain Mrs. Carrick, who is said to have run a studio in Calcutta. By 1885, Indian women had taken up photography.[97]

Nude and semi-nude images of Eastern women were marketed in many ways. Sensual pictures, in which the model wore traditional clothing to mark her ethnic identity, were issued in *cartes-de-visite*, miniatures, postcards, and albumen prints (Fig. 3.84). The

académies, or figure studies of women ostensibly sold as aids to painters, sometimes featured Middle Eastern women, whose hairstyle and jewelry signaled their identity and class to the viewers.

Explicit photographs of sexual acts, featuring both Western and non-Western participants, were marketed in the major European capitals and were also available by mail order catalog.[98] Bruno Braquehais, who photographed the French Commune (see Fig. 3.25), also made images of individuals and couples engaged in sexual activities.[99]

"Dying Cultures"

Anthropological photography took on a moral urgency as the notion spread that indigenous peoples did not have the physical and mental strength to survive the encroachment of Western civilization. At the 1866 Intercolonial Exhibition in Melbourne, Australia, a section was devoted to "The Last of the Tasmanians."[100] The number of aboriginal Tasmanians was indeed severely reduced—in 1847 only forty-six individuals had remained. Professional photographer C. A. Woolley (1834–1922) made a studio study, in the style of Western

3.83
PHOTOGRAPHER UNKNOWN, *Arab Woman and Turkish Woman, Zangaki, Port Said*, 1870–80. Albumen print. Victoria & Albert Museum, London.

In this studio photograph, a Turkish woman is masked by a semi-transparent veil, reclining in the manner of an odalisque, suggestively holding a *narghileh* (water pipe). The standing woman grasps a tambourine. The image gratifies the fantasy view of the "Orient" as a place where time has stood still.

**3.84
KUSAKABE KIMBEI,**
Geisha Resting, c. 1885.
Hand-colored albumen
print. Richard W. Gadd
Collection, Monterey
Museum of Art,
California.

**3.85 (below)
C. A. WOOLLEY,**
Trucanini, 1866. Paper
print. Royal Anthropo-
logical Institution of
Great Britain and
Ireland, London.

Trucanini was pho-
tographed in the
Western portrait style,
not in the full body pose
often adopted for non-
Western people. Yet her
eyes look fierce and her
mouth suggests both
fear and disdain. When
Trucanini died in 1876,
Woolley marked her
photograph "Last
Tasmanian," as if she
had some sense of her
people's demise.

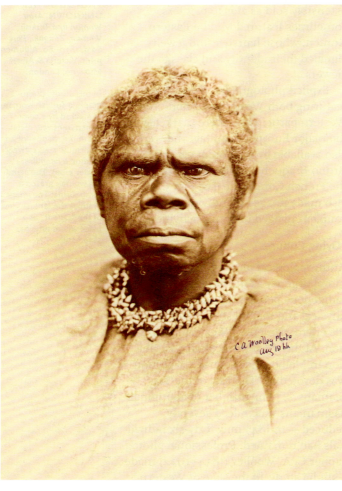

portraiture, of a Tasmanian woman
named Trucanini (Fig. 3.85). Though
they ultimately fared better than the
Tasmanians, the notion of vanishing
races was also applied to Native North
Americans (see pp. 126, 196).

In 1879, responding to the belief that
the traditional life of Native Americans
was endangered by development, the
United States established the Bureau of
Ethnology.[101] John K. Hillers (1843–
1925) was appointed staff photographer
under John Wesley Powell (1834–1902),
the agency's first director. Hillers had
met Powell while working as a boatman
for Powell's survey of the Colorado River
in 1871. The expedition's photographer
E. O. Beaman (1837–1876) taught
Hillers how to use the camera, and
when Beaman left the group, Hillers
took over, making about 3,000 images
of the Grand Canyon and of Native
Americans. For the Bureau of Eth-
nology, he produced more than 20,000
negatives.[102] After the massacre at
Wounded Knee in 1890, when the
Indian Wars all but ceased, photogra-
phers took up the "grand endeavor"
to capture the likeness of Native
Americans before they disappeared.

POPULARIZING ETHNIC AND ECONOMIC TYPES

The idea of creating assemblages of thematically related photographs of people was not restricted to scientific pursuits. Studios around the world offered exotic images of people deemed typical of an ethnic group. In Rio de Janeiro a portraitist advertised "a large collection of black tipos [characters] and their customs, very appropriate for those who are leaving for Europe."[103] The Scottish-born photographer William Carrick (1827–1878) worked in Russia photographing "Rasnoshchiki," the street sellers of St. Petersburg[104] (Fig. 3.86).

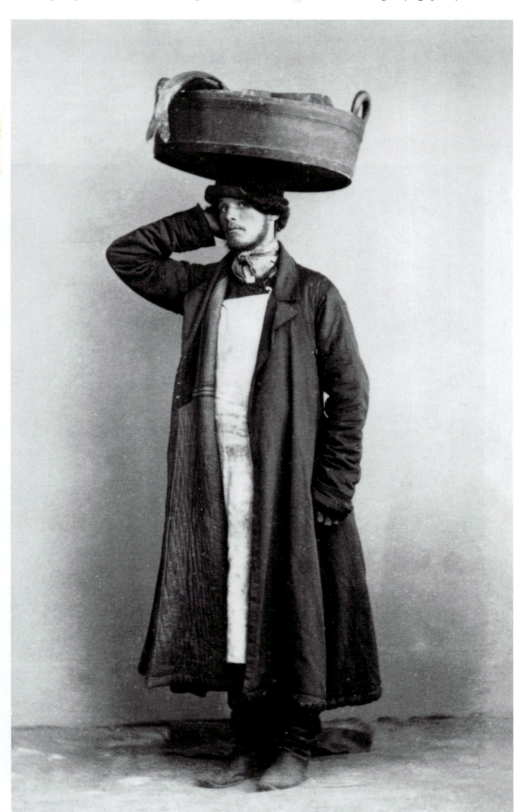

3.86
WILLIAM CARRICK,
A Fishmonger, St. Petersburg, 1859–78.
Carte-de-visite. **Scottish National Portrait Gallery, Edinburgh.**

The backdrop, the erect, carefully prepared posture of the fishmonger, the attention drawn to his profession (the escaping fish), all indicate that this "street seller" is posing for Carrick in a studio.

In the later nineteenth century, factories and industrial sites were photographed with increasing frequency, and studio shots of laborers, especially craftspeople dressed in work clothes and carrying their tools, became the subjects of many *cartes-de-visite*.[105] Nevertheless, the reality of the urban poverty associated with industrial capitalism was seldom photographed before the end of the nineteenth century. One exception was Henry Mayhew (1812–1887), whose *London Labour and the London Poor* (1851) contained engravings based on daguerreotypes. It was a financially successful publication, perhaps because government-sponsored welfare programs were beginning to be accepted as a part of modern life. Photographs of strikes, even during the European depression of the 1870s and its labor unrest, are also rare. The poor could not afford photographs, and newspaper images tended to reflect the point of view of private industry. Moreover, reformers in the mid-nineteenth century were generally not stirred to photograph societal problems or remedial programs, because the camera for them was largely associated with the evils of industrialization.

As European cities implemented modernization schemes, the people displaced by renovation were seldom

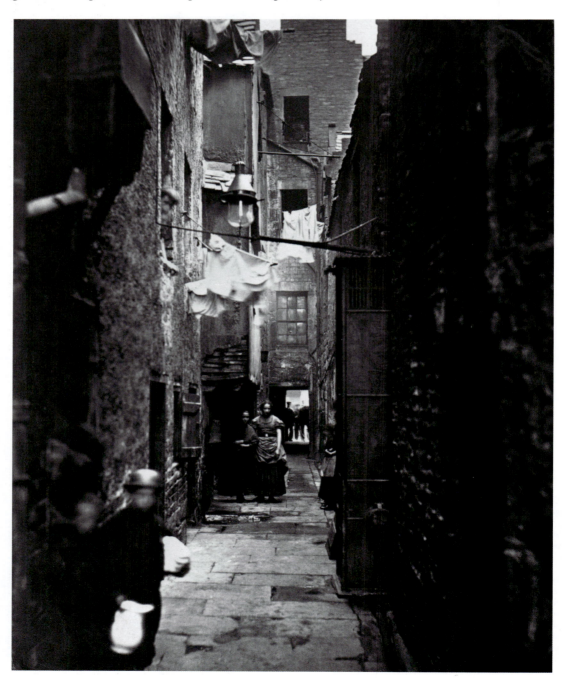

3.87
THOMAS ANNAN,
Close No. 37, High Street, 1868, from *The Old Closes and Streets of Glasgow*, from *Photographs Taken for the City of Glasgow Improvement Trust*, 1900. Engraving. Gernsheim Collection. Harry Ransom Humanities Research Center, University of Texas at Austin.

Most of Annan's photographs artfully balance tones to render the distressed buildings and filth-laden alleys picturesque, but one view included a group of residents posed at the end of a narrow street.

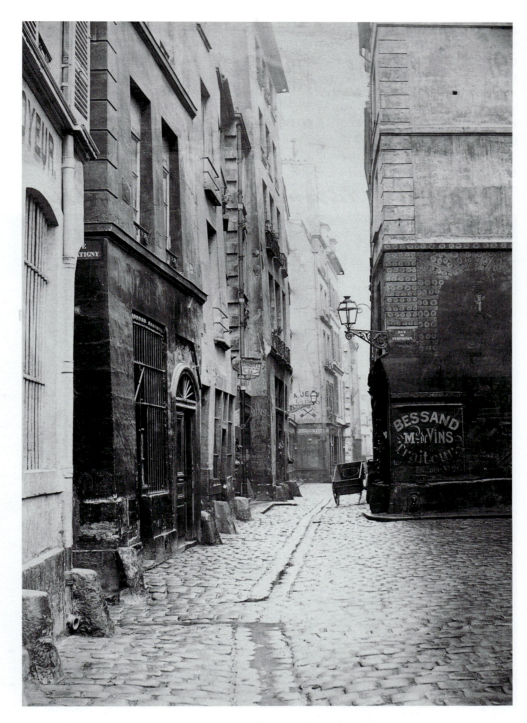

**3.88
CHARLES MARVILLE,
14, Rue des Marmousets
(destroyed): *View from
the East. At left, Rue de
Glatigny* (destroyed,
replaced by the Hôtel-
Dieu), n.d. Paper print.
Bibliothèque Historique
de la Ville de Paris.**

Baron Haussmann was
entrusted by Napoleon
III with the planning of a
radical redesign of Paris.
Broad boulevards
(avenues), railway
stations, and new apart-
ment blocks replaced
the cramped, winding
streets of the old city.
Whole districts, like this
eastern section of the Île
de la Cité near Notre
Dame, were torn down
in the process.

photographed, although the buildings
were. An unusual picture was made by
Thomas Annan (1829–1887), a photog-
rapher in Glasgow, Scotland, who was
asked by the Glasgow City Improvement
Trust in 1866 to record the vast slums
that grew up around mills and factories
before the buildings were torn down
and rebuilt (Fig. 3.87). Charles Marville
(1816–c. 1879), a French artist and
photographer, was among the many
who produced photographs of old Paris,
before the implementation of Baron
Haussmann's (1809–1891) improve-
ments (Fig. 3.88).

When John Thomson returned from
Asia to Britain, he became a portrait
photographer, whose studio was
equipped with the usual painted back-
drops and fancy posing chairs. He also
undertook a photographic survey of
London's poor with writer and social
activist Adolphe Smith Headingly, who
wrote under the name of Adolphe
Smith. *Street Life in London* was issued
in twelve monthly installments, begin-
ning in February 1877, and was pub-
lished as a bound book one year later.
Thomson and Smith acknowledged
Mayhew's efforts on behalf of the poor,

presenting their own work as an updated version. Their preface stresses the function of photography to document objectively, without omission or exaggeration. One remarkable picture shows an impoverished homeless widow who made her living minding the children of poor working women (Fig. 3.89).

In the last third of the nineteenth century, photographs were used slightly more often in private social reform efforts. Thomas Barnardo (1845–1905), who administered homes and training programs for poor and homeless children, made before-and-after images to advertise his work and to raise funds (Fig. 3.90). In most of the images, Barnardo exaggerated the children's poverty, dressing them in torn clothes and posing them in pitiful positions. The images could be purchased singly or in packets.

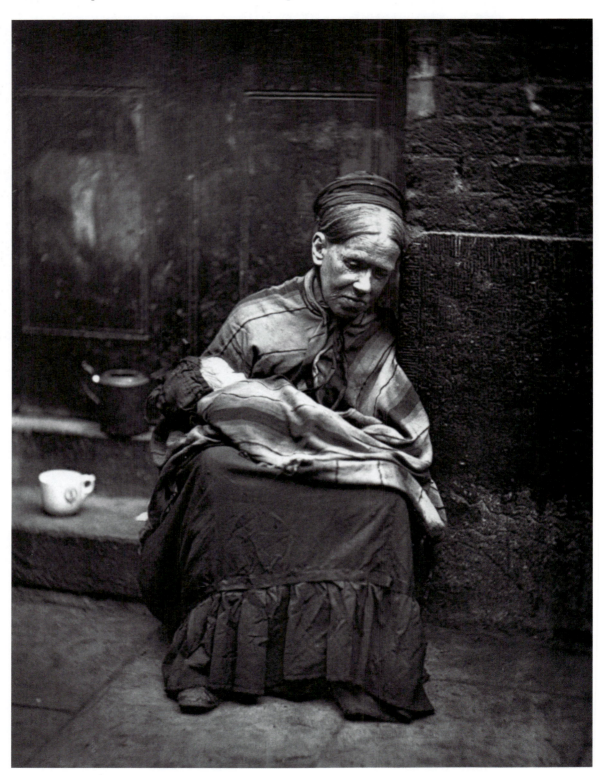

3.89
JOHN THOMSON, *The Crawlers,* 1877–78. Woodburytype. Victoria & Albert Museum, London.

Street-dwellers such as the woman pictured here were termed "crawlers," because they would occasionally have enough cash to buy tea leaves, then "crawl" to a pub for hot water. The image of the crawler shows greater emphasis on the individual, in contrast with Thomson's often static presentation of street types.

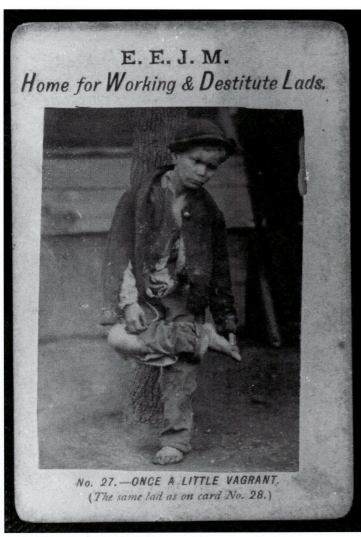

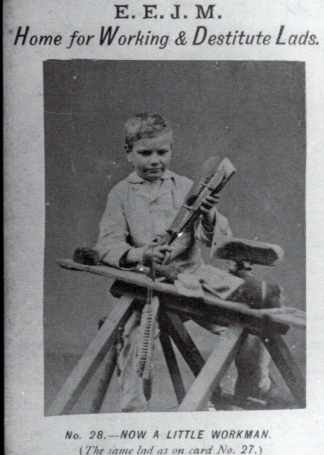

No. 27.—ONCE A LITTLE VAGRANT.
(*The same lad as on card No. 28.*)

No. 28.—NOW A LITTLE WORKMAN.
(*The same lad as on card No. 27.*)

ART AND PHOTOGRAPHY

The idea of photographic representation as acutely accurate permeated the art world. An 1860 issue of the *Art Journal* contended that "the photograph cannot deceive; in nothing can it extenuate; there is no power in this marvellous machine either to add or to take from: we know what we see must be TRUE."[106] The emphasis on photographic imagery as rendering what actually took place before the camera helped to suppress the use of a partially photographic technique called the *CLICHÉ VERRE*. The process, invented in 1839 by British engravers, was renewed by several experimenters including French image-makers A. Cuvelier (1812–1871) and L. Granguillaume (active 1850s), in 1853. It employed a glass plate covered with a dark coating, like opaque black varnish, something akin to William Henry Fox Talbot's earliest experiments (see p. 18). The artist scratched an image into the coating with a sharp stylus. Since light could pass through the areas scratched away, the plate could be used as a photographic negative. It was placed on sensitized paper, and exposed to light, which cut into the opaque coating; many prints could be made from one plate (Fig. 3.91). Because the *cliché verre* seemed neither sufficiently handmade nor wholly photographic, however, it found only limited success.

To many artists and critics, photographic truth had an undertone of moral truth. Writing in 1859, Francis Frith argued that "we can scarcely avoid moralizing in connection with this subject; since truth is a divine quality, at the very foundation of everything that is lovely in earth and heaven; and it is, we argue, quite impossible that this quality can so obviously and largely pervade a popular art, *without exercising the happiest and most important influence, both upon the tastes and the morals of the people.*" At the same time, Frith wrote, photography

3.90
PHOTOGRAPHER UNKNOWN, *Before and After Photographs of Young Boys*, c. 1875. Albumen prints. Barnardo Photographic Archive, Ilford, England.

Barnardo was accused of overly dramatizing the before-and-after photographs he took of children who entered his homes and training programs. In response, he claimed that he was doing what painters were allowed to do: create fictions that aimed at a higher truth than the imitation of appearances. In all, he took about eighty pairs of before-and-after photographs.

3.91
JEAN-FRANÇOIS MILLET, *The Sower*, **1862. Cliché verre.** Victoria & Albert Museum, London.

Cuvelier and Granguillaume showed the *cliché verre* process to the artist Camille Corot (1796–1875), who experimented with it, as did other painters, such as Jean-François Millet (1814–1875).[107]

was "*too truthful*. It insists upon giving us 'the truth, the whole truth, and nothing but the truth.' Now, we want, in Art, the first and the last of these conditions, but we can dispense very well with the middle term."[108]

The debate over how to make room for imaginative camerawork, while maintaining respect for the utilitarian uses of photography, became a war of words. A British portrait photographer, C. Jabez Hughes (1819–1884), suggested that photography ought to be divided into three classes. The first, mechanical photography, was literal or exact depiction. In the second category, art-photography, the maker, not content with things as they appear, "determines to infuse his mind into them by arranging, modifying, or otherwise disposing them, so they may appear in a more appropriate or beautiful manner." The last category included "certain pictures which aim at higher purposes than the majority of art-photographs, and whose aim is not merely to amuse, but to instruct, purify, and ennoble."[109] The many tensions between depiction and imagination, objective description and moral uplift, education and amusement permeated photographic practice and criticism.

ART REPRODUCTION

On the face of it, the photographic reproduction of artworks seems like a simple project. Suggested early in photography's history by François Arago and William Henry Fox Talbot (see pp. 19–20), the reproduction of artworks began as an effort to combine the cataloging capability of photography with the interests of education. In 1852, Roger Fenton was employed to photograph prints, drawings, and sculpture at the British Museum, a position he took up again at the end of the Crimean War.[110] The art dealers P. & D. Colnaghi negotiated with the museum to sell the museum's photographs.[111] Similarly, Charles Thurston Thompson, the photographer at the South Kensington Museum who trained Royal Engineers in the medium (see p. 120), photographed items from the museum's collections.

As early as 1851, Francis Wey suggested that the Louvre in Paris create a gallery of photographs of paintings by French artists not represented in French museums.[112] In Paris, the Print Room of the Bibliothèque Nationale and the Bibliothèque des Arts Décoratifs collected photographs of architecture and art during the last half of the nineteenth century. At the same time, museums were collecting, however haphazardly and sporadically, works by leading photographers who specialized in picturesque views or architectural photography.

Photographers soon formed firms largely devoted to art reproduction. In 1866, Alsatian photographer Adolphe Braun (1812–1877) began an art reproduction business that quickly became international both in the scope of its reproductions and in its sales. Fratelli Alinari Fotografi Editori, a company that still sells art reproductions, was founded in 1854. *Photographic Art Treasures* (1856), a collection of picturesque views, art reproductions, and morally edifying photographs, appeared in Britain. Throughout the 1860s and 1870s, publishers in Italy, Germany, and France produced *cartes-de-visite* that illustrated art objects. Lantern slides, sometimes called magic lantern slides, were made of art objects and architecture. The magic lantern was a device for project-

ing images on to a screen; early lanterns used oil lamps. In the 1870s, when courses on the history of art were slowly introduced into America, Great Britain, Germany, and France, the market for slides enlarged.[113]

In the later nineteenth century, the rationale for making photographs of art objects available to the public was more democratically phrased than Arago or Talbot had considered, and came to the fore in a more commercial culture than either of them envisaged. American photographer Marcus Aurelius Root (1808–1888) emphasized that images of culture, as well as nature, could benefit "the lowliest of the community." Photographs could bring to "the masses … abundant and infinitely various stores of knowledge and entertainment," and "no small measure of artistic training."[114] Art education was linked with the process of cultivating taste and temperament in the poor; in an era that stressed self-improvement, art reproduction was touted as a social equalizer. "With a pile of pictures by their sides, which cost almost nothing, they can make the European tour of celebrated places, and not leave the warm precincts of their own firesides," wrote one observer.[115] Reviewing an exhibit of art reproductions, the *Athenaeum* pronounced that "The old selfish aristocratic days of hoarding are gone for ever. Rare Titians, kept in cases to be gloated over at a miserly moment, will be seized and photographed … Great and true Art is republican, and is for all men, needing no education to appreciate it—no more than we need education when we fall in love."[116]

THE PHOTOGRAPHER AND FINE ART

The notion that photography could replicate art more accurately than other reproductive media arose because of the belief that photography itself was not an art, that is, not a medium open to imagination or subjective response. This belief in photography's objectivity prompted a variety of responses from those who defined art as an expression of human imagination. The American painter Rembrandt Peale (1778–1860) succinctly summed up the complaint when he wrote, "We do not see with the eyes only, but with the *soul*."[117]

3.92
ÉTIENNE CARJAT,
Charles Baudelaire,
c. 1862. Woodburytype.
Metropolitan Museum
of Art, New York.

Although he was friendly with such photographers as Carjat and Nadar, Baudelaire did not believe that photography could be an art. Carjat set up his portrait of Baudelaire against a plain background, and carefully modulated the lighting of the face to bring out the poet's strength of concentration.

French poet and critic Charles Baudelaire (1821–1867) (Fig. 3.92) accepted photography as a means of record-keeping, yet lamented what he saw as its broad social consequences. He contended that photography's supporters were unwittingly constricting the range of human imagination. Baudelaire wrote that "each day art further diminishes its self-respect by bowing down before external reality; each day the painter becomes more and more given to painting not what he dreams but what he sees."[118] He thought that those who considered that "Photography and Art are the same thing"[119] thinly rationalized soul-deadening matter-of-fact pictures. Similarly, the French painter, Eugène Delacroix, insisted on a crucial differentiation between the insights that follow on the interaction of eye and mind and what occurs in the process of photography. Although Delacroix commissioned photographic studies of models to be used in his paintings (see Fig. 2.55), he insisted that the camera was a machine that yielded pictures untrue to the complexities of human perception. For him the central activity of art—soul speaking to soul—was foreclosed by photography.[120]

While many painters in Europe and America collected, commissioned, and used photographs, they insisted that it was merely a recording instrument. The influence of the photograph on art was seldom discussed positively, even by painters such as Jean-Léon Gérôme (1824–1904), whose highly detailed views of the Middle East resemble contemporary photographs in glossy appearance, fine detail, and subject-matter.[121]

Both Baudelaire and Delacroix sat for photographers and socialized in their circles. French photographer Étienne Carjat (1828–1906) was typical of the emergent artist-photographer who led a bohemian life. Trained as a painter and working as a caricaturist and writer, Carjat moved in the world of Paris culture, where he met writers, musicians, artists, and their patrons (see Fig. 3.92). Comparable portrait work was done by another French caricaturist turned photographer, Nadar (Gaspard Félix Tournachon). Nadar drew political cartoons and caricatures of prominent figures, and conceived his *Panthéon Nadar* as a lithograph that would show 1,000 portraits of contemporary celebrities. He

managed to complete only one section of the grandiose work, in 1854 (Fig. 3.93). Nadar learned photography late in 1853, at about the same time as his brother Adrien Tournachon, who would go on to aid Duchenne de Boulogne (see p. 137). In a short-lived partnership, the brothers produced a series of photographs of the mime Jean-Charles Deburau, posed as Pierrot (Fig. 3.0).[123]

Nadar initially capitalized on the upper-class taste for images of creative people. His quick perception and judgment, learned as a caricaturist, helped him to specialize in making heroic portraits of contemporary cultural figures, especially bohemian artists and writers. Nadar not only sold large, high-priced images, he also marketed his public persona. With photographer Gustave Le Gray (see Figs. 2.69, 2.70), he maintained that he was not a simple operator of photographic equipment but an artist, sensitive to the nuances of personal character as well as rules of composition. "What can't be learned," he wrote, "it's the sense of light, it's the artistic appreciation of the effects produced by different and combined qualities of light."[124]

3.93
NADAR, *Panthéon Nadar*, 1854. Lithographic print. George Eastman House, Rochester, New York.

Nadar's *Panthéon* shows famous people coming to pay homage to a bust of the French writers George Sand, Chateaubriand, and Frédéric Soulié.[122] Making caricatures may have helped him concentrate on facial features that indicate personal temperament.

3.94 (above)
NADAR, *Théophile Gautier*, 1854–55. Albumen salted paper print, mounted on Bristol board. Musée d'Orsay, Paris.

Gautier's disheveled clothes and deep-set eyes cast in dark shadows beneath a well-lit brow portray artistic insight and personal intensity gained at the expense of bourgeois social graces.

Nadar's photographic studio became a fashionable intellectual salon.[125] Like Hill (p. 72) and Brady, he conceptualized photographs, and he posed his sitters, but the image was produced and developed by a staff that grew in numbers with his success. Nadar's portrait of Théophile Gautier (1811–1872), boisterous proponent of art for art's sake and author of the influential novel about Parisian bohemian life, *Mademoiselle de Maupin* (1835), visually summarizes the writer's antagonism toward the middle-class values of orderliness and civility (Fig. 3.94).

In addition to photography, Nadar was a fervent advocate of balloon transportation and aerial reconnaissance. He produced the first photographs of Paris from the basket of his balloon Le Géant (The Giant), and he administered the airmail service during the siege of Paris.[126] Nadar also experimented with artificial light, making the first photographs of the Paris sewers using a carbon arc lamp powered by Bunsen batteries (Fig. 3.95). His interest in science and technology complemented his reputation as a multi-talented originator. Coupled with the artistic and literary circles in which he moved, this helped considerably to elevate the status of the photographer generally.

HIGH ART PHOTOGRAPHY

Other efforts to elevate the public perception of photography included emulating the conventional subjects of painting. The popularity of photographic still lifes, beginning with Daguerre, indicates the success of this course. A different approach, occurring mostly in Britain, also borrowed from the painterly tradition. It took up the notion of High Art photography outlined by photographer C. Jabez Hughes, "to instruct, purify, and ennoble." In this photography, emphasis was placed on edifying subject-matter, such as scenes from the Bible or literary sources, including Shakespeare, Tennyson, and Walter Scott. *Tableaux vivants*, literally living pictures, were popular subjects for early photographers. The *tableau* required that the actors hold their poses for about twenty seconds, a time well suited to photography.[127]

William Lake Price (1810–1896), a British painter who adopted photography, made portraits of famous people, scenes from everyday life, still-life studies, and *tableaux vivants* from literature. His image of Don Quixote, hero of Miguel de Cervantes's (1547–1616)

3.95
NADAR, *The Sewers of Paris*, 1864–65. Modern print from a glass negative. Caisse Nationale des Monuments Historiques et des Sites, Paris.

Nadar used a carbon-arc lamp to create an eerie, ghostly apparition of subterranean Paris, etched into immortality by Victor Hugo's book *Les Misérables*.

**3.96
WILLIAM LAKE PRICE,
*Don Quixote in His
Study*, early 1850s.
Albumen print from a
wet collodion negative.
Victoria & Albert
Museum, London.**

Lake Price's image of
Don Quixote in His Study
shows Cervantes's
famous character sur-
rounded by items sug-
gested from yet another
literary source, Walter
Scott's novel *The
Antiquary*.[128]

romance of the same name, drew upon
the tradition of inspirational or uplifting
painting (Fig. 3.96). It also engaged the
interest in historically accurate repre-
sentation that was flourishing in paint-
ing at the time. Lake Price combined his
knowledge of art principles and the
techniques of photography in his 1858
publication, *A Manual of Photographic
Manipulation*. Photography was also
influenced by sentimental or moralizing
paintings and engravings, as in a stereo-
graph by British photographer James
Elliott (1835–1903) (Fig. 3.99).

The most famous High Art photo-
graph was constructed by Oscar
Rejlander (1813–1875), who worked with
Darwin to create studies of human
expression (see p. 139). Like many mid-
century photographers, Rejlander began
as a painter. While studying art in
Rome, he made a living by copying Old

Master paintings. There he became
acquainted with Raphael's famous
fresco *The School of Athens*, whose com-
position and theme of opposing points
of view became the basis for a large pho-
tographic work, *The Two Ways of Life*,
exhibited in 1857 (Fig. 3.97). In the cen-
ter of the Raphael fresco, Plato points
toward the heavens, the realm of the
ideal, and Aristotle seems to point to the
earth, source of material knowledge. In
Rejlander's *The Two Ways of Life*, a sage
introduces two youths to life: the one on
the left embraces the moral life of hon-
est industry; on the right, a callow rake
is about to venture into a life of dissipa-
tion and debauchery. The women who
posed were from Madame Warton's
(sometimes Wharton) Troupe, a popular
threatrical group who performed
tableaux vivants derived from paintings
and, especially, classical sculpture.[129]

The large print, about 31" wide, was made from more than thirty individual negatives in a technique termed combination printing which required a great deal of handwork. Rejlander argued that the labor involved, combined with the image's inspiration from a Renaissance source and the morally uplifting theme, distanced the work from ordinary photography and aligned it with painting.[130] Despite its notoriety, however, Rejlander made few more moralizing pictures. Like many photographers, his main means of support was portraiture.

Henry Peach Robinson (1830–1901), another painter-photographer, learned how to combine negatives from Rejlander. A hand-drawn sketch with a photograph inserted shows how Robinson planned his work (Fig. 3.98). The subject of his 1858 combination-print photograph *Fading Away* (Fig. 3.100) disturbed the public with its scene of a dying young girl being attended by her family. Although the space between the girl and the wall beyond the window is unnaturally compressed, the illusion of the image having been taken in one camera shot, not built up from individual pictures, is stronger in *Fading Away* than in Rejlander's *The Two Ways of Life*. Robinson depicted another dying heroine in a combination print titled *The Lady of Shalott* (1861), illustrating a scene in a famous poem by Alfred Tennyson. His book *Pictorial Effect in Photography* (1869) was a standard work throughout the nineteenth century.

3.100 (below)
HENRY PEACH ROBINSON, *Fading Away*, 1858. Albumen composite print.
Science Museum, London.

One of Robinson's most successful works, the image shows the all too familiar death of a child in the nineteenth century. Its symbolism is bolstered by the withering fruit arrangement in the center of the picture, and the dramatic, V-shaped cloud that leads the viewer directly to the girl's taut, pale face.

WOMEN BEHIND THE CAMERA

WOMEN AS AMATEURS

On rare occasion, a woman such as Harriet C. Tytler (1828–1907), who was married to a British officer in India, learned photography, traveled extensively, and produced a body of work alone, or as a joint effort with a spouse. Harriet Tytler and Robert Christopher Tytler (1818–1872) made about 300 photographs, some of then as large, two- and three-part panoramas, and exhibited them in India and in the India Office Library in London, where they remain today.[131] But many more women participated in formally arranged and informal exchange clubs for photographers who made non-commercial images. Called amateurs for their love of the pursuit, they were not amateurs in the modern sense of being unskilled or beginners. Most amateur photographers were people of means and accomplishment. Their work ranged from scientific pursuits to architectural and landscape views. John Dillwyn Llewelyn (see p. 35) shared his interests in botany, landscape, and still-life photography through exchanges with other amateurs. *The Sunbeam: Photographs from Nature* (1859), an album of photographs and poems edited by Philip Henry Delamotte (1820–1889), distilled a mood of quiet meditation in nature that attracted so many amateurs.

A few privileged women such as Lady Augusta Mostyn (1830–1912), an accomplished Welsh landscape photographer, participated in the Photographic Exchange Club in Britain (Fig. 3.101). After her marriage in 1855, she found it difficult to pursue her interests.[132] The photographic work of upper-class women in the nineteenth century is not widely known, because outside of the exchange clubs, their photographs were not exhibited, and many remain in private family collections. One such elusive figure is Lady Mary Filmer (1840–1903), an intimate of Queen Victoria's court, who made portraits, and who cut up photographs and inventively arranged them on sheets of paper upon which she painted watercolors (Fig. 3.104).

**3.101
LADY AUGUSTA
MOSTYN,** *Oak Tree in
Eridge Park, Sussex,*
**1856. Albumenized print
of collodion negative.
George Eastman House,
Rochester, New York.**

Venerable trees and
ancient parkland
attached to estates were
favorite subjects for
upper-class British amateur photographers.

PORTRAIT
Julia Margaret Cameron

The Victorian period's most enduringly famous photographer, Julia Margaret Cameron (1815–1879), did not take up photography seriously until she was given a camera in 1863, at the age of forty-eight. Born Julia Margaret Prattle in India, she was schooled in France, married when she was twenty-three years old, and took up photography only when her children were grown and her domestic duties reduced.

Cameron eagerly began her experiments with the medium, and during the next decade produced images in order "to ennoble photography and to secure for it the character and uses of High Art by combining the real and ideal and sacrificing nothing of Truth by all possible devotion to Poetry and beauty."[133]

Cameron took portraits of friends, and friends of friends, as well as Victorian cultural figures such as Charles Darwin and Alfred Tennyson. Her likeness of scientist and photography pioneer John Herschel, with whom she had been acquainted since 1836, illustrates her distinctive approach to male portraiture (Fig. 3.102). Herschel's hair, recently washed and, by her request, left uncombed, becomes an outward manifestation of his active mind. In her autobiographical writing, "Annals of my Glass House," Cameron recalled photographing Herschel and another Victorian sage, Thomas Carlyle (1795–1881). "When I have had such men before my camera," she wrote, "my whole soul has endeavoured to do its duty towards them in recording faithfully the greatness of the inner as well as the features of the outer man."[134]

In Cameron's work, friends, family, and servants were changed into characters from the Bible, Greek myth, and Renaissance painting, as well as figures in British lore and literature. By careful draping and delicate lighting, Cameron transformed her parlormaid Mary Hillier into the Virgin Mary. Like many women photographers, she posed more women than men. Because women generally did not have the identity and authority in the cultural and intellectual world enjoyed by men such as Darwin, Herschel, and Tennyson, they were more easily transformed into literary personages. Most of the time, she chose a crucial psychological moment in a story that would be well-known to her audience (Fig. 3.103). She illustrated an edition of Alfred Tennyson's *"Idylls of the King" and Other Poems*, published in two volumes in 1874–75. Cameron appreciated the languidly beautiful women in medieval costume who appeared in paintings by artists of the Pre-Raphaelite Brotherhood, and made several images especially similar to the work of Dante Gabriel Rossetti (1828–1882).

Cameron explained that the slightly blurred focus that became her characteristic style resulted from her early attempts at photography, when she was using a lens with such short FOCAL LENGTH that only a small region of the sitter's face would be sharp. However accidentally Cameron may have come upon her technique, and however much she was criticized as being technically inexpert for continuing to use it, the style suited her subject-matter. A detailed picture of the Virgin Mary would look too much like someone acting out the role, but a cloudy version appears like an imagined vision or a remembered dream. Unlike many women photographers, Cameron publicly displayed her photographs and attempted to sell them, using the well-established print dealers P. & D. Colnaghi in London. Even though her religious and cultural subjects would have been considered appropriate for a pious woman, her attempts to ease family financial difficulties with the sale of prints was frowned on, and provoked criticism of her style as ignorant or slovenly.[135]

3.102
JULIA MARGARET CAMERON, *Herschel*, 1867. Albumen print. Victoria & Albert Museum, London.

3.103
JULIA MARGARET CAMERON, *Ophelia, Study no. 2*, 1867. Albumen print.
George Eastman House, Rochester, New York.

3.104
LADY FILMER, *Untitled,* c. 1864. Collaged photographs with watercolor additions. University of New Mexico Art Museum, Albuquerque, New Mexico.

Lady Filmer may have been the first artist to collage photographs, that is, to cut, arrange, and paste photographs on a surface so as to make a statement separate from the individual items included in the work.[136] The figures in the arms of the cross are related to the person in the center. Lady Filmer also added watercolor adornments to her pictures.

Perhaps the most intriguing amateur photographer in the Victorian era was Lady Clementina Hawarden (1822–1865), who took up photography in the late 1850s and in the seven years before her death in 1865 produced about 800 images. Elected to the Photographic Society of London in 1863, she won silver medals for her work in that year and in 1864. Although she made some landscape images, her most intriguing pictures were made of her daughters, mostly in the family's London townhouse, where an upper floor was occupied by her photographic pursuits.[137]

Expert in lighting and composing a scene that seems tantalizingly part of a story, Hawarden often photographed the young women in costumes that probably came from the family's collection. She frequently used a mirror, which not only added depth to the scene, but also employed a favorite Victorian symbol for the tension between reality and appearance, and the line between art and life (Fig. 3.105). Though the photographs resemble *tableaux vivants*, they are mostly untitled, giving no direct clues to their meaning. They remained largely unknown in a family collection, until they were given to the Victoria and Albert Museum in London in 1939.

WOMEN AS PROFESSIONALS

Few women had the resources to set up full-time commercial photographic studios, but women were present in all phases of photographic production. Some, such as Marie Lydie Cabannis Bonfils (1837–1918), wife of the photographer Félix Bonfils (1831–1885), helped in the studio, especially in the making of photographs of women who were culturally uneasy with the camera. Others took over photographic businesses upon the death of a spouse. As albumen paper, which used egg white to give the final photograph a sheen, became more popular, women were employed by the thousands to break and separate eggs.

Women had sometimes been employed to add color to the cold silver tinge of the daguerreotype. When paper photographs supplanted the daguerreotype, women continued as colorists. As the *carte-de-visite* and stereograph industries boomed, women found employment as laboratory assistants, print cutters, and print mounters.[138] Except for some work with noxious chemicals, C. Jabez Hughes concluded that "in photography there *is* room for a larger amount of female labour, that it *is* a field exactly suited to even the conventional notions of women's capacity,

3.105
LADY HAWARDEN,
Girl in Fancy Dress,
c. 1860. Collodion print.
Victoria & Albert
Museum, London.

Lady Hawarden is remembered for images of her daughters in poses that suggest they were acting out scenes from literary sources. This image may derive from Alfred Tennyson's *The Lady of Shallot*, in which a woman weaves tapestry alone in a high tower. When she looks into the mirror, she sees the dashing Sir Lancelot, and fatally falls in love with his image.

and further, that it is a field unsurrounded with traditional rules, with apprenticeships, with vested rights, and it is one in which there is no sexual hostility to their employment."[139]

Professional training in photography could be more easily obtained than training in painting or sculpture. Women might be excluded or discouraged from art academies, but they could study with photographers who advertised for students, or learn through the many technical manuals. Women could not travel abroad as freely as did John Thomson and Francis Frith, but they did produce landscape work based on local scenery, as well as routine studio portraiture. Tellingly, women did not seem to secure copyright, or to publish their work to the extent that men did, possibly because these activities involved being in the world of business and commerce to a greater degree than was deemed suitable.[140]

PHILOSOPHY AND PRACTICE: "SUPERSEDED BY REALITY"

During the mid-nineteenth century, photography was defined by its makers and users as a complex and contradictory medium. At issue was the notion of realism. For some, like Oliver Wendell Holmes, realistic photographic images and the development of a commercial network of publishers promised a more democratic diffusion of knowledge in an era when acquired skills and mechanical invention were effectively eroding the authority of traditional power structures. For governments and the military, as well as topographical surveys, photography became a routine adjunct to operations. In science, specialty photography developed hand-in-hand with geology, biology, astronomy, chemistry, and other empirical pursuits. Photography not only recorded findings, but made it easier to arrange these findings into taxonomies, that is, broad classifications and categories.

Writing in 1864, Robert Cecil (1830–1903), later British Prime Minister (1885–92, 1895–1902), summed up the general feeling. "It is to science ... that photography, the child of science, renders, and will unceasingly

render, the most valuable aid Photography is never imaginative, and is never in any danger of arranging its records by the light of a pre-conceived theory."[141]

The growing acceptance of photography as a reliable representation of the world increased the credibility of photographic evidence. Cecil considered that "the noblest function of photography [is] to remove from the paths of science in some degree the impediments of space and time, and to bring the intellects of civilized lands to bear upon the phenomena of the vast portion of the earth whose civilization has either not begun, or is passing away."[142] Individual photographs thus became building blocks in systems that have since proved to be more fancifully theoretical than empirically thorough. For example, notions of racial difference were supported by photographs that emphasized some bodily distinctions, while neglecting similarities.

In law and police work, photographic evidence of personal identity, clothing, locales, signatures, and the like were increasingly used. In the 1880s these applications developed into internationally accepted systems to organize visual data. Photographic affidavits (a photograph used in a legal brief as sworn evidence) proved to be a potent challenge to hearsay evidence in the courtroom.[143] In addition, schemes to prevent crime by creating national identity cards containing a photographic likeness were proposed in Britain in the late 1860s. As one notable advocate of photography put it in 1869, the expanding domain of photography made earlier forms of evidence "superseded by reality."[144]

Because it was accepted as proof, photography confirmed whatever was photographed. This sense of authenticity was applied broadly, not only in war, science, and law, but also in everyday portraiture and views of foreign lands. It teased into being a craving for pictures of political, social, and cultural celebrities. As photography emerged as evidence, events and personalities began to be fashioned with an eye for public circulation.

At the same time, the absence of photographs effectively denied the significance of a subject or theme that was not regularly depicted. New bridges and

FOCUS
Lewis Carroll's Photographs of Children

Charles L. Dodgson (1832–1898) lectured in mathematics and was an ordained clergyman at Oxford University in Britain, but he is better known as the author of *Alice's Adventures in Wonderland* and *Through the Looking-Glass*, written under the pen name Lewis Carroll. He also created about 3,000 negatives during twenty-five years of photographing.[145] His landscape and architectural photographs are unremarkable, and his portraits of adults are mostly conventional, but the photographs he made of the female children of his friends and colleagues have been the subject of much debate. Carroll photographed Alice Liddell, the Alice of his stories, alone and with her sisters. His contrived image of her as a beggar child in artfully ripped clothing and bare feet is perplexing, because it is difficult to reconstruct the Victorian attitude toward children of the upper-middle class, and because Carroll may have been more than a little enthralled with Alice (Fig. 3.106). Certainly, Alice cannot be mistaken for a pauper: her costume, her grooming, and especially her pose suggest a child playing a role. But is it a sexually charged image?

In recent criticism, Carroll has been accused of instilling private erotic innuendo into his photographs of young girls.[146] The nude and semi-dressed photographs, most of which were destroyed by Carroll before his death, or ordered scrapped by him in instructions to his executors, were made with the knowledge of the girls' parents. Amidst the tumultuous changes in the Victorian period, the child became a potent symbol of purity and simplicity. The era insisted on childhood as a time of innocence, and Carroll's pictures pivot on the girls' ignorance of the teasing sexuality of their poses.

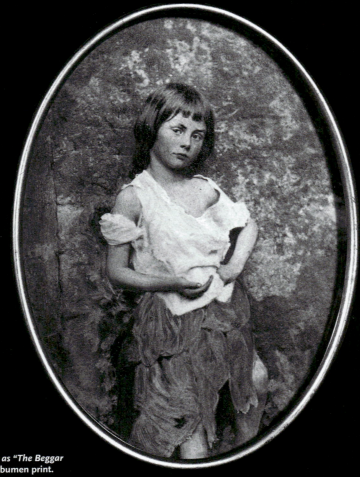

3.106
LEWIS CARROLL, *Alice Liddell as "The Beggar Maid,"* c. 1859. Hand-colored albumen print.

railroads were photographed; non-picturesque agricultural and industrial workers actually toiling in fields and factories were generally not pictured. The American Civil War military installations and battles were thoroughly photographed; the dismal record of slavery was not. Foreign wars and landscapes were programmatically photographed, as were foreign natural disasters, such as the Hong Kong typhoon (see Fig. 3.38), when they affected Western commerce. But devastating events and calamities outside the Western sphere mostly were not photographed, even though public faith deepened in photography's ability to confirm events.[147]

Writing from southern India during the Madras famine, a certain Dr. Cornish lamented: "I often regret that I have not a photographer temporarily attached to my office while moving amongst the famine-stricken people Words at best can but feebly represent the actual facts, but if members of Government could see the living skeletons."[148] Moving as they are, images of human suffering, such as those taken by British photographer Willoughby Wallace Hooper (1837– 1912) during the Madras famine in India in the late 1870s, were not routinely or methodically produced (Fig. 3.107).

Generally speaking, it was easier for photographers to conjecture the open-

ing of the Suez Canal (1869) as an aesthetically challenging and commercially lucrative subject for photography,[149] than for cameraworkers to imagine how to photograph the intangible ways in which life was swiftly changing in the developing world. Locomotives could be photographed; the speed of life could not. In effect, photography developed unevenly, omitting or neglecting the social and psychological responses to modernization that became the stuff of fiction and of art movements, such as Impressionism.

In the face of the societal acceptance of photography as evidence, those who pursued the possibilities of photography as art began to think of ways to counteract the look of photographic testimony. As early as 1853, the British painter and photographer William Newton advocated the development of an art photography that consciously worked against the glut of details produced by "chemical Photography." Like Julia Margaret Cameron, he proposed rendering a subject a little out of focus.[150] For artists and cultural commentators, the association of photography with scientific and industrial progress was not a blessing. British artist and critic John Ruskin (1819–1900) came to consider it a detriment to art and to society. He wrote that photography could not be an art because art "expresses the personality,

3.107
W. W. HOOPER,
Victims of the Madras Famine, 1876–78.
Albumen print.

Hooper's photographs of people affected by the Madras famine of 1876–78 were not taken as part of a relief effort, but as part of his general photographic survey of India. At the time, there was little demand for images of this sort, and no government agencies to collect or archive them.

the activity, and living perception of a good and great human soul."[151] "Almost the whole system and hope of modern life," Ruskin wrote, "are founded on the notion that you may substitute mechanism for skill, photography for picture, cast-iron for sculpture."[152] The camera and the machine both tamped down human imagination, replacing creativity, observation, and insight with mediocre readymade goods. In 1859, French critic Henri de la Blanchère (1821–1880) succinctly phrased the complaint: "The less machine, the more the art."[153]

High Art photography, with its emphasis on moral values and literary topics, was no match for the tide of photographic evidence that defined the wider social understanding of the medium. Julia Margaret Cameron's spiritually infused photographs were popular in her circle, but they did not influence ordinary portraiture. Oddly enough, critics raised few questions about the exactness of photographic realism outside the arts, even when scenes in such photographs as *Home of a Rebel Sharpshooter* (see Fig. 3.21) were openly admitted to be arranged for the

camera. Although the difference between an object seen and an object photographed was not much discussed, photographic realism was sometimes the brunt of humor, especially in portraiture, where realism seemed ugly, though truthful (Fig. 3.108). Yet the idea that there could be varieties of photographic realism, ranging from the sublimity of Samuel Bourne's Himalayan photograph (see Fig. 3.28), to the theatrical performance of mental states in the photographs produced for Charcot (see Fig. 3.79), and to the grittiness of John Thomson's views of street life in London (see Fig. 3.89), did not become part of a social dialogue. In sum, artists, photographers, and cultural critics did not offer a serious, sustained debate about the rise and acceptance of photographic realism in society.

As photography emerged as scientific and social evidence, it was also increasingly labeled counterfeit in art. The link between art and science in the popular phrase "the art-science of photography" weakened. In the last decade of the nineteenth century, and the early years of the twentieth century, art and science would be painstakingly disconnected.

3.108
ARTIST UNKNOWN, *Die Kunst der Zukunft (The Art of the Future)*, 1859. Lithograph. Museum Ludwig Köln/Agfa Foto-Historama, Germany.

Society's experience of photography sharpened the perception of difference between classical beauty (signified by the figures on the right, who depart sadly, reflecting that "The heart is dead") and the ordinary or the ugly, as typified by the other caricatures.

CHAPTER FOUR

Photography in the Modern Age (1880–1918)

4.0 FRANCES BENJAMIN JOHNSTON, *Self-Portrait (as New Woman)*, c. 1896. Gelatin silver print. Library of Congress, Washington, D.C.

The New Woman was the subject of serious essays, novels, and poems as well as parodies. Johnston's self-portrait seems like a gentle joke, for despite the "masculine" crossed legs and the cigarette, she is surrounded by souvenirs from her travels and portraits, probably from her successful Washington, D.C., studio.

By 1880, photography had been quietly absorbed into the texture of everyday life. In the late 1880s, there were more than sixty photographic journals and 161 photographic societies around the world,[1] and by the turn of the century, manufacturers of stereographs, such as Underwood & Underwood, were producing 25,000 images a day.[2] The increase in amateur photography prompted newspaper editors to run camera columns, and large photographic firms and news agencies in the developed countries continued to expand sophisticated networks for the accumulation and dissemination of images worldwide.

Nevertheless, there was no particular moment in the vast expansion and societal absorption of photography to mark the point at which it permanently altered the experience of modern life. Instead, the gathering momentum was expressed in multiple, interrelated technological developments during the 1880s, in response to the immense demand for photographs and the voracious information systems in Western society. Experiments in photomechanical processes led to the development of the HALF-TONE PROCESS, which allowed publications to reproduce photographic images directly, rather than through engravings. During the 1890s, it became cheaper, easier, and faster to use half-tones than to hire artists to make sketches, or to translate photographs into engravings. Spurred by advertising and illustrated periodicals, millions of half-tone images were produced. Along with the stereograph and the postcard, the half-tone invested modern life with visual information to an unprecedented degree.

The speed with which photographs could be reproduced with text, combined with the fast pace of urban life, altered newspapers, which had previously consisted mostly of columns of text with occasional line drawings, engravings, and advertisements. Specialized press photographers, agencies, and networks emerged, and pages were redesigned to include more photographs in place of descriptive text. Rather than wait for news to happen, news photographers were sent around the world to places where incidents were likely to occur. Political figures were regularly photographed, and the pictures rushed to press by land or sea, since, unlike text, they could not yet be cheaply

wired to newspapers over telephone lines. Interestingly, a specific date was not appended to many news photographs, perhaps because of the time-lag between taking a picture and publishing it. For example, illustrations derived from photographs of the great flood of May 31, 1889 in Johnstown, Pennsylvania, where more than 2,000 people lost their lives, were published in New York's *The Daily Graphic* on June 6. The delay was longer for international pictures. Photographs from the World War I battles near the Somme in France (June 24 – November 13, 1916) ran in *Leslie's* on January 25, 1917.

In the 1880s and 1890s, such periodicals as the *Berliner Illustrirte* [sic] *Zeitung* (*Illustrated Berlin Newpaper*), the *Illustrated London News*, and the *Illustrated American* presented political news together with entertainment listings, social happenings, and society reporting. Non-news, human interest articles, and reports on the doings of celebrities increased and were accompanied by photographs. For news and feature stories, editors sought unusual, candid, or dramatic pictures. American audiences could be counted on to buy papers with scenes of natural and human-induced disasters, such as earthquakes and fires.[3] Although press photography created full-time work for photographers, their output was considered to be the property of the paper. The images were routinely cropped, retouched, and sequenced without the photographer's prior knowledge or permission.

The popularity of illustrated newspapers spawned new daily and weekly newspapers, as well as magazines, all of which engaged in intense rivalry for original pictures (Fig. 4.1). The competition for pictures to sell to the press spurred photographers to invade the privacy of public figures, such as German statesman Otto von Bismarck, who was clandestinely photographed on his deathbed by photographers who climbed in a window.[4] At the same time, public figures and celebrities often orchestrated events for the cameras that followed them. Theodore Roosevelt (1858 – 1919) welcomed the picture and print press on his election campaigns. Photographers Wade Mountford, Jr. (active early twentieth century) and

William Warnecke (1881 – 1939) were with New York City mayor William Jay Gaynor moments after a 1910 assassination attempt, and made pictures showing his startled alarm.

Advertisers began using photographs to sell an ever-increasing number of products. Along with the growth of department stores, catalog shopping, and national advertising campaigns, photography's own association with modernity gave products cachet and fostered a culture of display. In the cities, window shopping became a Sunday afternoon activity.

The invention of DRY PLATES made photography faster and easier. In contrast to the cumbersome wet-plate process, mass-manufactured dry plates did not need to be prepared and processed close to the time of exposure. Writing in 1894, photographer James Lawrence Breese (active 1890s) concisely summed up the impact: "the photographic artist has ... a wider range at the present time than ever before, for the modern dry plate, so rapid in its action, permits photography from the rigging of a ship in motion, as well as on the busiest thoroughfare of the metropolis."[5] In 1839, exposures could take several minutes; by the end of the nineteenth century, exposure time was reduced to 1/5,000 of a second.

In addition, early photographic chemicals were not sensitive to the full range of colors in the natural world. They rendered some shades of red and blue as dark black. But by 1900, the responsiveness of black-and-white film to the range of colors was perfected and applied to the dry plate, making it better able to reproduce tonal variation in monochromatic prints.

Yielding faster exposure times throughout the 1880s, dry plates worked well with new, smaller, and more portable cameras, called hand cameras. In part, the short exposure time of the dry plate led to the design of camera shutters, which could open and close more quickly than the hand could remove and replace a lens cap. The dry plate allowed photographers to record movement, and permitted them greater mobility and anonymity. Because the image registered so quickly, the photographer did not need a tripod. In addition, an elaborate process for making color

4.1
JOHN D. HOWE,
The front page of
William Randolph
Hearst's *New York
American*, April 24,
1906, with a photo-
graph of San Francisco
in flames. New York
Public Library,
New York.

On April 16, 1906, a
tremendous earthquake
followed by raging fires
demolished the center
of San Francisco. News
of the tragedy was
circulated around the
country long before
photographs could be
transported. The *New
York American* bragged
that it has the first pho-
tographs—only eight
days after the event.

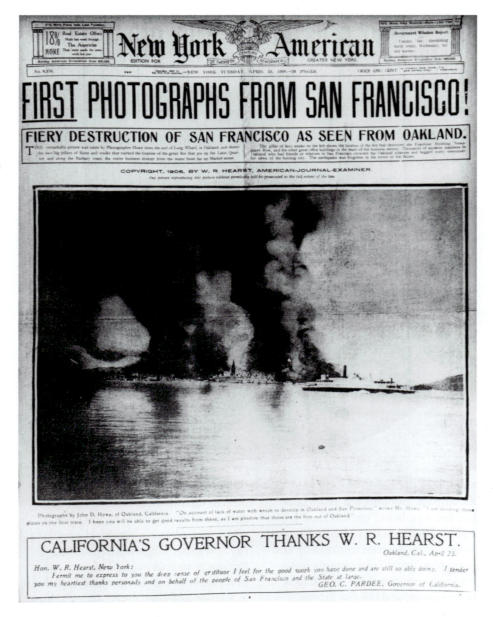

photographs called AUTOCHROME was developed in 1904 by Louis Lumière (1864–1948) and Auguste Lumière (1862–1954), inventors of the motion picture projector in 1895. Subject to fading, expensive to create, and not capable of being duplicated, the autochrome enjoyed a vogue with amateur photographers (see Fig. 4.23).

In 1888, the Eastman Dry Plate Company in Rochester, New York, began manufacturing the Kodak camera, the first of many cameras intended for casual use by middle-class consumers. The camera had a fixed focus, that is, the photographer did not focus the lens, nor look through a viewfinder. The No. 1 Kodak, introduced in 1888, used what the company founder George Eastman (1854–1932) called American film, a roll of paper coated with light-

sensitive material. The camera came loaded with film containing 100 exposures. When all the pictures had been taken, the entire camera was sent back to the company in Rochester, where the prints were developed and the camera was reloaded. The company slogan, "You press the button—We do the rest," enticed people to carry a camera and make spontaneous shots in a way that had not been done before. The resulting snapshots—the word was probably coined by John Herschel in the mid-nineteenth century—were 2$\frac{1}{2}$-inch diameter circular pictures (Fig. 4.2).

The No. 2 Kodak, which came on the market in 1889, yielded 3$\frac{1}{2}$-inch images. In 1900, the company launched the inexpensive "Brownie" camera, which it marketed initially to children. Though snapshots were mostly personal

4.2
**PHOTOGRAPHER
UNKNOWN,**
Untitled, c. 1888.
Early Kodak print.
Eastman Kodak Co.,
Rochester, New York.

The earliest snap-
shots were round, not
rectangular as they
are today. The ease
afforded by snapshot
cameras allowed
photographers
greater spontaneity.
They began to take
pictures of ordinary
events such as pic-
nics and parties.

pictures, they did have a significant
public impact. Not only did snapshots
reduce the number of professional por-
trait photographers, they also deepened
the association between informality and
photographic truth. Increasingly press
photographs emulated the casual look
of the snapshot, and the few artists
remaining at newspapers made their
drawings look more sketchy, as if done
quickly on the spot.

Small cameras were not merely
intended for amateurs. Manufacturers
slimmed down cameras and experi-
mented with roll film to create compact,
lightweight hand-held devices such as
Hawkeye, P.D.Q. (Photography Done
Quickly), and, of course, Kodak, used by
professionals and amateurs alike. At the
same time, the camera was miniatur-
ized. Tiny cameras fitted into walking-
stick handles, pistols, and jewelry were
marketed as detective or secret cameras,
capable of taking pictures covertly. The
SINGLE-LENS REFLEX CAMERA, such as
the Graflex, was rigged with an internal
mirror that allowed photographers to
examine the scene before the lens. It
became the standard news photog-
rapher's camera.

The private world exposed by the
detective camera contrasted with the
public world broadcast by the postcard,
which rivaled stereography in popula-
rity and sheer range of subject-matter.
Picture postcards evolved after changes
in nineteenth-century postal regulations
in Europe and the United States autho-
rized a simple, undecorated card with a
message to be mailed. At the turn of the
century, when printing methods such as
the half-tone process facilitated repro-
duction of pictures and text, photo-
graphic postcards began to appear in
large numbers. Like *cartes-de-visite* and
stereograph images, they were both
collected and sent to others (Fig. 4.3).
Before long-distance telephoning
became common, when radio and the
movies were infant technologies, people
wrote often to each other. Notes jotted
on postcards were casual hellos, like
e-mailed friendship cards.

Photographic postcards depicted
tourist spots as well as ethnic types and
news events. Erotic images, like those
displaying partially clad women from
colonial Africa, were produced in great
numbers. Veiled Islamic women, long a
subject for ethnographic and erotic pho-

4.3a, b
PHOTOGRAPHER UNKNOWN, *Untitled* (Front and back of postcard), 1918. Collection of the author.

The front of this postcard shows Ida Root (Sarazen) and Anne Northrup (Warner). Before telephones became common in rural areas, postcards were often sent over short distances to convey friendship and affection. This card was dispatched by a woman in Bethel, Vermont, to her daughter and niece visiting at a nearby farm in Bellows Falls. The message on the back reads, "Dear Children, Write to me, From Mother."

tography, were also pictured on postcards.[6] At the end of the nineteenth century, photographer William Henry Jackson (see p. 126) joined with two other entrepreneurs to form the Detroit Publishing Company. Postcards, sometimes in boxed sets, comprised most of the seven million images issued by the company in an average year. Panoramas, slides, and hand-colored prints, mostly of American farms, factories, cities, natural wonders, and that ubiquitous favorite, the cowboy, were marketed worldwide to schools, libraries, and governments, as well as to individuals.[7]

At the height of the craze, Kodak manufactured the Folding Camera 3A, especially for producing picture postcards. The United States Post Office reported that from June 1907 to June 1908 more than 667 million postcards, many of them picture postcards, were sent.[8] The postcard rage originated a type of popular image that would not have seemed humorous in photography's first decade, when trifling with the appearance of reality was considered misplaced. Photographic exaggerations showed grasshoppers the size of turkeys, apples as large as mansions, and geese twice as tall as men (Fig. 4.4).

4.4
WILLIAM H. MARTIN, *Taking our Geese to Market*, 1909. Silver print postcard. Franklin County Historical Society, Kansas.

The postcard vogue faded after World War I (1914–1918), in part because of new postal regulations that discouraged it.

The overall effect of technological developments in photography around the turn of the twentieth century was to relocate some control of the image from the individual photographer to large manufacturers and the press. This tendency paralleled the development of other major networks and industries, such as the power companies that produced and delivered electricity, and also the large corporations that manufactured and distributed name-brands.

THE CHALLENGE FOR ART PHOTOGRAPHY

On the occasion of photography's fiftieth anniversary in 1889, American artist J. Wells Champney (1843–1903) wrote an article surveying the familiar list of its social and technological accomplishments in the fields of science, anthropology, criminology, and military applications. He ended with what would become a frequent refrain: the lack of parallel progress in art photography. "As an aid to science, as a recorder, as a duplicator, photography has helped advance civilization," Champney remarked. Yet "it has failed to occupy the place it may yet hold as a means for expressing original thought of a fine order."[9] At the turn to the twentieth century, more people came to believe that a modern art must evolve at a pace and inventiveness similar to that of science and technology.

NATURALISTIC PHOTOGRAPHY

Champney appears not to have known the writings of British photographer Peter Henry Emerson (1856–1936), who a few years before had taken up eagerly the perceived challenge of science to art and art photography. Emerson acquired his first camera during his medical training at Cambridge University. By 1885, with the assurance of a private income, he chose to practice photography rather than medicine. He insisted that in the modern world, science was the only authentic basis for art and photography. Just as the French novelist

Émile Zola (1840–1902) had adopted the scientific method and outlook of the doctor Claude Bernard (1813–1878), Emerson seized on the ideas of German scientist Hermann von Helmholtz (1821–1894), whose studies of the human eye's range of focus he took as instructive for photography. Both Zola and Emerson attempted to align art with the cutting edge of science, and to make it part of the modern world. In 1880, Zola famously proclaimed that "metaphysical man is dead; with physiological man our position changes."[10] Speaking to the Camera Club of London in March 1886, Emerson likewise declared that "the days of metaphysics are over."[11]

In his most important theoretical work, *Naturalistic Photography* (1889), Emerson expounded his theory of photography. He rejected the idea of art as primarily a vehicle for personal and emotional expression. While maintaining that the artist was a person of special character and ability, he derided works of the imagination as untrue.[12] His own notion of naturalism was based in contemporary science, not art theory, notably Helmholtz's idea that "perfect artistic painting is only reached when we have succeeded in imitating the action of light upon the eye."[13] At a time when technical improvements enabled photographers to make sharper pictures, Emerson denied that the camera could make art by merely transcribing physical reality. Instead, he argued that the artist should translate exactly how the eye sees, concluding that the photographer should focus on the main subject of a scene, allowing the periphery and the distance to become indistinct. Called differential or selective focus, this approach varied from William Newton's earlier idea of making the entire image slightly out of focus (see p. 164).

Much of Emerson's photography was done on the Norfolk Broads, a marshy area in southeast England where industrialization had not penetrated to the degree that it had in other parts of the country. There Emerson found rural life and traditional occupations; he ignored the beginnings of tourism that was bringing people to the shallow, navigable waters of the Broads. His first major work, *Life and Landscape on the Norfolk Broads* (1886), was a folio of forty

**4.5
PETER HENRY
EMERSON,** *Poling the
Marsh-Hay,* **plate 17
from his book** *Life and
Landscape on the
Norfolk Broads,* **1886.
Victoria & Albert
Museum (Library),
London.**

Emerson's photographs
of country life some-
times resemble the
paintings of peasants by
Jean-François Millet
(1814–1875), whom he
admired. Depicting rep-
resentative types, rather
than individuals, both
often used a low angle
to monumentalize
figures against the sky.
Photographed in low
November light, *Poling
the Marsh-Hay* focuses
on the sturdy figure
of the woman in the
foreground, allowing
other figures to pass
into shadow.

mounted PLATINUM PRINTS (called
platinotypes in the period) with accom-
panying text by Emerson and his friend
and traveling companion, the artist
Thomas Frederick Goodall (1857–1944).
Emerson's pictures emphasized the
unchanged relationship of people to the
land (Fig. 4.5).

Emerson was known as an eccentric
art celebrity, whose ideas and work were
controversial, like those of American
painter James McNeill Whistler (1834–
1903). When he rejected his own theory
in a black-bordered pamphlet titled *The
Death of Naturalistic Photography* (1890),
the public was skeptical. Yet Emerson
maintained that his early theory was
based on a belief that tones in a photo-
graph could be manipulated to a greater
degree than chemists now proved possi-
ble. Having promoted art photography
as a cutting-edge application of recent
science, he cast it off because he saw it
as limiting the individuality of the artist.

PICTORIALISM

Although Emerson wrote that he found
much amateur and art photography pre-
tentious, many practitioners ignored
his insults, and based their ideas of art
photography on his photographs, with
their subdued middle-gray tones, soft
focus, and peaceful, agrarian subjects.
Amateurs of art photography creatively
misunderstood Emerson's writings to
authorize moving away from faithful
depiction toward more evocative and
expressive photographs. The resulting
international photographic movement
known as Pictorialism gathered strength
in the mid-1880s, peaked in the 1900s,
and persisted into the 1920s.

Pictorialists adopted Emerson's dis-
gust with industrialization and mass-
produced goods, as well as his belief in
photography as a full-fledged modern
art form. They embraced his choice of
subjects, but jettisoned allegiance to

4.6 (right)
JANE REECE,
*The Poinsettia Girl
(Self-Portrait),* 1907.
Sepia-toned gelatin
silver print. Dayton Art
Institute, Dayton, Ohio.

Reece lived in New York
City for a time in 1909,
and exhibited her
work with the Photo-
Secession.[16] Her min-
gling of contemporary
art styles was typical of
Pictorialists, who, like
earlier nineteenth-
century photographers,
allied themselves with
art in other media.

recent science. In Pictorialist hands, Emerson's selective or differential focus became a dislike of the distracting details associated with vulgar commercial photography. Pictorial photographers often overlaid large parts of a picture with shadow and fog. In contrast to their simple subjects, they strove for tonal complexity choosing techniques such as platinum printing that yielded abundant soft, middle-gray tones. They favored procedures that allowed for handworking of both negatives and prints. Their results were in obvious visual opposition to the sharp black-and-white contrasts of the commercial print. Pictorial photographs were frequently printed on textured paper, unlike the glossy surface of commercial photographs, so that they resembled watercolors, and evoked the earlier Victorian photographs of David Octavius Hill and Julia Margaret Cameron (see pp. 70–72 and p. 158), which they admired and exhibited.

Pictorialists valued the symbolic control over industry, and a sense of superiority over the snapshooters, who did not even develop their own film. One Pictorialist asserted that "the photographer is not helpless before the mechanical means at his disposal. He can master them as he may choose, and he can make the lens see with his eyes, can make the plate receive his impressions."[14] Pictorialist writing encouraged a self-image of cultural heroism, striking back at the worst of the modern world. In his influential 1901 book, *Photography as a Fine Art*, critic Charles H. Caffin (1854–1918) described the "men and women who are seeking to lift photography to the level of one of the Fine Arts" as "'advanced photographers'," and Alfred Stieglitz (1864–1946), who would emerge as the foremost art photographer, as an "artist, prophet, pathfinder."[15]

As Emerson's justification of selective focus—that is, to match the way the eyes see—faded from currency, the writings of Henry Peach Robinson, which Emerson strongly disliked, were devoured by a new generation. Robinson, best known for his combination prints (see p. 155), was probably even more responsible for popularizing the word "pictorial" than Emerson. His book *Pictorial Effect in Photography*, first pub-

lished in 1869, was still read at the turn of the century. A few photographers made elaborate *tableaux vivants* of Old Master paintings, extending Robinson's own practice. Serious amateurs, as they were called, sometimes blended contemporary styles and themes in their work. Jane Reece (c. 1869–1961), a

commercial portraitist in Dayton, Ohio, combined turn-of-the-century interest in Japanese prints, with their flattened space, and the principle that one should beautify the experience of everyday life, an idea promoted by the Arts and Crafts movement and the followers of Art Nouveau (Fig. 4.6).

To Emerson's annoyance, another British photographer, George Davison (1854–1930), expanded upon Emerson's theories and promoted an imprecise notion of impressionistic photography. Whereas Impressionism, the French art movement of the 1870s–80s, aimed at capturing a momentary visual imprint of a scene, impressionistic photography attempted to render a personal response to a subject. Soon the words, "poetic," "art," "naturalistic," and "impressionistic" all came to signal Pictorial photography, exemplified by Davison's *The Onion Field* (Fig. 4.7). Unlike Emerson's work, where the main subject was in focus, the entire surface of *The Onion Field* is indistinct. Davison thus shifted the

foundations of art photography from science to art. Yet the "fuzzygraph," as Pictorial photographs were mockingly called, helped foster the photographic industry, as commercial manufacturers produced soft-focus lenses and textured photographic papers for amateur use.

Emerson's renunciation of naturalistic photography did not stop him making pictures or criticizing the growing popularity of the GUM-BICHROMATE PROCESS that made it possible to add pigment and texture to a print. French photographer Robert Demachy (1859–1936) promoted the technique in influential articles and worked extensively in it himself (Fig. 4.8). Another proponent of so-called gum printing was German photographer Heinrich Kühn (1866–1944), whose painterly photographs using the technique vexed viewers at the first amateur photographic exhibition held in Berlin (1896) (Fig. 4.9). Like Emerson, Kühn was a scientist and a doctor, but his training did not lead him to a scientifically based theory of art.

4.7
GEORGE DAVISON, *The Onion Field*, 1889, from *Camera Work*, January 1907. Photogravure. Library of Congress, Washington, D.C.

The blur in Davison's image was produced using a PINHOLE CAMERA, which softened edges and imparted a dreamy haze not necessarily present at the time of exposure. Printed as a GRAVURE, a technique favored by Pictorialists because it suppressed detail, the image seems to have flowed into the fabric of the paper on which it is printed.

4.8 (left)
ROBERT DEMACHY, *Struggle*, from *Camera Work*, January 1904. Photogravure. Library of Congress, Washington, D.C.

Gum printing allowed Demachy to demonstrate that a camera's image was only the starting point for the production of an artwork. Like a painter, the photographer could use a brush or other instruments to alter and color a scene.

4.9 (above)
HEINRICH KÜHN, *On the Hillside*, 1910. Gum bichromate print. Gilman Paper Company Collection, New York.

Pictorialists' conservative philosophical outlook was sometimes countered by experiments with pictorial space. In this image, the background all but disappears, and the figure is pushed to the foreground, as in a Japanese print.

4.10 (right)
FRANK EUGENE, *Adam and Eve*, 1910, from *Camera Work*, April 1910. Photogravure. Library of Congress, Washington, D.C.

Eugene scratched his photographic negative with obvious etching needle marks, creating a hybrid between photography and print-making. His method shocked photographers, print-makers, and painters, who objected to the mixing of techniques and to Eugene's refusal to make seamless illusions.

With photographers Hans Watzek (1848–1903) and Hugo Henneberg (1863–1918), Kühn exhibited under the name Das Kleeblatt (The Trifolium, or Cloverleaf, referring both to the three-lobed leaf, and the three-part window of Gothic architecture). Kühn moved easily between groups of European photographers and painters. American-born Frank Eugene (1865–1936) was equally international. He sometimes combined photography and printmaking (Fig. 4.10), and favored dreamy views of leisured women enjoying nature, a popular theme in Pictorial photography. In 1906, he moved to Germany, where he made both paintings and photographs.

Like Art Nouveau artists in Europe and America, the Pictorialists raised aesthetic experience to a paramount life goal. From their point of view, what was needed was aesthetic reform of the whole society, and they hoped to start the process by banishing the harsh and unsightly realm of industry from their

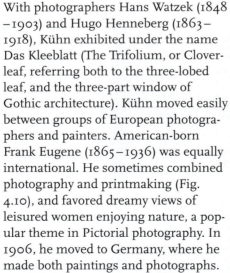

**4.11
SERGEI LOBOVIKOV,**
The Widow's Pillow,
c. 1900. Bromoil and
varnish. Mikhail
Golosovskii Collection,
Krasnogorsk, Russia.

Despite the blurry
image, the woman's
raised hand makes clear
that she has endured a
life of manual labor. She
clutches a bundle of
straw gleaned, perhaps,
from the field before her.

work. Pictorialism created international networks of artists and amateurs. In Russia Sergei Lobovikov (1870–1942) adopted it to render traditional peasant life, not as ethnographic data, but as an expression of nostalgia for nature and simpler times (Fig. 4.11). Like other Pictorialists, Lobovikov worked with gum bichromate and made platinum prints; he also favored the BROMOIL PROCESS, which allowed him to apply color to the print with a brush. In Japan, the Pictorial look dominated

portraits, street scenes, landscapes, and ethnographic photography until the mid-1930s, when it finally gave way to the pressures of modernism and abstraction.

MOVEMENTS AND MAGAZINES

The first photographic associations brought together people with diverse interests and occupations. Their publications covered subjects from art exhibits and travel to technical instructions and new commercial products. In

4.12
HANS WATZEK,
Sheep, from *Camera Work*, January 1906. Photogravure. Library of Congress, Washington, D.C.

4.13 (right)
HUGO HENNEBERG,
Villa Falconieri, from *Camera Work*, January 1906. Photogravure. Library of Congress, Washington, D.C.

As it had for generations of painters, the Italian landscape and its ancient villas attracted Pictorial photographers. Henneberg's image shows the Pictorial concern with light, water, clouds, and reflections.

the 1890s, however, Pictorial photographers felt constrained by the uncritical commercialism of the older photographic organizations and the mediocrity of the images their members produced. They worried haughtily that snapshot photography was impairing the aesthetic sensibility of the public. Believing their medium equal to the other arts, and a source of spiritual and aesthetic fulfillment, they wanted to associate with like-minded people and to arrange their own exhibits.

Among the first associations formed solely to advance art photography was the Wiener Kamera Klub (Vienna Camera Club), in 1891, which celebrated its founding with a show of 600 art photographs. Its members included Watzek, Henneberg, and Kühn. Artists in other media acknowledged the aesthetic aspiration of Pictorial photographers by sitting on juries for photographic exhibitions, and by showing art photographs at their own shows. For example, Watzek's gum bichromate photographs were presented at an 1898 exhibit sponsored by the Munich Secession, an association of artists formed in 1892 with interests akin to the Pictorialists' (Fig. 4.12). A similar group, the Vienna Secession, showed Henneberg's gum prints in 1902 (Fig. 4.13).

Art photography organizations were typically international in membership: Watzek, Henneberg, and Kühn, for

4.14
ÉMILE JOACHIM CONSTANT PUYO, *Puyo, Robert Demachy, and Paul de Singly with Model*, 1909. Platinum print. Gilman Paper Company Collection, New York.

example, were also members of the Photo-Club de Paris, which broke from the more conservative Société Française de Photographie in 1894. Two of the Photo-Club's founders, Robert Demachy and Charles E. J. Constant Puyo (1857–1933), had an international audience for their writing about the gum bichromate process (Fig. 4.14).

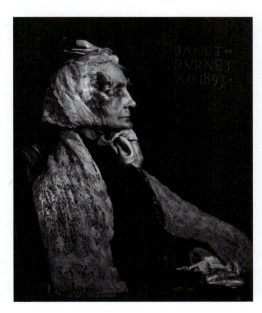

Watzek, Henneberg, and Kühn were also elected to the British association called the Linked Ring—formed in 1892 in opposition to the Photographic Society of Great Britain—whose fifteen founders included Henry Peach Robinson and George Davison. The "Links" thought of themselves as members of a spiritual and aesthetic fellowship. Their Photographic Salons were held yearly, exhibiting work they approved, such as that of James Craig Annan (1864–1946), son of photographer Thomas Annan, who had photographed the Glasgow slums before they were demolished (see Fig. 3.87). James Craig Annan admired the work of Hill and Adamson; as a youngster he met Hill, and in the 1890s he began making prints from Hill and Adamson negatives. Having learned the gravure process in Vienna from its inventor Karl Klïc (1841–1926), Annan began working with his father doing fine printing (Fig. 4.15).

American photographer Clarence H. White (1871–1925) was also elected to the Linked Ring. White's photographs

4.15 (left)
JAMES CRAIG ANNAN, *Miss Janet Burnet*, 1893. Vintage tissue photogravure from *Camera Work* by Alfred Stieglitz, 1907.

Annan's photograph of Janet Burnet shows how Pictorialists blended artistic themes and ideas. He sometimes printed the photograph with the subject looking left and sometimes to the right. He may have been influenced by Whistler's *Arrangement in Gray and Black (Whistler's Mother)*. In the background, the sitter's name is rendered as it might be in a print by German artist Albrecht Dürer (1471–1528).[17]

4.16
CLARENCE H. WHITE,
Morning, 1908.
Photogravure print.
George Eastman House,
Rochester, New York.

The purity of morning
and the idea of a fresh
beginning are indicated
by bright light filtering
through fog. The glass
globe that the model
carries appears in sev-
eral of White's images.

centered on familiar Pictorial themes, rendered with delicate atmospheric effects (Fig. 4.16). Through his teaching at Columbia University in New York City, White became influential in American photography. He had been hired at Columbia by the painter and theorist Arthur Wesley Dow (1857–1922), whose understanding of *notan,* a Japanese concept of graphic patterning, was widely experimented with by the Pictorialists.

White went on to found a photography school in his own name in 1914. His students included luminaries such as Dorothea Lange, Margaret Bourke-White, and Paul Outerbridge.

Another American, F. Holland Day (1864–1933), was also elected to the Linked Ring. Day explored the possibility of using the camera to depict religious scenes in his Sacred Art series (Fig. 4.17). These photographs provoked ardent

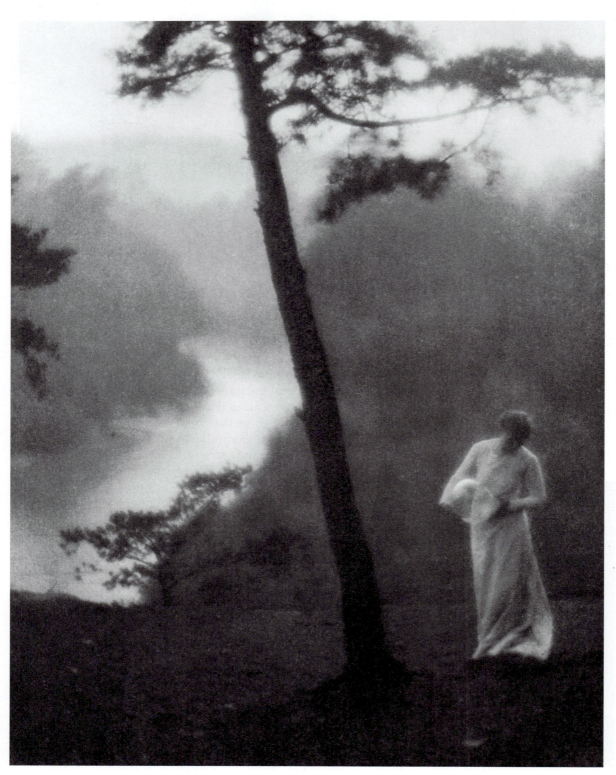

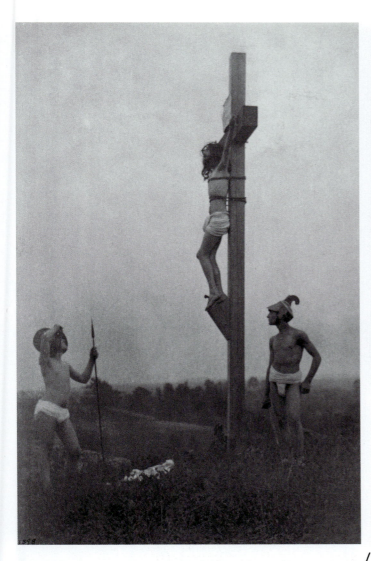

4.17
F. HOLLAND DAY,
Untitled (Crucifix with
Roman soldiers), 1896.
Platinum print.
Library of Congress,
Washington, D.C.

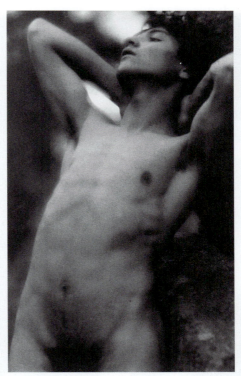

4.18
F. HOLLAND DAY,
*Nude Youth with Laurel
Wreath Standing
Against Rocks*, c. 1907.
Platinum print.
Library of Congress,
Washington, D.C.

Day's sensuous images
of the male nude
blend a fondness for
classical sculpture with
eroticism. Somewhat
obscured by his Pictorial
technique, Day's nudes
were not censored for
their explicitness but
applauded for their
refinement.

discussions about what constituted a proper photographic subject. A man of independent means, Day was the co-founder of the Boston publishing firm Copland & Day, which published the American editions of such controversial volumes as Oscar Wilde's *Salomé* and Aubrey Beardsley's *The Yellow Book*. His interest in the erotic human form was expressed in a number of nude and semi-nude photographs (Fig. 4.18).

Another Link, British photographer Frederick H. Evans (1853–1943), rejected the special lenses and negative manipulations used by many Pictorialists, in favor of what he called "pure photography."[18] Writing about his work, mostly platinum prints, Evans explained that he found architecture best suited for art photography. His goal was to record an emotional and aesthetic response to space, light, and shadow, especially in the interiors of historic English churches, cathedrals (Fig. 4.19), and French châteaux.

THE PHOTO-SECESSION

Writing in *American Amateur Photographer* in 1904, critic Sadakichi Hartmann (1867–1944) used an exhibition at the Carnegie Institute in Pittsburgh, Pennsylvania, as a springboard for his thoughts on contemporary photography. Not attempting to disguise his distaste, he called the organizers "pictorial extremists, who lay more stress on 'individual expression' than on any other quality." Some works, he scolded, "overstep all legitimate boundaries and deliberately mix up photography with the technical devices of painting and the graphic arts." He wondered whether the Pictorial photographers were doing an "injustice to a beautiful method of graphic expression," that is, photography. "Why then," he asked, "should not a photographic print look like a photographic print?" He called for "straightforward depiction" or "straight photography."[19]

One of the organizers of the 1904 Pittsburgh show was the American photographer Alfred Stieglitz, who was well positioned to lead an art movement. Through his work as an editor of *American Amateur Photographer* and *Camera Notes*, the journal of the Camera Club of New York, Stieglitz knew the work of the major Pictorial photographers in Europe and America. He

4.19
FREDERICK H. EVANS, *Steps to Chapter House: A Sea of Steps, Wells Cathedral*, 1903. Platinum print. Museum of Modern Art, New York.

The staircase of the Chapter House at Wells Cathedral in Britain was the subject of commercial architectural photography before Evans photographed it. But the low vantage point and concern with the effects of light favored by Pictorial photographers were especially suited to dramatizing the sweep of stairs. Evans chose a point of view that opposed the wide lower stairs with the foot-worn, wave-like higher stairs on the left. His photograph was taken at a time of day when the individual steps were fringed with light, like whitecaps on the sea.

wanted *Camera Notes* to be international in scope, and to make American photography the equal of European painting, much revered in the United States. By the time Camera Club members objected to his aesthetic agenda, Stieglitz had already built up a following of art photographers who were ready to form their own association. Adopting the word "secession" from the art movements in Vienna and Berlin that were "seceding" from conventional academic work, and in the spirit of the Linked Ring, Stieglitz launched the Photo-Secession in February 1902. Three weeks later, the Photo-Secession sponsored a large exhibition of "American Pictorial Photography" with the works of thirty-two photographers, among them Frank Eugene, F. Holland Day, Gertrude Käsebier, Clarence H. White, and Alfred Stieglitz. In December, the Photo-Secession then issued a statement of purpose:

> The object of the Photo-Secession is:
> To advance photography as applied to pictorial expression;
> To draw together those Americans practicing or otherwise interested in the art, and
> To hold from time to time, at varying places, exhibitions not necessarily limited to the productions of the Photo-Secession or to American work.[20]

Stieglitz became a major organizer of the new art photography, but this role was not unprecedented. Influential shows had been organized in Berlin by his mentor, Hermann Wilhelm Vogel (1834–1898); by the Amateur Photography Club in Vienna; by the Society for the Advancement of Amateur Photography in Hamburg; and, of course, at the annual salon sponsored by the Linked Ring.[21] In the United States, too, Clarence White proved an able advocate for photography with the shows he sponsored at the Camera Club of Newark, Ohio. Before the founding of the Photo-Secession, Day proposed an "American Association of Pictorial Photographers," to be based in Boston. In 1900, he organized an exhibition of about 300 images, called the "New School of American Photography," which was sponsored by the Royal Photographic Society and shown in London, and the next year by the Photo-Club de Paris in the French capital. Though Day's photographs were shown

by the Photo-Secession, he never formally joined the group, perhaps because of his rivalry with Stieglitz.

One advantage Stieglitz possessed was his periodical *Camera Work*, published from 1903 to 1917. Modeled on fine art publications, *Camera Work* was printed in decorative typography on deluxe paper; abundant samples of the new photography were mostly reproduced in gravure. Other journals advocating art photography included such lavishly illustrated German magazines as *Photographische Rundschau* (*The Photographic Review*) and *Die Kunst in der Photographie* (*The Art of Photography*). Stieglitz enlarged the scope of *Camera Work* to encompass the other arts and art theory. In July 1912, for example, he published selections from Russian painter Wassily Kandinsky's (1866–1944) *Concerning the Spiritual in Art*.

The covers for *Camera Work* were designed by Edward Steichen (1879–1973), a painter-photographer who was also a founding member of the Photo-Secession. Outside *Camera Work*, Stieglitz continued to promote photography in popular magazines and journals. In a 1903 pamphlet, Stieglitz manifested the outlook that made him notoriously difficult to work with. In scarcely veiled self-praise, he announced that progress is not achieved by the masses, but by the "fanatical enthusiasm of the revolutionist, whose extreme teaching has saved the mass from utter inertia." Photo-Secessionists, he announced, possess a feeling of "rebellion against the insincere attitude of the unbeliever, of the Philistine."[22]

Stieglitz also ran the Little Galleries of the Photo-Secession, which opened in November 1905 at 291 Fifth Avenue, in Steichen's former studio. Steichen organized the first exhibition at "291," followed by a show of French photography selected by Demachy. Prints by Hill and Adamson (see Figs. 2.63, 2.64), greatly admired by Pictorial photographers, were also shown, and reproduced in *Camera Work*. Working with Steichen, Stieglitz showed artwork in other media: drawings by Auguste Rodin (1840–1917), Henri Matisse (1869–1954), and Picasso; watercolors by Paul Cézanne (1839–1904) and Picasso; sculpture by Constantin Brancusi (1876–1957) and

PORTRAIT
Alfred Stieglitz

Born in Hoboken, New Jersey, Stieglitz took up photography while he was an engineering student in Berlin, studying photochemistry with Vogel. Soon his photographs were winning awards, and he was writing essays on the aesthetics and technical obstacles of the field. His early work includes the familiar tranquil scenes and all-over blurriness of Pictorialism, but his depiction of light and textures is clearer than Pictorial photography. For instance, *Sun's Rays—Paula, Berlin* (1889) delineates the bands of light that pass through the shutter slats outside the room (Fig. 4.20). The technical virtuosity required to create a photograph in this lighting would be understood by photographers, but the personal symbols Stieglitz included would only be grasped by his immediate circle. On the wall behind his companion Paula are photographs of and by Stieglitz. One of them shows the letter-writer in bed, suggesting their intimate relationship. The Valentine hearts and the caged bird also speak to the private subject-within-a-subject, a favorite visual strategy Stieglitz would use throughout his life.

When he returned to the United States from Europe in 1890, he worked for five years at the Photochrome Engraving Company in New York, and continued to make photographs. His marriage to Emmeline Obermeyer, a woman of financial means, and an allowance from his father, permitted Stieglitz to leave the business and pursue photography full time. His street photographs in New York City and during extended European trips centered on such everyday scenes as horse-drawn streetcars, rain-slicked avenues, and street children. Foreshadowing the 1904 critique of Sadakichi Hartmann (see p. 181), Stieglitz's images in the 1890s became more

4.20
ALFRED STIEGLITZ, *Sun's Rays—Paula, Berlin*, 1889.
Chloride print. Alfred Stieglitz Collection. Art Institute
of Chicago, Chicago, Illinois.

4.21
ALFRED STIEGLITZ,
The Steerage, 1907, from
Camera Work, no. 34.
Photogravure. Museum of
Modern Art, New York.

straightforward, with an increasing emphasis on form, rather than atmosphere. His interests in contemporary art moved toward urban realism, like that of American painter Robert Henri (1865–1929), whom Stieglitz nonetheless accused of making "colored photographs."[23] Stieglitz also responded to the geometric experiments of such European painters as Pablo Picasso (1881–1973).

While sailing on a trip to Europe aboard the *Kaiser Wilhelm II*, Stieglitz experienced what he recalled as a watershed moment. He was looking over the first-class deck to the steerage below, recognizing there not the disheartened immigrants returning to Europe, but a combination of abstract forms that evoked a profound response:

A round straw hat, the funnel leaning left, the stairway leaning right, the white draw-bridge with its railings made of circular chains—white suspenders crossing on the back of a man in the steerage below, round shapes of iron machinery, a mast cutting into the sky, making a triangular shape . . . I saw a picture of shapes and underlying that the feeling I had about life.[24]

The resulting photograph, *The Steerage*, became his favorite image (Fig. 4.21). The instantaneous visual recognition of a personal, not public, symbol informed much of Stieglitz's photography. His numerous photographs of his second wife, painter Georgia O'Keeffe (1887–1986), show how he, like Picasso, used everyday life as a basis for art.

PORTRAIT
Edward Steichen

Were it not a gum-print, the self-portrait of Edward Steichen might be mistaken for that of an emotionally intense Romantic artist, with his head, hands, and palette brightly highlighted, and his face partially sunk in shade (Fig. 4.22). Early in his career, Steichen took up painting and photography, both of which he pursued until World War I. After two years studying art in Paris, he returned to the United States in 1902 and opened a portrait studio at 291 Fifth Avenue, which later became the Little Galleries of the Photo-Secession. A close friend of Stieglitz (Fig. 4.23), Steichen collaborated with him on *Camera Work* and on exhibitions. Elected to the Linked Ring in 1901,

4.22
EDWARD J. STEICHEN,
Self-Portrait, 1902. Library of
Congress, Washington, D.C.

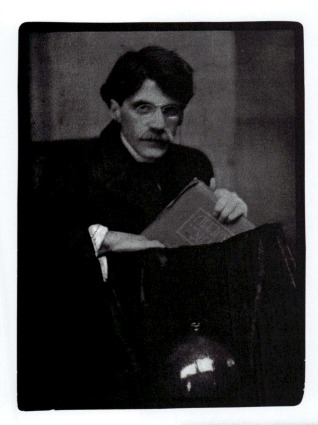

and a founding member of the Photo-Secession in 1902, Steichen worked on the exhibits that brought modern European art to 291. His Pictorial work resembles that of Alvin Langdon Coburn (1882–1966) (see Figs. 4.40, 4.41) in its emphasis on design and powerful graphic contrasts (Fig. 4.24). With Stieglitz and other Pictorial photographers, Steichen experimented with the color photography process known as autochrome (see p. 169), whose muted colors and pebbled surface had a Pictorial quality.

Unlike Stieglitz, Steichen had no family money. He supplemented his income as an art photographer by doing portrait, advertising, and other commercial work. Born in Luxembourg, he felt he had to show his allegiance by enlisting in the United States Army, where he set up a department of aerial photography. In 1923 he began a career as the chief photographer for Condé Nast publications. During World War II (1939–45), he returned to military service, directing United States naval combat photography. He also organized two patriotic photographic exhibitions at New York's Museum of Modern Art, the *Road to Victory* (1942) and *Power in the Pacific* (1945), which helped him become director of the influential Department of Photography at the museum. In 1955, he organized *The Family of Man* (see Chapter 6).

4.23 (above)
EDWARD J. STEICHEN,
Alfred Stieglitz, 1907. Four-color halftone. Museum of Modern Art, New York.

4.24
EDWARD J. STEICHEN,
Nocturne: Orangerie Staircase, Versailles, c. 1910. Pigment print. Albright-Knox Gallery, Buffalo, New York.

4.25
ALFRED STIEGLITZ,
Equivalent, 1930.
**Gelatin silver print. The
J. Paul Getty Museum,
Los Angeles, California.**

Stieglitz chose the word,
Equivalent, as a title in
a series of cloud studies.
The images were equiva-
lent to a state of mind
or emotion for which
there are no words.

Elie Nadelman (1882–1946); litho-
graphs by Henri de Toulouse-Lautrec
(1864–1901); artwork by Americans
such as Marsden Hartley (1877–1943),
John Marin (1870–1953), and Georgia
O'Keeffe; as well as children's art and
Japanese prints.

The 291 gallery regularly showed
modern art, including the first Ameri-
can exhibition of Picasso in 1911.
Stieglitz praised Picasso's "antiphoto-
graphic" work, meaning that it had
renounced the simple vanishing-point
perspective imposed by the camera.
He advocated that art photography
should be similarly antiphotographic,
not necessarily through abstraction, but
by reaching beyond subject-matter for
personal and spiritual expression.
Stieglitz's own work was shown only

once in a one-person exhibition at 291,
during the so-called Armory Show in
1913, when about 1,300 pieces of mod-
ern European art were exhibited in New
York, including Marcel Duchamp's
(1887–1968) *Nude Descending a
Staircase* (see Fig. 4.55).

During the 1920s, Stieglitz contin-
ued his photographic experimentation,
creating hundreds of what he called
Equivalents (Fig. 4.25). These cloud stud-
ies show how he never relinquished the
assumption of Pictorial photography
that the ordinary world abounded with
evocative symbols of emotion.

THE NUDE AND PICTORIALISM

Pictorialism's emphasis on nature and
the natural gave rise to studies of the
male and female nude, created by

White, Steichen, Demachy, Puyo, and Annie Brigman (1869–1950), among others. Alice Boughton (1886–1943), a member of the Photo-Secession, published an image that subtly compared the bodies of pubescent and pre-pubescent girls in a 1909 issue of *Camera Work* (Fig. 4.26). Those interested in creating more explicit and sexually arousing images took advantage of the acceptance of the Pictorial nude, imitating its soft-focus, painterly surface, or classical references. Wilhelm von Gloeden (1856–1931) mixed the exoticism of earlier nineteenth-century sexual photographs with Pictorial themes. He photographed Italian lads in Sicily, reclining on animal skins and Persian rugs, and surrounded by planters bearing classical motifs (Fig. 4.27).

WOMEN IN THE PICTORIAL MOVEMENT

The long-standing association of women with both nature and domesticity made feminine subjects a favorite in Pictorial practice. Women, too, worked with these themes; in particular, Californian photographer Annie Brigman portrayed women as spirits or souls of trees, rocks, water, and even photography (Fig. 4.28). Portraiture was thought to be done

4.27 (below)
BARON WILHELM VON GLOEDEN, *Nude Sicilian Youths*, c. 1885. Gelatin silver print. The J. Paul Getty Museum, Los Angeles, California.

4.26 (above)
ALICE BOUGHTON, *Nude*, from *Camera Work*, April 1909. Library of Congress, Washington, D.C.

Boughton frequently photographed children. The public's understanding that an intimate natural bond exists between women and children protected her from charges of indecency.

4.28
ANNIE BRIGMAN,
The Heart of the Storm,
**c. 1910. Platinum print.
The J. Paul Getty
Museum, Los Angeles,
California.**

The nude figures leaning
into each other emulate
the arc of the storm-
blasted tree trunks in
which they seem to be
taking shelter. Brigman's
photographs often
situated female nudes
in nature to evoke
ideas such as suffering,
endurance, and love.

better by women, who were considered
to possess a more intuitive grasp of the
sitter's personality and a wider range of
emotional response than men. With the
increased acceptance of women's apti-
tude, their work was shown in large
exhibits and magazines.

Frances Benjamin Johnston (1864–
1952) ran a successful business, branch-
ing out from flattering Pictorial portraits
of prominent people in Washington,
D.C. She photographed architecture,
industrial sites, and documented the
activities of the Hampton Institute in

Virginia, where young African-Ameri-
cans received training in the trades.
Johnston promoted photography as a
means of employment and recreation
for women, writing upbeat essays in
such magazines as *Ladies Home Journal.*
In 1900, she arranged an exhibit of
142 women's photographs in Paris, at
the same time as the international
Exposition Universelle. The show trav-
eled to Moscow, and then back to Paris,
but never found a venue in the United
States. Johnston created a self-portrait
as a caricature of the New Woman, a

4.29
PHOTOGRAPHER UNKNOWN, *Untitled (Is your wife a Suffragette?)*, postmarked 1908. Postcard.

4.30 (below)
PHOTOGRAPHER UNKNOWN, *"Mrs. How Martyn Makes Jam,"* from *Suffragettes at Home*, n.d. Postcard. Museum of London.

The Suffragists used popular media such as the postcard to show that women who crusaded the vote had no intentions of abandoning their domestic duties.

THE WOMEN'S FREEDOM LEAGUE, I, Robert Street, Adelphi.

SUFFRAGETTES AT HOME.—(3.) Mrs. How Martyn Makes Jam.

4.31 (right)
ARTIST UNKNOWN, *Untitled* (Advertisement for Kodak cameras), c. 1910. Poster. George Eastman House, Rochester, New York.

To persuade more women that photography was a chic hobby, Kodak created the Kodak Girl, a fashionable, independent, yet feminine New Woman, who took her camera with her on holiday adventures.

figure in revolt against contemporary standards of feminine behavior (Fig. 4.0).

In its depiction of women, Pictorial photography expressed a deep-seated conservatism at the historical moment when more women were working outside the home in schools, factories, and offices, and when there were focused international efforts to gain women the right to vote. In Britain, anti-suffragist imagery ridiculed women activists as mannish brutes who neglected their domestic duties and showed men as reduced to doing housework (Fig. 4.29). To counter such propaganda, suffragists portrayed themselves as tender mothers and caring homemakers who wanted to influence government policy on children (Fig. 4.30).

The acceptance of women practicing photography, especially as amateurs, was expressed in the advertising image of the Kodak Girl, introduced in 1901, and continued, with fashionable updates, for decades[25] (Fig. 4.31). Pictorialism's soft focus and association

PORTRAIT
Gertrude Käsebier

Gertrude Käsebier (1852–1934) was probably the most successful American portrait photographer in the first decade of the twentieth century. Like Julia Margaret Cameron (see p. 158), Käsebier came to photography later in life, first as a hobbyist, then as an art photographer, and finally as a sought-after portraitist. Her photographs of women sometimes relied on implicit storytelling in the manner of Lady Hawarden (see p. 161). *Blessed Art Thou Among Women* (1899) shows a mother about to send her child into the world (Fig. 4.32). The mother-and-child theme, prominent in Käsebier's photography, was often depicted with the mother helping the child negotiate the

4.32
GERTRUDE KÄSEBIER, *Blessed Art Thou Among Women*, 1899. Platinum print on Japanese tissue. Museum of Modern Art, New York.

passage into life, rather than holding the child close. The photograph, with its religious overtones, is a portrait study of Agnes Rand Lee and her daughter Peggy. A print of the Annunciation (when the Angel Gabriel appears to the Virgin Mary) hangs on the wall behind the figures. Agnes Lee is dressed in loose, flowing robes, as advocated by British artist and reformer, William Morris (1834–1896). Soon after the photograph was made, Peggy Lee died. Agnes then posed as the sorrowful mother in Käsebier's 1904 photograph, *The Heritage of Motherhood*.

Käsebier's photographs were honored abroad, and she was elected to the Linked Ring in 1900. *Blessed Art Thou Among Women* was included in the first exhibition of the Photo-Secession, and her work was showcased in the first issue of *Camera Work* (January 1903).

Käsebier's sensuous *Portrait—Miss N.* redresses the saccharine charms of motherhood so much associated with her work. It depicts Evelyn Nesbitt, the sixteen-year-old showgirl and mistress of prominent architect Stanford White[26] (Fig. 4.33). Nesbitt figured in a sensational early twentieth-century scandal and murder fictionalized by E.L.Doctorow in the novel *Ragtime* (1975): she married railroad heir Harry K. Thaw, who, spurred by jealousy over her previous relationship with Stanford White, shot him dead in 1906.

4·33
GERTRUDE KÄSEBIER, *Portrait—Miss N. (Evelyn Nesbitt)*, 1902. Platinum print. National Gallery of Canada/Musée des Beaux-Arts du Canada, Ottawa.

MRS. CONDÉ NAST
*wife of the distinguished pub-
lisher of Vogue, Vanity Fair,
and House and Garden, is a
social leader of exceptional
charm. The exquisite taste and
smartness of her clothes are
matched by the intellectual bril-
liancy and the fascinating per-
sonality of their wearer.*

*"Women are realizing more and
more the necessity of a clear,
smooth youthful skin. The very
clothes they wear — so chic and
simple of line — call for youth in
their faces.
"Pond's Two Creams are the
foundation of a sure and simple
means of caring for the skin, of
keeping the complexion in ex-
quisite condition."*

Mrs Condé Nast

Photo—Baron de Meyer

MRS. CONDÉ NAST
on the importance of being beautiful

IN Mrs. Condé Nast's apartment that morning I sensed the bustle of arrival. Trunks bulked excitingly in the background and Mrs. Nast herself, from the cut of her shoes to her black bengaline frock with its white organdie collar and cuffs—was the chic, the youthfulness of Paris itself. While her line-free, exquisitely cared for skin bespoke youthfulness as eloquently as did her clothes.

"Paris was never so fascinating," Mrs. Nast was saying. "The clothes? Marvelous! So chic and simple of line, so unadorned! But they call for youth in the face as well as in the figure. So the smart woman *must* keep her skin youthful—radiant."

"What did you do for your own skin while you were abroad?" I asked her. "It looks perfect."

"I took plenty of good cold cream along," replied Mrs. Nast. "I positively depended upon it for cleansing. Pond's of course."

Then we talked of both the famous creams Society women are using to keep that youthfulness of skin Mrs. Nast finds essential for harmony with the mode.

This is How to Use Them

Once a day at least, and especially after exposure, smooth Pond's Cold Cream liberally over your face and neck. Let its pure oils bring to the surface the powder and dust with which the pores are clogged.

Repeat this process, and finish with a dash of cold water. Let a little cream stay on all night if your skin is inclined to be dry.

For the delicate finish you want by day, smooth in a light film of Pond's Vanishing Cream. It is instantly absorbed, giving your skin such a soft, lustrous finish that now your powder goes on smoother than ever before and clings longer. And you are perfectly protected against winter cold and wind. So before you go out be sure to use Pond's Vanishing Cream. The Pond's Extract Company, 131 Hudson Street, New York City.

*Every skin needs these
Two Creams*

Mrs. REGINALD VANDERBILT
Mrs. GLORIA GOULD BISHOP
Mrs. O. H. P. BELMONT
Mrs. MARSHALL FIELD, Sr.

are among the women of distinguished taste who have expressed approval of Pond's Two Creams.

with women, the major purchasers of home products, was particularly persistent in advertising[27] (Fig. 4.34) and portraiture (Fig. 4.35).

ANTHROPOLOGICAL PICTORIALISM

Together with Pictorialism, the International Arts and Crafts movement, with its emphasis on hand-crafted art objects and on home life, provoked an interest in Native American peoples.

Idealized as living close to nature, they were also known to be under threat from the incursion of Western civilization into their lands.[28] To meet amateurs' interest in Native American life, George Eastman sponsored the photographic expedition of Frederick Monsen (1865–1929). His *With a Kodak in the Land of the Navajo* (1909) was both a photographic booklet and an advertising device. Edward S. Curtis (1868–1952)

made numerous photographs of Native American life using gravure or platinum printing techniques, lending the pictures a soft, faded quality (Fig. 4.36). Curtis also asked his subjects to enact ritual dances and battles. He carried Native American costumes that his customers associated with pre-industrial life, using them occasionally to dress his subjects in what his viewers saw as authentic garb. Curtis produced a twenty-volume work, *The North*

4.36
EDWARD S. CURTIS,
Photograph and article
"Vanishing Indian
Types," from *Scribner's*
Magazine, **June 6, 1906.**
Library of Congress,
Washington, D.C.

Curtis's images of Native Americans often used a soft focus, giving expression to Western culture's notion that indigenous people would dwindle under the pressure of modern life.

From a photograph, copyright 1905, by E. S. Curtis.

Crow warriors on the edge of a precipice in the Black Canyon.

VANISHING INDIAN TYPES
THE TRIBES OF THE NORTHWEST PLAINS

By E. S. Curtis

ILLUSTRATIONS FROM PHOTOGRAPHS BY THE AUTHOR

THE Northwest Plains Indian is, to the average person, the typical American Indian, the Indian of our school-day books—powerful of physique, statuesque, gorgeous in dress, with the bravery of the firm believer in predestination. The constant, fearless hunting and slaughtering of the buffalo trained him to the greatest physical endurance, and gave an inbred desire for bloodshed. Thousands of peace-loving, agricultural-living Indians might climb down from their cliff-perched homes, till their miniature farms, attend their flocks, and at night-time climb back up the winding stairs to their home in the clouds, and at-

tract no attention. But if a fierce band of Sioux rushed down on a hapless emigrant train the world soon learned of it.

The culture of all primitive peoples is necessarily determined by their environment. This, of course, means that all plains tribes —though speaking a score of languages— were, in life and manner, broadly alike. They were buffalo-hunting Indians, and only in rare cases did they give any attention to agriculture. Buffalo meat was their food, and the by-products their clothing, tools, and implements.

The plains tribes in earlier times were certainly true nomads. For a time, in the

Pictorial photography. Degas seems to have enjoyed resolving particular formal and aesthetic photographic problems. "Daylight gives me no problem," he commented, "What I want is difficult—the atmosphere of lamps or moonlight."[30] (Fig. 4.38).

Norwegian painter Edvard Munch (1863–1944) used photography throughout his life, not only as a sketching instrument for his paintings, but also to create a series of what he called Fatal Destiny Photographs, in which melancholic sitters, including the painter, appear transparent, with the background visible through them. Munch's photographs resemble some of the experiments of Swedish playwright August Strindberg (1849–1912), who took up autobiographical photography, and hoped to make psychological photographs of sitters by intuiting their innermost thoughts. He developed a "Wunderkamera"—a large camera able to take life-size photographs of faces—to increase the sense of psychological presence, and wrote a defense of spirit photography, as photographs purporting to depict the presence of the dead were called.[31] Critic, playwright, and social

American Indian (1907–30), containing more than 1,500 photogravures as well as text. Like Stieglitz's *Camera Work*, the books were produced in limited editions on fine paper.

NON-PICTORIAL VISIONS

As the invention of dry plates, roll film, and hand cameras encouraged a greater number of hobbyists, it also allowed them to go their own way. Pictorialism did not appeal to everyone—amateur photographer Charles L. Mitchell (active 1890s) put it bluntly in 1900: "There are too many 'impressions' and too few clearly conceived, thoroughly expressed realities; too few real pictures, and too much 'trash.'"[29] Non-Pictorial efforts can be seen in the work of amateurs whose fame in other endeavors preserved their photographic work. For example, the novelist Zola took up photography in the late 1880s, producing unexceptional family portraits and trip mementos. Occasionally, though, he created a bold experiment with composition (Fig. 4.37). French painter Edgar Degas, whose paintings of the ballet inspired some Pictorial photographers, also found a visual challenge outside of

4.38 (below)
EDGAR DEGAS, *Berthe Morisot's Salon: Auguste Renoir and Stéphane Mallarmé*, c. 1890. Albumen print.

Degas's portrait of painter Auguste Renoir (1841–1919) and poet Stéphane Mallarmé (1842–1898) reveals Degas in the mirror, operating his camera, while Mallarmé's wife and daughter watch. Degas' face is obscured by the intense light of an oil lamp.

activist George Bernard Shaw (1856–1950) took more than 10,000 pictures. His self-portraits, pictures of friends, and landscapes typify the varied output of amateurs. Shaw also wrote extensively about photography, defending it as an art and advocating that photographers stick to the inherent qualities of the camera, which he considered to be sharp focus and no handworking of the negative and the print. Of George Davison (see Fig. 4.7), Shaw wrote "if I saw the edges of a house blur as they blur in Mr. Davison's pictures, I should conclude that I was going to faint, and probably do it too."[32]

A whimsical child in an eccentric, privileged French family, Jacques Henri Lartigue (1894–1986) took his first photograph at the age of six. His photography seems to have been guided more by his interest in stopping action than in making art images. He photographed early racing cars, flying machines, and fashionable people parading the boulevards. Although they seem worldly and sophisticated, many of his photographs were taken while he was a child or young adult. While his photographs were mostly taken with a stereographic camera, better able to stop time, they were not meant to be three-dimensional or commercial (Fig. 4.39).

PICTORIALISM: A CONSERVATIVE AVANT-GARDE

By 1909, the Photo-Secession was open to assault by its own revolutionary rhetoric. A vast 1909 international show in Dresden, Germany, arranged by Stieglitz with Steichen's help, was criticized for "doing nothing new,"[33] and many considered the art photography in *Camera Work* to be repetitive. When asked to prepare a large exhibit for the Albright Art Gallery in Buffalo, New York (now the Albright-Knox Art Gallery), Stieglitz staged what photohistorian Robert Doty called "a finale."[34] The 1910 exhibition of about 600 Pictorial photographs was organized as a retrospective of Pictorialism, with contributors asked to provide old and new work. The show is often cited as marking the historical moment when photography was accepted as an artform worthy of museums. It was also the point at which the Pictorial style had become visually sterile, though the

"fuzzygraph" vocabulary continued for another decade in commerce and advertising, and was popular in Japan and South Africa into the 1930s.

Was Pictorialism an avant-garde movement? Certainly it introduced a visual fashion dominant for thirty years, and mixed painting and photography in a way that anticipated the hybridization of art media in the late twentieth and early twenty-first centuries. At the same time, its sentimental subject-matter and its rendition of otherworldly women harked back to the nineteenth-century view of women as angels trapped in a domestic environment. Through Stieglitz and 291, art photography did engage with the European avant-garde, such as the Fauves and Cubists, but these painters did not substantially influence art photography in general, which seized upon the notion of an uncomplicated subjectivity. The Pictorialists largely ignored the raw emotionality and anxiety that marked Expressionism, the mainly German art movement much discussed in the 1890s. When Stieglitz and his colleagues took the city as a subject, they did so when atmospheric effects, such as fog, rain, and snow, softened the bleakness.[35]

Like other late nineteenth-century avant-gardists, the Pictorialists and Photo-Secessionists advocated self-expression as soul-preserving in the world of mass production and mass taste. Despite practicing promotional techniques in their magazines akin to those of the newly formed field of advertising, they did not court the praise of critics or the funds of patrons. Rather, they established a network of institutions, publications, and selection strategies to validate their work, while laying claim to unsullied virtue.[36]

As historian Ulrich Keller pointed out, art photography was not primarily concerned with art theory so much as it was with "spiritual exclusiveness," being "away from 'the Philistine' and 'the masses.'"[37] Stieglitz disparaged those who let money taint their art, though he was in a financial position to take the moral high ground. In 1899, he wrote that "nearly all the greatest work is being, and has always been done by those who are following photography for the love of it, and not merely for

4.39
J. H. LARTIGUE, *My
Cousin Bichonnade*,
1905. Association des
Amis de J. H. Lartigue,
Ministry of Culture,
Paris.

Lartigue wittily pictured
the life of his fashion-
able French family.
Caught jumping from
the middle of the stair-
case, cousin Bichonnade
seems to fly forward,
defying gravity.

financial reasons."[38] In an age of raging
labor disputes, Stieglitz praised working
for love, not money, but he also empha-
sized that amateurs were workers too.
After the horrors of World War I, the
ideology of Pictorialism was in full
retreat. Nevertheless, Pictorial-style pho-
tographs continued to be made, espe-
cially in advertising and amateur work,
despite the challenges of Russian
Constructivism, which stressed design
as a way for artists to participate in
changing society for the better, and
European Dadaism, which questioned
the plausibility of beauty and purity after
the horrors of trench warfare (see
Chapter 5).

Advocates of art photography have
viewed Pictorialism as avant-garde on
account of its tendency to stress abstract
patterns, which became a key visual
characteristic of art photography in the
1920s. The work of such photographers
as Alvin Langdon Coburn used the
visual conventions of Pictorialism,
including flattened space and dimin-
ished detail, to create abstract patterns
on the surface of the photographic print.
Coburn corresponded with American
painter Arthur Wesley Dow about *notan*
(see p. 180) and the Japanese use of per-

spective (Fig. 4.40). Despite the blurry
surface values of Coburn's prints, nei-
ther Emerson's differential focus nor
Davison's notion of personal impres-
sions are prominent in his work.
Instead, drawn to spiritualism and reli-
gious symbolism, Coburn sought out
patterns in nature as clues to a great
spiritual immanence. It is ironic that
Coburn, who spurned modernity later
in his life and became a Druid, also
made the first completely abstract
photograph).

Through the influence of poet Ezra
Pound (1885–1972), Coburn took up the
idea of Vorticism, an English art move-
ment named by Pound in 1913. The
movement's magazine, *Blast*, explained
that Vorticism would integrate the
dynamic movement of Futurism with
the static geometric analysis of Cubism.
The movement hoped to blast away the
remnants of the past. Coburn experi-
mented with abstraction, building a
Vortescope, a combination of mirrors
that produced an image like that of a
kaleidoscope, and photographing the
result (Fig. 4.41). Coburn's interest in
total abstraction lasted only about a
month; he never embraced the notion
that radical changes in the visual arts

**4.40 (opposite)
ALVIN LANGDON
COBURN**, *Wapping*,
plate 10 from his book
London, 1909. Victoria
& Albert Museum,
London.

Coburn's photographs
resemble the tonal
paintings of James
McNeill Whistler,
because they were both
interested in the space
and pattern of Japanese
prints, rather than illu-
sionistic representation.

**4.41 (right)
ALVIN LANGDON
COBURN**, *Vortograph*,
1917. Coburn Collection.
George Eastman House,
Rochester, New York.

Coburn created abstract
photographs called
Vortographs that resem-
ble the work of British
painter Wyndham Lewis
(1882–1957), the
primary Vorticist painter.
Both borrow heavily
from Cubism and
Futurism. In some of his
Vortographs, like this
one, Coburn used multi-
ple exposure to increase
the abstract effect.

could promote change on the social
front, an assumption that would guide
experimental photography in the 1920s
(see Chapter 5).

In the last issue of *Camera Work*
(June 1917), Stieglitz featured work by
Paul Strand (1890–1976). Strand was
younger than Stieglitz and Steichen, and
came to photography not through art,
but through social concern. As a student
of Lewis Hine (see p. 208) at the New

York Ethical Culture School in 1907,
Strand learned photography in an intel-
lectual atmosphere of moral concern for
humankind. He frequented the Little
Galleries of the Photo-Secession, where
he became acquainted with abstract art,
as well as with Pictorialism. Like critic
Sadakichi Hartmann, Strand rejected
the soft-focused "fuzzygraph" in favor of
what he called "absolute unqualified
objectivity" and "straight photographic

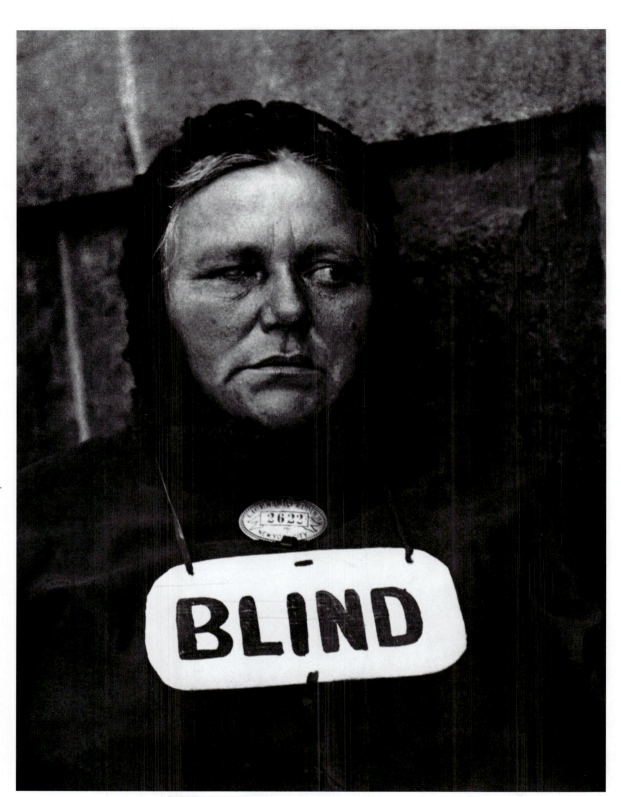

4.42
PAUL STRAND,
Photograph — New York
(Woman with sign
that reads "Blind"),
from *Camera Work,*
June 1917. Photogravure.
Library of Congress,
Washington, D.C.

Strand took his street
photographs with a trick
camera that led people
to believe he was shoot-
ing in another direction.
His portraits of the poor
were not part of a social
reform program, but
intended to be matter-
of-fact examples of life.
His audience would not
have known about the
trick camera, but they
would have understood
the picture's ironic
slant, namely, the con-
trast between the
camera's clear eye and
the woman's blindness.

means."[39] The 1913 Armory Show of contemporary European art, especially abstraction, also influenced him. In 1917, when *Camera Work* devoted its last issue to Strand's photography, Stieglitz wrote that Strand's work was "brutally direct," and "devoid of trickery and any 'ism.'" "These photographs," Stieglitz concluded, "are the direct expression of today."[40] Stieglitz included two areas of

Strand's work: close-up unsentimental portraits of street people, and near abstractions made by focusing on repeated patterns of light and dark found in the experience of everyday life (Figs. 4.42, 4.43).

In an essay accompanying his photographs, Strand stated his dislike of Pictorialism. He called gum-printing, oil-printing, and handworking of the

negative and the print "the expression of an impotent desire to paint." Yet Strand understood the Pictorial goal to make photography responsive to the photographer's intellect and emotion, which he called the "organization of objectivity."[41]

Strand credited Stieglitz for creating, through *Camera Work*, a true American art. "America has really been expressed in terms of America without the outside influence of Paris art schools or their dilute offspring here," Strand wrote,

**4.43
PAUL STRAND,**
Abstractions, Porch Shadows, Connecticut,
1915. Gelatin silver print by Richard Benson. Museum of Modern Art, New York.

Strand obscured his subject matter—shadows cast by a porch railing and posts—in a pleasingly balanced abstraction of complementary geometric shapes and tones of light and dark.

comparing the work of White, Steichen, Käsebier, and Eugene to the unique experimentation manifested by the builders of skyscrapers.[42] He was wrong, of course, about the absence of European influence on American photography, including his own, but right to sense that Pictorialism had had its day.

PHOTOGRAPHY AND THE MODERN CITY

Pictorial photographers occasionally photographed the urban environment, modifying it with a mantle of color or cloud. Photographers independent of Pictorialism also rendered the city and its inhabitants. British photographer Paul Martin (1864–1944) recorded street life and seaside entertainment in a casual style associated with the snapshot (Fig. 4.44). E. Alice Austen (1866–1952) of Staten Island, New York, photographed the social life of her genteel friends, but also ventured into Manhattan to photograph immigrant life (Fig. 4.45). Neither photographer's work was ever aimed at bringing about social improvements.

New York City, especially after the opening of Ellis Island in 1892, was the port through which most of the immigrants entering the United States passed. In 1900, over 35 percent of the population in big cities such as New York and Chicago were foreign-born. Immigrant neighborhoods became the subject of much public curiosity and concern. Photographers in expanding American cities provided the public with an array of images of the poor. Firms such as Underwood & Underwood issued boxed sets of stereographs depicting immigrants and urban life. Some pictures, for example the lantern slides produced by Chicago photographer Sigmund Krausz (active 1890s), reinforced ethnic stereotypes and cliches about the urban poor. The rural poor were not major photographic subjects,

4.44
PAUL MARTIN,
Dancing to the Organ, Lambeth, c. 1895.
Gelatin dry plate.
Victoria & Albert Museum, London.

Because of their spontaneous, snapshot appearances, Paul Martin's photographs seemed unprofessional to some. The images gained more public appreciation in the twentieth century, when the snapshot itself came to stand for unaffected photography. Martin also pioneered night photography, in which a calm stillness contrasts with his city pictures.

204

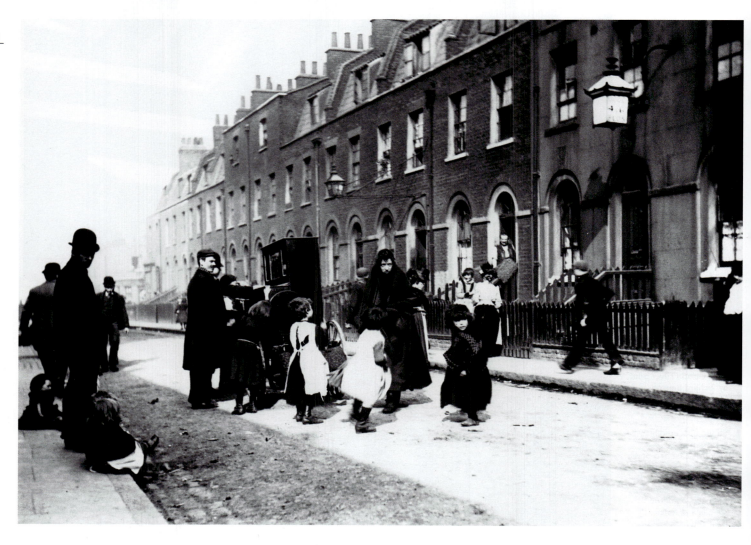

4.45
E. ALICE AUSTEN,
*An Organ-Grinder
Couple*, New York, 1896.
Library of Congress,
Washington, D.C.

Unlike earlier nine-
teenth-century street
photographers, Alice
Austen showed her sub-
jects in the lively context
of the city. Near the
organ-grinder couple,
a street sweeper is at
work. In the back-
ground, a trolley is
approaching, while
wagons and carriages
move along the street.

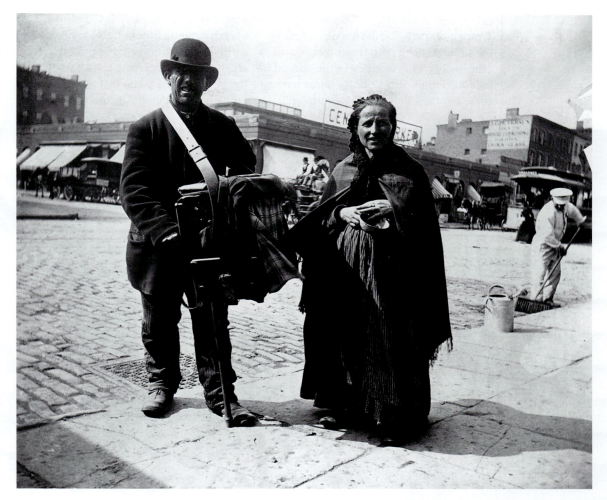

outside the idyllic scenes produced by
Pictorial photographers.

SOCIAL REFORM PHOTOGRAPHY

From the beginning, British suffragists
used photography to record the lives of
poor women and children, arguing that
giving women the vote would bring
more attention to poverty. After a slow
start, reform organizations and settle-
ment houses — privately run charities
that did social work among the poor —
began using photography to promote
their work.[43] As social work moved from
a voluntary occupation to full-time pro-
fessional employment, photographs
were increasingly used in conjunction
with other data. As the public became
more familiar with photographs of the
poor, two unexpected consequences
occurred: repeated images of people in
squalid conditions bolstered stereotypes
of the poor as inferior; and what is now
called "compassion fatigue" set in, as
happened toward the end of the Ameri-
can Civil War when, as photographic
coverage increased, public response
declined.

Photographs of the poor were still
novel and engaging, however, when
Jacob Riis (1849–1914) produced his
book *How the Other Half Lives* (1890),
which contained fifteen half-tone
images, and forty-three drawings based
on photographs. Riis, a Danish immi-
grant who became a journalist in New
York City, lectured on the condition of
the slums, and projected stereopticon
lantern slides to illustrate his points.
Like many reformers, Riis believed that
individuals were formed by their
environment. For him the crowded,
unsanitary tenements, that is, shoddy
apartment houses, were the cause of
crime and moral decay. By contempo-
rary standards, Riis was conservative in
his suggestions for reform: he did not
call for government intervention, but
hoped that the wealthy would consider
tenement construction as a work of
charity and that private investors would
take less profit when building tene-
ments, in order to provide adequate
lodgings (Fig. 4.46).

Like many social observers, Riis
implicitly divided the poor into two

categories: deserving and undeserving. Women and small children often fitted the first category, with unemployed and criminally inclined males in the second. Oddly enough, Riis's photographs have come to stand for late nineteenth- and early-twentieth century social reform, overshadowing other efforts to record the living conditions of the poor in an effort to foster change, such as the photographs taken by the Berlin Housing Enquete in Germany. Also

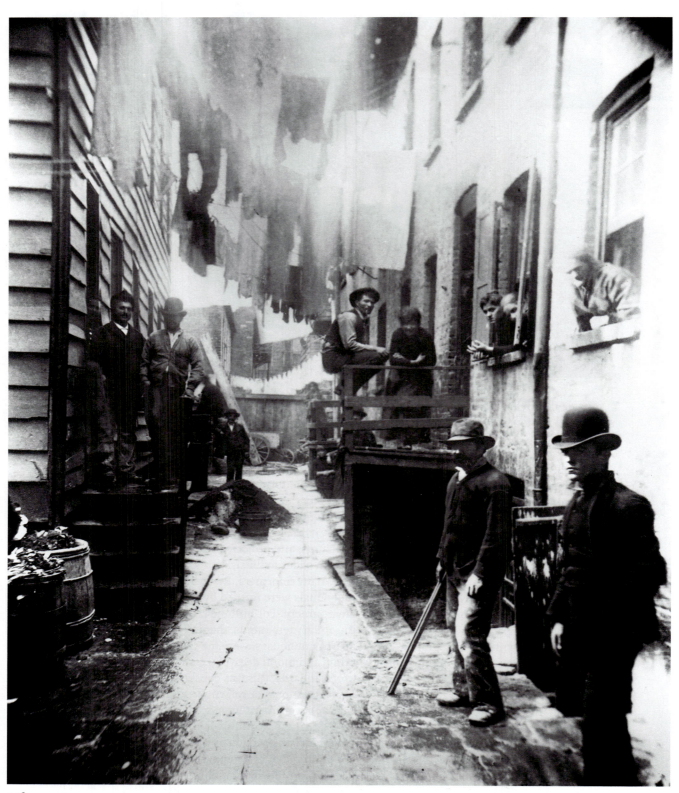

4.46
JACOB RIIS, *Bandits' Roost, New York*, 1888. Gelatin silver print from the original negative. Museum of the City of New York, New York.

"On either side of the alley are stale beer dives in room after room, where the stuff is sold for two or three cents a quart. After buying a round the customer is entitled to a seat on the floor, otherwise known as a 'lodging' for the night."[44]

PORTRAIT
Jacob Riis

Jacob Riis emigrated from Denmark to the United States in 1870, where he endured hardships while looking for work during the depression years of the 1870s. Riis acquired a job as a police reporter in the Lower East Side of Manhattan, and began writing about the slums, using photography to illustrate his points. Initially he used photographs by others, but eventually took his own. He presented his work in several formats. Lantern-slide lectures were given to mostly middle-class audiences in New York, who had little direct experience of the slums, where they were afraid to venture. He also published his photographs in newspaper and magazines. "Flashes from the Slums: Pictures Taken in Dark Places by the Lightning Process,"an 1888 illustrated newspaper article in the *Sun*, described a foray made by Riis and a group of photographers to research and photograph the life of the "other half."[45] His party toured at night, using the now standard magnesium flash powder to illuminate the darkness and to surprise subjects. The harsh look of the sudden burst of intense white light and the shock registered on the faces of those photographed came to stand for candid and objective photography (Fig. 4.47). Riis's photographs acquired credibility in part because their compositions resembled the spontaneous look of the newly introduced snapshot. Not all his photographs were spontaneous: his images of street children show them obviously feigning sleep.

Riis's photographs have been the subject of debate, both because of the photographer's intrusion on the lives of the poor, and because of the interpretations to which they have been subject since Riis's death. The first Jacob Riis exhibit at the Museum of the City of New York in 1947 presented prints that were cropped and enlarged to increase their impact. In grand, artful exhibition prints, the technical defects and spontaneous character of Riis's photographs were suppressed. The show exemplified changes in Riis's reputation following his death in 1914. With the popularity of documentary photography in the 1920s and 1930s, Riis, who photographed only for a short period and downplayed his efforts, was cast as a major recorder of the American experience and a forerunner of the documentary approach. Questions persist about his lack of sympathy with his subjects, and about the transformation of his untidy photography by the museums from its original context in social reform into American art.[46]

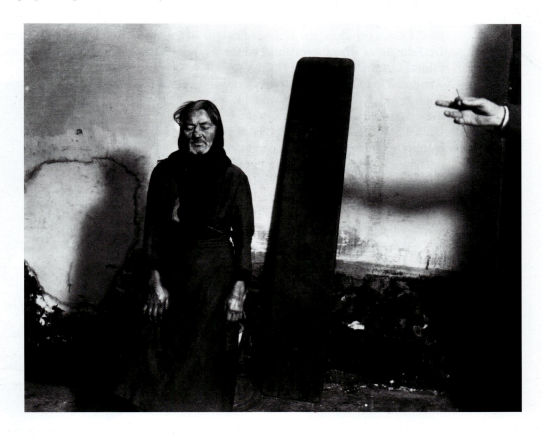

4·47
JACOB RIIS, *Police Station Lodgers* (Eldridge Street Station, an old lodger, and the plank on which she slept), c. 1898. Museum of the City of New York, New York.

often overlooked are the photographs made by American novelist and avid amateur photographer Jack London (1876–1916) for *The People of the Abyss* (1903), his account of the slums of London's East End. London used photographs, mostly his own, to depict the effects of industrialization on the poor, and to conclude that criminal mismanagement of society was to blame for poverty.

Like Riis, Lewis Hine (1874–1940), did not have a background in art photography. Although he visited Stieglitz at 291, and introduced Strand to him, Hine jokingly called the members of the Photo-Secession, the "Seceshes."[47] Hine taught a number of subjects at New York's Ethical Culture School, a progressive institution. He learned photography at the school's request, and went on to work exclusively in the medium. Beginning in 1904, as part of the school's curriculum, Hine made photographs of immigrants arriving at Ellis Island, and living in the poor neighborhoods, so that the students might "have the same regard for contemporary immigrants as they have for the Pilgrims who landed at Plymouth Rock"[48] (Fig. 4.48).

While working at the Ethical Culture School, Hine began freelancing for the National Child Labor Committee (N.C.L.C.), a private agency founded by Dr. Felix Adler, who also established the Ethical Culture Society. The N.C.L.C. attempted to reform child-labor by urging legislation to control industrial hiring practices. Hine traveled around the United States, often assuming a false identity, to photograph children at work in factories, mines, canneries, and mills (Fig. 4.49). Working for the N.C.L.C. and other social welfare organizations, Hine created what he called the "photo story," a narrative composed of pictures and words to be published in journals and magazines. Hine's layouts were often non-linear, linked more by ideas than a flow of narrative images. In 1937, he criticized the photographs in the new *Life* magazine for "the fetish of having a unified thread."[49]

Hine frequently insisted on receiving a credit line for his images, at a time when photographic reproductions generally did not carry them. He also took advantage of the possibilities for illustration offered by the half-tone process and the recently created illustrated magazine. He worked extensively on *The Pittsburgh Survey* (1909–14), a multivolume study of working-class life in a city whose mix of immigrants and comfortable professionals, as well as its bitter history of labor conflict, seemed to many to epitomize the industrial metropolis. Hine's images and words aligned with the objective orientation of economic reports and the emergent profession of social work, in contrast to the personal approach favored by Riis. Hine went on to photograph the work of the Red Cross in Europe after World War I, and to publish *Men at Work: Photographic Study of Men and Machines* (1932), which showed the construction of the Empire State Building.

After his years with the N.C.L.C., Hine's attitude toward social photography shifted away from showing abuse to picturing the dignity of the working class. His later photographs, especially what he called "work portraits," put laborers in the center of the picture, celebrating their skill and perseverance. Although he addressed the workers as his audience, most of his photographs appeared in journals read by professional and volunteer social reformers.

Speaking to the National Conference of Charities and Corrections in 1909, Hine suggested that workers be encour-

4.48
LEWIS W. HINE,
A Madonna of the Tenements, c. 1911. Gelatin silver print on glass. George Eastman House, Rochester, New York.

Hine deliberately used religious motifs, such as the Madonna and Child, to create compassion for the newly-arrived settlers, who were looked down upon and subject to ethnic slurs.

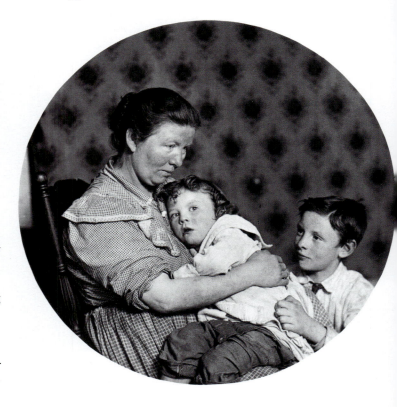

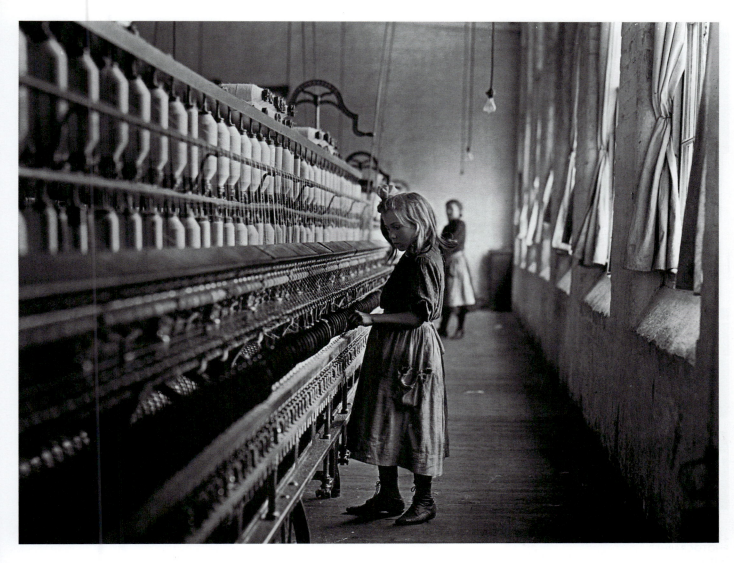

**4.49
LEWIS W. HINE,** *Child in Carolina Cotton Mill,* 1908. Gelatin silver print on masonite. Museum of Modern Art, New York.

Lewis Hine photographed youngsters at work in an attempt to instigate legislation against child labor. His photographs do not show children actively being abused or neglected, but coping with their situations. Though she is small in relationship to the machine, the young girl in a cotton mill seems self-assured and competent at her job.

aged to photograph their own situations. The idea of worker photography later briefly took hold in Europe, between the world wars. The turn of the twentieth century was an active time for the formation of labor unions in industrialized nations, but there was no systematic network to distribute photographs recording labor grievances, or offering union interpretations of the many labor actions and strikes that took place. As historian Larry Peterson observed, "workers' organizations adopted photography more slowly and haltingly than corporations." He contends that even such militant new unions as the International Workers of the World (I.W.W.) failed to adopt the mass media publicity techniques associated with corporations.[50] Instead, labor groups promoted craft skills and art historical knowledge because they were thought to stimulate the mind and the feelings. During the 1913 textile strike in Paterson, New Jersey, for instance,

workers used posters that looked like rough woodcuts, and staged a pageant of their complaints just a few blocks from the Armory Show (see p. 188). There is no extensive photographic protest showing workers trying to keep pace with speeded-up assembly lines, or learning to perform repetitive actions more quickly. More often than not, it was newspaper photographs of labor confrontations, not photographs taken by the unions, that galvanized worker opinions.

Industry, by contrast, used photography to present a positive vision of the company to the workers. The Pullman Company, makers of railroad sleeper cars, was the site in 1894 of a violent labor strike. *The Story of the Pullman Car* (1917) contained thirty-four photographs describing the work of the company, and the company newspaper, the *Pullman Car Works Standard* (1916–19), presented the company as "Pullman's Big Family" to the public and employees.[51]

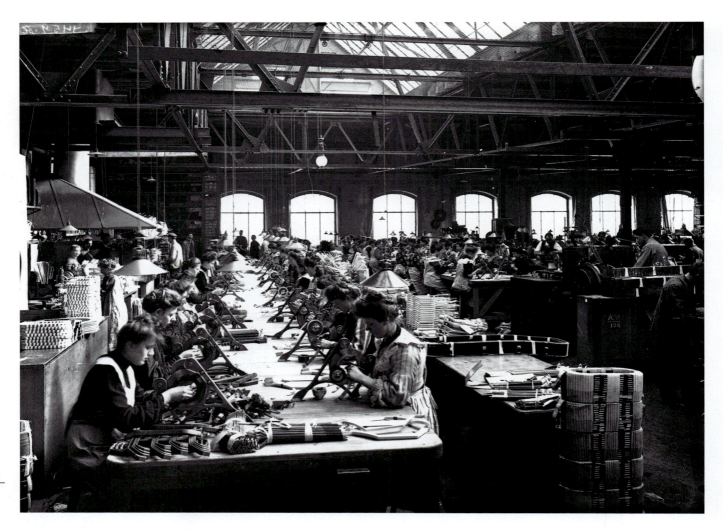

**4.50
PHOTOGRAPHER
UNKNOWN,** *Female
Employees at AEG,*
1906. Deutsches
Technikmuseum, Berlin.

The AEG company in
Germany hired women
to assemble electrical
appliances. Although
women's employment
in factories is associated
with wartime labor
shortages, in 1907
women comprised
nearly 36 percent of the
working population in
Germany.[52]

Companies used their financial
resources and ready access to the factory
floor to make photographs that served
their interests; images of admirable
working conditions and engineering
feats were encouraged in the press (Fig.
4.50). The paternalistic attitude toward
workers that developed in some facto-
ries was exemplified in the Ford Motor
Company's booklet *Helpful Hints and
Advice to Employes* (*sic*) (1915), which
contained photographs showing proper
living conditions for a Ford worker. The
company's Sociological Department
took photographs of ideal kitchens and
bathrooms as examples to workers.[53]
Similarly, General Electric Company
began publishing a magazine called
Work News, which emphasized the
notion of community through pho-
tographs of workers and company
sports teams.[54]

THE IDEAL CITY

The ideal city at the turn of the century
was presented at a world's fair held in
Chicago during 1893, called the World's

Columbian Exposition. Dubbed "the
White City," for its classically derived,
all-white Beaux-Arts architecture, the
Exposition expressed the notion that
American economic success could
renew cities and make them the centers
of civilization. Charles Dudley Arnold
(1844–1927), director of the Photogra-
phic Division of the Exposition, made
every effort to control photographs of
the fair. All newspapers and periodicals
had to use photographs issued by him
and his office, or approved by them.[55]
His view of the Exposition is best
expressed in the official images he made
on mammoth plates and printed on plat-
inum paper (Fig. 4.51). As photographic
historian Peter Bacon Hales noted,
Arnold's view resonates with the paint-
ing of American artist Thomas Cole
(1801–1848), in whose work *The
Consummation of Empire* (part of *The
Course of Empire* series), classical archi-
tecture is celebrated as a symbol of
American advancement.[56] Night-time
photographs of the White City were
calculated to demonstrate the union of

culture and progress, symbolized by electricity, as the fair's buildings were traced by thousands of incandescent lights. In the photographs overseen by Arnold, the presence of people was minimized, thereby magnifying a vision of order.

The White City featured a Midway or "Midway Plaisance," with the first Ferris Wheel, constructed as an engineering feat meant to rival the Eiffel Tower in Paris, which was built for the 1889 Exposition Universelle. From atop the Ferris Wheel, visitors could look down at living ethnological exhibitions placed along the Midway in a conscious effort to merge information and entertainment. Strollers could enter the most talked about area, a street in Cairo, modeled not after an actual street, but after a similar stretch at the 1899 Paris Exposition. Native villages with ethnic types, including Native Americans, dotted the

Midway area, where the daily life of residents was periodically punctuated with ceremonial rituals, some of which had long passed from practice. Anthropologist Franz Boas (see p. 236) recruited Kwakiutl people from British Columbia, whom he asked to execute ritual dances in front of a white sheet, so that the various moves were easier to see and to photograph. One of roughly 600 souvenir photographic albums, titled *Portrait Types of the Midway Plaisance* (1894), which contained ethnic images, announced that "Truly there was much of instruction as well as joy on the Merry Midway."[57]

African-Americans were discouraged from participating in the Exposition. They protested their lack of visibility in letters to newspapers and visits to public officials when they were represented on the Midway by people from Dahomey, now Benin, in West Africa.

4.51
CHARLES DUDLEY ARNOLD, *Basin and the Court of Honor*, 1893. Platinum print. **Chicago Historical Society, Chicago, Illinois.**

The Chicago World's Fair was conceived as an ideal modern city, combining the past, symbolized in its classical architecture, with the future, denoted in its extensive use of electric lights. Arnold saw the beautiful city as one in which order reigns. Shooting from above and near the middle of the reflecting pool, he exaggerated the length of the water and the surrounding buildings.

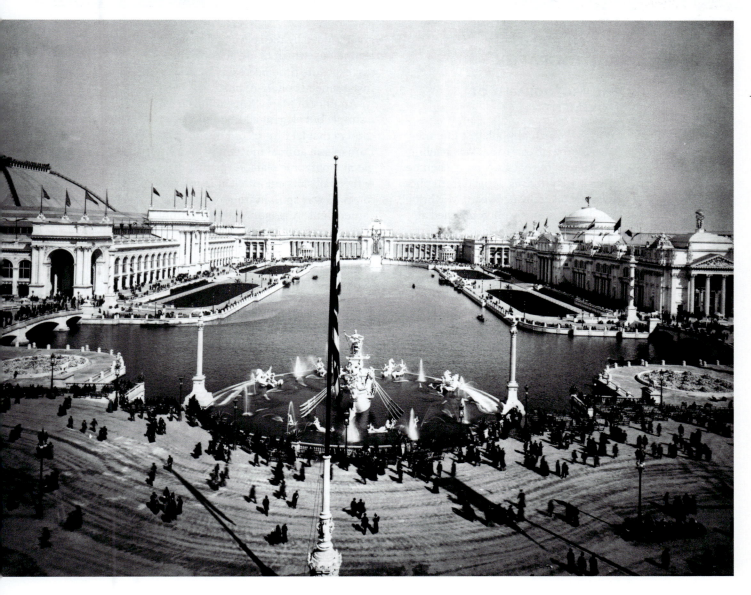

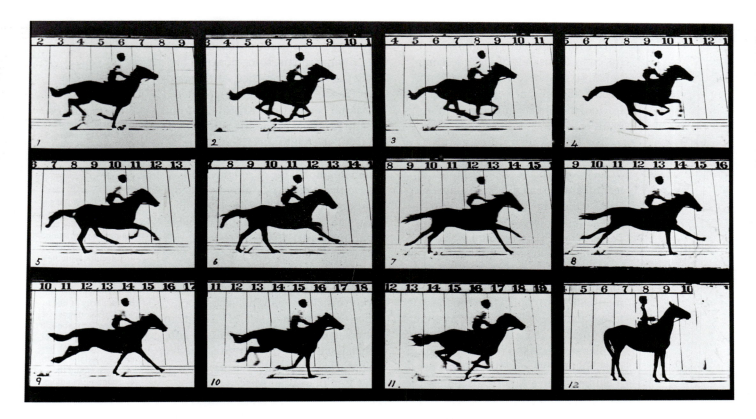

SCIENCE AND PHOTOGRAPHY

THE PHOTOGRAPHY OF MOVEMENT

In 1878, French physiologist Étienne-Jules Marey (1830–1904) was reading the science journal *La Nature* when he came across images derived from photographs taken by Eadweard Muybridge, who had previously photographed at Yosemite in California (see Fig. 3.61). Muybridge's photographs resolved an age-old question for equine experts and painters: Do all four legs of the horse leave the ground when the horse moves quickly? (Fig. 4.52). To make the photographs, Muybridge lined a raceway with fifteen-foot sheeting, upon which lines were drawn at twenty-one-inch intervals. As a horse rushed past, its hooves tripped cotton threads, which in turn tripped shutters on twelve cameras set up opposite the sheeting. Marey, who had been studying human and animal locomotion for a decade, was motivated by the Muybridge images to experiment with photography. In the early 1880s, he invented a gun camera like that used by Pierre-César Jules Janssen (see p. 134), with which he made exposures rapid enough to record the bodily movements of a bird in flight. Marey's work was greatly aided by the speed of dry-plate technology, which made possible the fast exposure time necessary to make instantaneous photographs.

Another of Marey's inventions used a simple but elegant addition to the camera that let him record the flow of human and animal movement on a single photographic plate. A rotating disk with small slots cut into it at regular intervals was spun in front of an open camera lens. A person walking in front of this apparatus would be in a different position each time the open slot on the disk allowed an image to register. The result showed human movement in time and space. Marey called his work chronophotography, that is, time photography.

Marey's images are visually puzzling and attractive, yet he was not primarily interested in their aesthetic merit, but in the way in which they isolated the imperceptible phases of movement (Fig. 4.53). He continued to improve his photographic devices so that he could eliminate any overlapping of moving figures. He created a camera in which light-sensitive material moved with each exposure. When continuous photographic film, like that used today, was invented, Marey employed it to produce a short film in July 1889, showing how the human hand works. He published

**4.52
EADWEARD MUYBRIDGE,** *Untitled* **(Sequence photographs of the trot and gallop), from** *La Nature,* **December 1878. Gravures.**

The third photograph in the top row clearly shows all four hooves of the galloping horse in the air, rather than extended or touching the ground, as most painters had rendered them. Muybridge's work had begun in the 1870s at the instigation of former California governor Leland Stanford, who owned race horses.

4.53
ÉTIENNE-JULES MAREY, *Joinville Soldier Walking,* 1883. Negative Print. Collège de France, Paris.

his results in articles and books, notably in *The Flight of Birds* (1890), which influenced early attempts to build airplanes.

The photographer Albert Londe (1858–1917), who worked with Charcot (see p. 140) at La Salpêtrière during the 1880s, extended his medical photography into the creating of X-ray photographs and the study of movement. A line drawing by Paul Richer (1849–1933), based on one of Londe's stop-action photographs, may have provided the visual vocabulary for *Nude Descending a Staircase # 2* (1912), the influential painting by Marcel Duchamp (1887–1968). In addition, the dotted lines in the center of the canvas probably derive from Marey's geometric drawings[58] (Figs. 4.54, 4.55). Perhaps the greatest effect in the art world of late nineteenth-century photographs of movement was on the Italian Futurists, who came to prominence in 1909.

As his fame and influence grew, Muybridge became a science celebrity, traveling and giving lectures. He visited France, where he met Marey, and he was invited by the University of Pennsylvania in Philadelphia to carry on his experiments there in a specially built outdoor studio. One of Muybridge's supporters at the university was the American realist painter Thomas Eakins (1844–1916). An accomplished amateur photographer, Eakins used Muybridge's photographs in both his teaching and his art to show how humans and animals actually moved. His 1879 painting *A May Morning in the Park* referrred to Muybridge's studies of the horses' gait. By blending scientific accuracy with artistic color and composition, Eakins made his point that modern art had to take the findings of science into account. He helped to bring Muybridge to the University of Pennsylvania, and worked with the photographer in 1884 (Fig. 4.57). Though he later lost interest in perfecting photographs of human movement, Eakins used outdoor photographs of the nude male for his paintings, both as figure studies and to learn how sunlight illuminates the body. In his own way, he attempted to refresh the classical nude. "Nature," he said, "is just as varied and just as beautiful in our day as she was in the time of Phidias [an ancient Greek sculptor]."[59]

Muybridge's time in Philadelphia proved highly productive. He refined his techniques, creating 100,000 images of movement. He photographed female and male nudes, some in casual poses such as turning to embrace a child or laying bricks, which, if not strictly

4.54 (below)
PAUL RICHER, *Man Descending a Staircase,* from *Physiologie artistique de l'homme en mouvement,* Paris, 1895.

4.55 (right)
MARCEL DUCHAMP, *Nude Descending a Staircase # 2,* 1912. Oil on canvas, 58 x 35 in (147.3 x 88.9 cm). Louise and Walter Arensberg Collection. Philadelphia Museum of Art, Philadelphia, Pennsylvania.

FOCUS
Photography and Futurism

The Italian Futurists were a pre-World War I group of artists thrilled by the prospect of a future filled with motion, activity, and change. They were intrigued by the visual language of stop-action photographs. Giacomo Balla (1871–1958) interpreted photographs of sequential movements in a humorous painting, *Dynamism of a Dog on a Leash* (1912). Balla and his celebrated painting were photographed in the photodynamic style developed by Anton Bragaglia (1890–1960). A photographer and filmmaker associated with the Futurists, Bragaglia accentuated the blur of motion that most action photographers regarded as a fault in their images and tried to remove.

His photodynamic images appeared in a 1913 book, *Fotodinamismo futurista* (Fig. 4.56). In words that approximate the goals of Victorian High Art photography, Bragaglia thought his multiple exposures would help revolutionize photography, by "purifying[,] ennobling and truly elevating it to art."[60] Unlike other practitioners, who tried to elevate photography by making pictures carry a moral lesson or by copying Old Masters, Bragaglia believed that the photographic artist should render the world's invisible vital energy. He proceeded to dissolve the clear resolution and distinctly segmented pictures of motion studies. He adapted Marey's strictly scientific images to his metaphysical aims, believing that both art and science should seek to reveal the spiritual. The photodynamic photograph, with its obscure and blurry areas, allowed him to record reality "unrealistically."

4.56
ANTONIO GIULIO BRAGAGLIA, *The Futurist Painter Giacomo Balla*, 1912, from *Fotodinamismo futurista*, Rome, 1913.

215

4.57 (right)
THOMAS EAKINS,
The Pole Vaulter,
1884–85. Multiple-expo-
sure gelatin silver print.
Gift of Charles Bregler,
1941 (41.42.8).
Metropolitan Museum
of Art, New York.

Images such as this
one, which revealed
actions that the unaided
eye could not perceive,
helped undermine the
association of optical
reality with truth. ✓

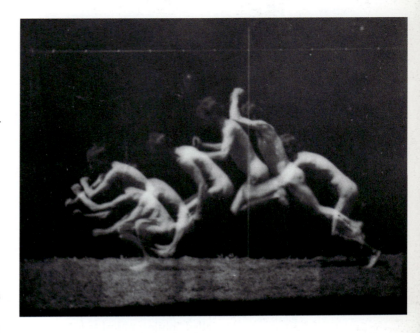

4.58 (below)
EADWEARD
MUYBRIDGE,
*Ascending and
Descending Stairs*, from
Animal Locomotion,
plate 504, 1870s.
Library of Congress,
Washington, D.C.

The progression of
climbing and descend-
ing the stairs is not
sequential, yet in most
cases the eye seems
willing to assume
a continuity where
none exists.

scientific, may have been influenced by Eakins's location of beauty in everyday modern life. After setting up a studio in the zoological gardens, Muybridge recorded the movements of such animals as elks, camels, and elephants. His eleven-volume work *Animal Locomotion* (1887) offered 781 large plates ($19\frac{1}{8}$ inches x $24\frac{3}{8}$ inches). The studies attracted a varied audience, including prominent scientists such as Louis Agassiz; inventors such as Thomas Edison; and artists including Auguste Rodin.

Muybridge's notes indicate that he always made twelve lateral and twenty-four foreshortened (that is, from the front, or from the back) views of his subjects. But few of his final prints contain thirty-six images (Fig. 4.58).[61] As scholar Marta Braun discovered, Muybridge often fabricated his final composite pictures, assembling images that play upon the willingness of the eye and mind to see photographs arranged from left to right as having been taken in that order. About 40 percent of Muybridge's photographs of movement are composed of images that were not taken successively, as he had claimed.[62] Muybridge's stop-action pictures contrast with the

unaltered scientific investigations of Marey. Possibly his artistic sensibilities intervened when he encountered technical difficulty, or perhaps his willingness to give the appearance of truth began with his misleading photographs from the Modoc War (see pp. 129–30).

Directly or indirectly, chronophotographs influenced art. Most immediately, such artists as the French painter

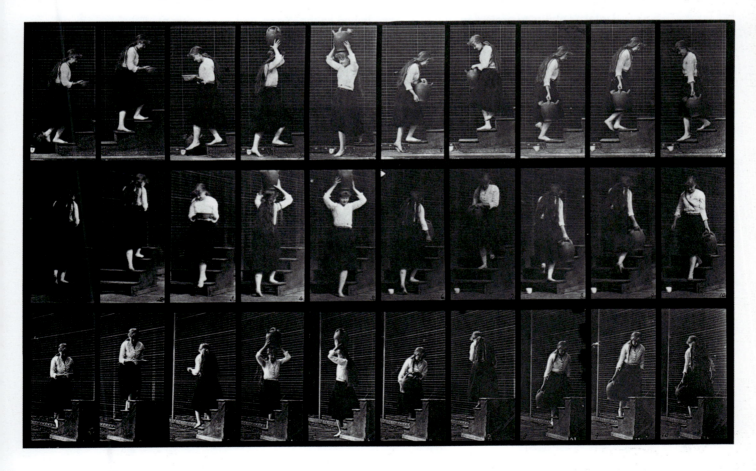

Jean-Louis-Ernest Meissonier (1815–1891) and Thomas Eakins made their paintings of horses accord with what the photographs showed, rather than what the eye perceived. Adapting art to science, however, was seen by some critics as a capitulation to the machine. As stop-action photographs became known outside of scientific circles, they fueled the discussion about the role of human perception in modern art.

PHOTOGRAPHY AND THE INVENTION OF MOVING PICTURES

Although devices creating the illusion of moving pictures existed before the development of photography, in the late nineteenth century there was a burgeoning of parlor-game machines and what were called "philosophical toys," which whirled images around a horizontal cylinder. Viewed through tiny slits in the cylinder, the sequence of pictures showing running horses and the like created the impression of movement. Limited by the size of the cylinder, devices like the zoëtrope, the praxinoscope, and the phenakistoscope operated on the same general principle of tricking the eye into seeing motion. Muybridge experimented with a contrivance he called the zoöpraxiscope, which added the magic lantern's ability to project an image to the zoëtrope's simulation of movement. Muybridge used his own photographs of movement, heavily outlined or painted over, to form silhouettes. The device, first demonstrated in 1879, was again limited by the size of the turning disks.

About the same time that he was developing the phonograph to record and project sound, Thomas Edison (1847–1931) took a hint from the success of Muybridge's zoöpraxiscope and began work on making pictures move. His kinetoscope, introduced in 1894, made images move in a box-like structure with a viewer. Commonly called a peep show after the popular street entertainment begun in the eighteenth century, the kinetoscope used flexible film about 50 feet in length. The film was illuminated behind a magnifying lens, and it sped by the viewer at forty-eight frames per second, generating a show that lasted only thirteen seconds. In Europe, several inventors added public projection to the private peep-show. In

France, the brothers Auguste and Louis Lumière introduced their film projector to the Parisian public late in 1895.

Although attempts to make pictures move predated the invention of photography, the concurrent invention of motion pictures by different inventors in the late 1880s and the 1890s seems to have been sparked by stop-action experiments, such as those of Marey and Muybridge. Photographic skills expedited the leap from still to moving pictures: for example, Edison viewed Marey's photographs of movement placed on a moving film strip, and the Lumière brothers manufactured photographic supplies in Lyons, before creating their Cinématograph.

The effect of motion pictures on photography within professional, artistic, amateur, and hobbyist circles is a little known aspect of photographic history. Some photographers became filmmakers, but the wider impact of moving pictures on still photography has yet to be written. Where the first photographs immediately explored artistic, travel, and documentary uses, the first films tended to demonstrate movement itself: the arrival of a train, acrobats prancing and tumbling, workers leaving a factory. Photography's varieties were well established by the 1890s, and none seem to have been superseded by the emergence of film.

THE X-RAY

The 1895 discovery of the X-ray by Wilhelm Conrad Röntgen (1845–1923), a Dutch-German physicist working in Germany, had profound effects outside science and medicine. Röntgen, who had a practical knowledge of photography, was experimenting with electricity and a cathode ray tube, which beamed an image on a screen, when he chanced to observe a force he would later call the "X" or unknown ray. It emanated from the cathode tube and caused a piece of cardboard coated with a fluorescent material to glow in the dark. He soon learned that the rays could pass through the human body, blackening a photographic plate except where they were absorbed by the calcium in bones (Fig. 4.60). In effect, his X-ray photographs were shadowgraphs like those made by William Henry Fox Talbot decades earlier, though not created by light.

FOCUS
Worker Efficiency: The Gilbreths' Time and Motion Studies

Studies of human movement were not confined to the realm of science. The American engineer Frederick Winslow Taylor (1856–1915) studied the steps laborers use to perform tasks. In 1898 he was hired to reorganize the machine shops at Bethlehem Steel in Pennsylvania. To make the shop operate in a linear, rational way, akin to the machine itself, Taylor renovated the shop floor. His most influential change came from his observation of the most efficient workers and the motions they employed to accomplish a task. After breaking down these actions into the smallest units, Taylor ordered the workers to imitate exactly the motions used by the efficient workers to accomplish tasks. His name became synonymous with what he called scientific management. An idea that had been suggested as early as the 1851 Crystal Palace exhibition's celebration of mass-production (see p. 29), "Taylorism" spread through the world, boosting productivity and giving management increased control.

Followers of Taylorism used photography to isolate the individual actions used by workers to perform mechanical acts. As electrification of factories and the use of the assembly line and conveyor belts speeded up production in the early twentieth century, Frank Gilbreth (1868–1924) and Lillian Moller Gilbreth (1878–1972) claimed to demonstrate to industrial laborers the most efficient way to get the job done with a minimum of fatigue. In their essay "The Effect of Motion Study upon the Workers" they contended that the orderly performance of tasks would make the workers happier and more prosperous.[63] To make what was called a chronocyclegraph, or time-cycle image, Frank Gilbreth attached small light bulbs to a worker's hands, and photographed the lights as they traced the worker's actions (Fig. 4.59). The Gilbreths then made models of the light tracings in wire. These wire replicas of the most efficient and speedy actions were used to train workers, who ran their hands over the wires to learn the best pattern for their hands to take.[64] The Gilbreths also filmed "micro-motion" studies of workers' actions. Their work was influenced by the photographs of Muybridge and Marey.

The Gilbreths' time-and-motion studies were seen as modern, scientific management of business, and their work, like Taylor's, was imitated around the world. Labor unions soon protested against intrusive cameras, and a philosophy of business that reduced humans to a set of standardized, repetitive actions.

4-59
FRANK B. GILBRETH, *Chronocyclegraph of Woman Staking Buttons*, 1917.
Gelatin silver print. National Museum of American History, Smithsonian Institution, Washington, D.C.

**4.60
WILHELM RÖNTGEN,
Frau Röntgen's Hand,
1895. X-ray. Deutsches
Röntgen Museum,
Remscheid, Germany.**

Röntgen's X-ray of his
wife's hand accompa-
nied his initial scientific
paper reporting on
the phenomenon. He
exposed the left hand of
his wife Bertha to the
X-ray for fifteen minutes
to create one of the
first images of its kind.
The large bulge is her
wedding ring.

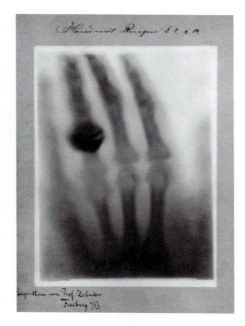

X-ray apparatus, like early photo-
graphic gear, could be easily con-
structed. Like the initial response to
the daguerreotype and calotype, the
reception of the X-ray was essentially
confident. Earlier scientific uses of pho-
tography had not provoked the immense
fascination that the X-ray did. An inquis-
itive public could gawk at X-rays at
amusement parks and department
stores—also new phenomena on the
urban scene. Department store cus-
tomers stood in line to look through
their own hands at the living bone. Even
when Edison created the fluoroscope in
1896, eliminating the use of the photo-
graphic plate, people still associated the
X-ray with photography. Indeed, before
the professionalization of radiology,
photographers thought of the X-ray as a
branch of their practice; "radiophotogra-
phers" were not required to have long
medical training. After only a year's
preparation, Elizabeth Fleischmann
(c. 1865–1905) became the first person
to open an X-ray laboratory in Califor-
nia, and pioneered the use of multiple
views of a patient's body.[65]

In the public imagination, the X-ray
photograph was sometimes associated
with the occult. If the X-ray, a powerful
but unseen element, could reveal hid-
den existence, perhaps it could do other
things, such as reviving the dead.[66]
Maybe there were other imperceptible
rays that could make ghosts visible
and humans invisible, reveal human
thoughts, or locate a fourth dimension.
The idea of a fourth dimension, simpli-

fied from mathematics and philosophy,
extended the promise of a break with
traditional thinking.[67] Some saw the
X-ray photograph as proof that spirit
photographs, that is, images purporting
to record invisible emanations coming
from ghosts, were authentic (Fig. 4.61).
What seems today like pseudo-science
was taken seriously in certain academic
circles. In 1909, at the Sorbonne in
Paris, a committee was established to
study transcendental photography of
invisible beings and forces.[68]

To some viewers, seeing beneath
clothing via the X-ray had the erotic
shiver of the forbidden. A London store
even offered X-ray-proof undergar-
ments. Literature's most famous X-ray
photograph may be that in Thomas
Mann's famous 1924 novel, *The Magic
Mountain*, in which the main character,
Hans, finds an X-ray of his beloved sexu-
ally arousing, but identifies a fluoro-
scope of his own hand with death. One
of the most enduring science fiction
novels, H. G. Wells's *The Invisible Man*
(1897), is based on the idea that a man's
exposure to "roentgen rays" can make
his body invisible.

A few doctors and dentists purchased
X-ray machines as soon as they were
manufactured. Public acceptance grew
gradually, along with medical use dur-
ing armed conflict, beginning with
X-ray-equipped field hospitals set up by
the Italians in their 1896 attempt to col-
onize Abyssinia, and culminating in the
routine use of the X-ray during World
War I. Soon X-ray photographs were
taken from many angles, so as to pin-
point the location of bullets and shrap-
nel. As research trickled in about the

**4.61
W. MOBSBY, *Untitled*
(News photograph of
Arthur Conan Doyle),
1921, from Conan
Doyle's *The Wanderings
of a Spiritualist*, 1922.**

Arthur Conan Doyle
(1859–1930) was an
amateur photographer.
Late in life, he became
a spiritualist, and col-
lected spirit or psychic
photographs. He
included this blurred
photograph of himself
in *The Wanderings of a
Spiritualist* (1922), claim-
ing that it showed the
presence of super-
natural forces.

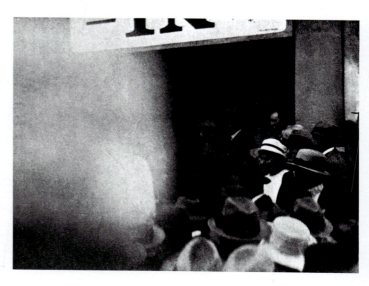

dangers of X-rays, in an era when the average medical exposure was about one hour long, the public had to adjust to the idea that they could be injured by a substance that could not be seen or tracked, and which took months or years for its effects to develop. California X-ray pioneer Elizabeth Fleischmann died from cancer induced by the new technology.

As historian Bettyann Holtzmann Kevles points out, X-rays were "the first invisible substances generated by scientists to profoundly affect human perception."[69] Several scholars have suggested that the multiple perspectives and monochromatic Cubist palette of Picasso and Georges Braque (1882–1963) may relate to X-ray photographs. The Italian Futurists embraced the X-ray. One of the movement's founders, Umberto Boccioni (1882–1916), believed that the X-ray would help to wipe away outworn attitudes. "Who can still believe in the opacity of bodies," he wrote. Futurist art, he maintained, was like the X-ray—they both "sharpened and multiplied sensitiveness."[70] A 1913 watercolor by Francis Picabia (1879–1953), a Paris-born artist who worked in France and the United States, was titled *New York Seen Through the Body* (in France, the phrase *à travers le corps*, literally, through the body, was used by practitioners to advertise X-ray examinations). Picabia's painting let viewers see through buildings to the structure behind them.

Experiments with X-ray technology by Viennese chemists Eduard Valenta (1857–1937) and Josef Maria Eder (1855–1944) (who would write one of the histories of photography) led them to issue a portfolio of X-ray photographs that expressed aesthetic delight in the revealing images (Fig. 4.62).

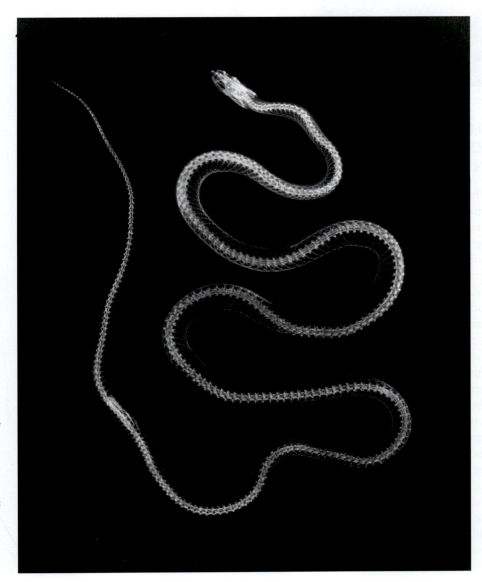

**4.62
EDUARD VALENTA &
JOSEF MARIA EDER,**
Aesculapian Snake,
1896, from the portfolio
Versuche über photographie mittlest der Röntgenschen Strahlen.
X-ray. George Eastman House, Rochester, New York.

In their arrangement, Valenta and Eder emphasized the delicate bones of the snake by coiling it in repeated curves upon the photographic plate. American critic Christian Brinton wrote that "there is no phase of activity or facet of nature which should be forbidden to the creative artist. The X-ray may quite as legitimately claim his attention as the rainbow."[71]

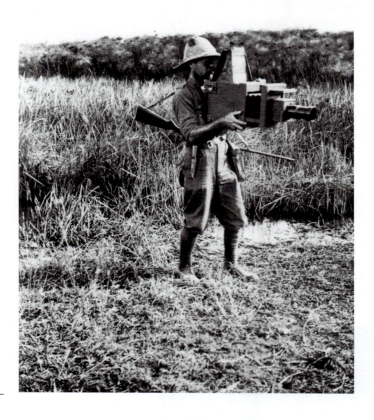

PHOTOGRAPHY, SOCIAL SCIENCE, AND EXPLORATION

While art photography was influenced by science and technology, travel, exploration, survey, and social-scientific photography continued patterns set in the mid-nineteenth century. The encyclopedic urge to collect images was newly invigorated by the growing sense that traditional life around the world was disappearing so rapidly that it must be recorded. In the *British Journal of Photography* (1889), Cosmo Burton suggested that a responsible photographic society should "keep a library of great albums containing a record as complete as it can be made, and in *permanent photographs only* of the present state of the world."[72] Similarly, British anthropologist and colonial administrator Everard im Thurn (1852–1932) wrote that "primitive phases of life are fast fading from the world in this age of restless travel and exploration, and it should be recognised as almost the duty of educated travellers in the less known parts of the world to put on permanent record, before it is too late, such of these phases as they may observe."[73] Roland Bonaparte (1858–1924), relative of Napoleon I, commissioned thousands of photographs around the world, and photographer John Thomson wrote in 1885, "no expedition, indeed, now-a-days, can be considered complete without photography to place on record the geographical and ethnological features of the journey."[74]

Official expeditions set out to clarify national and regional borders, as well as to research roadways, railroads, and resources. As in the mid-nineteenth century, the camera and the gun were accepted equipment for the journey (Fig. 4.63). Likewise, the classification of human types through physical differences continued apace, aspiring to become ever more comprehensive. In short, while the completeness of photography was debated in the realm of art, the medium's objectivity was increasingly central to social science.

PHOTOGRAPHING AFRICA

In Africa, the Western imagination constructed an alternative to the industrializing world, while simultaneously exploiting its natural wealth. Notions of Africa as the "dark continent," historically cut off from the European Enlightenment and racially inferior, were rekindled in the late nineteenth century. Social Darwinists misinterpreted Darwin's theories to mean that people and societies that had not developed in the manner of Western culture were inherently inferior. Africa, particularly Sub-Saharan Africa, was seen as a prime example of timeless backwardness.

Renowned missionary Dr. David Livingstone (1813–1873), famously assumed lost during one of his attempts to bring Christianity to Africa, brought along his brother Charles (1821–1873) as a photographer on an earlier Zambezi Expedition (1858–64). Livingstone the missionary also commanded an official British exploration, seeking mineral wealth and agricultural potential. He favored visual aids to his work, referring to the magic lantern he brought with him to show Bible stories as the "oxyhydrogen light of civilization."[76] Charles Livingstone was replaced by John Kirk, who made the first camera images of an

4.63 (left)
ARTHUR RADCLYFFE DUGMORE, *The Author and his Camera*, from *Camera Adventures in the African Wilds*, 1910. **Royal Geographic Society, London.**

Arthur Radclyffe Dugmore's *Camera Adventures in the African Wilds* appeared in 1910. Opposing big-game hunting in Africa, he claimed that hunting with the camera was more exciting than hunting with the gun.[75]

4.64 PHOTOGRAPHER UNKNOWN, *Henry Morton Stanley and Kululu* (detail), c. 1872. Albumen *carte-de-visite*. London Stereoscopic Company, National Portrait Gallery, London.

The setting of this *carte-de-visite* was a painted backdrop in a London studio. Stanley is being served tea by Kululu (Ndugu M'hali) (1864–1877), who was given to him by a slave-trader. From the age of eight, Kululu was Stanley's personal servant. He died crossing the Congo River during Stanley's 1874–77 expedition.[78]

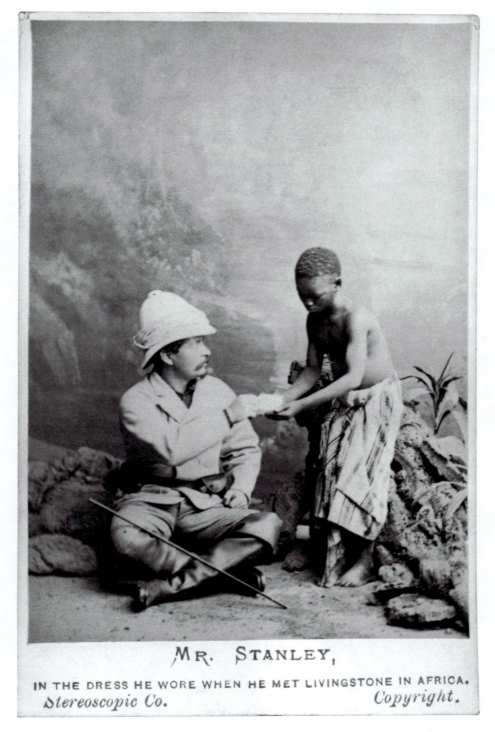

MR. STANLEY,

IN THE DRESS HE WORE WHEN HE MET LIVINGSTONE IN AFRICA.

Stereoscopic Co. *Copyright.*

official British expedition in Africa.[77] In Kirk's photographs, the dense African foliage indicated fertile land, potentially suitable for Western agriculture. At the same time, the jungle also symbolized to Europeans the triumph of nature over civilization.

While writing for the *New York Herald* in 1871, Henry Morton Stanley (1841–1904) found the ailing missionary, and uttered the now well-known phrase, "Dr. Livingstone, I presume?" There were no photographers on the scene, and Livingstone's death in 1873

in a remote area of Africa precluded photographs being made of him. But public curiosity was served when Stanley was photographed in a London studio, supposedly dressed in the very clothes he wore when he met Livingstone (Fig. 4.64).

By 1880, companies that commissioned and published photographs were established in coastal areas of colonial Africa.[79] Interest in Africa grew after the 1885 Berlin Conference, which authorized European nations with coastal bases to expand their interests

FOCUS
The *National Geographic*

The National Geographic Society in the United States began in 1888 as a relatively small group of professional geographers and sponsors. When Alexander Graham Bell (1847–1922), the inventor of the telephone, took over the society's leadership, he stressed dissemination of knowledge. Gilbert H. Grosvenor (1875–1966) was employed to build circulation of the society's publication, which he did by studying the content and marketing of widely read magazines, such as *Harper's*. The *National Geographic*'s friendly tone and especially its uncomplicated pictures made it a success. While the society's 1915 policy statement underscored "absolute accuracy," it also envisaged an "abundance of beautiful, instructive, and artistic illustrations." Moreover, *National Geographic* promised that "nothing of a partisan or controversial character is printed."[80] The possible conflicts between these goals, such as the clash between accuracy and aesthetics,

were not engaged. In his 1909 book *Scenes from Every Land*, Grosvenor reprinted upbeat, pleasant images from the magazine, offering armchair adventure, while avoiding the worst stereotypes of native people. Still, *National Geographic* often pictured people in the less developed world as primitive, implicitly suggesting that non-industrial societies remain static without Western intervention. Despite early twentieth-century prudery, the magazine did show nudity, especially female nudity (Fig. 4.65). In the United States, a longstanding joke has it that American teenagers have their first look at naked bodies in *National Geographic*. Its policy of accuracy, and its announced educational goal, allowed, even invited, readers to look. In effect, *National Geographic* carried forward the high-minded dual pursuit of information and entertainment beloved by fans of the stereographic photograph.

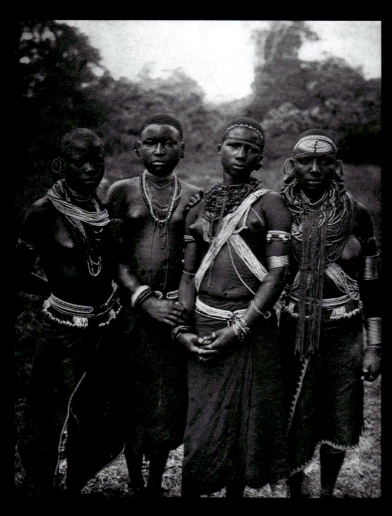

4.65
UNDERWOOD & UNDERWOOD, *Girls in a Village of East Equatorial Africa*, **1909. Photo and copyright by Underwood & Underwood, New York.**

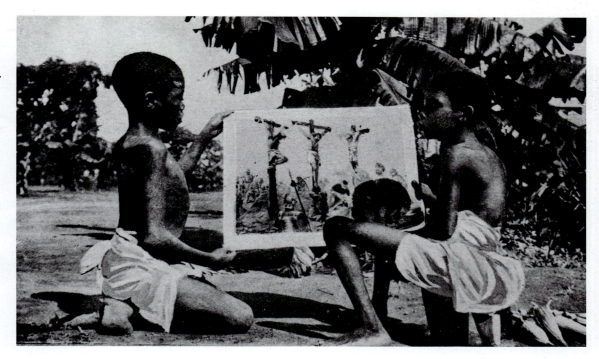

4.66
PHOTOGRAPHER UNKNOWN, *The Sons of the Cannibals Contemplating the Passion of the Redeemer,* c. 1910. Postcard. Archivio Provinciale dei Padri Cappuccini, Milan, Italy.

Schools were often set up by missionaries in Africa. The exaggerated shadow of the child's head on the print of the Crucifixion was probably added to show symbolically that Christianity was appropriate for Africans.

into the African interior so long as they did not impinge on other colonial territories. Beginning in the 1880s, large photographically illustrated books depicting people, land, and riches were published.[81] Trophy animals hunted during safaris were also frequently photographed. Typically, photographs showed Africans as primitive, and European culture and enterprise as progressive. At the turn of the nineteenth century, when the postcard fad flourished, images of Africans were often reproduced in this format (Fig. 4.66). It has been argued that Picasso adapted poses of Africans on postcards made by François-Edmond Fortier (1862–1928), who published more than 8,000 postcards of Africa, for his work during 1906–07, including *Les Demoiselles d'Avignon* (1907).[82]

The spirit of African expansion was expressed in *The Queen's Empire* (1897), a British book celebrating Queen Victoria's Diamond Jubilee. It contained 300 photographic images, including customs, education, and Western engineering feats. The text boasted that "in every part of the Empire we shall find some trace of the work which Britain is doing throughout the world—the work of civilizing, of governing, of protecting life and property, and of extending the benefits of trade and commerce."[83] Armed conflict in Africa was photographed, but was subject to censorship, as in the Boer War (1899–1902), when

soldiers and armaments were regularly photographed. Yet, as historian Jorge Lewinski remarked, "there are no pictures of barbed wire, of the results of the scorched-earth policy, of Boer women and children in prison camps where the mortality rate was nearly 50 per cent and where some 20,000 died."[84] Instead, photographers produced symbolic and sentimental pictures. Underwood & Underwood issued individual views and boxed sets from the Boer War for an international market, including a staged stereographic photograph of a patriotic dying soldier making a last bugle call (Fig. 4.67).

PHOTOGRAPHING THE PACIFIC PARADISE: SAMOA

In Western art and literature, the Pacific islands were long seen as a paradise, where labor was almost unknown, and physical wants, including sexual ones, were easily gratified. At the same time, the inhabitants were seen as exotic primitives, unable or unwilling to live according to Western standards. Great curiosity about the Pacific area was sustained in the eighteenth and nineteenth centuries by the teasing contradictions between the Western Puritan work ethic and a life of reputedly unearned ease and abundance. In particular, images of nude or sparsely clad Pacific island women were taken to indicate a sexual and moral slackness, due to the lack of struggle with nature.

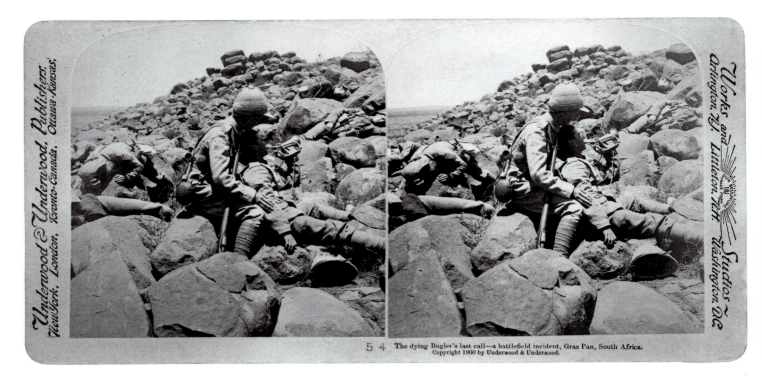

The dying Bugler's last call—a battlefield incident, Gras Pan, South Africa.
Copyright 1900 by Underwood & Underwood.

**4.67
UNDERWOOD &
UNDERWOOD,
*The Dying Bugler's Last
Call—A Battlefield
Incident*, Gras Pan,
South Africa, 1900.
Stereograph, gelatin
silver print. Gernsheim
Collection. Harry
Ransom Humanities
Research Center,
University of Texas
at Austin.**

Historian Roy Flukinger
observed that this pho-
tograph was among
the last sentimental and
idealistic images of
war.[85] The harsh realities
of combat and its harm-
ful effects on individual
soldiers would be pic-
tured throughout the
twentieth century.

Commercial photographers were
aware of these powerful preconceptions,
and were quick to respond. In the late
1890s, as the Samoan Islands became
trade and naval bases for the United
States and Germany, they attracted wide-
spread interest. John Davis (active mid-
1870s; d. 1893), the first commercial
photographer in Apia (then German
Samoa; now the capital of Western
Samoa), told a visitor that "hundreds of
native girls and youths presented them-
selves at his studio in hopes that they
would make photographs of commercial
value for book illustrations and for sell-
ing to tourists." Yet he chose "only two,
or three at the most, who possessed the
thick lips and sensual features which
coincided with the stock European idea
of the South Sea type."[86]

Photography supported social stereo-
types, even for people who had been
there and bought photographs as sou-
venirs. Historian Alison Devine
Nordström suggested that, because the
commercial photographs used for post-
cards, stereographs, and half-tones were
stereotypical, once dealers and distribu-
tors collected enough images to satisfy
customers, they did not require new
ones.[87] These images reinforced the
notion that Samoa, like most of the
Pacific islands, was a timeless, uneventful
ful place. Postcards of Samoa frequently
featured Samoans in scanty native cloth-
ing, as well as beaches, palm trees, and

waterfalls (Fig. 4.68). The Western pres-
ence, in the form of commercial and
governmental buildings, was also pic-
tured. Anthropological photographs
often featured body tattoos, long associ-
ated in visual representations with the
Pacific islands.[88]

CRIMINAL LIKENESSES

During the 1880s, photographs of crimi-
nals became routine in police work. In
the past, the camera had been used
occasionally to record the appearance of
suspects and criminals. In the 1850s,
the Swiss government used it to register
indigents and stateless persons, and
Alexander Gardner made portraits of
President Lincoln's assassins and of
their execution (see Fig. 3.22). But in the
late nineteenth century, the photography
of criminals became as standardized as
anthropological photography, largely
because of the work of Paris police offi-
cial Alphonse Bertillon (1853–1914).
Son of Louis Adolphe Bertillon, a well-
known anthropometrician who used sta-
tistics to describe humankind, Alphonse
Bertillon developed a verbal and visual
system to describe criminals. His main
interest was to identify recidivists, that
is, repeat offenders. Called "speaking
likenesses," Bertillon's invention was
what is known today as the mugshot
(Fig. 4.69).

As historian Allan Sekula pointed
out, Bertillon's system resembled

4.68
JOHN DAVIS,
Samoa Princess
Fa'ane, Apia,
c. 1895. Albumen
print on board.
Phillips Library
Collection. Peabody
Essex Museum,
Salem,
Massachusetts.

Bare-breasted
Samoan women
were often pictured
wearing an elaborate
traditional head-
dress and carrying a
large club. Western
photographers
favored the exotic
look of the *taupou*,
or village maiden,
a position of honor
in Samoan society.
Thus anthropologi-
cal imagery mixed
with tourist visions
of the Pacific.

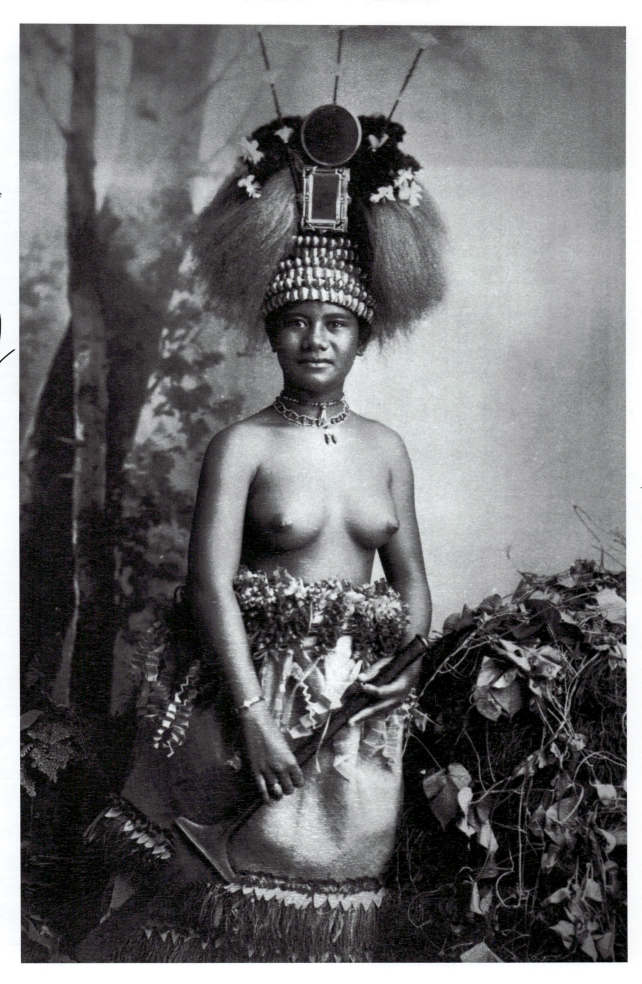

225

PHOTOGRAPHY, SOCIAL SCIENCE, AND EXPLORATION

**4.69 (opposite)
PHOTOGRAPHER
UNKNOWN**, *Synoptic
Table of Facial
Expressions for the
Purposes of Systematic
Identification*, **according
to Alphonse Bertillon's
system**, n.d. Musée
de la Préfecture de
Police, Paris.

Alphonse Bertillon con-
sidered that objective
photographs of a per-
son's face and profile,
together with measure-
ments and typology of
specific body parts,
such as the ear and the
mouth, would produce
a unique record of an
individual that could be
used by the police to
identify criminals. To
standardize his pho-
tographs, he insisted
on a consistent focal
length, lighting, and
distance of the subject
to the camera.

the efficiency systems developed by
Frederick Winslow Taylor, and Frank
and Lillian Gilbreth (see p. 217). Break-
ing down physical appearance into
small, standardized units allowed
unskilled clerks to file and retrieve crim-
inal photographs.[89] The creation of large
information archives, such as those
used in police work, strengthened gov-
ernment control of the populace and,
with anthropological photography, came
close to fulfilling the abiding nine-
teenth-century dream of a vast, encyclo-
pedic collection of images.

Bertillon's publications, such as
*L'Identité des récidivistes et la loi de régula-
tion* (*The Identity of Recidivists and Legal
Regulation*) (1883) and *Identification
anthropométrique* (*Anthropometric
Identification*) (1893), influenced crimi-
nology and police procedures around
the world. They fit into an existing trend
that saw criminality as evidence of
degeneration, that is, of faulty innate
tendencies in the individual brought out
by the pressures of modern society.

French statistician Gabriel Tarde
published *La Criminalité comparée*
(*Comparative Criminality*) (1886), and
British science writer Havelock Ellis fol-
lowed with his own tract *The Criminal*
(1890), which contained photographs of
American, Russian, and Australian
criminals, purporting to show the stig-
mata, or physical signs, of their moral
defects. Ellis's friend, American medical
doctor Eugene S. Talbot, proclaimed that
"criminals form a variety of the human

family quite distinct from law-abiding
men," and liberally illustrated the
1901 edition of his book *Degeneracy: Its
Causes, Signs, and Results* with pho-
tographs of criminals and others whom
he considered deviant.[90] New York
city police inspector Thomas Byrnes
glamorized detective work in his 1886
Professional Criminals of America, which
was also illustrated with photographs.
Perhaps the most influential crime tract,
Italian Cesare Lombroso's *L'Uomo delin-
quente* (*The Criminal Man*) (1876), was
expanded in the 1890s with added illus-
trations. Unlike Bertillon, Lombroso
thought criminality inherent, the expres-
sion of a biological element persisting
from primitive times. In the late nine-
teenth century, fingerprinting, devel-
oped under British colonial rule in India
and promoted by British scientist
Francis Galton (see below), was gradu-
ally introduced alongside the mugshot.[91]

Even small, local police departments
commissioned mugshots of criminals.
In Marysville, California, a small town
in the Sacramento Valley, portrait pho-
tographer Clara Sheldon Smith (b.1862)
fulfilled a contract with the city from
1900 to 1908, contributing about 500
photographs to the local rogues' gallery
(Fig. 4.70). Because prisoners were
often brought to her studio unan-
nounced, she sometimes photographed
them using the backdrops and lighting
set up for her regular customers.[92]

Another systematizing approach to
human description and photography

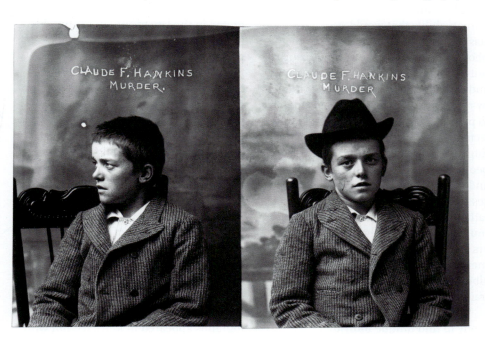

**4.70
CLARA SHELDON
SMITH**, *Claude F.
Hankins: Murderer*,
1904. Arne Svenson
Collection.

On July 1904, fourteen-
year-old Claude F.
Hankins shot and killed
an older man whom
he claimed tried to com-
mit "a crime against
nature" with him.
He was sentenced to
sixteen years in San
Quentin State Prison.
He received early
parole in 1914.

4.71
FRANCIS GALTON,
Untitled, from *Inquiries into Human Faculty and its Development,* 1883.

On a single photographic plate, Galton combined images of the mental and physical types, exposing one negative after another until all had been registered. He computed the exposure time by dividing the exposure time for one plate by the number of photographs he planned to register. Galton used composite photography to obtain what he called "representative faces" and "pictorial statistics" that condense large statistical tables.

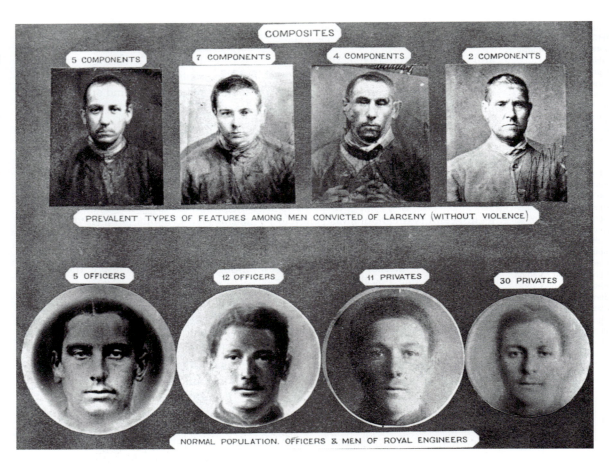

was used by Francis Galton (1822–1911), the British scientist best known for his studies of heredity and for founding the science of eugenics, which he defined as "science which deals with all influences that improve the inborn qualities of a race."[93] In Galton's words, an improved humankind (presumably British), "should be better fitted to fulfill our vast imperial opportunities."[94] Eugenics suggested a natural social order based on human ability that would surpass social class and wealth; Galton believed that photographs would show human superiority, just as they showed mountains and cathedrals. Photography was touted by reformers such as Galton as superior to painting, which was based on subjectivity, not objective description. Eugenics and photography attracted people in science, industry, academia, and government who had gained success through intellectual achievement rather than birthright. Galton used the mugshot format to photograph prisoners as well as patients, and recommended that the public create family albums with full-face and profile portraits arranged chronologically.[95]

Where Bertillon hoped to use photography to find unique individuals within a vast photographic archive, Galton sought to show general hereditary laws. For his 1883 *Inquiries into Human Faculty*, he invented a form of composite photography to make his points. Relying on the belief in photography's truthfulness, he called such images "real generalization,"[96] of criminals, tuberculosis patients, Jews, and families (Fig. 4.71). Composite images never ceased to interest viewers. They were powerfully invigorated in the late twentieth century by the ease with which images could be melded by computers.

WAR AND PHOTOGRAPHY

The capacity of newspapers and magazines to print photographs, the growth of journals devoted to contemporary events, and increased speed in communications and transportation systems, made it technically possible for the public to see much more of war than in the past. During the American Civil War, topical photographs had to be viewed in a gallery, photographic studio, or bookseller's shop, often weeks after an event. Only engraved interpretations of photographs appeared in journals. But with

the success of the half-tone processes for printing photographs with text, photographs could be quickly reproduced and generously displayed in the press. As historian Susan D. Moeller argued, the Spanish–American War became the first "living-room" war.[97]

THE SPANISH–AMERICAN WAR

The conflict between Spain, which ruled Cuba, and the United States simmered for several years before American troops were sent into Cuba. Egged on by many inflammatory articles and shocking photographs of atrocities published in newspapers owned by the Hearst and Pulitzer syndicates, Americans empathized with the Cuban guerrilla forces fighting for independence. American newspapers further inflamed the situation by blaming the Spanish for the sinking of the U.S. battleship *Maine*, on February 15, 1898, in the harbor of Havana, Cuba. "Remember the *Maine*" became a popular slogan, and large photographic firms marketed stereographs of the incident. Of all their pictures, Keystone View Company sold more of the wreckage of the *Maine* than any other.[98] The Spanish–American War (April 25– August 12, 1898) was probably the first war filmed by the motion picture camera. Some early filmmakers even faked battle scenes on the roofs of New York City buildings, using toy boats floating in bathtubs, and cigar smoke for the fumes of burning.

On April 25, 1898, the American Congress voted for war, setting off a stream of volunteers to serve in the military. Among them was the then Assistant Secretary of the Navy, Theodore Roosevelt, who formed the First Volunteer Cavalry, known as the Rough Riders. The war's lack of planning, shortages of supplies, and general mismanagement recall the Crimean conflict. Roosevelt's famous cavalry charge up San Juan hill, sung in the press as a valiant and heroic act, was in fact a rash strategy born of desperation. There were no photographs of the actual charge, and the celebrated paintings of the incident by Frederick Remington (1861– 1909), who was in Cuba to make illustrations for William Randolph Hearst's New York *Journal*, were made after Remington had returned to the United States. Nevertheless, the favorable pub-

licity generated by the charge ushered Roosevelt into the governorship of New York (1898–1901).

Despite the public interest in the war, few photographers were assigned to it. Frances Benjamin Johnston, who was running a successful portrait studio in Washington, D.C. (see p. 190), worked as a correspondent for the Bain News Service. When Admiral George Dewey was returning from the American victory in the Philippine Islands, a Spanish possession ceded to the United States at the end of the conflict, she got the first interview with him, titled the "Hero of Manila Bay." With Jessie Tarbox Beals (1870–1942), the first American woman to hold a full-time position as a staff photographer on an American newspaper, Johnston was among the earliest women photojournalists.

James Henry Hare (1856–1946) gained a reputation for war photography (Fig. 4.72). Journalists about to sail to cover the Mexican Revolution (1911–14) asked, "Where is Jimmy Hare? This cannot be a war. Jimmy Hare is not here."[99] His notoriety bespeaks the hot competition among magazines and newspapers that sparked the expansion of photojournalism in the early twentieth century. He became part of a team of writers from *Collier's*, which covered both sides of the war between Russia and Japan (1904–05). He also photographed the San Francisco earthquake of April 1906, the First Balkan War (1912–13), the Mexican Revolution (1914), and World War I. The magazine boasted that "wherever there is an army in the field, and clash of arms and bullets and the tragedies of war … there, too, is a man from *Collier's*."[100]

WORLD WAR I

During the Spanish–American War, while news stories could be cabled to newspapers competing for the most topical articles, photographs still had to be transported by sea and land. Nevertheless, the potential existed for civilians to see war in greater detail than ever before. By World War I, it was clear to military officials that both photographs and news stories should be broadly managed to keep clandestine operations secret, and to keep up spirits at home. The assassination of the Archduke Franz Ferdinand (1863–1914), heir to

230

4.72
JAMES "JIMMY" HARE, *Carrying out the Wounded During the Fighting at San Juan,* **c. 1914. Gernsheim Collection. Harry Ransom Humanities Research Center, University of Texas at Austin.**

During the Spanish–American War, Hare photographed exclusively for *Collier's* magazine. With American writer Stephen Crane, he followed the Rough Riders up Kettle Hill, the major fortress in the San Juan hills. He did not photograph the famous charge, but depicted the removal of the wounded.

the Austro-Hungarian monarchy, in the Bosnian city of Sarajevo on June 28, 1914 became the trigger for conflict between Germany, Austria-Hungary, and Italy (the Triple Alliance) and Belgium and the Triple Entente, which consisted of France, Russia, and Britain. The United States did not enter the engagement until April 1917. Trench warfare, which characterized the conflict on the Western, or European, Front, caused unprecedented loss of life (see Fig. 4.75). Ten to thirteen million people died in hostilities sustained by the mass production of armaments.[101] On average, troops endured a death and injury rate of fifty-eight percent.

During the Spanish–American War, newspapers led public opinion in the United States, but during World War I, governments took the lead. Homefront morale proved less of a problem than expected, because the press practiced self-censorship. During the war, photographs were shown in galleries, including the Grafton Galleries in London, which in December 1916 exhibited work

done for the Canadian War Records Office. The prints, enlarged to 3 by 3 feet, up to 6 by 10 feet, resembled traditional heroic painting in both size and subject-matter.[102] Although the press did not seek to undermine official pronouncements, or to offer the soldier's view of battle, it did critique the photographs of the enemy. In Germany, a regular column in the *Deutsche Photographen Zeitung* (*German Photographic Newspaper*) reported "the photographic lies our enemies tell."[103] Britain prohibited making photographs of corpses or scenes of conflict. After 1916, soldiers were buried where they were killed, rather than transported home.[104] Horrific tales from battles such as Gallipoli and Verdun were generally not backed up with photographs that the public could see, creating a profound difference between the experience of soldiers and public awareness, especially in Britain, which did not undergo trench warfare on its own soil.[105]

Photographers were eventually banned from the Western Front, causing

newspapers and illustrated serials to rely on artists, and photographs already in stock. Another problem troubled photographers and editors alike. *The War Illustrated*, a serial, announced in November 1914 that "from the pictorial point of view modern warfare lacks much which the battlefields of the past provided. Soldiers today are fighting enemies on the continent whom they never see … For this reason the great mass of photographs which reach us do not show actual hostilities."[106] Others complained that the war, conducted on flat plains, under cover of cloud and darkness, offered uninspired photographs. Occasionally, events such as soldiers "going over the top" of the trenches, were staged for the camera, the presence of which would draw fire during a real charge.[107]

Press photography was not the only kind made during the war. In Britain, the Snapshots from Home League encouraged citizens to send comforting pictures to soldiers (Fig. 4.73). Nurses,

THE AMATEUR PHOTOGRAPHER & PHOTOGRAPHIC NEWS

August 2, 1915.

Y.M.C.A. **Send them all Snap-shots from Home!** Y.M.C.A.

This three-panel poster, to a size of 12 feet by 10, and in colours, is being placed upon the hoardings by the Y.M.C.A. "Snapshots from Home" League.

"SNAPSHOTS FROM HOME."

HOW THE WORK IS BEING ORGANISED.

OUTSIDE the Y.M.C.A. headquarters in Tottenham Court Road (writes a correspondent) an artistic sign invites you to the "Snapshots from Home" League. Entering a swing door, you will find a large hall on the ground floor has been given over to the work of this movement. Ordinarily the hall is used for concerts and meetings, but now, instead of the sound of stringed instruments, there is heard the rattle of several typewriters, while the platform is occupied by a roll-top desk, and on the wall behind it is a reproduction of the excellently drawn poster which will soon be familiar to the public. On three sides of the building are large filing racks for the registrations which have yet to come, and at four long tables are seated some thirty or forty girls and women engaged in the business of filing, indexing, addressing, and all that detail work which is required in order to get such an organisation as this on its feet.

Long before any announcement was made to the public, a large staff was working day and night upon the preliminary arrangements. The morning of my visit was the one on which Mr. Yapp's appeal first appeared in the Press, but the activities were already such as to characterise a going concern. Heaps of parcels were ready for dispatch to the Y.M.C.A. camps in France, containing forms for requests to be filled up by the men. Two hundred thousand such forms were being sent to Salisbury Plain alone; others had just been sent on their way to India and Egypt. Many of the staff were making a microscopic study of county maps, with a view to dividing the country into effective local areas, and writing names of places on blue cards, which were filed according to the respective counties; while others were compiling complete lists of dealers, professional photographers, and other people with whom it was desired to get into touch.

The rest was all the paraphernalia of a great business establishment. There were cardboard boxes innumerable, mounting heaps of envelopes, tens of thousands of little reminder labels for sticking on to packets of plates and the like. Then there were register books, like cheque books in appearance, for the enrolment of voluntary workers, with particulars of their town and district, and the number of families to whom each of them was willing to supply free snapshots. Altogether, under the direction of Mr. W. C. Thorn, Mr. Yapp's able lieutenant, the machine bade fair to get smoothly into working order, and to leave not one of those loopholes for failure which are due to inattention to trifling details.

88

4.73
ARTIST UNKNOWN,
Send them all Snapshots from Home! from *Amateur Photographer,* **August 2, 1915. Birmingham Central Library, Birmingham, England.**

Part of the British volunteer effort on the home front was the coordinated effort to send soldiers abroad pictures of their loved ones at home. In a poster made for the YMCA, which sponsored the drive, the woman on the right can be seen taking a photograph of a young child. In the center, a soldier brags about the image he has just received.

crazy
faant

4·74
PHOTOGRAPHER
UNKNOWN, *Untitled*
(Soldiers in World War I
trenches), n.d.

Although forbidden to
do so, soldiers some-
times brought cameras
with them to the front.
In this haunting image,
a technical flaw caused
the figure on the right to
fade into the muddy wall
of the trench, inadver-
tently symbolizing the
death of soldiers trying
to gain a small amount
of ground separating
them from the enemy.

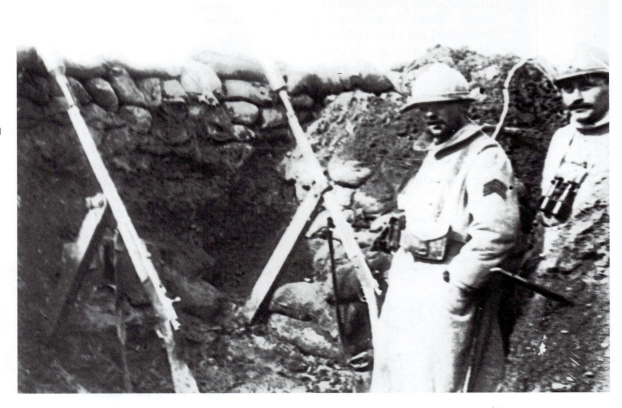

4.75 (below)
WILLIAM RIDER-RIDER, *Untitled* **(Devastation on the battlefield of Passchendaele taken with**
a panoramic camera), 1917. Imperial War Museum, London.

In June 1917, the poet T. S. Eliot forwarded a letter written by a soldier to *The Nation*. Eliot's
correspondent described the front as "mud like porridge, trenches like shallow and sloping
cracks in the porridge, porridge that stinks in the sun."[108]

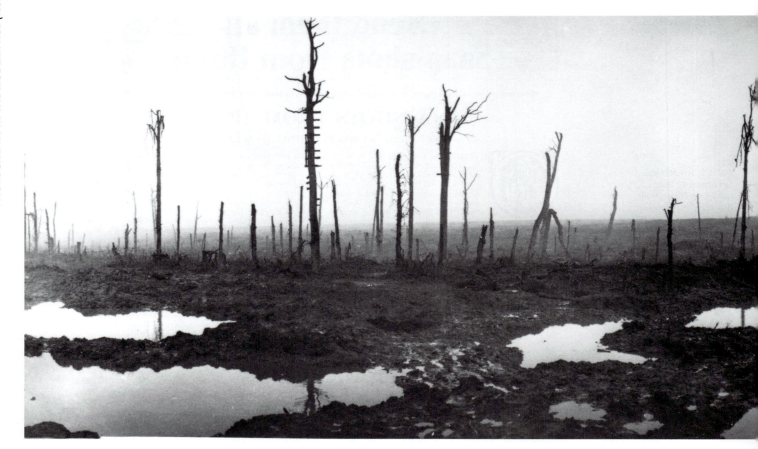

ambulance drivers, and soldiers brought small cameras to the war (Fig. 4.74), and newspapers printed photographs found on battlefields, in hopes of identifying the soldiers who might have possessed them. Personal photographs recorded shocking material not considered appropriate for general circulation. The military, meanwhile, experimented with official photographers, whose numbers were limited, but who were given privileged access to troops and events. Britain, Australia, Canada, New Zealand, France, the United States, and Germany all employed official photographers, often military personnel, whose role was to record, rather than issue photographs to the press. International photographic distributors, such as Underwood & Underwood and Keystone View, sent photographers to the war. Aerial photography for military reconnaissance was perfected; in 1918 Steichen (see pp. 186–87) became chief of the newly formed Photographic Service for the United States military.

As in previous wars, gruesome images of the enemy dead were published, but pictures of one's own casualties were mostly limited to the injured receiving speedy humane treatment. A German directive urged photographers to record the "fairness of the German troops and the destructive cruelty of the enemy."[109] Yet as the war went on, greater recognition of its terrible cost began to show up in photographs. Official Canadian photographer, William Rider-Rider (1889–1979) took photographs of the dismal, muddy trenches at Passchendaele, where the Germans first used mustard gas (Fig. 4.75). After the war, as the public learned more of its horrors, images of the trenches came to epitomize the conflict.

THE RUSSIAN REVOLUTION

The uprising of workers and intellectuals against the Russian monarchy was facilitated by the government's distraction during World War I. The various confrontations between March and November 1917 were not programatically photographed, and, until recently, most photographs of the Revolution seemed to derive from motion picture film of such events as the storming of the Winter Palace. In the post-Cold War period, images are beginning to emerge from Russian archives, promising more information about the use of photographic propaganda by all the factions.

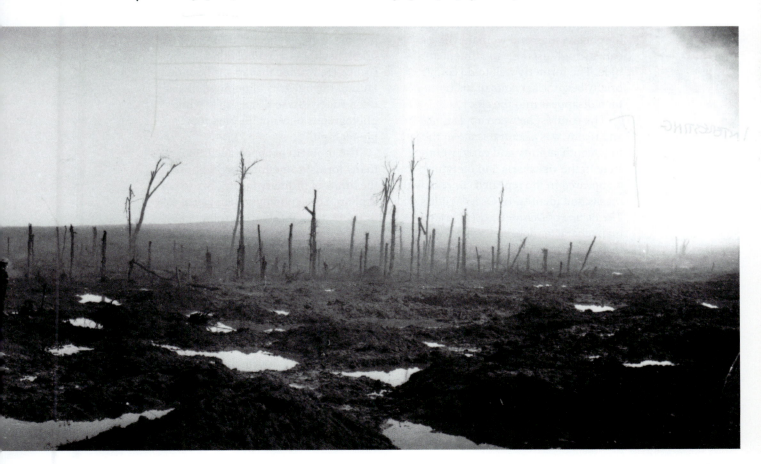

One series of images of the Russian Revolution was made by the Bulla photographic agency (Fig. 4.76). Founded by Karl Bulla (1854–1929), the agency sent photographs to such publications as Germany's illustrated newspapers. Bulla, who also made photographs of the Russian elite, emigrated to Estonia after the Revolution, leaving his sons to carry on the business. Viktor Bulla (1883–1944?) became one of the first to film the news with a motion picture camera.

PHILOSOPHY AND PRACTICE: THE REAL THING

In his 1893 short story "The Real Thing," Henry James told of a handsome and prominent husband and wife who have lost their fortune. Once they were such social celebrities that photographers made their likenesses to sell in shops. Now financially desperate, the couple visits an artist who makes illustrations of contemporary life for magazines. They hope to earn money by posing as "the *real* thing; a gentleman, you know, or a lady."[110] But the artist is frustrated in attempts to create the illusion of wealth and elegance by using them as models, and employs instead a lower-class man and woman who can convincingly assume an affluent attitude. The formerly well-to-do couple briefly become servants in his home, then disappear into the city.

The contrast between appearance and reality was a central issue in the late nineteenth century and early twentieth. In both the visual arts and literature, it appeared in the repeated concern with masks and identity. In Oscar Wilde's *The Picture of Dorian Gray* (1884), the main character does not age or betray the effects of his debauched behavior, but a portrait of him evidences physical and spiritual decay. The developing relationship between acceptable public appearance and the avid consumption of mass-produced commodities is reckoned in Theodore Dreiser's *Sister Carrie* (1900), a novel whose eponymous heroine is an actor who defines herself in fantasies of material goods, especially as arrayed in a department store.

Photography was increasingly used in the fabrication of biased social evidence. A much reprinted story in legal journals during the late 1880s told of a lawyer who meets a photographer. The attorney accuses the photography profession of making him lose a case. The photographer replies, "you should get some photographs taken on your side also."[111] In effect, the photograph simultaneously confirmed and denied truth, while emphasizing the appearance of accuracy.

In 1893, when Abdulhamid II (1842–1918; r. 1876–1909), ruler of the Ottoman Empire, learned that his dominion was being perceived as "the sick man of Europe," he sent elaborate photographic albums to Britain, France, Germany, and the United States, hoping to change perceptions. Rather than images featuring timeless peasant life, the albums contained photographs of girls' schools, fashionable Western-style shops, a modern military, and factories located in the Empire. Whereas the Ottoman Empire album comprised actual photographs, the half-tone process enabled localities to produce "booster books," illustrated descriptions of cities emphasizing only those aspects that would encourage commerce.

In a 1909 address to the National Child Labor Committee, Lewis Hine spoke directly to the question of photographic truth. He held that the photograph itself was a symbol of reality, not reality. He warned that an "unbounded faith in the integrity of photographs is often rudely shaken," because "while photographs may not lie, liars may photograph."[112]

The problem of appearances took many forms, sometimes highlighting the limits of ordinary human sense perception. Some photographers, such as Stieglitz, were influenced by the French philosopher Henri Bergson (1859–1941), extracts from whose *Creative Evolution* and *Laughter* appeared in *Camera Work*. Bergson's concern with the limits of intelligence and the need for intuition to perceive beyond appearances was deliciously vague and readily popularized. It blended with notions of the occult and the fourth dimension, and fostered the belief that the spirit photograph and the X-ray revealed a world not heretofore perceptible. For Stieglitz, stretching toward the immaterial meant photographing clouds, not as

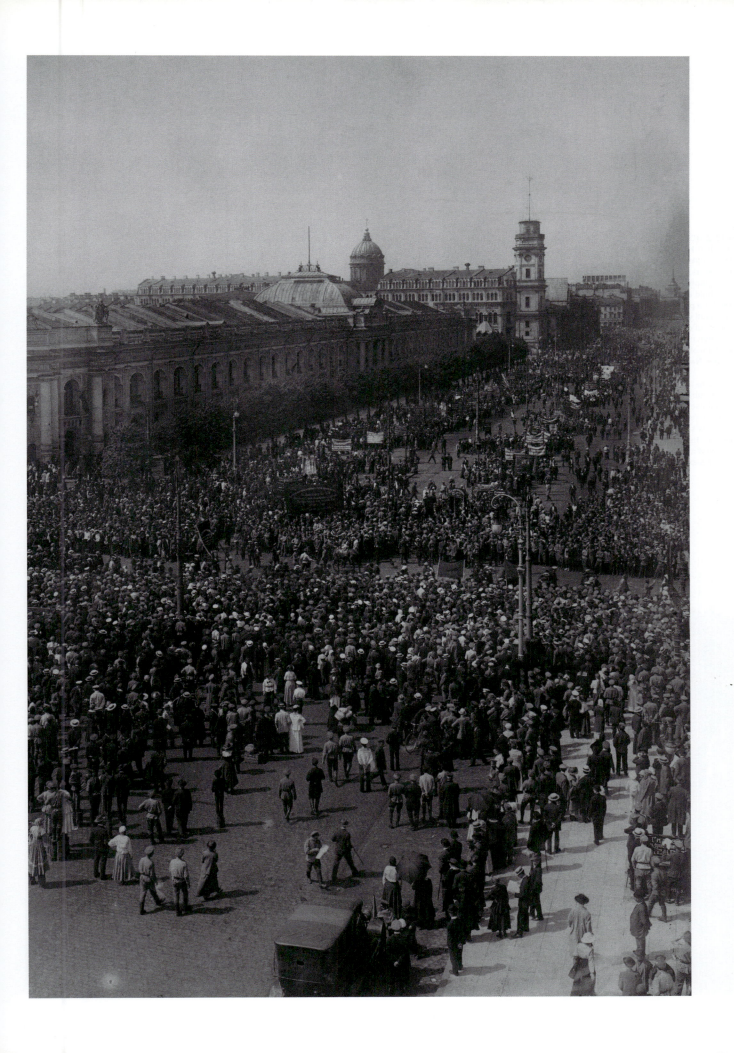

weather phenomena, nor as pleasing abstract shapes, but as "Equivalents" to ideas that were beyond words (see Fig. 4.25). To art photographers, intuitive insight meant rejecting the appearance of optical reality, and investigating a world of symbols and clues to hidden meanings. In that sense the haze of Pictorialism did not mask reality, but suggested its promise.

In contrast to the static, compartmentalized domain of the archive, Bergson's world was in constant flux. It resembled the experience of the modern, dynamic city, where anonymous people flowed along the streets, an endless current—like the electricity increasingly lighting the metropolis and energizing the factories. While Bergson himself saw camera images as stubbornly mundane, others found just the opposite in scientific photographs of movement, which they argued hinted at a spiritual world beyond physical fact.

For those photographers who eschewed Pictorialism, authenticity was not a simple matter. At the 1904 World's Fair in St. Louis, which presented about 2,000 indigenous peoples in the largest anthropological exhibition ever staged to date, one was invited to travel from Africa to Asia, visiting simulated environments and buying photographs and postcards of places that were staged especially for the fair. The effect was far more sophisticated than the painted scrim and gently tinkling cowbells of Daguerre's Diorama (see pp. 11–12), but visitors still accepted the photographs and the environments as simulations, a category between the real and the false that was neither actual nor deceptive. Similarly, while studying the indigenous peoples of the northwest coast of Canada and the northeast coast of Siberia, anthropologist Franz Boas (1858–1942) eliminated traces of the contemporary world, photographing people performing traditional tasks in front of backdrops (Fig. 4.77). Performances before the camera were as old as photography itself, but the practice that

4.77
FRANZ BOAS AND GEORGE HUNT, *Untitled* (Anthropologist Franz Boas, left, and photographer George Hunt hold up a backdrop for a photograph of a Kwakiutl woman in the process of cedar-bark weaving), n.d. American Museum of Natural History, New York.

The poses assumed by Boas's subjects were often those that he hoped to recreate in New York's Museum of Natural History, whose president had sponsored his expedition.

would eventually be called documentary photography maintained the myth of objective and unaltered observation.

A split emerged between those who maintained that photography was a channel for intuitive insight and self-expression, and those who set up systems relying on the medium's objectivity. It was a split implicit in photographic practice from the first, but it broadened as that practice expanded. The wide division echoed the conflict between positivism—the outlook adopted by science and social science, which asserted that knowledge was derived from the observation of facts—and metaphysics, which suggested that there were important meanings beyond those perceptible in human intellectual systems.

The disagreement was summed up by a commentator for a popular magazine in 1894: "Wherein [photography] presents facts, it is a science. Wherein it presents ideas, it is an art."[113] Science was not without ideas, but it derived its legitimacy from impersonal observation and record keeping. Art, on the other hand, originated in the personal and intuitive experience, and yielded another, even greater sort of truth. Scientific observation rested on a separation between the observed and the observer that did not acknowledge that photographers tinkered with what was observed, as, for example, Muybridge did when he reordered sequences of photographs, or as Hine did when he deliberately eliminated from his picture "non-essential and conflicting interests."[114] Bergson rejected that division, in favor of a fluid interchange between the observer and observed.

At the turn of the twentieth century, photography was no longer associated with new and sudden social shifts. The quickening of technological and scientific progress, and resultant social change, were symbolized above all by electricity, which was lighting cities, running street cars, and powering large factories. As a machine, the camera was aligned with the First Industrial Revolution. Electricity powered the Second Industrial Revolution, which included the telephone; the combine, which reaped and threshed grain; automatic looms in the textile industry; the adding machine; the widespread use of typewriters; and the electric light bulb, together with power plants and the network delivering electrical power. Many late nineteenth-century writers saw electricity as a metaphor for rapid and powerful change; the camera gave way to the dynamo. When that tireless boy-inventor Tom Swift improved his camera, in Victor Appleton's 1914 *Tom Swift and His Photo Telephone*, he hitched it to the telephone and electricity.

At the end of World War I (1918), fiercely explicit photographs of the sufferings of the troops began to circulate. The ultimate shocking collection was *War against War!* (1924), gathered by the German pacifist Ernst Friedrich (1894–1967) and published in German, English, French, and Dutch. The experience of the war led some intellectuals and artists to believe that Western civilization itself had lost its authenticity, that is, a claim to cultural and scientific achievement. This perception followed on the declaration of Sigmund Freud (1856–1939) that human nature harbored an unconscious psychic realm that influenced behavior, but which could not be fully known. Alienation, arising from the experience of war and the psychological fragmentation of self, finally did away with Pictorialism's grander assumptions about making life an art, and brought into question the very concept of representation in the post-World War I era.

Importance of altering truth for aesthetic reasons — problematic b/c of photo assumption of the real?

CHAPTER FIVE

A New Vision (1918–1945)

5.0
WALKER EVANS, *Allie Mae Burroughs,* 1936, from *Let Us Now Praise Famous Men* by Walker Evans and James Agee, 1941. Gelatin silver print. Harry Ransom Humanities Research Center, University of Texas, Austin, Texas.

Posed against weathered clapboards, Allie Mae Burroughs's prematurely lined face, with its thin smile and narrowed eyes, corresponds to the horizontal shadows and wood grain behind it, as if the person and the house were close relatives. While the camera's closeness to the subject was calculated to jolt the viewer, its mass of photographic detail connoted honesty and objectivity on the part of the photographer.

A photographer entering the profession in the years between the world wars did so in circumstances vastly different from those prevailing at the turn of the century. The swift proliferation of industry after World War I changed how people worked, the goods they consumed, and thus the images they required. In the 1920s, the industrialization of photography reached a new level, with the expansion of newspapers, general and special-interest magazines, and professional periodicals, all of which employed photomechanical means of reproducing images.

During the 1920s mass media grew at an astonishing pace. For instance, the city of Berlin, Germany, boasted forty-five morning and fourteen evening newspapers. In addition, hundreds of illustrated magazines and journals were devoted to special topics, such as fashion, health, and the automobile.[1] As mass-market illustrated journals proliferated, the word "photojournalism" entered into common usage. The inescapable presence of photomechanical illustration influenced many of the artistic movements that took root in Berlin, and the city's culture became known throughout Europe and Russia

for its visual arts experiments. The popular weekly periodical *Berliner Illustrirte* [sic] *Zeitung* (*Illustrated Berlin Newspaper*), started in 1890, but redesigned to carry many photographs, had a circulation of over two million during the 1920s[2] (Fig. 5.1). *BIZ*, as it was popularly called, pioneered the photo-essay, which was rapidly copied at home and abroad. Politically aligned illustrated magazines soon appeared, such as the German left-wing *Arbeiter Illustrierte Zeitung* (*Workers' Illustrated Newspaper; AIZ*), established in 1921 by Willi Münzenberg (1889–1940) specifically to foster liberal and humanitarian causes and critique capitalism.[3] On the political right, the Nazi party founded *Die Illustrierte Beobachter* (*The Illustrated Observer*), which became one of its official papers. In France, *Vu* (*Seen*) was launched in 1928 with the aim of communicating liberal ideas to the working class.

The hardships of postwar Germany and central Europe forced many art photographers to turn to photojournalism for a living, among them Hungarian-born Martin Munkacsi (1896–1963),[4] who photographed for *BIZ* and other magazines owned by the Berlin firm of Ullstein Verlag, then the world's largest

5.1 (above)
MARTIN MUNKACSI, Cover of *Berliner Illustrirte Zeitung*, July 21, 1929.
Bildarchiv Preussicher Kulturbestitz, Berlin.

Munkacsi's experience as a sports reporter who captured in words the quick movements of players helped him create visually dynamic photographs for the illustrated newspapers. His split-second responses to action scenes encouraged a taste for the fleeting image among photojournalists, art photographers, and the readers of the new illustrated periodicals.

publishing house (see Fig. 5.1). A decade later influential mass-circulation picture magazines were still being set up. In the United States, *Life* magazine, founded in 1936, took its cue from European models, both in terms of their style and their use of expert photographers (see Fig. 5.61). Britain's *Picture Post* began in 1938, under the direction of Stefan Lorant (1901–1997), who had previously made the *Münchner Illustrierte Presse* (*Munich Illustrated Press*) an outstanding picture newspaper.

Between the two world wars, the average person in the industrialized nations saw more photographs than his or her late nineteenth-century counterpart, although these images were not original prints but photomechanical reproductions in newspapers and magazines. Photographic historians Colin Osman and Sandra S. Phillips concluded that "taking 1927 as the departure point of the new thinking in picture journalism, the progress made by 1937 was far greater than in the whole of the previous history of press photography."[5] While mass-manufactured images, in the form of *cartes-de-visite* and stereographs, had been common in the home in the late nineteenth century, these were chosen by viewers, arranged in personal albums or collections, and could be looked at repeatedly. Newspaper and magazine images, by contrast, were selected by photo-editors or advertising designers, circulated for a short time,

5.2
ERICH SALOMON,
***Hague Conference*, January**
3–20, 1930. Gelatin silver print.
Bildarchiv Preussischer
Kulturbesitz, Berlin.

then superseded by more images. Photographers had many more outlets for photographs, representing a wide range of political positions. Moreover, the glut of images was producing an increasingly visually sophisticated audience that rapidly came to see printed images as transitory and expendable.

Technological improvements increased the range of pictures that could be taken. The Leica camera, developed before World War I as a device to test movie film, was introduced to a wider audience in 1924. The Leica and its rival, the Contax camera, used 35-mm roll film, whose sensitivity, that is, "fastness," was continually being improved. Also in 1925, magnesium flash power was replaced by the safer flashbulb developed in Germany. Preferring the greater detail rendered by larger negatives, some photographers continued to use big cameras, but there was a universal tendency to mimic the spontaneous look made fashionable by the small-camera users. The public delighted in "candid photography," a phrase first used to describe the work of German photojournalist Erich Salomon (1886–1944), whose social connections gave him access to the corridors of power, where he made photographs that *seemed* beyond artifice (Fig. 5.2). Salomon's work, published in the *Berliner Illustrirte Zeitung*, implied the importance of the public's right to see behind the scenes of important political events.

The inter-war period witnessed the rapid development of journals largely devoted to pictures, especially the TABLOID newspaper, a compact journal featuring eye-catching pictures and far less text than the earlier broadsheet newspapers. Tabloids featured sensational crime and violence pictures, candid celebrity shots, and spectacular disaster photographs—just the thing to pick up while traveling to work on the streetcar, or while downing a quick meal in the factory lunch room. Tabloids told their stories quickly, through large pictures and brief captions.

In London, a women's magazine called the *Daily Mirror* was transformed in 1904 into a picture-driven daily newspaper. In the United States, the *New York Illustrated Daily News*, which became the *New York Daily News*, appeared in June 1919. The masthead of the *New York*

Daily News featured a camera with wings, symbolizing the speed with which photographers pursued their stories. By 1930, its circulation had grown to more than 1.5 million. Typical of the audacious spirit of the *Daily News* was photographer Tom Howard's (active 1920s) quest of a picture of murderer Ruth Snyder at the moment of her electrocution. The picture ran with the one-word headline: "DEAD!" (Fig. 5.3). Then, as now, there was highbrow opposition to the prevalence of pictures in tabloids. As journalism historian Michael L. Carlebach observed, "abundant use of pictorial material" was understood "as conclusive proof both of declining literary standards and a nefarious plan to exploit hopelessly naive and illiterate people."[6]

Newspapers aimed at middle-class audiences were also lavishly illustrated. Themed ROTOGRAVURE sections (a process that allowed photographs to print with text) were inserted into Sunday papers. Fashion and high society were all the rage in the inserts, as noted in Irving Berlin's popular tune *Easter Parade* (1933), in which a lad boasts to his lady that "On the Avenue/ Fifth Avenue/The photographers will snap us/And you'll find that you're/in the rotogravure."

5.3
TOM HOWARD, *Dead!* (Execution of Ruth Snyder), front cover of *Daily News*, January 13, 1928. *Daily News*, New York.

The *Daily News* encouraged photographers to get images by whatever means possible. The blurry photograph of murderer Ruth Snyder at the moment of her electrocution was taken by their photographer, Tom Howard, who strapped a hidden camera to his ankle and raised his leg at the appropriate moment.

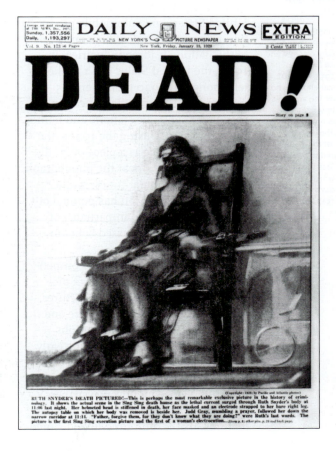

5.4
PHOTOGRAPHER UNKNOWN, *"Zeppelin Blast Kills Thirty-Five,* **from** *Los Angeles Times,* **Friday, May 7, 1937. Newsprint.**

Many photographers were present when the *Hindenburg* crashed and burst into flame on May 6, 1937. A radio announcer choked and wept over the airwaves of his station, and his grief was broadcast around the country. Images of the disaster were wired to newspapers across the United States, which ran them in next day's edition— a rapid response at that time.

The illustrated newspaper was not the only nineteenth-century innovation to expand rapidly in the inter-war period. By 1920, there were about 10 million registered automobiles in the United States, and automobile production was on the brink of becoming one of the nation's leading industries. In 1900, the United States had 1 million telephones; by 1920 there were 7.5 million.[7] Widespread electrification made possible radio stations and home radio receivers. During the 1920s, the radio took its place as a piece of family furniture, perhaps near the phonograph, which played popular tunes. As the historian William Stott has pointed out, trust in the truth and impartiality of radio broadcasts surpassed belief in newspapers.[8]

Newspapers responded to competition from radio by adding more pictures, in particular, dramatic pictures. Although experiments with wire and radio transmission of photographs began before World War I, in the early 1920s publication still depended on the mails or special couriers to deliver photographs. Consequently, newspapers and magazines turned to "evergreen" features, that is, non-time-linked single-

topic photo-series and essays about a person, place, or event. Such features were so popular that they continued even after technology allowed instant transmission of news photographs. Photographs achieved some of radio's immediacy when more reliable, though expensive, image transmission systems became available in the late 1920s. The founding of the Associated Press Wire-photo division in January 1935 marked the start of cheaper transmitting systems and networks, which remained technologically similar until replaced by electronic systems in the 1980s. The you-are-there feeling of radio and photography was jointly captured in May 1937, when the fashionable transatlantic zeppelin (airship), the *Hindenburg,* crashed and burst into flames in Lakehurst, New Jersey (Fig. 5.4).

During the 1920s, motion pictures evolved from an arcade amusement to a widespread public entertainment. From 1935 on, stylish newsreels, such as *The March of Time,* preceded the featured film. The emergence of a technologically driven popular culture in which a literate, largely urban mass audience could see the same photographs, go to the same films, and hear the same records, affected the way photographers conceived their images. No longer was a photograph from a faraway place thrilling in itself. Kurt Schwitters (1887–1948), a successful advertising designer and avant-garde artist, remarked that "modern man hears and sees such an enormous amount of impressions, that already he is accustomed to unconsciously turn off."[9]

In his 1925 article on "The Magazine as a Sign of the Times," German editor and radio personality Edlef Köppen linked the hectic activity of modern life to the character of the illustrated magazines. "The mark of our age is haste, hurry, nervousness," he wrote. "People have no time, indeed they flee the calm of contemplation." The public, Köppen scolded, wanted the pleasure, variety, and brevity of short acts in a theatrical review.[10]

The social significance of mass media was quickly perceived by artists. Hungarian-born painter and sculptor László Moholy-Nagy asserted the unique qualities of sound recording, film, and photography, which he thought were the

best media for representing the modern experience. Similarly, in 1921, Vienna-born German artist Raoul Hausmann (1886–1971) asked, "Why don't we paint works today like those of Botticelli, Michelangelo, Leonardo, or Titian? Because our spirits have utterly changed. And not simply because we have the telephone, the airplane, the electric piano, and the escalator. Rather, because above all these experiences have transformed our entire psycho-physiology."[11]

Hausmann was among the first artist-critics to argue that there may be a threshold in human biological capacity at which the proliferation of mediated experiences provided by photography, film, radio, and sound recording alters the individual's perception of the world. That claim is still contested, especially in relation to television, computers, and cyberspace. Nevertheless, the readiness with which people in the 1920s both desired and accepted reproductions of events not directly experienced was remarkable. It was in Germany and Russia, countries in which the legacy of war was particularly far-reaching, that the dream of a utopia achieved through technological means found its most animated vision. "The mechanization

of our planet," as German architect Hannes Meyer (1889–1954) called it in 1926, offered "palpable proof of the victory of human consciousness over amorphous nature." For him, the speed of planes and automobiles broke the bounds of place and tradition. The speed of life made us live faster, and therefore longer. It made us see that things could change: "We learn Esperanto," Meyer wrote; "*We become citizens of the world.*"[12]

REVOLUTIONARY ART: THE SOVIET PHOTOGRAPH

In Russia, the Revolution of 1917 (see pp. 233–34), which placed revolutionary socialists in power, had a deep impact on artists, particularly the avant-garde. Even before the overthrow of the tsar, abstraction had already become a symbol for a future untainted by the past. After the Revolution artists experimenting with Cubism and Futurism responded to the Communist Party's buoyant utopianism, expressed in *The ABC of Communism* (1919), which proclaimed that "within a few decades there will be quite a new world, with new

**5.5
EL LISSITZKY, *The Constructor*, 1924. Photomontage. Getty Research Institute, Los Angeles, California.**

Borrowing from two Russian art movements, Suprematism and Constructivism, both of which favored abstract geometric shapes in unshaded colors, Lissitzky superimposed an image of himself on a piece of graph paper, and layered on top a picture of his hand, uniting hand and eye in a symbol of ideal labor. Superimposing one image on another recalled the experiments of Cubism.

people and new customs."[13] El Lissitzky (1890–1941), an architect who worked in many media, including photography, was one of the most politically committed artists. He renounced self-expression in art, along with easel painting, which he associated with a corrupt past and stagnant aesthetics. With others, Lissitzky insisted that the artist's role was now linked to industry and to reshaping everyday life. In avant-garde circles, the terms "production art" and "production artist" began being used, to indicate that the artist would employ technology in order to mold a new society. Photography was favored precisely because it was the product of a machine that could be mass-produced by other machines.

Lissitzky's *The Constructor* (1924) (Fig. 5.5) shows the artist in his new role as builder or engineer. It features the

5.6
GUSTAV KLUCSIS,
Electrification of the Entire Country, 1920. Vintage gelatin silver print. Merrill C. Berman Collection, New York.

Klucsis used photomontage to advocate the continued modernization of the Soviet Union, symbolized by electricity and the figure of Lenin striding into, and towering over, the future. Designed as a poster, this propaganda image is combined with abstract shapes that resemble Lissitzky's work (see Fig. 5.5).

austere geometric overlays frequently used by Russian avant-garde image-makers, who favored non-realistic, intersecting planes that flattened Renaissance perspective and thereby condemned the older art of morally bankrupt elites. In Lissitzky's image, the artist's hand fingers a compass, which seems to have drawn a perfect circle around his head. The circle forms a halo, as in a Russian religious painting.[14] The "sainted" new Soviet artist worked with geometric shapes and signs, as well as printers' type, which emerged as primary elements in Soviet poster design and magazine illustrations. Lissitzky also designed trade exhibitions, demonstrating Soviet industrial progress. In these installations, he transformed the shape of the room by having images and text bulge out from the wall or droop from the ceiling.

Many Soviet artists were also writers and theorists addressing national and international audiences. Latvian-born Gustav Klucsis (sometimes Klutsis) (1895–1944) realized that it was imperative "to construct *iconic* representations for a new mass audience."[15] He used PHOTOMONTAGE (see pp. 247–50), assembling images and text from a variety of mass media sources, such as newspapers and magazines. The result overturned the expectations of everyday experience and of realistic painting with arresting image collisions. Klucsis, however, insisted that his images should be understood by the illiterate as well as the educated. In *Electrification of the Entire Country* (1920) (Fig. 5.6), a giant-sized Soviet leader, Vladimir Lenin (1870–1924), strides forward confidently into the future as workers on the roof-top cheer him on.

The prospect of a revolutionary art was eagerly taken up by Aleksandr Rodchenko (1891–1956), a Russian painter and sculptor who had absorbed the geometric abstractions of Cubism and who valued the process of COLLAGE, pioneered by the Cubists in the decade before World War I. As his political activity increased in the new arts organizations initiated by the Soviet government in its early years, Rodchenko investigated the role art might play in society. He resolved to make art less theoretical and more practical. With other artists, he went to factories to

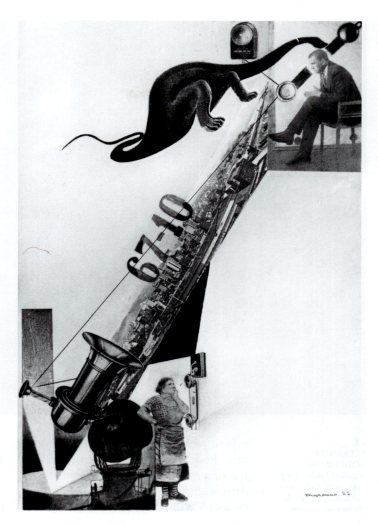

learn design needs first hand, and he conceived posters, fabrics, and furniture. Rodchenko wholeheartedly embraced photography because he felt it freed artists from inherited aesthetic ideas, especially perspective and the other techniques used to render the world as it is, rather than as it might be. He promoted the notion that new concepts could not be expressed in old media, and was a leading proponent of *faktura*, the idea prominent in Soviet art theory that an artist should discover a medium's distinctive capabilities by experimenting with its inherent qualities.

Looking at the work of photographers who traveled to foreign countries, Rodchenko sneered, "They photograph with museum eyes, the eyes of art history."[16] Rodchenko's hope for new media such as film and photography was enhanced by looking at German art and fashion magazines, like *Die Dame* (*Woman*), *Junge Welt* (*Young World*) and *Moderne Illustrierte Zeitschrift* (*Modern Illustrated Journal*), which featured

5.7
ALEXANDR RODCHENKO, *Untitled*, 1923, to accompany Maiakovskii's poem "Pro Ito" ("About This"). Photomontage. Rodchenko & Stepanova Archive, Moscow.

Rodchenko's photomontages for Maiakovskii's poem rely on an elaborate symbolic programme. Here, telephone lines and a telephone number (67-10) are traced along a tilted skyscraper skyline of what may be New York City. In the top right frame, Maiakovskii listens intently, his passion symbolized by the dinosaur. However, the call is answered not by his sweetheart but her bored housekeeper.

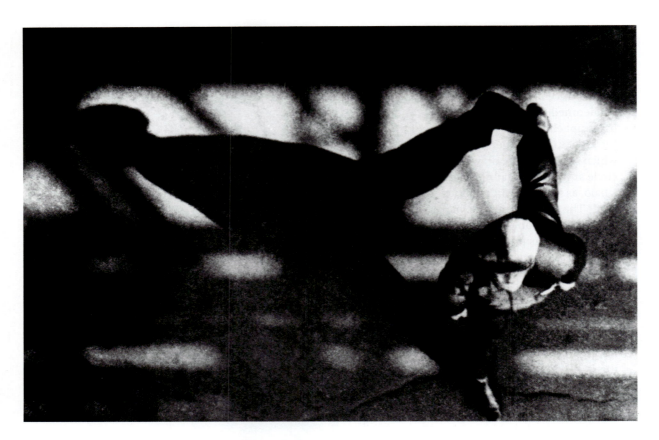

**5.8
ALEXANDR
RODCHENKO,**
Untitled (Walking fig-
ure), 1928. Gelatin silver
print. Rodchenko &
Stepanova Archive,
Moscow.

In this disconcerting
image Rodchenko dis-
covered an unusual
camera angle and
haunting shadow
effects, which together
jolt the viewer into see-
ing and examining the
complex patterns cre-
ated from an otherwise
ordinary scene of a walk-
ing man.

experimental German photography. In
turn, Rodchenko's work appeared in the
Russian magazine *LEF* (*Left Front of the
Arts*), a left-wing arts magazine founded
by poet Vladimir Maiakovskii (1893–
1930). In 1923, Rodchenko gathered
images from the picture press, and also
commissioned a series of photographs
from another photographer. He joined
these images to make photomontage
illustrations for Maiakovskii's poem
"Pro Ito" ("About This") (Fig. 5.7). These
images are visually arresting, but it is
hard to see how uninitiated viewers
could have interpreted their symbolic
meanings.

The post-revolutionary Russian
avant-garde advocated making images in
such a way as to obstruct habits of see-
ing. Odd camera angles, unrecognizable
close-ups, multiple exposures, and con-
fused perspective all served to "make
strange" the expected appearance of the
world.[17] In the mid-1920s, Rodchenko
learned to make his own photographs
and moved from photomontage to
straight photography (Fig. 5.8). Never-
theless, he continued to disparage "belly
button" camerawork, that is, the conven-
tional, balanced picture taken with a
camera held near the waistline, while
the photographer peered into the view-
ing screen.

In the years immediately after the
Revolution, the Soviet government
courted experimental artists in its
search for innovative methods of mass
communication. But by the early
1930s, the romance turned sour.
Official policy shifted from avant-garde
art—seen as intellectual, bourgeois,
and thus part of the capitalist sys-
tem—and instead promoted Socialist
Realism, that is, a conventionally real-
istic style used as a vehicle for rousing
propaganda messages that could be
universally understood by the workers.

As the avant-garde was losing offi-
cial sanction, Rodchenko began the
huge official task of photographing
the construction of the White Sea
Canal (the Stalin Canal). Using a less
startlingly inventive approach than in
his earlier work, Rodchenko produced
about 3,000 photographs, some of
which were published in a special
1933 edition of *USSR in Construction*,
a magazine intended to show Soviet
progress, especially to audiences
abroad. Tellingly, Rodchenko did not
record the used of forced labor, nor
the deaths of thousands of workers at
the site—subjects forbidden by the
propaganda controls enforced in the
Soviet Union under Stalin's leadership
in the 1930s.

DADA AND AFTER

During World War I, a group of writers, artists, and poets met at the Cabaret Voltaire, in Zurich, Switzerland, a cultural outpost in a politically neutral country. The group strongly objected to the war and to the bankrupt materialism of the age. They envisioned a new art that expressed their despair, but that would also sweep away tiresome conventions and intellectual barriers. The Romanian-born artist Tristan Tzara (1896–1963), who wrote the *Dada Manifesto* of 1918, saw the task to be done as "a great negative work of destruction."[18] The origins of the name "Dada" are unclear; this nonsensical-sounding word may have been chosen because it has different meanings in several European languages. Through the visual arts and performances, Dada accentuated the disruptiveness of chance collisions of images and sounds.

Christian Schad (1894–1982), a German artist associated with the Zurich Dada group, was influenced by the French artist and poet Jean, or Hans, Arp (1887–1966), who emphasized the need to be unconstrained by traditional notions of composition, and who made low-relief sculptural collages of found objects. Schad, too, created small collages of newspaper clippings and odd bits of paper, and used a similar method to make abstract photographs (Fig. 5.9). Several of Schad's abstract photographs were acquired by Tzara, who dubbed them "schadographs." This sounds like shadowgraph, a process used by such early photographers as William Henry Fox Talbot (see p. 18). Tzara may have been aware of this, but was perhaps also alluding to the meaning of the German word "schaden," which means damaged, evoking the Dada sense of things falling apart.

Another group of Dada artists met in Berlin as Germany was disintegrating toward the end of the war. More political than the Zurich Dadaists, they wanted to make social statements. In the words of one their leaders, Richard Hülsenbeck (1892–1974), "the highest art will be that which in its conscious content presents the thousandfold problems of the day, the art which has been visibly shattered by the explosions of last week, which is forever trying to collect its limbs after yesterday's crash."[19] Berlin Dadaists adopted photomontage as a key medium. Often the initial *Klebebild* or "paste picture" was photographed, producing a more finished look, and preparing the image for reproduction in one of the many avant-garde magazines.

The origins of the photomontage have long been debated, but it seems that Hannah Höch (1889–1978) and Hausmann were two of the earliest Dadaists to make such images. Höch's large photomontage *Cut with the Kitchen Knife Dada through the last Weimar Beer Belly Cultural Epoch of Germany* (*Schnitt mit dem Küchenmesser Dada durch die letzte weimarer Bierbauchkulturepoche Deutschlands*) (1919) made its appearance at the First International Dada Fair in Berlin (1920) (Fig. 5.10). As art historian Maud Lavin observed, the diversity of mass-media sources in Höch's picture testifies to the vast proliferation of newspapers and journals in the years following World War I, and the growing perception that mass-media images were forming a common visual culture.[20] Even though the individual images in early photomontage were generally easy to read, their combination

5.9
CHRISTIAN SCHAD,
Schadograph 24b,
c. 1920. Gelatin silver print.

Schad placed pieces of randomly collected paper and objects atop photographically sensitive paper, pressing them down with a sheet of clear glass. As the assemblage was exposed to light on a windowsill, Schad observed its development and occasionally moved objects around as they were appearing on the paper.

yielded pictures whose meaning was difficult to decipher. In effect, photomontage itself was the message of change. Nevertheless, some parts of *Cut with the Kitchen Knife* can be decoded (they are described in the caption).

Like American photographer Frances Benjamin Johnston (see p. 190; Fig. 4.0), Höch engaged the theme of the New Woman.[21] She juxtaposed images of smartly dressed contemporary women with women in traditional social roles and with such symbols of modernity as automobiles, machinery, and electric lightbulbs. While she criticized contemporary politics and society's hypocrisy toward women as both workers and sexual objects, the jazzy exuberance of her compositions reveals an optimism for avant-garde art and the joy of art-making. During the 1930s, Höch collaged pictures of objects in German ethnographic collections with symbols of Modernism, so as to contrast Western materialism and non-Western traditional practices. Her photomontage

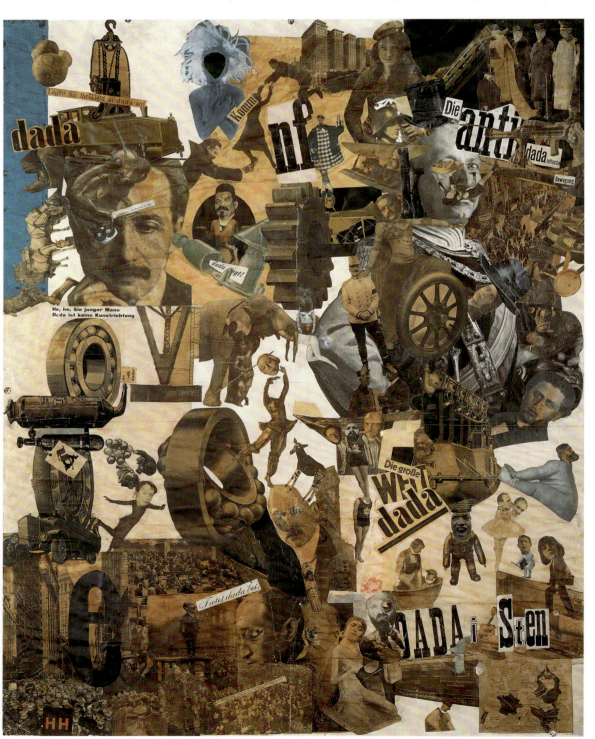

5.10
HANNAH HÖCH,
Schnitt mit dem Küchenmesser Dada durch die letzte weimarer Bierbauchkulturepoche Deutschlands **(Cut with the Kitchen Knife Dada through the Last Weimar Beer Belly Cultural Epoch of Germany), 1919. Photomontage. Nationalgalerie Staatliche Museen, Preussischer Kulturbesitz, Berlin.**

In the center a popular dancer of the time pirouettes beneath the head of the artist Käthe Kollwitz (see Fig. 4.35). The head has been speared by a man in front of an elephant. The dancer's right foot rests on a giant ball-bearing. Beneath that is a young revolutionary sailor who is saying "Join Dada" ("Tretet Dada bei"). The word "Dada" is also scattered throughout the work.

FOCUS
Photomontage or Photocollage

Soviet and German experimental photography developed at the same time, and practitioners vigorously exchanged ideas. Photomontage originated in Germany, but was adopted in Russia soon after World War I, through artists' visits and through magazines.

The avant-garde Dada movement, initiated by artists who took refuge in Switzerland during the war, spread to Berlin, and from there to Moscow. Experimental artists cut pictures from magazines and newspapers and pasted them together in composite images whose jumbled scale and perspective challenged conventional expectations (Fig. 5.11). These collages (from the French word for glue) were sometimes photographed so that the unique first image could be printed in multiple versions. Soviet experimental artists did not call such images photocollages but photomontages. The word montage has various sources. In silent film, for example, it specified the rapid succession of images that indicated a change of place or the transition of ideas. The Berlin Dadaist Hausmann

wrote that the group agreed on the term "photomontage" because of "our aversion at playing the artist and, thinking of ourselves as engineers (hence our preference for working-men's overalls) we meant to construct, to assemble [*montieren*] our works."[22] Experimental artists used the word photomontage almost exclusively after World War I. Although a photomontage may resemble a Cubist painting, on to which such materials as tickets and menus have been pasted, experimental artists in Germany and Russia aimed to use such materials in a different way. The jumbled appearance of photomontage was more than formal inventiveness; it was a token of the quick changes and disruptions of modern life that seemed, in the period immediately after World War I and the Russian Revolution, to promise progressive social change.

5.11
GEORGE GROSZ & JOHN HEARTFIELD, *Leben und Treiben in Universal City um 12 Uhr 5 Mittages (Life and Activity in the Universal City at Five Past Twelve)*, 1919. Akademie der Künste, Berlin.

series *From an Ethnographic Museum* produced unsettling effects by juxtaposing snippets of Western and non-Western body parts and artifacts (Fig. 5.12).

Höch's lover for seven years, Raoul Hausmann, was one of the few communists to insist on women's equality in any new society. More subtle than his copious political writing, Hausmann's photomontage images included his contribution to the 1920 Dada Fair, *Tatlin at Home* (Fig. 5.13). This photomontage was more an exercise in freewheeling mental associations and concern for artistic form than a penetrating portrait or social critique. For example, Hausmann explained that he added machinery, including an automobile

steering wheel, to the main figure's head because he was interested in portraying a man who had machines for brains. The man with his pockets turned inside out was included because Hausmann fancied that Tatlin could not be rich. Like many photomontagists, Hausmann painted parts of the picture, such as the background.[23]

Another Berlin Dadaist, George Grosz (1893–1959), one of the most politically active artists to emerge from the Berlin Dada group, was also a pioneer of photomontage. Grosz's photomontages have a plainly discernible message expressed in an apparently spontaneous accumulation of images and texts (see Fig. 5.11).

**5.12
HANNAH HÖCH,**
Denkmal I: Aus einem ethnographischen Museum (*Monument 1: From an Ethnographic Museum*), 1924. **Collage, photomontage. Berlinische Galerie, Landesmuseum für Moderne Kunst, Photographie und Architektur, Berlin.**

Höch's ethnographic series contrasted contemporary feminine attire and poses with artifacts from the past and from tribal peoples. Modern eyes peer out of a ritual mask, while an arm and torso become a leg.

5.13
RAOUL HAUSMANN,
Tatlin at Home, **1920.**
Collage (destroyed).
Statens Konstmuseet,
Moderna Museet,
Stockholm.

Despite the title, the
central image of a man's
head is not a portrait of
Vladimir Tatlin (1885–
1953), the highly
esteemed leader of the
new Soviet art, who was
lauded at the Dada Fair
by a sign that declared:
"Art is dead! Long live
the machine art of
Tatlin." Instead,
Hausmann took an
existing image from a
newspaper or magazine
that reminded him of
the Russian artist.

MOHOLY-NAGY AND THE BAUHAUS

László Moholy-Nagy (1895–1946) arrived
in Berlin just before the 1920 Dada Fair.
He soon met Höch, Hausmann, and
other members of the Berlin Dada
group. Like them, Moholy-Nagy favored
the use of industrial materials and con-
cepts, and he embraced Soviet artists'
notion of *faktura*, which he understood
to mean that a new vision could be cre-
ated only when photography was prac-
ticed for its own inherent qualities, not
as an imitation of painting. While the
Dadaists were politically active, many

5.14 (above)
LÁSZLÓ MOHOLY-NAGY & LUCIA MOHOLY, *Photogram*, 1924. Gelatin silver print. Museum Ludwig, Cologne, Germany.

Collaborating with his first wife, photographer and critic Lucia Moholy (1894–1989), Moholy-Nagy explored the implications of the argument that photography should move beyond reproducing the appearance of reality and begin to produce something new. The photograms they created did not depict objects or views, but abstract shapes, shades, and forms.

joining the Communist Party, Moholy-Nagy concentrated instead on technology and its relation to art. He insisted that "the first and foremost issue" for photography was to determine "a more or less exact photographic language," independent of the past.[24] His social concern was expressed in his theory that mass production, especially the wide circulation of images, made it possible for an artist to change perceptions of the world, thereby creating a desire for social revolution.

Moholy-Nagy claimed that photography's chief characteristic was light, and that artists should experiment with patterns of light and shade. "This century belongs to light," he argued, and "photography is the first means of giving tangible shape to light, though in a transposed and ... almost abstract form."[25] "Today," he wrote, "everything is concentrated, more powerfully than ever before, on the visual." Moholy-Nagy looked to science to research the physiological and psychological basis for visual presentations, which would be as effective as written language. He announced that "the illiteracy of the future will be ignorance of photography."[26]

Like Rodchenko, Moholy-Nagy proposed that photographers should radically change the angle of camera vision. He advocated such devices as distorting mirrors that would alter normal views, and he anticipated the invention of new sorts of cameras that would allow the operator to play with perspective. He also envisaged photographers adapting microscopes, telescopes, and X-ray equipment to their repertoire of image-making. Among his proposals was the making of cameraless photographs, which he called PHOTOGRAMS (Fig. 5.14).

In 1923, Moholy-Nagy was invited to join the faculty of the Bauhaus, the German art school established by architect Walter Gropius (1883–1969), whose goal was to integrate the arts with industry. Moholy-Nagy already had an international reputation for his abstract paintings and sculptures, some of which used industrial materials and processes, such as porcelain enamel on steel; he was an energetic member of a faculty that would later include artists Wassily Kandinsky (1866–1944) and Paul Klee (1879–1940). The Bauhaus curriculum did not include classes in photography until soon before it was closed by the

5.15 (below)
HERBERT BAYER, Cover of *Bauhaus 1*, 1928. From a photomontage. Bauhaus-Archiv, Berlin.

Nazis in 1933, but Moholy-Nagy's ideas were influential. In addition, his 1925 book *Malerei, Photographie, Film* (*Painting, Photography, Film*), published by the Bauhaus, became an international reference for the new photography.

The upbeat mood of experimental photography was captured in the title of an article by Bauhaus artist Johannes Molzahn (1892–1965), "Stop Reading! Look!" (*"Nicht mehr lesen! Sehen!"*). Molzahn was convinced that formal education should adapt to the increasingly visually portrayed world rendered in mass-media newspapers and magazines. He offered "Stop Reading! Look!" as the guiding motto for teaching and learning.[27] Also at the Bauhaus was Austrian-born designer and photographer Herbert Bayer (1900–1985), whose design for the first cover of the institu-tion's publication, *Bauhaus*, was a photomontage (Fig. 5.15). Bayer's post-Bauhaus career included the design of an infamous photomontage for a Nazi brochure, which demonstrated the extent to which photomontage was not a technique intrinsically wedded to pro-gressive politics, but a style whose aes-thetic features could serve any political persuasion (see Fig. 5.41).

German-born photographer Germaine Krull (1897–1985) absorbed the techniques promoted by Moholy-Nagy, and grasped the swift interplay of images advocated by Russian filmmaker and writer Sergei Eisenstein (1898–1948), as well as her companion, film-maker Joris Ivens (1898–1989). Like the French painter Fernand Léger (1881–1955), she celebrated industrial-ization as a marvelous marriage of the

**5.16
GERMAINE KRULL,
Cover of *Métal*, 1928.
Collotype. Museum
Folkwang Fotografische
Sammlung, Essen,
Germany.**

Krull's portfolio of pho-tographs, *Métal*, cele-brated industrialization and modernization. The cover bore Krull's name superimposed in chunky letters that looked like they had been mechani-cally stamped out. For decades after its con-struction in 1889, the Eiffel Tower in Paris was a powerful international symbol for change and innovation.

human body and the machine. Her 1928 collection of images, *Métal*, was advertised as "the dance of the metal nudes."[28] The portfolio's cover showed a disconcerting view of the elevator wheels that boosted people to the top of the Eiffel Tower in Paris (Fig. 5.16). Krull's sixty-four unbound prints of French and Dutch industrial sites in *Métal* were uncaptioned, and sequenced so as to jump from soothing conventional views to slippery superimpositions. Because of her dizzying dynamic angles and other techniques, many of the actual locations were unrecognizable, and had to be taken as symbols of modern life rather than depictions.

DADA AND PARIS

In Paris, Dadaists turned away from the Berlin group's political activism to embrace a wider cultural criticism. It was in Paris that Marcel Duchamp drew a mustache on a photographic reproduction of Leonardo da Vinci's (1452–1519) *Mona Lisa*, and relabeled it with a title lewd when read aloud in French (Fig. 5.17). Before he came to Paris and met with the Dadaists, German painter Max Ernst (1891–1976) was already making psychologically disorienting photographic collages and creating disquieting effects on canvas and paper

5.17
MARCEL DUCHAMP,
L.H.O.O.Q., **1919.**
Color reproduction of
Mona Lisa **altered with**
a pencil. Private
Collection.

Duchamp's comical addition to a postcard of Leonardo da Vinci's *Mona Lisa*, and his bawdy retitling of the image, expressed his attitude toward unthinking acceptance of tradition.

L. H. O. O. Q.

using such techniques as *frottage* (rubbing a surface so that the texture of an object beneath it shows through). Eerie enigmas pervaded his work (Fig. 5.18). Ernst had little respect for the Berlin Dada's political orientation: "German intellectuals can't even shit or piss without ideology," he snarled.[29]

André Breton (1896–1966), one of the leaders of Paris Dada, praised Ernst and lauded his photography, relating it to the Dada practice of automatic writing. This entailed writing or speaking a haphazard sequence of words to evade the censorship of the rational mind: "Automatic writing," Breton wrote, "is a true photography of thought."[30] Breton's curiosity about psychic states led him toward psychology, especially the theories of Sigmund Freud, which suggested that human behavior is motivated by forces and desires hidden deep within the human psyche, which individuals and society are generally reluctant to acknowledge. Around 1924, Breton rejected the anarchism of Dada, which relied on an ability (difficult to sustain indefinitely) to shock, disturb, or outrage viewers. He sought a more constructive program that would still be based on the power of the unconscious and irrational mind. This led to the founding of the Surrealist movement, of which Breton became one of the major theorists.

DADA AND THE MACHINE AGE IN NEW YORK

In the United States, meanwhile, Dada had had a further manifestation, spurred by contact between exiled European artists and their American counterparts. Man Ray (1890–1976), the American artist born Emmanuel Radnitzky, maintained that there was no such thing as New York Dada,[31] and indeed conditions there were markedly different than in Europe. Involved in World War I in only the final stages, the United States also did not endure years of conflict on its own soil, and was therefore spared the disillusioned anguish that questioned the role of traditional art in an age of trench warfare. Moreover, Americans did not identify non-objective art with political revolt and social change to the degree that many European experimenters did. New Yorkers responded to the visually

5.18
**MAX ERNST &
HANS ARP,**
*Physiomythological
Diluvian Picture*, 1920.
Collage with fragments
of a photograph,
gouache, pencil, pen
and ink on paper laid on
card. Sprengel Museum,
Hanover, Germany.

Combining the optical
reality of a photograph
(the woman's head)
with media suggestive
either of flatness or per-
spective allowed Ernst
and Arp to create an
image full of puzzling
contradictions.

provocative 1913 Armory Show, the first
large-scale exhibition of modern art
from Europe and the United States, as a
display of art, not as progressive social
propaganda. Through the influence of
Duchamp and Picabia, both of whom
came in 1915 to New York from Europe
for extended stays, a spirited group of
artists came together around the notion
that the machine and industrial society
formed the fountainhead of a new cul-
tural expression. Duchamp found work-
space in the New York home of Walter
and Louise Arensberg, wealthy collec-
tors whose residence emerged as the
gathering-place for artists including
Man Ray, Morton Schamberg (1881–
1918), and Charles Sheeler (1883–1965).

The first and only issue of the maga-
zine *New York Dada* appeared in 1921
with a photograph of Duchamp, dis-

guised as his female alter ego Rrose
Sélavy, which had been affixed to a recy-
cled perfume bottle. The issue also car-
ried an experimental photograph by
Stieglitz (see pp. 184–85), whose circle
of friends overlapped with those in the
Arensberg salon. Stieglitz permitted
Picabia and others to use his "291"
gallery on Fifth Avenue as the title of a
magazine inspired mostly by European
Dada experimentation. Despite its liveli-
ness, the New York Dada movement had
little enduring impact on photography
in the United States.[32]

Schamberg and Sheeler were
painters who initially took up photog-
raphy to make a living, and gradually
gained attention for their camerawork.
In both his painting and photography,
Schamberg moved toward the sharp, flat
delineation of geometric forms that was

later to influence the group of American abstract realists known as the Precisionists (Fig. 5.19). Sheeler, a founder of Precisionism who specialized in art and architectural photography, made several photographs of Duchamp's *Nude Descending a Staircase* (1912). The term "Precisionism" has been used to describe paintings depicting specifically American building types, such as skyscrapers and barns, in a near-abstract manner that stresses geometric form. Although Sheeler did much the same thing in his photographs, they are not routinely called Precisionist. With Paul Strand (see pp. 201–4), Sheeler worked on the 1920 experimental film, *Manhatta*, which celebrated the city

as a wellspring of progressive modern life, from its newly erected skyscrapers to its smoke-belching chimneys. Geometrically lean and striking shots of the city were interspersed with high-spirited quotations from American poet Walt Whitman (1819–1892). Reflecting on the experience, Strand remarked that "both of us were well along the road of abstract organization of reality."[33]

Sheeler supported his art by working in advertising, producing promotional pictures for spark plugs, tires, and typewriters. In 1927 he received a commission to photograph the Ford Motor Company's plant near Detroit on the Rouge River.[34] Sheeler avoided putting workers in his shots, for fear that view-

**5.19
MORTON SCHAMBERG,** *Untitled (Cityscape)*, 1917. Vintage gelatin silver print. Hallmark Photographic Collection. Hallmark Cards Inc., Kansas City, Missouri.

Schamberg was one of the first American photographers to picture the modern city as a series of interlacing geometric shapes, formed by rooftops, walls, and windows.

**5.20
CHARLES SHEELER,**
Industry, 1932. Gelatin
silver prints (triptych).
Art Institute of Chicago,
Chicago, Illinois.

Sheeler's photographs,
sometimes used as
sources for his paint-
ings, sometimes left to
stand on their own,
included dynamic
images of the Ford
Motor Company's River
Rouge plant, then the
largest and most com-
plex industrial site in
the world, occupying
1,100 acres.

ers would concentrate on them, not the
plant's machinery; and he overlooked
contemporary labor issues by attending
to the massive mechanical elements that
took raw materials and converted them
into automobiles. His large three-part
mural *Industry*, now generally known
only through its much smaller study,
centers on the criss-crossed conveyors
that carried coal and coke (Fig. 5.20). On
either side of the central panel, Sheeler
placed photographs of gigantic stamp-
ing presses. The buildings at the River
Rouge plant thrilled Sheeler, as much as
the French Gothic cathedrals he once
photographed. For him, industrial archi-
tecture marked a stupendous movement
in human progress. "Our factories are
our substitute for religious expression,"
he proclaimed.[35] Many of Sheeler's can-
vases take up the same subjects as his
photographs, profiting from the simpli-
fication of tones and generalization of
forms that he learned through the use
of the camera.

SURREALIST PHOTOGRAPHY

The Surrealist movement was born in
Paris in the mid-1920s. Unlike Dada,
which always remained individualistic,
Surrealism was a self-proclaimed move-
ment. Breton's *Surrealist Manifesto*, pub-
lished on October 15, 1924, announced
the primacy of the irrational and the
belief in a truth above or beyond real-
ism. Surrealism was deeply indebted to
Freud's theory of the unconscious, and
the methods he proposed for revealing a
person's unconscious desires, notably
dream analysis and free association
sequences of words and ideas. Rather
than emphasizing social change on the
state level, the Surrealists advocated the
transformation of human perception
and experience through greater contact
with the inner world of imagination.

Photography was central to Surrealist
practice. In theory, at least, making pho-
tographs could be the visual equivalent
of free association, and other methods
of side-stepping the monitoring rational
mind. Some Surrealists pointed their
cameras haphazardly, recording what-
ever happened to be in front of the lens.
Other efforts were more purposeful,
such as Man Ray's experiments with
the photogram or "rayograph" (Fig. 5.21).
His untitled rayographs, featuring
unlikely conjunctions of mundane,
recognizable objects, such as a knife and
comb, were published as *Les Champs
délicieux* (*The Delicious Fields*) (1922).
Tzara contributed a preface cleverly
titled "Photography inside out" (*"La*

photographie à l'envers"), referring both to the reversal of tones in the rayographs, and to the idea that photographic practice might be turned on its head.

Brassaï (1899–1984), born Gyula Halasz in Brasso, Transylvania, the town from which he adapted his name, was working as a correspondent for both Hungarian and German newspapers when he met the Paris Surrealists. His 1933 series *Involuntary Sculpture* shows Surrealist influence (Fig. 5.22).

Most Surrealist photography alludes to psychological intimations and innuendoes, a scenario in which something has just happened or is about to happen, as in Man Ray's untitled image for the Surrealist publication *Minotaure* (Fig. 5.23). Like several early twentieth-century art groups, the Surrealists believed that "primitive" art and myth bypassed conscious, rational thought to reach into the fertile unconscious. Forbidden sensuality and sexuality were frequent Surrealist topics. Hans Bellmer (1902–1975), born in the German-dominated area of Poland called Silesia, encountered the Berlin Dadaists while studying engineering. Following the well-trodden path to Paris in 1924, he came in touch with the Surrealists. After seeing Jacques Offenbach's (1819–1880) opera *The Tales of Hoffmann*, about a

beloved automated doll that is demolished, he was inspired to create his own dolls and photograph them (Fig. 5.24).

Belgian-born Raoul Ubac (1910–1985) was as technically experimental as his sometime collaborator Man Ray. Both solarized prints, a technique Man Ray originally investigated with Berenice Abbott and Lee Miller, who were his studio assistants at different times (see pp. 290–92, 304–5). SOLARIZATION involves briefly exposing a print or negative to light during the development process. The result is a reversal of tones, especially along the edges of objects.

5.22
BRASSAÏ (GYULA HALASZ), *Sculpture involontaire (Involuntary Sculpture)*, 1933.

Brassaï explored the Surrealist notion that the fantastic could be found in the ordinary. He sequenced close-up photographs of discarded chewing gum, theater tickets, cigarette butts, and paper wads, producing bizarrely monumentalized objects.

5.21
MAN RAY, *Abstract Composition*, 1921–28. Rayograph. Victoria & Albert Museum, London.

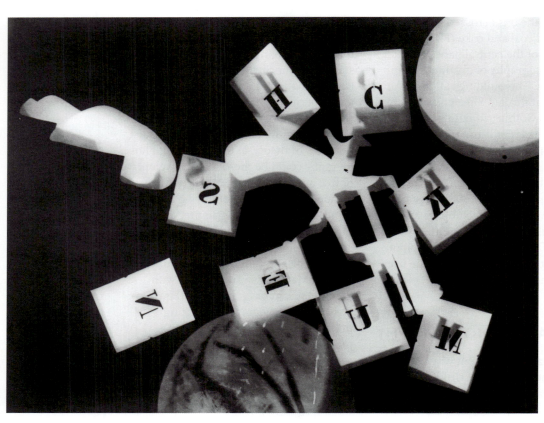

**5.23 (above)
MAN RAY, *Untitled*,
from *Minotaure*, 1936.
Silver print. Michael
Senft Collection, East
Hampton, New York.**

For the Surrealist publication *Minotaure*, Man Ray used ominous shadows to suggest that a ~~man's~~ upper torso was transforming itself into the head of a bull. In Greek mythology, the Minotaur was a creature half-man, half-bull, to whom the Athenians periodically sent young men and women for sacrifice on the island of Crete.

woman's torso

**5.24
HANS BELLMER,
Doll (La Poupée),
1935. Gelatin silver
print with applied
color. George
Eastman House,
Rochester, New York.**

In these photographs, Bellmer mismatched and twisted mannequins body parts. His grotesque figures have been scrutinized for insights into his personal Oedipal conflicts, and read as a sophisticated retaliatory response to the fair-haired stereotypes of the normal, that is, Aryan body, celebrated in Nazi propaganda pictures.[36]

5.25
RAOUL UBAC, *La Conciliabule*, 1938. *Brulage* print. Galerie Adrien Maeght, Paris.

The prints Ubac produced using *brulage* depict slippery-looking dissolving forms that signal the transitory quality of human identity. The technique gives the whole print a shimmering, dreamlike quality.

5.27
CLAUDE CAHUN, *Self-Portrait*, 1928. Gelatin silver print. Musée des Beaux-Arts, Nantes, France.

5.26
DORA MAAR, *Père Ubu*, 1936. Gelatin silver print. Metropolitan Museum of Art, New York.

Maar found an element of something extra-ordinary—and disturbing—in this close-up shot of an armadillo.

Sometimes called edge reversal, solarization is unpredictable, making it a favorite of the Surrealists. Ubac also developed a technique called *brulage*, or burning, in which film emulsion was melted to produce swirling shapes (Fig. 5.25).

Male Surrealist painters and photographers often used female forms as symbols of the primitive, the mysterious, and the erotic. As recent feminist critics have pointed out, they also pictured women's bodies caged, distorted, or dismembered, as if they were primal forces to be trapped, observed, or punished. The women artists in Surrealist circles did not generally adopt this iconography. Painter Dora Maar (1909– 1997), often unjustly remembered only as a lover of Picasso and as a subject in his paintings, was also a member of Man Ray's circle and an experimental photographer with a knack for contriving unsettling images (Fig. 5.26). Claude Cahun (1894–1954), an activist writer and photographer involved with Surrealism in Paris during the 1930s, made self-portraits exploring shifting subjective moments and female gender identity (Fig. 5.27). Born Lucy Renée Mathilde Schwob, Cahun adopted

the first name of Claude, which is both a male and female name in French.

The Surrealist sensibility persisted well beyond its historical highpoint in the 1920s and 1930s, although shorn of its early radicalism and intense psychologizing. Brassaï's recognition that the extraordinary always prowls close to the ordinary informs his book of photographs *Paris de nuit* (*Paris by Night*) (1933), which teems with people who exist at the twilight of respectable society. To many photographic artists, such outsiders as vagrants and prostitutes represented freedom and non-conformity.[37] Brassaï's *Paris by Night* carried no message of social reform or personal redemption, but showed such people of the night as "Bijou" ("Jewel"), who relished the extremes of life (Fig. 5.28).

For André Kertész (1894–1985), a Hungarian-born photographer and mentor to his Paris friend, Brassaï, Surrealist distortion of the human figure was a short-lived, if much discussed, experiment (Fig. 5.29). Nevertheless, the Surrealist feeling for the magic of coincidence and presence of the mysterious in everyday life stayed with him

5.28 (below)
BRASSAÏ (GYULA HALASZ), *"Bijou" of Montmartre,* from *Paris de Nuit (Paris by Night),* c. 1933. Gelatin silver print. David H. McAlpin Fund. Museum of Modern Art, New York.

Like Toulouse-Lautrec before him, Brassaï introduced viewers to people they might not ordinarily meet, placing viewer and subject in uncomfortably confrontational relationships that exploited the photograph's psychological power.

5.29 (above)
ANDRÉ KERTÉSZ, *Distortion # 102,* 1933. Gelatin silver print. Gift of Graham Nash. San Francisco Museum of Modern Art, San Francisco, California.

throughout his career, as in *Meudon* (Fig. 5.30). Kertész's joy in seizing a fleeting, yet resonant visual moment influenced many twentieth-century photographers, including Robert Capa (see pp. 306–7) and Henri Cartier-Bresson (b. 1908).

A painter and student of art history, Cartier-Bresson recalled that he was influenced more by Surrealist theories of the irrational than by Surrealist art practice. He fastened on to "the role of spontaneous expression … and of intuition and, above all, the attitude of revolt."[38] He is legendary for describing his instantaneous composition of a scene as "the decisive moment," which he defined as "the simultaneous recognition, in a fraction of a second, of the significance of an event as well as of a precise organization of forms which gave that event its proper expression."[39] A famous example is his image of a man suspended over a rain-drenched area (Fig. 5.31).

A NEW VISION (1918–1945)

5.30
ANDRÉ KERTÉSZ, *Meudon*, 1928. Gelatin silver print. Museum of Modern Art, New York.

In *Meudon*, an old Paris neighborhood, a man is seen carrying a package wrapped in newspaper. He moves toward the viewer's right just as a train advances to the left on what looks like a high Roman aqueduct, rather than a railway trestle. Kertész dwelled on split-second coincidences that seemed to hint at an uncanny alchemy underlying ordinary events.

5.31 (opposite)
HENRI CARTIER-BRESSON, *Behind the Gare St. Lazare*, 1932. Gelatin silver print.

Previously, street photographers had set up scenes of this kind to test the speed of small cameras.[40] But whereas other puddle-jumpers were shown reaching a dry curbstone, Cartier-Bresson's plump leaper is poised forever above a watery landing. He both imitates the acrobat on the fence poster and seems to defy the solidly earth-bound figure.

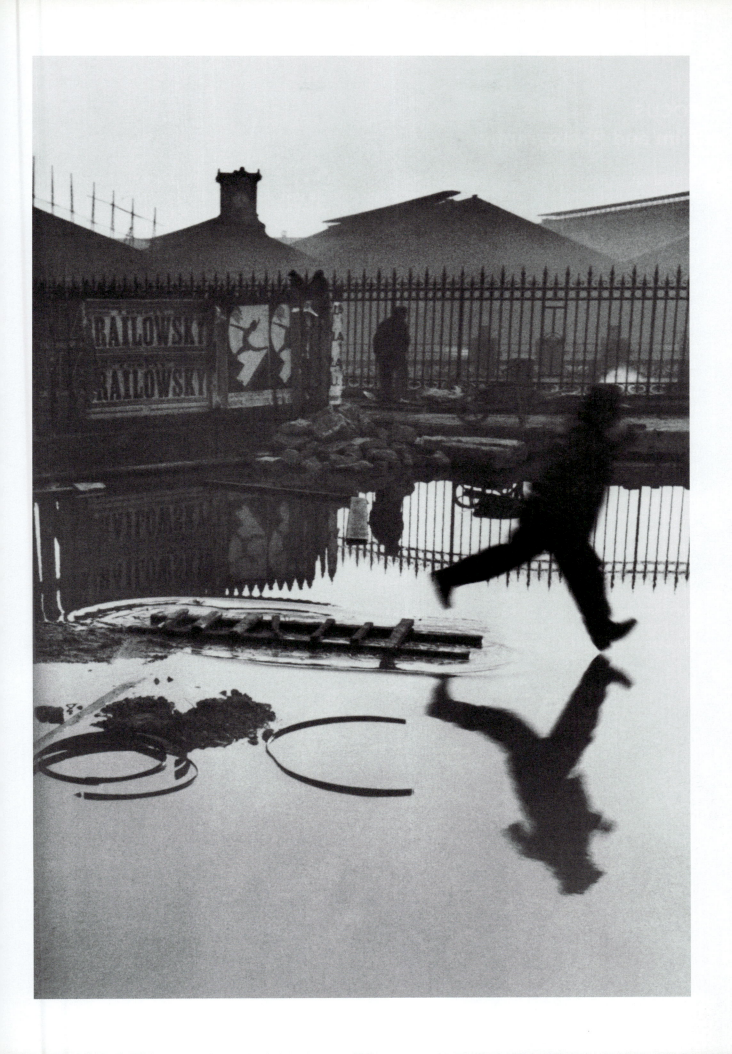

FOCUS
Film and Photography

Throughout the 1920s and 1930s, photographers and film-makers embraced many of the same radical social theories about the visual arts, and used similar techniques to break down preconceptions. In the Soviet Union, cinematographer Dziga Vertov (1896–1954) employed unusual camera angles, superimpositions, and rapidly montaged scenes in such films as the exhilarating *Man with a Movie Camera* (1929), in which a cameraman sweeps through a city recording modern life (Fig. 5.32). Vertov famously announced,

I am kino-eye [film-eye]. I am in constant motion. I draw near, then away from objects, I crawl under, I climb onto them. I move apace with the muzzle of a galloping horse, I plunge full speed into a crowd, I outstrip running soldiers, I fall on my back, I ascend with an airplane, I plunge and soar . . .[41]

Much the same could be said for the quick changes of meaning in photomontage, or the surprising angles in Rodchenko's photographs (see Fig. 5.8). Both photographers and filmmakers scorned the laws of gravity, and propelled the viewer on a visual roller-coaster ride. The Russian filmmaker Sergei Eisenstein also used the new techniques in such patriotic films as *The Battleship Potemkin* (1925) and *October* (also known as *Ten Days that Shook the World*, 1927). *October* reenacted the Russian Revolution of 1917, with realistic scenes of the storming of the Winter Palace, a crucial moment in the Revolution when the Bolsheviks toppled the tsarist regime. The film scenes were later converted into photographs purporting to have been made during the actual assault (see pp. 233–4).

In the years after World War I, before the monopoly of big film studios, artists and photographers were attracted to film as a medium. In his 1922 book *Foto-Kino-Film* (*Photography-Cinema-Film*), Czech artist and writer Karel Teige (1906–1951) wrote enthusiastically about film's potential. Duchamp, Moholy-Nagy, and Man Ray all made non-commercial films. In fact, Man Ray's *Le Retour à La Raison* (*The Return to Reason*) (1923) applied the rayograph process directly to cinema. Among the Surrealist films with visual parallels in photography was *Un Chien andalou* (*An Andalusian Dog*) (1926), directed by Salvador Dalí (1904–1989) and Luis Buñuel (1900–1983), which deliberately shocked audiences with such scenes as a woman's eyeball being slit by a straight razor. At the exhibition *Film und Foto* held in Stuttgart, Germany, in 1929, the interplay between cinema and photography was manifest (Fig. 5.33). The show of about 1,000 photographic works from Europe, the Soviet Union, and the United States included movie stills, and demonstrated reciprocal uses of camera angles, montages, and superimpositions, which migrated from experimental film and photography to mainstream movies by emulation and the changing employment of cinematographers and writers.

The year 1929 was pivotal in film history. Film speed was standardized at twenty-four frames per second, to accommodate simultaneous sound projection—an indirect indicator of the transformation of filmmaking into big business, and the subsequent influence of the large studios. Experimental film and photography gave way to documentary film and photography, forms thought to

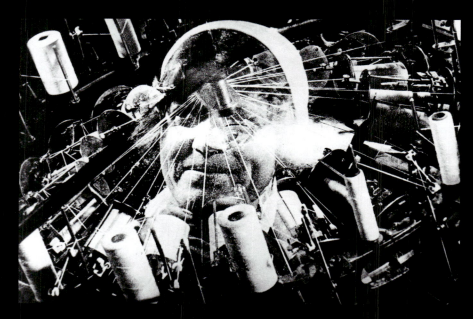

5.32
DZIGA VERTOV, *Man with a Movie Camera,* **1929.**

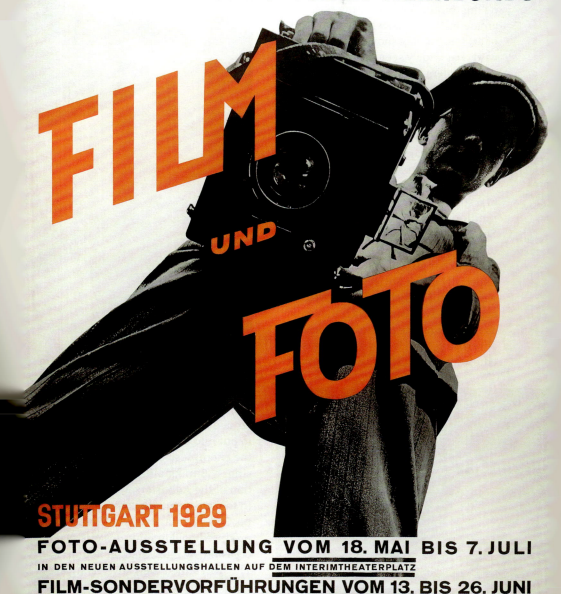

INTERNATIONALE AUSSTELLUNG
DES DEUTSCHEN WERKBUNDS

FILM
UND
FOTO

STUTTGART 1929
FOTO-AUSSTELLUNG VOM 18. MAI BIS 7. JULI
IN DEN NEUEN AUSSTELLUNGSHALLEN AUF DEM INTERIMTHEATERPLATZ
FILM-SONDERVORFÜHRUNGEN VOM 13. BIS 26. JUNI
IN DEN KÖNIGSBAULICHTSPIELEN

OFFSETREPRODUKTION DER FA. G. REISACHER STUTTGART DRUCK DER UNION STUTTGART

...nces. In Depression-era America,
...ncy (RA), which evolved into the
...istration (FSA) (see p. 281), spon-
...hy and film. In 1935, filmmaker Pare
...was hired to chronicle the Dust
...consequence of soil erosion in the
...cided with the economic depression.
...tial photographers such as Paul

Strand (see p. 201), Lorentz made the poignant film *T...*
Plow that Broke the Plains (1936), employing visual te...
niques and emotional subjects that FSA photographe...
would soon emulate.[42] Similarly, members of Film an...
Photo Leagues included still photographers and moti...
picture makers. The New York branch (see p. 296) m...
Workers' Newsreel, which they attempted to have show...
theaters.

EXPERIMENTAL PHOTOGRAPHY AND ADVERTISING

Experimental photographers in Europe and, to a lesser extent, America applied their graphic techniques and theories to commerce. In the United States, with its lingering affection for the serious amateur Pictorialist who created works of art for love, not money, advertising work was widely seen as a betrayal of artistic talent. Nevertheless, such photographers as Canadian-born Margaret Watkins (1884–1969) (Fig. 5.34) and her protégé, American Paul Outerbridge (1896–1958) (Fig. 5.35), both contrived images that translated Modernist visions to advertising.

In Europe, advertising carried less of a stigma, and was even considered a meritorious photographic pursuit. Some Soviet artists saw it as a crucial aspect of modern mass media that could be used to change the public's outlook. Especially in the Soviet Union, theorists were careful to distinguish between capitalist advertising, which they saw as misleading the public, and socialist advertising, which they argued was an educational tool. In 1923, Maiakovskii

**5.35
PAUL OUTERBRIDGE,**
Ide Collar, 1922.
Platinum print.
Metropolitan Museum
of Art, New York.

Outerbridge's advertising images stylishly portrayed commodities. His close-up portrait of a disposable shirt collar is gently shaded, as if it were a likeness of the wearer.

and Rodchenko formed an association that they called Maiakovskii–Rodchenko Advertising-Constructor. Maiakovskii's manifesto "Agitation and Advertising" argued that he and Rodchenko "had to put into action all the weapons that the enemy also uses, including advertising."[43] Similar aims guided the formation of the Adbusters Media Foundation in the late twentieth century (see pp. 471–73). Maiakovskii–Rodchenko produced bold graphic designs that occasionally integrated photographs. The firm aimed their advertising at a proletarian audience, and promoted a variety of products including state-manufactured candy, pacifiers, and beer.

In capitalist countries such as Germany, Modernist chic sold upscale products. Moholy-Nagy routinely produced commercial photographs for clients including fashion magazines, publishers, an airline, and an optical company[44] (Fig. 5.36). German photographer August Sander (see p. 293) created an uncharacteristic photomontage for a brand of cologne, and Krull photographed for automobile companies such as Citroën and Peugeot. French

**5.34
MARGARET WATKINS,**
*Advertisement for
Myer's Gloves*, 1920s.
Gelatin silver print. Jok
Mulholland Collection,
Glasgow, Scotland.

Early advertising used sexually charged images to sell products. Watkins's suggestive style, with its echoes of modern art movements, influenced a generation. She was one of the first women photographers to be employed at a major advertising agency.

artist and commercial photographer Maurice Tabard (1897–1984) brought a touch of sophistication and class to a glittering advertisement for a Dunhill cigarette lighter (Fig. 5.37). Speculating on the effectiveness of advertising photography in 1930, German writer Willi Warstat concluded that "the public simply believes without reservation that the *photographic* representation of an object is truer and more real than any artist's graphic representation."[45] Warstat maintained that advertisers must take advantage of that illusion of truth. Advertising photographs in fact presented goods as more than they were, endorsing them with suggestions of sexual allure and financial success. Through advertising, the product became a commodity favored not because it cleaned teeth or provided transportation, but because it pledged to gratify human desires. Swiss-born photographer Hans Finsler

5.36 (above)
LÁSZLÓ MOHOLY-NAGY, *Goerz*, 1925. Gelatin silver print. George Eastman House, Rochester, New York.

5.37
MAURICE TABARD, *Publicité Dunhill*, 1930. Gelatin silver print. Musée National d'Art Moderne, Centre Beaubourg, Paris.

In order to convey sophistication, the conspicuous ace of clubs is reflected in the gleaming surface of a cigarette lighter. The two edges of playing cards nearest the viewer are reflected near the top of the lighter to suggest a pair of fixated eyes in a face.

(1891–1972), who taught art history and ran a commercial studio in Germany, was one of the best photographic enchanters (Fig. 5.38).

The techniques of experimental photography, including photomontage, close-up, and severe angles, were gradually disengaged from utopian aspiration for social change of the sort that followed the Russian Revolution. Nevertheless, the experimental look remained closely associated with dapper newness and swanky modernity. For example, German photographer Albert Renger-Patzsch's (1897–1966) intense close-up advertisements (see Fig. 5.40) zeroed in on the repetitive patterns of rows of commodities, ranging from coffee beans to bathtubs. Former Bauhaus students Ellen Auerbach (b. 1906) and Grete Stern (b. 1904) used their childhood nicknames for their Berlin partnership, foto ringl + pit. They accepted commissions for advertisements and magazine illustrations (Fig. 5.39), as well as fashionable portraits. By 1931, when the New York show called the *Exhibition of Foreign Advertising and Industrial Photography* brought to America the

5.39
Foto ringl + pit, *Petrole Hahn Advertising*, Berlin, 1931. Bauhaus-Archiv, Berlin.

Foto ringl + pit counted on viewers being so accustomed to the pose of a glamorous model that they would only gradually detect not a living woman but a mannequin.

**5.38 (above)
HANS FINSLER,
Untitled (Toothpaste and brush), c. 1930.
Gelatin silver print. San Francisco Museum of Modern Art, San Francisco, California.**

Finsler excelled in glamorizing everyday goods such as toothpaste by cleverly lighted close-ups that hinted at the good life that might be achieved through the use of the product.

work of European Modernists including Moholy-Nagy, Man Ray, and Bayer, their politics were out of the picture.

EXPERIMENTAL PHOTOGRAPHY AS STYLE

Moholy-Nagy was influential in organizing the international 1929 *Film und Foto* exhibition held in Stuttgart, Germany, to which he contributed ninety-seven photographs, photomontages, and photograms (see Fig. 5.14).[46] At *Fifo*, as the exhibition was called, viewers could see how far photography had changed from the fuzzy look and rural subjects of turn-of-the-century Pictorialism. Collectively, the *Fifo* photographs dwelled on the urban-industrial environment, emphasizing form and texture. Borrowing the name of a contemporary German art movement, observers described such work as exemplifying the *Neue Sachlichkeit*, or New Objectivity. More imprecise terms, such as "New Vision" ("*neue Optik*"), "Modernist Photography," or "New Photography" were also used to denote the emphasis placed on industrial subjects, close-ups, odd angles, and repeated visual patterns.

Some critics decried the commercialization of the Modernist style. Karel Teige angrily observed that *Film und Foto*, as well as the 1930 Munich exhibition called *Das Lichtbild* (*The Photograph*, literally "the light picture" in German), propagated a visual fashion emptied of its initial social activism. He noted the tendency in such popular books as *Es kommt der neue Fotograf!* (*Here Comes the New Photographer!*) by writer and filmmaker Werner Graeff (1901–1978), and the triple-titled *Foto-Auge = Oeil et photo = Photo-eye*, a 1929 compilation of seventy-six contemporary photographs edited by photographer-critic Franz Roh (1890–1965) and proponent of experimental typography Jan Tschichold (1902–1974). In particular, Teige targeted the book *Die Welt ist Schön* (*The World is Beautiful*), by Renger-Patzsch (1897–1966), claiming that its concentration on formal beauty spawned a modish, socially irresponsible version of art for art's sake.[47]

Originally titled *Die Dinge* (*Things*), the book consisted of 100 photographs organized in eight sections, including technology, architecture, and plants. Renger-Patzsch emphasized "thingness"

by choosing a view that standardized and regularized the subject (Fig. 5.40). While praising the new photography for tearing the medium "loose from the grip of the petty business machinations of the studios, and from artistic dilettantism," Teige insisted that "photography did not triumph over painting in order to take its place."[48] He appealed for a photography that was grounded in social life, not the art gallery, and invited photographers to recognize that the medium could be successfully practiced by amateurs. Not surprisingly, Teige admired Soviet photography, asserting that it had not lost sight of its ideological mission. "Service," he concluded, "is the future of modern photography and its tasks will be utilitarian: to serve science, ideas, and social progress." In effect, he called for a progressive, socially committed documentary photography.

For similar reasons, Renger-Patzsch's book was also denounced by German critic Walter Benjamin (1892–1940), who called its style "the posture of a photography that can endow any soup-can with cosmic significance but cannot

5.40
ALBERT RENGER-PATZSCH, *Fingerhut* (*Foxglove*), c. 1924. Gelatin silver print. The J. Paul Getty Museum, Los Angeles, California.

Whether photographing plant life or factory life, Renger-Patzsch's hard clarity and close-up views dwelled on repeating patterns, be they flower petals or factory smokestacks.

5.41
HERBERT BAYER,
Brochure for the exhibition *Deutschland Ausstellung*, Berlin, 1936.

Although they deemed much modern art degenerate, the Nazis often took advantage of the dynamic composition and iconography within experimental photography. Here, three laudable German types—a soldier, a farmer, and a factory worker—loom over an admiring throng at a Nazi rally.

grasp a single one of the human connections in which it exists."[49] Benjamin mocked what he called creative photography, the tendency to look for engaging visual juxtapositions that delighted the eye, but ignored the mind. He maintained that taking subjects out of context, as in severe close-ups, turned photography "into a sort of art journalism."[50]

The depoliticizing of experimental photography at *Fifo* was not an overt, organized effort. In fact, the show seemed progressive in its inclusion of a wide variety of work, ranging beyond art to X-rays, photomicrographs, press photographs, and advertising. Yet the continuous repetition of the style in newspapers and advertisements dulled its newness. The art director for Condé Nast publications, M.F. Agha, shrewdly remarked "Modernistic photography is easily recognized by its subject matter." He continued: "Eggs (any style), twenty shoes standing in a row. A skyscraper, taken from a modernistic angle. Ten tea cups standing in a row. A factory chimney seen through the ironwork of a railroad bridge (modernistic angle). The eye of a fly enlarged 2000 times. The eye of an elephant (same size). The interior of a watch. Three different heads of one lady superimposed. The interior

of a garbage can. More eggs …"[51] At the same time that the Modernist style descended into triteness, the Soviet government shifted its support away from photographic experimentation (see pp. 243–6), in favor of high-impact, easily understood propaganda images.

During the 1930s in Germany, the rise of the Nazi party, with its love of nationalistic pictures, and disgust with what it called cultural Bolshevism, cooled photographic experimentation and sent many photographers seeking asylum abroad. At the same time, the Nazis recognized the power of photography, and organized their first successful propaganda event around photography in October 1933. *Die Kamera* (*The Camera*) exhibition in Berlin took to heart the words of Joseph Goebbels, the chief Nazi propagandist, who declared that "the experience of the individual has become the experience of the people, thanks solely to the camera." Through photography exhibitions such as *The Camera*, the Nazis tried to create a glory-strewn chronology of their rise to power.[52] Ironically, they used the graphic impact of new-vision photography in a brochure designed by Bayer (see p. 253) to accompany the 1936 Berlin Olympic Games[53] (Fig. 5.41). By the end of the 1930s, the experimental photography

developed in the 1920s knew no nationalism or political persuasion. It could be used by Nazis, or against them, as on the cover of *Vu* for April 25, 1934 (Fig. 5.42).

Reflecting on the evolution of photomontage, one of its inventors Raoul Hausmann noted that "over time the technique of photomontage has undergone considerable simplification, forced upon it" by application in "political or commercial propaganda."[54] Commercial propaganda, that is to say, advertising,

brought experimental techniques quickly to the mainstream. Packaging and advertising design were coordinated to conflate the newness of the imagery with claims for a commodity's originality and effectiveness. Where earlier forms of product promotion used extensive text, designers now turned to the terse forms in modern art and photography.

The visual techniques of Surrealism were adapted for commercial purposes, most notably in fashion photography.

5.42
ALEXANDER LIBERMAN, "In Germany, toward a mass army," from *Vu*, April 25, 1934. Neogravure. Victoria & Albert Museum (library), London.

The huge gun barrel that looms over the ranks of Nazi soldiers is not merely an emblem of conflict. It also refers to Germany's continuing investment in and development of long-range guns such as "Big Bertha," which during World War I was capable of hurling shells nearly ten miles.

Russian-born George Hoyningen-Huene (1900–1968) worked in Paris, where he moved in the same circles as Man Ray and Dalí. He photographed such international celebrities as Marlene Dietrich and Charlie Chaplin, as well as the former British monarch Edward VIII, who took the title Duke of Windsor after his abdication in 1936 to marry the American divorcee Wallis Simpson. He quickly moved into the world of *haute couture*, fusing experimental techniques and surreal suggestion in photographs for such magazines as *Vanity Fair* and *Harper's Bazaar* (Fig. 5.43).

Hoyningen-Huene's friend and student Horst P. Horst (1906–1999) also learned from experimental photography and Surrealist art (Fig. 5.44). The most outlandish advertising photographs in the period were made by Lejaren à Hiller (1880–1969), who revived the *tableau vivant* (see pp. 42, 153–54) for a series of photographs depicting the history of medicine in the 1933 series *Surgery Through the Ages*, commissioned by the firm of David and Geck, which made surgical sutures (Fig. 5.45). These photographs were often reprinted and used to decorate doctors' offices.[55]

5.43
GEORGE HOYNINGEN-HUENE, *Schiaparelli Beachwear,* 1930, from *Harper's Bazaar,* 1935. Gelatin silver print. Victoria & Albert Museum, London.

Hoyningen-Huene absorbed the visual vocabularies of twentieth-century art movements, ranging from Cubism to Surrealism, turning them into modish advertisements for upscale goods.

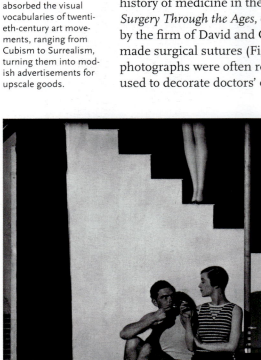

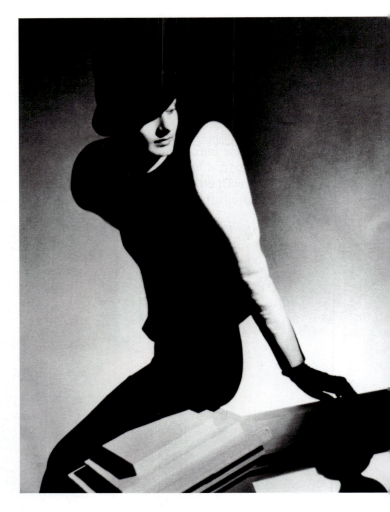

CALIFORNIA MODERN

In the United States, advanced technological image-making came to be associated with corporate propaganda, as in Sheeler's images for Ford (see Fig. 5.20). Left-wing political movements mostly rejected such visual effects, favoring instead the look of handcrafted images to communicate their message. Advertising photography had recourse both to the blurry appearance of the Pictorialist "fuzzygraph" and the lean lines and crystalline light derived from European experimental art and photography. Abstraction, which in Europe had been strongly associated with the social utopianism of early Modernism, was valued by American photographers more for its aura of artistic seriousness. Surrealism similarly lost its political content (in 1930s Europe closely bound with the fight against fascism) when it crossed the Atlantic.

The mists of Pictorialist photography (see pp. 173–204) were still thick in California in the late 1920s, when a

5.44 (above)
HORST P. HORST, *Untitled,* 1936. Victoria & Albert Museum, London.

Horst used the slim, overlapping planes of Cubism, as well as the negative–positive look of photograms, in his carefully lit fashion photography. Here he seems to have merged the look of photomontage with the appearance of the rayograph, invented by his friend Man Ray.

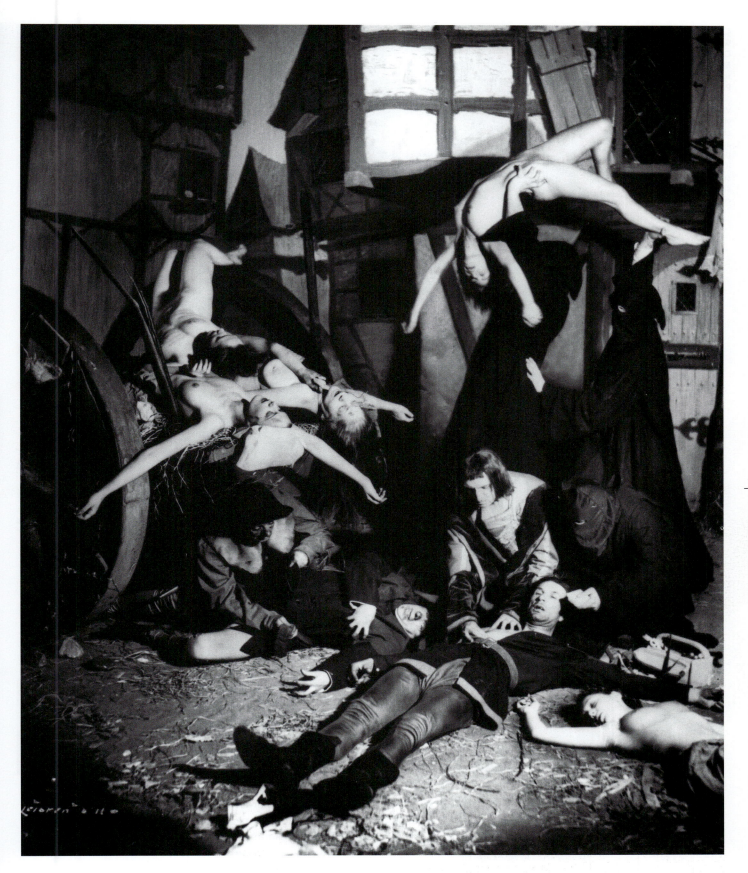

5.45
LEJAREN À HILLER, *Étienne Gourmelen*, c. 1933, from *Surgery Through the Ages*,
1933. Gelatin silver print. George Eastman House, Rochester, New York.

Lejaren à Hiller's advertisements may owe no direct debt to contemporary art, but
exemplify the heightened sensationalism of advertising imagery in the 1920s and
1930s. In his staged image of Étienne Gourmelen, a sixteenth-century physician who
treated plague victims, the men are clothed, while the slim, nude women disport them-
selves in sexually suggestive poses—a little-known symptom of the plague!

**5.46
WILLARD VAN DYKE,**
*Cement Works,
Monolith, California,*
**1931. Gelatin silver print.
Private Collection.**

Van Dyke's angle of
vision made the large
chimney on the right
appear flattened and
tipped inward slightly, as
if it were applied to the
surface of the picture,
similar to a Cubist
collage.

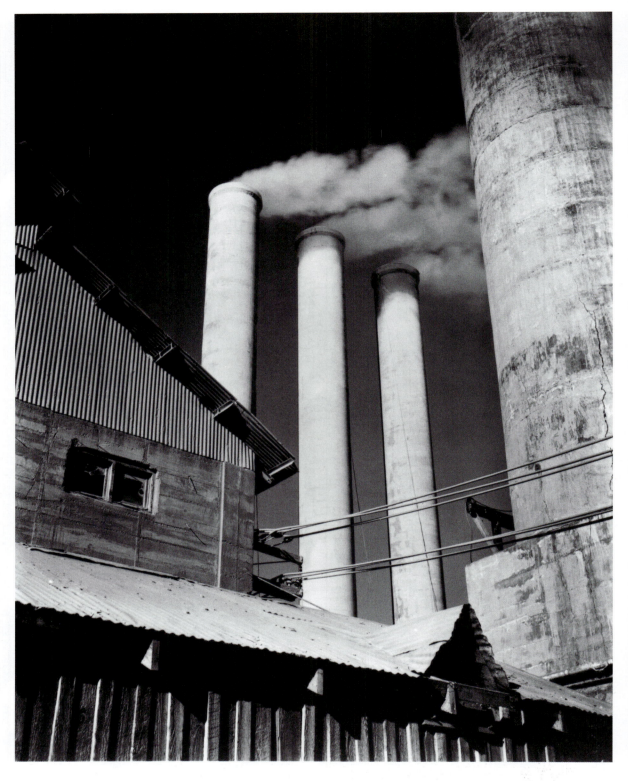

loose affiliation of friends dubbed them-
selves Group f.64, and issued a mani-
festo: "The members of Group f.64
believe that Photography, as an art-form,
must develop along lines defined by the
actualities and limitations of the photo-
graphic medium, and must always
remain independent of ideological con-
ventions of art and aesthetics that are
reminiscent of a period and culture
antedating the growth of the medium
itself."[56] In other words, Group f.64
dismissed Pictorialism, despite the fact
that several of its members had prac-
ticed it, and urged the exploration of
camera vision. Their name referred to
the small lens opening on their cameras
that produced clear detail in the fore-
ground as well as the background, and
indicated that they had more in com-
mon with regard to the appearance of
the photograph than its subject-matter.

It is difficult to say exactly how the general strains of Modernism reached the Group. Certainly they traveled, and they were familiar with contemporary magazine design and advertising. In addition, the Oakland Art Gallery in California exhibited Bauhaus abstract art, German posters, and works by the Blue Four (*Blauen Vier*), a group of Bauhaus painters, including Kandinsky and Klee, formerly associated with the German Expressionists collectively called the Blue Rider (*Der Blaue Reiter*), from the title of a picture by Kandinsky. In fact, the Blue Four was not a formal organization, but a term chosen specifically to acquaint American audiences with their work, while alluding to the success of the Blue Rider. The first American Blue Four show was held in Oakland, and led to criticism that Group f.64's notions were drawn from the German artistic invasion of America. Opponents discounted the fact that f.64 did not promote social change, as did the Germans. In West Coast parlance, the Modernist work of Moholy-Nagy was called "pure photography," a term f.64 used at the "First

Salon of Pure Photography" (1934), and which their enemies derided as the "carcass" of transatlantic ideas.[57]

The Group's energetic organizer, Willard Van Dyke (1906–1986), photographed a cement works, usually a dusty business, as if it were a sun-drenched Cubist apparition (Fig. 5.46). In the middle of the Depression, Van Dyke began to respond to the growing sentiment that artists should contribute directly to the nation's economic recovery. He did a stint as camera operator for Lorentz (see p. 265) on the shooting of *The Plow that Broke the Plains*, which recorded the plight of midwestern farmers, and went on to make other documentary films.

As a teenager, Imogen Cunningham (1883–1976) was so impressed with a reproduction of Käsebier's *Blessed Art Thou Among Women* (see Fig. 4.32) that she decided then and there to be a photographer. After college, she went to work in the studio of Edward S. Curtis (see p. 196), where she learned the intricacies of platinum printing. Following photographic study in Germany, in 1910 she opened a portrait studio in

**5.47
IMOGEN CUNNINGHAM,**
Snake in a Bucket, 1929. Gelatin silver print. © The Imogen Cunningham Trust, San Francisco, California.

Cunningham made seemingly simple photographs from elements of her home environment. When her children brought home a snake in a bucket, she made the creature a subject.

Seattle, Washington. When exhibited, her Pictorialist nude interpretation of the Adam and Eve story became the scandal of Seattle. A move to California increased her contact with other photographers, especially Edward Weston (1886–1958). During the 1920s and 1930s her work shifted toward a starkly geometrical style of straight photography. Her female nude studies and close-ups of plants and flower portraits began to be compared to the simple, sinuous forms favored by American painter Georgia O'Keeffe (see Fig. 5.73).

Some of her plant studies were exhibited at the 1929 *Film und Foto* show in Stuttgart. Cunningham's strength in this period rested on her ability to find a visually arresting, sensuous picture in trifling moments (Fig. 5.47). Her later work capitalized on her knowledge of portraiture, as in her informal series picturing older people (Fig. 5.48).

Ansel Adams (1902–1984) and Edward Weston, probably the best-known members of f.64, shared a philosophic regard for natural forms.

**5.49
ANSEL ADAMS,** *Valley View, Yosemite National Park, California,* **c. 1933. Gelatin silver print. Collection Center for Creative Photography, University of Arizona, Tucson, Arizona.**

Among Adams's most famous photographs are those he took at Yosemite National Park. These views favored startling depth of field and physical details, as well as an attentive eye for light and weather effects.

Adams revealed his belief in the spiritual value of nature to society when he remarked, "I still believe there is a real, social significance in a rock—a more important significance therein than in a line of unemployed."[58] Nevertheless, Adams spoke and showed his prints at the politically involved Photo League in New York. Adams's concentration on dramatic images of natural light effects was fixed well before he became acquainted with Group f.64. During the 1920s, for example, while working as a guide and custodian in California's Yosemite National Park area, Adams photographed the region (Fig. 5.49).

Meetings with Strand (see p. 201) and Stieglitz (see p. 184) strengthened his resolve to photograph full-time. At Yosemite, in the midst of the scenery swooningly recorded by Carleton E. Watkins (see pp. 124–26), Adams worked out the beginnings of what he would call the "zone system" of photog-

raphy. His method allowed a photographer to previsualize the finished print by comparing light intensities in the scene to be photographed with a chart showing an ascending scale of tones, ranging from black to white. In other words, the main work of picture-making took place not in the darkroom, but before the film was exposed.

After the United States entered World War II, following the Japanese bombing of Pearl Harbor on December 7, 1941, Adams and Dorothea Lange (1895–1965) expressed their sense of outrage at the forced round-up and confinement of Americans of Japanese descent at the California internment camp called Manzanar Relocation Center in Owens Valley. Though given access to the camp, Adams and Lange were forbidden to photograph guards, guard towers, or barbed wire. Pictures of camp life were also made by Toyo Miyatake (1895–1979), a Modernist

Japanese-American photographer interned at Manzanar (Fig. 5.50).

Though Edward Weston did not originate an elaborate system of tonal equivalents as Adams did, he, too, believed that "the finished print is pre-visioned on the ground glass while focusing ... the shutter's release fixes forever these values and forms."[59] Like Adams, Weston joined Group f.64

when he was already established as a photographer, perhaps to underscore his allegiance to Modernism. His first book of images, *The Art of Edward Weston*, was available at the group's inaugural show at San Francisco's M. H. de Young Memorial Museum in November 1932. A decade before this exhibition, Weston had visited Stieglitz in New York, an event he treasured,

5.51
TINA MODOTTI,
Workers, Mexico,
c. 1926–30. Gelatin silver print. Amon Carter Museum, Fort Worth, Texas.

Modotti's political views and her photographic practice were stimulated by her stay in Mexico. She moved away from making Modernist close-ups of natural forms to photographing workers, exalting the dignity and virtue of manual labor, as in her image of two workers managing a load.

5.52
EDWARD WESTON,
Excusado, Mexico, 1925.
Gelatin silver print.
Center for Creative
Photography, University
of Arizona, Tucson,
Arizona.

Weston compared his
image of a toilet with
the beautiful form of
Greek statues. "Photog-
raphy is realism!" he
announced. "Why make
excuses?" He portrayed
the unpretentious object
as a shape so captivat-
ingly smooth that it
shed its vulgar associa-
tion with mere bodily
functions, and was
transformed into an
instance of formal
grace.

even though the older photographer
dropped one after another of Weston's
prints on the discard pile. In 1923,
Weston left his struggling portrait busi-
ness and went to live in Mexico with
his companion, the photographer Tina
Modotti (1896–1942). Modotti came
into her own in Mexico, evolving away
from Weston's interest in beautiful pat-
terns to a concern for injustice in society
(Fig. 5.51). After 1930, she largely gave
up photography in favor of political
work. Several of her photographs
appeared in *Der Arbeiter Fotograf* (*The
Worker Photographer*)[60] (see p. 294).

In Mexico, Weston made his most
notorious image, the *Excusado* (the
Spanish word for toilet) (Fig. 5.52). The
toilet exemplifies Weston's close-up,
sharply detailed approach to everyday
objects such as sea shells and vegeta-
bles, especially his celebrated photo-

graphs of peppers, which he compared
to the sleek sculpture of Romanian
Constantin Brancusi (1876–1957), him-
self an accomplished photographer.
By the time of the inaugural f.64 show,
Weston had organized the American
contribution to the 1929 *Film und Foto*
show, enjoyed a major exhibit of his
work at the M. H. de Young Memorial
Museum in San Francisco, and had
two successful shows in New York City.

Though eagerly involved, Weston's
active participation in f.64 activities was
only a brief phase in his life. Continuing
in style and visual themes he groomed
in Mexico, Weston went on to make
several series of images involving light,
shade, and texture in nature. Oddly
enough, his photographs of deeply
pleated light and dark patterns of sand
dunes, or twisted cypress trees and worn
rocks at Point Lobos, California, seem

**5.53
EDWARD WESTON,**
Nude, 1934. Gelatin
silver print. Center for
Creative Photography,
University of Arizona,
Tucson, Arizona.

Many of Weston's
images of human nudes
are not erotic, but
arresting glimpses of
the body's contortions.
By contrast, his pho-
tographs of subtle,
textured shadows origi-
nating in nature are
often more sensual.

more sensual than his images of the human nude (Fig. 5.53). Where Stieglitz is remembered as the photographer who put modern art and photography on the American cultural radar, Weston is revered as a Romantic figure, who sacrificed emotional and economic stability to pursue his creative life.

SOCIAL SCIENCE, SOCIAL CHANGE, AND THE CAMERA

While many American photographers of the 1930s had been influenced by f.64's Modernist aesthetic, their subject-matter during this decade was more profoundly determined by their varied responses to the social and political realities of the Depression. The emergence of documentary photography as a means of addressing those realities would have a far-reaching legacy for the medium.

The sustained world economic and industrial growth of the 1920s ended abruptly in 1929. In the United States, the stock market crash on October 24, 1929 wiped out over 60 percent of the value of securities, and set off a chain reaction of bank failures, factory shutdowns, and mortgage foreclosures.

Conditions worsened further in the early 1930s, because of the impact of European financial crises on the United States. Unemployment grew, while foreign trade declined. By the election of 1932, one in four workers was unemployed, at a time when families primarily depended on a single breadwinner, and when relief programs were minimal. Franklin D. Roosevelt (1882–1945) came to the American presidency with a broad series of recovery plans collectively known as the New Deal. As during his governorship of New York, Roosevelt and his associates banned photographs showing him in his wheelchair or wearing the heavy leg braces that he needed as a result of having had polio. Roosevelt was keenly aware of maintaining public faith in his good health. Though there were occasional exceptions, the press largely complied. When he fell flat approaching the speaker's platform at the 1936 Democratic Convention, no written reports noted it and no photographs of it appeared in the press.[61]

In the United States, the Depression was viewed as a challenge to the notion of America as a land of limitless opportunity for those willing to roll up their sleeves and work. As the Depression was gradually perceived as an enduring, not temporary experience, many photographers softened the hard graphics of Modernist photography and adapted them to interpretations of how people now lived. The clear close-ups of troubled faces, angled pictures of ragged breadlines, and angry contrasts between poverty and wealth began to be called documentary photography.

THE ORIGINS OF DOCUMENTARY

In a broad sense, all non-fictional representation, in books or in images, is documentary. But during the 1930s, when the word "documentary" came into wide usage, its meaning was more limited. Writers, filmmakers, and photographers produced a blend of Modernistic style and realistic subject-matter, aimed at educating the public about the experience of hardship or injustice. Earlier photographers such as Thomson and Riis (see pp. 109–12, 205–8) had pictured misfortune, but they were not interested in visual innovation, and they tended to present people in categories, such as occupation, class status, or eth-

nic origin. Documentary photographers in the 1930s strove to present their human subjects as people like us, who were temporarily down on their luck, hoping that viewers would make the imaginative leap to apply the message to themselves. Earlier social documentary photography, with the exception of Lewis Hine's work (see p. 208), was more patronizing toward its subjects.

Filmmaking and film theory helped instigate the beginnings of documentary photography. For example, to make his popular *Man With a Movie Camera*, Vertov left the studio and roamed the streets recording life as it was lived, before editing it into a fast-paced visual roadshow (see p. 264). In the 1920s, documentary film combined derring-do with exotic stories, as in *Grass* (1923), an account of the hazardous yearly migration of the Bakhtiari people of Iran. *Grass* was shot by Merian C. Cooper (1893–1923) and Ernest B. Schoedsach (1893–1979), who went on to make *King Kong* (1933), a film whose early island scenes demonstrate the active, entertaining qualities of early documentary.

American filmmaker Robert Flaherty (1884–1951) spent sixteen months with the indigenous people near Hudson Bay in Canada chronicling their daily lives in the box-office success *Nanook of the North* (1922). Though acting and scripts were discouraged by documentary filmmakers, they were not purists. For example, during the shooting of *Nanook*, Flaherty restaged a walrus kill. Flaherty's public success helped legitimize the documentary mode, and sent the big film studios in search of "another *Nanook*." The first use of the word "documentary" in its new sense was probably made by influential British filmmaker and theorist John Grierson (1898–1972), in his review of Flaherty's South Sea island film, *Moana* (1926).

The documentary current flowed not only through film and photography, but also through social science writing, popular literature, radio programs, and art movements such as the American Ashcan school.[62] Each of these modes reinforced the other, suggesting that the practitioners were neutral observers, boldly recounting facts. Grierson suggested that documentary should be given the power of poetry and prophesy.[63] He maintained that documentary

was "an 'anti-aesthetic' movement" that knew how to use aesthetics.[64] However, photographer Ansel Adams (see pp. 276–7) rejected the new fusion of art and observation, complaining wryly that "What you've got are not photographers. They're a bunch of sociologists with cameras."[65]

Over time, as questions about the accuracy and completeness of documentary arose, its primary association with social observation and social advocacy weakened. Today the word is popularly used loosely to describe large visually and thematically related archives or extensive photographic projects, such as novelist Eudora Welty's (1909–2001) far-ranging photographs of three decades of life in the American South (see p. 290), or Carl van Vechten's (1880–1964) 1,400 portrait photographs of famous individuals (see Fig. 5.73). Contemporary documentary photography now frequently navigates between visualizing the personal experience of the photographer and a setting of profuse sociological text.

THE FARM SECURITY ADMINISTRATION

Initiated in 1935, the Resettlement Administration (RA) was among President Roosevelt's efforts to fight the Depression. It was an umbrella agency, charged with coordinating the various rural relief efforts in government departments, including the Agricultural Adjustment Administration and the Federal Emergency Relief Administration. The agency oversaw loans, flood control, migrant camps, and agricultural education. As its name implies, one of the RA's prominent initiatives was to move distressed farmers into more economically viable service and industrial work. The mission of the RA, like many of the New Deal agencies, was regularly questioned by conservatives who felt that direct, planned government intervention into the economy and the daily lives of citizens was un-American, or worse, crypto-socialist.

In 1937, the RA was subsumed into the Department of Agriculture and renamed the Farm Security Administration (FSA). Roy Stryker (1893–1976), who supervised the photographic activity of the RA, continued with the FSA, directing what was officially known as

the "Historical Section — Photographic." His job remained much the same: he was to gather photographic evidence of the agency's good works and transmit these images to the press. Stryker's background as a photo-editor consisted solely of his efforts to find illustrations for the textbook *American Economic Life and the Means of Its Improvement* (1925), written by his mentor, Columbia University professor Rexford Tugwell. When Tugwell came to Washington to head the RA, Stryker came with him.

Some scholars argue that the orchestration of public opinion through the mass media practiced by the FSA and other New Deal programs parallels the activities of experimental photographers in the early years of the Soviet Union[66] (see pp. 243–46). Certainly the United States and the Soviet Union both envisioned industrial expansion as crucial to future prosperity. But the RA/FSA did not financially support revolutionary departures from visual—or political— conventions, as did the Soviet Union. In fact, the United States government feared socialist connotations, and abstained from calling their efforts propaganda, preferring instead the word "publicity."[67]

The RA/FSA photographers were heir to an understanding of documentary that revolved around emotionally persuasive, stylized depictions of symbolic images. However much they asserted the hard reality of their pictures, they were no more averse to invoking religious imagery than was Hine (see p. 208). Indeed, the photographs that themselves have become part of American history, such as Arthur Rothstein's *Fleeing a Dust Storm* (see Fig. 5.58) or Dorothea Lange's *Migrant Mother* (see Fig. 5.56), elicited biblical associations of wandering in the desert or the Virgin Mary with the baby Jesus.

Early in his tenure, Stryker envisioned a smooth system in which full-time photographers exhaustively covered the agency's good works around the country, and returned the images to the RA for swift nationwide distribution to media outlets. Budget restraints reduced his grandiose vision, yet Stryker still scheduled assignments, drafted shooting scripts, and decided which photographs would be distributed to media outlets ranging from *Time* maga-zine to the *Junior Scholastic*.[68] By 1940, the agency claimed to be distributing an average of 1,400 images a month.[69] Stryker's pet idea of focusing on life in small towns may have come from conversations he had with sociologist Robert S. Lynd, who with Helen Lynd wrote the influential 1929 book *Middletown: A Study in Modern America*, a classic in-depth study of an average middle-American small city. Stryker once bragged about his ability to shape views of the Depression that avoided tabloid voyeurism and social strife, saying, "You'll find no record of big people or big events ... There are pictures that say Depression, but there are no pictures of sit-down strikes, no apple salesmen on street corners, not a single shot of Wall Street, and absolutely no celebrities."[70]

Roughly twenty photographers,[71] full and part-time, shot for the agency until 1942, at which time it was subsumed within the Office of War Information. Although some photographs were taken before the RA was renamed the FSA, and after it was engaged to do war work, the images are collectively known as the Farm Security Administration photographs.

Among Stryker's first hires was Walker Evans (1903–1975), who came to the agency with well-established credentials in June 1935. Through Berenice Abbott (see p. 290), Evans had had the opportunity to view the photographs of Eugène Atget (see Fig. 5.65), which Abbott had amassed in Paris and brought to New York City. Evans responded to Atget's straightforward recording of historic streets and buildings, as well as worn interiors and architectural detail that bespoke the persistence of the past in the present. Unlike the Surrealist photographers, who found Atget's work full of mystery and the uncanny, Evans located there a reserved and courtly melancholy about the transitions of modern life. He spoke of Atget's "lyrical understanding of the street, trained observation of it, special feeling for patina, eye for revealing detail, over all of which is thrown a poetry."[72] Atget's images heartened Evans's aesthetic inclinations, while the commercial and fashion photographs of Steichen (see p. 186) ran counter to his sensibilities. Evans wrote that Steichen's "general note is money, understanding

We wonder whether the great American dream

Was the singing of locusts out of the grass to the west and the

West is behind us now:

The west wind's away from us

USF342 — 1167A

5.54
WALKER EVANS,
Untitled, **from** *Land of the Free* **by Archibald MacLeish, 1937. Library of Congress, Washington, D.C.**

Evans's photograph symbolically showed the lives of workers in Bethlehem, Pennsylvania. He focused on electrical lines, which extend from the cemetery to the humble housing, and then to the steel mills in the background—the same factories where Frederick Winslow Taylor studied the steps laborers use to perform tasks (see p. 217). In his book *Land of the Free* (1937), Archibald MacLeish used the image, juxtaposing it with his poetry, as shown here.

advertising values, special feeling for parvenu elegance, slick technique, over all of which is thrown a hardness of superficiality that is the hardness and superficiality of America's latter day …"[73] In Evans's view, commercialism was not simply Steichen's personal dilemma, but America's national predicament.

Evans believed in finding scenes and objects whose appearance implied a story or acted like a metaphor for an attitude toward life. He felt that his unambiguous, clearly composed images owed a debt to the spare and rhythmic prose style of American author Ernest Hemingway (1899–1961).[74] Evans's image of Bethlehem, Pennsylvania (Fig. 5.54) symbolically guides the viewer from background to foreground through a fatal progression of work, home life, and death. The image shows no people, but used the locale and flattened perspective to indicate the compass of their restricted lives.

Evans secured a leave of absence from the RA to work for *Fortune* magazine on a project with his friend, writer James Agee (1909–1955). Like other publications in the mid-1930s, *Fortune*

contrived human-interest photo-essays on how the Depression affected individuals. For their joint venture, Agee and Evans chronicled the lives of three families of impoverished, cotton-growing tenant farmers in Hale County, Alabama. Agee's procrastination, and *Fortune*'s doubts about the project, eventually prompted the company to cancel the assignment. The project was eventually published as the book *Let Us Now Praise Famous Men* (1941), with a suite of Evans's uncaptioned photographs preceding Agee's text. Agee explained that his prose and Evans's photographs were to be viewed as "coequal, mutually independent, and fully collaborative."[75] Published in the shadow of the commercially successful *You Have Seen Their Faces* (1937) by Margaret Bourke-White and Erskine Caldwell (see p. 288), the Evans–Agee book was a financial failure.

Evans's image of twenty-seven-year-old Allie Mae Burroughs, thinly disguised as "Annie Mae Gudger" in the text, exemplified his approach to picture-making (Fig. 5.0).

Evans's disdain for Stryker's assignment guidelines and deadlines made him the legendary bad-boy of FSA

photography, and he was dismissed in 1937. It is difficult to imagine that the autocratic Stryker could tolerate Evans's desire to record handmade advertising signs or austere domestic interiors as an anonymous folk art. Evans's images tended to lift poverty and the economic effects of the Depression into a timeless picturesque universe. Spare and serene images comprised the bulk of Evans's pictures in *American Photographs,* the title of his 1937 Museum of Modern Art exhibition and his 1938 book. This book influenced a generation of younger American photographers, such as Robert Frank (see pp. 343–45). They admired its dispassionate approach, which for them indicated Evans's caustic alienation from society. His insistence on publishing the images without captions and in no chronological order suggested the sensibilities of an artist who demanded that his work be taken on its own terms.

After the FSA, Evans continued his artful documentary in such series as his subway photographs taken with a concealed camera. But his major source of

5·55
DOROTHEA LANGE,
Migrant Mother, 1936,
from *Midweek Pictorial,*
October 17, 1936. FSA
Scrapbook, FSA-OWI
Written Records.
Library of Congress,
Washington, D.C.

Lange's photograph recalls religious images of the Madonna and Child, but also expresses Depression era values. The children on either side turn away, symbolically ashamed of their wretchedness. The mother's careworn face, her tattered clothes, and the dirty baby near her breast indicate extreme distress, deserving of compassion. Yet her expression hints at a determination to persevere through hard times.

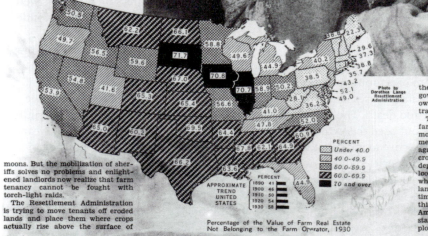

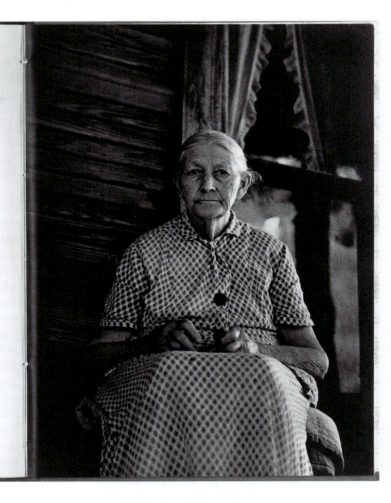

income was ironically as a writer and photographer for *Fortune*, a periodical devoted to big business.

Unlike Evans, Dorothea Lange came to the RA in 1935 with a sure sense of social justice and of how photography could reveal inequality. As a statement of her belief, in 1923 she tacked lines by English statesman and writer Francis Bacon (1561–1626) to her darkroom door:

The contemplation of things as they are
without substitution or imposture
without error or confusion
is in itself a nobler thing
than a whole harvest of invention.[76]

The seminar she took in New York City on basic photography, given by Pictorialist Clarence White (see pp. 179–80), did not influence the look or the subject-matter of her images.

During the early Depression she photographed labor demonstrations and breadlines in San Francisco. Her work with activist-economist Paul Taylor, whom she subsequently married, focused her attention on the plight of migrant farmworkers. For the RA, she produced the photograph that became the national icon of the Depression. *Migrant Mother* is one of several shots Lange took of a thirty-two-year-old woman and her children, who were stranded in a frozen pea field among the crop they had hoped to pick to earn some money. Undoubtedly the most popular image created during the Depression era, the photograph was repeatedly sent out to newspapers and magazines by the Farm Security Administration (Fig. 5.55).

Though powerful, *Migrant Mother* is not typical of Lange's work. She did not readily repeat the mother-and-child theme. With Taylor supplying the text, Lange published captioned photographs in *An American Exodus: A Record of Human Erosion* (1939), a book whose title refers to the destructive southwestern drought of the mid-1930s, and the migration it caused. In the book, photographs were accompanied by quotations from the sitters (Fig. 5.56), unlike the fictionalized statements created by Margaret Bourke-White and Erskine Caldwell for *You Have Seen Their Faces* (see p. 288).

5.56
DOROTHEA LANGE, *Ma Burnham*, from *An American Exodus* by Dorothea Lange and Paul Schuster Taylor, 1939, pp. 150–51. Library of Congress, Washington, D.C.

Lange's photograph of Ma Burnham remains at a respectful distance, and is typically shot from below, monumentalizing the figure. Though she had a fine sense of effective composition, Lange did not emphasize contrasting and harmonizing abstract forms in the manner of Walker Evans (see Figs. 5.0, 5.54).

After her five years with the RA/FSA, Lange continued to make photographs that accorded with her concern for social justice. She and Taylor were adamantly opposed to the 1942 War Relocation Authority (WRA), which forcibly moved Japanese-Americans to internment camps. Like Adams (see p. 277), Lange photographed the internees' life at Manzanar Relocation Center in California. For *Life* magazine, she profiled the daily life of a public defender in Alameda County, California, and chronicled the last days of farming communities in the Berrysea valley, northeast of San Francisco, on the brink of being flooded by the construction of a new dam.

Another early recruit to the RA was Arthur Rothstein (1915–1985), who made an enduring image of the Dust Bowl experience (Fig. 5.57). Rothstein's photography has been overshadowed by a notorious set of photographs he made in the barren Badlands of South Dakota during the summer of 1936. Having come across the sun-bleached skull of a steer resting on parched soil, he filmed it where he found it, but then moved it,

and experimented with close-ups and cast shadows. He was accused of fakery for moving the skull; the agency worried that their funds would be cut back, but did not dismiss Rothstein.[77] In fact, several RA/FSA photographers could have been charged with altering their images; Lange, for example, had a retoucher airbrush out what she considered a flaw in *Migrant Mother*.[78]

Photographers came and went at the RA/FSA, some working only a few months. Although about twenty individuals worked for the agency, only a half-dozen or so were employed at any one time.[79] Among the late hires at the FSA, when the agency's focus was changing from small town and rural life to urban enterprise and defense activities, were Gordon Parks (b. 1912) and Esther Bubley (1921–1998). Parks came to Washington, D.C. on a prestigious fellowship, which had been held by other African-Americans, such as Zora Neale Hurston (1891–1960) and James Baldwin (1924–1987), who wrote about the American South and the black experience. Parks began by photographing

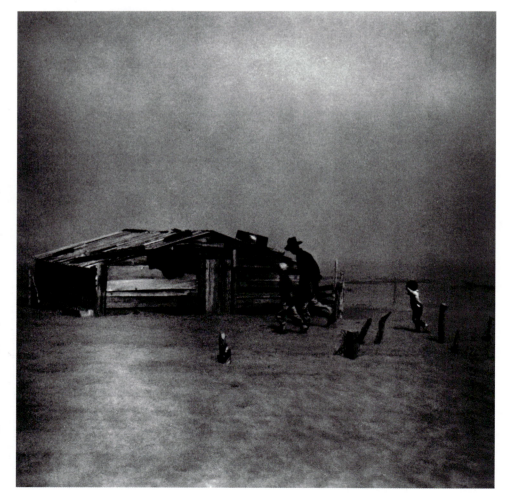

5.57
ARTHUR ROTHSTEIN,
Fleeing a Dust Storm,
Cimarron County,
Oklahoma, April 1936.
Gelatin silver print. FSA
Collection. Library of
Congress,
Washington, D.C.

Influenced by the poignant imagery of Pare Lorentz's film *The Plow that Broke the Plains* (1936), Rothstein traveled to the dustbowl area where it had been filmed to record the ceaseless wind and the sand-drenched atmosphere. This image shows a farmer and his children leaning into the incessant wind as it scours their land, removing the topsoil and thereby leaving their life in ruins.

5.58
GORDON PARKS, *Ella Watson (American Gothic)*, 1942. Gelatin silver print. Library of Congress, Washington, D.C.

As part of a composition that is replete with symbolism and that pointedly echoes Grant Wood's painting, *American Gothic*, Ella Watson stands before the American flag in the office of the Farm Security Administration.

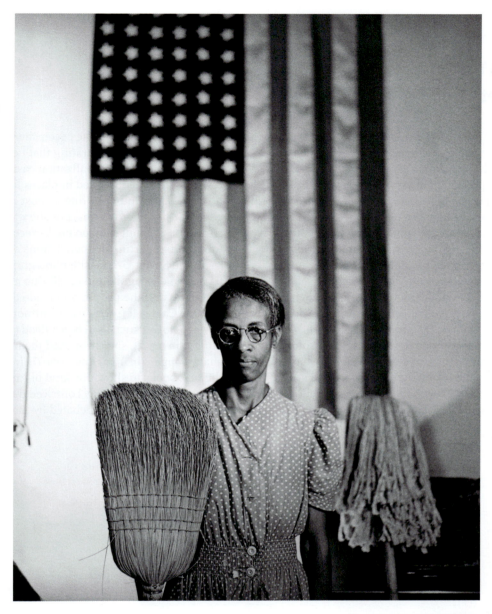

5.59 (below)
ESTHER BUBLEY, *Listening to a Murder Mystery on the Radio in a Boarding House Room*, 1943. Gelatin silver print. Library of Congress, Washington, D.C.

the life and work of Ella Watson, who cleaned the agency's office (Fig. 5.58).

Esther Bubley was hired in 1943, just as the agency changed its name to the Office of War Information. Her first assignment produced 445 pictures chronicling people she met on a Greyhound bus journey across the American South. Her images of solitary, pensive women differ greatly from the main visual themes of the FSA (Fig. 5.59). Bubley's subjects do not suffer the effects of poverty that might be alleviated by a government agency. Indeed, their haunted look of displacement was caused by the government's need for more female workers in Washington during wartime.

Bubley's bus-trip series and her boarding-house photographs were among the last assignments she did for

PORTRAIT
Margaret Bourke-White

By the time she was in her mid-twenties, Margaret Bourke-White (1904–1971) was in the news. Such captions as "This daring camera girl scales skyscrapers for art"[80] show the press's infatuation with a woman who climbed out on to the high steel frame of the Chrysler Building to record its construction, stood on the steel-mill floor amidst flying sparks to photograph a ladle full of molten metal, and shot pictures in remote Canadian logging camps where the temperature went below minus twenty degrees. Bourke-White loved being a celebrity — she even coordinated her camera-clothes to match her designer outfits. At the same time, though, she determinedly moved from assignment to assignment, for *Fortune* magazine, and then for *Life* magazine, often suggesting her own themes and subjects. Her photograph of the Fort Peck Dam in Montana, then the world's largest earth-filled dam, introduced the American public to the first issue of *Life* magazine on November 23, 1936 (Fig.

5.61). She not only had the cover, she wrote and illustrated the lead article, demonstrating that her ability to find powerful symbols of industrialization easily converted to revealing how people lived in places like the boom town near the dam. Bourke-White is most frequently remembered for her photographs, but she was also the author or co-author of about a dozen books recounting her adventures and imparting her convictions about social inequality.

In the Soviet Union, she photographed the new industrial town of Magnitogorsk, offering a paean of praise to machines and the people who made them work. With Erskine Caldwell (1903–1987), author of steamy Southern poverty stories such as *Tobacco Road* (1932) and *God's Little Acre* (1933), she chronicled the impoverished lives of sharecroppers in *You Have Seen Their Faces* (1937), one of the first books to show this kind of imagery in America. She and Caldwell frankly contrived dialogue to accompany the images, a deed still debated by those who believe that

5.60
MARGARET BOURKE-WHITE, *Staff Sergeant Robert Wilson and Private First Class Wilbur Derrickson (92nd Buffalo Division) at an Artillery Outpost, Italy, winter 1944–45.* Gelatin silver print. Syracuse University Library, Syracuse, New York.

5.61
MARGARET BOURKE-
WHITE, Cover of *Life*,
vol. 1, no. 1, November
23, 1936.

documentary work must record exactly what people have to say for themselves.

During World War II, she photographed German bombs falling on Moscow, was the first woman to fly a combat mission, and sent back raw, painful photographs from the Nazi concentration camp at Buchenwald. Also, she insisted on recording the contributions of the so-called "buffalo soldiers," military units composed of all-black troops (Fig. 5.60). After the war, she photographed Mahatma Gandhi's attempts to gain independence for India; the punishing lives of black gold miners in South Africa; and guerrilla warfare in Korea. At age forty-nine, her career waned, cut short by Parkinson's disease, which she fought for twenty years with the same courage that she deployed in the course of dangerous assignments.

Stryker. He left the Office of War Information to work in the photographic section of the Standard Oil Company; Bubley eventually joined him there, where she was employed to make another sequence of photographs about a cross-country bus trip.[81]

OTHER DOCUMENTS

While the RA/FSA photographs had a lasting effect on America's image of itself, other documentary photography projects were also instigated by government agencies during the Depression era. Berenice Abbott (1898–1991) photographed for the Works Project Administration (WPA), a controversial New Deal program that found public employment for artists, and Eudora Welty (b. 1909), who was hired as a publicity representative for the agency's work in Mississippi, brought her own camera (Fig. 5.62). A bitter look at the Depression and its psychological effects was created by writer and poet Archibald MacLeish (1892–1982), who juxtaposed FSA photographs with his verse in *Land of the Free* (see Fig. 5.54). MacLeish placed images next to pages of text, and in a reference to modern storytelling, put a narrow blue line across the top of

every text page, alluding to the soundtrack that was placed in a thin line along the edge of motion picture film. *The Grapes of Wrath* (1939), John Steinbeck's (1902–1968) stirring account of the lives of poor farmers displaced by the Dust Bowl, was first conceived by Steinbeck as a text with pictures by a *Life* magazine photographer called Horace Bristol (1908–1997).

Richard Wright (1908–1960) was the author of *Native Son*, the bestselling 1940 novel about racism in a northern American city. In the midst of the popularity of *Native Son*, Wright was commissioned to write another text about black life in America, *Twelve Million Black Voices: A Folk History of the Negro in the United States* (1941), which was illustrated with photographs from the FSA archive (Fig. 5.63). Listed as photo-editor was Edwin Rosskam (1903–1985), a photographer hired as an exhibition designer at the FSA, who also worked with Stryker to promote the use of the agency's images in publications.

The winnowing of the archive for images by different photographers, and the recaptioning of the pictures for *Twelve Million Black Voices*, have been questioned by critics. Foreshadowing reactions to *The Family of Man* show (see pp. 312–314), commentators claimed that reprinting works in a different context turned "what was news into history, what was propaganda into art, or vice versa, altering the relation of the photograph to actuality, confounding hopes for a single, authoritative, stable meaning."[82]

TRANSFORMING THE SOCIAL DOCUMENTARY

Although socially concerned documentary was prominent throughout the 1930s, most photographers were not creating work intended to kindle social change. In fact, like experimental photography, the documentary look became an apolitical visual style. Around the United States, newspapers sent their photographers into the countryside to bring back FSA-like photographs, safely shorn of any social welfare propaganda. The WPA funded American photographer Berenice Abbott to depict the growth of New York City. Her four-year project resulted in the book *Changing New York* (1939) (Fig. 5.64). Abbott typified the New Woman of the 1920s.

Wright addressed *Twelve Million Black Voices* to whites, using the word "you" from the outset, and he deliberately identified with other African-Americans, using "we" and "us" throughout the text.

We answer: "Our problem is being solved. We are crossing the line you dared us to cross, though we pay in the coin of death!"

The seasons of the plantation no longer dictate the lives of many of us; hundreds of thousands of us are moving into the sphere of conscious history.

We are with the new tide. We stand at the crossroads. We watch each new procession. The hot wires carry urgent appeals. Print compels us. Voices are speaking. Men are moving! And we shall be with them. . . .

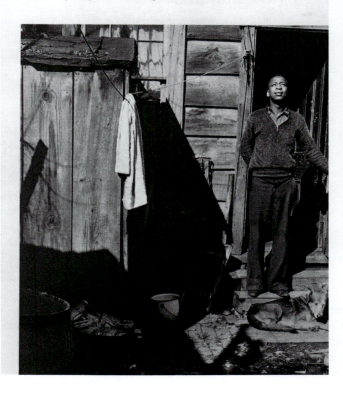

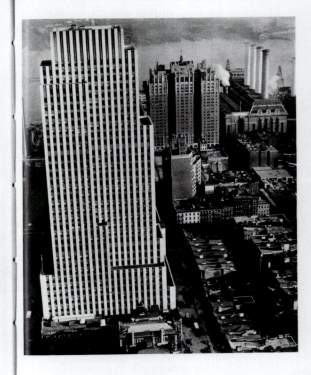

"Daily News" Building, 220 East 42nd Street, Manhattan; November 21, 1935. Completed: February, 1930. Architects: Howells, Hood & Fouilhoux. Owned by News Syndicate Company, Inc.

● Three million circulation Sundays, one and three-quarter million weekdays — more than double that of the next largest American newspaper — this is the DAILY NEWS. Such revenue made possible "The House that Tabloid Built," the DAILY NEWS Building, a 36-story skyscraper, costing $10,000,000.

142

5.65
EUGÈNE ATGET, *Café, Avenue de la Grande-Armée,* 1924–25. Silver print from glass negative. Gilman Paper Company Collection, New York.

Atget specialized in architectural photographs of old Paris; he also developed a personal system to record other visual subjects, including street vendors, storefronts, and gardens. His unpeopled photographs of Paris dwell on older neighborhoods and established ways of life.

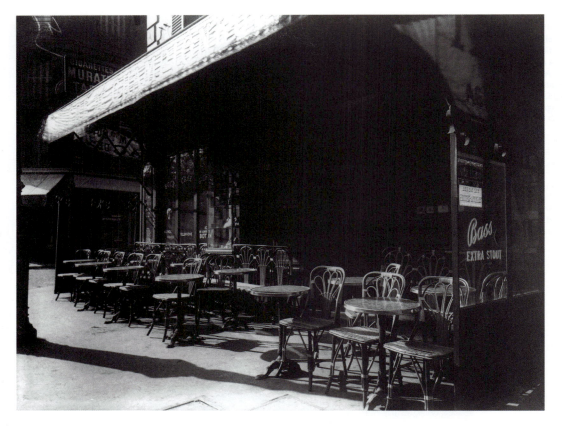

At twenty years of age, she had moved from Ohio to New York City, where she studied sculpture and met avant-garde artists such as Duchamp and Man Ray. Attracted to the bohemian life of Paris in the 1920s, she worked in the city as a studio assistant to Man Ray from 1924 to 1926, during which time she also co-invented the expressive use of solarization in photography.

While in Paris, Abbott also studied with Eugène Atget (1857–1927), a photographer who roamed Paris and its environs, producing about 10,000 prints in the early twentieth century (Fig. 5.65). Using a box camera and glass negatives, Atget resisted the then-fashionable Pictorial photographic style, and compiled clear objective images, which he called "documents." The Paris Surrealists found Atget's "documents" unsettling and evocative, and briefly put the reluctant Atget forward as an instinctive voice for their philosophy. By contrast, Abbott admired his methodical approach. After his death, she acquired Atget's images, which in time became part of the collection at New York's Museum of Modern Art.

American photographer Doris Ulmann (1882–1934), who learned some of her skills from Hine (see p. 208) at the Ethical Culture School,

also took classes with the Pictorialist Clarence White (see pp. 179–80). Melding their interests, she used an old-fashioned glass plate camera and tripod to put the grainy, slightly out-of-focus Pictorialist approach in service of American portrait studies (Fig. 5.66). Like the pre-World War I photographers

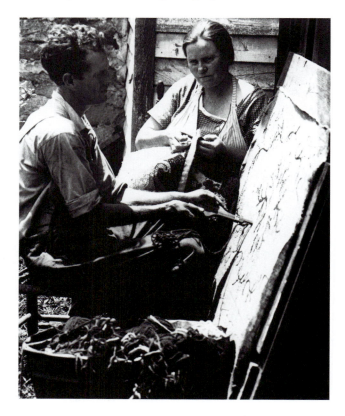

**5.66 (right)
DORIS ULMANN,** *Mr. and Mrs. Anderson,* Saluda, North Carolina. Platinum print.

PORTRAIT
August Sander

The detached approach to subject-matter favored by European New Objectivity (Neue Sachlichkeit) artists and what might be called "the archival tendency" came together in the haunting images produced by German photographer August Sander (1876–1964). While running his own commercial studio, he began making portraits of farmers in the rural Westerwald area of Germany, which spurred him to plan a systematic portrait gallery of occupational types, beginning with farmers, continuing through the industrial jobs, the professions, the arts, and ending with unemployed and disabled people. He planned to have forty-five portfolios, each consisting of twelve related images that would be collectively called *People of the 20th Century*. Sander was not unique in preparing a survey of the German people. As a post-World War I morale booster, perhaps, books containing a panoply of German portraits came into fashion during the 1920s.[83] Sander's plan extended the encyclopedic urge of nineteenth-century photography (see, for example, Chapters 3 and 4) into the twentieth century.

During decades of shooting, Sander used a set formula reminiscent of early photography. His usual method was to take sharp full-length or half-length portraits of subjects, posed with props and garments suggesting their work (Fig. 5.67). Most of his images show that he arranged his sitters, carefully focusing so that facial characteristics were distinctive, even unique. The relationship of the figure to the surroundings in his work is novel—a process of distance and isolation that unmasks qualities in the subjects, such as their relationship to others. This was a Modernist project, at least as it was understood by whole generations of photographers who came afterwards.

Sander's technique—and moments of humor—sometimes undermined the emotionally detached scheme he had in mind. He was not interested in the odd angles and cameraless photographs of the German experimentalist photographers, and he renounced both his youthful infatuation with Pictorialism and the casual spontaneity of the snapshot. Instead, he insisted on three guiding concepts:

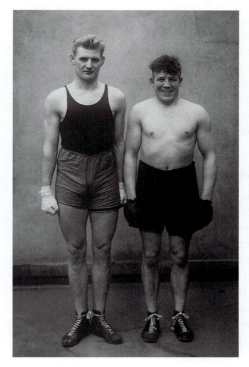

5.67
AUGUST SANDER, *Boxers Paul Roderstein and Hein Heese*, Cologne, 1929. Gelatin silver print. August Sander Archive, Cologne, Germany.

"See, observe, and think correctly!"[84] Although the immense project was never completed, Sander did publish sixty photographs in *Antlitz der Zeit* (*Face of the Time*) (1929). He also gave a pioneering series of radio lectures in 1931 on the history of photography.

In 1936, after the Nazi party came to power, remaining copies of *Face of the Time*, along with the printing plates used to produce them, were destroyed by order of the Government Bureau of Fine Arts. Sander's images showed how, in reality, many German people did not have the "Aryan" facial features and physiques promoted by the Nazis as the infallible marks of the German race. Moreover, his series ended with unemployed and disabled people—the very types the Nazis first targeted for removal to "purify" the Aryan race. After World War II, Sander added photographs of political prisoners and persecuted Jews to his work *People of the 20th Century*. He continued to work after the war, although wartime bombing was responsible for the destruction of his studio and a postwar fire that destroyed about 30,000 negatives.

Sander did not live to see the enormous influence his work and ideas would have on late twentieth-century photography. His detachment from the subject, coupled with his urge to create comprehensive series, fed the imaginations of Bernd and Hilla Becher in their ongoing sequences of antiquated technological structures (see Fig. 6.87). Through the Bechers, many prominent German contemporary photographers, such as Andreas Gursky (see p. 394), adopted photographic objectivity as a visual stance in relation to the built environment. Sander's work has been a touchstone of past and present international conceptual artists, who have investigated the qualities peculiar to photography, such as how far a subject is placed from the camera. Indeed, his images have nourished the notion that physical distance is an effective visual metaphor for psychic remove.

5.68 (right)
ERNST THORMANN,
Cover of *Der Arbeiter-Fotograf (The Worker Photographer)*, November 1929.

Ernst Thormann (1905–1985) focused on street vendors, the unemployed, the poor, and outcasts such as this gypsy child.

of Native Americans, from time to time Ulmann asked her subjects to wear old-time costumes and to pose with homestead equipment, like spinning wheels, which they did not and could not operate.[85] Contrary to her intentions, her Appalachian photographs were sometimes used by anti-immigration groups maliciously to contrast images of early settlers' perseverance and ingenuity with what they believed to be the indolence of immigrants.

WORKER PHOTOGRAPHY

In Europe and Russia during the 1920s, left-wing groups calling themselves worker-photographers organized to combat what they identified as "bourgeois picture-lies" about working conditions and attempts to organize protest movements.[86] Their concern to combat deceptive press images attests to the power of the illustrated newspapers and magazines as display cases for political ideas.

Like the sports and hiking clubs organized by the Communist Party to motivate workers, photography groups aimed to raise consciousness through picture-taking. Willi Münzenberg, the German publisher who founded *AIZ* (see p. 239), had his periodical carry photo-reports by workers, as well as being read by them. He also issued *Der*

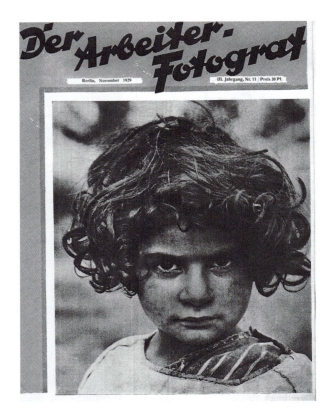

Arbeiter-Fotograf (*The Worker Photographer*), the journal of the German worker-photography association, which sought to instruct its readers how to make images with a "class eye,"[87] and to break down the customary distinction between the producer and consumer of mass-media images (Fig. 5.68). Often anonymously, camera-carrying workers

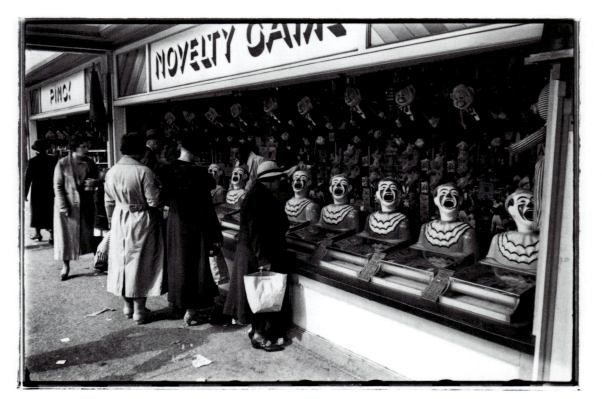

5.69
HUMPHREY SPENDER, *Midway Clowns,* Blackpool, 1937. Gelatin silver print. Bolton Museum and Art Gallery, England.

Spender made a documentary series of images in the north of England, showing life among the working class. He mixed the sharp, angular style of the picture press with a Surrealist's sense of the uncanny, as in this image of a fairground stall.

captured protest rallies and strike actions. They photographed workers' families, but were rarely successful in infiltrating factories to make images of hazardous conditions.[88] The worker-photographers brought their class eye to bear on Renger-Patzsch's book *The World is Beautiful* (see p. 269), claiming that the world was ugly and evil, and in need of change.[89] At the same time, artists such as Grosz and Köllwitz were criticized for making the condition of the workers seem too hopeless.[90]

Worker-photographer groups were also started in Holland, Belgium, and Britain.[91] A popular theme was a day in the life of an individual or a city. This was taken up in Britain by Mass-Observation, or M-O, a group that simultaneously targeted false mass-media images of workers and the middle class, and images promulgated by out-of-touch academic sociologists and self-interested government officials. They published *May the Twelfth*, containing written accounts of a day in the life

of over 200 observers. On this day— May 12, 1937—King George VI (1894– 1952; r. 1936–52) was crowned, ending the crisis that arose when Edward VIII abdicated the throne the previous December. M-O's intent in *May the Twelfth* was far from the simplistic "where-were-you-then" motif. The group hoped to undermine faith in government, by showing that it did not communicate with the people about the impending abdication. At the same time, M-O wanted to skewer British psychological reliance on the monarchy, exposing the operation of a modern myth. M-O gathered full and part-time writers, painters, poets, and local people to produce an "anthropology of ourselves."[92] Humphrey Spender (b. 1910), a photographer for the *Daily Mirror*, also shot for M-O. He traveled to the gritty towns of England's northern industrial areas, building a trove of about 900 images, most of which were not published due to the expense involved (Fig. 5.69).

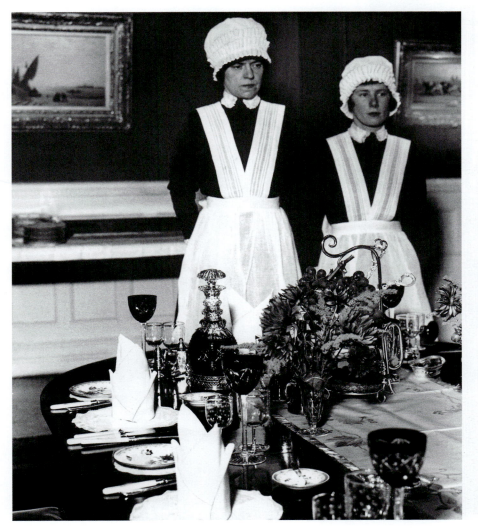

**5.70
BILL BRANDT,
Parlormaid and Under-Parlormaid Ready to Serve Dinner, 1932–35.
Gelatin silver print. Bill Brandt Archive, London.**

The two servants here are ready to attend at a lavishly set table. Their starched aprons and stiff poses resemble the folded napkins in the foreground. The taller woman's stern expression is set off by the anxious expression of the underling. The scene's implicit drama—the sense that something is about to happen—may owe to Brandt's infatuation with Surrealism.

Although he did not work for M-O, German-born and educated Bill Brandt (1904–1983) took up a similarly anthropological form of documentary when he settled in London in 1932, after studying with Man Ray in Paris. Two books of photographs, *The English at Home* (1936) and *A Night in London* (1938), examined British life, particularly its class system and behavior. Brandt's point of view is evident in the interpretive strategies he used in these books. His *Parlourmaid and Underparlourmaid Ready to Serve Dinner* (1932–35) (Fig. 5.70) is full of astute social observation.

Despite its name, the Workers' Film and Photo League, founded in New York in 1930, was not a working-class organization, but a group of filmmakers and photographers committed to depicting urban life, especially in poorer neighborhoods, and to keep a supply of class-conscious images available for left-wing publications. The filmmakers and photographers soon split into two groups, and the word "worker" was dropped from their titles. Members of the Photo League included W. Eugene Smith (1918–1978), who once served as president, and Jerome Liebling (b. 1924), whose two years spent with the League anticipated his lifelong career in humanistic documentary work (see p. 421). The Photo League offered lectures, classes, and cooperative ventures. While working for *Fortune* magazine, Bourke-White and Abbott attended meetings of the New York branch.[93]

Among the League's undertakings were "production groups," like-minded photographers interested in experimentation, or in such themes as contemporary youth and neighborhood life. Under the direction of Aaron Siskind

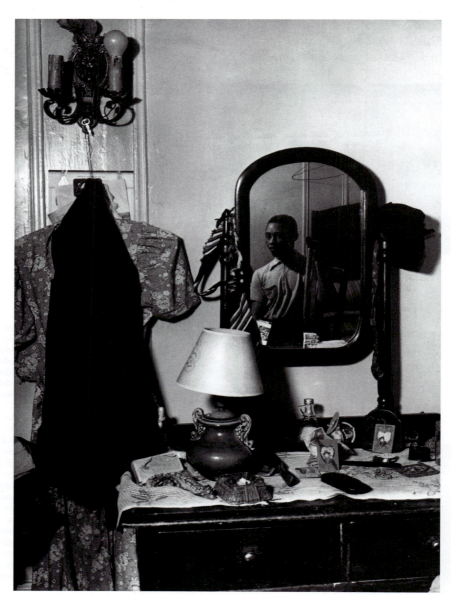

5.71
AARON SISKIND, *Reflection of a Man in a Dresser Mirror*, from *Harlem Document*, c. 1938. Gelatin silver print. George Eastman House, Rochester, New York.

From 1938 to 1940, the Features Group was the most publicly visible of the various project-oriented teams at the Photo League. Originally planned as a book, some of the pictures from the *Harlem Document* appeared in *Fortune* magazine, and were exhibited at the 1939 San Francisco World's Fair.

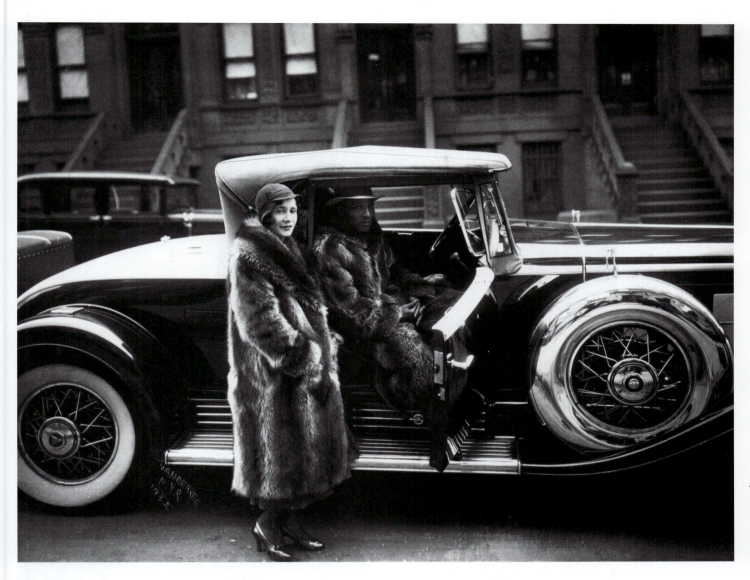

(1903–1991), the so-called Feature Group worked on the Photo League's most widely recognized project, the *Harlem Document*, containing pictures of the area's poor and a text composed by African-American sociologist Michael Carter[94] (Fig. 5.71). The Photo League was harassed by the FBI for seven years, beginning in 1940; it finally disbanded in 1951, after its listing as a subversive Communist front organization in 1947 made it difficult to continue.

While the Photo League was working on its *Harlem Document*, a different, generally more upbeat, Harlem document was being informally created by other image-makers. The work of James Van der Zee (1886–1983), a popular portraitist and street photographer, was steeped in nineteenth- and early twentieth-century devices, including extensive props and elaborately painted backgrounds. As historian Deborah Willis observed, his photographs of middle-

class African-American life often suggest that the postwar mass movement of blacks from the South to take factory jobs in northern cities was a success (Fig. 5.72). Like Van der Zee, Marvin (b. 1910) and Morgan Smith (1910–1993), twin brothers who ran a popular Harlem portrait studio, recorded social affairs and political events, and captured the beginnings of the Civil Rights movement in their pictures of the campaign "Don't Buy Where You Can't Work." At the same time, Carl van Vechten, the first American critic of modern dance, wrote for the *New York Times* in the era when Isadora Duncan was choreographing creative rebellion in that field. He promoted black artists and writers, and photographed his large circle of acquaintances ranging from poet-playwright Langston Hughes (1902–1967), to publisher Alfred A. Knopf (1892–1984), and the painter Georgia O'Keeffe (Fig. 5.73).

5.72
JAMES VAN DER ZEE,
Couple in Raccoon Coats, **1932. Gelatin silver print.**

Van der Zee made portraits and photographed the social activities and aspirations of the black middle class. Here a prosperous couple wearing fashionable raccoon coats display their late-model Cadillac.

**5.73
CARL VAN VECHTEN,**
Georgia O'Keeffe,
June 5, 1936. Library of
Congress, Washington,
D.C.

Carl van Vechten was a
writer and critic whose
serious hobby was pho-
tography. He amassed
an archive of about
1,500 celebrity photo-
graphs, including this
striking image of the
American artist Georgia
O'Keeffe, whose portrait
he cleverly composed
using angular shadows
reminiscent of her
paintings.

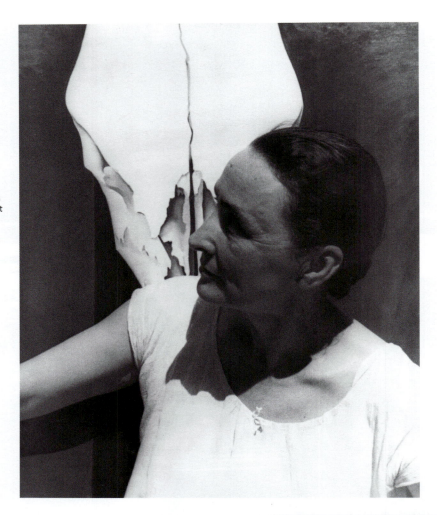

**5.74 (below)
LAURE ALBIN-
GUILLOT,** *Diatom,*
from *Micrographie
Décorative,* pl. xviii, by
Laure Albin-Guillot,
1931. Photogravure.
George Eastman House,
Rochester, New York.

POPULAR SCIENCE

At the 1937 Museum of Modern Art
exhibition of photographic history, the
first such comprehensive show in the
United States, curator and historian
Beaumont Newhall (1908–1993) pre-
sented samples of photojournalism,
sports photography, film stills, and
aerial photography, as well as an array
of art photography, organized histori-
cally. He also included scientific photog-
raphy, not simply to record technical
advances in that area, but also to display
the aesthetic appeal of forms and
processes revealed through scientific
procedures. From *Micrographie décora-
tive,* a 1931 portfolio of photogravures
by French scientist Laure Albin-Guillot
(1879–1962), Newhall chose a micro-
scopically enlarged view of a diatom (a
form of single-celled alga), showing its
ornate symmetrical design (Fig. 5.74).
Newhall did not, as later postmodern
critics have suggested, wrench a scien-
tific image from its original context and
force it into an aesthetic category so that
it could function as a museum display.

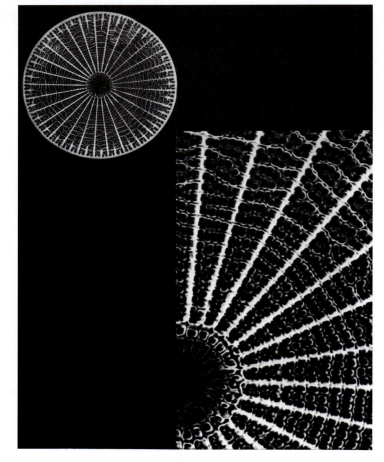

Zwei Welten ...

● Die Haut verbindet den Makrokosmos
mit dem Mikrokosmos. Sie ist die Berüh-
rungsfläche beider Welten.

Von der Verhaltungsweise der Haut hängt weitgehend
ab, ob die Gewalten des Makrokosmos sich nützlich
oder schädlich auf den Mikrokosmos auswirken. Die
Haut muß also stets gesund und voll lebendiger Spann-
kraft sein. Der beste Weg, diese Spannkraft zu erhalten
und zu stärken, ist die äußerliche Zufuhr von Aufbau-
stoffen, wie sie im Eukutol 3 enthalten sind.

Denn **Eukutol 3** liefert der Haut:

● den Aufbaustoff Cholesterin,
● das hauterneuernde Regenerationshormon,
● die hautschützenden sauren Mineralstoffe.

Grüngoldene Dose RM 2.15, große Tube RM 0.90, halbe Tube RM 0.45

Albin-Guillot had already enlarged the meaning of this type of photography with her choice of title and her selection of pictures.

The artistic and popular appreciation of scientific images owed much to the spread of illustrated magazines and journals aimed at a general audience, as well as the development of textbooks with photographically derived images. Even advertising utilized images drawn from science (Fig. 5.75). Theorists such as Moholy-Nagy encouraged viewers to look at X-rays, which were also included in the Newhall show, not as medical information, but as a remedial kind of new vision. At the 1929 *Film und Foto* exhibit, influenced by Moholy-Nagy's ideas, scientific photography was divided into three sections: documentation; research in photographic process; and expansion of the senses, a category more about seeing than about scientific knowledge.[95]

In the late 1930s, Berenice Abbott (see p. 290) began experiments with scientific photography. By the early 1940s, she saw the need to invent a visual recording system, called "Projection Photography" or "Supersight," which

**5.75 (left)
DESIGNER UNKNOWN, "Zwei Welten ..." (Two Worlds). Advertisement for Eukotol Skin Cream in *Münchner Illustrierte Presse*, no. 5, January 31, 1932, p. 105. Institut für Zeitungsforschung, Dortmund, Germany.**

**5.76
BERENICE ABBOTT, *Light Rays Through a Prism*, Cambridge, c. 1958. Gelatin silver print. New York Public Library, New York.**

Abbott invented several devices and techniques for scientific photography. This image, typical of her scientific illustration, clearly shows three properties of light as it passes through a prism. The rays are reflected in the glass, but also bent or refracted on the left and right, as they pass through the prism.

allowed the user to project and enlarge subjects on a 16" × 20" piece of film or paper.[96] When she became photography editor of *Science Illustrated*, she carefully selected views that explained scientific principles to lay readers. Her interest in scientific education continued throughout the 1950s, when she worked with a commission of scientists and teachers to improve the illustrations of science textbooks (Fig. 5.76).

After he escaped the Nazi campaign of terror against the Jews, Roman Vishniac (1897–1990) emigrated to the United States in 1940. Vishniac, who was a physician, microbiologist, and Ph.D. art historian as well as a photographer, added photomicrography to his skills, primarily to make a living. He specialized in depicting small living organisms, and wrote and lectured on the hidden beauty revealed by the microscope.

But in the public's mind, it was Harold Edgerton (1903–1990) who was most closely associated with demonstrating the beauty of scientific photography. His early work in the 1930s, taken with the STROBE lighting system he helped to invent, was a fixture in *Life* magazine, and appeared in books marketed to lay readers, such as *Flash! Seeing the Unseen by Ultra High-Speed Photography* (1939), and in short movies such as *Quicker Than a Wink* (1940), which won an Oscar. The 1937 Museum of Modern Art display exhibited Edgerton's crowd-pleasing stop-action image of the crown-shaped splash made by a milk drop as it hit the surface of the liquid (Fig. 5.77). Edgerton perfected strobe lighting throughout the 1930s by synchronizing intense but short bursts of light with turning engine rotors. In 1939 he began working with the military, developing the lighting necessary for night-time aerial photography, a technology that won him the Medal of Freedom in 1946.

WORLD WAR II

While German photographer Alfred Eisenstaedt (1898–1995) was working for the Associated Press, he photographed Joseph Goebbels, the Nazi party's chief propagandist who became the National Minister of Propaganda, at

the 1933 League of Nations Assembly in Geneva, Switzerland (Fig. 5.78). In that year, the Nazis required that all German photographers register with the government, a move that broke the worker-photography movement and sent *AIZ* into exile in Prague, Czechoslovakia. From the mid-1920s, Hitler's rise to power was orchestrated by the German illustrated press, which was increasingly controlled by Berlin's Ministry of Propaganda. Heroizing photographs of Hitler, montaged over pictures of the vast political gatherings the Nazi party staged, carefully portrayed him as a powerful, popular leader. Two volumes of photographs taken by Hitler's favorite photographer, Heinrich Hoffmann (1885–1957), showed him not only as a political figure, but also as a simple man of the people, reading the newspaper, talking with farmers, and pondering the wonders of nature.[97]

From 1933 on, as the Nazis fomented an atmosphere of race hatred and scapegoating, Jewish people were characterized as lazy and slovenly in print and in press photographs. Boycotts of Jewish

**5.77
HAROLD EDGERTON,
*Drop of Milk Splashing
into a Saucer of Milk*,
1936. Stroboscopic
photograph. Palm
Press, Concord,
Massachusetts.**

Perhaps the best-known photographer to produce images both for science and for public enjoyment, Edgerton also invented ways to use strobe lighting for wartime uses of photography. To make the picture of the milk drop, he perfected a strobe that could blast light at one-millionth of a second.

shops were encouraged by notices proclaiming, "Jewish business! Anyone shopping here will be photographed."[98] From 1935 to 1938, the Russian photographer Roman Vishniac, then living in Berlin, frequently worked with a concealed camera picturing eastern European Jewish life. Vishniac traveled to Poland, Russia, Hungary, and Romania on behalf of the American Jewish Joint Distribution Committee, making pictures that could assist their money-raising efforts to aid poverty-stricken Jewish communities (Fig. 5.79).

**5.78
ALFRED EISENSTAEDT,** *Joseph Goebbels,* **1933. Gelatin silver print.**

Eisenstaedt's riveting image of the Nazi Propaganda Minister, Joseph Goebbels, shows him with a menacing expression and claw-like hands. As Eisenstaedt recalled later, "He looked at me with hateful eyes and waited for me to wither. But I didn't wither. If I have a camera in my hand, I don't know fear."

**5.79
ROMAN VISHNIAC,**
Boy with Earlocks, **1937.**
Gelatin silver print.

Institute of Design, in Chicago. Roman Vishniac also came to America, where insufficient English kept him from practicing medicine, so he went on to do photomicrography. Erich Salomon got as far as Holland, where a Dutch Nazi betrayed him. He and his whole family died in Auschwitz.

When the war broke out in Europe in 1939, correspondents and photographers were sent there, sponsored by publications and photoagencies. As in World War I, war photography was censored. For example, Bourke-White's images were often printed as contact sheets (rows of small, negative-size images on photographic paper) and reviewed by military censors before being sent to *Life* magazine. Some photographs were sent by radio transmission, but most, with captions written by the photographer, were physically transported by the military. Photographers often had to form pools, meaning that photographs by any one of them could be used by all of them. The practice reduced the number of photographers

**5.80 (below)
JOHN HEARTFIELD,**
Durch Licht zür Nacht
(*Through Light to Night*), **May 19 1933.
Photographic collage.
Akademie der Kunst, Berlin.**

In his photomontages for *AIZ*, Heartfield criticized Nazi practices. In this image, he shows Propaganda Minister Joseph Goebbels ordering a book-burning. In the background is the former German parliament building, the Reichstag.

By the time war was imminent, Goebbels determined that there should be no independent media in Germany. Journalists, photographers, writers, film and radio producers, publishers, printers, painters, and poets were conscripted into the Propaganda Division of the Army.[99] The twisted logic of Goebbels's schemes was a favorite target of John Heartfield's (anglicized name of Helmut Herzfeld; 1891–1968) photomontage for *AIZ*. Heartfield, who had been one of the Berlin Dadaists, turned his talents to satirizing growing Nazi power (Fig. 5.80). A skilled designer of books and posters, Heartfield did not make his own photographs, but selected them from mass-media illustrations, or commissioned them from other photographers. His searing photomontages, which exposed the real effects of Nazi social policies on the ordinary citizen, appeared in *AIZ*. Rumblings of war, official censorship and persecution, and anti-Semitism sent many illustrious photographers in Germany into exile. In 1933, after *AIZ* was banned, Heartfield moved to Prague, and then to England in 1938. Moholy-Nagy came to the United States, where he founded a new Bauhaus (1937), soon renamed the

in the field and eased the work of censors. The huge improvement in cameras and film since World War I allowed soldiers from all sides to make snapshots and send them back home, although these, too, were supposed to pass through the censors' hands. By using handmade pinhole cameras and smuggled film, secret photographs were made by wily American prisoners of war in German camps.

For the Allied troops, motion picture studios issued millions of free celebrity images, including so-called pin-ups of popular stars such as Rita Hayworth and Betty Grable. The military trained photographers to accompany units, and aerial photography, some done by the naval

aviation unit under the command of Captain Edward Steichen (see p. 186), accounted for about 85 percent of the Allied information on the enemy.[100]

To avoid disclosing information the enemy could use, and because the 1930s documentary emphasis on individuals and typical days persisted, newspapers and magazines stressed the personal encounter with war far more than in World War I. Stationed in the Pacific, American photographer W. Eugene Smith managed to get so close to the action that he was seriously wounded on the island of Okinawa in 1945. His pictures centered on the physical and emotional experiences of soldiers at the front line (Fig. 5.81). *Life* magazine fought the

5.81
W. EUGENE SMITH,
U.S. Marines with a Wounded and Dying Infant, June 1944.
Gelatin silver print.

Smith's photographs emphasized the individual soldier's experience of conflict, helping the viewer relate to being in a foxhole or under fire. This image shows a wounded Japanese infant found by marines during bitter fighting on the island of Saipan. Smith's point of view influenced the photography of the Korean and Vietnam wars.

government to show the American wounded and dead, though not with the explicit horror accorded the enemy dead, especially the Japanese, who were also frequently the subject of racial caricature in print and in cartoons. The United States kept a secret file of ghastly war photographs, called "The Chamber of Horrors," in the Pentagon.[101]

The Museum of Modern Art staged large photographic exhibits to support the war effort. Two such shows, both curated by Steichen, were immensely successful with the public. *Road to Victory* (1942) used many RA/FSA photographs, updated and recaptioned from Depression themes to such patriotic slogans as "War—they asked for it—now, by the living God, they'll get it."[102] Designed by Bayer (see pp. 253, 270), who emigrated to the United States in 1938, *Road to Victory* used the exciting

shaped-space concepts of European experimental photography installations. The visual strategies that Bayer had used to promote the Nazi party were thus turned against them. Steichen's second show, *Power in the Pacific* (1945), utilized images from the United States Navy, whose photographic unit he had himself directed.[103]

At the end of the war, when troops entered the concentration camps where Jewish and other prisoners worked and died, photographers recorded the grim scenes. At Buchenwald, Bourke-White pictured the charred remains of victims and the shrunken bodies of living skeletons. Lee Miller (1907–1997), the photographer who had developed solarization with Man Ray, was a member of the London War Correspondents Corps, and later an accredited correspondent with the U.S. Forces. She, too, defied the

5.82
LEE MILLER,
Buchenwald, **April 1945. Gelatin silver print. Lee Miller Archives, Chiddingly, East Sussex, England.**

During World War II, Miller, who had turned her talent in fashion photography to recording the effects of the Blitz, or air war, in London, was among the first photographers to depict the horrors of Nazi concentration camps at Dachau and Buchenwald.

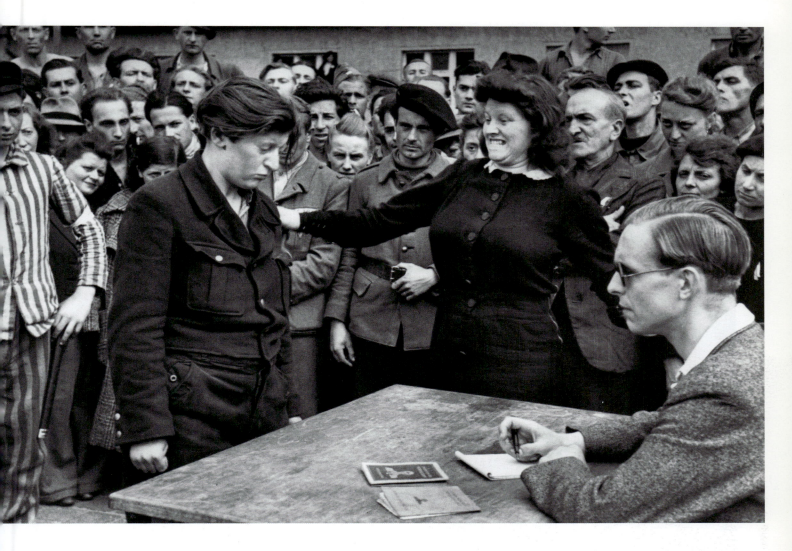

prevailing notion that women were too emotionally delicate to face the horrors of extermination camps. Her unsparing photographs at Buchenwald catalog the means of annihilation, and the lives of those who survived (Fig. 5.82).

Henri Cartier-Bresson was captured by the Germans during the war and imprisoned. He escaped and joined the French Resistance. After the war, he recorded the reaction of French people to those among them who had aided the Nazis. In this image he sought the decisive moment that told the story of the denunciation of a French Gestapo informer (Fig. 5.83).

PHILOSOPHY AND PRACTICE: THE "COMMON MAN" AND THE END OF MEDIA UTOPIA

In his much-cited 1936 essay "The Work of Art in the Age of Mechanical Reproduction," critic Walter Benjamin argued that the proliferation of photo-mechanical reproduction marked one of history's watershed moments. For the masses, he forecast that reproducibility would be truly revolutionary. In the end, it would "pry an object from its shell . . . [and] destroy its aura."[104] Thus removed from "the fabric of tradition," photographically reproduced and widely distributed pictures of once class-bound objects would become strategic elements in fomenting social change among the masses who could witness at first hand the decline of privilege in their new access to art reproduction. Benjamin's hopes for the mass media were echoed throughout European experimental photography, especially in Germany.

As historian Maud Lavin summed up, "the burning issue for the German avant-garde from 1922 until Hitler's seizure of power in 1933 was not at all a rebellion against art institutions, but rather a serious and prolonged engagement with mass culture."[105] Similarly,

5.83
HENRI CARTIER-BRESSON, *Gestapo Informer*, Dessau, Germany, 1945. Gelatin silver print.

Cartier-Bresson chose the precise moment in which a French Gestapo informer is denounced. The apparent glee of the accuser is matched by the emotions of anger, scorn, or disbelief etched on the faces of the assembled crowd.

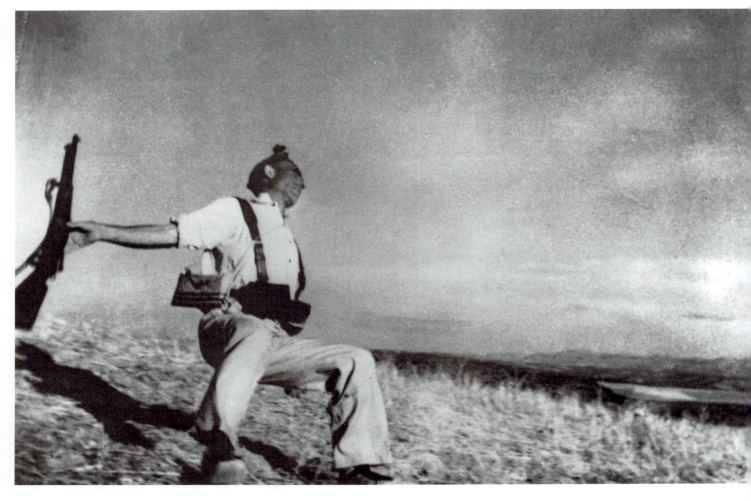

**5.84
ROBERT CAPA,** *Death of a Loyalist Soldier,* **Spain, 1936. Gelatin silver print.**

In Capa's image, a lone anti-fascist soldier pitches backwards at the instant bullets seem to rip through him. Published in *Vu* in September 1936 and *Life* in July 1937, it propelled its maker into international celebrity. The circumstances in which he took the picture, however, have been disputed for fifty years.

American documentary photographers thought their images were self-validating, needing only wide exposure in the press to change the hearts and minds of the people.

Benjamin was wrong about the special aura that unique objects have. Far from destroying the aura, art reproductions served to increase it. Photographs of Leonardo da Vinci's *Mona Lisa* roused people to want to see the original. Oddly, photographic reproducibility sometimes destroyed the aura of the original photograph. For example, the many thousands of people who cut out and saved press pictures of Dorothea Lange's *Migrant Mother* thought they had the original, because it was the very one that affected them.

Written from a left-wing perspective, Benjamin's essay is typical of international writing in the 1930s in its concern for what was alternately called "the people," "the masses," "ordinary humanity," and "the common man." Notions of progressive social change aimed at the common man sustained photographs in such divergent styles as those done

by the Russian experimental photographers and those published by the FSA. The immense brutality and destruction of World War II, and the advent of the atomic bomb, withered a great deal of faith in the future of the human race. At the same time, the dissolution of experimental photography into commercially viable styles, and the control of visual media by large corporations and news agencies, dampened belief in the inherently revolutionary nature of camerawork.

One mark of the waning faith in photography, which became widespread after World War II and continues today, is the repeated inquiry into the authenticity of the documentary photographs that emerged as icons of the war experience. The twentieth century's most famous war photograph, *Death of a Loyalist Soldier* (Fig. 5.84), was taken by the Hungarian-born photographer Robert Capa (1913–1954). This moment-of-death image purportedly shows an incident during the Spanish Civil War (1936–39), a conflict between a coalition of leftists called loyalists, and the

fascists, led by General Francisco Franco. The war inflamed much debate in Europe and America. However, stories that the image was not made by Capa, or that the death was staged, were rumored immediately after World War II, and came to wide public inspection in Phillip Knightley's 1975 book *The First Casualty*.[106] The issue and its evidence have been passionately discussed ever since, with no clear resolution.

Part of the controversy has to do with Capa's professional and popular reputation. His statement that "if your pictures aren't good enough you're not close enough" became the dictum for subsequent generations of war and adventure photographers. Less well-known, but still a guideline for photographers, photo-editors, and the public, was his observation on the slight blur in *Death of a Loyalist Soldier*: "if you want to get good action shots, they mustn't be in true focus. If your hand trembles a little, then you get a fine action shot." Ironically, another of Capa's celebrated images was also blurred—but by accident (Fig. 5.85).

Other famous World War II photographs have been similarly scrutinized. Joe Rosenthal's (b. 1911) picture of the raising of the Stars and Stripes on the Pacific island of Iwo Jima, another American icon, has been long rumored to be questionable[107] (Fig. 5.86). Indeed, the picture seemed staged to the editors at *Life* magazine, and they initially rejected it for publication. Perhaps the most widely reproduced war photograph, Rosenthal's *Iwo Jima* influenced Russian photojournalist Yevgeny Khaldei (b. 1917), who tried to emulate its composition and attract some of its renown when Berlin fell to the Soviet army (Fig. 5.87). In Europe and Russia, this image, thought not to be contrived in any way, was one of the strongest visual mementos of that conflict. Also often accused of being staged is Eisenstaedt's much-loved photograph of a sailor kissing a nurse in New York City's Times Square on V.J. day, when Japan surrendered and the war ended.

In the postwar phase of our age of mechanical reproduction, iconic

**5.85
ROBERT CAPA,** *Ed Regan, Veteran of Omaha Beach D-Day Landing,* **June 6, 1944. Gelatin silver print.**

Capa's images from the Normandy landings have been imitated in many war movies, including Steven Spielberg's *Saving Private Ryan* (1998). This shot of Allied soldiers coming ashore during the invasion that ultimately ended the war in Europe was blemished when a darkroom aide used too much heat and partially melted the film.

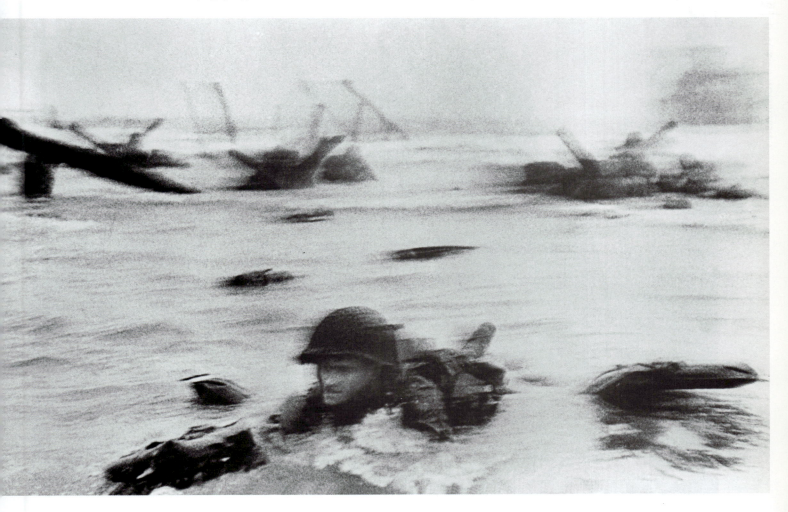

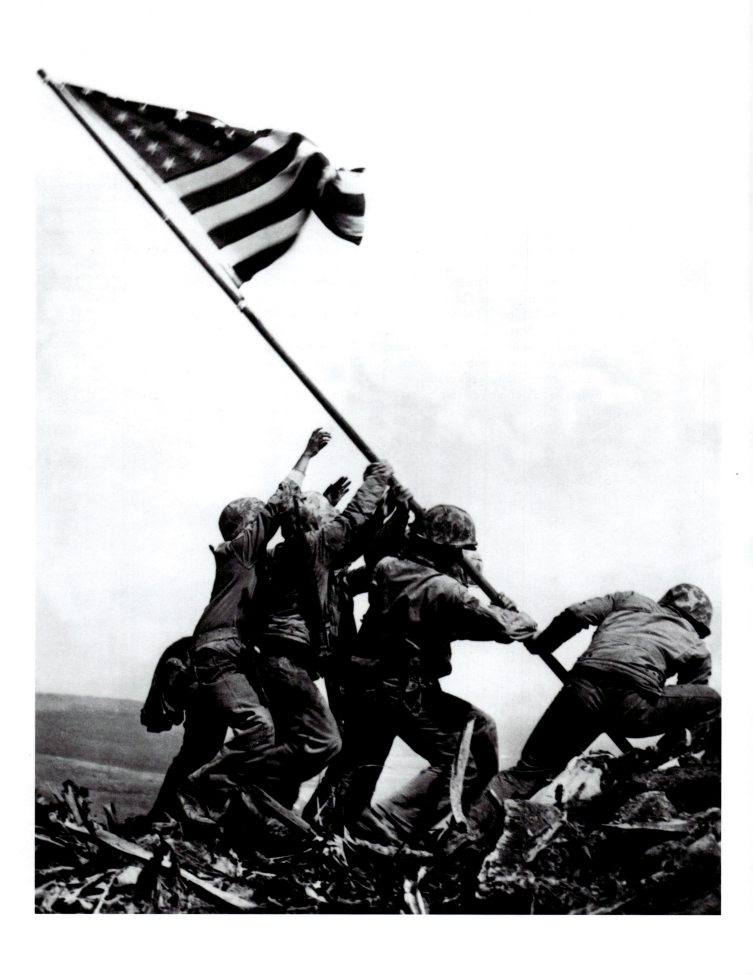

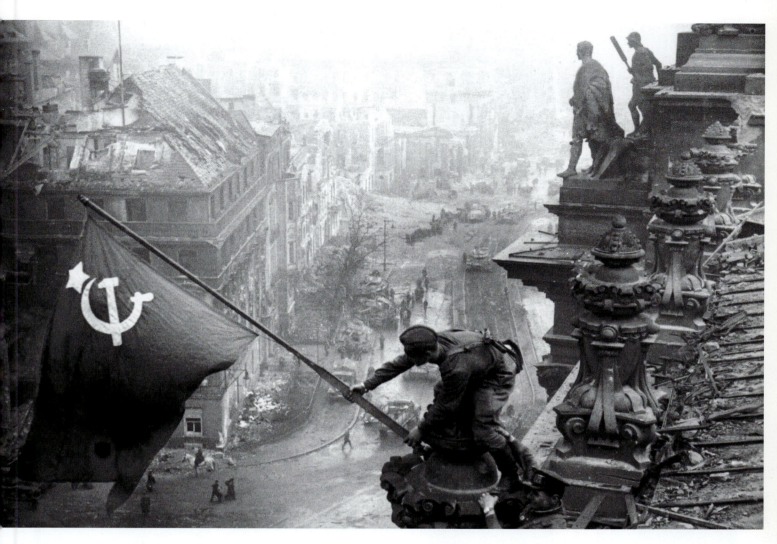

5.86 (opposite)
JOE ROSENTHAL,
*Marines Raising the
American Flag on Iwo
Jima — "Old Glory goes
up on Mt. Suribachi,"*
February 23, 1945.
Gelatin silver print.
Library of Congress,
Washington, D.C.

Rosenthal's image
became so popular that
it led to the making of a
movie in which the
scene photographed
was recreated. The
iconography of this
picture has persisted in
Western culture for
more than fifty years.
It was used in editorial
drawing to depict the
bravery of firefighters
and police at the time of
the attack on the World
Trade Center in 2001.

images have often been greeted with
suspicion. Almost a century earlier,
Alexander Gardner could openly
describe his staging of *Home of a Rebel
Sharpshooter* (see Fig. 3.21). By contrast,
war photographers such as Capa and
Rosenthal were unable to deflect doubts
that anyone can be lucky enough to be at
the right place at the right time to make

such powerful and well-composed sym-
bols. At the same time, the war years
had seen photography exploited to an
unprecedented extent by government
and the military on both sides to control
public opinion. Prized for its contribu-
tion to uniting nations during the war,
photography was far less certain of its
role in the postwar world.

5.87
YEVGENY KHALDEI,
Reichstag, Berlin, 1945.
Gelatin silver print.
Galerie Voller Ernst,
Berlin.

To make his version of
Rosenthal's famous
photograph (see Fig.
5.86), Khaldei rushed to
the blazing Reichstag,
the former German par-
liament building, with a
flag that he had his
uncle hurriedly make
from red tablecloths.
With the assistance of
three Russian soldiers,
he climbed to the roof,
positioned the flag, and
photographed the city
under Russian control.

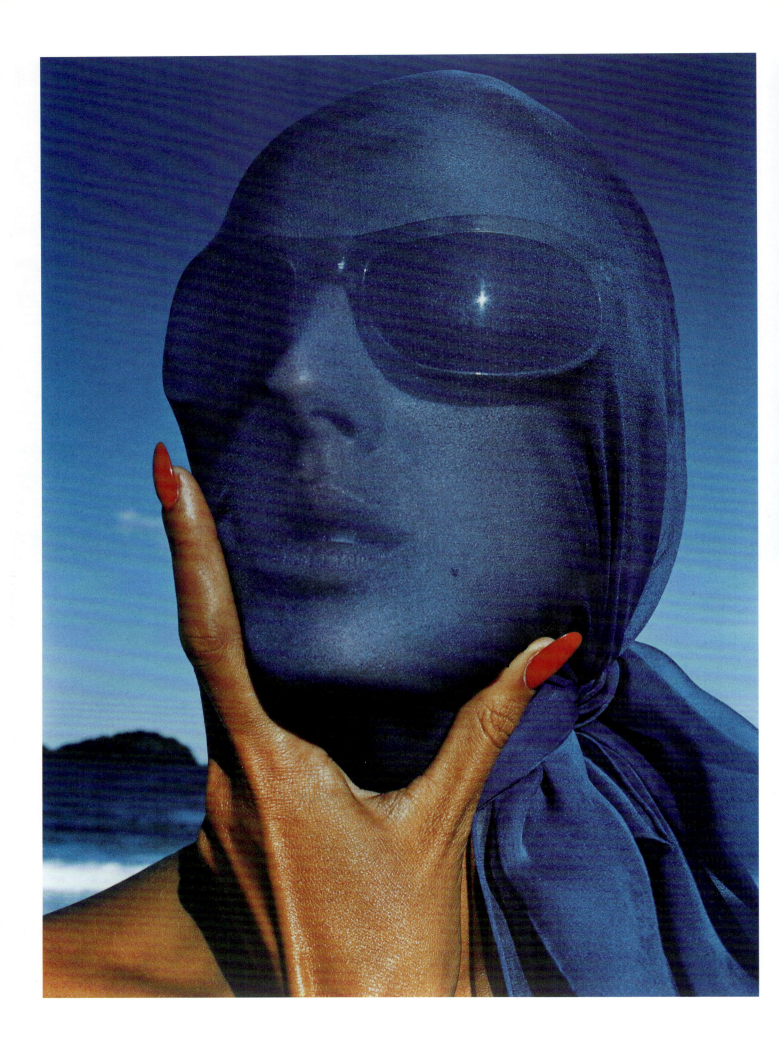

CHAPTER SIX

Through the Lens of Culture (1945–1975)

6.0
HIRO, *Tilly Tizzani with a Blue Scarf*, Antigua, 1963, from cover of *Harper's Bazaar*, May 1963. Victoria & Albert Museum, London.

Post-World War II magazine advertising quickly embraced color reproduction. In her fashion photography, Hiro tended to isolate figures and accentuate deeply saturated colors, all of which served to remove models from the real world.

While postwar Europe and Asia staggered under the loss of millions of people, coupled with economic devastation, the United States, which did not suffer physical damage on its mainland, emerged as the world's leading industrial and military power. By 1947, the relief and unity felt by the Allies after their victory in World War II had given way to a world polarized by what the American presidential advisor Bernard Baruch called the Cold War. Beginning in 1945, the Soviet Union established its influence among eastern European nations in the territories previously occupied by Nazi Germany. In addition, the Soviets administered eastern Germany, one of the four zones into which Germany was partitioned at the end of the war.

When the Soviet Union and the eastern European nations in its sphere of influence refused rebuilding funds under the Marshall Plan initiated by U.S. Secretary of State George C. Marshall, suspicion of Soviet long-term expansionist intentions rapidly spread in the West. Fired by the fear that its wartime ally wanted to spread communism throughout the world, and that the human misery of the immediate post-war period would make such a message attractive, the United States redoubled its economic aid to Europe and some Middle Eastern countries.

The ravaged condition of the European nations, and the surprisingly deep economic downturn of the postwar British economy, helped make the United States a superpower. America's exclusive possession of atomic weapons confirmed that position. In addition, the United States was the only postwar nation sufficiently prosperous to consider direct military and economic confrontation with communist countries. Fear of communism increased with the 1949 victory of Mao Zedong (1893–1976) in China, and mixed with nuclear fear when the Soviets exploded their first atomic bomb in 1949. In a 1946 speech, former British Prime Minister Winston Churchill (1874–1965) described an "iron curtain" dividing Europe: this seemed to come true in 1948, when the city of Berlin was cut off from the West by Soviet occupation forces, and supplies had to be airlifted to the city. Later, the Berlin Wall, built in August 1961, effectively isolated East Germany and the eastern European nations from the West.

THE FAMILY OF MAN

In 1955, a large photography exhibition titled *The Family of Man* was mounted at New York's Museum of Modern Art. The show proposed photography as a means through which the alarming tensions and uncertainties of the Cold War era could be seen in a wider context of human values, emphasizing the theme of common humanity against the destructive effects of political polarization and other forms of divisiveness. The exhibit reaffirmed a faith in humanity for an audience shaken by gruesome images of Japanese atomic injuries in *Life* magazine and troubled by the new specter of global nuclear war. It pleased the general public more than any previous photographic exhibition, and the book derived from it became the best-selling photographic book of all time.

Edward Steichen, who returned from his wartime duties (see p. 303) to head the museum's photography department, selected and organized the images according to universal themes, such as birth, work, and love. To generate the impression of global unison, Steichen homogenized the look of the individual photographs: cropped and shorn of their original titles, the exhibition prints were processed in a commercial lab, where their tonal values were harmonized. The prints were also transformed into poster-size images.

Steichen hoped that *The Family of Man* would illustrate "the essential oneness of mankind throughout the world." Aiming to highlight "human consciousness rather than social consciousness," he discarded images that demonstrated strong political and cultural differences.[1] The unity of humankind was stressed even during the planning stages of the show, and the Museum of Modern Art announced that it would open simultaneously in New York, Europe, Asia, and Latin America—a proposal that was never realized.[2] Steichen's utopian aspiration, in which supposed enemies and outcasts are revealed to share a common humanity, and national boundaries are ignored, should be seen against the background of hysterical anti-communism in early 1950s America and the equally shrill optimism of postwar consumer culture. The United Nations, founded in 1945, and its Universal Declaration of Human Rights, proclaimed in 1948, had offered a vision of the good society rising from the ashes of battle; Steichen's show underlined both the nobility and fragility of this vision.

To choose from among the 2.5 million photographs submitted, Steichen looked for "swiftness of seeing," the visual summing up of an idea in a single moment that formed the kernel of Modernist photographic practice familiar to audiences from nearly three decades of illustrated magazines and newspapers.[3] In the end, he selected about 500 images from 68 countries. As Jacob Deschin, camera editor of the *New York Times*, observed, *The Family of Man* was an "editorial achievement rather than an exhibition of photographs."[4] Steichen clustered untitled photographs around concise sayings drawn from cultures around the world. For motherhood, he chose the biblical phrase, "She is a tree of life to them ..." (Proverbs 3: 18); images of laborers carried a quotation of the ancient Hindu religious poem, the *Bhagavad-Gita*: "If I did not work, these worlds would perish ..."

Overall, his installation design owed its dynamic programming of ideas and emotions to the exhibition spaces created by Russian and German artists between the world wars (see pp. 243–54), but critics generally did not acknowledge these European precedents. Indeed, photographer Barbara Morgan (1900–1992) thought that the show was so original that it needed a new term, perhaps "photographic mosaic," "three-dimensional editorializing," or words that related it to rapidly shifting images, like movies or television.[5]

The concept of a photography based on universal human experiences also underpinned the first group project by Magnum Photos, the photographic agency founded in the penthouse restaurant of the Museum of Modern Art in 1947 by Robert Capa (see pp. 306–7), Henri Cartier-Bresson (see p. 262), and other photojournalists seeking greater editorial control over their pictures. "People are People the World Over," a series of monthly photo-essays showing common activities in rural families around the globe, such as laundering clothes, shopping, and cooking, was published in the *Ladies' Home Journal*.[6]

At *The Family of Man*, viewers walked

**6.1
PHOTOGRAPHER
UNKNOWN,**
The Family of Man
exhibition, January 24–
May 8, 1955. Museum of
Modern Art, New York.

The Family of Man
benefited from earlier
experimental European
installations, in which
the viewer's route
was directed. Walking
through the show was
like leafing through an
issue of *Life* magazine.
Indeed, Steichen mod-
eled many aspects of the
show on *Life*—from
the relative scale of the
images, to the use of
picture agencies, and
the anonymity of the
images' authorship.

through themed areas (Fig. 6.1). They
came across familiar images, such as
Lange's *Migrant Mother* (see Fig. 5.55),
and met unfamiliar ones as well. At the
end of the show, however, the seemingly
open-ended themes became more direc-
tive. A display of photographs depicted
three women, three men, and three
children; next to these was placed a
stark warning by philosopher Bertrand
Russell (1872–1970) about the capacity
of the hydrogen bomb to destroy all
human life. Just beyond was a panel
showing a dead soldier and a question
posed by Sophocles: "Who is the slayer?
Who the victim? Speak." Lastly, the
viewer passed under an overhead lamp
into a darkened area where a 6 × 8 foot
back-lighted TRANSPARENCY revealed a
red-orange image of the 1954 U.S. hyd-
rogen bomb test explosion on Bikini
Atoll in the Pacific Ocean. The glowing
picture erupted into the viewers' space,
startling them after they had become
accustomed to so many black-and-
white images. The exhibition plan then
directed viewers to a huge photograph of
the United Nations General Assembly,
and to a final series of images showing
children at play.[7]

Although public response to the
show was overwhelmingly positive,
some photographers objected to

Steichen's transformation of their work
into tonally harmonized, standard for-
mat prints. Further, they charged that
the show denigrated the skill involved in
making photographs, and lessened the
value of the medium just at the moment
when it was struggling for acceptance in
art museums and galleries. A few critics
also felt manipulated by Steichen's
agenda, and questioned his underlying
ideological message. Phoebe Lou Adams
complained, "If Mr. Steichen's well-
intentioned spell doesn't work, it can
only be because he has been so intent
on the physical similarities that unite
'The Family of Man' that he has neglec-
ted to conjure the intangible beliefs and
preferences that divide men into coun-
tries and parties and clans. And he has
utterly forgotten that a family quarrel
can be as fierce as any other kind."[8]

In his zeal to find international
common ground from which to work
against the widely feared nuclear cata-
clysm, Steichen had obliterated the spe-
cific cultural settings of the images. For
example, Farm Security Administration
photographs such as *Migrant Mother*
were blended with other images of
unspecified calamities. Images of work-
ers from the Belgian Congo, Bolivia,
Denmark, Germany, and the United
States were thematically linked, without

regard for the drastically unequal circumstances of labor in those countries. Nathan Farbman's (1907–1988) photograph of an African storyteller in Bechuanaland (now Botswana) became part of a cluster of images on education, twisting its meaning to relate it to Western educational practices. In addition, Steichen ignored most popular forms of photography. He included a few snapshots, but did not show photographs of everyday family life taken by non-professionals with unsophisticated equipment.

In a sense, *The Family of Man* was the last expression of the documentary social realism that had characterized American photography during the 1930s Depression era. Around the world, photographers were focusing on the cultural values that differentiate, not unite, societies and groups of people. The particular struggles, histories, and contexts that Steichen removed from the images were fast becoming major subjects. A major theme in photography outside the United States was resentment against the perceived Americanization of other cultures. When *The Family of Man* reached Paris, French critic Roland Barthes (1915–1980) identified its "ambiguous myth of the human 'community,'" which suppressed "the determining weight of History."[9] Barthes equated the exhibition's theme of universal oneness with American imperial aspirations.

CULTURAL RELATIVISM AND CULTURAL RESISTANCE

Steichen's focus on common humanity reflected a larger movement to affirm the basic rights of all peoples. The 1948 Universal Declaration of Human Rights defined those rights as the "common standard of achievement for all peoples and all nations," and listed thirty articles, first among them the idea that "all human beings are born free and equal in dignity and rights." Each of the articles expressed human rights in terms of individual rights. Group, ethnic, racial, or national rights were pointedly absent from the list.[10] As the historian Eric Sandeen concisely pointed out, the United Nations, like *The Family of Man*, represented a Western view of universal

community: "By using the rhetoric of international goals and principles, [the United Nations] bound the members together with one view of what was admirable and what was unacceptable in all human culture."[11] Even as the United Nations announced its Universal Declaration, mainstream cultural outlets from *Life* to *National Geographic* were giving renewed attention to the very different proposals found in the theory of cultural relativism.

The concept of cultural relativism was developed by anthropologists in the 1920s and 1930s, and encompassed several interrelated ideas. It asserted that human values are not universally the same, but emerge from dissimilar cultural experiences. In an era when modernization seemed to mean the loss or diminution of diversity, cultural relativism accented the value of tradition. American anthropologist Melville J. Herskovits (1895–1963) clearly articulated one of its core values: "Our civilization may indeed be recognized as in no way inherently superior to another … and this is why the imposition of a foreign body of custom, backed by power is so distressing an experience."[12] Around the world, notions of cultural relativism fueled resistance to outside interference, be it military intervention, economic takeover, or the promotion of ideas that might erode cultural identity.

Within the United States and Europe, as well as in other parts of the world, those who disagreed with measuring material wealth as a standard of well-being turned to non-Western and unassimilated indigenous cultures as sources of alternative values. In the United States, photographers again journeyed to Native American groups, not to picture them as vanishing peoples, as had happened in the early twentieth century (see pp. 195–97), but to venerate spiritual wisdom and ethical values, which they thought were more in tune with the rhythms of nature than were the artificial demands of modern society. *Through Navajo Eyes* (1972), a report of the 1966 project of Sol Worth (1922–1977) and John Adair (b. 1913) to teach members of the Navajo community to use motion picture cameras to assert their identity, enlivened many discussions about the potential of the camera to record non-Western experience.

FOCUS
Making an Icon of Revolution

In 1960, Cuban photographer Alberto Díaz (1929–2001), more popularly known as "Korda," photographed Ernesto "Che" Guevara (1928–1967), who was then serving in Fidel Castro's government. Korda was so impressed by his image of Guevara that he cropped out all extraneous visual information in order to emphasize Guevara's revolutionary zeal (Fig. 6.2). Undoubtedly, Korda's background as a portrait, advertising, and fashion photographer guided him in the process of making what would become a popular symbol of revolution. This image of Guevara, gazing into

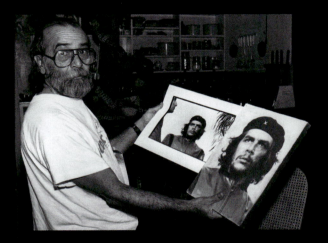

the future, beneath a beret bearing the revolutionary star, was not published when it was made, but became an international emblem of political resistance after Guevara was killed seven years later in Bolivia. On the evening of the announcement of Guevara's death, a ten-story portrait based on Korda's photograph was hung on the exterior of Havana's Ministry of the Interior building, which fronts on the plaza where Castro revealed the revolutionary's death to Cubans gathered there. The image was quickly disseminated throughout Latin America, where it became an icon of martyrdom. It was also adopted by American students and antiwar protesters during the Vietnam War era (1964–75). In the 1990s, Korda contested the photo's commercial exploitation in ways he said "dishonored" his subject; in 2000 he won a $50,000 settlement from a British advertising agency over the use of the photo in a campaign to market a brand of vodka. He donated the money to buy medicine for children.

UPI (United Press International, a news and photography agency) inadvertently promoted Guevara's fame, when it circulated a photograph of Guevara's corpse posed in a way reminiscent of religious paintings of the dead Christ, and thereby strengthened Guevara's identity as a self-sacrificing fallen martyr in largely Christian Latin America[13] (Fig. 6.3).

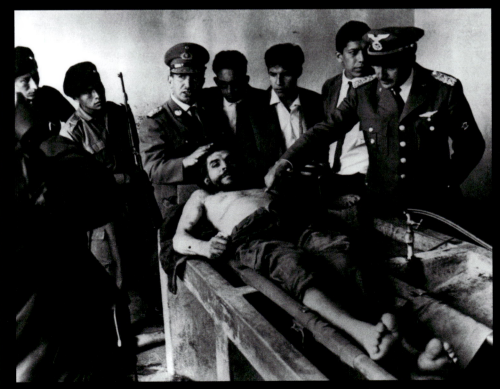

6.2 (above)
LIBORIO NOVAL, *Alberto Korda Holding Photos of Che Guevara,* March 5, 1960.

6.3 (left)
PHOTOGRAPHER UNKNOWN, *Death Picture of Che Guevara,* 1967.

Cold War tension between the United States and the Soviet Union politicized the arts. Both superpowers used artists and exhibitions to promote themselves around the world. Among the major cultural programs of the United States Information Agency (USIA) was the tour of *The Family of Man*, which traveled abroad from 1955 to 1962, appearing in thirty-eight countries to a total audience of nine million people. With additional materials commemorating Hiroshima, the exhibition was mounted in Tokyo and at Ground Zero, the spot in Hiroshima where the atomic bomb exploded. The Soviet authorities even let the exhibit run in Moscow. Publicity framed the show as evidence of the individual freedom that fostered American prosperity, much as the art movement Abstract Expressionism, with its gestural handling of paint and absence of realistic subject-matter, was cast as an example of American intellectual freedom, in contrast to Soviet Socialist Realism.[14]

The "American Way of Life," as it was called, derived from postwar economic prosperity, manifest in a housing boom, the growth of suburbs and shopping malls, and increased automobile use. It fostered the notion of material abundance as a universal gauge of societal achievement. The propaganda slogan implicitly disparaged "un-American" and "anti-American" societies, such as the Soviet Union, which offered fewer material comforts, but where all citizens were (at least in theory) seen as equal beneficiaries of centralized state-run programs, rather than lone competitors in a world governed by free-market capitalism.

Propaganda use of cultural objects during the Cold War set off the rapid politicization of artists and photographers. In Latin America, Africa, and Asia, where American art symbolized American political power and economic clout, photography came to be understood as a means to create and communicate a defiant, or at least oppositional, cultural identity.

LATIN AMERICA

In the postwar period, many Latin Americans resented the extensive cultural, political, and economic influence of the United States. Efforts to forge a distinctive Latin American identity in the arts and in photography erupted in reaction to U.S. interventions in South America and the Caribbean, beginning with the invasion of Cuba at the Bay of Pigs in 1961, and including U.S. support of Augusto Pinochet (b. 1915), who overthrew the elected Chilean government of Salvador Allende (1908–1973) in 1973, and of the dictatorial regime of Anastasio Somoza (1925–1980) in Nicaragua throughout the 1970s. As photographer and critic Fernando Castro (active 1970s) recounts, "Latin American photographers busied themselves exposing every trace of U.S. penetration they could find. Those who did not participate in this ideological purge, ridding themselves of any taste for U.S. art, dress, or speech, were branded *alienados*—alienated from their own people and culture."[15]

In the years before World War II, Latin American photographers had responded positively to European experiments in photographic form, such as Surrealism (see Chapter 5). In the decades after 1945, a wide range of photographic practice persisted, from local photographers using nineteenth-century studio styles, to those who were thoroughly conversant with contemporary international styles and techniques. This layering of practices could be found throughout the post-colonial world in the postwar period of modernization and nation-building. As in North America and Europe, photographers increasingly found work creating advertising and other commercial images. Throughout Latin America, photojournalism was carried out by press photographers attached to illustrated newspapers, or by freelancers, who sometimes sold their work through regional photographic agencies. Yet, despite the many professional photographers in Latin America, it was mostly foreign practitioners who were sent in when the area was portrayed in magazines abroad.

During the 1959 Cuban Revolution, local photographers such as Raúl Corrales (b. 1925) documented the progress of the struggle, along with foreign correspondents and photographers. Nevertheless, Cuban images were not purchased by international agencies, and most of the pictures of Cuba seen

around the world were taken by foreign photographers. A significant exception was Alberto Díaz (1928–2000), who created a defining image of the revolution (see Fig. 6.2). In the early years of the Fidel Castro (b. 1927) government, photojournalism played an important role in communicating ideas visually to a largely illiterate public. Castro reputedly waved a copy of *Life* magazine in front of one of his associates, saying "I want something like this"; *Revolucíon*, a picture magazine, was soon founded.[16]

In post-World War II Latin America, photography took many forms, ranging from the work of itinerants to fashionable portraits such as those made by Grete Stern, one of the partners in studio ringl + pit (see p. 268), who emigrated from Germany to Argentina. Especially before the spread of the Polaroid photograph (see p. 262) in the late 1960s, roving rural photographers used old-fashioned paper negatives, created in large wooden cameras constructed from parts of broken, older cameras. These itinerants used painted backdrops showing religious scenes or cityscapes, which they set up in designated spots for photographers near marketplaces and rural fairs. "Los Ambulantes," or the traveling ones, offered inexpensive portrait images[17] (Fig. 6.4).

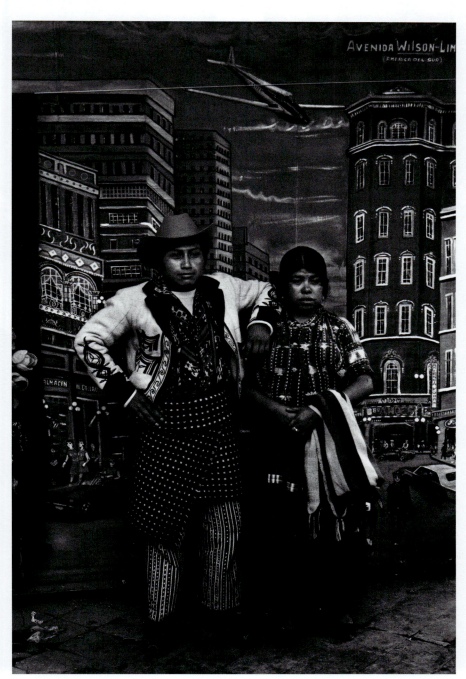

6.4
ANN PARKER,
Young Indian Couple with Cityscape, Sololá, Guatemala, **1973.**

While in rural Guatemala, Parker was struck by the lively practice of itinerant photographers, who traveled with elaborate painted backdrops against which peasants chose to be photographed. Dressed in traditional finery, the man and woman are pictured before a busy city street scene, complete with an airplane flying overhead.

During the 1970s, Latin American documentarians, photojournalists, and art photographers sought to counteract simplistic or derogatory depiction by foreigners, while still affirming the multicultural character of the region. The First Colloquium of Latin American Photographers, held in Mexico City in 1978, was accompanied by the influential exhibition *Hecho en Latinoamérica* (*Made in Latin America*). The title built ironically on the once common label "Made in America," which identified imported goods from the United States, not the other Americas. In an introduction to the catalog, organizer Raquel Tibol emphasized the growing desire to view Latin American photography as "an artistic family." "The narrow confinement within our borders was becoming unbearable," she wrote.[18] According to Tibol, Latin American photographers shared several outlooks, including "the rejection of an alienating and unjust society; the denunciation of exploitation, marginalization and colonization; a rupture with conventional aesthetic models, [and] an impulse toward a reaffirmation."[19] In other words, she hoped that photographers could unite a political

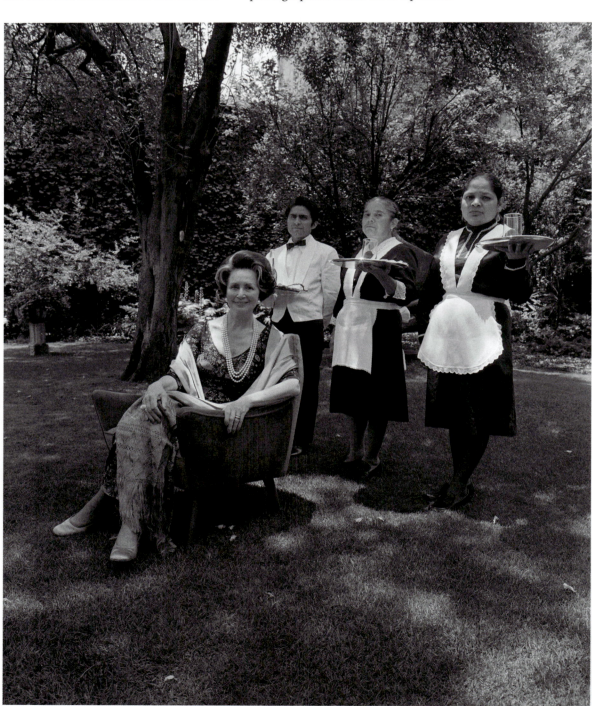

6.5
PEDRO MEYER,
Untitled (Wealthy woman with two maids and a male servant behind her), 1978, from *Hecho en Latinoamérica* exhibition, 1978. Gelatin silver print.

In this image from *Hecho en Latinoamérica*, Meyer uses visual devices to convey the contrasting attitudes of a wealthy woman and her domestic staff. She is seated and decked out in finery; they are standing, uniformed, and carrying serving trays. She occupies the foreground, while the servants form a strong wedge behind her back. Viewers can see the servants' peeved smiles, which are hidden from the seated woman.

vanguard with an artistic avant-garde. The socio-economic contrasts throughout the book underscored the disparities between rich and poor (Fig. 6.5).

Two more conferences and exhibitions were held in 1981 (Mexico City) and 1984 (Havana, Cuba). These efforts led to international group shows abroad, and a system of awards for outstanding work.[20] One result of the heightened regional identity was the increased activity of Latin American photographers working in Bolivia, Brazil, Chile, Cuba, Guatemala, Venezuela, and elsewhere, who chronicled the daily existence of the indigenous peoples threatened by modern development and ecological devastation.[21] Pre-Columbian peoples living traditionally came to symbolize a pure Latin American experience before colonization, and represented resistance to external political and cultural interference.

Brazil and Argentina

Claudia Andujar (b. 1931), a Swiss-born photographer who arrived in Brazil in 1955, embraced the outlook proclaimed at the First Colloquium of Latin American Photographers, and she exhibited her work in *Hecho en Latinoamérica*. During her treks in the 1970s and 1980s to photograph the Yanomami people of northern Brazil, she witnessed their deaths due to epidemics in the wake of a gold rush that brought 40,000 miners to the Amazon basin, and the dislocation of villages when the jungle was leveled to make way for roads. For a time, she gave up photography to set up health clinics among the Yanomami and to lobby the Brazilian government for the creation of a reserve the size of Portugal for them, a feat accomplished in 1992.

Andujar did not adopt the straightforward documentary style of the Farm Security Administration photographers (see pp. 281–7). Rather than rendering her subjects in simple compositions and lighting schemes, she used extreme contrasts of dark and light, to make the image's content ambiguous (Fig. 6.6). Unlike the early twentieth-century photographers who showed Native North American people as physically and mentally exhausted, and therefore unable to cope with modern life, Andujar manipu-

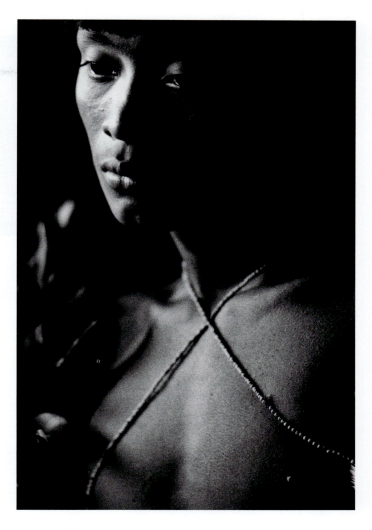

lated the graphic contrasts of her work to create sensuous surfaces that suggest vitality. Her book *Yanomami* (1978) conveyed the message that these people were endangered not by their inadequate cultural achievement, but by the moral deficiency of the major culture. She underscored the idea of an impending holocaust by dedicating the book to the people who perished at the Nazi concentration camp at Dachau. For her photographic and humanitarian efforts, Andujar was awarded the Lannan Foundation Cultural Freedom Prize in 2000.

Image-making among indigenous peoples became the hallmark of the photographers interested in portraying Latin American identity, but photographers also looked closer to home for instances of injustice and abuse. Civil unrest, revolutionary activity, and repressive government measures were routinely photographed. Argentinean photographers Sara Facio (b. 1932) and Alicia D'Amico (b. 1933) began collaborating in the late 1960s on a series

6.6
CLAUDIA ANDUJAR,
Yanomami Youth During a Traditional Reahu Festival, **1978.**

Andujar's portraits of Yanomami life are often permeated by dark shadows from which a figure slowly emerges. Her lighting is like that of the jungle, where bright sunshine occasionally penetrates the darkness created by the thick rainforest canopy. This strong stylistic interpretation stands in marked contrast to the conventions of nineteenth-century anthropological imaging (see Fig. 3.82).

**6.7
SARA FACIO AND
ALICIA D'AMICO,
Untitled, from their
book *Humanario*, 1976.**

Inmates lie or sit in the
sun-drenched courtyard
of a mental institution,
as if recently touched
by a terrible disaster.
The slack, isolated bod-
ies, stuck in a deep,
drug-induced stupor,
evince the disregard of
the asylum.

depicting life in a state-run mental insti-
tution, published in 1976 as *Humanario*
(Fig. 6.7).

MEXICO

In Mexico, photographers had already
avidly turned to local subject-matter
before the First Colloquium. They
recorded the lives of ordinary urban
dwellers as well as the persistence of
ancient religious practices among rural
peoples. In a series of influential photo-
graphic essays published in popular
Mexican illustrated magazines such
as *Hoy* (*Today*) and *Siempre!* (*Always*),
Mexican photojournalist Nacho López
(1923–1986) depicted everyday life in

Mexico City, sometimes posing his sub-
jects to create a humorous or poignant
effect. His photo-essays present the poor
as animated, capable actors in their
own realm, not as victims awaiting mis-
fortune's next call[22] (Fig. 6.8). López
believed that photography found its
finest expression in photojournalism,
which thrust the image-maker into the
midst of life's theater. He came to detest
what he and other Latin American pho-
tographers called "folkloric" photogra-
phy, the pursuit of picturesque subjects
rather than social contexts.[23] Another
Mexican photographer, Héctor García
(b. 1923), traveled the country seeking
out the survival of ancient, pre-colonial

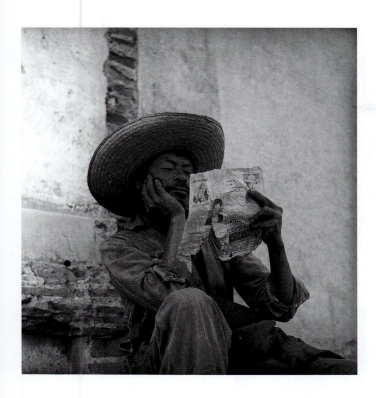

rituals. He concentrated on laborers, producing pictures that emphasize their individual imagination (Fig. 6.9).

Foto Hermanos Mayo, or the Brothers Mayo Photography, an anonymous collective originally from Spain, enthusiastically supplied Mexican and foreign illustrated magazines and newspapers with pictures that examined issues from the working-class point of view. The Mayo archive of about five million negatives is probably the largest of its kind in Latin America.[24]

During the 1970s, former painter Lourdes Grobet (b. 1940) used photography as an element in "environments," that is, multi-media precursors of installation art. She also made a series of bogus referendum ballots, to make her point about the deficiencies of the voting process (Fig. 6.10). Another Mexican photographer, Graciela Iturbide

6.8 (above)
NACHO LÓPEZ,
Campesino, 1949.
Nacho López Foundation. Fototeca del Instituto Nacional de Antropología e Historia, Mexico City.

One of López's most celebrated images, this photograph of a peasant reading a newspaper has been widely reproduced for over half a century. The man's hat hints at his rural background, but his overalls indicate that he has migrated to the city.

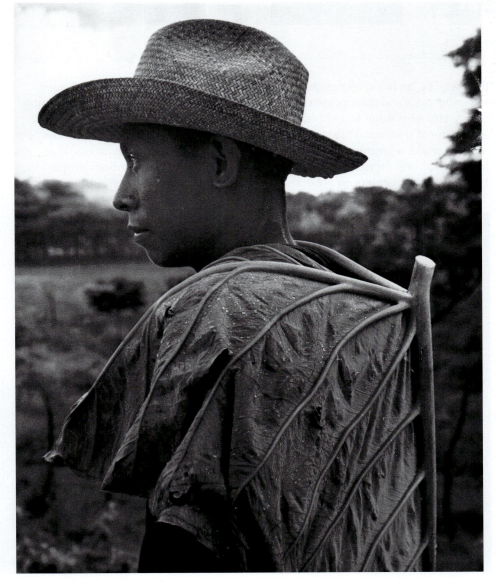

6.9
HÉCTOR GARCÍA,
Campesino Covered with a Leaf, 1965.

PROPOSICIONES

☐ Verdadero

☐ Falso

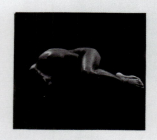

☐ Verdadero

☐ Falso

M.L Grobet 1978

**6.10 (above)
LOURDES GROBET,
Proposiciones, 1978.
Mixed media.**

Grobet's counterfeit ballots required the viewer to check boxes "true" (*verdadero*) or "false" (*falso*). But the information was aligned in such a way that it was impossible for the viewer to make such a coherent response.

(b. 1942), began her career photographing indigenous and rural people in the 1970s. Her work often focuses on the adaptation of traditional life to the modern world, a prominent motif in Mexican cultural expression (Fig. 6.11). Her recent work centers on Mexicans living in east Los Angeles, the largest Mexican population outside the country, and along the United States–Mexican border. She does not mourn the loss of cultural identity or romanticize the severe poverty that confines people in traditional cultures. Instead, she shows

**6.11
GRACIELA ITURBIDE,
Woman Angel, Sonara Desert, Mexico, 1979.**

A Seri Indian woman literally balances between modernity, symbolized by the portable radio, and the earth, an emblem of traditional life, which she reaches for with her left hand. Iturbide suggests the abiding spiritual life of her subjects, especially women.

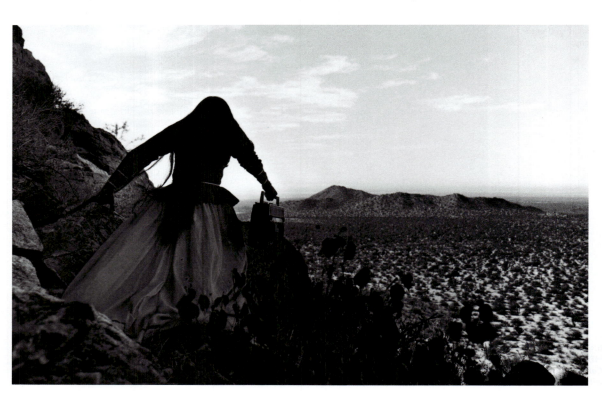

PORTRAIT
Manuel Álvarez Bravo

Nacho López, Héctor García, and Graciela Iturbide all studied with photographer Manuel Álvarez Bravo (b. 1902), the most influential photographer in Mexico during the last half of the twentieth century. Although Álvarez Bravo's uncanny compositions recall the eerie and mysterious visual spectacles favored by Surrealism,[25] he maintains that Surrealism has been a minimal influence.[26] More important, he claims, was his friendship with Tina Modotti (see p. 279) during the 1920s that led him to view the Modernist photographs of her companion, Edward Weston (see pp. 278–80).[27] Álvarez Bravo also confronted Modernist simplification of forms when he photographed the work of the Mexican muralists José Clemente Orozco (1883–1949), David Alfaro Siqueiros (1896–1974), and Diego Rivera (1886–1957), for the magazine *Mexican Folkways*.[28] "My work is more related to Mexican art and Mexican life than to photographic traditions," he asserted.[29]

Beginning in the 1940s, Álvarez Bravo's photographs were increasingly seen outside Mexico. Three of his images were included under sweeping categories such as "birth" and "death" in Steichen's *The Family of Man* exhibition in 1955. In these non-Mexican contexts, viewers could overlook Álvarez Bravo's many allusions to ancient myth, folklore, and ritual, with their multiple, intertwined inflections on fecundity and death. For example, *La Buena Fama Durmiendo* (1938–39) (*Good Reputation Sleeping*) shows a young woman slumbering in the sun (Fig. 6.12). She rests on a blanket or rug, and her ankles

and thighs are wrapped with what look like bandages. Her pubic area is emphasized against the white fabric. The seductive, sexually charged nude intimates Surrealism's concern with eroticism and altered states of consciousness; the image was shown at an exhibition organized by Surrealist leader André Breton.

The photograph is strongly imbued with particular Mexican themes that owe nothing to Surrealism. Within Mexican folklore, the thorny cactus pieces lying beside the figure are signs of danger. They warn about the perils of sleep, while protecting the sleeper. The bandages, which owe to an incident in which Álvarez Bravo observed dancers binding their feet, suggests an associative link between the sleeping figure and dancers portrayed in the sculptural reliefs of ancient Mexican civilizations. In one interpretation derived from Mexican cultural experience, the image simultaneously alludes to both the Virgin Mary and the ancient earth goddess Coatlicue, both of whom conceived sons without sexual intercourse.[30]

In Álvarez Bravo's work, some of which is especially staged for the camera, the past is alive in the present in a way different from Western history, which firmly situates events in chronological time and keeps the past at bay. It is interesting to note that Álvarez Bravo never offered extensive interpretations of his work, possibly because their poetic nuances might be sapped in prose. Consequently, he has not responded to the charge that his images promote an internal Mexican exoticism, of the sort nineteenth-century travelers sought in photographs of colonial subjects.

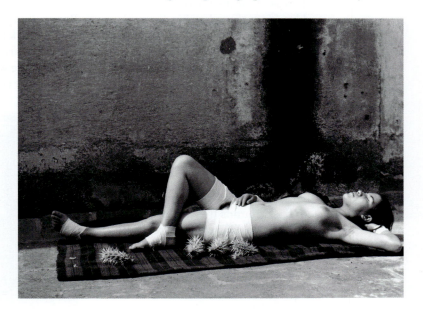

6.12
MANUEL ÁLVAREZ BRAVO, *La Buena Fama Durmiendo (Good Reputation Sleeping)*, 1938–39. Gelatin silver print. Museum of Photographic Arts, San Diego, California.

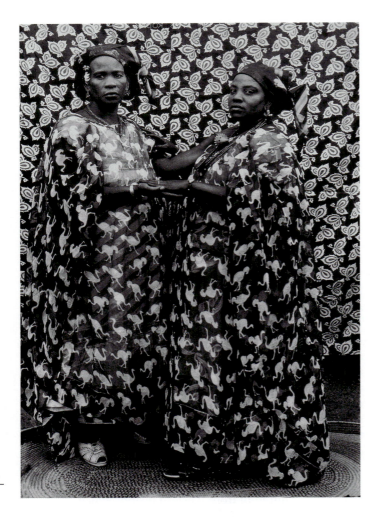

6.13
SEYDOU KEÏTA,
Two Women, 1959.

traits of government officials, shopkeepers, politicians, and socialites. Unlike anthropological photographs, which stress the primitivism of Africans, the participants and photographer in Keïta's work collaborate to create an image of lively, confident town life (Fig. 6.13)

Though most post-World War II portraiture in Africa, as in Europe, did not employ experimental techniques, a few photographers, such as Kenyan Omar Said Bakor (1932–1993), made composite portraits that sprang from the client's desire to add people to an extant photograph. Unlike European photomontage, however, Bakor's work was not strongly illusionistic. He used the technique in a way that let the process show, as a means of portraying people's inner desires and aspirations, and also perhaps as a visual equivalent to the nonlinear nature of African storytelling (Fig. 6.14).

The "Africanization" of portrait photography received fresh impetus in the 1960s, as many countries began to achieve political independence from colonial European powers. African backdrop scenes showed specific African scenes, and sitters increasingly chose to wear traditional African attire.[31] Independence also brought the establishment of official photography agencies, such as AMAP in Mali and A Foto in Angola, tasked with communicating government-approved points of view.[32] Inspired, possibly, by the achievement of independence in other countries, Mozambique photographer Ricardo Rangel (b. 1924) reoriented his own camerawork in the service of social change. During the 1960s, when guerrilla warfare was being waged against Portuguese colonial authority, Rangel

indigenous Mexican people as constantly in flux, accommodating to change that began half a millennium ago with the Spanish conquest.

AFRICA

Like most photographers living in colonial areas, Africans learned camerawork and business procedures in European-run establishments, or as part of service in colonial military units. Consequently, portrait photography by Africans of Africans adapted many attributes of colonial photography, such as the portrayal of worldly accomplishments, and the display of tokens indicating social class or personal interests. Photography was brought to villages by traveling photographers, who, like those in Latin America, made portraits against the cloth backgrounds they took with them.

Within the constraints of received traditions, photographers such as Mali resident Seydou Keïta (1923–2001) infused the Western portrait with African qualities. The urbanization of Bamako, a city where the railroad meets the River Niger, is evident in his por-

6.14
OMAR SAID BAKOR,
Untitled, 1975.
Photomontage.

When Bakor placed the photograph of two young women on the speaker of a radio, indicating their desire to be known as celebrities, he let the rough edges show.

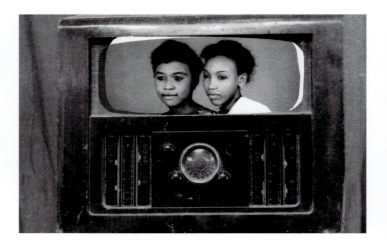

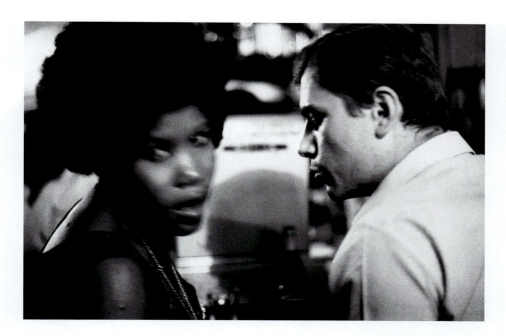

Using available light, rather than a flash, unpremeditated composition, and intentional blurring of forms, Rangel focused on interpersonal relations as observed in the night-spots of the Mozambique port of Maputo. His work repudiates sunny mainstream press photographs of life in wartime Mozambique.

shot a series called *Our Nightly Bread*, capturing the night-life in the port city of Maputo (Fig. 6.15). Rangel founded a photographic training center, which continues to instruct most students of photography in Mozambique.

By South African custom and law, press photography was reserved for white practitioners. Nevertheless, the medium was enlisted in the fight for social justice during the 1950s. In Johannesburg, the Progressive Photographic Society was formed, and *Drum* magazine, founded in 1951 as an entertainment magazine for urban blacks, was reformulated as a showcase for young writers and photographers who wanted to portray contemporary culture. *Drum* contrived ways to show the work of South African photographers, whether black, white, or of Asian extraction, including Cloete Breytenbach (b. 1933), Ernest Cole (1940–1990) (see below), Bob Gosani (1934–1972), and Ranjith Kally (b. 1925). They resolutely pictured life under apartheid, the policy of racial separation formalized in 1948 and regulated with increasingly severe laws throughout the 1950s. *Drum* magazine expanded to several other African countries; at its height, its circulation was about 450,000.

Since publications could be banned at any moment, the writers, editors, and photographers at *Drum* were not openly hostile to apartheid. Nevertheless, during the 1950s, the magazine pushed the limits of resistance, publishing Alan Paton's novel *Cry, the Beloved Country*, a

best-seller about the conflict between a black minister and a white supremacist farmer. Occasionally *Drum*'s photographers got themselves arrested in order to record the effects of the harsh criminal justice system, or such practices as convict labor.

Peter Magubane (b. 1932), who ultimately became chief photographer at *Drum*, once shrewdly turned the prevalence of black stereotypes to his advantage, in order to make a series of photographs of the 1956 trial of some apartheid protesters. Magubane hid his camera in a loaf of bread and lounged outside the courthouse pretending to eat it, all the while secretly photographing people as they arrived. At considerable risk, Magubane resolved to record abuse of black workers (Fig. 6.16) and anti-apartheid demonstrations, whose activities were distorted in the newspapers that backed government policy. Similarly, when detained by the police, Ernest Cole cleverly played on his captors' biases, claiming that he was doing a report on black juvenile delinquency. Cole's *House of Bondage* (1967) is one of the most comprehensive indictments of South African racial policy produced by a photographer (Fig. 6.17).

Drum photographers also contributed to political resistance by making pictures in such places as jazz clubs, where they showed black social life unfettered by apartheid policy. After 1960, when the ruling government reacted to anti-apartheid activities by declaring a state of emergency, black photographers

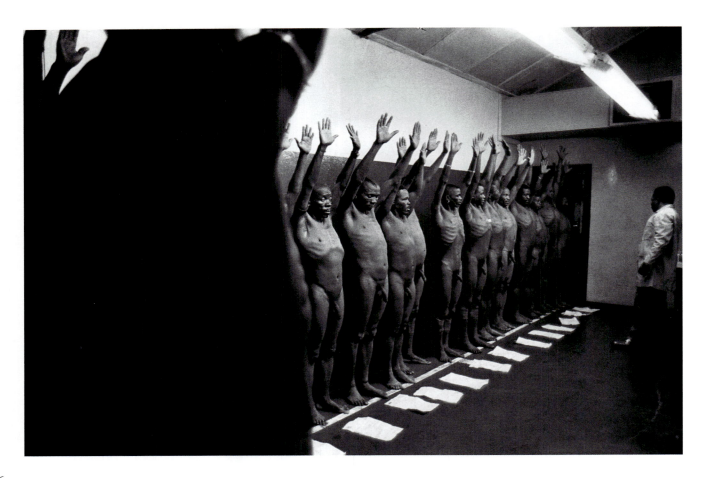

African township is bulldozed out of existence to make way for white expansion. Government trucks will move residents and their few possessions to matchbox houses in new locations, usually in remote areas, perhaps not even named on map. Even to live there, families must qualify. People at right did not, and thus have not only had their homes razed, but have nowhere to go.

56

**6.16 (opposite, above)
PETER MAGUBANE,**
Untitled **(The Wenela
Mine recruiting agency),
Johannesburg, South
Africa, 1967.**

Of this photo, Peter
Magubane has said,
"It was *inhuman* in the
African tradition to have
young and old men
stripped naked in the
same place, and these
are men who have gone
down the bellies of
the earth to dig the
gold that has enriched
South Africa."
(31 January, 2002)

**6.17 (opposite, below)
ERNEST COLE,**
Untitled, **pages from
his book *House of
Bondage*, 1967. Ridge
Press, Random House,
New York.**

Cole's searing render-
ing of South Africa
emphatically pictured
the effects of apartheid
policy on families. In lay-
ing out the pages of his
book *House of Bondage*,
Cole galvanized the
sequence by using shift-
ing points of view and
varying the distance
from the central scene,
so that the viewer had
to be constantly reacting
to the pictures.

faced jail or exile. Magubane was held
in solitary confinement for a year and a
half, and then was banned from taking
pictures for five years. Undeterred, dur-
ing the 1980s, Magubane and other
photographers, many of them trained in
their craft at *Drum,* used photography to
record the oppression and resistance
that led to the end of apartheid. Not all
anti-apartheid photographs directly pic-
tured incidents of injustice and racial
domination. For forty years, David
Goldblatt (b. 1930), a white man who
left his family's menswear business in
1962 in order to make photographs,
shot scenes of ordinary daily activities.
His views of shanty towns, billboards,
shacks, and public monuments subtly
alluded to the condition of racial
inequity. In *The Transported: A South
African Odyssey* (1989), Goldblatt col-
lected photographs he made during the
early morning, two-and-a-half-hour
one-way bus ride endured daily by black
workers from the segregated "home-
land" of Kwandebele to the city of Pre-
toria, where they labored but were not
allowed to live (Fig. 6.18).

The West began to take notice of
Afrocentric photography in the decades
after World War II. Stephen F. Sprague's
pioneering 1975 study of the use of pho-
tography among the Yoruba people of
West Africa made the case that they had
been integrating photography into their
art practice since the 1930s.[33] At the core
of Yoruba photography were cultural
guidelines about how to render like-
nesses; these were based not on art
conventions, but on broader rules for
human interaction. The notion of *jijora*
indicated that an image, including a
photograph, should be made at the
mid-point between generalization and
resemblance; individualizing specificity
should be avoided in favor of a modest
idealization. At the same time, the con-
cept of *ifarahon,* or visibility, suggested
clarity and order. In practical terms,
ifarahon meant that both the sitter's eyes
should be visible, so the sitter had to
look directly into the camera. Moreover,
the photographer should not employ
such poses as the profile view nor intro-
duce dramatic lighting or unusual
angles. Sprague's work is an example of
the shift in anthropological and cultural
studies toward a consideration of indi-
genous and post-colonial uses of the

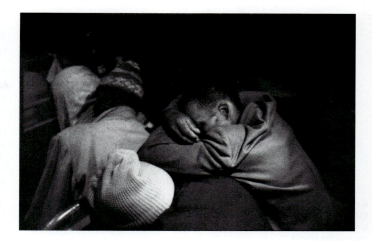

**6.18
DAVID GOLDBLATT,**
Untitled, **from his
book *The Transported:
A South African
Odyssey*, 1989.
© David Goldblatt/
South Photographs.**

Shooting in the spotty
available light of the
interior of a bus,
Goldblatt let the forms
of human figures
suggest themselves
out of the gray gran-
ular atmosphere.

medium. Yet it remains true that, as
anthropologist Joanna C. Scherer
observed, "the serious analysis of non-
Western or native photographers is a
relatively untouched field."[34]

ASIA
India

Photographic practice in India took off
quickly within months of the medium's
official disclosure to the world in 1839,
and grew rapidly among colonial and
Indian practitioners (see pp. 104–6).
In the years immediately preceding and
following World War II, India consti-
tuted a large market for photographic
supplies, manufactured by international
companies such as Kodak and the Ger-
man company Agfa. Illustrated publica-
tions such as the *Illustrated Weekly of
India* provided outlets for Indian-made
images. The pre-World War II period
saw the start of specialty magazines for
photographers, including *Indian Pho-
tography and Cinematography,* launched
by S. Lakshiminarasu in 1937, and
the Kodak-sponsored *Kodak Indian
Magazine* (later *Tropical Photography*),
founded in 1940. Camera clubs consist-
ing largely of Indian members were
well established in the bigger cities and
towns. However, as historian G. Thomas
reports, "no deliberate attempt was
being made by Indians to establish an
Indian idiom in photographic commu-
nications."[35] The British Royal Photo-
graphic Society's programs and its
operations were widely admired. As in
nineteenth-century Britain, various
groups in India exchanged photographs
by mail in what was called the "Postal
Portfolio" movement.

Although Margaret Bourke-White
(see pp. 388–89) photographed in

postwar India, publishing a book called *Halfway to Freedom: A Report on the New India* (1949), and Henri Cartier-Bresson (see p. 262) worked there several times, the pictures they produced were mostly not for the Indian market. After India achieved independence from Britain in 1947, a new proposal for photography "of Indians, by Indians, for Indians" was eagerly heard, and a national society, the Federation of Indian Photography, was established in 1953.[36] The call for Indian photography followed on the success of the Independence movement's wide distribution among the populace of photographic postcard images picturing organizer Mahatma Gandhi (1869–1948). Beginning in the 1930s, the postcards were used as a rallying device that could bypass British-controlled media. After Independence, cameras made exclusively for the Indian market were manufactured by New India Industries, in conjunction with Agfa, and Kodak changed its name from Kodak Limited to the Indian Photographic Company. By 1965, film was also being manufactured by Indians for Indians.

Homai Vyarawalla (b. 1913), a self-taught photojournalist who covered World War II for the *Illustrated Weekly of India*, recorded the jubilant crowds celebrating Independence and followed the political life of the new country during the 1950s. She worked for the *Times of India*, and as a contributor to *Time* and *Life* magazines. Another photojournalist to emerge during the Independence movement was Sunil Janah (b. 1918). His pictures of the 1942 famine, the Independence struggle, and Gandhi's assassination in 1948 gave him an international reputation (Fig. 6.19). When Margaret Bourke-White began her work in India, she sought him out for advice and contacts. Janah's Calcutta studio became a meeting place for artists and intellectuals, including the filmmaker Satyajit Ray (1921–1992).

India's best-known photographer at

6.19
SUNIL JANAH, *Untitled* (People pouring into the streets of Calcutta after the news of Gandhi's assassination), 1948.

During Janah's long career, he recorded major events in Indian life, such as Gandhi's assassination in 1948. In this image, most of the people who have rushed into the streets to hear the news are unaware of the photographer's presence.

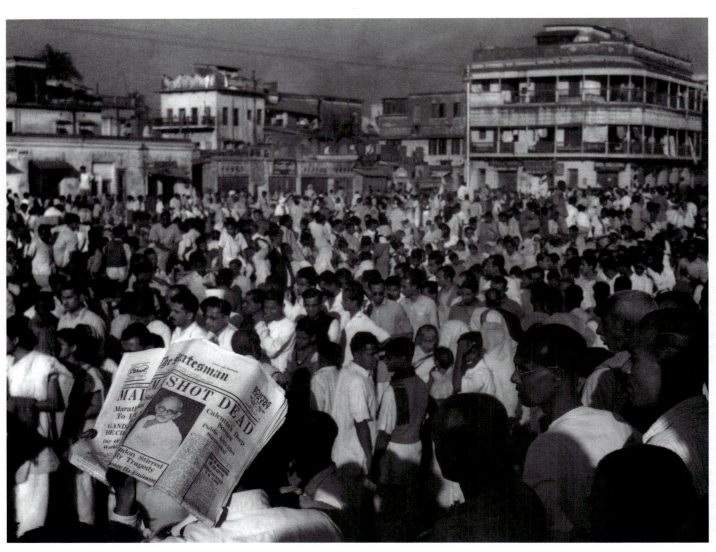

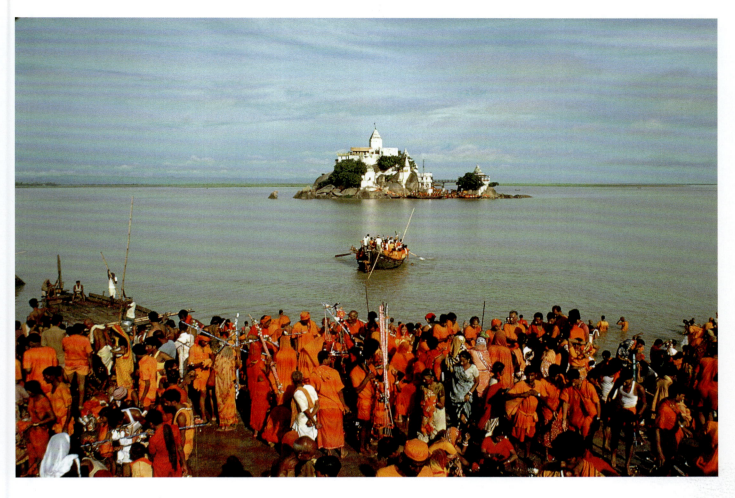

6.20
RAGHUBIR SINGH,
Shiva Temple,
Jahngira, 1983.

The Ganges: Sacred River
resulted from Singh's
six-year chronicle of life
along the river. He was
accused of prettifying
social problems to
create a representation
of India as a time-
less land, particularly
through his decorative
use of color. "I realized
fairly early," Singh
countered, "that there
was no contradiction
between sadness or
poverty, and color."[37]

home and abroad was Ray's friend
Raghubir Singh (1942–1999). Singh
credited his interest in photography to
his teenage viewing of Cartier-Bresson's
1949 book *Beautiful Jaipur.* Unlike
many non-Western photographers, for
whom the new reliable color film (see
p. 361) was too expensive, Singh started
his career in color photojournalism,
supplying images for international pub-
lications such as *National Geographic*
and the *New York Times.* During the
1970s, he began creating photographic
books on Indian regions, including
Kerala in the south, Kashmir in the
north, the Ganges River (Fig. 6.20), and
cities, such as Bombay (Mumbai) and
Calcutta. His books were sold interna-
tionally and marketed to tourists in
India.

Post-colonial Indian photography
took another turn in the industrial city
of Nagda and the village of Bhatisuda in
the central subcontinent. In this area
photographic practices developed out of
custom and religion, and disregarded
Western notions of realism.[38] Like the
Yoruba people of Africa, the residents of
Nagda and Bhatisuda created an aes-

thetic form and meaning for their works
that ignored the usual studio conven-
tions. Before the advent of widespread
color photography, they freely requested
that the photographic image be painted
over with color. In addition, photo-
graphs of family members were then

6.21
PHOTOGRAPHER
UNKNOWN,
Untitled (Manakal's
son), c. 1965.
Photomontage.
Bombay Photo Studio,
Bombay, India.

A child who died is
remembered in a pho-
tomontage that places
his image inside one of
a rose, linking associa-
tions of scent with
memory. As anthropolo-
gist Christopher Phinney
reported, commemora-
tive photography is
"prized for its capacity
to make traces of per-
sons endure, and to
construct the world in
a more perfect form
than is possible to
achieve in the hectic
flow of the everyday."[39]

montaged, sometimes bringing together relatives who could not attend a baptism, wedding, or funeral, in order to create an image of the whole extended family. A distinctive genre of montaged photographs emerged as memorials of the dead (Fig. 6.21). It has been suggested that the development of a moderately independent representational system such as that at Nagda and Bhatisuda may have sprung from classic Indian narratives, notably the story-within-a-story structure of the *Mahabharata*.[40] What might be called non-Western photographic folk practice exists side by side in rural and urban settings with Western-derived photojournalism.

Japan

Taking its cue from Western examples, Pictorialism dominated Japanese still-life, landscape, and portrait photography into the 1930s. It was followed by other Western-inspired styles, such as Modernism, whose sharp angles and severe close-ups affected art photography, advertising, and portraiture. Likewise, Surrealism and European experimental photography were investigated in Japan, and their disjointed and collaged effects were adapted to create visually exciting commercial art. As in other countries, the pre-World War II period saw the flourishing of illustrated publications, specialty magazines for photographers, and the manufacture of Japanese cameras for the home market. While international styles flourished in prewar Japan, some photographers, such as Shinzo Fukuhara (1883–1948) and his brother Roso Fukuhara (1892–1946), sought to counteract both the fuzzy look of art photography and the deep perspective offered by the camera (Figs. 6.22, 6.23).

Shinzo and Roso Fukuhara were the sons of Arinobu Fukuhara, founder of the cosmetics firm Shiseido. Like their father, who modeled his merchandise on European products, they judiciously borrowed Western visual styles for their photography. Shinzo, who studied pharmacology in the United States, took over the company presidency in 1915, and streamlined the firm's advertising and window displays in the manner of Western Modernist art and photography, but his and his brother's photography

was resolutely otherworldly. Much of Shinzo's work was destroyed in a 1923 earthquake.

During World War II, Japanese propaganda and war photographs dwelled on injured or dead enemy bodies and ruined buildings, the same subjects pictured in other war-torn countries. Japanese photographers arrived on the scene soon after the atomic bombings of Hiroshima and Nagasaki. At the epicenter in Hiroshima they found a ghastly photograph-like silhouette of a man's shadow scorched into a wall by the heat and light of the bomb. Sent to Nagasaki by the Japanese military, photographer Yosuke Yamahata (1917–1966) spent August 10, 1945 making images of the city's ruins. His 119 pictures are the largest archive of photographs made of an atomic bomb site, gained at the cost of severe radiation exposure that probably contributed to his early death from cancer. Some of his pictures were pub-

6.22
SHINZO FUKUHARA, *Light With Its Harmony 8: Pond*, c. 1910. Gelatin silver print. Shiseido Corporation, Japan.

Shinzo and Roso Fukuhara's work alluded to the spatially compressed vistas of Japanese painting and the look of traditional brush and ink work—a look that continues to intrigue contemporary Asian photographers.[41]

6.23
ROSO FUKUHARA, *Sangaatsudo*, c. 1915. Gelatin silver print. Shiseido Corporation, Japan.

6.24
YOSUKE YAMAHATA,
A Boy with a Rice Ball,
from his book *Atomized*
Nagasaki, **1952. Gelatin**
silver print.

The cover image from
Yamahata's 1952 book,
Atomized Nagasaki,
shows a dazed child,
clothed in a headdress
thought to protect the
wearer from radiation,
and looking directly into
the camera. Unlike the
other photographs
hung near it in *The
Family of Man* show,
which were labeled only
with their country of
origin, Yamahata's
image was specifically
labeled "Nagasaki."

lished in Japanese newspapers immediately after the country surrendered, but the army of occupation under American General Douglas MacArthur soon banned all atomic-related information and pictures for seven years.[42] When Edward Steichen traveled to Japan to gather images for *The Family of Man* exhibition, he met Yamahata and was moved by his book *Atomized Nagasaki* (1952). For the anti-nuclear war section of the show, Steichen used a Yamahata photograph of a small injured boy, clutching a rice ball (Fig. 6.24).

Defeat in World War II raised questions about postwar national identity for Japanese artists working in such media as dance and film, as well as photography. As Mark Holborn observed, "it is impossible to look at postwar Japanese photography without recognizing the effect of the almost inconceivable events of 1945 on the collective imagination of the nation."[43] The war experience reverberates through Japanese postwar artwork, in themes linking death, devastation, and defeat. After the atomic bombings, the anatomy of the human body, not a major subject in traditional Japanese art, was thrust forward as a contradictory symbol of ruin and endurance. The countervailing desire

for normalcy also coursed through post-war Japanese photography. Because Japan's museums did not take a major interest in exhibiting and collecting photography, books became the primary way to circulate photographs. Consequently, Japanese photographers conceived their work in terms of visual properties that would reproduce effectively in the dull, grainy palette of printer's ink, and which would be viewed consecutively on book pages. The delicacies of fine photographic prints, best appreciated in a portfolio or in a gallery, became secondary.[44]

After a prohibition by the U.S. authorities on atomic-bomb related images was lifted in the early 1950s, several photographers began to shape meanings from the experience of Hiroshima and Nagasaki. Indeed, the havoc wrought by the bomb on human beings and on civic life became a central symbol for life and death in the iconography of postwar Japan. Ken Domon (1909–1990), a photographer with wide-ranging interests including the photography of Japanese art, published *Hiroshima* (1958), an unsparing look at the survivors of the blast. For the Japanese, this book became the best-known account of the bombing. Wanting to underscore the perseverance of Hiroshima's people, Domon issued *Living Hiroshima*, twenty years after his first study (Fig. 6.25).

In 1950, Domon co-founded the Shudan Photo Group, which renounced prewar Pictorial prettiness as well as modes of extreme self-expression. The group exhibited in Japan with Western photographers they admired, including Margaret Bourke-White, W. Eugene Smith, Henri Cartier-Bresson, and Bill

6.26
SHISEI KUWABARA,
Untitled **(People affected by "Minamata Disease"), from his book** *Minamata Disease,* **1972.**

Kuwabara's use of heavy shadows to portray people physically affected by mercury poisoning helps to hinder voyeurism, while expressing the seriousness of the situation.

Brandt.[45] Their philosophy was soon superseded by that of another group, Junin-no-Me ("The Eyes of Ten"), which favored stylized interpretations of physical existence. After viewing the work of Junin-no-Me, Domon remarked that the period of objective documentary was over and that a period of subjective documentary had begun.[46]

In the early 1960s, industrial pollution introduced poisonous mercury into the waters near the fishing village of Minamata, causing profound birth defects. Shisei Kuwabara (b. 1936) photographed the tragic results in images whose grainy dark surfaces parallel the visual language used by photographers to chronicle the physical effects of atomic devastation (Fig. 6.26). Influenced by these pictures and Kuwabara's book on Minamata, American photographer W. Eugene Smith (see p. 303) similarly recorded the calamity, producing a large series of photographs that trace the introduction of mercury waste into the water, its effects on a generation of children, and the attempts of citizens to seek justice through the court system.

Some photographers shunned subjectivity and sought other means to chronicle postwar Japan. Eikoh Hosoe (b. 1933), who was a child during World War II, fused ancient Japanese myth and contemporary experimental dance in his series of thirty-five prints called *Kamaitachi* (1969), which visually narrate the lot of villagers fatally enchanted

6.25
KEN DOMON,
Hiroshima: The Marriage of A-Bomb Victims, **1957. Gelatin silver print. Ken Domon Museum of Photography, Yamagata, Japan.**

The longing to return to normalcy after exposure to atomic radiation was frequently expressed in pictures of domestic life and the happiness born of daily existence.

PORTRAIT
Shomei Tomatsu

Introducing his photographs about the effects of the atomic bomb blast at Nagasaki, Shomei Tomatsu (b. 1930) wrote: "Nagasaki has two times. There is 11:02, August 9, 1945. And there is all the time since then."[47] The pivotal influence of the explosion on post-war Japanese experience was summarized in the introductory photograph of Tomatsu's book, *Nagasaki: 11:02* (1966). It shows a scorched wristwatch stopped at the time of the detonation (Fig. 6.27). The text accompanying Tomatsu's pictures begins with impersonal scientific data on the heat and energy of the blast, as well as the symptoms of radiation exposure, but the photographs are far from objective. For instance, when Tomatsu photographed a beer bottle melted in the infernal heat, he lighted it in such a way that it suggests a skinned animal carcass. In another image, a man's head appears out of black shadows into a spotlight where dark and light abstract shapes reveal themselves to be skeins of scar tissue moving up his neck. The man's face is dramatically lighted to indicate the skull beneath the skin. With Ken Domon, Tomatsu also worked on an extensive project, the *Hiroshima–Nagasaki Document* (1961).

Tomatsu's work was at the forefront of the trend in postwar Japan toward subjective documentary, in which the presence and the world-view of the photographer fuse with the subject-matter. He forcefully argued that merely reporting a scene does not help to illuminate situations.[48] In many of his photographs, the subject is off-center, or lies at the edge of the work, or is masked with dark shadows. In a hospital just for atomic bomb victims, the face of an obviously ill man addresses the viewer from the extreme upper left of the picture; the disfigured face of a child injured in the womb by radiation is all but lost in a welter of tree leaves that discreetly obscure the face while offering the comforts of nature. Tomatsu was also concerned to show the period of recovery. In his work, immutable human scars and bomb-induced changes in the landscape are balanced by photographs that show the restoration of work and family life in Nagasaki.

The devastation of the atomic bombings caused Tomatsu to think that Japan had to begin afresh, not by trying to revive the past, as some, such as the writer and actor Yukio Mishima (1925–1970), urged. Consequently, Tomatsu's work examined the emergence of postwar Japanese identity. His willingness to make images of contemporary, often urban life helped sever the allegiance of many photographers to the notion of a purely Japanese aesthetic based on older visual arts traditions. The pensive, personal character of his images, with their deliberate shaping of a subject through exaggerated contrasts of black and white, has been a major force in Japanese photography.

6.27
SHOMEI TOMATSU, *Time Stopped at 11.02, 1945,* Nagasaki, 1961. Gelatin silver print. San Francisco Museum of Modern Art, San Francisco, California.

**6.28
EIKOH HOSOE,**
Kamaitachi 31, 1968,
from his book
Kamaitachi, **1969.**

For Hosoe, photography
is a component of a
multimedia artistic
expression. Created for
his *Kamaitachi* exhibi-
tion, a hunched dancer
posed on the edge of a
rural fence beneath an
ominous sky. Founder of
the Black Dance Theater
(*Ankoku Buto-Ha*),
Tatsumi Hijikata
plunged his palms into
gold ink and stamped
each print in a ritual act
of authorization.

and wounded by a dancer taking the
part of an evil wind, representing the
nuclear blast. Throughout the book, the
lowering sky threatens the ever-darken-
ing earth, and fear of the vicious wind
becomes panic about the atomic explo-
sion. The narrative ends with a picture
of total darkness. Presented as a book
and an exhibition in 1969, *Kamaitachi*
(Fig. 6.28) expresses both a dangerous
innocence and the persistent anxiety the
Japanese felt about continued American
influence.

The war between Japan and the
Allied forces lasted three years and eight
months; the postwar occupation of
Japan, largely administered by Ameri-
cans, was about twice as long (August
1945–August 1952), and the United
States maintained large military bases
in the country after the official end of
occupation. During the 1960s, anti-
American student demonstrations
sparked by indignation at the Vietnam
War heightened national interest in ele-
ments of traditional Japanese culture
and religion thought to have been
erased by Americanization. Where
Kamaitachi spoke to a Japanese audi-

ence about these concerns in a mythic
structure, Hosoe's most famous book
Barakei (*Killed by Roses*) (1963; second,
revised edition 1971) established the
photographer's international reputation.

In *Barakei*, Hosoe collaborated with
Mishima, whose themes revolved
around Japan's humiliation by occupy-
ing forces. Their presence compelled
the emperor to renounce his divinity
and to align himself with modernization
and rapid reconstruction. No doubt
Hosoe and Mishima were among the
millions of Japanese who reeled when
what became known as "The Photo-
graph" appeared in the press (Fig. 6.29).
Depicting the first meeting of the
Emperor Hirohito (1901–1989; r. 1926–
89) and General Douglas MacArthur,
designated Supreme Commander for
the Allied Powers in Japan, "The
Photograph" showed an informally
posed and somewhat casually dressed
MacArthur standing beside the self-
conscious, formally outfitted emperor.

Hosoe and Mishima both attempted
to blend experimental art with ancestral
Japanese art forms, and to infuse the
postwar westernizing present with the

strength of ancient Asian tradition. Hosoe's portraits of Mishima in *Killed by Roses* dwell on Mishima's fascination with samurai swords and physical pain, an uncanny anticipation of the writer's famous act of ritual suicide. Rehearsed and performed like a theater piece, Mishima's *hara-kiri* was enacted on November 25, 1970, after he and a band of his supporters took over a military office and demanded to address soldiers about the loss of traditional Japanese values, and the erosion of the emperor's power in modern, democratic Japan.

Despite growing anti-American sentiment, the Modernist photograph was not neglected in Japan. It found a staunch advocate in the work of American-born Yasuhiro Ishimoto (b. 1921), who learned photography in the Colorado relocation camp where he was interned during World War II. He also studied at

the Chicago Institute of Design, founded by László Moholy-Nagy as the New Bauhaus in 1937. Under Moholy-Nagy, who brought Aaron Siskind and Harry Callahan to the school's faculty, the Institute of Design acquired an international reputation for its dedication to experimental techniques and formal innovation in graphic design and photographic practice. Ishimoto traveled to postwar Japan where he applied the lessons of Moholy-Nagy's new vision photography (see pp. 252–53). Although he continued to spend time in the United States, Ishimoto became a Japanese citizen in 1969. Responding to a comment by photographer Minor White, Ishimoto stated: "I studied at the New Bauhaus in Chicago, so I agree that my work can be said to contain American and German influences, but I do not agree that I have any Japanese traits."[51] Indeed, Ishimoto's work in Chicago

**6.29
PHOTOGRAPHER UNKNOWN,** *Untitled* ("The Photograph"— the first meeting of General MacArthur and Emperor Hirohito, September 27, 1945), 1945. National Archives, Washington, D.C.

The seemingly simple news photograph upset Japanese viewers, who thought that General MacArthur insulted the emperor by dressing too casually. The picture reputedly marked the moment when the Japanese recognized that they had been defeated and that the Americans were in charge.[49] Yet the picture also showed that the Americans would support some form of continuing monarchy.[50]

FOCUS
Photographing the Atomic Bomb

Photographs from the atomic bombings of Hiroshima and Nagasaki did not run in U.S. newspapers on the days these cities were bombed (August 7 and August 9, 1945, respectively, United States time). The pictures that were released on August 11, 1945 were taken from the air by George R. Caron, a tailgunner aboard the *Enola Gay*, the airplane that delivered the bomb to Hiroshima. They were published widely in subsequent weeks, appearing, for example, in the August 20, 1945 issue of *Life*. Though they gave many people their first look at the tall, dome-topped cloud rising 20,000 feet over the city, the Hiroshima images scarcely approximated the mushroom-shaped cloud that emerged as the emblem of the atomic age. A photograph of the Nagasaki explosion that accompanied it in the same issue of *Life* came closer.

Comparisons of the soaring column of dirt and debris that follows an atomic fireball explosion to a mushroom first occurred in military descriptions of the tests preceding the Japanese bombings. In fact, the resemblance began to enter the language vocabulary before the 1946 atomic test on Bikini Atoll that produced a distinctive mushroom shape. The public repeatedly viewed the Bikini blast in photographs as well as through newsreels and television (Fig. 6.30). In a bizarre twist, the Pacific island later gave the famous bathing suit its name.

Aerial views of the destruction at Hiroshima and Nagasaki appeared in the United States within weeks of the bombings, but close-up images of the damage to people and property shot by the Japanese were confiscated by the United States War Department before they could be disseminated. Bits of movie footage, cut from film made by the Japanese shortly after the Hiroshima explosion, were included in an August 1946 newsreel about the Bikini Atoll tests. The *New York Times* reported that one of the images showed victims who appeared "as though they had been seared by an acetylene torch."[52] In that same month, the *New Yorker* published writer John Hersey's vivid chronicle of what he saw in Hiroshima. Pictures made by Japanese photographers were not widely seen by the American public until a 1952 issue of *Life*. When the magazine ran pictures of the first hydrogen bomb explosion in 1954, it also published an editorial tinged with fear and relieved with death-bed humor, reflecting increased public apprehension about the specter of nuclear warfare.[53] The initial public feelings of awe and patriotism following Hiroshima and Nagasaki eroded throughout the 1950s, allowing the anxiety about the atomic bomb gradually to spread. Nevertheless, atomic energy remained a strong, yet contradictory, prospect for the future. To some, harnessing the atom foretold a utopian tomorrow, in which nuclear power freed humans from work and nuclear medicine cured diseases. To others, experiments with the atom launched a growing pessimism about the dark side of human nature.

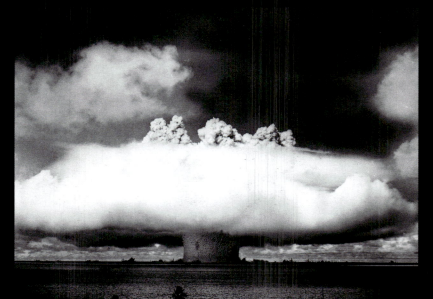

6.30
PHOTOGRAPHER UNKNOWN, *Atomic Cloud During Baker Day Blast at Bikini*, 1946. Gelatin silver print. National Archives, Washington, D.C.

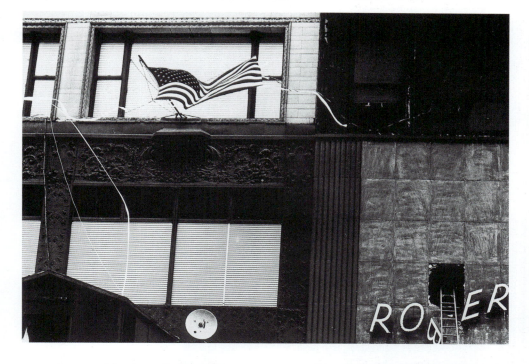

6.32 (right)
DAIDO MORIYAMA,
*Stray Dog, Misawa
Aimori*, 1971. Gelatin
silver print. Gift of
Van Deren Coke.
San Francisco Museum
of Modern Art, San
Francisco, California.

Moriyama's stray dog,
an unwanted and
dangerous animal, is an
outcast and a loner and
blends the photogra-
pher's sense of himself
as an angry outsider
with the perception that
his country is irretriev-
ably conquered. The fig-
ure appears elsewhere
in Japanese postwar
photography and film as
a frightening symbol for
social isolation, as in
Akira Kurosawa's 1949
film, *Stray Dog*.

strongly resembles that of other street
photographers in the postwar period.
Waiting for the exact moments of align-
ment when, for example, shadows
appear to be following the people who
make them, Ishimoto's work recalls
that of European photographers such
as Cartier-Bresson and the work of
Ishimoto's American teacher, Harry
Callahan. Never sentimental, Ishimoto
grasped the feelings of alienation,
self-delusion, and futility expressed
in American photography during the
1950s (Fig. 6.31). Misunderstanding
Ishimoto's disheartened perception of
human relationships, Edward Steichen
put two of his photographs in the exhibi-
tion *The Family of Man*.

Ishimoto's international reputation
was sealed when he published the result
of his six-year-long study of Katsura
Rikyu, the so-called Detached Palace
in Kyoto, Japan. In these images, the
palace from the early 1600s resembles
the spare geometry of modern architec-
ture. Published in 1971, *Katsura: Tradi-
tion and Creation in Japanese Architecture*
was a collaboration with Modernist
architect Kenzo Tange (b. 1913), as well
as Bauhaus artists Walter Gropius,
who wrote an introductory essay, and
Herbert Bayer, who designed the book.

Despite the recovery of the Japanese
postwar economy and the efforts of sev-
eral prominent Japanese photographers
to recuperate postwar culture, Daido
Moriyama (b. 1938) lingered on the

notion of social decline, beginning with
defeat in World War II and the subse-
quent "Americanization" of the nation.[54]
His most famous image is a gravelly pic-
ture of a dirty, exhausted, snarling stray
dog (Fig. 6.32). Like his mentors,
Tomatsu and Hosoe, Moriyama exploits
photography's graphic properties to
express fierce emotion. His images are,
as photographer Leo Rubinfien
observed, "the visual equivalent of nau-
sea, vertigo or horror."[55] Their tilted,
slightly out-of-focus quality shows
Moriyama's acknowledged debt to the
idiosyncratic work of American photog-
rapher William Klein (see Fig. 6.43).

Where Tomatsu's expressionistic
images ultimately rely on the factual
credibility of what was before the lens,
Moriyama's work is radically personal:
"My photographs have always been …
private letters that I write and send to

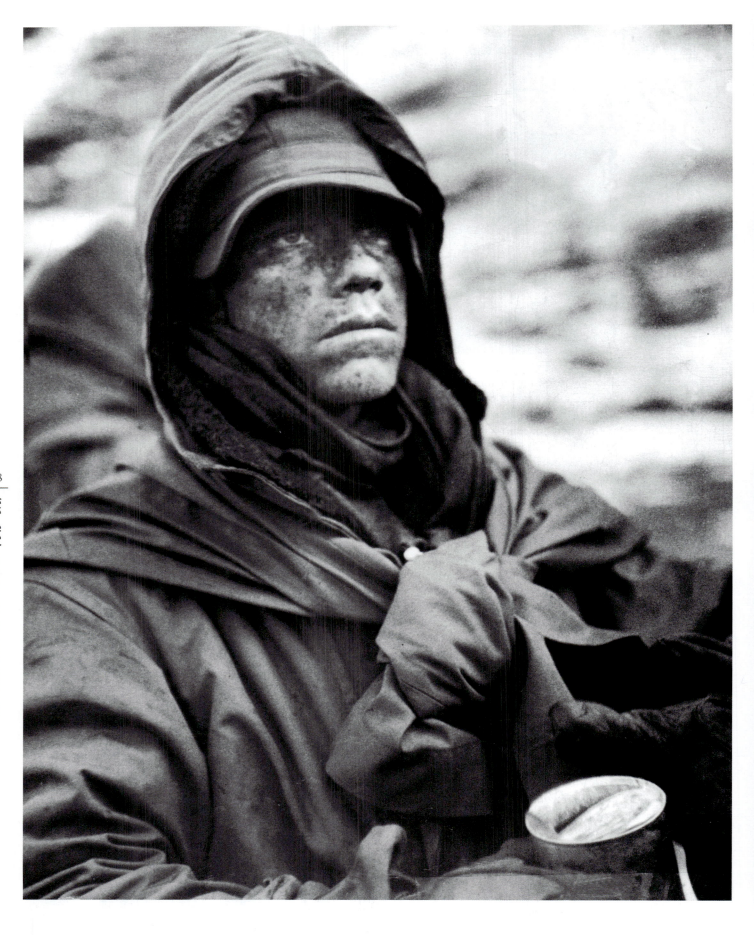

myself," he explained.[56] He once renounced all hope by rejecting photography in a 1972 collection called *Sashin yo sayonara* (*Farewell to Photography* or *Photography, Good Riddance!*), in which pictures were "blurred, too dark, too light, or otherwise hard to read."[57]

THE WEST AND THE COLD WAR

Fear of communism and the threat of nuclear warfare hung over the war in Korea (1950–53), which was the outcome of festering economic and political discontent in North Korea about the Allies' postwar decision to divide the country in two along the 38th parallel. Soviet- and Chinese-supported North Korean troopers battled South Korean and United Nations forces, composed of fifteen nations, including the United States. In contrast to their patriotic photographic coverage of World War II (see Fig. 5.86), newspapers and magazines heightened public fear of nuclear warfare and stirred doubt about the war's goals using anti-heroic images of ordinary soldiers enduring danger far from home. Battle-toughened photographers such as Larry Burrows (1926–1971), Carl Mydans (b. 1907), and David Douglas Duncan (b. 1916) sent back close-up photographs of ordinary soldiers suffering cold, privation, and the death of friends. Duncan's photo-essay for *Life*'s 1950 Christmas issue undermined cozy assumptions about what a Christmas essay should contain. Entitled "There Was a Christmas," it showed an image of a young Marine more as victim than victor (Fig. 6.33).

The Korean War ended in 1953, but international tensions continued to rise. In 1955, the Soviet Union and the eastern European nations of Poland, Czechoslovakia, Hungary, Romania, Bulgaria, Albania, and East Germany signed the Warsaw Pact, a mutual defense agreement. In November 1956, a Hungarian revolt against Soviet occupation was suppressed, and in October 1957 the Soviets launched the space satellite Sputnik 1, proving the superiority of its long-range rockets. In the United States, anti-communist hysteria led to fear that "reds" were infiltrating the nation's institutions. Federal

employees were asked to sign loyalty oaths. Senator Joseph McCarthy still zealously headed the powerful House Committee on Un-American Activities (HUAC), which had subpoenaed prominent entertainers as suspected communists in 1947 and 1951.

The livelihood of many within the arts community was seriously threatened by these investigations. In 1954, McCarthy set out to locate communists in the U.S. Army, a campaign that led to his downfall. After more than a decade of highly visible political photography during the New Deal and World War II, artists and photographers left the fray, having been harassed by the government or discouraged by the slowness of social change. Recalling the 1950s, photographer Lisette Model exclaimed, "It was terrible. You didn't know *what* to photograph."[58] Disgusted with politics and angered by the shallow materialism of what economist John Kenneth Galbraith famously called "the affluent society" in his 1958 book of the same name, many artists, writers, and photographers turned to the inner world of private contemplation.

ANNIHILATION, ALIENATION, ABSTRACTION: AMERICA

As writer Tom Englehardt observed, "from 1945 to 1975 victory culture ended in America."[59] The "heroic war ethos" of 1945 gave way to fear, insecurity, and societal disillusionment. America's inability to end the nightmarish spiral of the arms race slowly undermined the logic of mutually assured atomic destruction and confidence in the nation's place in the world. The national mood was captured in a best-selling book by the sociologist David Riesman. First published in 1950, *The Lonely Crowd* leapt to prominence in a paperback edition of 1953 that sold 1.4 million copies.[60] It warned of a major shift in the American character, a turning away from guidance by an inner compass, toward seeking direction from others. Reisman substantiated readers' worries about the American postwar future. Artist and photographer Ben Shahn (1898–1969), who had made images for the Farm Security Administration, summed up the parallel changes in photographic practice: "during the thirties art had been swept by mass ideas, so

6.33 (opposite)
DAVID DOUGLAS DUNCAN, *Untitled*, cover of *Life* magazine, 25 December, 1950.

The text accompanying David Douglas Duncan's photo-essay noted that the holiday celebration took place in "the valley of the shadow of death," recalling the disastrous charge of the Light Brigade during the Crimean War (see Fig. 3.9). The image was captioned, "This is the face of a man who eats frozen rations in the snow and who may be interrupted at any moment to run, to fight, or to die."

during the forties there took place a mass movement toward abstraction. Not only was the social dream rejected, but any dream at all."[61]

Perhaps the best example of the shift from social documentary to abstraction is provided by Aaron Siskind's work (see pp. 296–97). An active member of the Photo League, and promoter of its famous *Harlem Document* (see Fig. 5.71), Siskind began experimenting in the 1940s with abstract qualities in nature and the built environment. He photographed sites where humans had left their marks, but not the human figure, unless isolated and contorted into an unusual shape. At the same time, he eliminated any hint of narrative content, and worked against the camera's con-

struction of deep perspective, flattening the photographic image as if it were an Abstract Expressionist canvas by an American painter such as Franz Kline (1910–1962), Mark Rothko (1903–1970), or Willem de Kooning (1904–1997), whom he knew and whose artwork he photographed. One of his images was hung at the Ninth Street Show (1951) in New York City, an exhibit that was instrumental in bringing Abstract Expressionism to a wider audience.

As Siskind put it, "the so-called documentary picture left me wanting something." However much close-ups of peeling paint might look like an abstract painting (Fig. 6.34), Siskind insisted that this sort of work was not "a com-

6.34
AARON SISKIND,
Jerome, Arizona, **1949. Gelatin silver print. Aaron Siskind Foundation. Hallmark Cards Inc., Kansas City, Missouri.**

By coming in close to what appears to be peeling paint, Siskind isolated a composition with a central, if abstract figure, balanced by an array of shapes in the upper and lower parts of the picture. The photograph may owe to Siskind's close relationship with Abstract Expressionist painters, who employed thick slashes of paint on their canvases.

6.35
LOTTE JACOBI,
Photogenic, c. 1950.
Vintage gelatin silver
print. Lotte Jacobi
Archives, Dimond
Library, University of
New Hampshire,
Durham, New Hamp-
shire. Courtesy
Hallmark Cards Inc.,
Kansas City, Missouri.

While never a major
trend, abstract pho-
tographs, such as those
produced in Jacobi's
Photogenic series,
repeatedly appeared in
post-World War II
image-making, challeng-
ing the notion that
photography's role is to
record the appearance
of reality. In this image,
Jacobi sketched forms
and created a sense of
depth by moving a
light source over photo-
sensitive paper.

promise with reality. The objects are
rendered sharp, fully textured, and
undistorted (my documentary train-
ing!)." Siskind described the instant of
finding his subjects in the world of
visual experience as "emotional," "psy-
chological," and "utterly personal." He
concluded that "the inner drama is the
meaning of the exterior event." Like
many artists in the 1950s, he sought to
begin anew in primal experience, or as
he put it, to unlearn socially educated
responses so as "to see the world clean
and fresh and alive, as primitive things
are clean and fresh and alive."[62]

While Siskind turned to exploring
the inner world, other artists and writers
looked to indigenous peoples for lessons
on living outside the tainted modern
world. John Collier, Sr., who served from
1934 to 1945 as President Franklin
Roosevelt's Commissioner of Indian
Affairs, helped arrange the landmark
exhibition *Indian Art of the United States*
at the Museum of Modern Art (1941).
The tone for postwar appreciation of
Native Americans was set at that exhibit,
when its organizer René d'Harnoncourt
dismissed the notion of primitivism as a
backward stage of early civilization, and
underscored the moral weight of Indian
culture.[63] John Collier, Jr. (1913–1992),

the commissioner's son, made extensive
and generally unromanticized photo-
graphs among the Navajo people and
among Peru's indigenous peoples.
Similarly, Laura Gilpin (1891–1979),
who spent the greater part of her career
photographing among Native Ameri-
cans in the Southwest, ardently studied
Navajo history and life for her 1968
book *The Enduring Navajo.*

Detached from their origins in
Europe between the world wars,
Surrealism and abstraction became
international visual languages, not only
in advertising, but for a younger genera-
tion of artists. Lotte Jacobi (1896–1990),
who left Germany for the United States
in 1935, combined a career in portrait
photography with the production of
abstractions she called "photogenics."
These resulted from drawing with a
light source, such as a pen light, on pho-
tographically sensitive paper (Fig. 6.35).
Working in Arizona for more than fifty
years, Italian-born Frederick Sommer
(1905–1999) blended Surrealism and
abstraction in psychologically disturbing
images. He photographed still lifes
made from the desiccated corpses of
desert animals, fusing formal beauty
with frightening decay. Like his friend,
the Surrealist Max Ernst (see p. 254),
Sommer experimented with de-forming
the photograph's realism. He superim-
posed images, created *clichés verres,* and
constructed negatives from oil paint
sandwiched between sheets of cello-
phane. Even his straight photographs
look like altered images (Fig. 6.36). Like
Siskind, with whom he photographed in
1949, Sommer favored blocking out the

6.36
FREDERICK SOMMER,
Arizona Landscape,
**1943. Gelatin silver
print. Center for Creative
Photography, Tucson,
Arizona.**

horizon line and focusing on surface texture and flatness.[64] Just as Abstract Expressionists such as Jackson Pollock (1912–1956) brought to center stage the physical process of making art, so Sommer emphasized technique at the expense of realistic description.

As happened in Europe, American Surrealist photography gradually lost its sense of outrage and estrangement, becoming more a means of psychic inquiry and fanciful imaginings. Even though American Jerry Uelsmann (b. 1934) claims that his seamless separate realities draw on what he calls "the darker side of myself,"[65] there are no horrific scenes in his work. A student of Minor White (1908–1976), Uelsmann creates illusionistic images that seem to capture a parallel world, where elements recombine in unexpected, but not repugnant ways (Fig. 6.37). In one print he showed himself in the bathtub as Oscar Rejlander (see p. 154) and as

Henry Peach Robinson (see p. 155), a reference to the nineteenth-century combination-print makers and their efforts to insert visual information into the photograph that the camera was incapable of recording.

Surrealism and abstraction were among a number of strategies for contesting the notions that photography must record the external world, or that it was obliged to support the humanitarian task of social betterment. Minor White, a photographer who sought spiritual insights in poetry, psychological theory, myth, and religion, did not so much reject the material realm as reconfigure it. White thought of photography as a process wherein the visual world was rediscovered as a font of spiritual illumination for those willing to look. Widely seen as a mystic, White nonetheless stressed that the poet-photographer must move beyond self-discovery to communication. Writing to a person

6.37
JERRY UELSMANN, *Untitled* **(Landscape with a floating tree), 1969. Victoria & Albert Museum, London.**

Uelsmann's precise combination-printing techniques allow him to invent alternative worlds in which nature operates in ways contrary to its habits on earth.

6.38
MINOR WHITE, *Empty Head,* from sequence 14 of *Sound of One Hand Clapping,* 1962. Gelatin silver print. Minor White Archive. Princeton Art Museum, Princeton, New Jersey.

White's assimilation of Eastern religions allowed him to bring a contemplative quality to his photography. The *Empty Head* is more than a wondrous shape made up of ice crystals. It refers to the emptying out of the noisy self during the practice of meditation.

seeking his advice, White counseled: "Your photographs are still mirrors of yourself. In other words your images are raw, the emotions naked. These are private images not public ones. They are 'expressive' meaning a direct mirror of yourself rather than 'creative' meaning so converted as to affect others as mirrors of themselves."[66]

White much admired Stieglitz's photographs, especially the series known as *Equivalents* (see Fig. 4.25), in which he used cloud shots to intimate inner states. Like Stieglitz, White insisted that photographs could be much more than literal transcriptions of optical reality, and he preferred to work in series of images arranged to form complex poetic meanings. He began making "sequences" soon after returning from service in World War II, and this "cinema of stills" became his basic unit.[67] Wanting a more interactive interpretation of his work, White often spoke of "reading" photographs, not merely glimpsing them. In the 1940s, he was already numbering his sequences, some of which were personal explorations of homoerotic desire that were never publicly exhibited during his lifetime. The order of individual photographs within a sequence was not fixed, but changed from time to time. Certain themes recur in his work, such as the fleeting performances of natural light. Ordinary doors and windows open on to unanticipated glimpses of fantastic yet momentary illumination (Fig. 6.38).

At the end of the nineteenth century, White might have been a Pictorialist, locating spirituality in suggestive haziness. Instead, he looked to the intensely detailed views and vigilant printing methods of Ansel Adams (see pp. 276–77) and Edward Weston (see pp. 278–80), and to their use of the straight photograph to convey metaphysical meaning. In the postwar period, when social reform efforts were too often misconstrued as communist ventures, White became a spiritual activist. His teaching at institutions on the East and West coasts, and curatorial position at George Eastman House in Rochester, New York, allowed him to encourage personal insight and spirituality among photographers, and to promote the use of photography as metaphor or symbol. In 1952, White became editor of *Aperture,* a magazine devoted to art photography, which he founded along with others, including Dorothea Lange and Ansel Adams. Although his work was criticized by postmodernists in the late twentieth century as "mystical trivia,"[68] White's influence on photography endures in the meditative fine printing of his students, such as Paul Caponigro (b. 1932) and Jerry Uelsmann.

The Americans

Minor White's spiritualism was not the only personal approach to photography to have a lasting impact on the medium. The photographs of Swiss-born photographer Robert Frank (b. 1924) induced many young photographers to cruise the streets and highways of America looking for pictures. A commercial and fashion photographer when he came to the United States, Frank also made his own work, which came to Steichen's attention while he was selecting images for *The Family of Man* exhibition.

In 1955, the year of the exhibit, Frank began the first of several road trips around the United States, where he made pictures that would unravel the certitude of documentary photography as practiced by the F.S.A. photographers

and the picture press. Where Depression-era documentarians witnessed a troubled yet resilient America, summed up in such images as Lange's *Migrant Mother* (see Fig. 5.55), Frank saw a soul-damaged population, fluctuating between violence, ignorance, and despair. In the collection of these images called *The Americans* (French edition, 1958; American edition 1959), first published in France because no American publishing house would issue it, Frank transformed tokens of American postwar prosperity, such as automobiles and television sets, casting them as conduits of an insidious commercialism that was profoundly alienating individuals from each other and from the wider society. In this way, he can be seen as part of a wider artistic resistance movement, which included the Beat poets and novelists, engaged in the struggle to find alternatives to the power of consensus-based art forms. Despite Frank's recurrent images of motion and communication, such as highways or telephones, the people in *The Americans* seem stuck in one place: the loneliness of their own psyches. As Peter C. Mazio observed, "The only mobile person in Robert Frank's *The Americans* is the artist himself."[69] In his book, American flags sometimes fly in the faces of observers, obscuring their vision, and people seldom find eye-contact with each other (Fig. 6.39).

Rather than the clear, detailed pictures of photojournalism and the documentary tradition, Frank's prints are often gritty, tilted, and blurred. Shot with a 35mm camera, which allowed him to take pictures quickly and secretly, they have an unpremeditated look that —like the action paintings of Jackson Pollock—combines great intensity with a free, risky handling. *The Americans* does not progress through a legible visual narrative, but consists of fragmented "indecisive" moments experienced by the photographer. For some viewers, Frank's focus on ragtag Americans, and his apathetic attitude toward the craft of photography, was tantamount to "un-American" behavior of the kind persecuted by McCarthy's committee.

With the wider circulation of a 1960s American edition, and subsequent republications that kept the book in print, Frank's photographs gained a wide intellectual presence as a protest against numbing mass culture, materialism, and social conformity. The preface to this United States printing was written by Beat generation writer Jack Kerouac (1922–1969), whose jittery romantic novel of the American highways, *On the Road*, was published in 1957 and featured Frank as one of its characters. Kerouac's hipster language, reeled off in streams of association, like a poem by Allen Ginsberg (1926–1997), located the authenticity of the pictures in their apparently impromptu nature, reminiscent of jazz improvisation.

Kerouac also drew Frank—and photography—into the sphere of American existentialism and Beat generation hauteur, with its emphasis on cool, self-absorbed rebelliousness in the face of narrow social conformity. In effect, Kerouac suggested that Frank's photographs could be savored like serious avant-garde literature, which assailed the deeply rooted American tradition of rural innocence and integrity, and prophesied the coming of shabby morality and self-delusion to the American heartland. Like his mentor, Walker Evans (see pp. 282–84), whose *American Photographs* (1938) pictured automobiles, graveyards, and luncheonettes as signposts of American feeling, Frank became a photographer-hero, both for his vision and for his lifestyle, which reflected personal discoveries. Evans had, in fact, helped to obtain for Frank the Guggenheim Fellowship that allowed him to make the trips on which *The Americans* was based.

In 1962, Frank remarked that "photography is a solitary journey. That is the only course open to the creative photographer. There is no compromise: only a few photographers accept this fact."[70] Taking a cue from the New York Abstract Expressionist painters and Beat generation poets, among whom he lived and worked in the 1940s and 1950s, Frank believed that anti-authoritarianism was a basic form of political resistance. How one lived was far more consequential than overt political action. In the 1960s, he moved away from photography to filmmaking. Ultimately he left the United States for a remote area of Nova Scotia, Canada, where he continues to make photographs and films.

6.39 (opposite)
ROBERT FRANK, *Drug Store, Detroit,* 1955, pl. 147 from his book *The Americans,* 1959. Gelatin silver print. Courtesy Pace McGill Gallery, New York. © the artist.

The Americans captures the sense of unfulfilled lives and spiritually vacant environments of the post-World War II period. Whether by accident or design, contemporary issues sometimes intrude on Frank's work, as in this view of a lunch counter where white men are served by African-American women, who would not be welcome to eat at the counter they serve.

On the Streets

6.40 (opposite)
HARRY CALLAHAN,
Chicago, **1961. Gelatin silver print.**

Shooting from below so as to accentuate the jumble of lines created by the tall buildings and splaying streetlight, Callahan focused on the determined facial features of the shopper. The floral pattern on her dress contrasts with an environment that has rebelled against nature.

Street photography is as old as the medium itself; one of Daguerre's early images shows a Paris Boulevard (see Fig. 1.13). But in the postwar period, street photography was increasingly practiced by art photographers who discovered in the shifting crowds on America's city streets countless images that expressed the photographer's inner feelings or evinced the seedy materialism of postwar American culture. Harry Callahan (1912–1999), Siskind's colleague at the Chicago Institute of Design, found fresh material on the streets through what he called "seeing photographically."[71] Callahan's brooding street photographs are crammed with

stark contrasts of black and white, allowing few middle gray tones (Fig. 6.40). While he viewed the city as tense and inhospitable, he could shift outlooks to savor lyrical flashes of beauty in humble tufts of grass, elegant lines drawn by utility wires against the sky, or the graceful features of his wife's form (Fig. 6.41).

Although Callahan's influence was felt throughout American photography, street photographers were generally more enchanted with what became known as the "snapshot aesthetic," an apparently uncomposed everyday subject, illuminated only with available light, and taken in a way that mimics instantaneous sight. Although the trend toward making these seemingly casual and unprepared, sometimes blurry, and often deliberately imperfect pictures owes to the influence of Frank's *The Americans,* several photographers had earlier explored the snapshot aesthetic.

For example, when Roy DeCarava (b. 1919) worked on the photographs for the book *The Sweet Flypaper of Life* (1955), with a fictional text by writer Langston Hughes, he balanced posed portraits with unrehearsed scenes on Harlem's streets and in people's homes. Neither Hughes nor DeCarava attempted to make a sociological report or to advocate reform measures. Each insisted on rendering Harlem artistically.[72] Thickly shadowed or blurred images alternate with studies of sharply delineated light and shade. In DeCarava's work, the snapshot aesthetic merged with Cartier-Bresson's "decisive moment." The mixture is apparent in a shot showing an elegantly dressed young woman on her way to her graduation (Fig. 6.42).

The former painter William Klein (b. 1928), who spent most of his career abroad, had begun to snatch cheerless images along New York City's streets before Frank published *The Americans.* Klein conceived his early work in book form, where he would have greater control of the printing and arrangement of his images, as in his self-published *Life is Good and Good for You in New York: William Klein Trance Witness Revels* (1956). Less well known than Frank, Klein was even more experimental in his camerawork. He distorted the image, over-exposing with a flash, or

347

THE WEST AND THE COLD WAR

6.41 (left)
HARRY CALLAHAN,
Eleanor, **1947.**
Gelatin silver print.

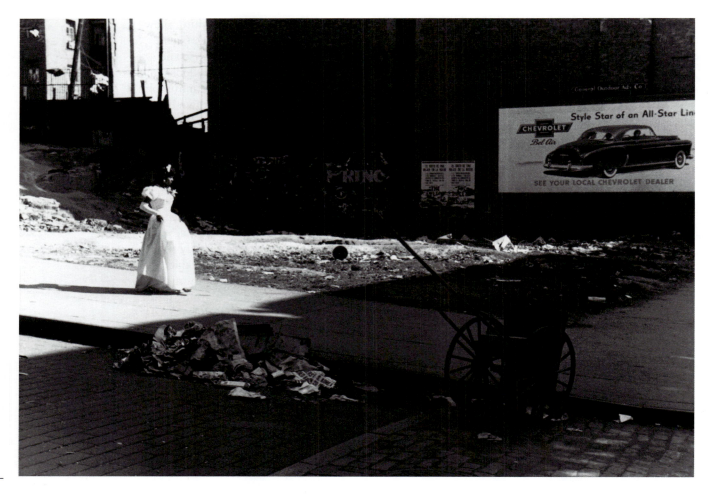

6.42
ROY DeCARAVA,
Graduation, 1949, from
his book *The Sweet
Flypaper of Life,* 1955.
George Eastman House,
Rochester, New York.

Some of DeCarava's
photographs are so
thick with shadow that
forms are barely visible.
In this image, however,
the girl's pleasure on
the way to a graduation
is highlighted in a
wedge of light that
pierces the desolation
of the empty lot. The
billboard does double
duty, as a caption for the
girl's achievement, and
as an ironic contrast
with its surroundings.

deliberately using wide-angle lenses for
close-ups, in order to blur or stretch
shapes (Fig. 6.43). Self-taught, Klein
bypassed prescribed methods of taking
pictures and looked to the tabloids.
"My aesthetics was the New York *Daily
News,*" he wrote. "I saw the book I
wanted to do as a tabloid gone berserk,
gross, grainy, over-inked, with a brutal
layout, bull-horn headlines."[73]

The impertinent tabloid photographs
Klein enjoyed may have been made by
Weegee, the nickname of Austrian-born
Arthur Fellig (1899–1968), who sold
his specialty, raw crime-scene photogra-
phy, to many New York newspapers. His
well-deserved moniker derived either
from the squeegee he used in one of his
first jobs as a darkroom assistant, or
from the ouija board, a device thought to
predict the future. With a short-wave
radio in his car and home, Weegee mon-
itored police broadcasts and arrived so
quickly on the scene that he seemed
able to anticipate the crime. Weegee's
New York is a place of barely submerged
brutality, fear, and confusion (Fig. 6.44).
Weegee became an art-world celebrity,
who exhibited and lectured at the

Museum of Modern Art in New York.
His sensational images of crime and
violent death, rendered in the harsh
light of the exploding flash, were not
unique, however. The ubiquitous tabloid
newspapers established a stylish visual
vocabulary and cast of urban characters
(corpse, cop, and criminal) that encour-
aged *films noirs* such as *Murder, My*

6.43
WILLIAM KLEIN,
*Swing and Boy and
Girl,* New York, 1954.
© William Klein. Gelatin
silver print. Howard
Greenberg Gallery,
New York.

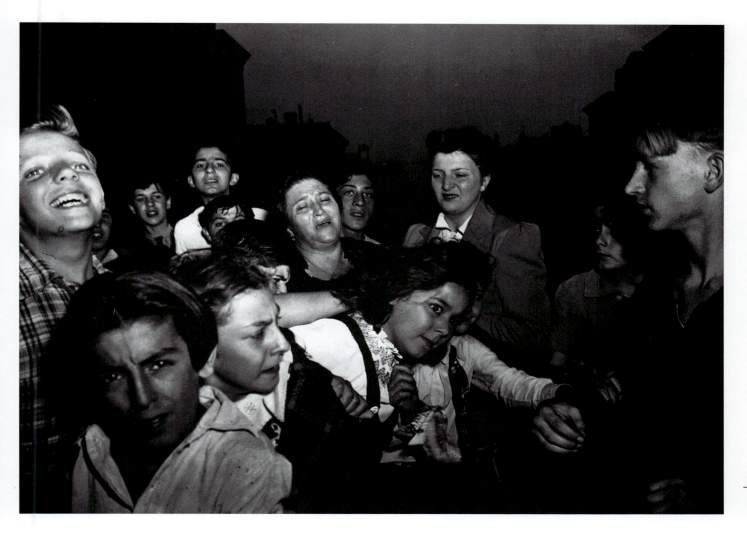

Sweet and *Double Indemnity*, both released in 1944, and *The Naked City*, adapted from Weegee's 1945 collection of photographs with the identical title.[74]

The Social Landscape

The appearance of a new photographic trend, indifferent to social reform but acutely focused on the qualities of camera vision, was recognized in 1966, at the Brandeis University exhibition *Twelve Photographers of the American Social Landscape*. The show gave the style its name, and was quickly followed by another compendium at George Eastman House, Rochester, New York where curator Nathan Lyons opened *Toward a Social Landscape* (1966). Soon after, the Museum of Modern Art mounted its exhibition *New Documents* (1967). In these presentations, Lee Friedlander (b. 1934) emerged as a major figure. He was impressed by Frank's *The Americans*, and made his own road trip around the United States, shooting cemetery stones and memorial

statues for an elegiac project called *The American Monument* (1976). Friedlander admired Weegee's hardheaded urban dramas and André Kertész's grasp of visual coincidence (see pp. 261–62). He balked at supplying viewers with clear visual clues with which to decipher his work. Whether picturing the jumble of signs and traffic on the street, or layers of reflections in the glass of storefronts, Friedlander obscurely hinted at a story, only to fall back on an exercise in camera vision. He saw photography as a picture-making system with rules as peculiar to itself as painting. Just as the painter's brush leaves marks on the canvas, so the camera leaves marks of its rectangular framing device, the kind of lens used, and the chemistry of the film and processing. In *New Orleans* (1968), Friedlander toyed with the photographic tradition of deep perspective (Fig. 6.45). He frequently includes his reflection or shadow in his work, not to indicate that the image is a personal metaphor for a state of mind or emotion, but to demonstrate that it is a picture made with the

6.44
WEEGEE (ARTHUR FELLIG), *Their First Murder***, October 9, 1941. Gelatin silver print.**

Weegee photographed murder and mayhem for tabloid newspapers. His signature style often included an array of human reactions, from shock and grief, to excitement about the chance of getting one's picture in the newspaper. He liked to include bystanders, who, in their ability to ignore death and human suffering, and become ghoulish voyeurs, acted as surrogates for newspaper readers.

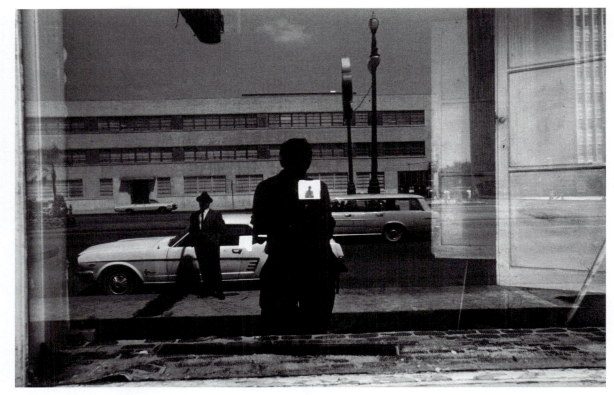

6.45
LEE FRIEDLANDER,
New Orleans, 1968.
Gelatin silver print.

Friedlander never lets
the viewer forget that
the photograph is a con-
scious construction of
reality. In this image, the
photographer stands
in front of a plate-glass
window taking a picture
of the man and the
street behind him, as
well as of a small picture
inside the shop. The
viewer's eyes move back
and forth trying to
establish a point of view.

camera whose outlines often show in
the print.

More blunt than Friedlander, Garry
Winogrand (1928–1984) was also
among the new social landscape image-
makers. Like Friedlander, he did a stint
as a photojournalist for the picture
press. One of his images, an uncompli-
cated view of a couple frisking in the
water at a bathing beach, was included
in *The Family of Man*. It did not give an
inkling of the psychologically complex
and tense series of street photographs
that he would begin in the 1960s.
Winogrand is often quoted as saying "I
photograph to find out what the world
looks like photographed."[75] Where
Friedlander's work resembles fortu-
itously found collages, Winogrand's pic-
tures homed in on human gestures and
body stances that indicate interpersonal
tension and inner turmoil. Sometimes
his caustic view of human nature is
echoed in abrupt cropping of the image,
or in shots where the camera has been
tilted.

Winogrand asserted that the photo-
graph was not simply a window on the
world but a new fact. His fear that the
subject-matter of the street might over-
whelm his investigation of photogra-
phy's unique picture-making qualities
was well-founded.[76] In his image of a
man with multiple amputations

(Fig. 6.46), the chance arrangement of
figures, oddly reminiscent of a *tableau
vivant*, is not so compelling as to blunt
the tense human implications of the
scene.

Comparing the work of Friedlander
and Winogrand to European street pho-
tographers, such as Kertész, one can see
that the American work tips the balance
between form and narrative toward
form, and tilts the scales between indi-
vidual expression and neutrality toward
neutral vision, or disinterested irony.
What remains personal in much social
landscape photography is the selection
of the picture, especially so because
Friedlander and Winogrand both
exposed many rolls of film and picked
the picture from contact sheets.

The influence of the social landscape
photographers was felt throughout the
1960s, but it did not completely obliter-
ate the work of street photographers
with a greater interest in content and
personal point of view. For example,
when Austrian-born photographer
Lisette Model (1901–1983) emigrated
to the United States in 1938, she had
already polished her observation of
human foibles and vanities. In France,
where she had lived since 1926, Model's
lens recorded the self-delusions of the
rich and fashionable as they lounged in
the fancy resort area of Nice. In New

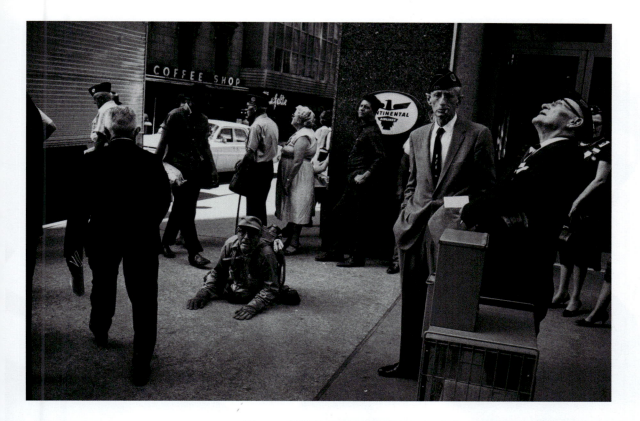

6.46 (above)
GARRY WINOGRAND, *American Legion Convention, Dallas, Texas, 1964.* Gelatin silver print. Museum of Modern Art, New York.

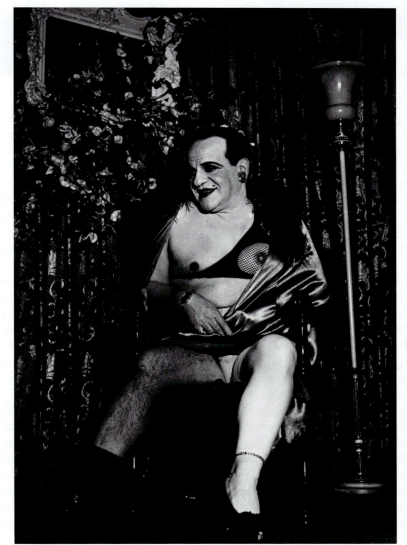

6.47 (right)
LISETTE MODEL, *Albert-Alberta, Hubert's Forty-Second Street Flea Circus, New York, c. 1945.* Gelatin silver print. National Gallery of Canada/Musée des Beaux-Arts du Canada, Ottawa.

Model was unsparing in her portraits, focusing on departures from the norm, as in this photograph of a freakish character who was an attraction at a 42nd Street dime museum.

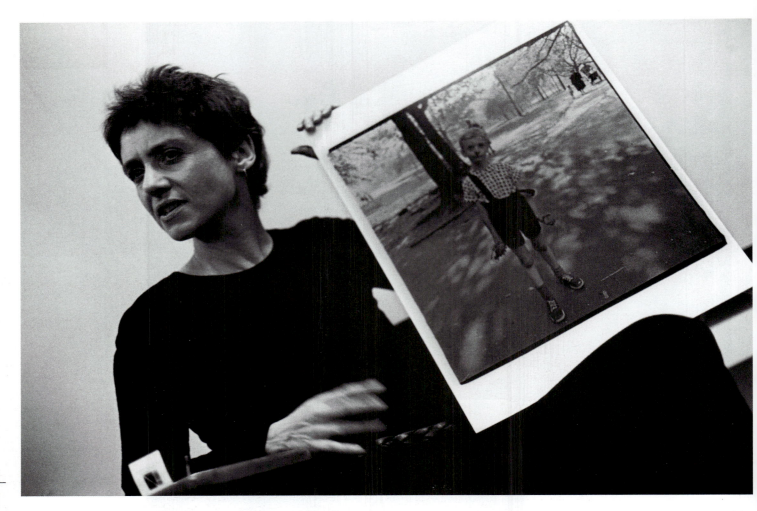

6.48
STEPHEN FRANK,
Untitled **(Diane Arbus with her photo of a boy holding a toy grenade in Central Park, New York), 1970.**

When Diane Arbus lectured at the Rhode Island School of Design in 1970, she showed several of her photographs to the assembled students. One of them, Stephen Frank (b. 1947), took this picture of Arbus with her print of a grimacing boy holding a toy grenade in Central Park. His threatening appearance is made all the more chilling when juxtaposed with the young family approaching in the distance, the very semblance of normality.

York, she showed her work at the Photo League (see pp. 296–97), and continued to be fascinated by those who are infatuated by glamor, including people on the margins of society (Fig. 6.47). Because she was not able to make a living with her art and freelance fashion work, Model turned to teaching in 1949, eventually becoming one of New York City's leading photo-educators.

Among her students was Diane Arbus (1923–1971), who took private lessons from Model, and also studied with her at the New School for Social Research. Arbus responded to what she saw as Model's hard-boiled audacity and courage to confront extremes in human situations. In addition, Arbus sharpened her nerve when she accompanied famed New York tabloid ace Weegee on his assignments to photograph murders. Included with Friedlander and Winogrand in the 1967 *New Documents* exhibition at the Museum of Modern Art, Arbus's work was more personal, transforming the social world into a visual terrain to be mined for metaphors resonating with her inner feelings.

Arbus turned normalcy on its head, making the ordinary bizarre and naturalizing the unusual. In her photographs of people, many of them made while she roamed the streets of New York, clothes and cosmetics are futile efforts to camouflage psychic emptiness or damage. When Arbus photographed children, she revealed them as little versions of bad-tempered, mean-spirited adults (Fig. 6.48). On the other hand, her photographs of people at the margins of society, such as female impersonators, show them to be more virtuous for having unmasked their subjective inclinations. For Arbus, marginal people were symbols for her own psychological fragility and trauma.

During the postwar period in American photography, Arbus was not alone in undermining sentimental ideas of the innocence of childhood. Ralph Eugene Meatyard (1925–1972) coaxed children to wear weird masks that did not so much conceal their innocence as reveal their strangeness (Fig. 6.49). Teenage life became a regular subject in the work

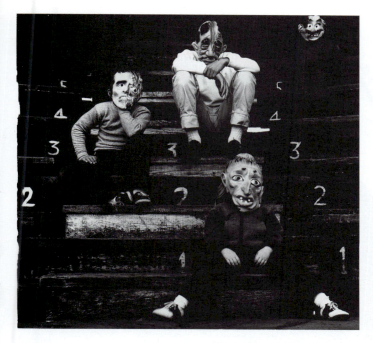

of many street photographers, including Bruce Davidson (b. 1933). Davidson spent months chronicling the lives of a Brooklyn gang called the Jokers, and two years photographing the homes of families living on New York City's East 100th Street (Fig. 6.50). Like many photographers of his generation, Davidson was inspired by Frank's *The Americans*: "in it I saw an America that diminished the dream and replaced it with piercing truth. It was hard for me to endure those bitter, beautiful photographs, for I had still within me the dream of hope and sympathy that I had found in the widow, the dwarf, and the gang."[77]

Davidson's resilient empathy reveals itself in his New York City photographs, which dwell on the strong community and family relationships that persist in

**6.49 (above)
RALPH EUGENE MEATYARD**, *Romance (N) from Ambrose Bierce, No. 3*, 1962. Gelatin silver print. George Eastman House, Rochester, New York.

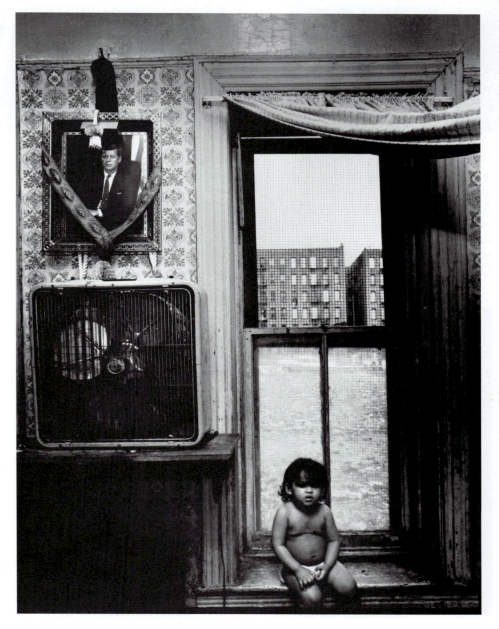

**6.50
BRUCE DAVIDSON**, *Untitled*, from his book *East 100th Street*, New York, 1966–68.

Davidson was one of the few photographers adept at blending the dark outlook of postwar photography with the attentive humanism of the Depression era. Using a large-format view camera and a flash, he spent two years photographing life on East 100th Street in New York City, where he balanced scenes of hardship with those of hope and endurance.

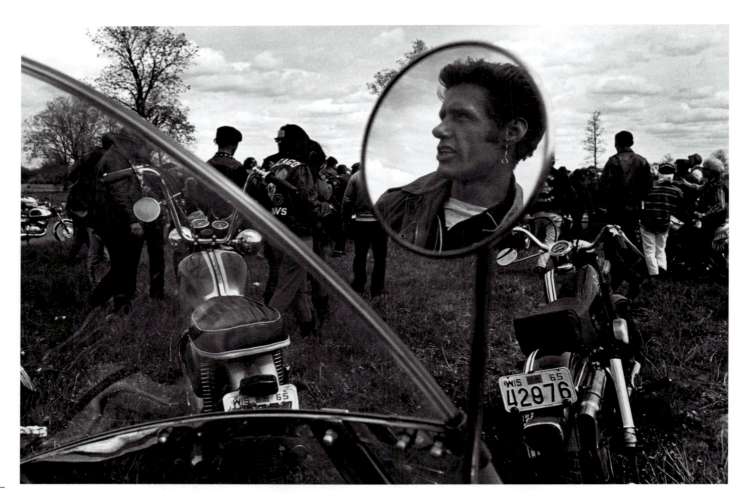

**6.51
DANNY LYON,**
Cal, Eikhorn, Wisconsin,
**1966. Gelatin silver
print.**

the face of deprivation. His approach stands in sharp contrast with that of other photographers who prowled American streets to expose living symbols of alienation and despair. As historian Jonathan Green observed, "the icons of the sixties have few redeeming features: the dwarf, the freak, the prosti-

tute, the disenfranchised, the outlaw motorcyclists, the drug addict, the insane, the retarded, the prisoner, the napalmed child, the brutal cop, the assassin's assassin."[78] Danny Lyon (b. 1942), who assisted Robert Frank with filmmaking, chronicled motorcycle gangs in his own work. He presented

**6.52
LARRY CLARK,**
Tulsa Portfolio, **1972.
Gelatin silver print.**

Clark's photographs of the deteriorating lives lived by drug dealers and users in Tulsa, Oklahoma, assailed the bright humanism of Depression-era documentary photography. In this image, in which a man lies in pain from an accidental gunshot wound, the viewer's sympathies are pulled in different directions.

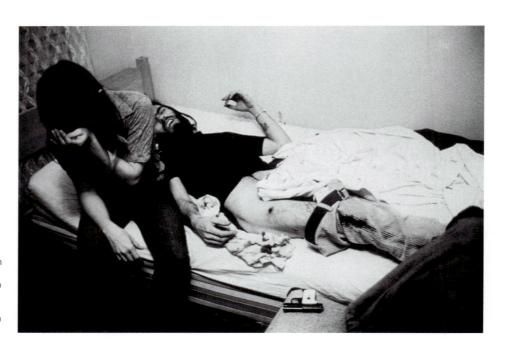

In her photographs of poor and ethnic neighborhoods in New York City, Levitt focused on street life, and, especially, the interactions of children. Her debt to Henri Cartier-Bresson, who was living in New York when Levitt began photographing, shows in the contrast between the obviously pregnant young woman, and the insouciant smile of the girl carrying milk bottles at breast height.

tional in their amiable, bemused observations, an attitude more familiar in the work of European photographers.

Many postwar photographers worked in extensive series based on life experiences, be they road trips, or observations gained through insight and meditation. The scope of these series, dramatized by the photographer's unique perspective on how to order the images, propelled the photographic book into prominence. The rhythm, connections, and contradictions of form and subject generated by sequenced images had a lasting impact on contemporary photographic practice. In the work of Duane Michals (b. 1932), the photographic sequence blended with two other postwar trends, the deliberate staging of scenes to be photographed, and the addition of text, not as an explanatory caption, but as an integral part of the work. A successful advertising photographer, Michals developed a signature blend of photography and the film frame during the late 1960s. His book *Sequences* (1970) contains arrangements of images that narrate appearances of spirits and passages between life and death. Like many postwar photographers, Michals favored a palette of dense black, hazy grays, and form-dissolving light (Fig. 6.54).

Suburbia

Postwar prosperity fueled the migration of Americans from the cities to the suburbs, where the prospect of green space and domestic comforts was underwritten by the larger hope of rising to a higher social class. As historian David Halberstam wrote, many in the freshly minted middle class "were children of people who never owned a home and who had rented cold-water flats in the years before the war."[80] In the American West, long a symbol-laden landscape in art and photography, the spectacular banality of regularized suburban houses suddenly springing up in formerly open expanses caught the critical eye of photographers such as Lewis Baltz (b. 1945) (Fig. 6.55) and Robert Adams (b. 1937), who preferred the distanced view and a seemingly neutral style, the visual analog of their prosaic subjects (Fig. 6.56).

This approach to landscape photography was reported in an influential 1975 exhibition, *New Topographics:*

these young people as rebels whose choice to live outside middle-class social values paid off in strong bonds of companionship (Fig. 6.51).

Perhaps the most disturbing images of teenagers were rendered by Larry Clark (b. 1943), who gained fresh notoriety for his 1995 film *Kids,* which features explicit scenes of underage drug use and sex. His 1973 book *Tulsa* covered similar territory: it is a firsthand account of the time he spent among drug-users, some of whom were his friends (Fig. 6.52). While postwar photographers, such as Lyon, spent extensive time among their subjects, Clark personally sampled the drug culture he imaged. His candid photographs provoked negative reactions, in part, as critic Joseph Marshall observed, because "Clark implied what [Robert] Frank didn't say … that getting high, despite its social costs and its dangers, is an appropriate response to the banal meaninglessness of American life."[79] Compared to this abrasive nihilism, Helen Levitt's (b. 1913) sometimes whimsical, always compassionate, street photographs of children (Fig. 6.53) are excep-

6.54 (opposite)
DUANE MICHALS,
The Bogeyman, 1973.

Michals staged events
to be photographed, so
as to produce a narra-
tive series of images
telling about psycho-
logical fears and obses-
sions. In this sequence,
the child reading, per-
haps about monsters,
is carried away by a coat
transformed into
a phantom.

6.55
LEWIS BALTZ,
*Southwest Wall, Ware,
Malcom, & Garner,*
from *The New Industrial
Parks Near Irvine,
California,* 1974.
Collection Centre
Canadien d'Architec-
ture/Canadian Center
for Architecture,
Montreal, Canada.

Photographs of a Man-Altered Landscape,
at Eastman House in Rochester. The
drab, dispassionate images in this show
rebutted the sometimes lush, some-
times sublime attitude toward the land
expressed in a photographic tradition
derived from nineteenth-century
images of the American West. In addi-
tion, the neutral vision that framed
New Topographics linked photography
with the international art movement
called conceptualism (see p. 377), and

6.56
ROBERT ADAMS,
*Newly Occupied Tract
Houses, Colorado
Springs, Colorado,* 1969.

Many American suburbs
were built in the decade
following World War II.
Their rapid appearance
in isolated clumps
surrounded by open
landscape attracted
photographers, who
implicitly contrasted
the open and vacant
suburban terrain with
the congested urban
environment.

6.57
BILL OWENS, *Untitled,*
from his book *Suburbia,*
1972, 1999.

Owens's suburban
images balance between
parody and commisera-
tion. He was alert to
the range of feelings
brought forth in the new
surroundings, and to
the intrusion of public
events into private lives.
Holding a baby in the
midst of a messy
kitchen, this woman
argues, "How can
I worry about the
damned dishes when
there are children dying
in Vietnam?"

helped accelerate the acceptance of cam-
erawork in academia and the art world.

In a series of photographs published
in the book *Suburbia* (1972, 1999), Bill
Owens (b. 1938), a photographer for a
small newspaper in Livermore, near the
Bay Area of California, portrayed not
only the look of the suburbs but also the
dreams, longings, and discontents of the
residents. Owens admired the visual
sociology of the F.S.A. photographs, and
his work is replete with small, telling
details.[81] Ungroomed nature is threaten-
ing: one photograph shows a teenager
straddling the branches of a small tree,
shaking off all the leaves to be raked by a
second lad below. In another picture, a
couple sits in a garage crammed with
motorcycles and other vehicles. In the
quotation accompanying the photo-
graph they mellowly remark "We enjoy
having these things." When Owens
moved inside suburban homes, he
found the focus of the modern living-
room to be the television set, mostly left
on and disgorging advertisements, foot-
ball, old movies, space launches, and
occasional glimpses of a grimly deter-
mined President Richard Nixon (1913–

1994). Owens not only captured the
tackiness of furnishing and ubiquitous
polyester clothing, but also the dissent
and dislocation of suburbanites, whom
he does not patronize or stereotype.
An African-American woman notes that
her children are growing up without
an anchor in black culture; a Chinese-
American family cannot find Asian gro-
ceries nearby. Teenagers grumble that
there is nothing to do in the suburbs.
The impact of the national mood is
caught in women's complaints about
staying home and taking care of chil-
dren (Fig. 6.57).

TECHNOLOGY AND MEDIA IN POSTWAR AMERICA
Color Photography and the Polaroid Process

The concluding segment of Steichen's
The Family of Man exhibition disrupted
the long chain of black-and-white pho-
tographs with a large color transparency
of a hydrogen bomb explosion. Before
the war, and in the decade after it, maga-
zines such as *National Geographic* used
color transparencies. Magazine advertis-
ing occasionally appeared in color, and

Avedon's long relationship with the fashion magazine *Harper's Bazaar* allowed him to try out color as much as—or more than—any experimental photographer of the period. His palette derived from trendy colors of the time, including hot pink, which he helped spread through the clothing and cosmetics industries.

APRIL 1965　HARPER'S　75¢

BAZAAR

**WHAT'S
HAPPENING?**
OP
and
**TOP
FASHION**
**FRUG
THAT
FAT
AWAY:**
Death
of
the
Diet
**BEAUTY
BLAST-OFF:**
Lunar
Glow

fashion photographers leapt at the chance to use color to depict clothing and to glamorize settings. Horst P. Horst (see p. 272), Paul Outerbridge (see p. 266), Richard Avedon (b. 1923) (Fig. 6.58), and Avedon's student, Japanese-born photographer Hiro (b. 1930) (see Fig. 6.0) electrified the pages of large-format fashion magazines with strong color accents. Soon color slipped the bonds of description and was used by image-makers such as photographer and art director Bert Stern

(b. 1929) to contrive seductive advertisements in which bright color saturates the whole environment (Fig. 6.59). Similarly, Deborah Turbeville (b. 1937) created her own distinctive cool-toned colors and dusky atmosphere for fashion shoots, and contrived scenarios for the models to perform (Fig. 6.60).

Natural light and hues seemed particularly suited to color work. Radiant pops of chromatic light were rendered in transparencies by Minor White, who even planned programs of dual-screen

**6.59
BERT STERN,** *Martini and Pyramid,* **1955. Dye-transfer print.**

Necessity was the mother of Stern's inventive treatment of a cocktail made with Russian vodka. During the Cold War, Russian products seemed un-American. Stern's solution was to make the vodka seem un-Russian, by photographing chic, exotic settings.

**6.60
DEBORAH TURBEVILLE,** *Radio City Music Hall, New York,* 1981.

October 3, 1858

Standing on the railroad I look across the pond to Pine Hill,
where the outside trees and the shrubs scattered generally through the
wood glow through the green, yellow, and scarlet, like fires
just kindled at the base of the trees,—a general conflagration just fairly
under way, soon to envelop every tree. The hillside forest is all aglow
along its edge and in all its cracks and fissures, and soon the
flames will leap upwards to the tops of the tallest trees.

6.61
ELIOT PORTER,
October 3, 1858, **from
Henry David Thoreau's
book** *In Wildness Is
the Preservation of the
World*. **Sierra Club
Books, San Francisco,
California, © 1962.**

The title of Porter's
book, taken from the
writing of nineteenth-
century American essay-
ist and poet Henry
David Thoreau (1817–
1862), praised nature as
both a spiritual and
material resource.
Throughout his book, he
juxtaposed quotations
from Thoreau with
intensely colored
images of nature.

projection for his work. Eliot Porter (1901–1990), who used color transparencies and the cumbersome but more permanent DYE-TRANSFER system, collected his nature views in the book *In Wildness Is the Preservation of the World* (1962) (Fig. 6.61), and in large-sized or "exhibition format" prints, both of which were sponsored by the Sierra Club.

Despite color's intermittent successes, in the 1950s and early 1960s most magazines continued to run black-and-white images, which were less expensive and less time-consuming to produce. In 1955, the year of *The Family of Man*, color film that a photographer could process had been available for less than a decade. To promote the use of color film, the Kodak company then attempted to persuade leading photographers such as Ansel Adams, Paul Strand, Charles Sheeler, and Edward Weston to try it by commissioning images from them. When the firm wrote to photographer Weston, asking if he would make an 8 × 10 inches Kodachrome print, Weston reluctantly agreed, saying that he loved the landscape around Point Lobos in California so much that he would have abhorred

seeing "it murdered in color by an 'outsider.'"[82] Weston accepted an offer from Kodak to revisit some of his favorite spots, where he rendered images that showed a visible tension between the descriptive powers of color and the expressive qualities of line (Fig. 6.62). Weston's anxiety about color film was grounded in what he perceived as its greater realism, that is, its more comprehensive resemblance to the world of experience.

Walker Evans remained resistant to the process throughout the 1960s. He railed against "screeching hues," and the "bebop of electric blues, furious reds, and poison greens," and asserted that "there are four simple words which must be whispered: color photography is vulgar."[83] Like other art photographers, Evans thought that color was too embedded in commercial culture to be used by serious artists.

Despite these reservations, Evans did experiment with color. During his postwar years as a photographer with *Fortune* magazine, he issued portfolios of photographs that he hand-tinted so as to control the selection and strength of the color. In the early 1970s, Evans began to try Polaroid film and cameras.

6.62 (above)
EDWARD WESTON, *Waterfront, Monterey*, **1946. Silver dye bleach print
(Cibachrome). Center for Creative Photography, University of Arizona,
Tucson, Arizona.**

The black-and-white linear elements of this image, like the masts and lines,
set off the color of the boat and the water. Nevertheless, Weston was skeptical
about color photography, holding that, "as a creative medium, black and
white photography has, at the start, an advantage over color in that it is already
a step removed from a factual rendition of the scene."[84]

Invented in 1947 by Edwin H. Land
(1909–1991), the Polaroid process origi-
nally generated monochromatic prints.
By the 1970s, the method had improved
to yield so-called instantaneous color
prints, that is, pictures developed on the
spot. Evans worked with the Polaroid
SX-70 system, a fully automatic method
that timed the film's development inside
the camera and expelled a final print for
which the photographer made no contri-
bution to the color scheme. Using the
somewhat subdued colors of Polaroid's
SX-70 system, Evans returned to mak-
ing pictures of American signs and let-
ering, themes he began in his youth and
which he carried out in his work for the
Farm Security Administration. He
praised the Polaroid quick payback
process, saying that it encouraged sud-
den inspiration. As he had in his earlier
work, Evans conceived Polaroid images
in series. Importantly, he challenged the
tenacious complaint that color need-

6.63 (left)
WALKER EVANS,
Untitled **(Crushed
beer can), 1973–74.
Polaroid print.
Metropolitan Museum
of Art, New York.**

6.64
RALPH AMDURSKY,
Colorama (Blue "Woody" Stationwagon in Front of Summer Cottage) n.d. Kodak print. Eastman Kodak, Rochester, New York.

Kodak designers fashioned the perfect home and ideal domestic life for a large transparency that hung above Grand Central Terminal in New York City. The new house has traditional elements, such as columns and shutters. The family's leisure time activities are indicated by gardening tools and recreation equipment.

lessly prettified photographs. In such prints as the one depicting a crushed beer can (Fig. 6.63), Evans integrated color and form; despite the small $(3\frac{1}{8} \times 3\frac{1}{8}$ inch) format of the print, the scene has a puzzling monumentality.

In spite of the efforts of Kodak and Polaroid to convince artists to work with the new techniques, the biases against color photography expressed by Weston and Evans permeated the world of serious art photography. Notwithstanding the occasional museum exhibition of color work, art photography persisted mostly as a black-and-white medium. This attitude put it at odds with commercial photography and photojournalism, both of which adapted more quickly to the possibilities of color to promote products or to interest readers. The art photographers' preference for black-and-white sharply contrasted with the adoption of color film by amateurs, who happily moved from black-and-white snapshots to color pictures. The proliferation of color in commercial photography transformed the experience of the average person. The reality effect—the sense of authenticity and honesty—passed from black-and-white film to color. Millions of people gazed up at the Kodak-sponsored 18 × 60 foot color transparencies called *Colorama* hung on the east balcony of the Grand Central Terminal in New York City[85] (Fig. 6.64). Ansel Adams, who occasionally worked on the Kodak projects, nev-

ertheless calculated that these displays were "aesthetically inconsequential but technically remarkable."

Curiously Adams, a consummate technician, did not seem to realize that technically remarkable images, like pictures from space, have their own aesthetic of the marvelous. In fact, the public came to expect that photography would keep up with other kinds of technological advances. In 1969, Apollo II's pictures of the far side of the moon needed to be as accomplished as the mission was successful (Fig. 6.65). As space exploration continued, audiences

6.65
APOLLO II, *Untitled* (The far side of the moon), Apollo II mission, July 1969.

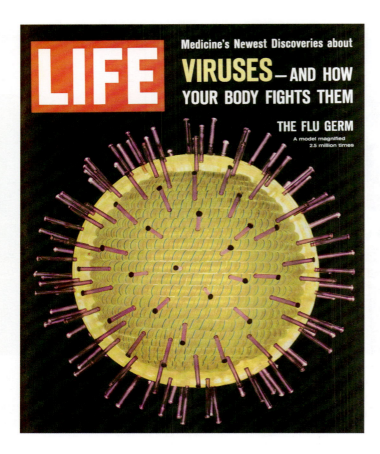

**6.66
PHOTOGRAPHER
UNKNOWN, Cover
of *Life Magazine*,
February 18, 1966.**

Just as the public
thrilled to photographs
taken in the vastness of
space, images of minute
entities such as viruses
delighted the readership
of popular magazines
such as *Life* and under-
scored the power of
science.

took it for granted that the picture maga-
zines would render views of the earth
from space in color. Similarly, advances
in science have been accompanied by
parallel accomplishments in scientific
imaging. Pictures of a human fetus's
development in the womb, patterns
observed by particle physicists, and the
hypnotic beauty of small viruses were
issued in color for audiences to enjoy
as scientific and aesthetic wonders
(Fig. 6.66).

Color motion pictures, costly to pro-
duce before World War II, became less
expensive and more common after the
1950s period of *film noir*, with its deeply
shadowed, highly stylized ambience.
Television, too, began the transforma-
tion from black-and-white to color. The
first all-color children's television show,
Howdy Doody, began in 1955, following
the appearance of color television sets
on the market in 1953. By the mid-
1960s, color television sets became
more affordable and so their sales
increased.

Television, Photojournalism, and National Events

Despite increased sales of television sets
by the mid-1960s, national television
news did not surpass newspapers and

picture magazines as the public's major
source of current events information
until the early 1970s. By that time, tele-
vision news programs progressed from
fifteen-minute readings of the news,
accompanied by a few still photographs,
to nightly half-hour broadcasts, with
reports from news bureaus around the
world, supplemented by film, videotape,
and occasional live coverage. In effect,
television seized the market for instanta-
neous images, the previous domain of
newspapers, and, to some extent, news
magazines. The public's shift from print
media to television was signaled by the
demise of *Life* magazine's weekly publi-
cation in 1972, due to declining advertis-
ing revenues, as clients switched to
purchasing television commercials.

Public events, such as the November
1963 assassination of President John F.
Kennedy (1917–1963) and its aftermath,
entered the public memory through a
mix of photography, radio, film, and
television broadcast. Pictures obtained
from the space exploration, which began
in the late 1950s, were all photographs,
until astronauts sent back a live televi-
sion broadcast from the moon in 1969.
Arresting in themselves, photographs of
the earth from space graphically demon-
strated the interdependence of earth's
natural systems (Fig. 6.67).[86]

Americans also learned about the
Civil Rights movement, which started in
the late 1950s to protest racial segrega-
tion in the South and to secure voting
rights for African-Americans, from a
mix of photography and other media.
Photographers such as Davidson and
Lyon were on the scene, picturing events
and confrontations. In fact, Lyon joined
the Student Nonviolent Coordinating
Committee (SNCC), where he helped to
produce posters and other organiza-
tional materials. Civil Rights organizers
knew how to use the media to gain pub-
licity, and how to craft events with visual
appeal for the nightly television news
shots. Ernest Withers (b. 1922), the first
African-American police officer hired in
Memphis, Tennessee, also worked as a
photographer, and expressed his sup-
port with a memorable image of the
famous march on Memphis by sanita-
tion workers (Fig. 6.68). Photographer
Charles Moore (b. 1931) caught mem-
bers of the Birmingham, Alabama,
Fire Department as they turned

6.67
ATS SATELLITE, *Earth, as Viewed from ATS Satellite,* **November 1967.**

6.68 (below)
ERNEST WITHERS, *Workers Assembling for a Solidarity March, Memphis, Tennessee,* **1968.**

Withers took his picture from a spot in which the individual identities of the marchers were somewhat obscured, in effect, replacing faces with the repeating signs declaring, "I *am* a man." This strike by Memphis sanitation workers brought Civil Rights leader Martin Luther King (1929–1968) to the city, where he was assassinated.

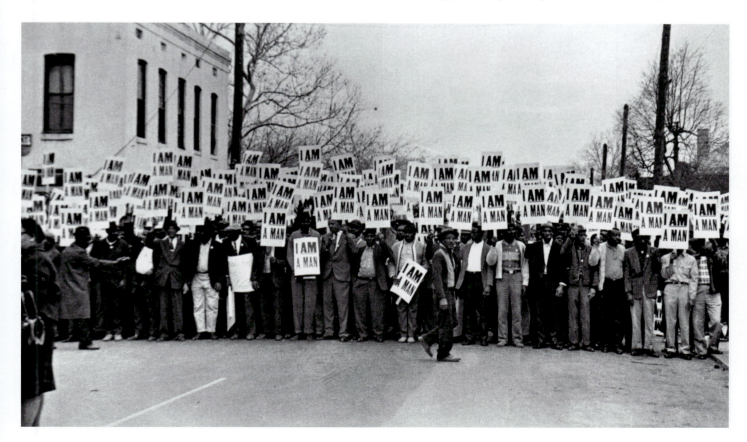

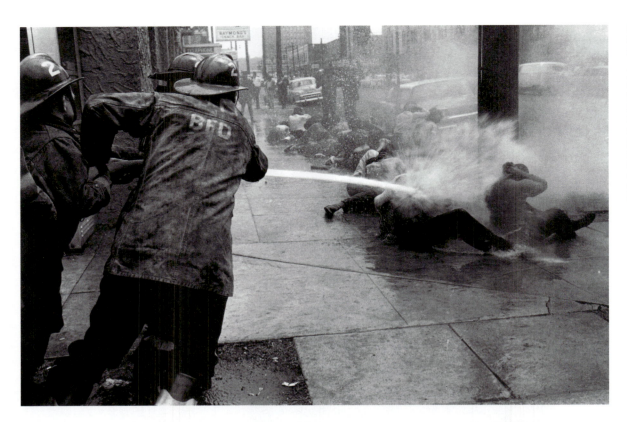

CHARLES MOORE,
Birmingham, 1963.

Moore effectively places
the viewer close to the
firefighters who are
buffeting non-violent
Civil Rights protesters
with water from high-
pressure hoses. The eye
urgently follows the
stream from left to right,
where the force of the
water explodes on the
body of a protester.

high-pressure hoses on protesters
(Fig. 6.69).

From 1955 to 1975, television and
photography combined to disseminate
images of the Vietnam War. While *Life*
magazine's photographs never ap-
proached the patriotic fervor expressed
in Joe Rosenthal's images of the flag-
raising on Iwo Jima during World
War II (see Fig. 5.86), they did repeat-
edly communicate the average person's
experience of the war, an approach pio-
neered by W. Eugene Smith (see p. 308
and Fig. 5.81). That theme was promi-

6.70
LARRY BURROWS,
*At a First-Aid Center
During Operation
Prairie,* 1966.
Dye-transfer print.
Spencer Museum
of Art, University of
Kansas, Missouri.

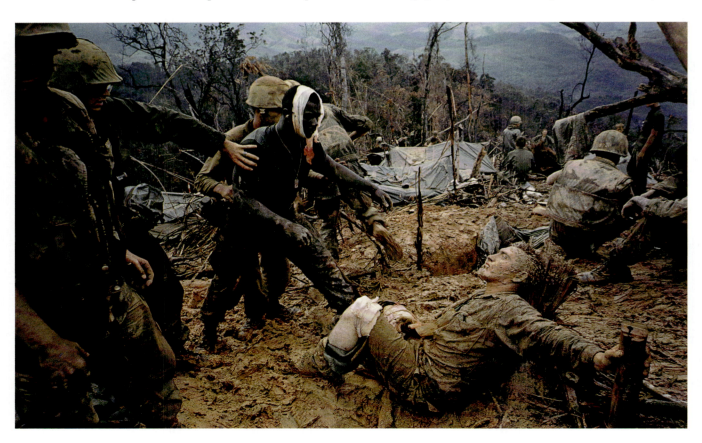

nent in the June 27, 1969 issue of *Life*, which displayed "The Faces of the American Dead in Vietnam," in what resembled a high-school yearbook of the perished.[87] Feature stories concentrated on the experience of individual soldiers, as Smith had done in World War II.

For example, the April 16, 1965 edition of *Life* published twenty-two black-and-white pictures by British photographer Larry Burrows, who chronicled the war experiences of a twenty-one-year-old soldier. Burrows, who later died in a helicopter crash, mounted a camera on the airborne machine gun the soldier used during battle so as to record the gunner's facial expressions. But it was the pungency of his color work that transformed the battlefield's ankle-deep mud into an emblem for America's futile involvement in Vietnam (Fig. 6.70). David Douglas Duncan, who saw the ordinary soldier in Korea as a reluctant aggressor (see Fig. 6.33), was soured by the wanton violence of Vietnam. The pictures he shot there were gathered in his book *War without Heroes* (1970). Philip Jones Griffiths (b. 1936), who would later write and illustrate *Vietnam, Inc.*, a scalding indictment of the war as big business, photographed the conflict for three years, mostly as it

6.71
PHILIP JONES GRIFFITHS, *Napalm Victim*, Vietnam, 1967. Gelatin silver print.

was experienced by the Vietnamese peasants (Fig. 6.71). The image of a South Vietnamese general executing a handcuffed Vietcong suspect was captured by photographer Eddie Adams (b. 1933) (Fig. 6.72).

Some lasting images of the war experience were created only in photography. For example, when President Richard Nixon ordered the bombing of enemy camps in Cambodia, student protests

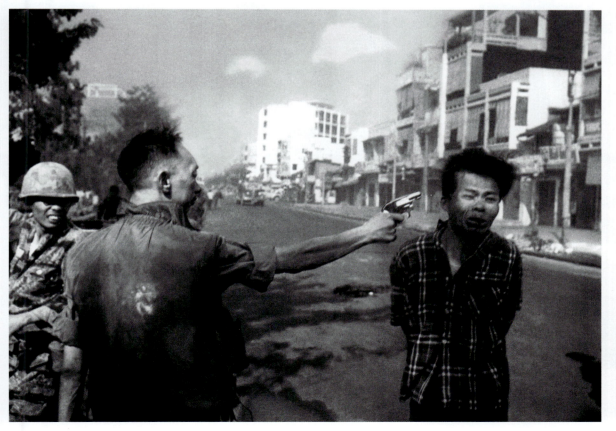

6.72
EDDIE ADAMS, *General Loan Executing a Vietcong Suspect*, February 1, 1968. Gelatin silver print.

This image, recording the execution of a suspected communist sympathizer, roused national anger in the United States against the summary street justice administered by a Vietnamese general.

arose around the country. Photography student John Paul Filo (b. 1948) caught the outcry of a young woman as she knelt beside the body of a Kent State University student shot dead by a member of the Ohio National Guard (Fig. 6.73). Vietnamese photographer Huynh Cong ("Nick") Ut (b. 1951) provided the lasting document of terrified and injured children running from an accidental napalm attack on a building where non-combatants had taken cover (Fig. 6.74). Motion-picture and video equipment were absent when Ron Haeberle (b. 1941), an army photographer, recorded the massacre of civilians in the Vietnamese village of My Lai by a United States Army company. Haeberle submitted the black-and-white pictures he took to the army, but kept the color film, which he began showing in the United States when he was demobilized. An image published in the Cleveland (Ohio) *Plain Dealer* soon traveled around the world. Working together, staff from

the Museum of Modern Art and members of the Art Workers' Coalition used the image to create a gripping anti-war poster, which the museum later refused to sanction. With the question and answer, "Q: And babies? A: And babies", derived from a television interview with a soldier who had witnessed the massacre, the poster became a rallying point against the war (Fig. 6.75).

Yet it was Adams's still image (see Fig. 6.72) that became an acclaimed symbol of the war's injustice and its cold-blooded attitude toward the loss of life. More than twenty-five years after the war ended in 1975, photographs taken by North Vietnamese civilian and military photographers were published through the efforts of British photographer Tim Page (b. 1944), who had photographed the war in the south. Page discovered that North Vietnamese photographers such as Vo Anh Khanh (b. 1939) (Fig. 6.76) used mostly inexpensive black-and-white film and relied

6.73
JOHN PAUL FILO,
Untitled **(Kent State: girl screaming over dead body), May 4, 1970.**

Filo created an enduring image of anger fused with grief, when student Mary Ann Vecchio reacted after National Guard troops killed the first of four students during an anti-war rally.

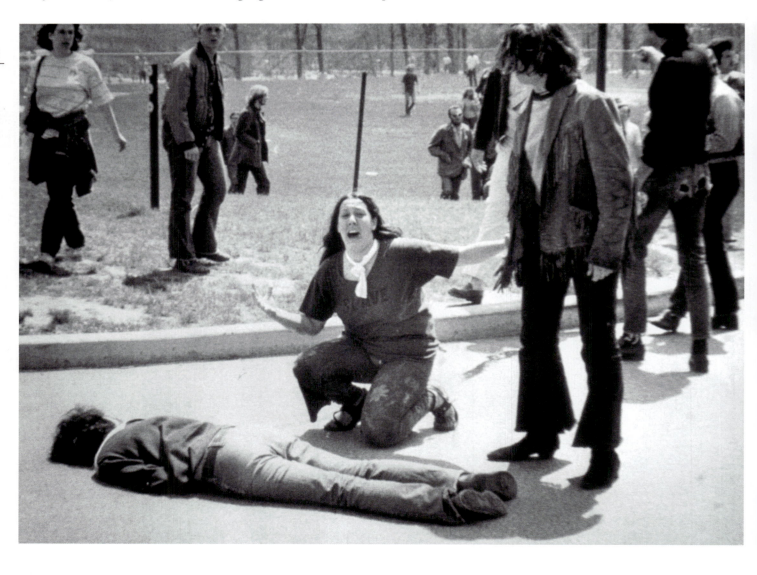

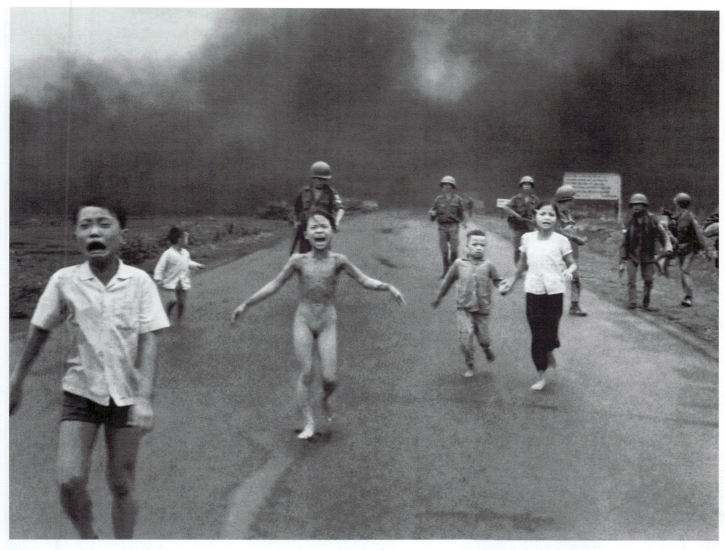

6.74 (above)
HUYNH CONG
(NICK) UT, *Children
Fleeing a Napalm
Strike*, June 8, 1972.

6.75
RON HAEBERLE &
PETER BRANT,
*Q. And Babies? A. And
Babies*, 1970. Offset
lithograph, printed in
color. Museum of
Modern Art, New York.

The photograph taken
by Haeberle, then a U.S.
Army photographer,
showing the result of
deliberate killing of
civilians, became the
most famous anti-
Vietnam poster in the
United States and
around the world.

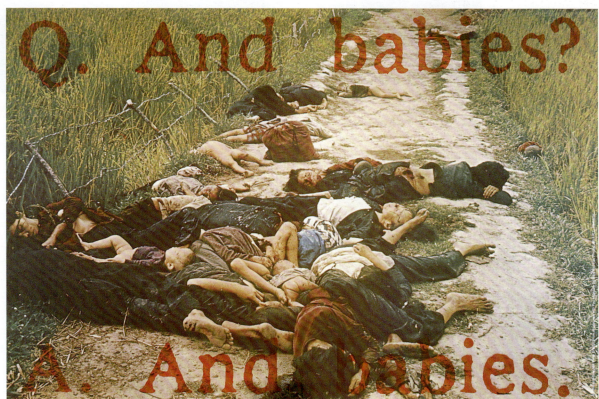

During what they called
"The American War,"
civilian and military pho-
tographers from North
Vietnam rode bicycles to
the front to capture
scenes of suffering and
courage. Vo's image of a
mosquito-netted operat-
ing room located in a
swamp to avoid detec-
tion is all the more
startling because its
subjects seem so unruf-
fled in their improbable
setting. The victim was a
guerrilla wounded by
American bombing.

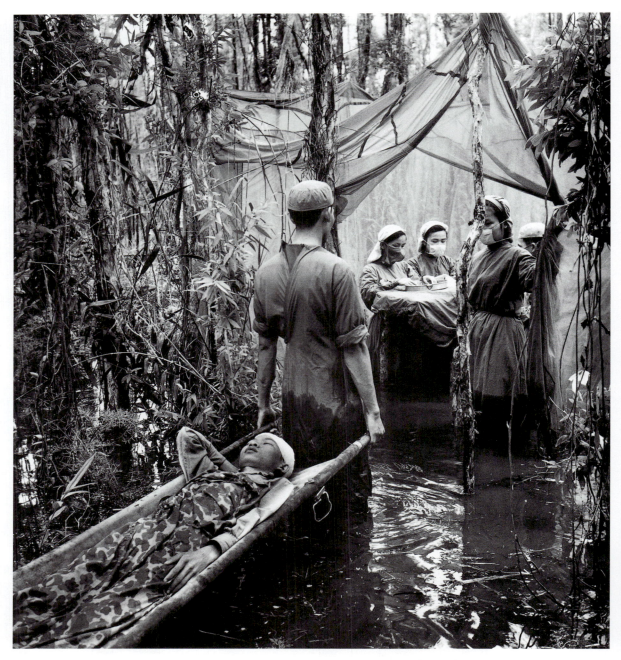

on the jungle night to create an out-
door darkroom. They seldom pho-
tographed the dead, but set out to
inspire their embattled viewers with
scenes of endurance and patriotism.

PHOTOGRAPHY IN ART

During the postwar decades, while pho-
tography gained a greater presence in
international art movements, photo-
journalism emerged as a new source
for artists interested in topical issues.
Sculptor Duane Hanson (b. 1940) mod-
eled his *Vietnam Scene* on published
war photographs, and George Segal
(1924–2000) created sculptures based

on Civil Rights Movement images, as
well as on the shooting of students at
Kent State University during the
Vietnam War protests.

The wider use of photography also
owed to the fact that artists in many
media increasingly employed the cam-
era to record their work. Meanwhile, the
growth of mass media, especially in ser-
vice of advertising, roused artists and
critics to attend more closely to the
effects of photography. The European
avant-garde movement called the
Situationist International, which
emerged in the late 1950s, based its cri-
tique of consumer culture on what
French critic Guy Debord (1931–1994)
called in a 1967 book of the same title

"the society of the spectacle." Inspired by Dadaist debunking, the Situationists attempted to subvert the profusion of mass media by appropriating its images and re-presenting them in ways that demonstrated the superficiality and hypocrisy of advertising and newspaper illustrations. At times, they freely rearranged appropriated images; in other instances, they let captions interpret the image (Fig. 6.77). The Situationists' examination of the mass media's impact on everyday life prefigured the critiques of consumer culture and gender stereotyping in the late 1970s and 1980s (see pp. 432–35).

The Situationist movement was generally secretive, its members largely anonymous, and much of its work ephemeral; consequently, it was not a primary influence on later movements such as Pop art. Begun in Britain during the 1950s, Pop art derived from the word popular, as in popular culture. The seminal Independent Group (IG) included artist Richard Hamilton (b. 1922), whose 1956 collage *Just what is it that makes today's homes so different, so appealing?* combined advertising images for products such as television sets and

vacuum cleaners (Fig. 6.78). In the context of postwar Britain's severe economic recession, Hamilton's collage is a bittersweet parody that simultaneously critiques and celebrates the prospect of long-denied consumer items, symbolized by American products and attitudes toward conspicuous consumption.

British Pop art was anti-academic, rejecting the traditional themes and subjects taught in art school. Members of the Independent Group took inspiration from Moholy-Nagy's 1947 book *Vision in Motion*, and from his belief in the vigor of advertising, and the need to express the modern world through collage and the reuse of scientific photographs such as X-rays.[88] But they reversed Moholy-Nagy's complaints about the throwaway design of American goods, finding them entirely appropriate for an art that they insisted must be of its time. Hamilton analyzed the admirable elements of popular art as "transient, expendable, inexpensive, witty, sexy, gimmicky, glamorous, and 'big business'."[89] Hamilton's collage has been canonized in the history of art, surpassing works by other members of the Independent Group, for whom photography played a

**6.77
PHOTOGRAPHER
UNKNOWN,** *Roles
Reserved for the Negro
in the Spectacle,* 1963,
from *The World of
which We Speak,* 1970.
Situationist International.

Situationists took photographs intended for one purpose, changing their captions to reveal other meanings. In this case, what appears to be a newspaper or travel industry shot has been recaptioned to highlight the condition of black South Africans.

Des rôles réservés au nègre dans le spectacle. — I. Bon nègre, en République Sud-Africaine, 1963.

« Le président Johnson inaugurera mercredi la foire internationale de New-York... un spectacle de 1 milliard de dollars... D'autre part le Congrès pour l'égalité raciale... a fait part de son intention

**6.78
RICHARD HAMILTON,
*Just what is it that
makes today's homes so
different, so appealing?*,
1956. Collage on paper.
Kunsthalle, Tübingen,
Germany.**

Hamilton combined
American mass-pro-
duced consumer
images. For the ceiling
of the room, he used
an image of the earth
from space taken by a
rocket and published in
a 1956 issue of the
picture magazine *Look*.

major role, including Nigel Henderson
(1917–1985) and Eduardo Paolozzi
(b. 1924), who together assembled
collages that incorporated mass-
media images of movie stars, house-
hold products, and hot cars (Figs.
6.79, 6.80).

In the United States during the
1960s, Pop artists were nonchalant
about "the society of the spectacle,"
accepting mass-produced commodities
and images as the inescapable norm
of modern life. Artists Larry Rivers
(b. 1923) and Andy Warhol (1928–1987)
appropriated sensational tabloid images,
such as car crashes, enlarging their scale
and deepening their tonality to accentu-
ate the omnipresence of photographic
reproduction. Warhol was a dedicated
fan of film stars, beginning a collection

of their publicity photographs when he
was a child. He carried a camera with
him to social events, and snapped flat-
tering pictures of people that he felt
were always on camera, always perform-
ing a public identity. He also concen-
trated on the paparazzi, or celebrity
photographers, who stalked their prey,
embodying the public's delirious curios-
ity about such figures, as in the charac-
ter of Paparazzo in Federico Fellini's
1961 film, *La Dolce Vita*. Warhol
exploited the thrill of illicit looking at
the same time that he critiqued it in his
repetitive images of the famous. Like-
wise, celebrity photographs were central
to *Interview*, the tell-all magazine he
founded in 1969.

Warhol urged portrait clients to visit
Photomats, the four-for-a-dollar auto-

6.79 (left)
NIGEL HENDERSON,
Head of a Man, 1956.
Photograph on board.
Tate, London.

6.80 (right)
EDUARDO
PAOLOZZI, *Meet the
People*, 1948. Collage
mounted on card.
Tate, London.

matic photograph machines common in amusement arcades. Before the lens they could self-dramatize for images that Warhol later turned mostly into SILKSCREEN prints. Some of his most famous work was based on publicity shots of such luminaries as Elvis Presley and Marilyn Monroe (Fig. 6.81). The repetition of the portrait image in such works registered the fan's longing for more glimpses of the celebrity, and anticipated the extraordinary public appetite for photographs of Diana,

Princess of Wales (1961–1997) in the 1980s and 1990s.

Warhol's friend, artist Robert Rauschenberg (b. 1925) had been creating photograms, or cameraless photographs, on blueprint paper since the

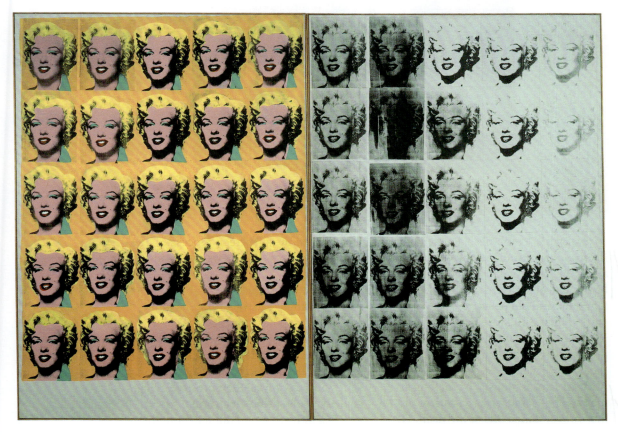

6.81
ANDY WARHOL,
Marilyn Diptych, 1962.
Acrylic on canvas.
Tate, London.

Warhol used the silkscreen technique to create repeating rows and columns of Marilyn Monroe's portrait. He altered each of the pictures, letting the colors bleed into each other, smudge, and overlap in an echo of the cheap color printing methods of celebrity magazines. The exaggerated result was a counterpart to the frantic public appetite for celebrity likenesses.

6.82
ROBERT RAUSCHENBERG, *Untitled Combine (Man with White Shoes)*, 1955. Panza Collection. Museum of Contemporary Art, Los Angeles, California.

Based on a mysterious image of a man in a white suit, Rauschenberg's combination of collaged photographs and a chicken does not so much tell a story as argue that art can be made from the detritus of life.

1950s. In his "combines," Rauschenberg incorporated mundane objects found along the street, such as pieces of cardboard, bits of signs, magazine photographs, and old postcards, as well as paint (Fig. 6.82). More than Warhol, Rauschenberg wanted to puncture the pretensions of "high art" in traditional media, especially the work of the Abstract Expressionists, by making art that was not conceived as a mirror of life, but contained bits of life itself. He,

too, adapted the silkscreen process, blending images from newspapers and magazines.

At about the same time, some painters adopted a style known as photorealism to respond to the look of color photographs, in particular their flatness and illusion of depth. To render these qualities, they projected photographic slides on to a canvas, then precisely copied details, using an airbrush, which sprays a thin stream of diluted paint that

6.83
RICHARD ESTES,
Woolworth's, 1974. Oil
on canvas, 38 × 55 in
(96.5 × 139.7 cm). San
Antonio Museum of Art,
San Antonio, Texas.

6.84
CHUCK CLOSE,
Big Self-Portrait, 1967-8.
Acrylic on canvas,
8 ft 11½ in × 6 ft 11½ in
(2.73 × 2.12 m). Walker
Art Center Collection,
Minneapolis, Minnesota.
Art Center Acquisition
Fund, 1969.

are silent about the subjects' personal characters. The photographic source of photo-realism became a favorite theme in the work of Audrey Flack (b. 1931), who arranged snapshots like elements of a still life, and who mimicked the way the camera can exaggerate highlights. The garish colors of her work may also derive from photographic sources, particularly the deeply saturated shades employed in advertising (Fig. 6.85).

For Conceptual artists, active internationally in the 1960s and 1970s, photography became important because its record-keeping function favored their focus on making and communicating ideas or concepts, rather than producing material objects. In addition, photogra-

leaves no trace of handwork. Like street photographers, the photo-realists chose mostly urban scenes, and dwelled on highly polished surfaces such as glass and chrome (Fig. 6.83). American Chuck Close (b. 1940) employed the photo-realist vocabulary in portraiture (Fig. 6.84). His eerily airless large-scale, close-up portraits anticipate the approach of late twentieth-century photographers such as Thomas Ruff (see Fig. 7.25), whose big pictures show abundant physical details of sitters, yet

6.85 (below)
AUDREY FLACK,
World War II (Vanitas),
Incorporating Part of
Margaret Bourke-White's
Photograph "Buchen-
wald, April 1945,"
1976–77. Oil over
acrylic on canvas,
8 × 8 ft (2.43 × 2.43 m).

In this work, Flack
gathered such objects
as a Star of David, and
copied part of a photo-
graph by Margaret
Bourke-White, showing
Jewish survivors of Nazi
concentration camps to
create a tribute to those
lost during World War II.

phy was used by artists who found no irony in making lasting images of ephemeral projects, such as installations, performance art, and the so-called Happenings of the late 1950s and early 1960s, in which impromptu public events or situations were presented to onlookers.

Celebrated for his earthworks, such as *Spiral Jetty*, which became familiar mostly through photographic reproduction, Robert Smithson (1938–1973) was one of the many postwar artists who may have come to photography to record their work, but who soon began to investigate the medium on its own terms. He also explored photography's relationship to time, through what he called "mirror displacements," produced while traveling in the Yucatán area of Mexico (Fig. 6.86). In his writings, Smithson imagined an "Infinite

Camera," a voracious yet indifferent perpetual machine that would gobble up the visual stream and produce unlimited reproductions.[90] His thoughts parallel those of other artists, such as Warhol, who exalted the impersonal camera.

Similarly, the British pair of artists known as Gilbert and George (Gilbert Proesch, b. 1943; George Passmore, b. 1942) moved from performances, in which they presented themselves as living sculpture, to making "photo-pieces." Unlike Smithson, who continued to work in sculpture and earthworks, Gilbert and George turned primarily to the large photoworks. In their living sculpture artworks from the late 1960s, they collapsed the distinction between art and life. In similar fashion, their personal lives and interests became the subjects of their photo-pieces.[91]

**6.86
ROBERT SMITHSON,
Seventh Mirror Displacement, 1969.
Guggenheim Museum, New York.**

Arranging a dozen mirrors in the ordinary landscape, rather than near the often photographed monuments of ancient Mexican cultures, Smithson used a small, inexpensive Instamatic camera to record his construction. After the picture was taken, he packed up the mirrors, leaving the landscape as he found it. The brief insertion of mirrors then existed only as a photographic record.

6.87
BERND & HILLA BECHER, *Gas Tower (Telescoping Type), off Pulaski Bridge, Jersey City, New Jersey, U.S.A*, 1981.

Although they focus on structures associated with outdated technology, the Bechers' images carry on the notion of neutral vision popularized by the New Objectivity artists in Germany during the 1930s.

Photography's boundless potential for mimicking appearances prompted American Douglas Huebler (1924–1997) to propose his *Variable Piece # 70*, in which he set out to do the impossible: photograph everyone living on the planet. Huebler was adroit at mining the vein of deadpan ridicule that ran through Conceptual art. By contrast, German photographers Bernd (b. 1931) and Hilla Becher (b. 1934) soberly began elevating the photograph's ability to archive the appearance of specifically so-called "dead-tech" objects, namely,

antiquated industrial constructions such as blast furnaces and gas towers (Fig. 6.87). Because of their dispassionate style, these images were included in the 1975 show *New Topographics* (see pp. 355–56). Yet the rich gray tonalities of their work, along with the public nostalgia aroused by the disappearance of mechanical technologies, prompted audiences to respond with a sentimentality that was alien to Conceptual philosophy.

The photographic interests of Conceptual artists bypassed the fine arts

6.88
HARRY SHUNK,
Yves Klein Leaping into the Void, near Paris, October 23, 1960. Gelatin silver print.

Though not primarily a photographer, Klein had himself photographed leaping from a tall stone wall in an image of the artist as risk-taker. He altered the original image to remove the circle of assistants holding a trampoline.

tradition of Alfred Stieglitz, the spiritualism of Minor White, and even the formalism of Lee Friedlander and Garry Winogrand. Instead Conceptualists plunged into an examination of publicly accepted notions of photographic truth. American painter Mel Bochner (b. 1940) and British artist Victor Burgin (b. 1941) formulated work that probed photography's ability to create an aura of authenticity. Bochner's *Misunderstandings (A Theory of Photography)* from 1967–70 consisted of an index-card sized negative of a photograph of his arm. Because it is a direct product of the camera, the negative is putatively closer to the original scene, more truthful than the positive. In London, Burgin also alluded to photography's relationship to reality when he created what he called a *Photopath* (1967). Photographing sections of a gallery floor, Burgin then printed images the exact size and tonality of the wood and stapled them to the boards, creating a system in which

"images are perfectly congruent with the objects."[92] One of the most famous photographs to emerge in the postwar era—an image that found its way on to public kiosks and studio walls—also toyed with the notion of photographic truth. Idiosyncratic French artist Yves Klein (1928–1962) produced a picture showing himself springing off a wall into space (Fig. 6.88).

Conceptual art's attempts to dematerialize the art object not only put an emphasis on less expensive materials, such as photographic film, but also stressed language, which was used to describe works that were conceived, but never intended to be made. Conceptualists maintained that words, like photographs, function in a web of social meanings. The interaction between image and caption, ever-present in magazines, advertising—and textbooks—had been shunned in art photography, which expected the image to carry the full burden of meaning. But the cap-

**6.89 (right)
BRUCE NAUMAN,**
Self-Portrait as a Fountain, **from the series** *Photograph Suite,* **1966. Chromogenic color print. Whitney Museum of American Art, New York.**

Where Marcel Duchamp brought a urinal into a gallery and labeled it a fountain, Nauman inverted the image by photographing himself spewing water upwards.

tioned photograph became a wellspring for Conceptual artists. Bruce Nauman (b. 1941) made a photograph called *Self-Portrait as a Fountain* (1966), in which he spurted water from his mouth (Fig. 6.89). The photographic work of Belgian artist Marcel Broodthaers (1924–1976) often turned on the contradiction between image and words. He amusingly wrote that "the idea of inventing something insincere finally crossed my mind and I set to work straightway."[93] His *La Soupe de Daguerre* (*Daguerre's Soup*) (1976) is a collage of photographs, including photographs of other media, all referring to food (Fig. 6.90).

Not all Conceptual artists used photography to critique the medium and

**6.90
MARCEL BROODTHAERS,**
La Soupe de Daguerre, **1974. Twelve color coupler prints on paper.**

The soup in Broodthaers's title refers to the various fluids used in the chemical processes of photography, and perhaps also to the image-filled society begun by Daguerre's invention.

its myths. Dutch painter Jan Dibbets (b. 1941) turned from monochrome painting to abstract photography to explore time and manipulate the elements of perspective. As its title implied, Dibbets's series of photographs, *The Shortest Day of 1970 Photographed in my House Every Six Minutes*, recorded the passage of daylight before the camera. Similarly, Japanese photographer Nobuo Yamanaka (1948–1982) used the camera to suggest the flow of human sight. In the early 1970s, he helped organize installations that relied on slides projected on to the surface of a river or through suspended sheets of transparent material. He also constructed a large, walk-in camera obscura, not for purposes of tracing a drawing, but to experience a fugitive image hovering on a wall.[94]

Likewise, Hitoshi Nomura (b. 1945) combined an interest in human sight with an inquiry into what he called "afterimages," meditations on duration and phenomena, such as decay and evaporation, which must be seen over time. Reminiscent of time-lapse photog-

raphy, like that of Étienne-Jules Marey (see pp. 212–13), Nomura employed the look of scientific photography to tease out an awareness of duration and perception (Fig. 6.91).

The biggest change in the relationship between photography and art was the developing interest of artists in the medium. While recording their work, exploring the possibilities of dematerializing art, or critiquing mass media, artists who had little or no training in photography discovered fresh visual possibilities in it. As they adopted the camera, they did not take up the burden of prejudices and received ideas that weighed down photographic practice throughout the nineteenth and early twentieth centuries. The appeal of what seemed to be an under-utilized, non-traditional medium set American artist John Baldessari (b. 1931) on a one-way street away from painting. He burned his easel works and turned to reproducible media, such as photography and video (Fig. 6.92). For most artists, the discovery of photography was not so drastic, but was quietly revolutionary. In

6.91
HITOSHI NOMURA,
'Moon' Score, **1977–80.**
National Museum of Modern Art, Tokyo.

Nomura bluntly stated that "My artmaking begins precisely with a desire not to talk about it."[95] Nomura's work gently parodies scientific records. For the *'Moon' Score* series, he shot a full roll of film (thirty-six exposures) each night for more than a decade.

6.92
JOHN BALDESSARI,
Untitled, 1967. Acrylic
and photoemulsion
on canvas.

Baldessari, who aban-
doned painting for
newer media such as
photography, challenges
the "how-to" books
that suggest a photogra-
pher should be careful
not to create implau-
sible or comic effects.
Here he contrasts a
bold statement about
individuality with a
banal photograph of
a parking lot.

AN ARTIST IS NOT MERELY THE SLAVISH
ANNOUNCER OF A SERIES OF FACTS.
WHICH IN THIS CASE THE CAMERA HAS
HAD TO ACCEPT AND MECHANICALLY
RECORD.

the postwar decades, photography grad-
ually emerged as another medium, like
paint, wood, or stone, in which artists
routinely worked.

PHILOSOPHY AND PRACTICE: PHOTOGRAPHY "BORN WHOLE"

Reviewing the importance of Bill
Brandt's photographs, John Szarkowski
(b. 1925), the influential director of the
Photography Department at New York's
Museum of Modern Art, wrote in 1973
that "for purposes of approximate truth,
it might be said that photographic tradi-
tion in England died sometime around
1905." In the 1930s, he continued,
"England had forgotten its rich photo-
graphic past, and showed no signs of
seeking a photographic present."[96]
These ideas offended British photogra-

phers, who quickly pointed to the work
of fashion photographer David Bailey
(b. 1938), whose images of such cultural
celebrities as the Beatles and Andy
Warhol helped shape the notion of the
Swinging Sixties (Fig. 6.93). A star in
his own right, Bailey's carefree lifestyle
became the basis for the internationally
popular movie *Blow-Up* (1966), which
scrutinized the limits of a photogra-
pher's societal observations. Szarkowski
also completely overlooked British Wor-
ker Photography (see pp. 294–97), per-
haps because of its ties with socialism.
Szarkowksi's central theme, particu-
larly as expressed in the influential *The
Photographer's Eye* (1966), was exactly
the reverse of the nineteenth-century
notion that photography should emulate
the other arts, especially painting.
Szarkowski insisted that photography
needed to abandon its "allegiance to tra-
ditional pictorial standards" and be

inventive in terms of inherent qualities with which "photography was born whole."[97] In other words, he articulated the excitement about the medium that postwar artists such as John Baldessari had discovered.

Szarkowski repeatedly asserted that the images by little-known photographers, or commercial photographers operating in areas such as photojournalism, could as successfully explore the medium's potential as the work of art photographers.[98] To prove his point, he built a 1973 exhibition called *From the Picture Press* from the archives of the tabloid newspaper, the New York *Daily News*. In the show's catalog he wrote that "as images, the photographs are shockingly direct, and at the same time mysterious, elliptical, and fragmentary, reproducing the texture and flavor of experience without its meaning."[99]

Improvising on a seasoned theme in art history, expressed specifically in the work of architectural historian George Kubler, Szarkowski proposed that the history of an art form should be traced through apparent changes in its formal characteristics such as line, not through changes in its subject-matter.[100] Simply put, as media evolve, they elaborate and explore their formal potential. In his popular book *Looking at Photographs* (1973), Szarkowski envisioned a kind of historical check-value in which formal innovations could only go forward. "The chief arbiter of the game is Tradition," he wrote, "which records in a haphazard fashion the results of all previous games, in order to make sure that no play that won before will be allowed to win again."[101] In other words, progress in photography centered on novelty — not new subjects, but fresh formal approaches.

Szarkowski listed five interdependent characteristics unique to photography. The first, "the thing itself," declared that the photograph was a picture, not the equivalent of reality. The second feature, "the detail," referred to photography's "compelling clarity," and also to the fact that photography can only "isolate a fragment" of reality. He emphasized the importance of "the frame," or the "central act of choosing and eliminating," and he noted the "vantage point," which allows photographers to present the subject from unexpected points of view. On a more philosophical note, Szarkowski insisted that "all photographs are time exposures, of shorter or longer duration."[102] Each of the five characteristics of photography was illustrated by the work of historic and contemporary photographers. Whether distance shots or close-ups, virtually all the images in *The Photographer's Eye* are sharply focused and readily accessible.

Among the trends Szarkowski held up as definitive examples of photography's progressive investigation of its inherent characteristics were "the decisive moment" developed by Henri Cartier-Bresson, the "straight photograph" exemplified by Paul Strand and Walker Evans, and the humanistic Depression-era documentary, as embodied in the work of Dorothea Lange and Russell Lee. The next in line in the chronological discovery of formal properties were the efforts of contemporary American photographers such as Robert Frank, Lee Friedlander, Garry Winogrand, Harry Callahan, and Danny Lyon.

Szarkowski also extended his standards to color photography, praising the work of William Eggleston (b. 1939) as no less than the "discovery of color photography."[103] Eggleston's pictures dwelled on ordinary objects, such as a tricycle, a backyard barbecue, or a lightbulb (Fig. 6.94). In the 1976 catalog of Eggleston's work, Szarkowski noted that the photographer was true to the landscape of the Memphis, Tennessee area, where he worked, and also faithful to "photography as a system of visual editing." The goal of photography, Szarkowski continued, "is not to make something factually impeccable, but seamlessly persuasive." The photographer's work is to discover "new patterns of facts that will serve as metaphors for their intentions." Color, in Szarkowski's view, challenged the photographer's ability to resist its simple prettiness and devious nullification of form.[104] He argued that in Eggleston's photographs color and subject-matter were faultlessly blended into a formally exciting private view of the world.

By 1978, when Szarkowski mounted the extensive exhibition, *Mirrors and Windows: American Photography since 1960*, it was evident to him that a lot more had been taking place in photo-

6.93
DAVID BAILEY, *Mick Jagger*, 1964.

David Bailey emerged as the photographer of "cool" in the London of the Swinging Sixties. Although there were three inspirational models for Michelangelo Antonioni's 1966 film *Blow-Up*, it is David Bailey whom the public identified with the raffish, whippet-thin, womanizing fashion photographer in the film, who drove a Bentley and mixed with supermodels and rock stars. A poorly educated lad from London's East End, Bailey absorbed the rudiments of picture making from the movies, and taught himself photography; he counts Cartier-Bresson and Bill Brandt among his influences.

Bailey's meteoric rise at *Vogue* magazine owed to his insistence on bringing fresh faces, such as models Jean Shrimpton and Penelope Tree, to fashion shoots. His emerging fame also owed to his large black-and-white portraits of hip celebrities such as Andy Warhol, or those whose class background matched his own, such as the actor Michael Caine.

Although he also photographed the Beatles, Bailey fell in with the Rolling Stones early in his career and made many portraits of them, including the one featured on the cover of the album *Out of Their Heads*. He photographed Mick Jagger several times, including this famous portrait. There is a political dimension to many of Bailey's photographs. They often mix the notions of royalty and rock in an obvious assault on a class system that habitually categorizes people by definition of their accents and family lines.

6.94
WILLIAM
EGGLESTON,
Greenwood, Mississippi,
1970. The J. Paul Getty
Museum, Los Angeles,
California.

William Eggleston's
photographs resemble
photo-realist paintings,
in that they often
dwell on qualities
of light, and reflections
on different surface
textures, such as metal
and concrete.

graphic practice than he had envisioned twelve years earlier in *The Photographer's Eye.* He tried to organize the *Mirrors and Windows* exhibition along a continuum ranging from the idea of the mirror, or artist's concern with self, typified by the introspective photography and writing of Minor White, and the notion of window, typified by Robert Frank's book *The Americans* (see p. 344), with its emphasis on the appearance of the world. But the variety of photographs he selected quickly eluded that terminology and became more of a postwar survey. He included work done mostly in the 1960s through the mid-1970s, including images by Eggleston and Eliot Porter, as well as such artists as Sol LeWitt (b. 1938) and Robert Smithson. Along with the photographers such as Friedlander and Winogrand, who exemplified the quest for what Szarkowski called photography's inherent characteristics, there were new imaging technologies, including John Mott-Smith's (b. 1930) 1966 series of pictures arising from computer analysis, and the Polaroid pictures of Lucas Samaras (b. 1936) in which the photographer manipulated the soft, freshly

exposed chemical emulsion with his fingers or other mechanical aids (Fig. 6.95).

Mirrors and Windows recognized the growing significance of appropriated mass-media images in the work of such artists as Rauschenberg and Warhol. Also included was work by West Coast artist Ed Ruscha (b. 1937), who saw the camera as essentially a bland, inexpressive device with which to record dispassionately a banal human environment (Fig. 6.96). Similarly, the scoffing humor of Conceptual artist Robert Cumming (b. 1943) was evident in two prints, one a positive and the other a negative, showing blackboard exercises for students learning how to shade shapes such as rectangles and cones to create the illusion of depth. Of course, the negative print reversed the black and white values, turning the lesson inside out (Figs. 6.97, 6.98). Cumming was one of the earliest American photographers to construct scenes of this kind solely to be photographed. His work also anticipated the fabricated-to-be-photographed style of the 1980s. *Mirrors and Windows* also contained the work of Robert Heinecken (b. 1931),

6.95
LUCAS SAMARAS,
Untitled, 1973. Polaroid.
Hallmark Cards, Inc.,
Kansas City, Missouri.

While experimenting
with the Polaroid
process, Samaras dis-
covered that he could
move the gooey chemi-
cals around while the
picture was being
developed between
two pieces of paper.
The result is often a
frightening distortion of
the human figure.

6.96 (below)
ED RUSCHA,
**From *Nine Swimming
Pools and a Broken
Glass*, 1968.**

Ruscha not only made
neutral photographs
of ordinary subjects
such as gas stations,
parking lots, and swim-
ming pools, he also
gathered them in books
without any explanatory
text. *Nine Swimming
Pools* is just that, nine
photographs of
swimming pools.

6.97
ROBERT
CUMMING,
*Academic Shading
Exercise*, 1974.
Positive contact
print.

THROUGH THE LENS OF CULTURE (1945–1975)

6.98
ROBERT
CUMMING,
*Academic Shading
Exercise*, 1974.
Paper negative
print.

who transformed advertising and pornographic images, and experimented with collage, printing processes, and even the shape of the work (Fig. 6.99).

Szarkowski also chose images by Ray K. Metzker (b. 1931), and praised his "photomosaic," in which a dimly perceptible human figure appears in forty-nine different poses within a large grid, a successful attempt to find beauty in scientifically-derived systems. Metzker's figure is reduced to the significance of a slim squiggle of paint (Fig. 6.100). Likewise, body parts in the Heinecken photomosaic have all but lost their identity. From a standard viewing distance on the gallery wall, both the Heinecken work and the Metzker image rely on the visual rhythm of overall abstract patterns rather than subject-matter.

Missing from the *Mirrors and Windows* catalog and show was work by video-maker and photographer, William Wegman (b. 1943), whom the general public was coming to appreciate for humorous portraits of his dog, Man Ray, named for the Surrealist artist. Costumed and posed for black-and-white, as well as color Polaroid photographs and videotape, the dog patiently modeled for Wegman, whose pictures were meant to underscore the theoretical point that representation is the product of a photographer's interpretation and creation, not an objective view of the world. Moderately successful in the art world, the images were a hit on calendars sold around the world to people with little or no knowledge of Conceptual art (Fig. 6.101).

Increasingly in the 1960s and 1970s, artists working in other media, as well as photographers not committed to notions of the medium's uniqueness and purity, began to exploit mass-media images. Szarkowski included an array of

6.99
ROBERT HEINECKEN,
Refractive Hexagon,
1965. Twenty-four moveable photographic pieces on wood. Gelatin silver prints. Center for Creative Photography, University of Arizona, Tucson.

The abstract shapes suggestive of the human body may be rearranged to form other shapes or series than the six-sided object into which the twenty-four pieces have been shaped. Acknowledging Heinecken's efforts to dissolve the residue of fact in his work, Szarkowski recognized that a joyless sexuality managed to seep through the abstraction.

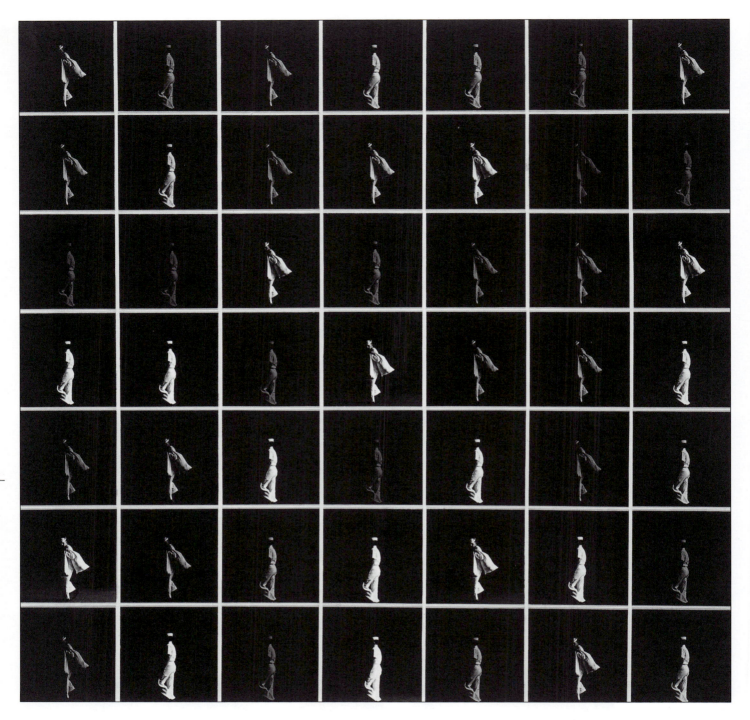

these kinds of pictures in *Mirrors and Windows*, but he does not seem to have understood the extent or direction of this change in American art. He mainly argued that in the quarter century before *Mirrors and Windows*, photography had moved from "public to private concerns."[105] Recalling the serious, broadly based social concern of Farm Security Administration and Depression-era American photography, Szarkowski stated that *The Family of Man* exhibition marked the end of the period in which photographers willingly submerged their personal interests to a larger goal.

For him, the two major tendencies of new photography could be found in the realistic, yet personal pictures of such photographers as Robert Frank, and the romantic and spiritual approach typified by Minor White. As he wrote, "neither pretended to offer a comprehensive or authoritative view of the world, or a program for its improvement."[106]

For Szarkowski, the shift away from the public realm reflected larger social conditions. The picture magazines were failing in the 1960s—even before *Life* magazine suspended publication in 1972. Their grand ambitions, seen in

6.100 (opposite)
RAY K. METZKER,
*Composites:
Philadelphia*, 1964.
Gelatin silver print.
Purchase. Contemporary Exhibition Fund, Alfred Stieglitz Restricted Fund, Alice Newton Osborn Fund. Philadelphia Museum of Art, Philadelphia, Pennsylvania.

At first, Metzker's sequences of images resemble the motion studies done by Marey and Muybridge. But a close look reveals that many of the figures repeat, with different shadings, and that no progressive flow of motion is achieved in any direction.

photo-essays such as Margaret Bourke-White's attempt to explain the effects of World War II in the Soviet Union, or Eugene Smith's efforts to define the ancient culture of a Spanish village in a mere seventeen images, were strained beyond the capacity of the medium. In particular, Szarkowski pointed to "photography's failure to explain large public issues" such as the Vietnam War. He claimed that neither the images of British war photographer Don McCullin (b. 1936) (Fig. 6.102) nor those of Larry Burrows (see Fig. 6.70) could even "begin to serve either as explication or symbol for that enormity." Instead, he proposed that the shock of the war was best communicated by the psychologically expressive photographs of Diane Arbus.[107]

For Szarkowski, photography's shrinking authority was due in part to the success of television and to air travel, which made the world seem less exotic. But the basic conundrum was what he perceived to be the limitations of photography. "Most issues of impor-

tance," Szarkowski concluded, "cannot be photographed." The world-renowned photograph showing the moment when Jack Ruby shot President John F. Kennedy's alleged assassin, Lee Harvey Oswald, showed a man in pain, but did not—and could not—explain the political and emotional significance of the event[108] (Fig. 6.103).

Szarkowski did not fathom that photographers, artists, and viewers tended to experience the mass media as one medium—a blend of pictures originating in advertising, television, radio, film, and magazine journalism. The era's media guru, Marshall McLuhan (1911–1980), understood the media melange, which prompted him to revive a confident faith in the direct educational powers of media not seen since the 1858 issue of *The Athenaeum* envisioned young lower-class British lads imaginatively rambling around Egypt by way of the stereograph (see p. 83). McLuhan got it wrong when he argued that the medium was the message, meaning that the subject of a work was inextricably

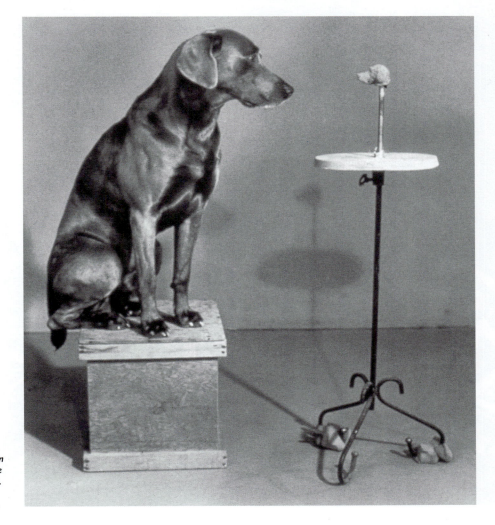

6.101
WILLIAM WEGMAN,
Man Ray Portfolio-Man Ray Contemplating the Bust of Man Ray, 1978.
Silver gelatin print.
Collection of the artist.

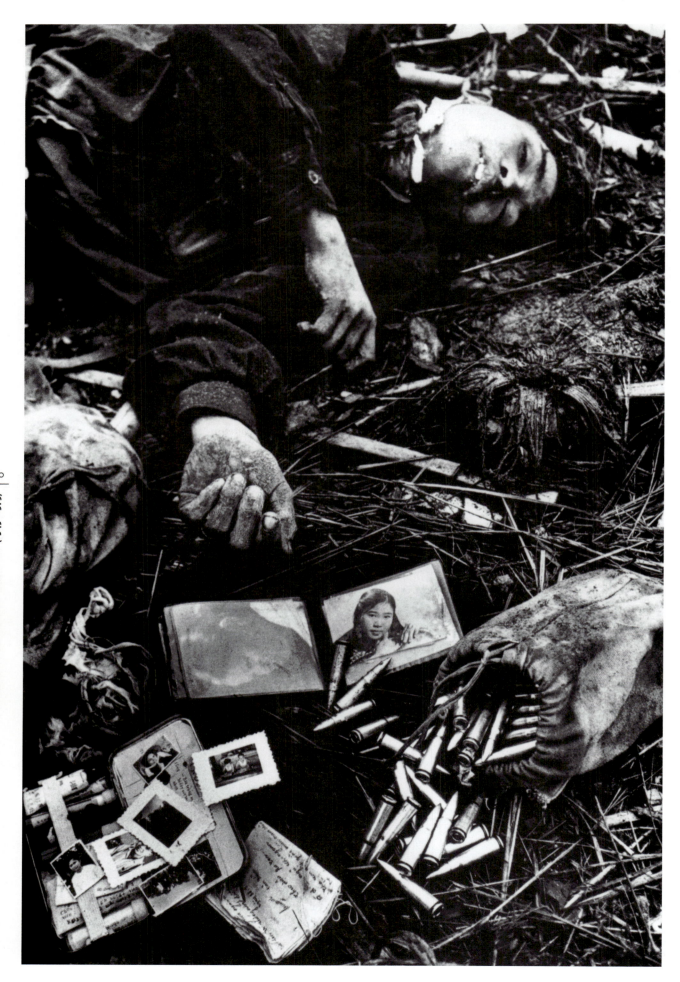

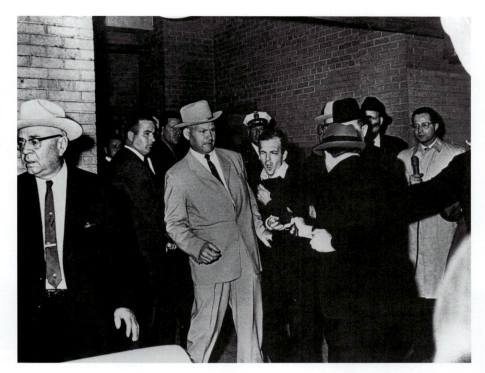

6.102 (opposite)
DON McCULLIN,
*Corpse of North Viet-
namese Soldier*, 1968.
Copy-negative print.

McCullin juxtaposed
the grisly corpse of a
fallen North Vietnamese
soldier with his personal
effects, including
photographs and letters,
scattered on the ground
by plundering Amer-
ican soldiers who did
not find them valuable.

6.103
BOB JACKSON,
*Lee Harvey Oswald
Shot*, 1963. **Gelatin
silver print.**

On live television, on
film, and in pho-
tographs, Americans
saw the accused assas-
sin of President John F.
Kennedy shot in a
Dallas, Texas police
station. By the mid-
1970s, critics such as
John Szarkowski would
ask just what photogra-
phy could reveal
about this or any
other event.

linked to its means of broadcast, and
that the means was more important
than the subject. The so-called "cool,"
disjointed style of television was easily
adapted into what McLuhan had
thought to be the "hot," or linear charac-
ter of photography. Indeed, Frank's *The
Americans* had the loose, jumpy quality
McLuhan felt typified television.

On the other hand, McLuhan's
enthusiasm for a coming-together of
societies around the world, and a fusion
of the arts, brought about through the
widespread use of electronic media, was
far more attuned to the heightened
attractiveness of pluralist approaches
and multi-media techniques in the arts,
especially those that emerged in the late
1960s and early 1970s. While the arts
were actively looking into what was
then called intermedia, combinations of
older media such as photography and
paint with sound, theater, dance, and
newer media, such as film and video,
Szarkowski promoted photography
as a unique and pure picture-making
process.

Szarkowski's emphasis on the
unique formal properties of photogra-
phy helped to promote the institutional
life of photography in museums and
universities. Founded in 1937, the Dep-

artment of Photography at the Museum
of Modern Art became the major arbiter
of trends in the United States during
the postwar period.

In 1947, George Eastman House in
Rochester, New York (now the Inter-
national Museum of Photography at
George Eastman House, IMP/GEH),
named for the Kodak Corporation's
founder, began collecting and archiving
historic film and photography under the
guiding hand of historian Beaumont
Newhall (see p. 298). Especially in the
1960s, departments of photography
were established at numerous American
colleges and universities to teach what
was regarded then as an independent
medium with its distinctive history and
methods.

The Society for Photographic
Education, an organization of photogra-
phers, writers, historians, and curators,
that came together in 1963, was origi-
nally formed on similar assumptions. In
other words, just as many image-makers
were starting to explore the persuasive-
ness of mass-media photography, which
made the world seem "already seen," the
leading photographic institutions were
grounding the medium's existence as an
academic and museum subject in the
notion of its uniqueness.

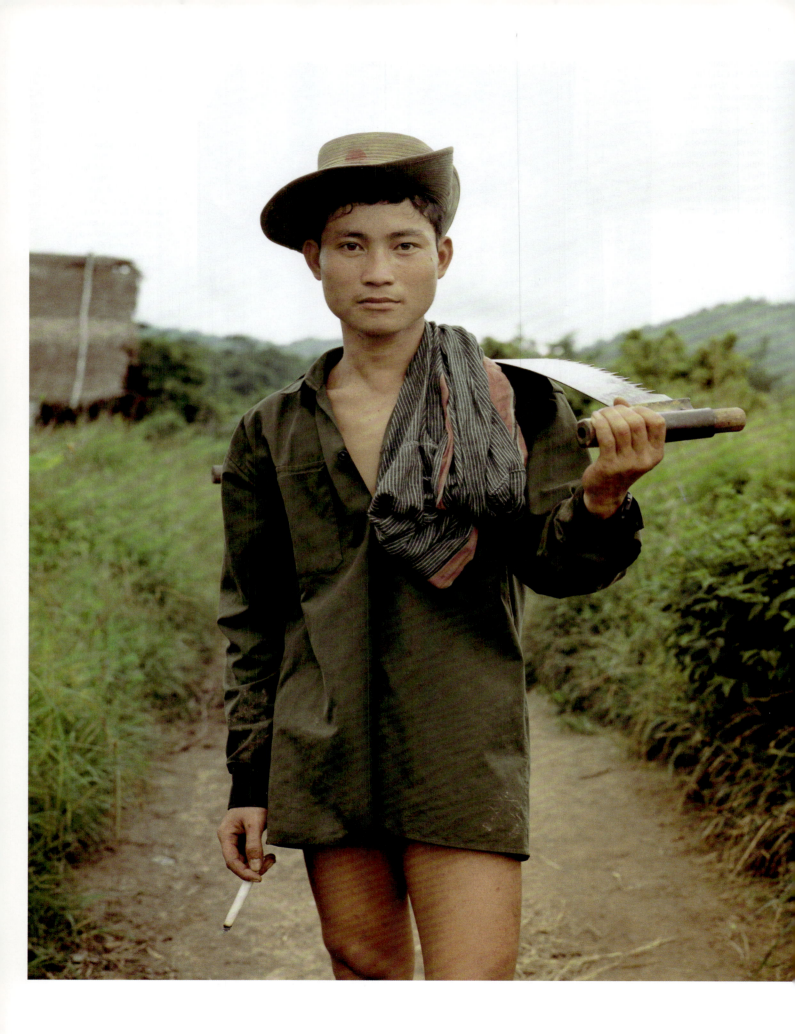

CHAPTER SEVEN

Convergences (1975–PRESENT)

7.0
CHAN CHAO, *Member of KNLA,* **from his series** *Something Went Wrong,* **1999. C-print.**

Chao's highly detailed portrait photographs of students who organized guerrilla attacks against the repressive government of Burma aim to distinguish their individuality and thus frustrate propaganda attempts to classify them as anonymous outlaws.

The worldwide convergence of political systems, economic networks, and cultural creations has been escalating for about five hundred years. In the mid-nineteenth century, when Félice Beato (see pp. 104–12) photographed in the Middle East, and then moved on to India, China, and Japan, he recognized the growth of new markets among Europeans anxious for views of the countries in which their nations had political, military, and commercial involvements. In contemporary terms, Beato was reacting to globalization, the dynamic outreach of the developed nations, which wove together worldwide systems of trade and political coalitions, assisted by far-reaching communications and transportation networks, as well as military strength.

People living in the last decades of the twentieth century experienced a globalization so rapid that Beato would barely have recognized the phenomenon. Advances in communications expedited commercial and cultural exchanges to the speed of computers. The integration of world financial markets and trade agreements, such as the European Community, stimulated the production and trading of consumer goods. Record numbers of skilled workers and manual laborers migrated around the world in search of employment. This unprecedented international mobility of people, money, and materials was a key function of globalization, which also encouraged a transnational perspective on such issues as the phenomenon of global warming, the potentially disastrous shift in climate that is seen by many scientists to be the result of human activity in the form of industrial pollution and vehicle emissions.

Culturally, globalization saw some national and ethnic cultural practices being amalgamated into internationally appreciated forms. World music, a blending of Caribbean, African, and other local musical styles with rock and roll, was heard all over the planet. Conceptual art, a movement that originated in North America and Europe during the 1960s (see p. 357), had been disseminated around the world by the 1980s. Conceptualism's emphasis on art as idea continued to be expressed in photography, film, and video, and was adapted to specific political circumstances. As Cuban photography curator Cristina Vives Gutiérrez observed, conceptualism is an attitude about the function of art, not a clearly identifiable '

visual style. Its manifestations can be remarkably diverse.[1]

The promises and threats held out by globalization were frequently voiced together in the late twentieth century. Vast global systems seemed to endanger the significance of individual human lives. The architectural manifestations of globalization and their impact on people were rendered by German photographer Andreas Gursky (b. 1955) in huge photographs of large, contemporary buildings, such as the Hong Kong Stock Exchange, or the German Bundestag, or parliament building (Fig. 7.1). Gursky studied with Bernd and Hilla Becher (see p. 377). His photographs are simultaneously glamorous and ominous. He favors architectural subjects such as large hotels, office buildings, and stock exchanges that cater to global capitalism. His big photographs, sometimes ten feet long, approach the size of historical paintings, and shine with intense color, like that used in William Eggleston's work (see p. 382), which influenced Gursky. Despite their loud colors, these large prints have a neutral quality, owing to the physical distance of the camera from the subject, and to their high finish, like commercial work, which makes them look like large pieces of colored plastic. Gursky's images are frequently computer-modified and computer-printed, making use of the vast array of new tools for picture-making available to photographers in the digital age.

To date, globalization has not meant the total homogenization of cultural values and expression. Corporate logos and consumer goods reach into every corner of the world, yet some aspects of cultural experience remain local, regional, and national. Indigenous ways of life have been cruelly disrupted, even destroyed, by the invasion of Western media, yet others have found satellite broadcasts and the Internet to be potent countervailing forces. Globalization has been accompanied by an ongoing negotiation of cultural difference. For example, the extinction of many of the world's languages through the historical process of colonization, and the rise of global media outlets that promote English, now either the first or second language of much of the commercial and scientific worlds, have been met

with resistance in areas where language signifies cultural attainment to its speakers. Thus Catalans in Spain use television to maintain the vigor of their language, and Inuits in northern Canada keep the Inuktituk language alive through satellite broadcasts to far-flung settlements. The notion that global capitalism can be tailored to specific cultural settings is clearly problematic—but it has remained popular nonetheless. Russians repeatedly voiced a desire for global ties shaped by a distinctly Russian capitalism that would protect the singularity of the indigenous culture. Similarly, social thinkers in India called for a uniquely Indian modernization that would reject certain industrial and technological pathways as inappropriately Western.[2]

Ironically, the compression of time and space made possible by jet travel and instant electronic communication has enabled transient workers to maintain active ties with political, cultural, and religious practices in their home countries or ethnic groups. By contrast, the European immigrants photographed by Lewis Hine (see Fig. 4.48) shortly after their passage through New York's customs station on Ellis Island might have to wait months for a letter from family and friends back home. Whereas, in the past, moving to a new country often meant severing ties, an immigrant traveling to the United States today can (money permitting) phone home from the plane, or send photographs by email from a laptop computer. Free e-mail accounts and access to the Internet through public libraries and other agencies let immigrants stay in touch with their homelands, and read electronic newspapers in their native languages.

As never before, hybrid cultural identities can be maintained through generations. An Italian-American immigrant during Hine's time probably did not fully assimilate into American culture, but the children and grandchildren of immigrants did. In the late twentieth century, however, immigrants and their descendants could choose to hover between the cultural and ethnic identity of their families, and the culture of their new country.

Migrations of people from place to place, whether to seek work, escape famine, or to flee political tumult and

7.1 (opposite)
ANDREAS GURSKY,
Bundestag, Bonn, 1998.
Mixed media.

In his rendition of the Bundestag, built in Berlin after the reunification of Germany in 1990, Gursky shows individuals stunted by the huge gleaming structure, and, symbolically, by the mega-systems that they have built.

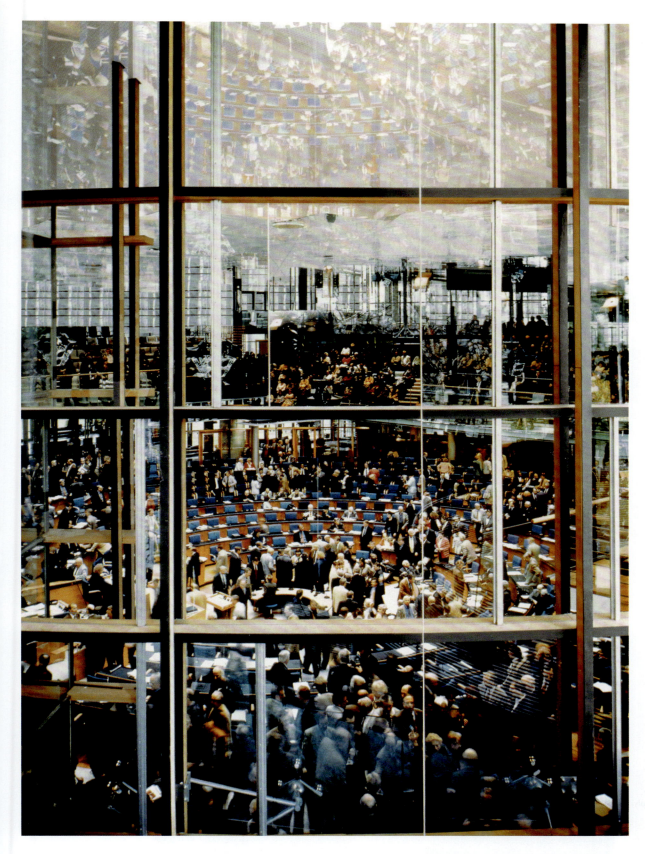

repression, became frequent photo-graphic subjects, both for photojournal-ists and for those photographers who experienced cultural dislocation first-hand. Writing about her sense of dis-placement, Korean-born image-maker Young Kim (b. 1955) noted, "My work reflects the continuous process of nego-tiating between two cultures. It is based on my experience of immigration and of locating myself in relation to ever-chang-ing definitions of home in personal, social, and cultural contexts."[3] Kim depicts psychological distance through

physical distance, placing little family pictures in large frames (Fig. 7.2).

Crossing borders was a characteristic of photographic practice itself in the late twentieth century. By the mid-1970s, photography had moved squarely into the art world, and artists active in other media integrated photography into their work, either through the direct use of the medium, or by making reference to the ubiquitous presence of camera-generated pictures in the contemporary world. As it had been for sculptor Robert Smithson (see p. 376), photography continued to be an adjunct to late twentieth-century artists working primarily in other media, such as installation-maker

and sculptor Kiki Smith (b. 1954), video-maker Matthew Barney (b. 1964), who recorded ephemeral work, or printed stills from videos, and Adrien Piper (b. 1948), who easily moved among performance, installation, video, and photography (Fig. 7.3). Sigmar Polke (b. 1941) made reference to the ominous overhead lights and the barbed-wire enclosure of concentration camps as shown in post-war news photographs (Fig. 7.5).

Throughout the Western world, artists who came of age after the skirmishes to confirm photography as an art medium found the camera to be an exciting image-making process, whose full potential had not been explored.

7.3 (opposite)
ADRIEN PIPER,
Pretend no. 3, 1990.
Four black-and-white photographs, one pencil drawing on graph paper, silk-screened texts.

To suggest that the public regularly denied the violence against protesters during the American Civil Rights movement, Piper superimposed red-lettered captions on news photographs, and included a line drawing of the monkeys who, in the popular saying, "see no evil, hear no evil, and speak no evil."

7.2
YOUNG KIM,
Distances, no. 3, 1992.
Gelatin silver prints, plywood, ink, acrylic.

To express growing psychological remove from her Korean heritage, Young Kim framed small family photographs on larger panels, with inscriptions. The difficulty in making out the images suggests the struggle to stay connected and the sense of absence.

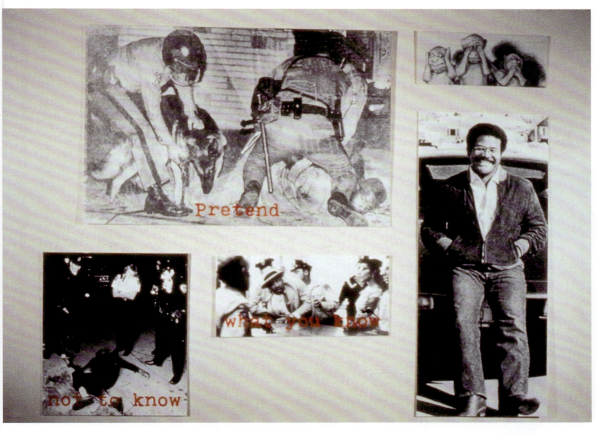

7.4 (below)
ANSELM KIEFER,
*Siegfried's Difficult Way
to Brünhilde*, **1988. Lead
and photo in a glazed
steel frame.**

Photography allows
Kiefer to relate
Germany's modern his-
tory to familiar elements
of mythology. Siegfried,
the hero of a medieval
German saga, rode
through flames to res-
cue Brünhilde. In this
image, the path seems
to be a rotting railway,
recalling the trains that
took Jews to the death
camps.

German artists Anselm Kiefer (b. 1945) (Fig. 7.4) and Gerhard Richter (b. 1932) (see p. 428) employed photography in their image-making, largely without reference to the celebrated masterworks of photographic history, or the reigning technical standards of photographic image production. British artist David Hockney (b. 1937) collaged sequences of snapshots or Polaroid prints, creating a total picture that contains myriad alterations of the angle of view and distance from the subject, in conscious reference to early twentieth-century Cubist painting and collage (Fig. 7.6). Sliced, crumbled, over-printed, under-exposed, blurred, and even cameraless photography was welcome in the art world.

7.5
SIGMAR POLKE, *Lager,* **1982. Acrylic and various pigments on fabric, 158 x 98 in (401.4 x 250 cm).**

Polke worked on unprimed canvas so that his pigments would seep through the fibers like a stain. In this image, the stain courses through an image of a German concentration camp.

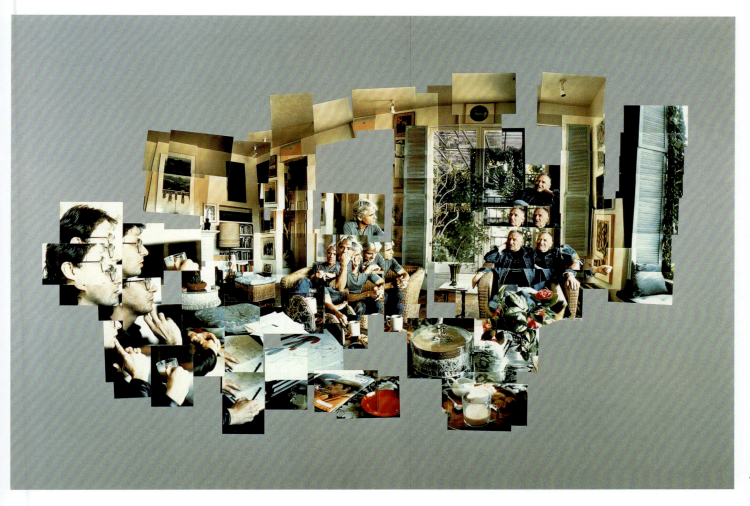

**7.6 (above)
DAVID HOCKNEY,**
*Christopher Isherwood
Talking to Bob Holman,
Santa Monica, Califor-
nia, 14 March 1983,*
**1983. Photographic
collage.**

**7.7 (right)
ORLAN,** *Omniprésence
Vénus,* **2001. Composite
photograph.**

In this composite photo-
graph, Orlan melded her
features with those of
Venus in Renaissance
artist Sandro Botticelli's
Birth of Venus (c.1480).
Wavering between the
real and the ideal, the
photograph grotesquely
epitomizes ceaseless
desire.

Once a simple means to record per-
formance art, photography gradually
became integral to the initial conception
of performance pieces. For French per-
formance artist Orlan (b. 1947), pho-
tographs are indispensable traces of the
repeated surgical remodeling done on
her face to make it resemble famous art-
historical versions of feminine beauty.
Submitting to the surgeon's knife in
cumulative stages, rather than in a sin-
gle operation, Orlan targets the inces-
sant, intense longing for perfection
some feel about their physical appear-
ance. She has used video, photography,
and most recently digital imaging to
record and investigate the surgical trans-
formation of her face (Fig. 7.7).

The continuing assimilation of pho-
tography into the art world was only one
of the many camerawork convergences
during the period. Photojournalism and
documentary work blended with each
other, and with art photography. Fashion
and celebrity photography adopted tech-
niques from art photography, and art
photographers mined the methods of
fashion and celebrity images for the

sake of social commentary. In addition,
advertising photography sometimes
took up social issues, and the visual lan-
guage of documentary photography.
The effects of these new hybrids are still
unfolding, but the preliminary outlines
of the changes wrought by these conver-
gences are apparent in a number of new
configurations, including the photogra-
phy of social concern.

THE PREDICAMENTS OF SOCIAL CONCERN

The decline of the picture magazine after World War II, and the concomitant rise of television news, shrank the number of outlets available for documentary and photojournalistic images. Newspaper and magazine photo-editors increasingly prescribed the exact subject and style they wanted from photographs, thereby cramping the individual initiative of photojournalists. To a greater degree than in the past, editors rather than photographers chose which, if any, images submitted would be published. As a consequence, though documentary photographers and photojournalists continued to work for newspapers and magazines, they also published books, and exhibited in museums and galleries, where they were able to exercise greater control over the selection and presentation of their work, and where they did not have to contend with tight deadlines.

The presence of documentary and photojournalistic photographs in museums and galleries was not new. From the beginning, reportage images, such as those taken by Roger Fenton of the Crimean War (see pp. 86–89), were presented in art spaces. Images made for the Farm Security Administration (see pp. 281–290) also found their way into the art world. Nevertheless, in the past, image-makers, audiences, curators, and scholars had considered art photography, documentary photography, and photojournalism as having their own separate lines of development and different social agendas. By the late twentieth century, however, these distinct photographic genres were increasingly coming to resemble each other in style and subject. No single term emerged to express this hybridization, but the need for a label to describe the new phenomenon is evident in the attempt of Weston Naef, curator of photographs at the J. Paul Getty Museum in Los Angeles, California, to characterize the work of Brazilian photographer Sebastião Salgado (see pp. 408–9). Although Naef described him as "an artist, using photojournalism as the vehicle for his art," Salgado has repeatedly maintained that he is not an artist, but a documentarian.[4]

As critic and historian Vicki Goldberg observed, "some of the most arresting documentary work now leans heavily, even self-consciously, on art and art photography.[5] The blending of documentary work, photojournalism, and art photography is apparent in the images of Americans Mary Ellen Mark (b. 1940) and Eugene Richards (b. 1944). Affiliated with the Magnum Agency (see p. 312), both sought employment where their ideas would be subject to the least interference by editors. Their work centers on the plight of unfortunate people, yet their images are seldom sentimental. Mark and Richards did not venerate the poor in the manner of the confidently humanistic pictures made by photographers working for the Farm Security Administration. Although Mark's images are frequently seen as having been influenced by Diane Arbus's work (see pp. 351–52), she does not deliberately belittle subjects, as Arbus sometimes did, nor are they primarily symbols for her own psychological outlook. Mark's photographic series on homeless children and teenagers in Seattle, Washington, is compassionate yet unflinching (Fig. 7.8).

While photographs showing unfortunate people as victims of political injustice and catastrophic circumstance continued to be made and shown, in the new hybrid of art, documentary, and photojournalism, the romantic humanism of the popular 1955 *The Family of Man* book and exhibit (see pp. 312–314) was being overturned. Instead the idea became current that human nature is a convoluted and unpredictable blend of dignity and imperfection.

To be sure, this chastened estimate of human nature is not simply a photographic phenomenon. The twentieth century's grim record of millions of deaths caused by large and small wars, as well as by many disregarded famines, does not inspire faith in the inherent goodness of humankind. The end of the Cold War, and of the tendency to see the world in terms of sharply competing ideologies, may also have contributed to a diminution of human expectations. From Lewis Hine to the Photo League (see pp. 208, 296), social documentary photography was animated by the idea that images could precipitate social change. During the late 1950s and the 1960s, social documentarians began to lose faith in the capacity of pictures to

In the past, a photographer such as Dorothea Lange (see pp. 285–86) might have elected to photograph a homeless child as the casualty of social neglect, rather than as a willful runaway with a gun. Mark, by contrast, suggests these children's quick passions and uncertain judgments. She constructed the image so that a long tunnel of receding space seems to push the children forward for our attention, while simultaneously signaling their estrangement from society.

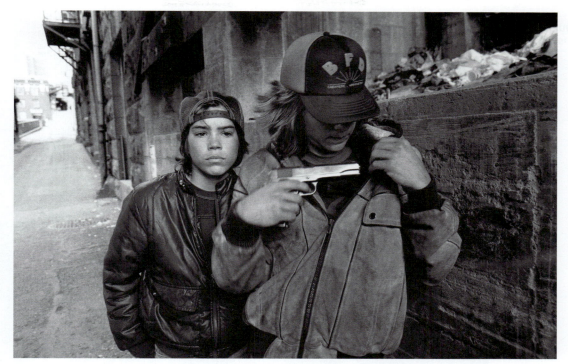

do this.[6] Robert Frank and Diane Arbus (see pp. 344, 351–52) used the camera to denote their dissatisfaction with society's shallowness, not the need for social change. Their mood of dark resignation was sustained in the documentary photography of the next generation. For instance, in his book *Interior America* (1978) Chauncey Hare (b. 1934) laid waste to whatever hopefulness Bill Owens (see p. 358) had found in suburbia, and cast his camera on the bleak settings that framed the experience of even bleaker Americans.

The work of British photographers Chris Killip (b. 1946) and David Hurn (b. 1936) is typical of the ongoing turn away from promoting change towards personal observation and interpretation of the social scene. Killip's book *In Flagrante* (1988) pictured the effects of deindustrialization on downtrodden residents in and around the northeastern city of Newcastle-upon-Tyne. Working primarily in black and white, Hurn shoots mainly on the streets, catching people in moments of social isolation that are sometimes laced with humor (Fig. 7.9). A longtime member of Magnum, the photographer's collective (see p. 312), Hurn was also the founder of the highly influential School of Documentary Photography at the University of Wales in Newport.

Martin Parr (b. 1952), a British photographer directly influenced by both

Killip and Hurn, achieved an international reputation for his images of self-centered British middle-class suburban life. Unlike Killip's sullen introspective views, Parr's *The Cost of Living* (1989) is punctuated with wry, satirical perceptions of human behavior (Fig. 7.10).

Photography's blighted vision of human nature was accompanied by a change in the formal appearance of documentary and photojournalism. In a hurried era, with round-the-clock television news, ubiquitous video-cameras, and small, concealable digital cameras that could quickly transmit still photographs around the world, the static, balanced, easily discernible images promoted in the past by the Farm Security Administration and picture magazines such as *Life* blurred and shattered. Audiences exposed to television images for many hours a day adjusted to rapid, highly condensed picture sequences, such as thirty-second advertisements and rapid-cutting music videos. Largely through exposure to television and film, viewers became accustomed to quick transitions, such as jump-cuts, and shaky hand-held camera motions. Typically, photojournalism and documentary work also picked up on the look of speed and chance.

While Mark's images are dispassionate renderings of passionate situations, Eugene Richards's pictures are more stylized, regularly using dim light,

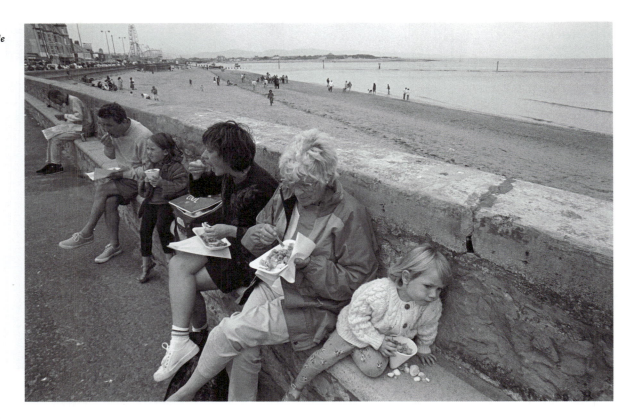

surprising angles, and disjointed sequences that remind the viewer of the photographer's presence and interpretive role. Like Mark, he spends long periods with his subjects, returning time and again to keep up with their progress, and his photographs are accompanied by text that reads like a personal diary.

Exploding into Life (1986), Richards's paradoxically titled chronicle of the med-

ical experiences he and his companion Dorothea Lynch endured during her losing battle with breast cancer, is a searingly frank presentation of what was then a largely unphotographed theme, the individual experience of cancer in the milieu of modern medical technology. *Cocaine True, Cocaine Blue* (1994), a collection of pictures and intimate personal stories about drug use, brought

7.10
MARTIN PARR,
Tupperware Party, 1985,
from his book *The Cost of Living*, 1989.

While listening to a Tupperware demonstrator, the women in the audience display contrasting expressions of polite boredom. Unlike many other photographers of his generation, Parr admires these visual anecdotes and seeks them out.

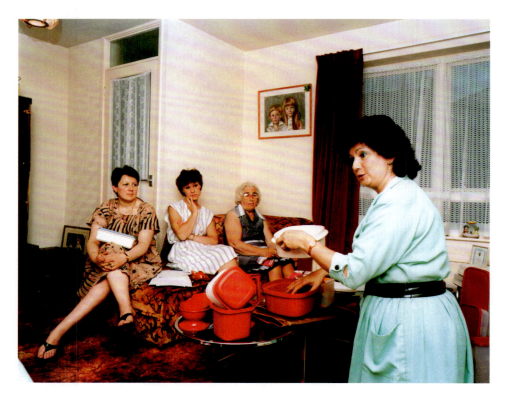

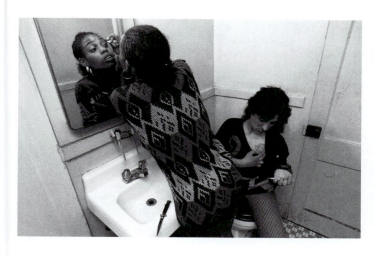

7.11
EUGENE RICHARDS,
Crack Plague in Red Hook, Brooklyn, **1994. Gelatin silver print.**

"Composed shots lie," Eugene Richards believes, because they turn "people into archetypes — The Hungry Child, The Drug Addict. I feel more comfortable taking fragmentary photographs, so you know that this is not the final, correct answer."[7]

viewers into a world of day-to-day self-deception and ruin (Fig. 7.11). Viewing the exhaustion and despair in so much of Richards's work, Cornell Capa, brother of Robert Capa and former director of the International Center of Photography in New York City, noted that "He is too strongly attuned to misery."[8] Others have declared that Richards's intimate pictures encourage voyeurism.[9]

Another characteristic of recent photojournalism and documentary work is an increased reliance on words to contextualize photographs. In the past, large books by socially concerned photographers such as Dorothea Lange relied on extensive text written by someone else. Sociologist Paul Taylor fur-

nished the data and arguments that accompanied Lange's pictures in *An American Exodus: A Record of Human Erosion* (1939). American Susan Meiselas (b. 1948), who combines history, social science, and photography in her work, emerged as one of the main photographers of the protracted small-scale wars that characterized the last decades of the twentieth century. Her books *Nicaragua* (1981) and the much larger *Kurdistan* (1997) contain not only photographs, but also substantial data orchestrated by Meiselas. In Nicaragua, where she photographed life under the late 1970s regime of dictator Anastasio Somoza, rebels had taken up arms against a brutal right-wing government that was receiving U.S. aid. The hostilities eventually left about 50,000 dead and one-fifth of the population homeless. Meiselas's images captured the spasmodic flurry of street fighting (Fig. 7.12) and the evidence of atrocities.

Like Meiselas, French photographer Gilles Peress (b. 1946) prepares extensive historical chronologies to accompany his books and gallery exhibitions. With fragmented foreground close-ups, slanted horizon lines, and visual components that enter the frame at all angles, Peress's images often resemble the work of American street photographers Garry Winogrand or Lee Friendlander (see

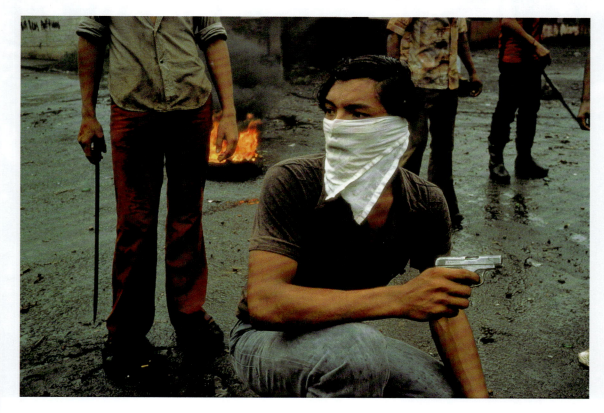

7.12
SUSAN MEISELAS,
Street Fighter in Managua, **from her book** *Nicaragua,* **1981. Gelatin silver print.**

7.13
GILLES PERESS,
*Demonstration in Favor
of the Ayatollah
Shariatmadari, Iran,*
1980. Gelatin silver
print. Courtesy the
artist.

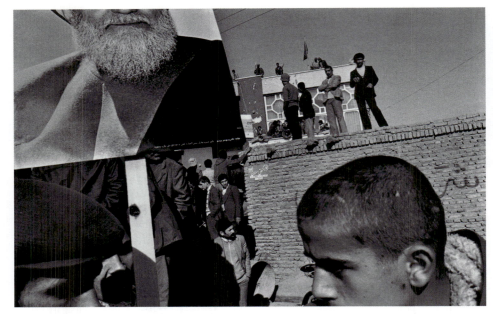

Peress disowned the
notion of neutral, com-
prehensive reporting in
his book *Telex Iran,*
which integrates images
with copies of the
telegrams sent to and
from his photoagency,
Magnum. He warned
readers that "these pho-
tographs, made during a
five-week period from
December 1979 to
January 1980, do not
represent a complete
picture of Iran, or a final
record of that time."[10]

pp. 349–50) (Fig. 7.13). Like them,
Peress embraces disunity as a condition
of the world, and tries to find its visual
equivalent for his work.

Despite a growing acceptance of
visual ambiguity and jumpiness in pho-
tojournalism and documentary work,
this approach has not pleased the public
in times of crisis. In American photo-
journalism, for example, abiding social
conditions, such as poverty, may be ren-
dered with harsh shadows or despon-

dent graininess, but traumatic events
such as the April 1995 terrorist bombing
of the federal building in Oklahoma
City, Oklahoma, are considered to
demand a clear, uncomplicated compo-
sition and explicit visual narrative that
connote sincerity and truthfulness.
Except for its startling use of color, the
image that became a national symbol of
the event, that of a firefighter holding a
dead child, could have been made in the
1930s (Fig. 7.14). Similarly, as critic and

7.14 (below)
**CHARLES H. PORTER
IV,** *Fireman and Child
in Oklahoma City,* 1995.

The public fastened on
the photograph of mor-
tally wounded one-year-
old Baylee Almon in the
arms of a firefighter
who responded to the
terrorist bombing of the
Alfred P. Murrah
Federal Building in
Oklahoma City.

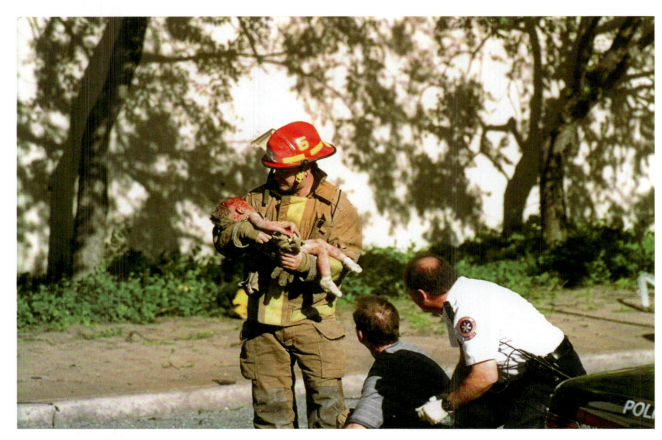

7.15
DONNA FERRATO,
Cover photograph of her book *Living with the Enemy*, 1991.

In 1991, the same year that *Living with the Enemy* was published, Ferrato started a non-profit organization called the Domestic Abuse Awareness Project (DAAP) to raise funds for women's shelters. She recalled that "I felt it was important to find ways to show as many aspects of the problem as I could."[12]

THE COLOR OF CONCERN

Concerned photojournalists and documentarians, such as Susan Meiselas, and American James Nachtwey (b. 1948), author of the 1989 *Deeds of War* (Fig. 7.16), were sometimes reproved for using sensational high-key colors that startled the viewer, but did not foster contemplation. Black-and-white work continued to be associated with seriousness of purpose, and with a dedication to craft, even though one could argue that color film more accurately equates to the way we see the world. Philip Jones Griffiths (b. 1936), the British war photographer who produced the penetrating indictment called *Vietnam, Inc.* (1971) (see p. 367), denounced color as "the biggest single hindrance to photojournalism the world has ever seen."[13] Decades of amateur photography, and the broad use of color in advertising, made it seem too facile and too emotionally arousing for somber subjects such as war and human suffering. Moreover, increased use of color film in art photography prompted the association of color with fabrication and fantasy.

Documentarians and photojournalists working in color were accused of adulterating the medium by making the photograph look too much like a painting. Some did indeed mine the history of art and magazine advertising, which they scrutinized for clues to effective color usage. Larry Burrows (see Fig. 6.70), for instance, rummaged through Old Master paintings for ideas, and occasionally did sketches to precast the kind of battle photographs he wanted to make. The increasing custom of photojournalists and documentarians to publish beautifully crafted books and mount art gallery exhibitions added to the unease about blurring the line between personal expression and reporting. Lastly, to photographers who came of age in the first half of the twentieth century, color documentary and color photojournalism repudiated the venerable heritage of socially concerned black-and-white photography, such as that of Lewis Hine.

The profusion of color photography signaled for many the loss of ethical gravity, and with it the abandonment of the idea that photography could play a role in social change. Even in black-and-white work, raw emotionalism, the

historian David Perlmutter found, photographs used in social science textbooks are chosen for compositions that do not call attention to themselves or to their makers.[11]

In contemporary documentary and concerned photojournalism, extensive textual descriptions of the sitters' social or personal circumstances have become regular additions. Photographs are not expected to stand on their own, communicating to viewers in a universal language. In *Living with the Enemy* (1991), for instance, a book recording incidents of domestic violence and their aftermath, American photographer Donna Ferrato (b. 1949) did not linger only on battered women (Fig. 7.15). In abundant text and many pictures, she related life stories of the battered and the batterers, and she laid bare the circuit of violence, from home, to hospital, to court, to shelters, to prisons, or to therapy sessions. Ferrato's consciousness of domestic violence's large province earned her commendations by critics who otherwise questioned the effectiveness of documentary work.

CONVERGENCES (1975–PRESENT)

7.16
JAMES NACHTWEY,
*Rioters in Belfast,
Northern Ireland,* 1981,
from his book *Deeds of
War,* 1989. Gelatin silver
print.

In many of Nachtwey's
photographs, human
figures are seen in
incongruous poses, as if
they were participating
in modern dance, not
modern mayhem. The
tension between absur-
dity and tragedy ener-
gizes his signature style.

equivalent of color's supposed excess,
was suspect. Thus, the monochrome
images created by Brazilian-born photog-
rapher Sabastião Salgado (b. 1944) were
reproved for what critic and historian
Vicki Goldberg called "too much human-
ism"[14] (see pp. 408–9).

The proliferation of color photogra-
phy in Western advertising, commerce,
and art highlighted the economic
inequities that divide photographers
practicing in developing countries from
those in the developed world. The color
process is more expensive than the
black-and-white method, and it requires
a greater infrastructure, including costly
printers, or digital cameras, computers,
and connections to the Internet. Black-
and-white film can be developed and
printed in a simple darkroom. Often
Third-World newspapers and magazines,
especially those aligned with poorly
funded opposition causes, do not have
the capacity to print color photographs.

During the last decades of the twenti-
eth century, Western photographers were
typically college graduates, with special-

ized education in photography or related
subjects that stressed continual innova-
tion and offered exposure to a wide
range of historic and contemporary
image-making. By contrast, the primary
third-world route to learning camera-
work remained self-instruction or infor-
mal apprenticeships on newspapers and
in photographic studios. For example,
Héctor García (see pp. 320–21), who was
an orphaned street child and manual
worker, learned photography while serv-
ing as an office boy at several Mexican
publishing firms. An education like
García's does not acquaint learners with
many permutations of style, nor does it
offer much expensive, technologically-
based image-making. Therefore, while
photography produced in and for people
in developing regions may have ample
meaning and consequence for viewers,
its conventional approaches, lack of
color, and want of means by which to
circulate the images to the wider world,
make third-world photography and its
history largely ignored outside its imme-
diate domain.

NEUTRAL VISION

During the 1980s and 1990s, the notion of neutral vision was repeatedly examined by cultural critics and by artists. *The Predicament of Culture* (1987), a much discussed book by American anthropologist James Clifford, investigated twentieth-century ethnology and literature, to conclude that photographers had relinquished the idea of objectivity for subjective exploration. The British anthropologist Elizabeth Edwards and British critic David Green looked back at earlier, purportedly impartial anthropological photography, such as that initiated by Thomas Henry Huxley (see p. 142), and revealed the means by which these methods were used to demonstrate implicitly the superiority of Western civilization.[15] In a sweeping indictment, influential photographer-critic Allan Sekula (b. 1951) pointed out that Modernist photographic practice is "shielded by a bogus ideology of neutrality."[16]

One reason for the decline of the neutral-record photograph in the social sciences is that non-Western peoples, the former subjects of the record-keeping procedure, have taken up photography as a way of counteracting stereotypes propagated by it. Native American photographer Jolene Rickard (b. 1956) put it clearly: "Working in photography one is forced to deal with issues of representation or risk promoting visually the ideals other people have placed in your head"[17] (Fig. 7.17). In the United States, the Native American

Journalists Association sponsors "shoot out" contests in which Native American photographers vie to present scenes of contemporary everyday life that specifically counterbalance many stereotypes. Globalism and localism operate simultaneously within Native American photographic theory. Theresa Harlan, who teaches Native American Studies and curates photography exhibits, maintained that in her scholarship she uses "the term 'international' in place of 'intertribal' to stress the diversity of indigenous nations within and outside the borders of the United States."[18]

Some photographers, such as Hulleah Tsinhnahjinnie (b. 1954), concentrated on fracturing stereotypes of Native Americans by focusing on intertribal issues, or by investigating the laws that determine who is and who is not considered an Indian. Recently, she has begun working with computer-enhanced techniques and has linked up with indigenous people on other continents to share experiences, especially what it's like to be the subject of tourist cameras (see Fig. 8.15).

Another factor in the transformation of identity photography, both in the popular press and in social science, has been the ongoing domestication of the exotic. Once a source of titillating cultural difference existing at the margins of Western societies, the exotic can now be experienced in almost any large world city. Dutch photographer Bettina Witteveen found it while visiting New York and San Francisco. In a series she called *Hybrid Identities*, she extended the

**7.17
JOLENE RICKARD,** *Untitled*, adapted from the series *Scientifically Unnatural*, 1993. Ektachrome and silver gelatin print with rubbings.

Rickard is a member of the Turtle clan from the Tuscarora Nation. On the left of this combination picture are two costumed Native American dolls, teasingly anonymous due to their lack of facial features; on the right is an international group of women in traditional dress.

PORTRAIT
Sebastião Salgado

Although he was in the right place to make the well-known images showing the 1981 shooting of President Ronald Reagan (b. 1911), Sebastião Salgado is not a news photographer. An economist who never finished his Ph.D., Salgado has photographed in more than sixty countries, focusing mainly on people who survive day-to-day: physical laborers, refugees, victims of famines, and most recently groups who migrate because of natural disasters or civil unrest.

Through magazine and newspaper illustration, Salgado's work attracted an appreciative public that is mostly unfamiliar with new photography and its recent debates about the efficacy of documentary work. His popularity permitted him to pick his projects and to schedule his own time. Salgado rejects the use of color film, calling it a distraction. He prefers to use available light and highly sensitive black-and-white film, because he finds flash illumination artificial. Salgado pointedly differentiates his image-selection process from the "decisive moment" popularized by Cartier-Bresson (see Fig. 5.30). Where Cartier-Bresson perfected the technique of waiting for the one instant in which compositional elements and the subject of a photograph come together, Salgado attunes himself to the extended rhythms of a particular site.

His approach can be seen in his best-known series that records the bone-wearying toil of laborers excavating pyramid-sized pits in the wilds of northern Brazil in order to extract gold deposits. The series begins with a panoramic establishing shot showing hundreds of tiny, mud-swathed figures straining under loads of earth, and struggling up long ladders to the top of the pit. Salgado, who often packs his pictures with visual references to religious art, makes the workers look like souls trying to climb out of purgatory (Fig. 7.18). The next several pictures move in closer, allowing viewers to see the armed guards who overlook the scene, and to make out individual faces among the throng. Later shots come in closer still, to study the perseverance expressed on sweaty faces, or the grace of a hand holding a heavy burlap bag of earth. The final shot is again a wide expanse of the excavation and its denizens.

Salgado's style harkens back to the Depression era, when press and advocacy photography confidently presented humans as pure of heart, despite their suffering and hardships. Seen primarily in magazine articles, but also through books and exhibitions, his affecting pictures of human suffering during a famine in northern Africa helped to raise money for the humanitarian aid group, Médecins sans Frontières (Doctors without Borders). His photographs of Cambodian children who lost legs to land mines helped to raise funds for a factory to manufacture artificial limbs.

Despite his good works, Salgado has been the subject of two recurring questions—one concerning the implicit politics of his images, the other having to do with the formal qualities of his prints. He has been chastised for neglecting to record local struggles to organize and change conditions. Although Salgado has depicted worker protests, as in his pictures of Brazilian peasants marching for agrarian reform, it is not the dominant theme of his imagery. While showing human suffering at its most wretched, Salgado's images are elegant poems of composition and luminosity. Viewers understand the symbolism of harsh black-and-white pictures used to describe misery in photographs such as those by W. Eugene Smith or Shomei Tomatsu (see pp. 303, 333). But Salgado enhances shimmering light so that it transforms burlap sacks of earth into treasure pouches, and warms the gaunt faces of the starving so that they look like tranquil martyrs.

Salgado's own books, *Workers, An Archeology* (1993), *Migrations* (2000), and *The Children* (2000), generally disappointed the literati, who labeled his work "sentimental voyeurism," and who are uneasy in the presence of Salgado's signature mixture of beauty and affliction.[19] While no one openly accused Salgado of building his reputation on the backs of the unfortunate, his signature mixture of beauty and affliction not only made some viewers uneasy but also seemed to frustrate criticism, for fear of being thought to be insensitive to the plight of the unfortunate. Other observers judged Salgado's radiant prints offensive, because they seemed to suggest that misery is the immutable way of the world, or that a divine presence will enoble those who suffer.

Salgado's defenders point out that formal beauty has suffused panoramas of suffering throughout Christian art, and that, in an age when news photographs of misery are broadcast around the clock, beauty grips the viewer's attention and is a counterweight to the ubiquitous violence of television and film. In an era that has refined remoteness into an art language, Salgado boldly continues to wear his heart on his sleeve.

7.18
SEBASTIÃO SALGADO, *Serra Pelada, Brazil,* from his book
An Uncertain Grace, 1990.

7.19
BETTINA WITTEVEEN,
Jon, from the series
*Hybrid Identities, New
York City,* 1997–98.

traditional anthropological close-up view to contemporary white men and women whose bodies display a mix of modern Western and traditional South Pacific body art (Fig. 7.19).

Despite the mounting condemnation of neutral vision, it remained a strong component of twentieth-century imaging. Standardized poses, uniform backgrounds, and fixed distance were used routinely for millions of national identity cards, medical illustrations, passports, drivers' licenses, employee badges, and the like. Mug shots of prisoners looked much as they had in the nineteenth century (see Fig. 4.70). After the defeat of the Khmer Rouge regime

in Cambodia, the public was able to see the conventions of photographic objectivity used to produce more than 5,000 standardized images of people who were about to be killed (see p. 415).

The broad utilitarian use of would-be neutral photographs sparked many political and artistic responses. Internationally, conceptualism's take on objectivity persisted in the work of such artists as Ed Ruscha (see Fig. 6.96), Bernd and Hilla Becher (see Fig. 6.87), and a younger generation of photographers, such as Toshihiro Yashiro (b. 1970) (Fig. 7.20). Chinese photographer Zhuang Hui (b. 1963) parodied neutral vision's uniformity by making rigorously unvaried, single-shot panoramas of large groups, such as factory workers or the population of a whole town (Fig. 7.21).

Russian Vladimir Kuprejanov (sometimes Kuprijanov, b. 1954) energized monotonous ID cards when he photographed sixteen women telephone operators in Moscow, and then placed a line of verse written by Russian poet Aleksandr Pushkin (1799–1837) below the portraits, where one normally would find names and numbers (Fig. 7.22). Kuprejanov orchestrated an oblique political commentary in this sequence, called *In Memory of Pushkin*. The first few pictures in the series show weary, morose middle-aged faces, but the final images present younger, more contented-looking women. At the bottom of the images, the lines from Pushkin's poem "Farewell to the Sea" metaphorically advance from the present darkness to an inviting view of a distant shore.

7.20
**TOSHIHIRO
YASHIRO,** *Yanaginoya
Fukushima,* 1994, from
his series *Time-Space
(Ji-kukan),* 1994.

Time-Space (Ji-kukan)
series coolly imaged the
gender-segregated
Japanese public baths,
an architectural form
and social activity that
has been falling from
favor.

7.21
ZHUANG HUI,
Commemorative Picture
of Teachers and
Students of Loyang
Police School, Hunan
Province, May 13 1997,
1997. Gelatin silver
print.

The long, unvaried rows
of police cadets and
instructors extend
beyond the frame, help-
ing to homogenize the
figures as indistinct inte-
gers in a sequence of
interchangeable figures.

Created in 1985, the year that Mikhail
Gorbachev (b. 1931) assumed the office
of General Secretary of the U.S.S.R.,
In Memory of Pushkin conveys the
Russians' cautious hope for economic
reform and political liberalization.

In Chile, during the repressive
regime of Augusto Pinochet (see p. 316),
neutral vision's purportedly nonpartisan
stance was turned in on itself to create
images for the political opposition.
Photographer Eugenio Dittborn mocked
the regime's oppression by making an
accusatory hybrid of the identity card
and the mugshot (Fig. 7.23). Similarly,
Korean Conceptual artist Park Bul-dong
(b. 1956) satirized the appearance and
purpose of election campaign posters
(Fig. 7.24).

No words inform the large, richly
detailed, yet uninformative portraits
taken by Thomas Ruff (b. 1958), a
German photographer who studied
with Bernd and Hilla Becher (Fig. 7.25).
Ruff adapted the uniform picture-mak-
ing techniques used by the Bechers to
explore the extent to which viewers con-
tribute interpretations to portrait pho-
tographs. In contrast to the dramatically
lighted portraits of the past, such as

those of Carjat (see Fig. 3.92), where
posture, lighting, and facial expressions
cued a viewer's response, Ruff's work is
resolutely uninflected.

The scientific method, neutral
vision's mainspring, figures in the work
of American-born Canadian photogra-
pher, Lynne Cohen (b. 1944). No people
appear in the icy interiors of lecture
halls, laboratories, military installations,
and corporate headquarters she pho-
tographs. Cohen's sterile interiors evoke
a claustrophobia that seems to seep
through the antiseptic air. Working pri-
marily in black-and-white, her images
share the thin humor of pictures by
Conceptual artists such as Ed Ruscha.
As writer and cultural critic David Byrne
commented, in Cohen's pictures "cool-
ness is being flipped back on itself to
look ridiculous."[20] In the scientific
observation room, one of Cohen's
repeating subjects, it is never clear
what activity is being viewed or why
(Fig. 7.26). Cohen focuses on the stale
sameness of the observers' world, not
on the people, animals, or things they
scrutinize.

The public's continuing faith in pho-
tographic impartiality is an ongoing

Погасло дневное светило;

7.22
VLADIMIR
KUPREJANOV, "The
lights of the day extin-
guished," from his
series *In Memory of*
***Pushkin*, 1985.**

Kuprejanov's close-ups
imitate the visual tech-
niques used in modern
television news pro-
grams to indicate
authenticity. By focusing
so closely that the top of
the head is excluded, the
photographer brings the
viewer uncomfortably
close to the sitter's face
in this series of sixteen
photographs.

LISTA DE PRECIOS CASA DE CITAS REVISTA DE MODAS DIA DE AYER

TIERRA DE NADIE CAMPO DE JUEGO TIRO DE GRACIA HOMBRE DE CONFIANZA

PALOS DE CIEGO NINO DE PECHO PAÑO DE LAGRIMAS SEÑALES DE VIDA

7.24 (opposite)
PARK BUL-DONG,
Nightmare no. 3
(Electoral campaign poster), 1985. Collage of photograph and text on paper. Collection of the artist.

In a series of election posters promoting outlandish fictional candidates, political activist Park Bul-dong taunted the South Korean authorities with sarcastic humor that got him arrested and his work confiscated. His photo-based pieces relate insulting political ideas guaranteed to offend a staid voting public.

7.23
EUGENIO DITTBORN,
Commonplaces, **1984. Airmail painting no. 8, rubber stamp and photosilkscreen on wrapping paper.**

motif in the work of French artist Christian Boltanski (b. 1944). He suggests the public importance of his photo-based installations by setting them in civic spaces, such as Grand Central Terminal in New York, or by inventing the look of public places such as hospitals and churches in his museum installations. Boltanski conjures up the darkened interiors of shrines and churches by using miniature lights that glow like candles. He evokes the past by placing old objects, such as letters and clothing, next to portrait photographs. The dim illumination

and religious objects of his *Monuments (Les Enfants de Dijon)* (*The Children of Dijon*) hint at a memorial chapel (Fig. 7.27). Black electrical cords, like old cobwebs, power the tiny lights and link the images in an implicit web of meaning.

In France, where Boltanski is considered to be a Conceptual artist who manipulates ideas, his work is understood as a critique of adults' persistent yearning to reclaim the golden days of their youth. Elsewhere, Boltanski's *Monuments* are taken to be poignant mementos filled with emotionally charged references to the Jewish

7.25 (above)
THOMAS RUFF, *Portrait,* **1987. Chromogenic color print.**

Ruff's portraits are close-up and impersonal. All the facial details captured by the camera provide physical identity, but offer no clues from which the viewer can ascertain the sitter's mental attitudes or interests. He deliberately attempts to overturn the deeply ingrained notion that one can read personal character from a photograph.

7.26
LYNNE COHEN,
Observation Room, **n.d.**
Gelatin silver print.

Cohen's interior shots are frequently undated, adding to their eerie timelessness and banality. The past presence of never-seen workers, indicated by forgotten briefcases, soiled coffee cups, or, in this case, a sketch mounted on the table, poses questions about the emotional state of people who inhabit these rooms.

7.28 (below)
LORNA SIMPSON,
Five-Day Forecast, 1988.
Five black-and-white prints in one frame and ten engraved plaques.

Although the text and pictures in Simpson's work are clear, their combined meaning is not. The bottom row of words listing mistakes is not aligned with the top row listing the days of the week. Simpson places the burden of interpretation on the viewer, whose habits of linking words with pictures serve as a frustrating lesson in the complexity of meaning.

Holocaust. He has resolutely declared neutrality, stating that his art means whatever it means to individual viewers.

The presence of text accompanying pictures that play on the conventions of neutral vision is no guarantee of additional or clearer meaning. American photographer Lorna Simpson (b. 1960) appended words to her neutral photographs, yet the resulting combinations are puzzling (Fig. 7.28). The faces of the African-Americans in these life-size or over-life-size photographs are deliberately cropped, and their individuality disguised by plain backgrounds and simple clothing. Simpson uses standardized observational techniques, such as fixed distance, to disguise the differences among her subjects that can only be observed by carefully looking beyond the visual structures that suggest sameness. The sitter's arm positions and the folds of her simple gown are not identical in each image.

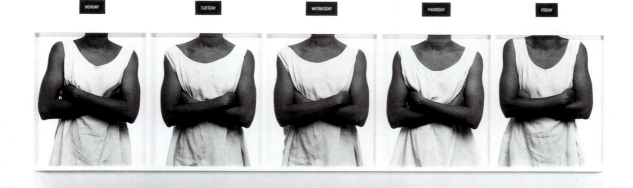

FOCUS
The Cambodian Genocide Photographic Database

When Cambodian Communist leader Pol Pot (c.1925–1998) assumed leadership in 1975, he directed his troops and supporters, known as the Khmer Rouge, to move urban populations to the countryside to work as farm laborers. Many died by succumbing to starvation, disease, and murder. Ultimately, Pol Pot oversaw the deaths of nearly 2 million of the country's 7 million people. While private possession of a camera was viewed as an emblem of privilege and a tool of political defiance during the Pol Pot era, government-sponsored photographs were produced, among them mugshots of the people who were jailed (Fig. 7.29).

Large-scale rural genocide sites, called the "killing fields," were discovered after Pol Pot's government was defeated by the Vietnamese. Prison records were also uncovered, including those for Phnom Penh's Tuol Sleng prison, known as "S-21," where as many as 20,000 people were imprisoned, tortured, and murdered. More than 5,000 of the Tuol Sleng mugshots have been found. Prisoners in these pictures have official-looking numbers pinned to their clothing, but the function of the images is not clear. The photographs do not identify specific individuals, nor do they reference remaining records of forced confessions. It may prove true that the pictures catalog batches of prisoners.

At Yale University in New Haven, Connecticut, the Cambodian Genocide Database has made more than 10,000 photographic images and thousands of documents related to the Cambodian holocaust available on the World Wide Web, in the Khmer language as well as English, in hopes that the mostly anonymous victims may be identified. Preserved and restored, the original photographs are part of the collection of the Tuol Sleng Museum of Genocide in Cambodia.[21]

7.29
PHOTOGRAPHER UNKNOWN, *Untitled*
(Cambodian prisoners), 1975–79. Gelatin silver print.

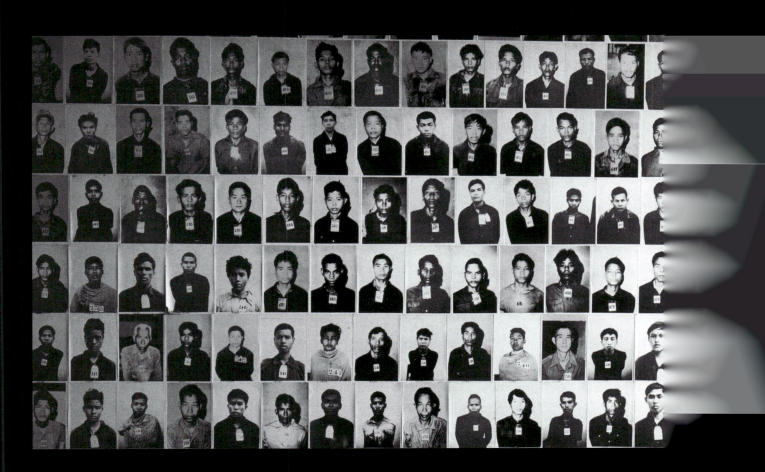

THE LOOK OF POLITICS

During the 1980s in South Africa, photographic agencies such as Dynamic Images, The Brotherhood, Vakalisa, The Black Society of Photographers, and Afrapix were founded to lend support to image-makers such as Peter Magubane and David Goldblatt (see pp. 325, 327), who were committed to using photography in the struggle for social change. These collectives furnished images to alternative and underground newspapers, as well as to the world press.

Afrapix, which ceased activity in 1990, had younger members such as Johannesburg-born Santu Mofokeng (b. 1956) who adopted a more stylized and autobiographical approach to photography. As Mofokeng wrote, "I was unhappy with the propaganda images which reduced life in the townships into one of perpetual struggle, because I felt this representation to be incomplete."[22] In the politically charged atmosphere of South Africa, where photographers were greeted with suspicion by many factions, the desire to move away from overtly political photography was taken by anti-apartheid partisans as a token of irresponsibility. Still, Mofokeng persisted in showing aspects of "unvictimized" life in the neighborhoods, as well

as moments of camaraderie and enjoyment (Fig. 7.30). Within the context of South African photography, he invented a new social documentary approach. In his recent work, Mofokeng has been collecting urban family albums made by middle- and working-class African blacks. Like his scenes of everyday life, which were so long excluded from public view, the old family portraits and other scenes had not been accumulated by libraries or museums.

THE NEW SOCIAL DOCUMENTARY

In the United States, a new social documentary also followed from specific political and social circumstances. A mix of anti-Vietnam War activism and Conceptual art ideas helped shape a new philosophy and practice that differed from the work done by Eugene Richards and Mary Ellen Mark. The ideas and interests of an informal study group that formed during the mid-1970s in California, proved important to a generation looking for direction about photographic practice in general, and documentary projects in particular. Members of this group, including Martha Rosler (b. 1943), Allan Sekula (b. 1951), and Fred Lonidier (b. 1942), emerged as intellectual and visual leaders of a new social documentary.

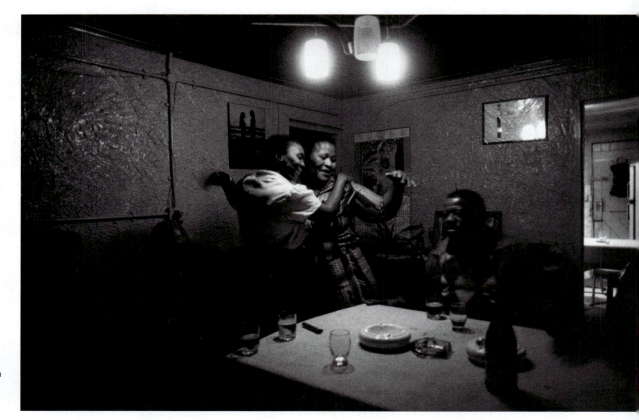

7.30
SANTU MOFOKENG,
*Shebeen in White City,
Soweto*, c. 1987. Gelatin
silver print. © Santu
Mofokeng/South
Photographs.

Among the most widely influential writings read by the group, and by others seeking a fresh direction in photography, was a 1936 essay penned by German historian and critic Walter Benjamin, called "The Work of Art in the Age of Mechanical Reproduction." Benjamin held that mechanical reproduction, principally based in film and photographic techniques, was capable of breaking down what he called the "aura" of the original work of art, that is, our sense of an artwork's uniqueness based on its having been made at a particular time and occupying a singular physical space. Simply put, he reasoned that, when multiple cheap reproductions of a work of art such as Leonardo da Vinci's *Mona Lisa* were readily available, many people could own it, and, therefore, would not feel a need to visit the original. In effect, there would be no original, because the actual painting would come to be understood as just another copy. Benjamin held that this ongoing democratization was the forerunner of a sweeping historical change that would break down tradition, making way for revolutionary social and cultural change.

It hardly mattered that Benjamin, writing decades before the glut of mass media, including television, was wrong about the popular effect of mechanical reproduction. In truth, the vast manufacture and marketing of copies, be they art or music, only increased people's desire to see the original in a museum or to hear it played at a concert. What attracted most of his readers was not Benjamin's historical foresight, nor his vision of a profoundly different socialist future, but his notion that the original could vanish in a welter of facsimiles. Benjamin's essay confirmed the existence of an image-world that molded people's perception of themselves, forged their desires, and fashioned their political beliefs. Importantly, the essay implied that political action consisted not only of protests, like those during the Vietnam War, but also of an ongoing, vigorous questioning of conventions and stereotypes promulgated by the mass media.

The study group also encountered the thoughts of Benjamin's close friend, the German critic and playwright Bertolt Brecht (1898–1956). The new social documentarians and their supporters favored analysis of the social and political context of photographs, and often vindicated their view with Benjamin's approving reference to Brecht's notion that "less than ever does a simple *reproduction of reality* express something about reality."[23] Among the other Brechtian ideas that found favor was his understanding of how to affect an audience with a story. Brecht believed in constructing obviously artificial situations and disrupting the anticipated narrative with the unexpected.

The study group also looked at contemporary art and film, especially the experimental work of French filmmaker Jean-Luc Godard (b. 1930), from whom they took the idea of recasting older themes and of thwarting the illusion of reality by letting the means of picture-making show. They debated articles appearing in *Screen*, a British journal whose theoretical inquiries into film realism could be broadly applied to other visual media.[24] In an interview with Benjamin Buchloh, himself an influential historian and critic of photographic practice, Rosler commented, "we wanted to be documentarians in a way that documentarians hadn't been. As readers of Brecht, we wanted to use obviously theatrical or dramatized sequences or performance elements together with more traditional documentary strategies, to use text, irony, absurdity, mixed forms of all types."[25]

Even before the study-group sessions, Rosler made political art in the form of three photomontage series called *Bringing Home the War* (1967–72) that combined mass-media images of the Vietnam conflict with pictures taken from design and architectural magazines (Fig. 7.31). Similarly, Lonidier integrated his political activities with his black-and-white photography, as in his *Twenty-nine Arrests: Headquarters of the 12th Naval District, May 2, 1972*, and Sekula was working on what he called a photonovel, titled *This Ain't China* (1974), a fabricated tale about rebellion by food-service workers. Soon, Rosler, Lonidier, and Sekula were at the core of what, by the mid-1980s, was being called the "new documentary," or the "new social documentary," created by sophisticated, college-educated, politically active intellectuals who wanted to

use photography as an important element of social critique.

Historian and critic Abigail Solomon-Godeau observed at the time that "it seems increasingly justified to speak of a new generation of photographers committed to rethinking documentary in a rigorous and serious way."[26] These thinkers did not want to make photographs, so much as they wanted to integrate image-making into political analyses of poverty and injustice. They vigorously studied historical documentary photography, such as that of Jacob Riis, Lewis Hine, and the Farm Security Administration photographers (see Figs. 4.47–4.50), and attempted to find ways in which they could comment on social oppression without generating what they called "victim photographs" that only evoked self-satisfying sympathy or excited voyeurism among viewers. Wary of fashioning such images, the new social documentarians surrounded their photographs with copious text that illuminated wider issues of corporate greed and government neglect, and expressed the experiences of manual workers and the poor. With limited success, they struggled to find venues beyond the art world for their work.

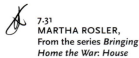

7.31
MARTHA ROSLER,
From the series *Bringing Home the War: House Beautiful,* c. 1967–72. Collage.

Using collage, political artists such as Rosler created up-to-date commentary by ripping pictures from newspapers and magazines. The juxtaposition of terror-stricken Vietnamese peasants and chic modern domestic interiors highlighted the disparities among Western and non-Western nations engaged in the Vietnam War.

Lonidier went on to make investigative series, such as *The Health and Safety Game* (1976), in which he juxtaposed photographs of workers' injuries and appended statements by them.[27] Aware of the social and economic distance between himself and the subjects of his photographs, Lonidier wrote that artists who pursue oppositional cultural practice must continually search for non-elitist ways of practicing.[28] Starting with his early photographs, Lonidier worked closely with labor unions. The effect of his continuing political agitation was witnessed during his 1999 exhibit in Tijuana, Mexico, which was critical of the North American Free Trade Agreement (NAFTA) and the establishment of *maquiladoras* (internationally run factories in Mexico, near the United States border, that employ Mexicans at a fraction of American wages). The show was shut down by the concerted efforts of the manufacturers, who put pressure on the Mexican government.

Lonidier's work received less academic attention than the images and ideas circulated by Rosler and Sekula, whose writings were widely read and debated in colleges, universities, and art journals. In particular, Rosler's image-and-text series *The Bowery in two Inadequate Descriptive Systems* (1974–75) condensed notions of documentary that held sway throughout the 1980s. Explaining the series, Rosler wrote that it is "a work of refusal. It is not defiant antihumanism. It is meant as an act of criticism."[29] In her *Bowery* series, Rosler demonstrated how both language and images are insufficient to a full description of a poor area of New York City where homeless persons gather to drink alcoholic beverages (Fig. 7.32). Rosler did not set out to provoke concern for the plight of those living in the Bowery; instead, she tried to examine the weakness of words and pictures to encompass social realities, and to puncture humanist assumptions about documentary photography's ability to contribute to human progress.[30]

These ideas found their way into her 1981 essay "In, Around, and Afterthoughts (On Documentary Photography)," in which Rosler leveled lasting criticism at American documentary photography, beginning with the work of Jacob Riis. She chastised

voyeurism and sensationalism in photo-journalism, and accused documentary photography of a politeness that discouraged tough-minded, analytical revolutionary politics. Rosler criticized photographers of social concern for not being more aware of the way in which their photographs were viewed. She contended that photographs of "starveling infants and despairing adults" were part of the visual spectacle of modern life, and that viewers measured stamina by how long they could endure this "visual assault without a flinch." Rosler was one of the first contemporary critics to look back at nineteenth- and early twentieth-century photographs of Native Americans and observe that they tended to portray their subjects as having sunk so low that they betrayed their own heritage. Rosler also opposed the attitude toward the uniqueness of photographic form expressed by John Szarkowski at the Museum of Modern Art (see pp. 381–91), because it disengaged images from the social world in favor of aesthetic characteristics. She did not suggest that documentary was defunct, but hoped that "a radical documentary [could] be brought into existence."[31]

Starting in the late 1970s, critical essays on the history and theory of photography by Rosler and Sekula, along with Douglas Crimp, Christopher Phillips, Rosalind Krauss, Abigail Solomon-Godeau, and Sally Stein hit the field of photographic studies like a sharp wind. Some readers resentfully closed their windows and turned away from what they identified as a damaging storm; others let the gust into the increasingly interdependent realms of the museum, gallery, and art school, where it unsettled received ideas. By 1983, when *New York Times* photography critic Andy Grundberg wrote his essay, "Two camps battle over the nature of the medium," it had become obvious that "lines are drawn between those who think of photography as a relatively new and largely virgin branch of art history, and those who rebel at the very notion of photography being 'estheticized.'" "The split is real," Grundberg commented, "and the rhetoric is fierce."[32]

Among the most forceful new writers was artist-critic Allan Sekula, who combined political theory, social commentary, and photographic criticism in a way

reminiscent of the politically engaged European artists and photographers between the world wars. Like Martha Rosler, Sekula insisted that photography was not simply an autonomous picture-making system, but knit into the broad patterns of global history. He reproached Edward Steichen's *The Family of Man* exhibition (see pp. 312–314) for its influential attempts to construct photography as a universal language, and for its covert promotion of the family "as the exclusive arena of all desire and pleasure."[33] With others, including British writers David Green and John Tagg, Sekula examined the history of photography within the development of fact-finding and cataloging systems, such as prison photographs and anthropometric images, that is, pictures made to show measurement of the human body, and thereby substantiate racial stereotypes.[34]

As part of the critical examination of Western cultures' misplaced belief in the transparent realism of photography, the new social documentarians looked at how photographic meaning was determined by conditions outside the photograph, such as societal values and personal presumptions. In particular, they linked the emergence of photography with the historical rise of the middle class, which prized the camera for its forthright depictions, yet which wanted to maintain the notion of creativity associated with the artist. In photography, Sekula pointed out, Realism and Romanticism could coexist.

Sekula's essay "On the invention of photographic meaning" (1975) became one of the most read, discussed, and anthologized articles within art and photography circles. Its basic premise, that the photograph is not a clear window on reality, but defined by the culture and setting in which it is found, became a commonplace in the field, especially among image-makers and historians looking for new ways to reinsert photography into the social world. Like Rosler, Sekula bluntly announced that "the ills of photography are the ills of aestheticism."[35]

Sekula's writings repeatedly came back to the problems of documentary photography, a form that he practices reciprocally with the theory he continues to develop. With Rosler, he was

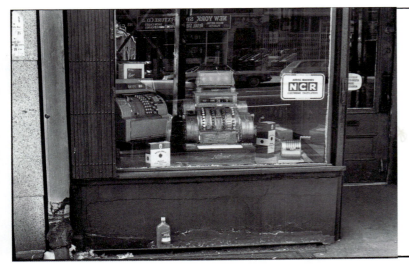

stewed

boiled

potted

corned

pickled

preserved

canned

fried to the hat

7.32
MARTHA ROSLER,
The Bowery in two
Inadequate Descriptive
Systems, 1974–75. Text
and gelatin silver prints.

In this series, Rosler
paired photographs and
slang words for drunk-
enness. None of the
images shows people,
just empty liquor con-
tainers. Similarly, the
words offer only short-
hand stereotypes, not
lives as they are lived.
The two parallel repre-
sentational systems do
not add up to a thor-
ough description of the
area.

among the first to probe the multiple
social uses to which former documen-
tary photographs had been put. In par-
ticular, he noted how documentarians
from Lewis Hine to W. Eugene Smith
had been transformed into artistic
geniuses by an art world hungry for
expressions of great human spirit.
Probably alluding to *The Family of Man,*
Sekula concluded that "the celebration
of abstract humanity becomes, in any
given political situation, the celebration
of the dignity of the passive victim."[36]

In his writing and photography,
Sekula proved to be less pessimistic
than other critics about the ability of
photography to document social experi-
ence and to effect change. He insisted
that he did not want to "ignore or
suppress the creative, affective, and
expressive aspects of cultural activity,
[because] to do so would be to play into
the hands of the ongoing technocratic
obliteration of human creativity."[37]
Sekula praised the photographic col-
lages of John Heartfield for deconstruct-
ing Nazi propaganda, and cited Rosler's
The Bowery in two Inadequate Descriptive
Systems as coming "the closest to having
an unrelenting *metacritical* relation to
the documentary genre."[38] He main-
tained that the window-on-the-world
style of concerned documentary and
photojournalism had to give way to "a
hybridized, pictorially disrespectful nar-
rative approach to the photographic
medium."[39] He commended Lonidier's
images, and his aim to show his case-
studies outside the art world. Signifi-
cantly, Sekula was also one of the few
critics to extend his perspective to other
than Western settings. While discussing

the photography of Ernest Cole, who
worked for *Drum* magazine in South
Africa (see pp. 325–26), Sekula recog-
nized that distinct social situations, such
as racial apartheid, called for approaches
particular to the situation. Moreover,
he cautioned critics and photographers
that it "would be wise to avoid an overly
monolithic conception of realism,
[because] not all realisms necessarily
play into the hands of the police."[40]

In discussing Cole's work, Sekula
noted that the South African preferred
to construct narratives using photogra-
phy and text in situations such as unem-
ployment or workplace struggles, where
"ideology fails to provide a 'rational' and
consoling interpretation of the world."[41]
Indeed, Sekula's series, from the early
This Ain't China: A Photonovel (1974),
through *Fish Story* (1995), a multi-media
investigation of the maritime trades, to
Geography Lesson (1997), which links
changes in the Canadian landscape to
the mining industry and wealth-seeking,
Sekula remained constant in his efforts
to relate the lives of working people to
the expansion and changes of global
capitalism. Recently, he collaborated
with the writer-activists Alexander
Cockburn and Jeffrey St. Clair, to photo-
graph the 1999 protests against World
Trade Organization labor policy in
Seattle, Washington.

Speculating in 1986, Abigail
Solomon-Godeau worried that the politi-
cal philosophy of the new documentari-
ans would be marginalized within the
art and photographic communities. In
fact, the opposite occurred. The new
documentarians found ample support
within the art world, whose practices

and supporters were the subject of their critiques, and at universities, where they gained influential faculty positions. New social documentary joined the panoply of late twentieth-century photographic practice. It did not dislodge the continuing popularity of earlier documentary approaches, such as the alienated vision advanced by Robert Frank (see pp. 343–45), the personal interaction model used by Eugene Richards, or the universal humanism exhibited at *The Family of Man* show.

When the Yale historian Alan Trachtenberg summed up the contributions of the revered American teacher and documentarian Jerome Liebling (see p. 296), he noted that Liebling remained unswayed by postmodernism's dilemmas. Liebling never wavered in his focus on the unfortunate, nor in his affection for Modernist composition, both of which were forged during the picture-magazine era. "Liebling's work," he concluded, "goes against the grain of contemporary fashion. His pictures are not tense with ironic subversions. They are not clever statements about photography itself."[42] Trachtenberg's synopsis epitomized the outlook of many photographers who rejected the theory-laden approaches of the emerging social documentary.

Interestingly, the new social documentarians did not make the distribution of cameras and instruction a central part of their political work, which, to be fair, was deliberately aimed at elites and elite knowledge. With the exception of Lonidier, who spent more than twenty-five years working with unions and other labor organizations, the new documentarians wrote in language that required familiarity with history and philosophical distinctions, an obvious obstacle to non-intellectual audiences. In Britain, however, various activist organizations used photography to communicate with the public at large. Beginning in the mid-1970s, the Hackney Flashers, of which Jo Spence was a member, produced photographic exhibitions and slide sets on women and inequity in the workplace, which traveled beyond the art gallery to community centers and libraries.

Similarly, from the late 1970s to the early 1990s, Lorraine Leeson (b. 1951) and Peter Dunn (b. 1946) collaborated with community groups to conceive visual responses to cutbacks and facility closures in a largely working-class neighborhood. Through such projects as the Bethnal Green Hospital Campaign (Fig. 7.33), the East London Health Project, and the Docklands Community Poster Project, they circumvented government-influenced mainstream media outlets, distributing eye-catching billboards and street posters as well as postcards. These were sent to other cities where neighborhoods situated in former industrial areas were being threatened by unsympathetic redevelopment.

Where American theorists tended to be overwhelmed by what they perceived as the mighty tide of mass-media images crushing all efforts at societal change, social documentarians and activists such as the Hackney Flashers held that political and personal transitions were possible, and could be achieved through photographs that exposed injustice. Similarly, as Nelly Richards reported on the use of the medium under the Pinochet regime in Chile (see p. 316), the opposition to the right-wing dictator believed photography to be a means of exposing the conditions that the military regime sought to hide, including the so-called torture and "disappearances" of protestors. Although Chilean image-makers associated with the opposition, such as Eugenio Dittborn (see pp. 411–12), acknowledged the sway of mass media, they chose not to accept the nihilistic view that change was unattainable.

THINKING PHOTOGRAPHY

Attempts to conceive a new social documentary were based on a thoughtful rejection of documentary traditions, as well as the incorporation of ideas from outside the area of photographic practice. Just as nineteenth-century photographer Peter Henry Emerson (see pp. 172–74) investigated contemporary philosophical and scientific ideas for ways to reform photography, so late twentieth-century photographers looked to concepts outside the discipline to inform their philosophy. The 1982 book *Thinking Photography*, edited by artist-critic Victor Burgin (see p. 378), introduced a new audience to the debates within the field of photographic studies, through an anthology of his own

7.33
LORRAINE LEESON AND PETER DUNN, *Health Cuts Can Kill,* one of a series for the Bethnal Green Hospital Campaign, 1978. Street posters.

Dunn and Leeson created posters and billboards to show how closing public health facilities would affect people in the working-class East London neighborhood. The signs told their own story, but also countered proposed plans to turn the neighborhood into a gentrified area.

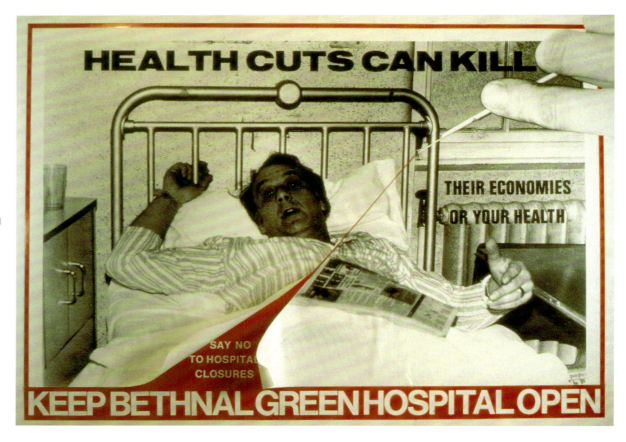

writing, and that of others, including Benjamin and Sekula.

One of the most influential thinkers in the period was French philosopher Roland Barthes (1915–1980), who coined two terms that were much discussed in photographic criticism. The first, "*studium,*" designated photographic content that interests the intellect; the second, "*punctum,*" taken from the Latin word to puncture, referred to the sudden arresting effect that a photographic image can have on the viewer. The terms were introduced in Barthes's 1980 book *Camera Lucida,* which, despite its title, did not refer to the pre-photographic tool used to make images (see p. 6), but to a philosophical light (*lucida*) thrown on photographic practice. Reviewing family photographs, Barthes found himself reacting only to the *studium,* or factual basis of the images, until he encountered a picture of his mother as a five-year-old child standing with her seven-year-old brother on a little wooden bridge in the family's Winter Garden, or greenhouse. "Something like an essence of the Photograph floated in this particular picture," Barthes wrote. Because the experience was so personal, Barthes refused to illustrate the photograph. "It exists only

for me," he observed: "For you, it would be nothing but an indifferent picture, one of the thousand manifestations of the 'ordinary.'"[43]

While contributing *studium* and *punctum* to contemporary critical discourse, *Camera Lucida*'s personal, unsystematic, and mystical essay disappointed some critics, who were hoping that Barthes would (uncharacteristically) use the book as an opportunity to bring together his earlier thoughts on photography. *Camera Lucida* followed other influential writing on photography. In "The photographic message" (1961), Barthes wrote that the newspaper photograph has two messages, one brimming with socially inscribed "denoted" and "connoted" meanings, which ride on a second perception that photography is "a message *without a code.*" In other words, he recognized that photography itself is an idea or mental concept, grounded in the notion of neutral vision. Another seminal question, articulated in such books as *S/Z* (1970; Eng. trans. 1974) and such essays as "The rhetoric of the image" (1964), and "The death of the author" (1968), repeatedly queried the notion of originality. Barthes suggested that, for a visual or verbal text to be understood, its meanings must

already exist in the social world. Consequently, the text, and, for that matter, perception of the world, cannot be entirely new, but result from a combination of already extant meanings that the reader/viewer brings to the text or image. When images and text exist together, as in photojournalism and advertising, the interplay between the bundles of meaning becomes even more complex, though not original.

Similar ideas were advanced by the French philosopher and historian Michel Foucault (1926–1984), who wrote persuasive books and essays on the furtive nature of power and pondered the originality of authors. Like Barthes, Foucault politicized photography without linking it to one or another particular social movement or cause.

For photographers and critics, the writings of Barthes and Foucault opened the way to a philosophical and historical reconsideration of photographic practice and discredited pictures of the kind deemed original by virtue of individual expression. Their ideas suggested a new image-making, cognizant of the social re-production of meaning, especially in mass media. Such ideas were close to those discussed and acted upon by Rosler, Sekula, and Lonidier, who tried to find new ways to integrate political action and camerawork. The photographers who admired both Barthes and Foucault, however, were frequently less politically active than the new social documentarians. They sought new insights and incentives for picture-making, not for directions on how to change society.

One of the most powerful ideas taken from Barthes and other thinkers concerned the futility of originality. Since mass-media photography was replete with messages, new pictures were not needed. In part or in full, existing images could be appropriated, and re-exhibited. These "ready-mades" differed from the everyday objects earlier proposed as art by Marcel Duchamp (see Fig. 5.17), in that they were not things, but pictures of things frequently marketed to arouse consumer desire. Some photographers argued that these acts of appropriation were inherently subversive, because the effect of seeing mass-media images framed in a new context would enlighten and politicize beholders. The recognition that images pil-fered from magazines and newspapers had visual forebears in Dada photography, as well as experimental camera-work between the world wars, sparked a renewed interest in what had hitherto been a neglected area of historical scholarship.

Beginning in the late 1970s, American critics such as Rosalind Krauss, Craig Owens, Hal Foster, and Douglas Crimp focused on the demise of the original as a vastly important sign that Modernism, with its enthronement of artistic expression and originality, was also dying. Two widely read essays by Crimp, "Pictures" (1977) and "The photographic activity of postmodernism" (1980), linked photography to French theory and to Benjamin's notions of aura and originality. Crimp was also among the earliest observers to see the fulfillment of contemporary theory in new approaches to photography, such as those employed by Cindy Sherman (b. 1954) (see Figs. 7.35, 7.36) and Sherrie Levine (b. 1947). By the late 1970s, photography was rapidly emerging as the vogue art, not simply because of its growing acceptance in the art world, but because of the way it dovetailed in practical terms with contemporary concerns about *re*presentation and originality. Simultaneously, the term "postmodern" became current, to characterize what was increasingly perceived as a new period following Modernism.

THE POSTMODERN ERA

The concept of the postmodern or postmodernity predated what has become known as the postmodern era. Historian Arnold Toynbee employed the term in *A Study of History* (written before World War II, but not published until 1947) to speculate on a vast historical period that began in the late nineteenth century, and which would culminate with the decline of Western power and the rise of non-Western societies. Toynbee's sweeping hypothesis was largely forgotten in the late twentieth century when Jean-François Lyotard's dense, short 1979 book *The Postmodern Condition* (Eng. trans., 1984) posited postmodernism as the next phase of Modernism. Lyotard maintained that Modernism's successor was already at work, disintegrating

(handwritten margin note: also part of discourse — which comes first?)



"metanarratives," or grand, longstanding social rationales about the improvability of the human condition made possible by the progress of knowledge, especially science. As these overarching visions declined, Lyotard argued that they would not be replaced by other unifying ideas, but by a welter of competing notions, whose fertile chaos would feed a new freedom from the oppression and authority of scientific knowledge.

Lyotard's analysis was fanciful, underestimating the predominance of science, and the prodigious ability of capitalism to adapt with the times. Nevertheless, from his book, philosophers, social commentators, critics, and artists construed a broad theory that explained and justified the present moment as a state of flux, propelled by instantaneous information churned out by mass media, and shaped by global finance and business networks, whose prevalence lessened the importance of the nation state in the world order.

In art circles, postmodernism came to mean a rejection of themes and subjects that interested Modernist artists, such as abstraction and the subjective expression of unique intellects. Artists in many media reintroduced the human figure, or turned to mass-produced kitsch for image sources. Photographers, too, dwelled on the body, often deriving or appropriating images from commerce, advertising, and film. Some explored the potentials of the blurred image, in which forms were suggested but not clearly delineated.

In his essay for the catalog accompanying the 1977 New York exhibit *Pictures*, Douglas Crimp acknowledged how the experience of media created a generation gap between those raised on television, movies, and ubiquitous magazines, and those brought up in the less image-saturated culture of the period prior to World War II. "To an ever greater extent," he wrote, "our experience is governed by pictures, pictures in newspapers and magazines, on television and in the cinema. Next to these pictures, firsthand experience begins to retreat, to seem more and more trivial. While it once seemed that pictures had the function of interpreting reality, it now seems that they have usurped it."[44] Soon after, in response to another exhibit ominously called "Last Exit:

Painting," critic Thomas Lawson argued that "the camera, in all its manifestations, is our god, dispensing what we mistakenly take to be truth."[45]

Although her writing was seldom cited by commentators on postmodernism and photography, cultural critic Susan Sontag built her widely read book *On Photography* (1977) upon the notion of a similar, even more noxious "Image-World," in which photographs injured human memory and drained away the instinct to know the world at first hand. This remove from reality, in Sontag's view, left us passive spectators at a spectacle of recycled pictures.[46] Sontag did not, however, put forward the consummate postmodern conviction that, because of its omnipresence, the image world provided a new source of realism for artists. She maintained that an authentic, valuable, first-hand reality had been plundered and debased. In sum, a chilly, sobering down-draft in the intellectual climate whirled away any remnants of Marshall McLuhan's rapturous 1960s praise for the mass media's educational and peace-making powers (see p. 389).

POSTMODERNIST PHOTOGRAPHY

Among the artists included in Douglas Crimp's "Pictures," and discussed in his "The photographic activity of postmodernism," was Sherrie Levine, who confronted the art world with her re-photographed well-known images made by famous photographers such as Edward Weston, Walker Evans, and Eliot Porter (see pp. 260–61, 278–80, 282–83). Called appropriation, Levine's reuse of images such as Walker Evans's image of Allie Mae Burroughs (see Fig. 5.54), highlighted the ascendancy of copies and the insignificance of the original. She underscored this theme by photographing reproductions found in books, not by copying archival images or printing original negatives. By taking an image, rather than making an image, Levine repressed the notion of her art as original and unique.

More frequently, appropriationists procured mass-media images. Artist and writer Richard Prince (b. 1949) found his source images in magazines, cutting, cropping, rearranging, and reprinting them to isolate the devices used in advertising to summon up desire

(Fig. 7.34). Levine and Prince are typical examples of the powerful convergence of image-making and social analysis that occurred during the last decades of the twentieth century. Social-science observation by artists, expressed primarily in art, became known as critical practice.

In "Pictures," Douglas Crimp noted the work of Cindy Sherman, who would become one of the most celebrated image-makers of the 1980s and 1990s. Her series of black-and-white photographs called *Untitled Film Stills* seemed to be derived from 1950s B-movie melodramas and from film stills, that is, the photographs displayed in theater lobbies. The film still exaggerated movie-born gender stereotypes, especially that of the beleaguered, fretful, or frightened heroine. While Sherman found suggestions in film-still poses, she did not make reference to any particular movie. Photographing herself in make-up, wigs, and costumes, she imitated or evoked a culturally prevalent image (Fig. 7.35). Viewers could recognize the source of her images, not because she actually clipped them from old movies, but because the poses she assumed condensed the much-repeated portrayal of women in films.

Crimp pointed out that Sherman's self-portraits do not ever reveal Cindy Sherman. Her *faux* film fragments played up the notion of the postmodern copy and its opposition to the ideas of invention and genius. Sherman's later work shifted to larger, deeply saturated color pictures, in which she performed appearances based on pin-ups, fairy tales, and Old Master paintings. Eventually, she took herself out of the picture, substituting prostheses or plastic body parts used in medical education, and combining them to form grotesque bodies (Fig. 7.36) in the manner of Surrealist photographer Hans Bellmer (see Fig. 5.24). Despite these changes, Sherman's interest remained constant in exposing not only the shallowness of gender stereotyping, but also the consciously titillating pleasure of looking.

7.34
RICHARD PRINCE,
Untitled (Cowboys),
1993. Ektacolor print.
Barbara Gladstone
Gallery, New York.

Through the 1980s, during the presidency of Ronald Reagan, Prince worked on a series of cowboy images derived from ads for Marlboro cigarettes. Usually more grainy and blurry than the originals, the appropriated images ironically maintain much of the glamor that was used to sell cigarettes. In addition, they becloud the American West as a heroic terrain.

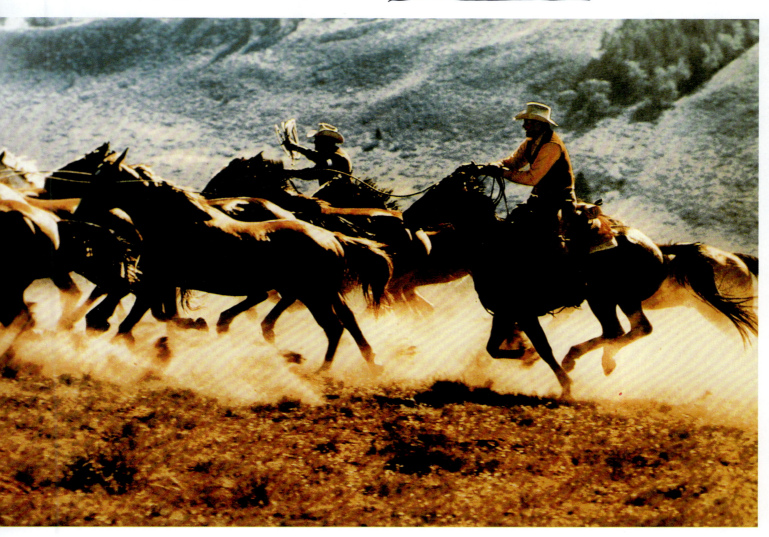

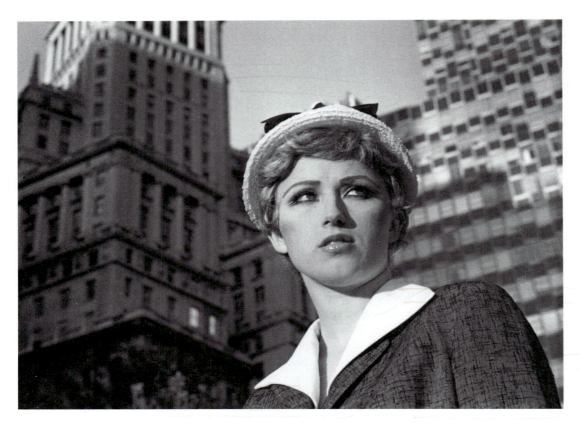

7.36 (below)
CINDY SHERMAN, *Untitled*, 1992.

**7.35 (above)
CINDY SHERMAN,
Untitled Film Still, 1978.**

Sherman costumed and coiffed herself to look like troubled and anxious women from B-movies of the 1950s. She enacted the stereotypical role of the woman in jeopardy, not taken from a specific film, but improvised from an array of them.

ART PHOTOGRAPHY AND PHOTOGRAPHY-BY-ARTISTS

The mid-1970s witnessed the increased use of photography by artists who usually worked in other media (see pp. 375–81), and the retreat from conventional art photography by image-makers such as Cindy Sherman. Noting the development, critic Abigail Solomon-Godeau commented that "although the attempt to draw a distinction between art photography and photography done by artists might initially be taken for a semantic quibble, or worse, as informed by the desire to privilege the photographic work of artists over that of photographers, there remain significant differences in the two forms of practice."[47]

Art photography, of course, had a history going back to the beginnings of the medium. One of Daguerre's first successful photographs rendered a traditional art subject, the still life (see Fig. 1.12). The quintessential art photographer was Alfred Stieglitz (see Figs. 4.20–4.22), an unashamed elitist who positioned art photography as the moral opposite of crass commercial imaging. As Solomon-Godeau pointed out, art photographers continued to treasure subjective and intuitive expression, the intricacies of craft, and the sharp

dividing line between fine art and commercial imagery. Briefly put, art photography aspired to the condition of painting, which meant recognition as a fully-fledged art, and access to the intertwined realms of gallery and museum.

In contrast, photography-by-artists owed little to the traditional aspirations and values of art photography. It critiqued the notion of personal expression, holding up to public view the way in which the mass media spewed out copies of copies of copies of stereotypes. For those who praised and those who disparaged her work, Cindy Sherman became the exemplar of the photography-by-artists movement. In fact, she was one of the first image-makers who worked exclusively in the medium, who was not called a photographer, but an artist.[48] Of course, the renunciation of personal expression was central to the philosophy of Conceptual artists and photographers, such as Edward Ruscha, who dispassionately itemized and compiled ready-made images of ordinary locations and buildings, such as gas stations and motel swimming pools (see Fig. 6.96).

Ideally, photography-by-artists was intended as part of a broad social intervention, aimed at exposing the so-called illusions of individuality and originality that formed the bulwark of the art market. In fact, the boundary between art photography and photography-by-artists broke down almost as soon as it was conceived. By the mid-1980s, photography-by-artists had not shattered or reformed the art market, but refreshed and recommercialized the notion of the avant-garde artist, whose attacks on mainstream society and consumerism had become an expected and marketable model of artistic behavior. Photography-by-artists was represented in chic galleries and showcased in prominent exhibitions and books. Because of its links to contemporary theories of language, notions of representation, and gender identity, photography-by-artists received an international academic welcome. It was the recurrent subject of lectures and discussions, not only in art and photography departments, but in literature, philosophy, and sociology classes as well.

For its part, the art photography exemplified by Stieglitz did not lose its appeal for the public, but considerably increased in monetary value as evidenced by the high auction prices recorded during the late twentieth-century economic boom. During the late 1970s and 1980s, the uncertain distinctions between art photography and photography-by-artists helped break down the compartmentalization of museum departments according to media, a configuration that was already taxed by hard-to-categorize activities such as installation and performance art. Heads of museum painting departments and photography departments vied with each other to collect work by such artists as Cindy Sherman. Sometimes museum photography departments broadened their acquisition goals; at other times new positions were created to embrace what were, and are, called new media.

By the end of the century, the terms "photo-based artist" and "photo-based work" replaced "photography-by-artists," and with that substitution also vanished the association of photography-by-artists with a tough, ongoing social or media criticism. At century's end, photo-based work was normal fare. Surveying the New York gallery scene during the year 2000, critic David Rimanelli observed a "narrowing of that time-honored (if rarely acknowledged) distinction between those spaces devoted to contemporary art (including that which is photographically based) and venues catering to photography." "Given its absolute and tiresome omnipresence," he opined, photography "looks like the academic painting of our time."[49]

BLURRING THE SUBJECT

The postmodern notion of indeterminate, circular meaning gave the blurred image a new lease on life as a multivalent symbol, alluding to transient and fragmentary moments, fuzzy or disfigured identities, or indistinct and ambiguous knowledge. Interestingly, blur has had many uses in the history of photography, the best-known of which was the Pictorial image, with its pretensions to high art. More recently, photographers such as Duane Michals (see p. 355) blurred the actions of human figures to add mystery and wonder to a scene. Similarly, Tunisian photographer Kamel Dridi (b. 1951) used blurred images to evoke, for people brought up

in the Muslim faith, early memories of ceremonial movements and gestures (Fig. 7.37).

Since the mid-1960s, German painter Gerhard Richter has reworked photographic sources, often his own snapshots, creating paintings that maintain photography's deep perspective, but blurring the surface almost to the point of unrecognizability. His so-called "photo paintings" sometimes glow with suffused Romantic light, but others have a sinister dreaminess to them, as if the subject, hovering between painting and photography, cannot or will not allow itself to be fully grasped (Fig. 7.38). Produced a decade after the events, Richter's paintings refer to a specific incident of the deaths in prison of politi-cal activists only to obscure it like a memory that is ten years old. Through blur, which indicates an eye dimmed with tears and a mind clouded with opinions, he transformed simple archival photographs into symbols for the tangled issue of German historical memory in and of the twentieth century. The smudged surfaces of the canvases erased the sharpness of their newspaper sources, imitating not only hazy recall, but the sense of lost idealism, felt especially by Germans who lived through the tensions and moral compromises of the Cold War.

Blur also found a place in staged photographs. While they were students at Yale University, photographer David Levinthal (b. 1949) and Garry Trudeau

7.37
KAMEL DRIDI,
Mosque, Fes, **1987.**
Société Française de la Photographie, Paris.

The bare lightbulb contrasts with the soft, suffused light emanating from the mosque's interior. Dridi records moments of daily prayer in which the faithful make gestures signaling submission to the will of Allah.

**7.38
GERHARD RICHTER,
Shot Down (1), 1988,
from his series
18 Oktober 1977. Oil on
canvas, 39¼ × 55 in
(99.7 × 139.7 cm).**

For *18 Oktober 1977*, a
series of gray-toned
paintings centering on
the prison deaths of sev-
eral left-wing activists,
Richter blurred lurid
newspaper photo-
graphs. Claiming not to
be political, he main-
tained that he wanted to
portray ideological com-
mitment, not a particu-
lar point of view.[50]
Nothing is certain about
the deaths; the activists
may have taken their
own lives, or been
murdered.

(b. 1948), the cartoonist who draws the political comic strip Doonesbury, collaborated on a book called *Hitler Moves East: A Graphic Chronicle, 1941–43* (1977). Levinthal leads viewers to believe that they are looking at old, blurred action shots of World War II taken by an intrepid photojournalist. In fact, he fabricated table-top scenes with toy soldiers and then obscured the resulting photograph sufficiently so that its miniature source was not immediately apparent. Viewers fill in missing visual information from their memories of war portrayed in photojournalism and film.

The work of James Welling (b. 1951) is also purposefully misleading. He photographs what appear to be black-and-white renditions of abstract paintings, or deeply shadowed abstract photographs (Fig. 7.39) in the manner of Aaron Siskind and Frederick Sommer (see Figs. 6.34, 6.36). Welling relies on the viewer's recollection of abstract art, especially as seen for years in black-and-white photography.

**7.39
JAMES WELLING,
August 16a, 1980.
Gelatin silver print.**

7.40
BARBARA ESS,
Untitled, from her series
Food for the Moon,
1986–87. Monochrome
color photograph
mounted on fiberboard.
National Museum of
American Art,
Smithsonian Institution,
Washington, D.C.

Ess is less interested in
subject-matter than in
camera effects. In this
image, the distortions of
perspective and loss of
clarity at the edges
transform the common-
place into an other-
worldly vista, at once
attractive and threaten-
ing. Ess usually works in
large-format prints that
approach the size of
paintings.

The pinhole camera, favored by
Pictorialists such as George Davison
(see Fig. 4.7) because its wide angle
stretched and fogged photography's
typically deep pictorial space, was rein-
vestigated by late twentieth-century
artists such as Barbara Ess (b. 1946)
(Fig. 7.40). Along with Japanese photog-
rapher Nobuo Yamanaka (1948–1982)
(see p. 380), Ess was one of the first
image-makers in the period to withdraw
from the high-tech possibilities of
advanced cameras and film, as well as
computer enhancement, in favor of the
simpler pinhole camera.

London-born Adam Fuss (b. 1961)
is likewise disposed toward older, ele-
mentary forms of photography. He
extensively employs cameraless image-
making in the form of the photogram
or what William Henry Fox Talbot called
photogenic drawing (see p. 18). Using a
technique that also fueled experimental
photography between the world wars,
Fuss sometimes records only the action
of light on sensitive film, or the concen-

tric circles made by falling droplets of water. For the enigmatically titled *Wish* (1992), he arranged two rabbits as if they were heraldic animals on a medieval shield (Fig. 7.41).

Spanish photographer Joan Fontcuberta's (b. 1955) approach to the photogram shows a greater responsiveness to the postmodern questioning of representations. He pairs mass-produced images with actual examples of the subject pictured; the manufactured and natural objects are then combined to make an image that plays on the viewer's knowledge that a photogram traces outlines of the real (Fig. 7.42).

The DIANA camera and other inexpensive instruments found favor with photographers who were attracted to its foggy, unevenly lit image. By shooting with a cheap plastic camera, Mexican photographer Carlos Somonte (b. 1956) rejected documentary realism in his series *The Last Poets*, which was based on images of the poor inhabitants of Mexico's northern and central desert areas (Fig. 7.43).

Easy to achieve with a Diana camera, Barbara Pollack's blurry photographs require considerable planning. Her

7.42 (left)
JOAN FONTCUBERTA,
Ich danke Ihnen für die Rosen, from his series *Paper Gardens*, 1990. Photogram on foil wrapping paper.

431

THE POSTMODERN ERA

7.41 (left)
ADAM FUSS, *Wish,* **1992. Color photogram.**

In Fuss's photogram, the entrails of two rabbits mix and flow into irregular shapes that look like thick paint. They form an enclosure for the suggestion of a human figure in the lower center of the image. The unsettling effect is like viewing the residue of a secret magic rite that left its remains on photographic paper.

7.43 (left)
CARLOS SOMONTE,
Woman with Rattlesnake Skin, San Luis Potosí, Mexico (Señora con piel de serpiente, San Luis Potosí, Mexico), 1990, from the series *The Last Poets (Los ultimos poetas).*

Somonte deliberately used an inexpensive camera to create a print looking deteriorated with age, perhaps to make his subjects look as though they have endured hardship for long periods of time, or as a visual metaphor for continuity between past and present.

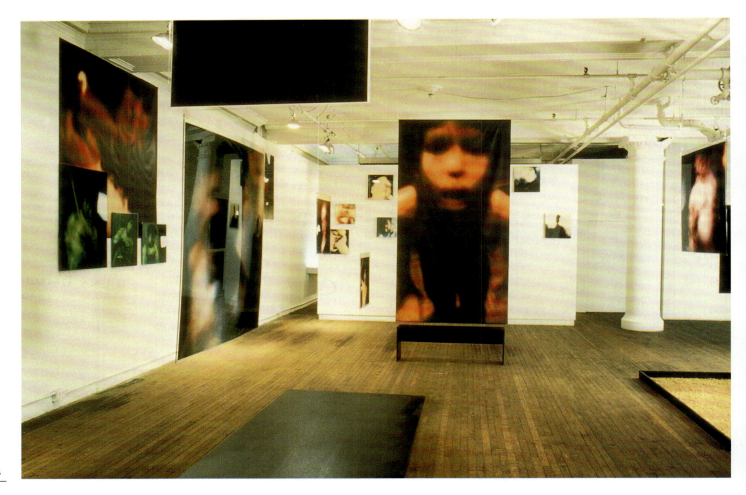

7·44
BARBARA POLLACK,
Installation view of *The Family of Men*, Thread-waxing Space, New York, 1999.

Pollack used out-of-date film and old Polaroid cameras to create *The Family of Men*. After exposure, she smeared and smudged the emulsion while it was developing. In contrast to Steichen's 1955 exhibition, *The Family of Man*, Pollack's show displays not universal harmony, but interpersonal tension embodied in strained visual distortions.

The Family of Men (1999) installation, which imitated the design of the 1955 exhibit at the Museum of Modern Art by suspending large-scale pictures at different heights (see Fig. 6.1) showed indistinct color photographs of her husband and son (Fig. 7.44). Pollack's main focus is voyeurism, that is, the desire to look, and what it feels like to be looked at. To that end, she intentionally blurs the image to frustrate the viewer's gaze, and make the viewer more aware of efforts to look.

FEMINISM AND POSTMODERN PHOTOGRAPHY

In an influential article titled "The discourse of others: feminists and postmodernism," critic Craig Owens pointed out a convergence of "the postmodernism critique of representation," and "the feminist critique of patriarchy."[51] He looked back at Martha Rosler's series, *The Bowery in two inadequate descriptive systems* (see Fig. 7.32), retroactively casting it as a postmodern work because of Rosler's attempt to undermine the truth value of visual and verbal texts. He reasoned that her "*refusal* of

mastery," that is, a deliberate effort not to resolve meaning in an image, was a critique of representation that also related to contemporary feminist rejections of imposed gender identity.[52] Owens also enlisted Cindy Sherman's film stills to point out how the artist assumed roles so as to reveal them as gender stereotypes. Applying the psychoanalytic theory of French thinker Jacques Lacan (1901–1981), Owens was one of the first to fix on the notion that, if gender is not innate but culturally acquired, it can also be culturally rejected and redirected. The initial bridge Owens built between postmodernism and feminism supported many subsequent accounts, and encouraged comparable investigations of received ideas on race and sexual preference.

The intense focus on gender as a kind of performance, rather than the expression of an inherent feminine temperament, followed a period in which some feminist photographers and photographic historians had begun to rehabilitate the reputations of nineteenth- and early twentieth-century women photographers such as Julia Margaret

Cameron and Frances Benjamin Johnston (see pp. 158, 190). After producing the book *The Feminine Eye in Photography* (1973), at a time when the work of many women photographers was largely unknown, Californian photographer Judy Dater (b. 1941) created portraits showing women comfortable with their own bodies (Fig. 7.45). Several other studies and exhibitions attempted to show the breadth of women's photographic work. Anne Tucker's *The Woman's Eye* (1973), Val Williams's *Women Photographers: The Other Observers, 1900 to the Present* (1986), and Naomi Rosenblum's *A History of Women Photographers* (1994) helped gather initial data, and gave impetus to the ongoing study of the social factors that have excluded women from histories of photography.

The restoration of women's past photographic pursuits and the presentation of female sexuality began to be berated by critics, who attacked the uncomplicated notion that there was something distinctive about images by women. They believed that it promoted the idea of an inherent feminine essence. For example, British writers Griselda Pollock and Janet Wolff asserted that there is no intrinsic feminine or masculine essence, only complex networks of culturally conditioned markers that construct what superficially appears to be coherent gender identity.[53] They questioned the experimental writings of French theorists Hélène Cixous and Julia Kristeva, both of whom put forward the concept of "writing from the body," or "feminine writing," that is, the possibility of creative expression that eludes through indirection the dominant male point of view.

The French theorists' ideas were becoming widely persuasive in academic settings including art schools, where it had already become important to visualize an alternative feminine condition, one sufficiently protean and anti-authoritarian that it could evade the pervasive gender stereotype of the nurturing, yet emotionally ruled woman. Conceptual artists such as the French image-maker Annette Messager (b. 1943) responded to this vein of feminist theory; she created her fragmented photo-pieces as an embodiment of Cixous's idea that the feminine was not fixed, but was, instead, an aggregate of unstructured perspectives that thwarted summarization. In *Mes Voeux* (*My Vows*), Messager suspended from strings of different lengths several hundred photographs of women's body parts (Fig. 7.46).

Efforts to undermine the fixity of feminine identity discouraged the retrieval of information on women photographers simply because they were women. Throughout the 1980s and 1990s, essentialist feminists, that is, people who believed that femininity is a real inborn trait, vied with culturalists, who held that gender roles were culturally determined. In photography, this argument ignited competing exhibition rationales and vigorous critical reviews. For instance, the 1987 show *Reclaiming Paradise: American Women Photograph the Land* was conceived to show a basic sameness underlying women's photography from different eras, a resemblance that stood in very opposition to landscape views taken by men. The exhibition hoped to show that women used visual strategies that indicate a caring attitude toward the earth, whereas, by contrast, men frame the land in ways that indicate a desire to possess and own

7.45
JUDY DATER, *Maureen with Fan*, 1972, from the book *Women and Other Visions*, 1972.

Dater's career as a portraitist led her to chronicle women as they would pose and costume themselves before the camera. Several sitters chose to allude to their ease and acceptance of sexuality.

it. Critic and photographer Deborah Bright (b. 1950) was among those who objected to the premise of a woman's landscape photography. She pointed out that aligning women with nature and natural functions had long been used historically to "devalue women and their cultural production." For Bright, the claim that women are "naturally" creative also suggested that men must create "artificially," through cultural and technological means alien to women.[54]

While scholars debated the desired direction of photographic history and practice, American graphic designer Barbara Kruger (b. 1945) culled photographically derived mass-media images for use in an extensive series of confrontational poster-like pictures based on postmodern assumptions about women in society. Like experimental German photographers between the

**7.46
ANNETTE MESSAGER,**
My Vows (Mes Voeux),
1990. Black-and-white photographs and string.

Messager's collection of images could have been collaged photographically, but she suspended each to accentuate their separateness and movement. They are held in suspension, just as, in feminist theory, gender identity is fragmented and transitory. In outline, the piece forms a circle, a symbol of wholeness and the mothering earth. Yet the pictures do not add up to one woman, or even several women.

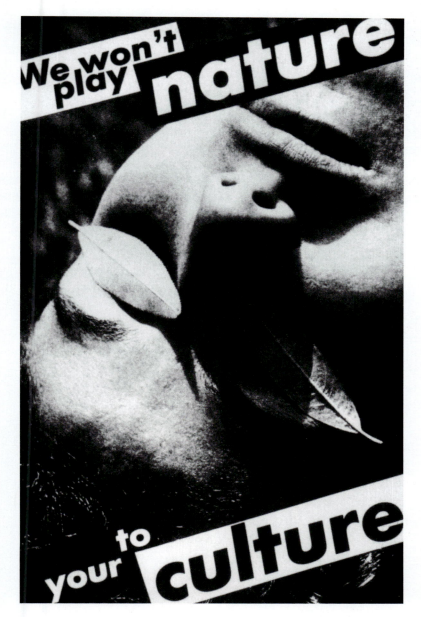

Kruger pointedly aimed her work at the audience, using personal pronouns such as "we," "you," and "yours"—in the manner of product advertisements. The tauntingly titled "We won't play nature to your culture" strenuously pointed out the exclusion of women from cultural work because of their association with the natural world.

435

THE POSTMODERN ERA

world wars, she inserted bold, blocky type derived from advertising into her compositions, both as design elements and for their meaning (Fig. 7.47). The art museum was only one location in which Kruger's work appeared. She sought out public venues and commercial formats, putting her images and slogans on billboards and even department store shopping bags.

Despite the oppositional messages in her images, Barbara Kruger was well incorporated into the art world, the sales gallery, and even advertising, where her work was considered stylish. Indeed, by the mid-1990s, appropriation itself was mocked as a worn-out visual device, as when Amy Adler (b. 1967) photographed her own drawing of Sherrie Levine's appropriation of a photograph by Edward Weston.

CONSTRUCTED REALITIES

In a period of multiple convergences, one of the most fruitful for photographic practice was the hybridization of Conceptual art's interest in ideas, postmodernism's investigation into visual and verbal signs, and the increased presence of installation art beginning in the late 1970s. The mixture was evident in the widespread practice sometimes referred to as the staged photograph. Interestingly, attempts to create fictions for the camera never acquired an accepted label. Especially in its early years, staging was awkwardly called the "fabricated-to-be-photographed" approach, meaning that a scene was composed mostly, but not always totally, of inanimate objects. Equally ambiguous terms were also tried, such as "the

FOCUS
Culture Wars

A fabricated-to-be-photographed image was at the center of a national debate in the United States about public funding for the arts. On May 18, 1989, New York Senator Alphonse D'Amato demonstrated his hostility to public funding of the arts in the United States by ripping up a photograph of a work by the then little-known artist Andres Serrano (b. 1950). The offending image showed a crucifix suspended in an illuminated bubbly, reddish-yellow liquid. The radiant glow around the crucifix made it seem like a work of devout religious fervor. Were it not for

the title, *Piss Christ*, viewers could not tell that the liquid was urine (Fig. 7.48).

The piece had been exhibited at a show of fellowship winners held by the Southeastern Center for Contemporary Art in Winston-Salem, North Carolina. The program was sponsored by private foundations, including The Rockefeller Foundation and The Equitable Foundation, as well as the government-funded National Endowment for the Arts.[55] Only the last organization, which channeled public money, was criticized for its support.

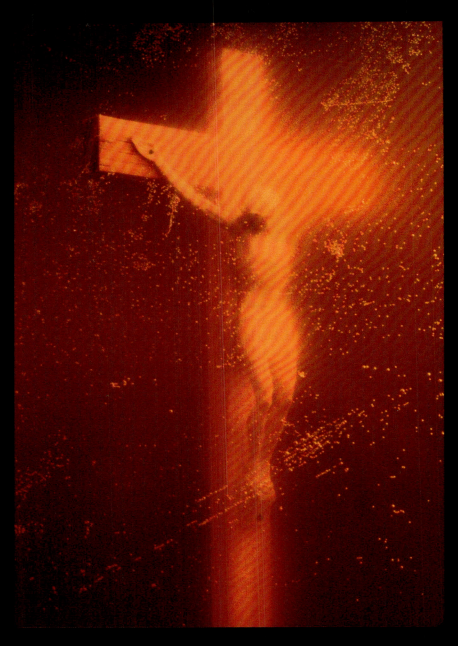

7.48
ANDRES SERRANO,
Piss Christ, 1987.
Cibachrome, silicone, plexiglass, wood frame, edition of 4.

Serrano devised and labeled his work to bring about a collision of extremes: intense aesthetic pleasure and strong physical revulsion. Another piece, *Semen and Blood III*, for example, shows these bodily fluids swirling in a dynamic abstraction (Fig. 7.49). But Serrano undercut the enjoyment of shapes and colors with a title that unambiguously declares its unorthodox materials, and put viewers in mind of the connection of sexuality with disease, particularly AIDS. Some observers complained that they were repelled by Serrano's pictures, just as if they were in the physical presence of the substances. Others felt fooled into experiencing visual pleasure from elements repugnant to them.

The dispute ignited by Senator D'Amato raged on, fueled by people of faith who felt that Serrano had desecrated a cherished religious symbol at public expense. Critic Steven C. Dublin observed that the public controversy over *Piss Christ* was prompted by a national sense of uncertainty about the future, which also kindled a longing for traditional values of home and church during the Reagan administration. These feelings found a target in Serrano's picture. In the end, government funding to the arts was placed under the scrutiny of the so-called "Helms amendment," named for its sponsor, North Carolina Senator Jesse Helms. It barred public moneys from underwriting so-called "obscene" work, unless it had "serious literary, artistic, political, or scientific value."[56]

7.49
ANDRES SERRANO, *Semen and Blood III*, 1990.
Cibachrome, silicone, plexiglass, wood frame, edition of 4.

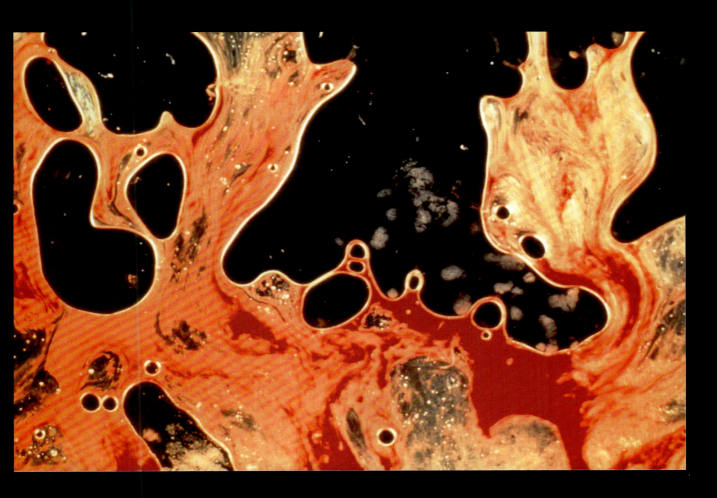

constructed photograph," which did not indicate the collage technique, but referred to any scenes assembled for the camera. As early as 1976, American critic A. D. Coleman outlined an extensive history for what he called the "directorial mode," in which he made the case that contemporary staged photographs had precedents, such as Civil War photographer Alexander Gardner's deliberate moving of a dead Confederate soldier so as to compose a more richly symbolic image (see Fig. 3.21), or the nineteenth-century stereograph, in which many narrative scenes were enacted as a matter of course (see pp. 82–83).[57]

Of course, the *tableaux vivants* orchestrated by nineteenth-century photographers Oscar Rejlander and Henry Peach Robinson (see Figs. 3.97, 3.100) were assembled to be photographed, but the artists' motives could hardly be more different from those of contemporary picture-makers. Sometimes Rejlander and Robinson could not make the stubborn paper negatives and imprecise lens clearly capture the image they had mentally conceived. Rejlander and Robinson welcomed the hands-on, directorial aspects of composite photography as a way to negate the criticism that photography was witlessly automatic and therefore not an art.

When fabricated-to-be-photographed approaches became widespread in the 1980s, former technical difficulties had long been overcome, and the issue of whether a photograph could be art wasn't contested. The omnipresence of movies and television, in which a director orchestrates scenes, may have subtly amplified photographers' desire to direct for the still camera. More to the point, mundane studio work normally demanded staging, rehearsal, and lighting strategies. In particular, advertising photography offered a steady stream of

7.50
SANDY SKOGLUND,
Revenge of the Goldfish,
1981. Silver dye-bleach (Cibachrome) print.

Skoglund unified the area in her room-sized installations by applying the same color paint to the walls, floors, and furnishings. The bright orange goldfish who fly in the air and wriggle on the floorboards make the picture both fanciful and menacing—a balance often achieved in her work.

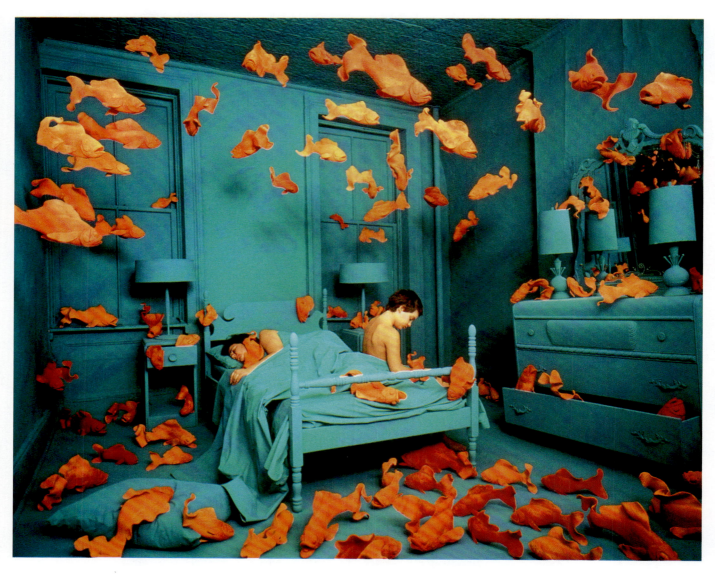

7.51 (above)
PETER FISCHLI &
DAVID WEISS,
Untitled, **from the series**
Stiller Nachmittag,
1985. Kunsthaus,
Zurich.

The balancing act of
vegetables and a cheese
grater may be a sly par-
ody of Cartier-Bresson's
"decisive moment."
Instead of finding an
instantaneous visual
anecdote on the streets,
the photographers
painstakingly made one
and photographed it.
Though contrived, the
childlike improvisation
of their work has been
taken as an antidote to
postmodernism's
blighted spirit.

common was not a philosophy, but a
methodology, and, perhaps, a boredom
or anger with the limitations of
Modernist idioms. Where Modernist
photographers combed the visual field
for delightful coincidence, poignant
metaphors, or abstract patterns, none of
which were (or should have been) con-
trived, the photographers working in the
directorial mode conceived and fabri-
cated subjects, disregarding photogra-
phy's traditional assignment of finding
meaning from the look of the world.

The making of scenes, rather than,
the taking of scenes, was epitomized in
the work of American photographer
Sandy Skoglund (b. 1946), who created
room-size installations to be viewed in
their own right as three-dimensional
sculpture, as well as photographs. In her
work, exaggerated objects, such as
cobalt-blue leaves or safety-orange fish,
invade spaces occupied by sense-dulled
people stranded in monochrome set-
tings (Fig. 7.50). Skoglund's work antici-
pated the partnership between sculpture
and photography that pervaded art in
the last decades of the twentieth century,
ranging from the tongue-in-cheek bal-
ancing acts pictured by Swiss artists
Peter Fischli (b. 1952) and David Weiss
(b. 1946) (Fig. 7.51) to the cool, cerebral
black-and-white world pictured by James
Casebere (b. 1953) (Fig. 7.52). Large,
richly colored and fabricated-to-be-

sophisticated fabricating techniques
used to enhance the appeal of products,
such as intricate artificial lighting and
suggestive, unnatural color.

The lack of an overarching "ism" for
staged photographs may owe to the fact
that it was not an art movement driven
by a core of beliefs, but an approach that
interested image-makers with different
artistic perspectives and ideological
positions. What the fabricators had in

7.52
JAMES CASEBERE,
Chuck Wagon with
Yucca, **1988. Gelatin**
silver print, edition of 7.

Casebere, who began
his career in sculpture,
works with both larger-
than-life pieces and doll-
house-sized objects, all
derived from the world
of experience but
presented in a flat
monotone, with the dis-
tinguishing edges and
textures smoothed away,
as in memory or a
dream. In this image,
the wheels of the chuck
wagon are too polished
to seem authentic and
the canvas covering
lacks roughness.

7.53
THOMAS DEMAND,
Copyshop, 1999. C-print
Diasec.

Demand takes great
care in constructing an
environment and pho-
tographing it so as to
present a convincing
illusion. A diligent
observer will notice that
the scene is too perfect,
or, conversely, recognize
that the paper or card-
board have buckled.
Indeed, Demand insists
on an attentive viewer,
because his titles often
do not indicate the his-
toric source for his
images.

photographed scenes were also made
by German artist Thomas Demand
(b. 1964). Employing only cardboard
and paper, Demand recreated life-size
environments that were often based on
historic locales pictured in books and
newspapers, such as the disorderly
Berlin bunker in which Adolf Hitler
spent his last days. When Demand has
completed a photograph, the cardboard
construction is discarded, making the
photograph an original work (Fig. 7.53).

Demand's fastidious planning con-
trasts with the work of Mexican artist
Gabriel Orozco (b. 1962), which dwells
on fleeting perceptions of art, especially
the unintentional presence of sculpture
in everyday life. Orozco points to the
gracefulness of a melting popsicle,
chronicles the brief life of a human
breath exhaled on to the polished sur-
face of a piano; he fabricates makeshift
scenes to be photographed (Fig. 7.54).
With many other late twentieth-century
artists who use the camera, Skoglund,

Fischli and Weiss, Casebere, Demand,
and Orozco do not want to be known
principally as photographers, but as
artists who work with photography, as
well as other media.

Small sculptural scenes, resembling
the maquettes architects make as pre-
liminary models, figured heavily in the
fabricated-to-be-photographed method.
Counterfeit table-top scenarios were
favored as a way of indicating falseness,
insincerity, and superficial knowledge,
as in Irish photographer Michael
Boran's (b. 1964) image in which a male
doll flees an artificially lighted brick
dollhouse (Fig. 7.55). American Laurie
Simmons (b. 1949) also works with
doll-house-like settings in which plastic
figures, almost exclusively women,
robotically act out routine incidents
of domestic life (Fig. 7.56). When
Simmons began making images of
males, she continued her concern with
authenticity and originality by manipu-
lating ventriloquists' dummies.

7·54
GABRIEL OROZCO,
Cats and Watermelons
(Gatos y sandías), 1992.
C-type print.

Orozco's work accentuates the temporary and the ephemeral. He makes fanciful, impromptu sculpture in public spaces, whose momentary existence is recorded with the camera, such as his whimsical grocery-store arrangement of cat food cans on a heap of watermelons.

7·55
MICHAEL BORAN,
Tony Potts, 1989.
C-type print.

Boran favors constructed photographs as a means to portray archetypal experience, such as the wish to bolt from constraining circumstances. Here, the character may be attempting to flee domesticity, indicated by the house and the background landscape, which Boran calls a "generic pastoral," purchased from a model railroad shop. The title refers to a pop song.

**7.56
LAURIE SIMMONS,
*Blonde/Red
Dress/Kitchen*, 1978.**

Simmons's doll-actors
and deadpan enact-
ments of women's roles
in society seemed to
find a response from a
generation that grew up
play-acting with Barbie™
dolls. Her work from the
mid-1970s to mid-1980s
was largely concerned
with female behavior,
enacted by the dolls
whose poses, gestures,
and facial appearances
were saturated with
clichés drawn from
mass media.

**7.57
TOKIHIRO SATOH, *Photo-
Respiration (Breath-graph no.
22)*, 1988.**

After making his large prints,
Satoh presents them in
Plexiglas boxes that serve as
frames, or he suspends the
images from the ceiling, as
here. In effect, the photograph
of a fleeting light sculpture
becomes three-dimensional
photo-sculpture.

The success of performance art before a live audience during the late twentieth century influenced the conception of staged photographs. For example, starting in the mid-1980s, Japanese photographer Tokihiro Satoh (b. 1957) initiated what might be called ephemeral sculpture or light performance pieces, not conceived for a live audience, but intended solely to be viewed as a photograph (Fig. 7.57). In interior settings, Satoh used projected light, such as a flashlight, and in exterior locations he captured and reflected sunlight with a mirror, all the while moving so quickly that his camera, adjusted for long, slow exposure, could record only twinkles and trails of bright light, not his body. Like Robert Smithson before him, Satoh created transient environments that exist only for the camera. Yet where Smithson tried to stop the flow of time, Satoh wanted his so-called *Breathgraphs* to suggest time's progress; he imagined that his pictures intimated the accumulated streams of human energy that had been expended in the settings he photographed.

Famous paintings from the traditional canon became sources for fabricated images. The Life of Christ, as seen in the history of art, inspired several photographers to stage such scenes as the Last Supper and the Crucifixion. In one of his series, the London-born, Nigeria-raised artist Yinka Shonibare (b. 1962), who works in many media, posed himself incongruously in the midst of figures enacting a scene whose setting, gestures, costumes, and colors resemble late eighteenth- and nineteenth-century painting (Fig. 7.58). American photographer Joel-Peter Witkin (b. 1939) also mined art history for ideas, occasionally improvising elaborate tableaux recalling familiar paintings in the Western tradition, and then aging the resultant image by scratching

**7.58
YINKA SHONIBARE,
Diary of a Victorian Dandy (21:00 hours),
1998. C-type print.**

Shonibare poses amidst well-to-do party-goers in a fabricated scene. Despite its nineteenth-century title, the image ironically recalls the eighteenth-century satirical paintings by William Hogarth (1697–1764), in which the black figure would not be an admired and socially prominent individual, but a servant. The photograph may reflect Shonibare's experience of his high-profile rise to prominence in London art circles during the 1990s.

the negative and antiquing the print's tone. The aging appearance adds an unsettling, dreamlike effect to his fantastic visions, which are often charged with an unsettling eroticism (Fig. 7.59).

As image-makers began to "make" and then "take" their subjects, they also increased the size and intensity of their pictures. For example, Satoh's *Breathgraph # 22* is 95¼" × 77½". This development was showcased in a 1983 exhibit at New York's Museum of Modern Art, called *Big Pictures*. Not only did photographs come to emulate the size of large paintings in museums and galleries, they also acquired deeply saturated, tropically hot colors, more obviously associated with paint than with photographic materials. Sandy Skoglund's installations and photographs erupt in the piercing colors of acrylic paint. Similarly, the collages of waste materials gathered together and photographed by British artist Tim Head (b. 1946) concentrate on the eye-catching density of the color used in packaging consumer goods. During the 1980s, Head began gathering discarded mass-produced materials to serve as the basis for his

photographs. At once luridly attractive and repugnant, Head's images of ecological casualty imitate the push-pull of desire and guilt (Fig. 7.60).

FAMILY PICTURES

Although staged photographs did not arise as part of a consistent art movement, several motifs recurred, among them the subject of the family, a topic taken up around the world during the late twentieth century. Focus on domestic life intensified, in part because the concept of the ideal family had been rocked by a high divorce rate, picked over in family therapy, and mangled in the popular media, from *Roseanne* through *The Simpsons*. During the Reagan administration (1981–88) in the United States, and the years that Margaret Thatcher was Prime Minister of Britain (1979–90), traditional values, in particular the glorified norm of the white, middle-class family, were enlisted as remedies for a tattered social morality thought to reveal itself in the increase of single-parent families, the rising

**7.59
JOEL-PETER WITKIN,
Las Meninas, New Mexico, 1987. Gelatin silver print.**

Witkin's image is based on a famous painting by the Spanish artist Diego Velázquez (1599–1660) called *Las Meninas (Maids of Honor)*, depicting a young princess flanked by her maids of honor. Witkin introduces homoerotic overtones through the display of paintings done by the late Renaissance artist Caravaggio (1571–1610), and replaces the princess by an older, more lascivious figure, apparently an amputee.

**7.60
TIM HEAD,** *Toxic
Lagoon,* **1987.
Cibachrome print.**

British curator and art
historian David Mellor
pointed out that Tim
Head's *Toxic Lagoon* typ-
ified the "sublime cata-
strophe" mode of
British art, in which the
lovely countryside is
transformed into a dam-
aged and polluted
space, indicative of the
boom-to-bust move-
ment of the British
economy and the break-
up of the social safety
net during the 1980s.[58]

demand for abortion and birth-control,
and in the growth of gay and lesbian
activism.

Of course, many early photographers
made images of their family members,
chiefly because they were near at hand.
William Henry Fox Talbot photographed
his wife, Constance, who also made her
own photographs. From the beginning,
amateurs and professionals practiced
lighting techniques and rehearsed
stances using members of the family.
Nevertheless, few nineteenth-century
photographers operated like Lady
Clementina Hawarden (see p. 161) and
Julia Margaret Cameron (see p. 158),
purposefully posing family members in
evocative attitudes suggestive of charac-
ters in literature and myth. In the post-
war period, Edward Steichen's *The
Family of Man* exhibition and the best-
selling book that accompanied it
became conceptual markers to which
most photographers had to attend,
whether they were inspired by the

emphasis on the universal bonds of
family life, or distressed by the omission
of personal, social, and economic cir-
cumstances that differentiate people
from each other.

In addition, throughout the twentieth
century, families accumulated extensive
collections of images, the majority taken
with simple cameras and increasingly
reliable film. The content of family pho-
tographs was dominated by celebratory
occasions, such as weddings, birthdays,
and vacations. Few families resolutely
set out to record the look of everyday
life, such as messy kitchens and
unmade beds. Fewer still made visual
records of emotionally trying times, or
used the camera for psychological self-
study or therapy. Interestingly, the very
themes and subjects omitted in family
pictures were explored by a wide variety
of photographers, and studied by artists
and scholars. British critic and photog-
rapher Jo Spence (1934–1992) was one
of the first image-makers to use her own

JO SPENCE,
Transformations, from her book *Putting Myself in the Picture*, 1986.

In the photo-therapy developed by Jo Spence, with the help of actor Rosy Martin, the sitter and the photographer work together to enact images of psychological traumas and visions of their remediation. Spence managed to infuse humor throughout the project.

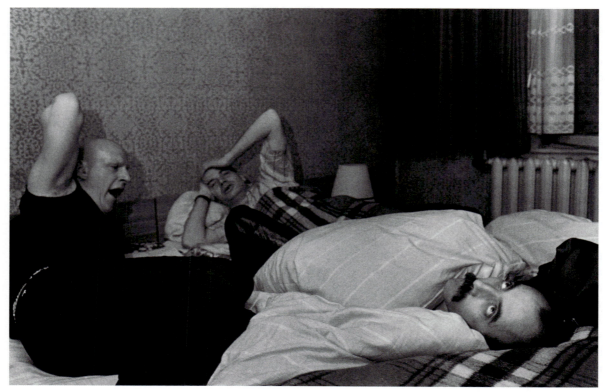

7.62
UTE MAHLER,
Untitled, from *Living Together,* c. 1981.

Mahler's photographic series *Living Together* focused on the family, an approved subject for East German photography. But she moved beyond the idealized, happy household to show the variety of people who live together, and their idiosyncrasies.

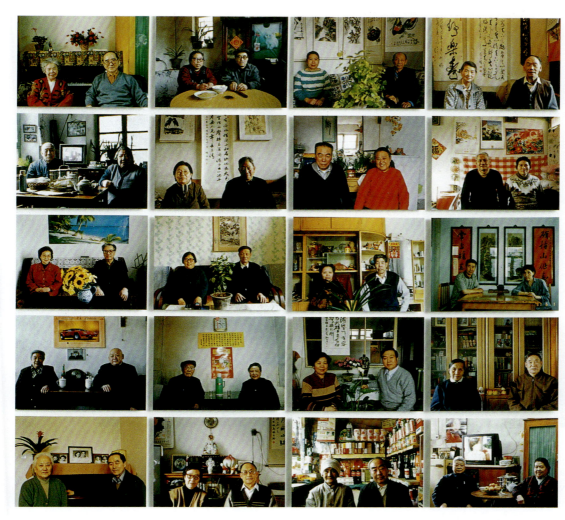

Wang shows middle-aged to older couples, who increasingly live by themselves, since the government policy of one-child families has fractured the traditional multi-generational family group. Rather than being known through their children, these couples display their possessions. In the last picture, photographs of family members have become peripheral to the electronic family presented on the television.

baby pictures, family snapshots, and early studio portraits to investigate her socialization into gender and class roles. Out of this experience she and actor Rosy Martin developed what was called "the reconstructive process," a psychological therapy in which new photographic portraits were made in order "to disrupt, replace or rework" an aspect of personality (Fig. 7.61). Artists came to view the casual snapshot, with its innocence of technique and composition, and the cheap camera, with its lack of sophisticated metering or fine lenses, as exciting means with which to extricate photography from its longstanding infatuation with "artistry." Canadian photographer Jeff Wall (b. 1949) dubbed this far-reaching, self-imposed, de-skilling of photographers as like "amateurization."[59]

Toward the end of the Cold War in Russia, Soviet photographers "amateurized" their photographs, creasing and spotting the print in experiments with what they called "the aesthetics of defect."[60] Ignoring the fact that the humble and crumpled snapshot could be as riddled with conventions as the refined studio portrait or the news photograph, some photographers looked to it as a means to escape the pervasive influence of Henri Cartier-Bresson's "decisive moment" (see p. 262). German writer Ulf Erdmann Ziegler accused the "decisive moment" of being an intellectually and visually reductive technique that diminished photography to a mere anecdote.[61]

Family photographs not only refreshed art, they also energized social commentary. In East Germany during the 1980s, Ute Mahler (b. 1949) pictured an array of households that repudiated the official state-sponsored view of the normal family (Fig. 7.62). The Chinese photographer Wang Jinsong (b. 1963) focused on the family as an act of political resistance. His *Standard Family* series illustrates the effects of China's policy of one-child families in images of middle-aged and older couples that would be immediately understood by Chinese viewers (Fig. 7.63).

**7.64
ANDRE ZELCK,
Untitled, from his series
*Familienbande (Family
Group)*, 1992–96.**

Zelck's family scene
seems to show a
moment beneath the
notice of most snapshot
makers. Despite its
apparent casualness,
the image is composed
of interlocking triangular
shapes, starting in the
lower right-hand corner
with the wedge of table
that enters the picture.
It reveals the difficulties
of breaking away from
the angular designs of
Modernist photography.

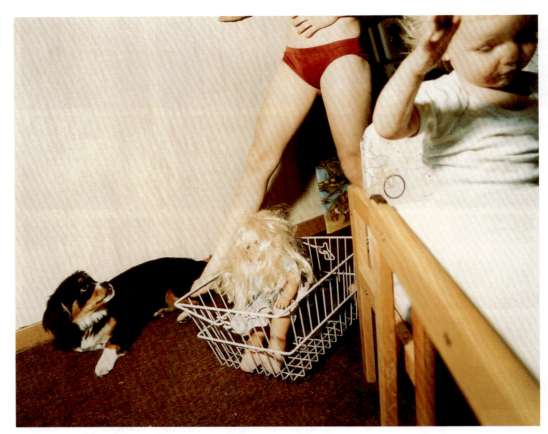

The fall of the Berlin Wall in 1989
and the reunification of the eastern and
western halves of Germany the follow-
ing year marked a change in German
photographers' attitude toward the
medium's social role. Arguing that the
post-1989 period lacked vitality and
ideological coherence, they became
engrossed by lengthy, non-narrative
depictions showing the tedium of daily
life. However, the hold of the "decisive
moment" was evident, even in the work
of image-makers who emphatically tried
to escape it. For example, Andre Zelck's
(b. 1962) pictures of a marginally
employed working-class family in the
heavily industrialized Ruhr area of
Germany vacillate between precise,
telling moments, and rambling pictures
of miscellaneous scenes (Fig. 7.64).

The notion that home life had
eclipsed street life in American art and
documentary photography was the
theme of a much discussed 1991 exhibi-
tion at New York's Museum of Modern
Art called *Pleasures and Terrors of
Domestic Comfort*. Curator Peter Galassi
sampled family photographs ranging
from the disconcerting staged tableaux
of Philip-Lorca di Corcia (b. 1953) (Fig.
7.65), through Tina Barney's representa-
tions of affluence (see Fig. 7.74), Sally

Mann's controversial images of her
immediate family (see Fig. 7.82), and
Larry Sultan's views of his parents' daily
routine (see Fig. 7.73). In the last decades
of the twentieth century, when photogra-
phers increasingly created sets and sce-
narios, family life and interaction with
friends were increasingly pictured. Larry
Sultan used his parents' home as the
setting for the photographs directed by
him, but other photographers, such as
French image-maker Bernard Faucon (b.
1950), contrived elaborate backdrops and
tableaux for domestic dramas (Fig. 7.66).

EXTENDED FAMILY

Photographers of daily life frequently
expanded the definition of family from
blood relatives to groups with which they
associated. German Göran Gnaudschun
(b. 1971) assembled his photo-book pro-
ject *Longe—44 Leningrad* as a chronicle
of his life with a folk-punk band called
44 Leningrad. In Gnaudschun's words,
Longe, or daily life, "does not aspire to
relate a story, but the everyday cycle of
constantly changing yet always recurring
basic feelings. . . ."[62]

Similarly, Wolfgang Tillmans
(b. 1968), a German who currently lives
in London, began his career photo-
graphing the London club scene and

street life for unconventional British fashion magazines such as *The Face*, but achieved an international reputation for informal photographs of his coterie of friends (Fig. 7.67). Like Baudelaire (see pp. 151–52), Tillmans believes that an artist must render the ever-changing look of the contemporary world and not pursue timeless beauty—a rationale, perhaps, for his continued work in fashion photography. He won the prestigious Turner Prize in Britain during 2000. American artist Jack Pierson (b. 1960) created clusters of disjointed,

blurry, or overexposed shots of his life and companions (Fig. 7.68). An air of listless "hanging around" is relieved by scenes of frantic sexual melodrama.

Although Tillmans and Pierson bear little resemblance to the politically inspired postmodern photographer in the late 1970s and 1980s, their outlook on truth as an unrealizable goal for photography is similar. By insisting on portraying the private self, both photographers testify to the modest limits of the medium. At the same time, they further glamorized the mass-media-

Pleasures and Terrors of Domestic Comfort

The Museum of Modern Art, New York

Peter Galassi

**7.65
PHILIP-LORCA DI CORCIA,** *Brian*, 1988, on the cover of the book accompanying the show *Pleasures and Terrors of Domestic Comfort*, 1991. Offset, printed in color. Museum of Modern Art, New York.

An edgy foreboding seeps through Philip-Lorca di Corcia's images of ordinary domestic life. In this picture, the boy's thoughts seem far removed from the simple task of making a snack.

7.66 (left)
BERNARD FAUCON,
Les Papiers qui Volent,
1977–95. Fresson tech-
nique, edition of 40.

Faucon frequently mixes
posed mannequins in
fantastic scenes that draw
on ordinary life and often
concern children. Yet not
all the figures in a Faucon
image are counterfeit.

7.67 (below)
**WOLFGANG
TILLMANS**, *Lutz and
Alex Sitting in the Trees*,
1992. C-type print.

induced fantasy that it is pleasurable to
be incessantly photographed in private
life, as well as in public.

During the last decades of the twenti-
eth century, exhibition pictures and
books of photographs showing family
and friends commingle the private and
public domains. By far the best-known
of these private–public works was the
sound and slide show (and subsequent
1986 book) by New York photographer
Nan Goldin (b. 1953) titled *The Ballad
of Sexual Dependency* (1983). The show
consisted of about 700–800 transparen-
cies (slides) detailing the intimate lives
of Goldin and her friends, her "re-
created family"[63] (Fig. 7.69). Her 1996
book *I'll Be Your Mirror* included per-
sonal interviews as well as pictures of
friends who were HIV-positive. Goldin
has traveled extensively and her sexually
charged work, characterized by a reveal-
ing flash and a palette of strong colors,
has been internationally influential
in validating the use of photography
as a diary of daily life. Her approach

7.68 (above)
JACK PIERSON,
Untitled, **from his book**
Jack Pierson: The Lonely
Life. **Edition Stemmle,**
Zürich, 1997.

Although he photographs friends and surroundings, Pierson is anxious not to narrate his photographs. Instead, he wants people to escape into the picture, completing "the story themselves," because, as he says, "there is a collective knowledge of common clichés and stereotypes that is very effective."[64]

has even been adopted in fashion photography.

The subject and shock-value of Goldin's images from the 1980s paralleled some of those produced by the Japanese photographer Nobuyoshi Araki (b. 1940), whom she met in the early 1990s. Araki roams the streets of Tokyo collecting photographs with an array of cameras ranging from the latest technological advances to inexpensive devices. Frequently tilted, these views glimpse the friction between traditional and ultramodern Japanese life. But Araki's most notorious images show women in sexually submissive or suggestive poses

7.69
NAN GOLDIN, *Nan*
and Brian in Bed, New
York City, **1983, from**
The Ballad of Sexual
Dependency, **1983.**

derived from pornography (Fig. 7.70). In both his street scenes and photographs of women, Araki attempts to show what he believes is an obsessiveness lurking in the Japanese character.[65]

In Japan, Araki's casual, snapshot-like photographs and Nan Goldin's diaries of friends and life experience had an unpredictable impact on young Japanese women photographers.[66] Until the 1980s, when formal training in photography became available through art schools, women in Japan found it difficult to learn the medium. Apprenticeships with master photographers were routinely given to men. A woman who succeeded in learning and practicing the craft was called a "*Joryu* photographer," meaning one who works in a woman's style.[67] The popularity of the diary-like photographs by Araki and Goldin served to validate women's lives and image-making. Indeed, Yurie Nagashima (b. 1973) became a celebrity for her images of family and friends (Fig. 7.71).

The extent and availability of family photograph collections, some tracing back several generations, spearheaded the late twentieth-century image-makers' reuse of old images, from daguerreotypes to snapshots. Korean photographer Young Kim (see Fig. 7.2) searched through her family's albums for materials with which to express her anxiety at living between two worlds. Californian artist Doug Muir (b. 1940) reprinted images he took with an inexpensive, fixed focus camera during his

7.70
NOBUYOSKI ARAKI,
Untitled, from his series
Desire and the Void,
1996–97.

At first glance, Araki's street views and his sexually charged pictures of women would seem to have little in common, even though they are part of a series called *Desire and the Void.* Yet both types of images contrast traditional Japanese ways of life with the present, and the temptations of modern existence.

7.71
YURIE NAGASHIMA,
"Self-Portrait," *Mother no. 2,* 1993. Gelatin silver print.

childhood. His pictures center on gestures and facial expressions that reveal interpersonal relationships that were probably unrecognized by the participants at the time (Fig. 7.72).

While Muir does not fundamentally alter the snapshots that form the basis of his work, another Californian, Larry Sultan (b. 1946), plainly demonstrates that his pictures are his interpretations, by bleaching, blurring, and enlarging family snapshots and home movie stills. For *Pictures From Home* (1996), an exhibition and book, Sultan directed his par-

ents in poses for new photographs (Fig. 7.73). Sultan's work went beyond the affections and tensions of his family, to offer a public statement about the erroneous exaltation of American family life promoted by the political right wing during the Reagan era.

At first glance, the photographs of Tina Barney's (b. 1945) relatives offer an inside look at the private lives of the wealthy, who actively work to prevent themselves from being seen candidly. Barney's images feature informal and secluded domestic moments, such as

7.73
LARRY SULTAN, *Untitled*, from his book *Pictures from Home*, 1992.

Reviewing his son's photographs, Sultan's father remarked to his son, "Whose truth is it? It's your picture but my image."[68]

453

FAMILY PICTURES

Day after day it continues. She's got to call so-and-so, but in the meantime she's on to the next week where she has to go to the cleaners and call a different so-and-so, and she can't do the things she says she has to do next week because she's doing the things she said she would do last week, things that she couldn't get around to doing.

Do you know what I'm saying? I really try to just take care of my own things and not get involved, but if I hear someone say for seven straight days that they have to call somebody, at a weak point I forget myself and say, "Did you call?"

"No."

"Well, for Christ's sake, call her," and, wham, there I am, caught in the senseless stream of someone else's errands.

The day-to-day stuff builds up over time. We're talking fifty-six years. We never, or I should say rarely, ever argue. We have nothing to argue about — never about finances, or work, or you guys. I tell her, "You're the only one who cares; no one outside of family gives a damn about me or you; everyone is only interested in their own lives." I've recognized this and understood it for a while, and that's why I'm reluctant to go out and socialize. Most people are so self-centered that they're not interested in anything outside of themselves, and so opinionated that you can no more talk to them than to a radio. It's not that I need an in-depth conversation, just a little understanding. And that's difficult to find.

102

7.74
TINA BARNEY,
Marina's Room, **1987.**

Barney's works have the look of informal snapshots. Nevertheless, though her pictures cut through the glamor of formal portraits, it would be naive to think that her subjects are completely unaware that they are performing in front of the large camera she uses. They have become expert in creating informal poses.

preparations for a party (Fig. 7.74). At the other end of the socio-economic scale, Richard Billingham (b. 1970) reveals people with a seeming indifference to the lens. Employing an inexpensive auto-exposure camera and budget film-processing, Billingham logged his British family's strained existence, much of which turned on his father's alcoholism (Fig. 7.75). The dirt, disorder, and dishevelment pictured in his work have long been associated with truthful photographic documentation, for example in the images made by Jacob Riis (see Figs. 4.46, 4.47). It is intriguing to compare the grime and raw passion in Billingham's pictures with the cleanliness and order transcribed in Barney's work. Despite the apparent artlessness of their images, Barney and Billingham do not break free from the prevailing stereotype that the rich and poor are the

way they are because of their inherent temperaments.

Family pictures provided an important source for authenticating forgotten social history. During the late twentieth century, museums began to exhibit and create histories for so-called Outsider Art, which drew on non-traditional forms of folk art and shed new light on family photographs. Sociologists such as Pierre Bourdieu scrutinized family picture-making with the belief that its social significance surpassed the stated intentions of the photographer. He and others deduced that family pictures consecrated social identity, within and beyond the family. Interestingly, lower-class families seldom had family-produced photographs of past generations, owing, perhaps, to an unease about the visual signs of their social identity, as well as to practical economics. Groups

7.75
RICHARD BILLINGHAM,
Untitled, 1994. Color print on aluminum.

Made while he was an art student, Billingham's candid photographs of his unsettled family life resemble the intrusive images captured with video cameras for reality television, which got its start about the same time.

for whom political powerlessness was accompanied by the lack of public visibility sought out family albums with which to reclaim their ancestors' stories and place in society's collective memory.

In addition to his own photographs of daily life, Santu Mofokeng (see p. 416) concocted an ongoing historical research project called *Black Photo Album: Look at Me, 1890–1950,* which attempts to locate and preserve family photographs of black South Africans, including the seldom acknowledged middle class. The big mixed-media works by Radcliffe Bailey (b. 1968), who is based in Atlanta, Georgia, incorporate real tintypes and other old photographs handed down in his family. Much like Mofokeng, Bailey wants to indicate the existence of a flourishing black middle class, and authenticates his research into late nineteenth-century African-American life by using actual photographs as evidence (Fig. 7.76).

On a large scale, historian and curator Deborah Willis brought together the first comprehensive view of African-American photographers in her *Reflections in Black: A History of Black Photographers, 1940 to the Present* (2000). Willis's earlier work, *Picturing Us: African American Identity in Photographs* (1994), gathered reflections penned by black writers, historians, and image-makers on the impact that a special

photograph had on them. Clarissa Sligh (b. 1939), one of the contributors to *Picturing Us,* recalled the lasting influence of a 1956 newspaper photograph of her taken when she was the plaintiff in a lawsuit aiming to integrate the segregated schools of Arlington, Virginia. Today, Sligh is an image-maker who regularly mines her family albums to reveal the ways in which the lives of her ancestors reflect African-American history

7.76
RADCLIFFE BAILEY,
Untitled, 1999. Acrylic, photograph, and mixed media on wood. Clarice M. Laubenheimer Collection.

(Fig. 7.77). The pictures that American Darrel Ellis (1958–1992) worked with during his short lifetime were taken by his father, who died one month before Ellis was born. Ellis altered the shapes in his father's images, creating fleeting light sculptures by projecting photographs onto irregular plaster surfaces and foam molds. He further distorted the pictures by photographing them from extreme angles that flatten and stretch the pictures' space. For Ellis, these mutations expressed a yearning for memories of his father (Fig. 7.78).

In a similar manner, Albert Chong (b. 1958), a Caribbean photographer of African and Asian descent, uses the medium to create a personal dialogue with his ancestors, and to encourage viewers to acknowledge the mixing of cultures. His self-portraits, called "I-traits," usually involve his moving so quickly in front of the camera that his identity is a blur. Other works incorporate old photographs in assemblages put together as part of a ritual to connect with the past. In *Aunt Winnie*, for instance, Chong constructed a homage to his mother's sister from a studio portrait made in the 1940s (Fig. 7.79). Similarly, Mexican image-maker Adolfo Patiño (b. 1954) accentuates the personal and home-made quality of family photographs by sewing them to handmade bark paper. He works in series, frequently repeating whole images or

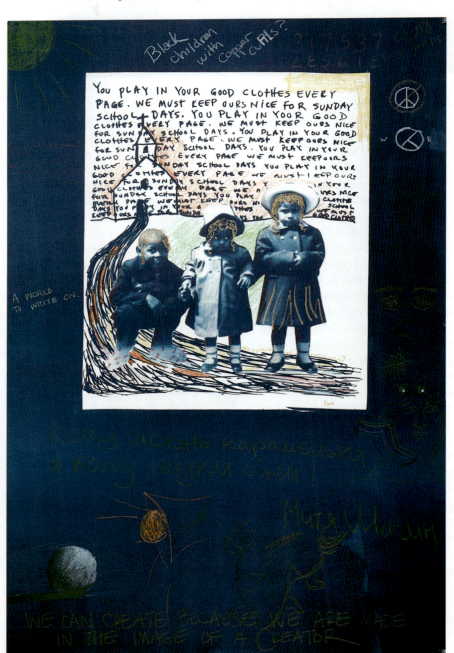

7.77
CLARISSA SLIGH, *Untitled,* **from the series** *Reading Dick and Jane with Me,* **1990. Cyanotype with crayon added while on exhibit at Art Awareness, Lexington, New York.**

In her series *Reading Dick and Jane with Me,* which elicits the racial assumptions of an old reading primer, Sligh altered family pictures with text and applied color, in an effort to show that memory is constructed, and never simple.

miscellaneous snippets, sometimes using a simple family photograph to elicit the feeling of memory and loss[69] (Fig. 7.80).

The rescue and reuse of family photographs further encouraged the growing interest of historians, curators, and artists in past photographic processes, such as cyanotype (which Clarissa Sligh employed), the tintype, the wet-plate collodion process, and even the use of room-size camera obscuras. Some nineteenth-century processes now even have their own websites. A personal investigation of alternatives to silver-based photographic processing led American photographer Bea Nettles (b. 1946) to concoct an enduringly popular 1977 volume called *Breaking the Rules: A Photo Media Cookbook.*

Even the tedious and physically hazardous daguerreotype method made a return during the late twentieth century. One enterprising photographer, Robert Shlaer (b. 1943), employed the technique during a four-year project retracing John C. Frémont's 1848 trip through the American West, deducing from engravings the actual scenes of now lost daguerreotypes made by the expedition's photographer.[70] In 2001, a Boston exhibit invented a name for the use of nineteenth-century techniques in contemporary photography, calling such work "crafted" images.

Artists' reuse of ordinary photography supplemented scholarly attention to vernacular photographic practice,

such as the heavily overpainted photographs studied by Christopher Phinney in his investigation of camerawork in India, and Mexican *foto-esculturas* or photo-sculptures. This hybrid between the flat photograph and the

**7.79 (right)
ALBERT CHONG,** *Aunt Winnie,* 1995 (original 1940s). **Chromogenic color print.**

Surrounded by purple flowers (the color of mourning), Chong's tribute to his (now aged and infirm) aunt evokes what amounted to a tragic romantic life. "These old studio portraits," says Chong, "are poignant signatures of individuals who peopled an age that now through the prism of time seems so different…"

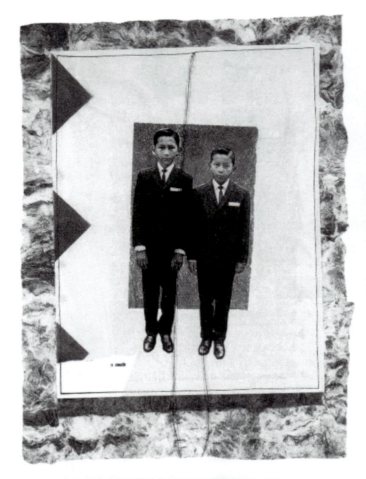

ADOLFO PATIÑO,
Constant Navigation
(Navegación constante),
1991–92, from the series
Elements for Navigation
(Elementos para una
navegación), from the
larger series *Relics of the*
Artist (Reliquias de
artista). Family photo-
graphs, Polaroid 669
photographs, negatives,
Canon laser copies,
Polaroid SX-70 pho-
tographs, old postcards,
prints on paper sewn
with cotton thread on
felt, satin, and amate.
Enriquez Schneider
Family Collection,
Mexico.

A stiff snapshot of the
artist and his brother
becomes, in the second
picture, a silhouette
framing repeated
images of Christ as the
Sacred Heart. In the
third image, the boys
have been replaced by
outlines. In the final
image, they are restored
to their original setting
but a medical illustra-
tion of a human heart
has been superimposed
on them, and below it is
an actual tin votive fig-
ure of human eyes, used
by worshippers to ask
for miraculous recovery
of the body part
represented.

spherical sculpture was invented in the
1920s and became popular through the
1950s. It was customary for the sitter to
direct the session, or to suggest flatter-
ing modifications to the photograph that
would be used to make the *foto-escultura*.

The practice of photo-sculpture evolved
from the public's longing to magnify the
vivid sense of personal presence. Not
surprisingly, photo-sculptures became
meaningful additions to funeral cere-
monies (Fig. 7.81).

ARTIST UNKNOWN,
Hombre (Man), c. 1950.
Hand-painted photo-
graph over wood, plas-
ter, woodframe, glass.
Private collection.

Foto-escultura, or photo-
sculpture, usually used
existing formal portraits,
which provided the
basis for a three-dimen-
sional wood form on
which they were eventu-
ally molded. Elaborately
framed, they were often
displayed on home
altars.

FOCUS
Looking at Children

During the 1980s and 1990s in the United States, some family photographs provoked boisterous debate about the right of both amateur and professional photographers to show children in poses that revealed genitalia, or to suggest that children possess adult sexual knowledge.[71] Photo-processing laboratories and drugstore photo-developing machine operators were put on notice to report pictures of nude children on the rolls of film brought to them. Laws prohibiting child sexual abuse and the sale of child pornography occasionally punished innocent snapshooters who pictured their naked children romping in a backyard wading pool. In the worst cases, children were temporarily taken away from parents and put in foster care until the legalities were cleared up, and homes were subjected to search and seizure of prints and personal records.

American art photographer Sally Mann (b. 1951) was surprised to find her work at the center of angry criticism from religious and conservative critics, as well as from those who deplored what they felt to be the vulgarization of the American family. Only twenty percent of the photographs that Mann published in the book *Immediate Family* (1992) showed her children topless or nude, yet for many the volume came to symbolize disturbing changes in American life, including how early it was that children were now becoming acquainted with the demeanor of

7.82
SALLY MANN, *Naptime*, 1989, from her book
Immediate Family, 1992.

adult sexual behavior. In addition, some of Mann's pictures, such as *Naptime* (Fig. 7.82), angered viewers who were repulsed by their own identification of erotic innuendo in the image of a young girl with tousled hair and pouting lips who is awaking from sleep.

Unlike the response to Mann's photographs, the explicit prepubescent frontal nudity pictured during the Pictorial era by photographers such as Alice Boughton (see Fig. 4.26) seems to have gone unremarked. This was perhaps because in the years before the immense use of sexuality in mass-market advertisements, the poses and expressions of children did not so readily suggest sexual awareness or pleasure.

Those who defended Mann's pictures asserted her right to make the images, and maintained that these were truthful portrayals of children's expressions of sexuality. Her advocates were quick to note that male photographers such as Harry Callahan (see Fig. 6.41) were not rebuked for photographing nudity in intimate family pictures. Mann's detractors held that, as an adult, she could comprehend the sexually expressive qualities of the photographs in a way that the children could not. Therefore, they accused her of abdicating her parental responsibility to protect her children from lewd gazes of strangers.

The display of child sexuality became an issue that cut across political divisions, uniting some feminists and some conservative activists in censorship efforts. Within photographic circles, the topic initiated new inquiries into the motivations of nineteenth-century photographers Julia Margaret Cameron and Lewis Carroll (see Fig. 3.106), both of whom showed nude or nearly nude children.[72] Critic Anne Higonnet helped to frame the discussion by contrasting representations of the innocent child, pictured in photographs and paintings as not understanding sexuality, with the knowing child who is sexually precocious. In her study and others, social history and psychological theory directed attention to the photographer, the viewers of such pictures, and the condition of women in the societies that provided a market for such images.

Regardless of circumstance, the fact that a child stood before the lens in a state of undress became the salient point in a number of legal actions. Across the United States, some photographers and arts publications were scorned or punished for presenting images of childhood sexuality. For example, in New York City, the publication *Nueva Luz* (*New Light*), issued by *En Foco* (*In Focus*), an organization dedicated to promoting photography by people of color, was criticized by the *New York Post* for publishing photographs by Ricardo T. Barros (b. 1953) that showed his nude wife and children.[73] The newspaper was outraged that the organization received public money with which they supported *Nueva Luz*.

The most notorious incident involving public hostility to sexual images took place in 1989. The threat of losing public funding drove the Corcoran Gallery of Art in Washington, D.C., to cancel an exhibit of Robert Mapplethorpe's (1946–1989) photographs, some of which were explicitly homoerotic prints, and a few others of which showed glimpses of children's genitalia. The parents of the children in the Mapplethorpe pictures knew the pictures and gave their permission for the prints to be exhibited. One of those pictures, titled *Rosie*, shows a little girl innocently raising her skirt while adjusting her pose (Fig. 7.83). Eventually the same Mapplethorpe exhibition was exhibited in Cincinnati, Ohio, where it gave rise to a much publicized trial, which, though won by the defendants, raised public ire at the use to which tax dollars were being put. Along with the uproar about Andres Serrano's pictures (see Figs. 7.48, 7.49), the publicity surrounding the Mapplethorpe show culminated in reduced national and local spending on the arts.

7.83
ROBERT MAPPLETHORPE, *Rosie*, **1976.**

NATURE AND THE BODY POLITIC

Of the millions of images of nature made by amateur and professional photographers, most operated within the enduring nineteenth-century visual vocabulary of awe and magnificence. Photographs from space followed the tradition of the sublime landscape, accentuating the distance of other galaxies and the breadth of celestial bodies (see Figs. 6.65, 6.67). As a matter of fact, the hold of the nineteenth-century sublime upon wilderness imagery remained so strong that a few contemporary landscape photographers preferred to operate primarily with cumbersome old equipment, like that used by Carleton Watkins and other nineteenth-century photographers of the American West.

In the late twentieth century, images of nature did not receive the critical scrutiny that converged on gender and ethnic identity. Occasionally a voice was raised to protest the intrusion of cameras in precincts where endangered species might be disturbed by the presence of the photographer and equipment.[74] A few critics pointed out that photographs and films of animals were not objective, but modeled on an idealized view of Western family life. Some artists, such as Scottish-born Andy Goldsworthy (b. 1956), created on-site and gallery installations of natural materials, which were either returned to nature or allowed to decay, their only record being a photograph.

The feeling of magic and manipulation of ritual that regularly shaped installation and performance work in the late twentieth century was felt infrequently in photography. Adam Fuss's photograms (see Fig. 7.42) sometimes seem like traces of ceremonial acts, and Robert Parke-Harrison's "Earth Elegies" (1968) portray him dressed in a priest-like black suit, while he tries to mend a simulated rupture in the earth. Similarly sacramental is *Patching the Sky* (1997), in which the formally dressed artist-shaman stands on a makeshift platform attempting to suture a spot in the unmistakably artificial heavens (Fig. 7.84).

**7.84
ROBERT PARKE-HARRISON**, *Patching the Sky*, 1997. **Photogravure with beeswax.**

Performance art was one of the forces that helped shape photography in the late twentieth century. It is a short step from photographing a performance to make a record of it, to performing for the camera. Parke-Harrison's rituals exist for the moment, and for the record.

WEEK 15
<u>Dec. 6</u> – **Beyond the Photographic: Reality and Vision in a Digital Age**
<u>Read</u>: Marien: Epilogue, "On Beauty, Science and Nature," 475-496
<u>Dec. 8</u> – ***QUIZ 3***
Conclusion

<u>Please bring a photograph to class that means something to you in relation to something you learned in class this semester</u>. This may be a personal photo or a reproduction of one that you have encountered in your research or in the textbook.

History of Photography Fall 2005
Prof. Otto (eotto@buffalo.edu)

<u>Updated Schedule and Readings</u>

Please note that all readings listed here are <u>required</u>, since you will understand more aspects of
the history of photography if you encounter different arguments and points of view. I'll be
asking you to do some writing (to turn in to me) about the essays from the online coursepack, so
be sure to bring your copies of articles, having read them carefully.

If you have trouble getting readings from the online coursepack, contact the library or one of the
help desks.

WEEK 12
<u>Nov. 17</u>
READ Marien: Chapter 6, "Through the Lens of Culture," read 343-363.

WEEK 13
<u>Nov. 22</u> – *SECOND PAPER DUE at the START of class*
Photographing Personality
READ Online Coursepack: Catherine Lord, "What Becomes a Legend Most: The Short,
Sad Career of Diane Arbus," *The Contest of Meaning*, 111-123.

<u>Nov. 24</u> – **THANKSGIVING / FALL RECESS**

WEEK 14
<u>Nov. 29</u> – **Photography and the Vietnam War**
READ Marien: Chapter 7, "Convergences," 363-423.
Online Coursepack: Susan Sontag, "America, Seen through Photographs, Darkly," *The
Photography Reader*, 506-20.

<u>Dec. 1</u> – **Postmodernist Photography / Feminism and Postmodernism**
READ Marien: Chapter 7, "Convergences," 423-473
Online Coursepack: Cindy Sherman, "the Making of Untitled," *The Complete Untitled Film
Stills*

 (over)

Nature was mostly a distant presence with which humans could not convincingly connect, but for whose fate they were implicitly responsible. In photography, this feeling of alienation had been foreshadowed by New Topographics photographers, such as Robert Adams (see pp. 355–57), who declared that "Scenic grandeur is today sometimes painful."[75] Where nineteenth-century artists sought spiritual sustenance through sublime and beautiful displays in the natural world, contemporary artists tended to express the loss of transcendence.

American Joel Sternfeld (b. 1944) mastered the distanced landscape photograph, as in his view of dead and dying whales (Fig. 7.85). Beginning in the 1970s, American John Pfahl (b. 1939) cleverly undermined landscape views with additions that prevented viewers from easily comprehending the spatial relationships before their eyes (Fig.

7.86). Where Pfahl constructs physical impediments to seeing in a landscape view, some photographers exploit obstructions that were already there, especially the automobile. To contrast with postcard and travel-magazine idealization of an uninhabited wilderness, they focused on the inevitable cluster of tourists' automobiles parked near the scenic outlook. Putting the human subject before nature, not being able to discern what is happening in nature, or being at a fixed, dream-like remove from the landscape characterized the human separation from the natural world.

As Andres Serrano's work showed (see Figs. 7.48 and 7.49), beauty and repugnance can be effectively mingled in the same work. A similar effect sometimes occurs in photographs of nature as a wounded victim. Pictures of strip mines, clear-cut forests, and oil spills flaunted intense coloration and spectral glamor. In Richard Misrach's (b. 1949)

7.85
JOEL STERNFELD,
Approximately 17 of 41 whales which beached (and subsequently died), Florence, Oregon, 18 June, 1979. Dye transfer print. Hallmark Photography Collection. Hallmark Cards Inc., Kansas City, Missouri.

Sternfeld uses physical distance to symbolize emotional detachment. The tragic death of the whales takes place in a space remote from the viewer, as if it were impossible to care about their plight.

pictures of *Bravo 20*, a bombing range in northwestern Nevada, the crater and rusting convoy teeter on the edge of abstraction and apocalypse (Fig. 7.87).

In art, documentary, and advocacy photography, the human body emerged as nature's chief representative. Within postmodern theories of representation, the body was repeatedly theorized as the point at which society's values shape human personality. Cindy Sherman's multiple self-portraits, in which she is always and never herself (see Fig. 7.35), and Annette Messager's fragmented body parts (see Fig. 7.46) epitomized the postmodern attitude that personality is ever-changing. Similarly, the disjunction between words and pictures in Lorna Simpson's pictures of the human body (see Fig. 7.28) showed the force of societal labeling. History, the body, appropriation, and issues of ethnic identity met in Carrie Mae Weems's (b. 1950) reuse of nineteenth-century daguerreotypes

made by J. T. Zealy to support Louis Agassiz's racial theories (see pp. 40–41). By rephotographing, reshaping, and framing the images, as well as adding a somber blue tone to the circular outer pictures, Weems transformed scientific photographs that made a spectacle of the body into an affecting memorial (Fig. 7.88).

Other sorts of personal identity also focused on the body. Sunil Gupta (b. 1953), an Indian-born Canadian citizen who lives in London, produced the photographic series *Exiles* (1987), depicting gatherings of gay Indian men (Fig. 7.89). While Gupta appreciates experimental techniques such as photomontage and digital representation, he nonetheless chose a straightforward view of the plight of those who are seldom represented except in pornographic pictures. In his choice of visual presentation, Gupta, who is gay and HIV positive, is typical of people seeking greater

7.86
JOHN PFAHL,
Australian Pines, 1977.

Pfahl introduces elements into his landscapes that make viewers wonder whether the scene was fabricated.

**7.87
RICHARD MISRACH,
*Bomb Crater and
Destroyed Convoy*, 1986.
Chromogenic color
print.**

In a lengthy plan
accompanying his
photographs, Misrach
proposed that the exper-
imental and practice
bombing site in Nevada
called *Bravo 20* by the
military be transformed
into a United States
national park to memo-
rialize an environmental
disaster.

social visibility. As video-maker and
writer Marusia Bociurkiw aptly pointed
out, "the absence of photographic repre-
sentations amid a larger culture so
heavily saturated by media images can
make the act of production seem
transgressive."[76]

American photographer Linn
Underhill (b. 1936) undermined the
conventions for women's portraits by
deliberately avoiding the association
of the female body with nature. She
refused to fragment the body or to
deflect the sitter's gaze from the camera,
and, hence, the viewer. Printed life-size,
and hung inches from the gallery floor,
Underhill's images unsettled viewers
who were accustomed to the hint of sub-
mission and seduction that character-
ized formal studio portraits of women
(Fig. 7.90). Underhill's women present
themselves as uncomplicated everyday
people, but Catherine Opie's (b. 1961)
sitters in the 1991 series *Being and*

Having manifested obviously fake acces-
sories, as if gender clues were some-
thing they put on or took off at will (Fig.
7.91). *Chicken* sports a false mustache
and even a phony tear. In a later series
showing lesbian couples, Opie, like
Underhill, reverted to a less experimen-
tal format and conventional studio tech-
niques, validating the sitters' frankness
with photography's styleless style.

During the period, homoerotic desire
was depicted by artists in direct images
of sexual arousal, and in pictures that
critique received ideas about gays and
lesbians. Following the lead of advocates
and artists, scholars took renewed inter-
est in the history of homosexuality and
its images. The then largely unknown
work of French Surrealist photographer
Claude Cahun (see Fig. 5.27) was stud-
ied and widely exhibited. Indeed,
Cahun's self-portraits were recast as a
forebear to Cindy Sherman's investiga-
tion of feminine roles.

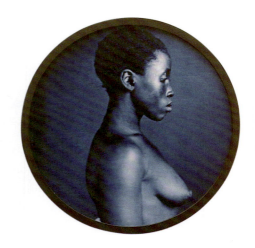

**7.88
CARRIE MAE WEEMS,**
Diana Portraits, from
the *Sea Island* series,
1992. Ektacolor prints,
three panels.

Because pictures of homosexuals in the mainstream media emphasized stereotypical looks and behaviors, the body became the locus of politically oppositional gay photography. Still, in Garth Amundson's (b. 1963) pictures, the body is implicitly rendered. For his 1995 piece *Dr. Kempf's Nightmare,* Amundson recast medical photographs gathered by psychiatrist Edward J. Kempf at the turn of the nineteenth century as part of his attempt to prove homosexuality an illness (Fig. 7.92).

The AIDS crisis of the mid-1980s sparked a variety of artistic responses, the best-known of which is probably the Names Project Quilt, with panels sometimes adorned with photographs com-

**7.89
SUNIL GUPTA,** *Lodhi
Gardens,* from the *Exiles*
series, 1988. C-type
print. Arts Council of
Great Britain Collection.

Gupta managed to construct a visually interesting image, all the while carefully manipulating the view to protect the identity of homosexuals, who hurry to turn their faces away so as to avoid identification in a country, India, where homosexuality is illegal.

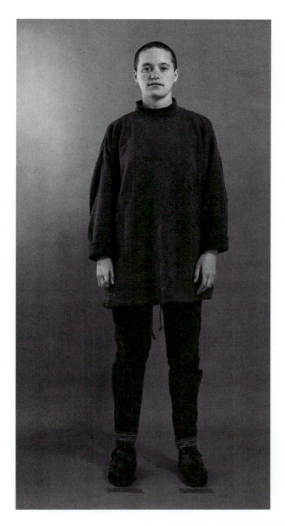

memorating individuals who died of the disease. Pictures of emaciated people suffering with AIDS, taken by photographers such as Nicholas Nixon (b. 1947), or those used in advertisements sponsored by the international clothing company Benetton, were subject to debates about their counter-productive voyeurism. Activist groups, such as ACT UP, argued for "the visibility of PWAs [People With AIDS] who are vibrant, angry, loving, sexy, beautiful, acting up and fighting back."[77] In response, media-savvy photographers created photographs of healthy-looking AIDS patients, and showed the pictures not only in galleries, but in poster-form in the streets. Photography was also the backbone of the safe-sex campaigns around the world, most notably in the internationally traveling exhibition called *Visual Aids*.

As happened in South Africa under apartheid, people whom society had marginalized were concerned not only to critique disparaging imagery, but also to originate depictions that had been absent or censored. For instance, when Burmese-American Chan Chao (b. 1966) photographed students and ethnic members of the Burmese resistance,

7.90 (above)
LINN UNDERHILL,
Untitled, from *Returning the Gaze,* 1995.

7.91
CATHERINE OPIE,
Chicken, 1991, from her series *Being and Having,* 1991. Chromogenic print. Patrick Breen Collection.

Opie's images often fuse stereotypes of outward physical appearances, in an attempt to make the viewer struggle to interpret ethnic and gender identity. In this image, the obviously false facial hair and artificial tear do not effectively change the appearance of the person wearing them, a lesson, perhaps, in the futility of gender pretense.

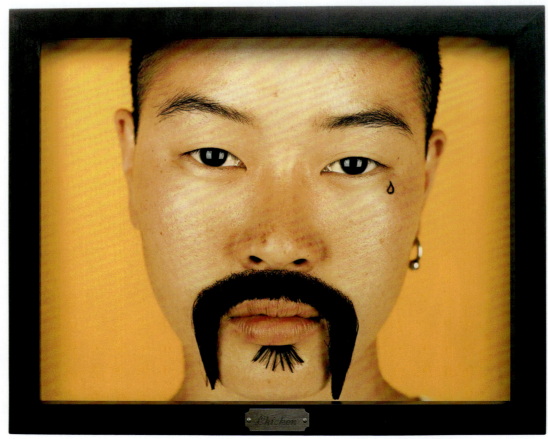

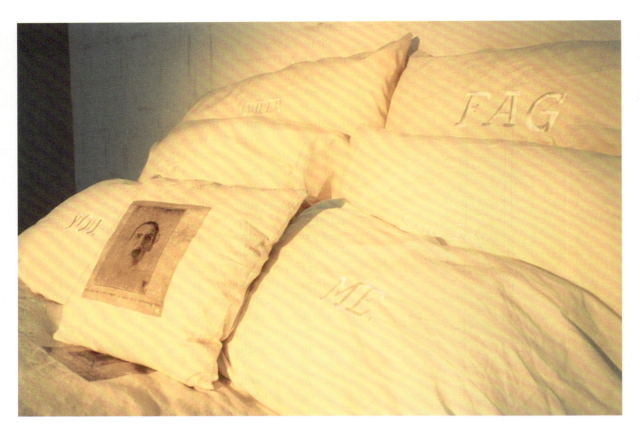

7.92
GARTH AMUNDSON, Detail from the installation *Dr. Kempf's Nightmare,* 1995. Muslin, embroidery, and transfer, queen-sized bed.

Amundson hand-stitched the pictures to muslin sheets that were also embroidered with derogatory labels for homosexuals. Putting the pictures and words on a bed, Amundson not only made reference to erotic desire, but used the display as a ceremonial wedding or acceptance of his homosexuality.

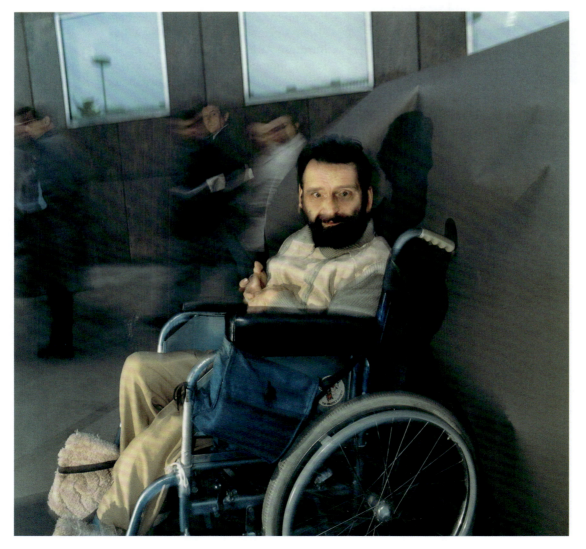

7.93
DAVID HEVEY, *Untitled,* from *Beyond the Barriers: Disability, Sexuality, and Personal Relationships,* 1992.

In Hevey's photographs, people with disabilities refuse to pose as victims of their conditions. Instead of presenting themselves as helpless and needy people, he shows them as active participants in the public realm. With such images, the disabilities movement attempted to reform advocacy photography, moving it away from the sentimental and the lurid.

he created large, direct portrait studies, concentrating less on the sitters' military exploits, which were played up in the press, than on their routine daily lives in the encampments along the border between Thailand and Burma (Fig. 7.0). A comparable approach has been taken world-wide by people with disabilities, who attempt to redress photographs that show them as victims. British photographer, writer, and activist David Hevey (b. 1959) has tried to devise what he calls a "post-tragedy form of disability representation" (Fig. 7.93). Hevey faults postmodern theory for not taking into full account the "distribution, audience and production" of images.[78] Like Jo Spence (see pp. 445–47; Fig. 7.61), whom he greatly admired, Hevey distrusts academic nit-picking and bickering, which he believes obliterates the larger issues of class with psychoanalytic analysis.

PHILOSOPHY AND PRACTICE: THE PASSING OF THE POSTMODERN

In a 1993 interview, photographer Barbara Pollack spoke for many when she announced her frustration with postmodernism:

It's the nineties. I don't have to discuss Lacan anymore. The phrase "postmodernism" presumed that everyone had already shared in the modernist expedition. But I consider myself a prime example of people who are saying, "Hey, before you say that modernism is over, let me share in that adventure." There are myths inherent in modernism that may romanticize the role of the artist or may be sexist but have certainly influenced my life. I am ambivalent about giving up those myths.[79]

The major ideas of postmodern photography were played out by the mid-1980s. Looking back in 1987, Abigail Solomon-Godeau was convinced that critical practice itself was in critical condition. Within a decade of Douglas Crimp's 1977 article "Pictures," which allied then little-known photographers such as Cindy Sherman with oppositional writing on the nature of language, power, and representation, postmodern photography had been incorporated into what Solomon-Godeau called the "emporium

of photography." Major postmodern shows in galleries dedicated to presenting art photography signaled what she aptly called "deconstruction in reverse." Instead of analyzing the art market, with its emphasis on originality and genius, postmodern photography itself began to be marketed as original and inspired, thereby vitiating its critical stance.

An indicator of this turnabout can be found in the work of twin brothers Mike and Doug Starn (b. 1961), who rocketed to popularity in the 1980s, with their take on appropriation. Enlarging and printing discontinuous sections of a photograph of a famous Western artwork, the twins then assembled another image, using tape or glue, all the while carefully showing the segmented, partial, and modified character of the reassembled image. Sometimes the segments were scratched, rumpled, overpainted, or chemically toned to imply a long passage through time. The uneven surface of the piece came to resemble low-relief sculpture (Fig. 7.94). The Starns' work amalgamated appropriation and staging, two of the basic strategies of the late twentieth century. Yet it was greeted as a renewal of photography's traditional emphasis on craft, the antithesis of postmodernism's concern with mass media.

In his monograph on them, critic Andy Grundberg suggested that the Starns might be attempting "to return to an 'innocent,' pre-commodified era of art-making."[80] Comparing them to artists of the Romantic era, such as Caspar David Friedrich (1774–1840) and William Blake (1757–1827), Grundberg argued that the Starns stood in opposition to political and social art criticism by reaching for the spiritual and transcendent.[81] Their fragmented and aged images did not critically analyze the art object, so much as memorialize the sorrowful passing of masterworks. Grundberg concluded that "to a large extent, the Starns' art is about the conditions and possibilities of picture making, and as such it constitutes a telling critique of the most pessimistic tenets of Post-modernism."[82]

How did the passing of the postmodern happen? Douglas Crimp, one of the first to announce the arrival of postmodern photography, was also the critic who noticed its slide into an accepted and

**7.94
MIKE AND DOUG
STARN,** *Mater
Dolorosa,* 1997.
Toned silver print,
tape, wood.

The Starns' selection
of the *Mater Dolorosa*
(*Sorrowing Madonna*)
by fifteenth-century
Netherlandish
painter Dieric Bouts
(d. 1475) expresses
their longing for the
influence art once
had in society. They
emphasize and
enlarge the tears of
Bouts's Madonna.
Presented against a
plain gold back-
ground, the image
deliberately recalls
religious icons, and
an age of faith.

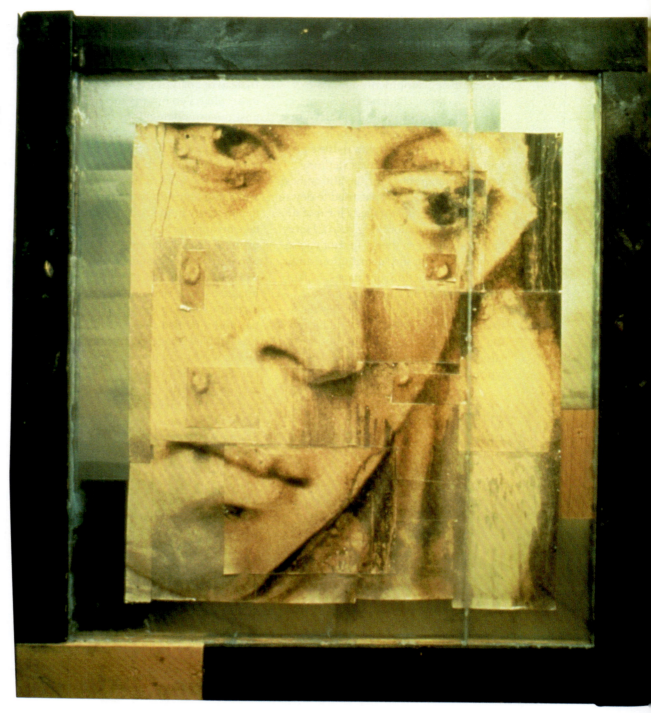

marketable commodity. In the wittily titled article "Appropriating appropriation," written for the 1982 catalog accompanying the show called *Image Scavengers*, he observed that postmodern photography was being diluted by the artists who first fashioned it, such as Richard Prince and Cindy Sherman, while simultaneously being subsumed into the art institutions as just another category of art. In that vein, Solomon-Godeau asserted that the conventions of art history and museum practice easily historicized postmodern photography as the photography after Modernism, just as Post-Impressionist painting followed Impressionism. Thus categorized, postmodern photography became what it so desperately attempted not to be, another art-historical style/period. In addition, the roaring art market of the 1980s latched on to postmodern photography, by then predigested in popular arts magazines and newspapers, and found it a profitable investment.[83]

The last gasp of postmodernism was signaled in the 1998 slick compendium of images called *Fashion: Photography of the Nineties*, in which the photographs critical of gender stereotypes and mass-

7.95
CORINNE DAY, *George
on the Bed*, 1995, from
Ray Gun magazine,
1995. Kodak print.
Courtesy the artist.

A lone, slim, sexually
ambiguous figure is
lying on a bed. By fusing
real-life situations with
fashion, Day subverted
the look of commercial
imagery, as in the fash-
ion magazine *Ray Gun*.
Like Larry Clark and Nan
Goldin, Day published a
candid photographic
diary of her personal life.

media advertising, by image-makers
such as Cindy Sherman, Catherine
Opie, and Richard Prince, were inter-
spersed among commercial fashion
photographs that had deliberately pro-
cured the look of social critique and gen-
der analysis.[84] *Fashion*, compiled by
Camilla Nickerson, an editor at Ameri-
can *Vogue* magazine, and art critic
Neville Wakefield, chronicled the extent
to which art photography and fashion
photography had merged. *Fashion*
demonstrated how once transgressive
subject-matter, such as Larry Clark's
Tulsa Portfolio (see Fig. 6.52) and Nan
Goldin's *The Ballad of Sexual Dependency*
(see Fig. 7.69), was in the 1990s being
photographed and fused with fashion by
British fashion photographer Corinne
Day (b. 1965) (Fig. 7.95).

Not shown in *Fashion* were various
attempts to blend political activism with
fashion, art, and advertising photogra-
phy. For example, when Wolfgang
Tillmans guest-edited *Big Issue*, a maga-
zine sold on the streets of London by the
homeless, he made the weekly periodi-
cal desirable by exhibiting in its pages a
mix of photographs from different gen-
res similar to those appearing in upscale
galleries (Fig. 7.96).

Also missing from *Fashion* was the
most notorious merger of art and poli-

tics sponsored by the Benetton Group,
an international clothing retailer. In
the mid-1980s, Benetton began to mar-
ket multiculturalism by attiring models
from different ethnic groups in its
clothing. By the 1990s, the "United
Colors of Benetton" ads turned away
from displaying the company's prod-
ucts and toward showing people in
distress, such as Haitian refugees, pris-
oners on death row, or persons dying
of AIDS (Fig. 7.97). The fact that these
images were widely criticized for instill-
ing class, ethnic, and gender stereo-
types did not deter the company from
expanding its mixture of marketing
and human concern. Under the leader-
ship of designer Tibor Kalman (1949–
1999), Benetton created the magazine
Colors. In the most famous issue, public
figures were made to look like people
of color, while people of color turned
white. The ad campaign and magazine
sparked consumer protest, and pro-
voked Benetton dealers in Europe and
the United States to sue the company
on the grounds that the advertisements
had a negative effect on sales. Benetton
advertisements prompted the interna-
tional use of new composite words,
such as advertorial (advertising + edito-
rial) and infotainment (information +
entertainment).

Martha Osamor. "She has devoted her life to campaigning for human rights across the world, nurturing small-scale pressure groups. She is totally committed to other people"

**7.96 (above)
WOLFGANG TILL-
MANS,** *Victoria Line*
and *Martha Osamor,*
from *The Big Issue,* spe-
cial edition "The View
from Here," August
28–September 3, 2000,
no. 401.

**7.97 (right)
DAVID KIRBY,** *Untitled*
(AIDS patient), 1992.

The Benetton company
linked themes of social
awareness to the drive
to create consumer loy-
alty by incorporating
photographs of people
afflicted by poverty and
disease.

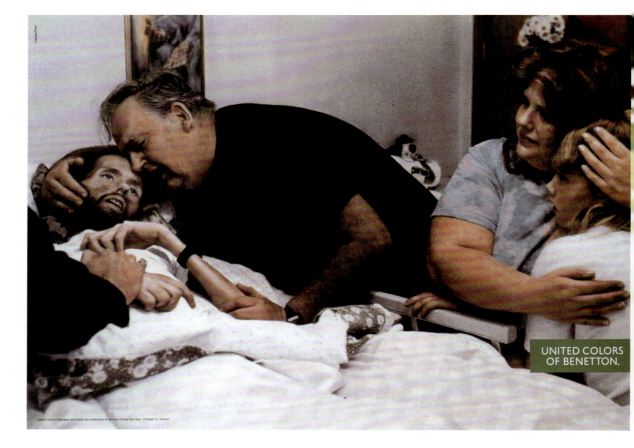

UNITED COLORS
OF BENETTON.

At first glance, the pouty blond looks like the standard cover-girl using sexuality to sell magazines. On closer inspection, one sees the heavy make-up that is unable to disguise her scarred cheek and large pores, flaws which would have been eradicated in conventional advertising images.

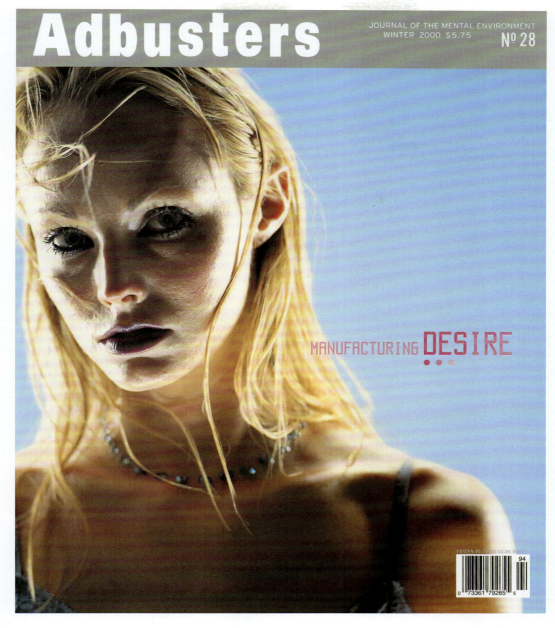

After the furor, it seemed unlikely that another manufacturer would attempt to join advertising and political action. However, the Adbusters Media Foundation, a countercultural enterprise based in Vancouver, Canada, launched the glossy magazine titled *Adbusters* (Summer 1989, vol.1, no.1), aimed at unraveling marketing strategies and critical of consumerism. Using the high-tech tools of advertising photography, *Adbusters* deconstructed visual clichés, such as the appearance of the cover-girl (Fig. 7.98).

Writing on what he called "the hidden potential of the post-postmodern crisis" of uncertainty, Adam Lammiman summed up what he believed to be the popular effect of the movement on the young: "Everything is relative and nothing is sacred … Many of us are either desperately clinging to a sinking ship of fixed ideals or floundering in a sea of ideas." But the "upside," as Lammiman called it, is that "it is no longer possible to ignore the existence of viewpoints different from your own. Seeing so many points of view, each with its weaknesses, makes it difficult to believe that your own ideas are flawless."[85] While less rigorously philosophical and more idealistic than postmodern photographers and theorists might like, this attitude might prove to be the lasting legacy of the postmodernist era.

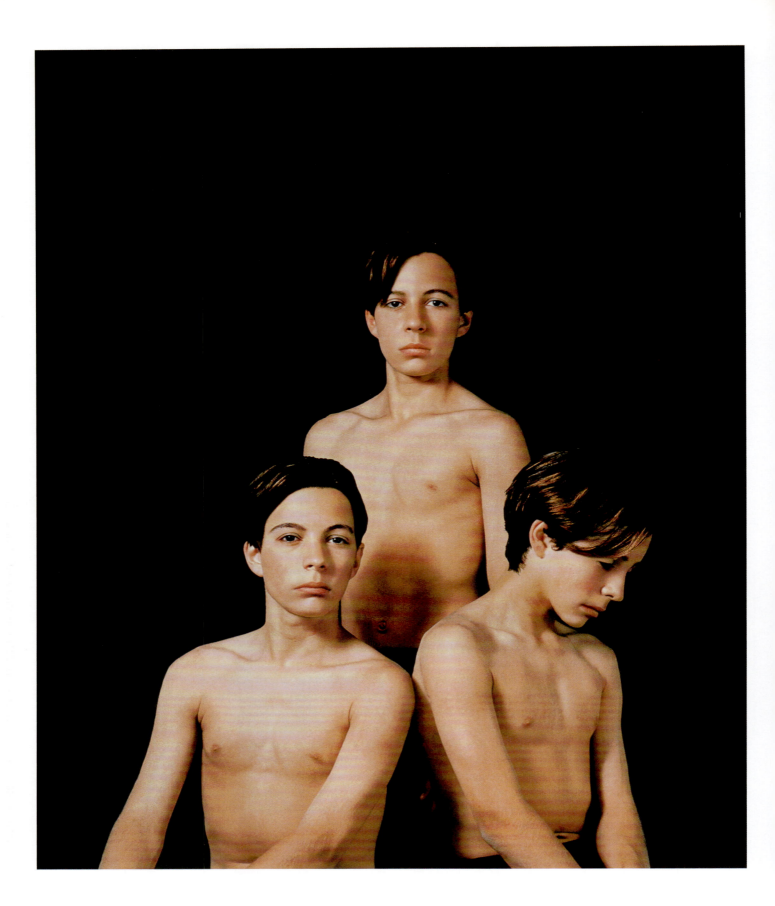

EPILOGUE

On Beauty, Science, and Nature

**8.0
KEITH COTTINGHAM,
Untitled (Triple), 1993.
Digitally constructed
color photograph.**

Digital triplets pose like
the Three Graces of
Greek mythology. The
too-perfect shadow on
the standing figure's
abdomen, the breadth
of his collarbone, which
seems to sweep over
his shoulders like the
ribbons on a cape, and
the highlights in his hair
that resemble brush-
strokes, remind the
viewer that these figures
are fabricated.

At the start of the twenty-first century,
the most discussed topic in photography
was the future of computer-manipulated
images, and the least considered subject
was the outlook for beauty. Throughout
the last quarter of the twentieth century,
beauty was held accountable for photog-
raphy's lapses and misdeeds, especi-
ally in the area of social concern. In his
enduringly influential essay, "On the
invention of photographic meaning"
(1975), photographer-critic Allan Sekula
savaged art for art's sake, writing that
"the ills of photography are the ills of
aestheticism," and that "aestheticism
must be superseded, in its entirety, for a
meaningful art, of any sort, to emerge."[1]
Critic Hal Foster concurred in his popu-
lar anthology *The Anti-Aesthetic* (1983),
whose title was drawn from a phrase
fashioned in Walter Benjamin's authori-
tative essay "The Work of Art in the
Age of Mechanical Reproduction"[2] (see
pp. 269–70, 305–6). Foster questioned
whether the aesthetic was now a thread-
bare illusion.[3] Time and again, beauty
was sent packing to the cobwebbed attic
of outmoded ideas.

Expunged from much of contempo-
rary art practice and academic concern,
beauty acquired the allure of the forbid-
den, especially for undergraduates,
whose academic study of the arts and
humanities had evolved into a long
interrogation of received ideas and dis-
guised social contexts. The seductive-
ness of banished beauty propelled
American critic Dave Hickey's *The
Invisible Dragon: Four Essays on Beauty*
(1993) into an underground book on
campus, even though Hickey shied away
from a direct discussion of beauty to
focus on the psychological experience of
visual pleasure and repulsion. For this
advocacy, Hickey received a prestigious
MacArthur Foundation "genius" award
in 2001. The notion of beauty as trans-
gressive also launched the careers of
French collaborators Pierre et Gilles,
who have been making sensuous, often
homoerotic photographs since the mid-
1970s (Fig. 8.1).

In addition, a few American and
European galleries cautiously made
beauty the subject of exhibitions. At
the Hirshhorn Museum, part of the
Smithsonian Institution in Washington,
D.C., curators Neal Benezra and Olga
M. Viso put together a 1991 exhibition
called *Regarding Beauty: A View of the
Late Twentieth Century*. Realizing that
they could not escape the shadow of

postmodern questioning, they acknowledged that, "approaching beauty … at this point in human history may seem a frivolous, even futile, endeavor."[4] Their show inevitably included such artists as Cindy Sherman (see Figs. 7.35, 7.36), whose work was at the forefront of post-modern interrogations of stereotypical feminine beauty. Also displayed was the work of German artist Rosemarie Trockel (b. 1952), whose photomechanically reproduced posters collectively called *Beauty* cleverly undermined the sunny global humanism of the "United

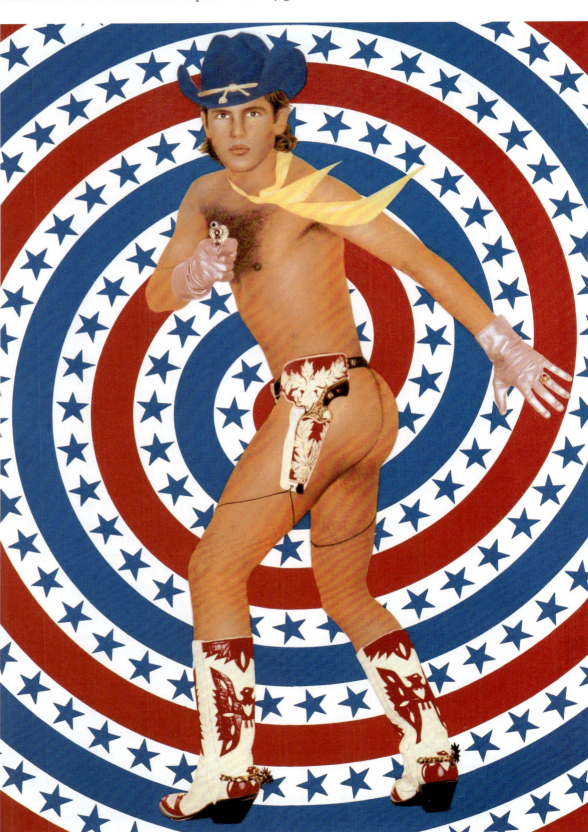

**8.1
PIERRE ET GILLES,**
Le Cowboy—Victor,
**1978. Painted
photograph.**

Adamantly anti-digital, Pierre et Gilles insist on the craft of hand-painting their photographs, which they assert show the beauty inherent in popular culture items such as pulp comics. Their work appears on posters and postcards, as well as in gallery prints.

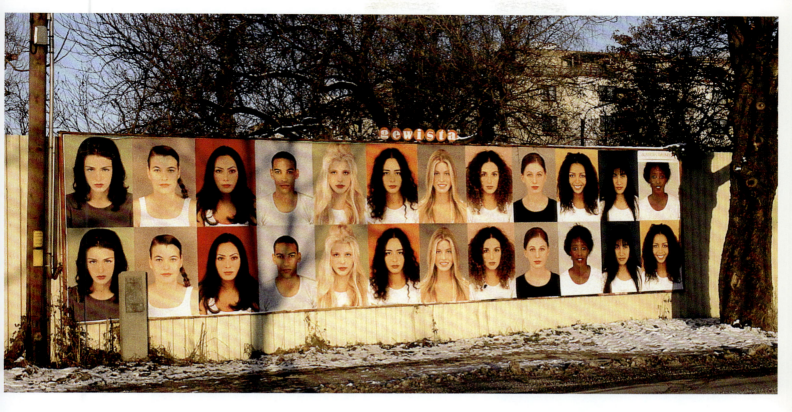

8.2
**ROSEMARIE
TROCKEL**, *Beauty*,
**1995–96. Posters,
photomechanically
reproduced.**

Colors of Benetton" advertisements (see Fig. 7.97), as well as the axiomatic contemporary concern with "race, gender, and ethnicity" (Fig. 8.2). Trockel trained as a painter, but now works in new media, such as video and installations. She bluntly rejects the postmodern notion that words and pictures are deceiving, and attempts to draw the viewer into the experience of seeing as a route to new knowledge.

Conjecturing what beauty might mean in the year 2096, critic Peter Schjeldahl suggested that it would become a quality of experience, not of things, and not, as Trockel suggests in her posters, a fixed and predetermined aspect of human appearance.[5] Mindful of the lessons from the recent past, a few critics, artists, and photographers modestly began to propose what might constitute a post-postmodern beauty. For Dutch photographer Rineke Dijkstra (b. 1959), beauty is as tentative as the hesitant step being taken by the adolescent boy she photographed in Berlin's Tiergarten (Fig. 8.3). Measured against the stark, blank faces of Thomas Ruff's photographs (see Fig. 7.25), Dijkstra's portraits are lush, informative, and loving.

German-born photographer Uta Barth (b. 1958) is mindful that, as Schjeldahl wrote, the aesthetic "has

been quarantined from educated talk."[6] Compare, for example, Barth's hesitant depiction of light and color (Fig. 8.4) with the more aggressively hued shot taken by William Eggleston (see Fig. 6.94). Both prefer fragmentary

**8.3 (right)
RINEKE DIJKSTRA**,
Tiergarten, Berlin,
**August 13, 2000.
C-print.**

Dijkstra tentatively reintroduced the human form as a source of visual pleasure by choosing to photograph the awkward grace of teenagers in a Berlin park. Her large color portraits of young people teetering between the free rein of childhood and adulthood's equipoise dwell on the casual, utterly unclassical and temporary beauty of transient states of being.

The rooms Barth photographs are usually almost empty, so as to emphasize their existence as containers for light. She focuses here on the unoccupied foreground space so as to blur the depth of field out of which dimly emerge two reproductions of paintings by Johannes Vermeer, *The Milkmaid* (Rijksmuseum, Amsterdam) on the left and *The Lacemaker* (Louvre, Paris) on the right. Barth's technique recalls Julia Margaret Cameron, for whom the avoidance of focus could suit the mood of her subject matter (see Fig. 3.103).

images from the panoply of visual experience and both dissolve narrative in a mesmerizing show of light and color. But Barth's blurry pictures are like memories of Eggleston's boisterous revelries. Where his work is assured and on an even keel, hers is restless and often off-kilter, like an unfocused eye fidgeting from place to place. Barth's pictures deliberately fix on an imaginary plane in front of a wall, thus throwing what might be the subject of the image out of focus. Her photographs express the impossibility of clarity and certain definition, as well as the desire, however repressed, to seek pleasure in looking. Her technique recalls the attitude of Victorian photographer Julia Margaret Cameron (see pp. 158–59), for whom photographic focus had to fit the mood

of the subject-matter, not necessarily mimic the clarity of normal optical vision.

The black-and-white series by New York-based Japanese photographer Hiroshi Sugimoto (b. 1948) shares with Barth a regard for the fragile beauty of uncertainty, expressed in grainy atmospheric effects. Sugimoto often works in series, beginning with his eerie photographs of wildlife dioramas at the American Museum of Natural History in New York, and including his lush black-and-white images of early twentieth-century movie theaters across the United States. For more than two decades, he has traveled the world seeking high vantage points from which to aim his camera at the point where the sky and ocean come together at the hori-

zon (Fig. 8.5). The boundless vistas he portrays are reminiscent of Pictorialism's thronging gray tones (see pp. 173–77). Sugimoto's work manifests the dichotomy between the rapture of visual pleasure and the cold comfort of human systems of measurement.

The relationship of photography, a technologically based medium, to advancements in science has long been a matter of concern. More than a century ago, Peter Henry Emerson asserted that photography had to reject the canons of established art and follow the cutting-edge of science for up-to-the-minute instructions on how a photograph should look. Today, the human relationship to nature and to science is examined from a point of view far from Emerson's understanding. Some contemporary observers, such as Jungian psychologist James Hillman, see science not as an ever-unfolding source of aesthetic options, but as an immense force that demystifies nature and thereby

stifles human perception of beauty in nature.[7]

As we learn more about the depletion of the rain forests, global warming, and the extinction of species, and take an expanded custodial attitude toward the planet, the wonder born of innocence and detachment from nature is likely to change. Where people are unable to experience feelings of awe in their regular surroundings, they tend to seek amplified experiences (Fig. 8.6). In the United States, national parks such as Yosemite that offer extremes of natural magnitude in sheer cliff walls and waterfalls have become overcrowded. Another response is conveyed in Derek Johnston's image of Havisu Falls, near the Grand Canyon in Arizona. In the image, wild nature is bottled and displayed as a specimen contained in a plain gallon jug (Fig. 8.7).

Where nineteenth-century inquiry focused on the visible manifestations of nature, such as geologic transformation

8.5
HIROSHI SUGIMOTO,
Aegean Sea, Pilion 1,
1990.

With all references to land eliminated, Sugimoto's delicate evocations of gray water, light, and mist seem as though they might have been taken anywhere near the sea. Nevertheless, he is punctilious in specifying the place he photographed and keeping records. Nineteenth-century photographers of the American West similarly anchored their delight in nature with specific geographic labels.

8.6
NASA, *View of Venus*,
May 26, 1993.

This image was produced by the Magellan science team at the Jet Propulsion Laboratory in Pasadena. Simulated color was used to enhance small-scale details. The bright area near the center is Ovda Regio, a mountainous area of Venus. The dark areas reveal the results of meteorite collisions.

and biological evolution, in the twentieth and twenty-first centuries attention turned to the invisible, yet crucial building-blocks of nature, from sub-atomic particles to the human genome. For South-African-born New York City resident Gary Schneider (b. 1954), science and technology have permanently altered the portrait, shifting it away from external appearances—a traditional source of beauty—to the irreducible kernel of identity lodged in the human chromosome.[8] As historian and curator Ann Thomas observed, Schneider's series of photographs, *Genetic Self-portrait,* is simultaneously a depiction of his uniqueness and a portrait of our

time, which tries to square cultural conditioning with the strength and scope of biological determinism, implied by the fact that, across the human spectrum, individual differences reside in only 1 percent of our genetic make-up.[9] Despite its title, Schneider's series extends beyond nuggets of genetic information to personal interpretation. Simply prepared photograms of Schneider's hands and ears (Fig. 8.8) accompany chromosome sequences (Fig. 8.9). The medium he uses—the platinum print—was a favorite of the Pictorialists.

High resolution, sometimes computer-aided microscopic imaging allows

the eye to look through the body at its smallest particles. The increasingly common experience of viewing DNA, in both the scientific community and the public realm, marks another crucial stage in the historical process of seeing inside the body, which began with the X-ray (see pp. 216–19), and now includes such techniques as magnetic-resonance imaging (MRI), positron emission tomography (PET), and ultra-sound scanning. Each of these techniques employs non-photographic means that are translated into computer-enhanced images, which are informally called pictures or photographs. Tomography, an advanced X-ray process, produces thin cross-sections of the body, not just from one point of view, like a photograph, but from 360 degrees. The ongoing *Visible Human Project* combines photography with the latest imaging devices to draw together an exhaustive archive of cross-sections of the human body to be used for medical research (Fig. 8.10).

The dual response of fascination and revulsion that such investigations into the natural world can inspire has been taken up by American Catherine Chalmers (b. 1957). She poses home-raised insects in front of shiny white backgrounds, as if they were fashion accessories (Fig. 8.11). In her series of images called *Food Chain*, she adapted fashion photography to the diminutive realm of rapacious insects, who reduce each other to scattered limbs.

**8.7
DEREK JOHNSTON,**
Landscape Specimen 004 (Havisu Falls),
1996. Hand-coated platinum/palladium print. Museum of Contemporary Photography, Chicago, Illinois.

Johnston pictures Havisu Falls, on the sacred land of the Havisu (Native American people living in Arizona), confined within a manufactured container. The image alludes both to the late twentieth century's notion of nature as an invalid in need of human care, and to the artificial boundaries of the Indian reservation where the waterfall is located.

8.8
GARY SCHNEIDER,
Ear, from *Genetic Self-portrait,* 1997.
Photogram. Courtesy the artist.

By pressing his ear against photograph-ically sensitive paper, Schneider eliminated the camera and pro-duced a direct print.

8.9 (left and right)
GARY SCHNEIDER,
Pair of Tumor Suppres-sor Genes on Chromo-some 11, 1997.
Platinum print.

Schneider used sophisti-cated scientific imaging processes to obtain pictures of his chromo-somes, which he then reclaimed as art by printing them in the platinum process.

8.10
STANFORD UNIVERSITY, *The Stanford Visible Male,* from *The Visible Human Project*™,
National Library of Medicine, 1990s. Stanford University, California.

The Visible Human Project began as a project to aid anatomy study and hone surgical skills. It has evolved
into an enormous, ongoing program to create exact multidimensional pictures of the human body.

8.11
**CATHERINE
CHALMERS,** *Bug* from
Food Chain, **1994–96.**
**Massachusetts Museum
of Contemporary Art,
North Adams,
Massachusetts.**

Greatly magnified and
presented in large, care-
fully lit color prints,
Chalmers's images of
the cycle of insect life
have all the fascination
of food photography
in a trendy magazine.
Because she has trans-
lated scientific photog-
raphy into glamor
photography, which
prizes looking for its
own sake, she has
been accused of
aestheticizing death.

484

By contrast, Suzanne Bloom (b. 1943) and Ed Hill (b. 1935), both pioneers in DIGITAL IMAGING who work under the name MANUAL, see an encouraging watershed moment in humankind's relationship to nature augured in digital information and imagery. Using image-manipulation software, they made combination-pictures of forests and abstract shapes (Fig. 8.12). Their installation of these photographs, *The Constructed Forest*, was subtitled " *('This is the End— Let's Go On'—El Lissitzky)*." It seized the Russian artist's idea that a new society must renounce the old Romantic art of self-expression and embrace industry and machine art, including photography, as the new wave of the future (see pp. 243–45).

For MANUAL, photography is now an impotent Romantic art, and the computer a means through which social progress might be made. Nature and culture—the forest and a new, digital art—come together in MANUAL's work, pointing away from the old promise of industrialization toward the positive potential of cyberspace.

No other technological innovation in the history of photography, a medium regularly jolted by inventions and their commercialization, brought on such

drastic conjectures about the future as did electronic or digital imaging. Computer-assisted picture-making made a largely unremarked-upon appearance in a 1966 work by American John Mott-Smith (b. 1930), shown in John Szarkowski's 1978 book *Mirrors and Windows*. Extensive discussion about the social consequences of computer-manipulated images sprang not directly from art practice, but from the public's reaction to stunning special effects in such movies as the *Star Wars* series, which began in 1977, and through the rapid spread of computers in the late twentieth century, which supplied the print and broadcast media with enhanced capacity to alter photographs easily and expertly.

When the cover picture of the February 1982 issue of *National Geographic* showed two of the famous pyramids at Giza in Egypt somewhat closer together than they are in fact, digital imaging overstepped a previously inconspicuous line between socially accepted fiction, such as *Star Wars*, and unacceptable tampering with the appearance of optical reality. *National Geographic* gave the public the jitters about the capacity for computer-assisted pictures to lie.

8.12
SUZANNE BLOOM & ED HILL (MANUAL), From *The Constructed Forest*, 1993. Digital color print.

The team that formed MANUAL helped pioneer art applications of digital imagery. This image combines conventional views of nature, represented by growing trees, with images that look like wood, but are, in fact, computer inventions. It suggests that the next social transformation will be achieved by embracing digital technology.

POST PHOTOGRAPHY

THE END

In 1839, when photography was disclosed to the world, painter Eugène Delaroche, a supporter of photography, is rumored to have declared, "From today, painting is dead." The attribution is probably apocryphal,[10] and in any event painting is still a very living art. Nevertheless, the remark became part of photographic folklore and has been repeatedly enlisted to insinuate that an ironic, cosmic cadence is at work in the history of the medium. If painting was killed by photography, then photography might be destined to die by means of a new medium. For example, while lauding the success of color photography in a 1985 issue of *Creative Camera*, Susan Butler claimed that "From today black and white is dead." Before long all of photography would be declared vanquished at the hands of an even more robust and welcome reformer.

In the 1990s, the critic Nicholas Mirzoeff looked back and identified traditional camerawork's time of demise, announcing that "photography met its own death some time in the 1980s at the hands of computer imaging."[11] Likewise, William J. Mitchell, an early advocate of digital manipulation at the Massachusetts Institute of Technology in Cambridge, paraphrased Delaroche, announcing in 1992 that "from this moment on, photography is dead—or more precisely, radically and permanently redefined as was painting one hundred and fifty years before."[12]

A more measured yet minority view was expressed by Spanish photographer and critic Joan Fontcuberta (see p. 431), who noted that, because the computer has become "a sophisticated technological prosthesis we cannot do without," it is not surprising that artists would use it as an accessory to their work, like a filter or a telephoto lens.[13] Fontcuberta pointed out that previous technological improvements did not fundamentally alter the medium, and that "the metamorphosis from silver grains to pixels is not itself that significant." After all, he cautioned, "the silver-grained structure of actual photographs has already been replaced in the print media by the photomechanical dot."[14] Moreover, he reasoned, from its inception, all photography has been "altered" in the sense that the camera frames and focuses on a chosen subject, thus eliminating other topics. Manipulation, Fontcuberta argued, "is exempt of moral value." What should be judged is the intent of the manipulation, not the process itself.[15]

Deceitful photographs, perhaps the most prominent concern from the mid-1980s to the early 1990s, did not start with the computer. In the 1870s, photographer Eugène Appert staged scenes with actors and used old-fashioned cut-and-paste methods on the resultant photographs to contrive political subtle propaganda for the forces opposing the French Commune (see pp. 101–3). Comparable attempts to alter recorded history were made on behalf of Joseph Stalin during his dictatorial rule in the U.S.S.R. from 1929 to 1953. Officials such as Leon Trotsky (1879–1940) who fell from favor were physically eliminated and their portraits were airbrushed out of group photographs.[16] Still, the availability of the means to falsify photographs does not mean that photographs will be routinely adulterated.

Anxiety about the effects of digital technology is the latest appearance of photography's oldest ghost, technological determinism, which continues to evoke illusory beliefs that, in its relative simplicity, past photography was more innocent than contemporary modes, and that "straight" photography is the norm of camerawork. During the 1980s and 1990s, concern for the possibly malevolent effects of computer-manipulated photographs overshadowed other powerful ways in which photographs have been and will continue to be deceptive. Omitting images, such as the scenes of forced labor that Aleksandr Rodchenko excluded from his series on the building of the White Canal (see pp. 245–46), can be as deceitful as reshaping pictures. Moreover, in a medium that thrives in multiples, a potential taken further by computer replication, important subjects can be hidden in plain sight in the midst of a plethora of distracting pictures.

Analyses of photographs of the Gulf War (1990–91) reveal that news magazines such as *Time*, *Newsweek*, and *U.S. News and World Report* ran pictures of

military hardware more than any other subject. Virtually no pictures of actual combat were shown, and the few photographs of American casualties that found their way into print followed the iconography established during the Korean War (see p. 339), as in David Turnley's (b. 1955) image of a grieving, wounded soldier accompanying the body of a dead comrade on an evacuation helicopter. Most television coverage was of military briefings and interviews with politicians and experts.[17] Nevertheless, the public perception persists that Operation Desert Storm was witnessed up close on television screens across the world. Delaying the publication of pictures is yet another form of concealment.

During the Gulf War, *Time* magazine and the *Associated Press* wire service (*AP*) both refused to publish or distribute grisly photographs of the charred bodies of Iraqi troops killed along the so-called "highway of death." Eventually *Time* published one of these pictures, in a year-end round-up issue, about nine months after the war. Potentially, computer-assisted and disseminated images

may fall into any or all of these modes of misrepresentation. Indeed, computer-assisted photographs have largely followed paths already heavily trodden by past photographic practice.

EVERYTHING OLD IS NEW AGAIN

Describing the work of Mexican artist and photojournalist Pedro Meyer (b. 1935), Joan Fontcuberta observed that Meyer's pictures run the gamut from snapshots to digitally altered images that obviously stray far from the appearance of optical reality. In general, that range describes the great extent to which computer-assisted imaging is used in newspapers, books, art, advertising, propaganda, and even pornography. A few photographs benefit from being unretouched, while most are adjusted to differing degrees on the computer screen. Computer manipulation has largely replaced and upgraded darkroom techniques of retouching photographs.

Although it is possible for computers to compile data and create pictures that mimic the appearance of the world without ever using visual bits of information captured from optical reality, at the pre-

8.13
PEDRO MEYER,
The Temptation of the Angel, 1991. Digital color print. California Museum of Photography, Riverside, California.

Meyer considers himself a documentarist who interprets reality, rather than a fabricator of alternative worlds. Here, a woman carrying a torch to light the *temescal* (traditional Mexican steambath) approaches a young woman portraying an angel. Meyer said he wanted the angel to be unaware of the older woman approaching her. Just what the angel might be tempted by remains unclear.

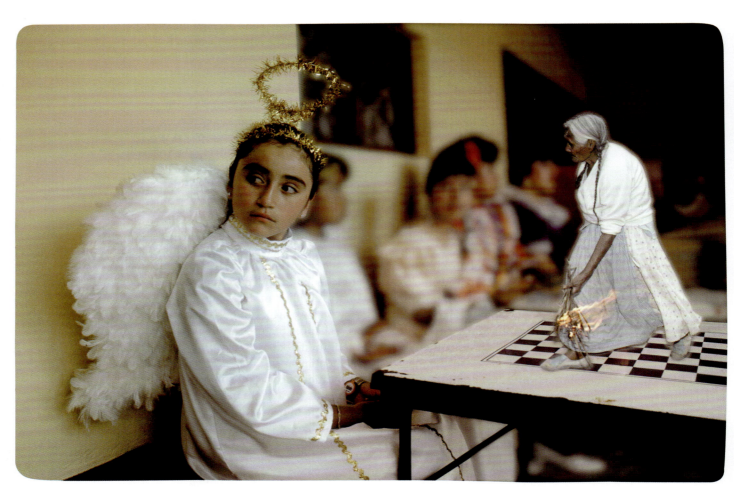

Marie's image is an improvisation on the lines of her hand. She uses digital means to deepen crevices into tiny spirals of pliant flesh.

sent time that practice is largely confined to entertainment vehicles, such as animated films and computer games. Most digitally modified pictures are processed so as to make them look more "real," and thereby convey notions of truth that have freighted the medium from the first. To denote this state of looking real by being made through digital means, Joan Fontcuberta invented the term, the *vrai-faux* (the true-false) and applied it to Pedro Meyer's particular use of the illusion of three-dimensional, photographic space in his magical, digitally-altered photographs (Fig. 8.13).

Critic Katy Siegel recently remarked that Andreas Gursky's photographs (see Fig. 7.1) "look loud," because he "digitally tweaked the colors for maximum saturation, to almost hallucinatory effect."[18] Gursky's "tweaking" also extends to transporting or removing forms and figures, but not to the point that it is evident to the casual viewer. For Gursky and many other digital technology users, the computer facilitates the production of clearly detailed enlargements. Perhaps the best example of the persistence of photography as an idea

issues from the millions of cyberspace-dwelling vernacular images of births, parties, and vacation trips, taken with digital cameras or made chemically, printed, and then scanned into computers. These images are widely understood by their makers and viewers to be historically continuous with chemically-based photographs, regardless of their electronic means of recording and dissemination.

Just as the notion of photography as optical truth has lived on in the digital era, past themes, concepts, and styles carried through into the present. Canadian Dyan Marie (b. 1954) employs digital techniques to soften and swirl forms (Fig. 8.14), in the manner of Surrealists such as Salvador Dali, in whose best-known work, *The Persistence of Memory* (1931), pocket watches melt like warm cheese. The ease with which computer software can appropriate, intermingle, and also dissolve images ensures the perpetuation of Surrealism's appeal to the incongruous, what the French poet the Comte de Lautréamont (Isidore Ducasse) (1846–1870) famously called the beautiful "chance encounter of a sewing machine and an

8.15
HULLEAH TSINHNAHJINNIE, *Damn! There goes the Neighborhood!*, 1998. Digital print.

Tsinhnahjinnie transposes white worries about the prospect of land values declining when non-whites move into the area.

8.16 (below)
CHIEH-JEN CHEN, *Self-Destruction*, 1996. Digital print.

Chen digitally inserted his body and face several times into an old photograph of Communist sympathizers being beheaded in Shanghai. He toys with the viewer's perceptions of how and why material comes to be understood as fiction.

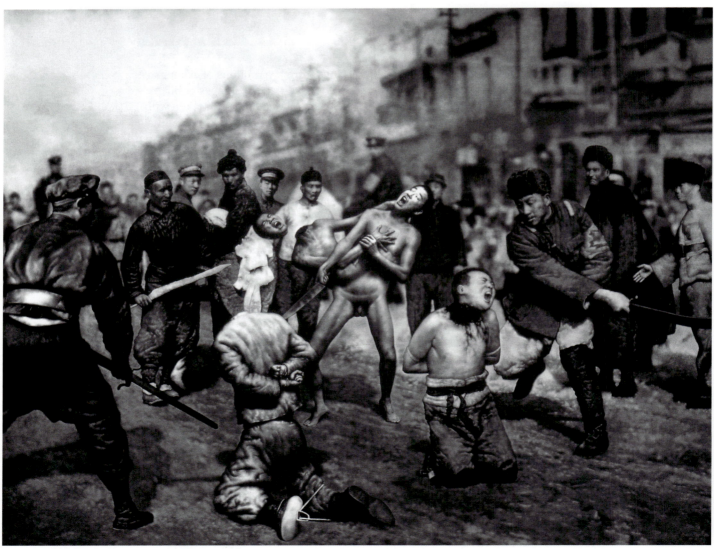

umbrella on an operating table" (*Les Chants de Maldoror*, 1868).

Digital processes have also been used by social campaigners and critics such as Hulleah Tsinhnahjinnie (see p. 407), for whom they facilitate copying old photographs and collaging them with bits of appropriated imagery, to create pointed yet humorous indictments of Eurocentric points of view (Fig. 8.15). In his work, Taiwanese artist Chieh-Jen Chen (b. 1960) has moved from performance art to digital photographs, in which he inserts himself into disturbing historical images of Chinese history (Fig. 8.16). Like many users of computer-assisted software, Chen paints and draws using the pen attached to the digital touchpad. Some electronic processes rely on a computer mouse to select and merge images, where others depend on traditional manual dexterity. In other words, computer-assisted image production has not completely superseded traditional drafting skills. Perhaps that is why critics lauded Canadian Jeff Wall (b. 1946) for reinventing painting in the 1990s.

Wall continues to work in the pre-digital format he developed two decades ago. He stages episodes for the camera, and displays the resulting images as large transparencies placed in front of light boxes, like those used to illuminate advertisements. Sometimes he has concocted scenes of contemporary life, making visual reference to famous paintings by Édouard Manet (1832–1883) or Paul Cézanne (1839–1906); in other instances, he updated the genre of history painting, transposing it to views of current events. His use of computer assistance is not usually evident in his final images, except in their large size, whose overall clarity is more readily attained with the assistance of software. For *Dead Troops Talk (A Vision After an Ambush of a Red Army Patrol, Near Moqor, Afghanistan, Winter 1986)* (Fig. 8.17), actors depicted an incident reminiscent of epic history paintings such as Antoine-Jean Gros's (1771–1835) *Napoleon on the Battlefield at Eylau* (1808), which filled a large canvas with a harsh winter battlefield, sensational gore, implausible heroism, and an incidental character who looked accusingly at the viewer.

Where Wall brings postmodern quotation into the present, Japanese photographer Yasumasa Morimura (b. 1951) pursues the movement's uneasiness with fixed notions of gender and ethnic identity. Before and since digital assistance became very widely available, Morimura made self-portraits in the guise of famous pictures. He inserted himself into the self-portrait by Dutch

8.17
JEFF WALL, *Dead Troops Talk (A Vision after an Ambush of a Red Army Patrol, near Moqor, Afghanistan, Winter 1986)*, 1991–92. Cibachrome transparency, fluorescent light, aluminum display case.

By comparison with nineteenth-century history painting, Wall's scene is a domesticated spectacle. Like many artists who came of age in the postmodern moment, he sometimes leaves clues to the image's artificiality, such as the obviously fake blood that stains the clothing of troops in *Dead Troops Talk*.

**8.18 (right)
YASUMASA
MORIMURA, *Self-Portrait (Actress), Red Marilyn*, 1996.
Ektachrome print.**

Through digital means, Morimura tries to combine his image with that of Marilyn Monroe. However, Morimura's incomplete transition from male to female, and from Asian to Caucasian, involves contemporary doubt about the mutability of personal identity.

artist Vincent van Gogh (1853–1890), which showed the artist with a bandaged ear. In his more recent work, Morimura enacted celebrated photographs of Western movie actresses, including Marilyn Monroe, in her famous pin-up pose published in *Playboy* (Fig. 8.18). Since the computer could have been used to conjure a more convincing imitation, one assumes that he intended to show the artificial breast-bra, polyester wig, lipstick-enlarged lips, and whitish make-up. Especially for a Japanese audience, these accoutrements are reminiscent of Japanese *kabuki*, a traditional form of theater in which men play all the women's roles.

Mariko Mori (b. 1976) similarly stars in and produces her own work, employing cutting-edge digital devices (Fig. 8.19). In *Pure Land*, her candy-colored galaxy is inhabited by futuristic images culled and combined from postwar monster movies, popular toys, and even bubble-gum flavors, such as artificial blueberry. *Pure Land* also recalls the Japanese concept of the "floating world." Once a Buddhist notion for transcendence of the material world, the floating world was appropriated in the seventeenth century to characterize transient

**8.19
MARIKO MORI, *Pure Land*, 1997–98. Glass photo interlayer (1 of 5 panels).**

Androgynous space-traveling Smurfs sit like Buddhas and play musical instruments, while hovering with a traditionally garbed Mori over what looks like a post-apocalyptic Japan. The image alludes to atomic-age cinema monsters such as Godzilla and Mothra, who required traditional maidens as sacrifices or as servants. In addition to photographs, Mori has also experimented with three-dimensional photographs and videos.

**8.20
MIROSLAW ROGALA,
Lover's Leap, 1995.
Installation.**

Rogala's installations
interact with participant-
observers, whose
entrances and move-
ments into the structure
and around the exhibit
set off the projection of
different pictures—a
procedure the viewer
quickly learns to exploit.

pleasures, and eventually applied to the elaborate erotic etiquette of the geisha, whose robes Mori seems to be wearing. Like Morimura, Mori jumbles references to tradition, commerce, fashion, and Japan's infatuation with the West into pictures that play on the persistent bearing of the past on the present.

Unexpectedly, the time saved by digital means allows some image-makers to make wider use of older, more time-consuming media. For example, Keith Cottingham (b. 1965) electronically hybridizes photographs of his soft-clay sculpture and anatomical drawing with appropriated images of race, gender, and age (Fig. 8.0). The resultant image, as in his *Fictitious Portraits* series, recalls the cool light and sensuous skin-tones of late Italian Renaissance artist Michelangelo Merisi da Caravaggio. Electronic reproduction permits Cottingham to "use and abuse photography's myth, its privileged claim to the real." Like Andres Serrano's images of bodily fluids (see Figs. 7.48, 7.49), Cottingham's pictures, are, in his words, "both beautiful and horrific," playing on the psychological longing to substitute the picture for the real thing.[19]

Perhaps in response to a world in which humans increasingly interact with machines, some image-makers have adapted the photograph to electronic environments that reciprocate the movements of visitors. In Polish-American artist Miroslaw Rogala's (b. 1954) *Lover's Leap*, computers track a viewer throughout the installation (Fig. 8.20).

Lover's Leap is far removed from Edward Steichen's *Family of Man* exhibition (see pp. 312–314), in which the viewer's path through the exhibit was as carefully determined as the images that could be seen there. Describing Rogala's installation, curator Lynne Warren voiced an increasingly familiar declaration: "This is the post-photographic image. The image-maker is no longer the god-like determinant of perspective and viewpoint."[20]

Rogala's work is physically based in a gallery, but long-time critic of American foreign policy, photographer Esther Parada (b. 1938), has taken advantage of digital montage for almost twenty years, and for a while made work that was entirely web-based. She orchestrated interactive sites, such as *Transplant: A Tale of Three Continents (Wherein a Victorian love story between a Chicago heiress and an English aristocrat reveals a web of colonial maneuvers connecting the United States, England, and India)* (Fig. 8.21).

Viewers were invited to follow their own path among photographs that are plainly or enigmatically labeled. A story about a young bride "transported" from her family home and then to India unfolded in an indirect, non-linear way, with clickable asides about such topics as British imperialist conduct in India during the nineteenth century. The essence of this phase of Parada's work—extensive series of photographs, framed by suggestive text, and made available on the World Wide Web—captured the imagination of those who long for inexpensive means of disseminating

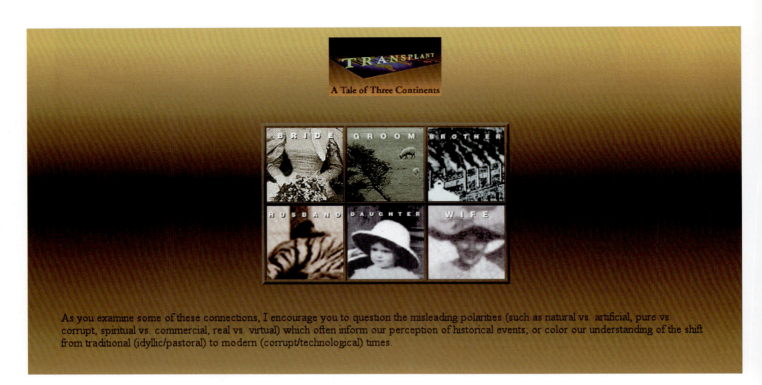

As you examine some of these connections, I encourage you to question the misleading polarities (such as natural vs. artificial, pure vs. corrupt, spiritual vs. commercial, real vs. virtual) which often inform our perception of historical events; or color our understanding of the shift from traditional (idyllic/pastoral) to modern (corrupt/technological) times.

ON BEAUTY, SCIENCE, AND NATURE

8.21
ESTHER PARADA,
Transplant: A Tale of Three Continents (Wherein a Victorian love story between a Chicago heiress and an English aristocrat reveals a web of colonial maneuvers connecting the United States, England, and India), **1996. Website.**

Parada turned to electronic media in the mid-1980s. She now exhibits her photographs in interactive series on the web, such as *Transplant,* which withholds all the details of a love story until the viewer has explored all the photographs and text available on the site.

images and text beyond established institutions such as newspapers and galleries.

Democratic access to images and to information developed as a permanent ideal in Western culture during the Enlightenment. It became attached to photography by the mid-nineteenth century, as in the enthusiasm expressed by an anonymous writer in an 1858 issue of the English journal *The Athenaeum,* who foresaw an educational revolution caused by stereographic photography, such that "perhaps in ten years or so the question will be seriously discussed … whether it will be of any use to travel now that you can send out your artist to bring home Egypt in his carpetbag to amuse the drawing room with" (see p. 83, note 7). Of course, international travel is an everyday event in the West these days, but remains beyond the economic means or political access of viewers in many countries. Indeed, it has been estimated that 95 percent of the world's computers are in the developed countries.

While websites may eventually offer more users a global reach into visual information, a strong countervailing trend developed at the beginning of the third millennium. Image-makers, museums, galleries, news organizations, and image archives have responded to the commercial possibilities of the web by commodifying more and more pictures

in extensive pay-per-view-or-use operations. For example, Corbis.com, an image-bank holding over seventy million pictures, was established by Microsoft founder Bill Gates in 1989. It resembles a nineteenth-century photographic studio from which users could get images in many sizes and qualities, ranging from postcards to archival prints. In image-banks, the name of the photographer is often omitted in favor of subject-matter. Mark Getty, founder of Getty Images and descendant of the family that founded the Getty petroleum firm, also owns about seventy million photographs. He succinctly summed up the economic potential of images when he remarked that "intellectual property is the oil of the 21st century."[21] Together, Gates and Getty control almost 50 percent of the nearly two-billion-dollar imagery business. Armchair travel on the web, through photographs of historic events, as well as the world's vistas and its art, may eventually acquire a pricetag.

FACE VALUE

The Fall 1993 cover of a special issue of *Time* magazine used computer software to create a female image of multiethnic America, combining physical attributes of Anglo-Saxons, Asians, Africans, and Hispanics, with those of people from South Europe and from the Middle East[22] (Fig. 8.22). To keep her from look-

Digital combination
prints, layering physical
aspects of different
ethnic groups, proved to
be one of the most
enticing visual motifs
in the last decades of
the twentieth century.
Fashion photographers
such as Hiro did it,
photoeditors on news
magazines called for it,
and artists such as
Nancy Burson (see
Fig. 8.23) explored the
overlaid look.

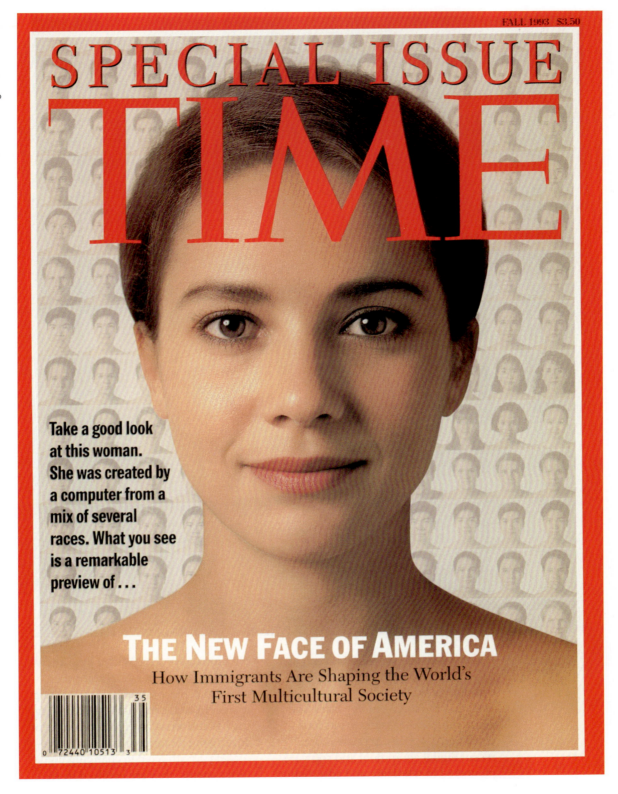

ing like the fabricated product she was, designers gave her an engaging semi-smile, and used shadows to imply the slightly asymmetrical face of real humans. The concept of merging portrait photographs has a long history, going back to the late nineteenth-century combination portraits of English scientist Francis Galton (see p. 228). During the 1980s, American

Nancy Burson (b. 1948) achieved notoriety for her eerie computer-generated composite pictures that blended the facial features of politicians including Stalin, Mussolini, Mao, Hitler, and Khomeni, or film stars such as Bette Davis, Audrey Hepburn, Grace Kelly, Sophia Loren, and Marilyn Monroe. Her blend of Black, Asian, and Caucasian features into an ominous mugshot

8.23
NANCY BURSON,
Mankind **(an Asian,
a Caucasian, and a
Black blended, weighted
according to current
population statistics),
1983–84. Gelatin
silver print.**

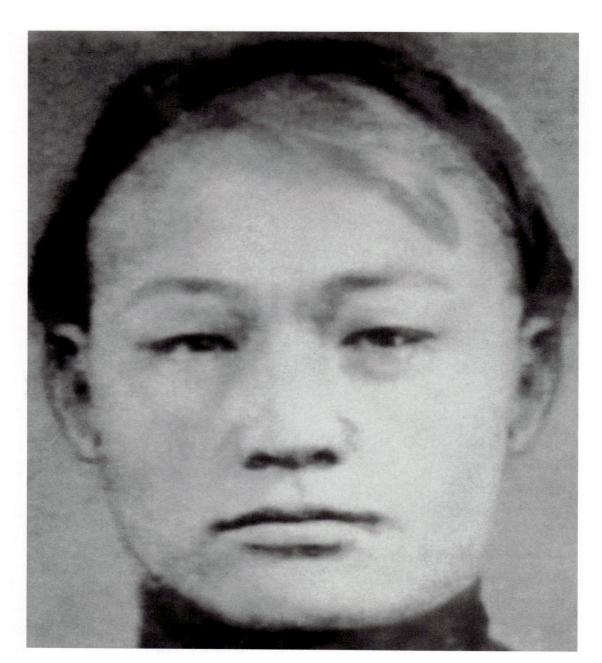

Burson's work walks a
fine line between art
and science. For twenty
years she has developed
computer programs
that combine portraits
in order to demonstrate
the transparency of
appearances. She has
also helped law-enforce-
ment agencies find
missing children by
"ageing" them with
the help of computer
software.

(Fig. 8.23) struck some critics such as
Allan Sekula as a pointless use of the
computer's skills.

Today, Burson's smudgy black-and-
white computer-assisted prints look
dated and graceless, because more
recent digital equipment and software,
pioneered in television and advertising
production, offer crisp, ultra-naturalis-
tic, and seamless production values.
Contemporary computer imaging in art,
journalism, and commerce tends toward
sharp realizations, oddly reminiscent of
the daguerreotype (see Chapters 1 and
2), whose mirror-like surface simultane-
ously gripped foreground and back-
ground visual detail, challenging how

the human eye sees. With a little know-
how, the average personal computer
user can achieve a professional-looking
image. In fact, computer-assisted imag-
ing has universalized the appearance of
advertising pictures. Insofar as image-
makers are attracted to changing high-
tech systems, they are involved in an
incessant and expensive game of catch-
up brought about by the vast prolifera-
tion of image-enhancing techniques,
and the rapid obsolescence of software
and computers. Digital devices age
rapidly: today's state-of-the-art gear will
soon show up at the beauty salon to
offer customers a chance to try on new
hairdos.

PHILOSOPHY AND PRACTICE

Even commentators wary of inflated digital enthusiasm are convinced, with Joan Fontcuberta, that "the true computer-photography fusion gives rise to a powerful electronic laboratory, which introduces factors too decisive for us to sustain our conventional views of image making."[23] From the vantage point of 1995, he predicted that the widespread use of digital-imaging by amateurs would vanquish the notion of photographic objectivity while permitting a faster and larger dialogue among artists and the public. Ironically, both digital ardor and digital angst owe to earlier postmodern attitudes, which questioned the truth-value of traditional photography while simultaneously hailing the social power of mass media. By the nature of its production techniques, digital imaging seems to have undermined the authority of the traditional photograph as an index of the material world. At the same time, the union of the photograph, the computer, and high-speed, broad-band transmission chimes with cultural dreams about a democratic art.

Unfortunately, picture-theory and philosophy, while helpful, are not adequate to the job of assessing the domain of digital imaging, because this realm is extending at such high speed into all areas of commerce, government, and private life.

The wider picture is glimpsed in *The Dystopia Series* created and commented upon by Aziz & Cucher (American Anthony Aziz [b. 1961] and Venezuelan Sammy Cucher [b. 1958]). In their large prints, sitters pose thoughtfully, while computer-generated skin closes their eyes, mouths, and ears (Fig. 8.24). These "desensitized" humans, whose minds are cut off from direct perception of the world, stand for the pair's suspicion of blind faith in digital futures, which they perceive as similar to the naive confidence that people in the second half of the twentieth century had with regard to the promise of nuclear power and the rewards of space travel. Recognizing that cyberspace brings with it the potential "democratization of the artistic impulse,"[24] they still counsel that uncritical attitudes toward the cyberworld will only deepen the individual

**8.24
AZIZ & CUCHER,
Dystopia, 1994.
Installation at the Jack
Shainman Gallery, New
York. Digital prints.**

Through digital means, Aziz & Cucher create portraits in which one can see the freckles and wrinkles on the faces of sitters whose senses have been blocked by computer-generated tissue, so as to make the sitters seem cut off from direct experience of the world.

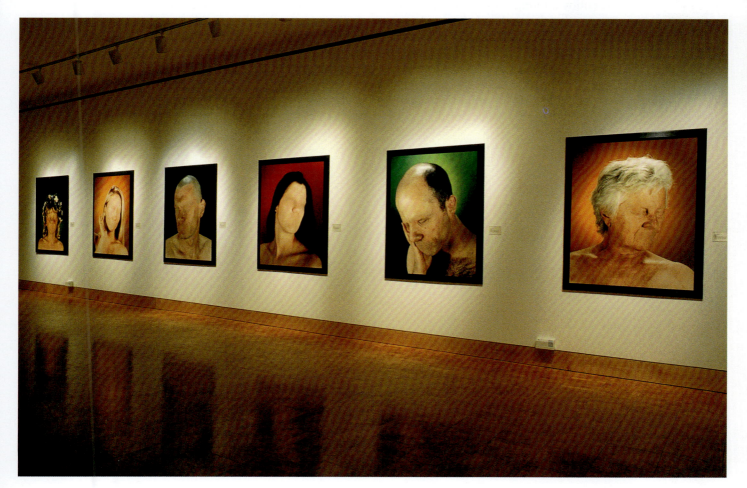

self-centeredness promoted by an on-line life, while diminishing the collective experience they deem crucial to society's welfare. Aziz & Cucher accuse technophiles of hymning a new romanticism, drawn from the jargon of bio-genetics, computer science, and popular psychology, to exalt "a smooth universe of interfaces, amazing speed, multilocality, and superconductivity, populated by friendly cyborgs, artificially intelligent machines and the shallow creations of our transpersonal selves." "No one seems to care," they admonish, "that this idealized world functions on the basis of extreme human isolation, mediated experience, and global consumerism."[25]

At photography's inception, when thinkers such as François Arago and William Henry Fox Talbot speculated about the medium's future, they saw it integrated into art, science, and industry, without a peep of protest on the part of those affected by the changes it might bring. The idea that photography so faithfully indexed the world made it seem objective, an aloof scribe, not an excitable, rabble-rousing partisan. Their scientific training disposed them to recognize that the medium's accepted neutral vision would become attached to the ideal of free and open information systems. They could not have foreseen that their medium would largely be responsible for generating the notion that mediated experience was to be dreaded, because it brought with it alienation from other humans and the shriveling of existence into an obsession with material pursuits. Nor could Arago and Talbot have anticipated that photography's compound of human wrong-doings would become the catalyst for conjectures about the medium's future.

A positive, even lyrical perception of mass media was constructed by the Cuban-born artist, Felix Gonzalez-Torres, who mused about how to rephrase the medium's contradictions while waiting tables. Improvising on Alfred Stieglitz's renowned series of *Equivalents* (see Fig. 4.22), a set of cloud photographs made to demonstrate that symbols of transcendence were freely available to those who looked for them in nature, Gonzalez-Torres stacked in a gallery hundreds of inexpensively produced pictures of clouds to be taken away by visitors (see Fig. 2). Whereas Stieglitz's *Equivalents* eventually sold for hundreds of thousands of dollars, Gonzalez-Torres's mass-produced pictures were free.

Photography's future is not a leaden certainty because people such as Gonzalez-Torres view the inconsistencies in its network of history, ideas, and practices as chafing faultlines whose energy can be routed to spark new insight and promise. However much we must be on our guard for the negative social effects of new media, we can also stay alert for and encourage new visions.

GLOSSARY

Albumen paper Light-sensitive paper used in conjunction with the collodion negative (*see* COLLODION PROCESS). Printing paper was coated with a mixture of egg white and salt allowed to dry, and then sensitized with a silver nitrate solution. The sensitized paper was placed under a negative and exposed. Albumen paper offered a rich tonal range and a stability greater than the paper treated with salt and silver nitrate that was used to create the salt print. The print had a glossy surface, different from earlier processes in which the image seemed to have sunk into the paper, like a watercolor. Albumen paper was perfected by Louis-Désiré Blanquart-Evrard, and quickly commercialized.

Aquatint An etching process added to engravings that produces light tones, resembling watercolor washes. Powdered resins are applied to the plate, which is then heated. As it melts, the resins create grains, which, when etched, produce tonal areas in the final print.

Autochrome Invented by Auguste and Louis Lumière in 1904 and marketed in 1907, the autochrome was the first practical method of making color photographs. Like the daguerreotype, the autochrome was a unique image, but developed on a glass plate, not metal or film. The process involved exposing a glass plate that had been covered with tiny granules of substances sensitive to colored light. In the darkroom, a positive was developed on the original glass plate, creating a transparency that could be seen by means of a hand-viewer, or through projection by a magic lantern device, precursor of the slide projector. The autochrome usually had a pebbly surface quality, which resulted from the little light-sensitive pellets used in the manufacturing process.

Bromoil process A variety of the OIL-PIGMENT PROCESS introduced in 1907 that was easier than the oil-pigment process and could be used for enlargements. Bromo-gelatine paper was exposed to a negative, then bleached to eliminate the silver image. The remaining gelatine formed a relief print upon which color could be applied with a brush.

Calotype Also called the Talbotype, after its British inventor, William Henry Fox Talbot, who patented the process in 1841. As with Daguerre's generous donation of the DAGUERREOTYPE to the world (which did not include England), there were legal restrictions on its use. Photographers had to apply for a license, although Talbot gave the calotype process free to science and amateur photographers.

To create a calotype negative, from which a positive print is made, good-quality writing paper or drawing paper was saturated with a solution of silver nitrate. After the paper dried, it was dipped in a solution of potassium iodide. A light-sensitive layer of silver iodide resulted. This paper could be prepared ahead of time. Before use, it had to be coated with a mixture of silver nitrate and gallic acid to sensitize it.

When the light-sensitive paper was exposed in the camera, it produced a LATENT IMAGE, that is, one that could not be seen by the eye. To bring out the latent image, the paper was washed in a mixture of silver nitrate and gallic acid, fixed with HYPO, and flushed with water.

The negative was then placed over sensitized paper called salted paper, which had been brushed or dipped into a solution of sodium chloride or ammonium chloride or a mixture of the two. Both were sandwiched in a printing frame and exposed to sunlight until a positive print was registered. The print was then rinsed in water to decrease its light sensitivity.

Camera lucida From the Latin for "light room." The camera lucida was neither a light, nor a room, but a prism, mounted on a slim rod attached to a drawing board. By adjusting the prism, an artist could create the illusion that a scene was projected onto the drawing board.

Camera obscura From the Latin for "dark room." The camera obscura was originally a darkened chamber with a hole or lens in one wall that allowed an image of the outside world to be projected onto the opposite wall. Small, portable versions were later constructed, which made it possible to copy images reflected on to a panel of translucent glass. The camera obscura ultimately became the box of the photographic camera.

Carte-de-visite Called a card photograph in the United States, the *carte-de-visite* was a small photographic portrait mounted on a cardboard backing that was about the size of a visiting card.

Chiaroscuro Chiaroscuro, from the Italian for "dark and light," refers to the contrasts between light and shade in a painting or a photograph. Chiaroscuro is often used to highlight an important subject and to create dramatic effects.

Cliché verre A coated glass photographic plate into which an artist scratches an image with a sharp stylus. Since light can move through the areas scratched away, the plate can be used as a photographic negative. It is placed on sensitized paper, and exposed to light, which passes through the lines cut into the opaque coating. Many prints can be made from one plate.

Collage The combination of different materials, such as paper, paint, fabrics, photographs, newspaper clippings. Usually pasted on a board or an artist's canvas.

Collodion process Also known as the wet-plate process. A technique developed by Frederick Scott Archer in 1851, in which glass plates were sensitized to light with a sticky substance called collodion mixed with light-sensitive silver salts. Unlike the CALOTYPE process developed by William Henry Fox Talbot, the collodion process was patent-free, which increased its popularity with photographers. By the 1860s, the technique replaced both the daguerreotype and the calotype. Glass plates were covered with a solution of collodion, a sticky mixture of ether, guncotton, and alcohol, to which light-sensitive silver iodide and iodide of iron were added. The plate was then sensitized with a coating of distilled water and silver nitrate. While the plate was still damp, it was placed inside the camera and exposed. The method was dubbed the wet-plate process, because exposure time was diminished when the plate was damp. After exposure, the plate needed to be developed quickly. In the field, photographers set up traveling dark-tents, complete with chemicals.

The process required relatively strong light and long exposure times—sometimes minutes. Moreover, the process was especially sensitive to blue, yielding dull, blank white skies. Yet since the light-sensitive materials were caught up in the film of collodion, they did not leave the kind of paper fiber imprint that paper negatives did. The collodion process was used with albumen paper.

Collotype An adaptation of lithography used to make multiple prints derived from photographic negatives. Photosensitized gelatin was applied to a glass plate, and then exposed to a negative. After careful processing, the resulting plate could be inked and printed on paper.

Combination printing A technique that uses two or more negatives to make a final print. Parts of the sensitive paper are masked so that they will not develop, while a negative is printed where desired. The technique was used by early photographers, such as Gustave Le Gray, to compensate for over-exposed skies, which did not register cloud formations.

Cyanotype A photographic technique invented by Sir John Herschel. It uses

iron salts to produce a deep blue image, and is the source of the blueprint or dyeline process used today.

Daguerreotype A photographic technique taking its name from Louis-Jacques-Mandé Daguerre. It used a silver or silver-coated copper plate to register an image in a camera obscura. The daguerreotype was a unique image, not capable of making multiple copies. Daguerreotype plates were eventually standardized in terms of size (width first):

a whole plate: $6^{1}/_{2}$ x $8^{1}/_{2}$ inches
a half plate: $4^{1}/_{2}$ x $5^{1}/_{2}$ inches
a quarter plate: $3^{1}/_{4}$ x $4^{1}/_{4}$ inches
a sixth plate: $2^{3}/_{4}$ x $3^{1}/_{4}$ inches
a ninth plate: 2 x $2^{1}/_{2}$ inches

Because early daguerreotypists sometimes had cameras made to their specifications, not all plates conformed to the standard. Also, large, so-called mammoth plates of no standard size were used in specially made cameras.

Diana This inexpensive camera had several "flaws" that proved attractive to photographers by generating surprises in film development: it leaked light onto the film; the shutter could be opened repeatedly on the same frame, yielding multiple exposures; the viewfinder didn't see accurately through the lens.

Digital imaging Also termed computer-assisted imaging, this process is used to alter existing pictures, or to create images, called virtual images, which are not based on photographs taken of the real world. Digital cameras do not use film, but translate optical reality into visual bits called pixels (a new word derived from the term "picture elements") that can be stored in a computer. Electronic images may be shown on a computer screen or other visual monitors. Similarly, a scanner surveys an image and renders it into a mathematical language that can be stored and retrieved by the computer.

Direct positive (*see* NEGATIVE)

Dry-plates (also called gelatin-silver bromide, or gelatin bromide photography). Perfected in the late 1870s, from experiments begun in the 1850s, dry-plates were mass-marketed in the 1880s. They were prepared by holding a light-sensitive mixture of silver nitrate, cadmium bromide, and gelatine at a constant temperature of 32° centigrade for several days. The resulting plate was commercially produced, freeing photographers from sensitizing and developing the wet collodion plate on the spot. The exposure time of the dry-plate was so fast that it allowed photographers to record movement. Moreover, because of the quick exposure time, the camera could be held in the hands, rather than being placed on a tripod. By the early 1880s, dry-plates were manufactured throughout Europe and America.

Dye-transfer An involved process for making color prints, which allows the maker great control over the range of color at every stage of the process. It requires exposing a color transparency three times with different filters of blue, red, and green. The resulting black-and-white negatives are then used to make a matrix, a shallow-relief mold whose thickness is etched by the amount of light reaching it through the negatives. Thus the matrix is responsive to subtle color modulations. Each mold is immersed in blue, red, or green dye, respectively. After the molds have absorbed the colors, and the photographer or printer has made chemical adjustments to the tones and hues, the molds are sequentially printed on a sheet of photographic paper. The dye-transfer method produces one of the most stable, that is, permanent, color printing processes.

Focal length The distance from the center of the camera lens to the point behind the lens where light rays from an object passing through the lens come into focus.

Gravure Gravure (or photogravure) is an etching process modified to reproduce photographs. A copper plate is treated with resin or bitumen powder, then exposed to a piece of carbon tissue paper that has a negative image on it. When soaked in warm water, the image transfers to the surface of the plate. It is then chemically etched with ferric chloride solution, leaving a recessed image that will accept ink. The process could be used commercial-ly to make many copies, or with a hand-press to make a few, as was done by the Pictorialists.

Gum-bichromate process Developed in the 1850s, the process became popular with Pictorial photographers during the late nineteenth century. The technique used the photograph as the basis of the image. A sheet of paper was brushed with gum arabic into which had been mixed potassium bichromate and a colored pigment. After it dried, the paper was exposed to a negative. The photochemically sensitive materials on the paper hardened in proportion to the amount of light received. The photographer then washed away the unhardened material, leaving a positive print. During the wash, the photographer could add color, or brush the print to create painterly effects.

Half-tone process The process whereby photographs may be printed with text in a book, newspaper or magazine by relief or by lithography. It was called half-tone because it allowed the reproduction of tones between black and white. Applying a principle discovered by William Henry Fox Talbot, the half-tone uses a fine screen to break up the surface of a print into tiny dots whose size accords with the darkness and lightness of a picture. The screen is printed on a metal plate covered with gelatin mixed with bichromate. The gelatine hardens and the non-printing areas of the image are etched with acid. The half-tone process was known and used sporadically before the late 1880s, when it was perfected, allowing newspapers routinely to include photographs.

Heliotype A method for reproducing photographs developed in the 1870s. It refined already existing lithographic processes for reproducing photographs in books. Like the WOODBURYTYPE, it was not compatible with type.

Hypo Originally hyposulphite of soda, a substance that dissolved silver salts and stopped the further development of the silver. Today "hypo" is the related substance, sodium thiosulfate.

Latent image An image registered on a photographically sensitive surface, like paper or a metal plate, but which is not visible to the eye. The latent image must be developed through a chemical process.

Lithography A printing technique in which an image is reproduced on a flat surface, originally a stone, but later a copper or zinc plate, rather than by being cut or gouged into a surface, like metal or wood. To make a lithograph, the surface is treated in such a way that the areas intended to convey an image will hold ink, and the remaining or negative areas, will repel ink.

Negative, Positive, Direct positive A negative is a photographically produced image in which the tones of the actual subject are reversed, that is, light areas are dark and darks are light. It is used to produce a positive print, in which the tones are re-reversed to create an image that reproduces optical reality. A direct positive is a unique, single image without a negative. In a direct positive print, like the daguerreotype, an image is produced on a surface and then treated chemically to imitate the tonal range of nature.

Oil-pigment process A process similar to the gum print. A piece of gelatine-coated paper was sensitized with potassium bichromate and exposed to a negative. Placed in a water bath, the print developed raised areas on the hardened gelatine. While wet, the print was brushed with pigments. The application of pigment could follow the subject of the negative, or be more expressive.

Pantograph An aid for copying prints and drawings. It consists of four bars, arranged in a parallelogram. A stylus is placed at the "V" joint of one set of bars and a drawing pencil is placed at the upper tip of the second set of bars. By tracing the stylus over a print, the drawing pencil makes an exact copy. The pantograph can also be used to enlarge or reduce an image.

Photogenic drawing A photographic technique developed by William Henry Fox Talbot that used light-sensitized paper to produce a negative from which multiple positive prints could be made.

Photogram Cameraless photographs made by casting light on photosensitive paper, or by placing objects directly on the light-sensitive surface. Some early photographers, such as William Henry Fox Talbot and Anna Atkins, made what would later be called photograms. The technique became popular with experimental photographers in Europe between World War I and World War II.

Photomontage A technique popular with experimental artists and photographers in the period after World War I. Images from such sources as advertising and newspapers were cut and reassembled to form composite images. Sometimes drawing or paint was applied. The final picture might be photographed or prepared for mechanical reproduction.

Physionotrace French engraver Gilles-Louis Chrétien adapted the PANTOGRAPH to make engravings in 1786, calling his invention the physionotrace. An artist viewed the sitter through an eyepiece, moving it to trace the sitter's profile. A stylus in the lower area of the physionotrace tracked the eyepiece movements exactly, registering them in ink on paper. The portrait was then transferred to a copper plate, etched, and used to make multiple images. The central parts of the image were then engraved by hand.

Pinhole camera An extremely simple camera, sometimes constructed by children from round oatmeal containers. It is a light-tight container with a pinhole used as a lens at one end, and light-sensitive film or paper placed at the opposite end. Pinhole cameras produce wide-angle soft-toned pictures with a minimum of detail.

Platinum prints Known in the late nineteenth- and early twentieth-centuries as platinotypes after the Platinotype Company, which manufactured platinum paper, beginning in 1879. The paper was saturated with a light-sensitive mixture of potassium chloroplatinate and ferric oxalate. After exposure to a negative, the paper was washed with potassium oxalate, which precipitated out the platinum. An expensive, long-lasting, and stable process, the platinum print yields a wide range of soft-gray tones.

Positive (*see* NEGATIVE)

Rotogravure An early twentieth-century printing process that allowed photographs to be printed with text. It was also the name for popular illustrated newspaper inserts, such as those found in Sunday papers. Fashion and high society were often subjects of the rotogravure.

Silhouettes Drawings or cut-out profiles of the human face, derived from cast shadows.

Silkscreen A printmaking process in which a stencil is made on silk or a synthetic textile tightly stretched over a frame. The technique can be adapted to photography, in which case the photograph is imprinted on the textile, and the artist can adjust the colors.

Solarization A technique that involves briefly exposing a print or negative to light during the development process. Discovered by accident in the nineteenth-century, the result is a reversal of tones along the edges of forms. Sometimes called edge reversal, solarization is somewhat unpredictable, making it a favorite of the Surrealists. It is also known as the Sabattier effect, for French photographer Antoine Sabattier (active 1850s), who is said to have discovered it.

Stereography A technique for producing photographs that when seen through a special viewer (stereoscope) produced the illusion of depth. Two images taken from slightly different angles are printed on a card, which is put in the viewing device. Stereographs approximate the distance between the two human eyes that helps to produce depth perception.

The stereoscope was invented by Charles Wheatstone (1802–1875) in 1832, before photography was announced to the world. It was an awkward viewing apparatus that used mirrors to simulate what the right eye and the left eye see separately. In 1849, Sir David Brewster (1781–1868) perfected a smaller stereoscope, better adapted to viewing stereoscopic photographs in both the daguerreotype and calotype formats. The earliest stereoscopic daguerreotypes, such as Claudet's *The Geography Lesson* (see Fig. 2.51), were taken with two cameras, each adjusted to mimic human sight. Twin-lens stereoscopic cameras were introduced in the mid-1850s.

Strobe Fast bursts of intermittent light used to illuminate moving subjects.

Tabloid More compact than nineteenth-century broadsheets, tabloid newspapers feature many illustrations, most of them photographs or derived from photographs. From the earliest post-World War I tabloids, the genre has featured sensational pictures, which carry as much meaning as the text.

Tintype An inexpensive photographic process that rendered images on thin sheets of iron, not tin. The tintype was lightweight, making it easy to send through the postal system.

Toning During or after the development of a print, it might be treated with a chemical solution containing silver and another ingredient, such as gold, platinum, or selenium. Toning allows the photographer to create a soft overall coloration, usually ranging from light gold to sepia.

Transparency As the word implies, a transparency is a positive film that allows light to pass through it. Transparencies may be in color or in black and white. The most familiar kind of transparency is the 35mm color slide, but transparencies can be made in larger sizes.

Waxed paper process An improvement to the CALOTYPE that allowed the light-sensitive paper to be prepared up to two weeks before exposure, and then developed a week after, though with variable results. As the name suggests, paper was coated with wax, then sensitized. It could be used wet, by being placed between two clean pieces of glass, or used dry. The prepared paper gave the photographer, especially when traveling, greater freedom and quickness.

Wet-plates *see* COLLODION PROCESS

Woodburytype A method of printing photographs for book illustrations. Woodburytype images could not be printed with text. Instead, they were tipped in, that is, pasted on separate sheets of paper in a book. Invented in 1866 by Walter Bentley Woodbury, the woodburytype used a gelatin film sensitized with potassium bichromate, which was exposed to a negative of the photograph to be copied. The resultant exposed film was then dipped in warm or hot water in a process that yielded a relief image, similar to low-relief sculpture, but much thinner. The various thicknesses of the gelatine corresponded to the different tones of the photograph. The negative was placed in a special press that transferred lead into the relief spaces. The lead mold was removed and used as the basis for printing a copy of the photograph.

TIMELINE OF PHOTOGRAPHS AND MAJOR DEVELOPMENTS

PHOTOGRAPHS AND RELATED WORKS	ARTISTIC, CULTURAL, AND POLITICAL DEVELOPMENTS

To 1839

Da Vinci, *Draughtsman Drawing an Armillary Sphere*, c. 1510 (1.1)
Brander, *Table Camera Obscura*, 1769 (1.6)
Sandby, *Windsor from the Goswells*, 1770 (1.7)
Lavater, *Silhouette Machine*, c. 1780 (1.4)
Anon, *Chrétien's Physionotrace*, c. 1786 (1.2)
Anon, *Bernie*, 1790s (1.5)
Daguerre, *Landscape with Gothic Ruins*, 1821 (1.11)
Niépce, *Cardinal d'Amboise*, 1826 (1.0)
Niépce, *View from the Window at Gras*, c. 1826 (1.10)
Varley, *Sketching with a Camera Lucida*, 1830 (1.8)
Talbot, *Terrace at the Villa Medici*, 1833 (1.9)
Talbot, *Latticed Window*, 1835 (1.18)
Daguerre, *Still Life*, 1837 (1.12)
Anon, *Magazine of Science*, 1839 (1.19)
Daguerre, *Boulevard du Temple*, c. 1839 (1.13)
Herschel, *William Herschel's Telescope*, 1839 (1.15)
Lotbinière, *Propylaea of the Acropolis*, 1839 (2.36)
Talbot, *Leaf with Serrated Edge*, c. 1839 (1.17)

To 1839

Camera obscura makes "camera" pictures, 16th–19th centuries
Developments in textiles, the steam engine, and coal mining usher in the Industrial Revolution, c. 1750–19th century
American Declaration of Independence, 1776
Romantic movement in art, late-18th–mid-19th century
Silhouettes become popular, 1780s
Gilles-Louis Chrétien adapts pantograph to engraving, resulting in physionotrace, 1786
French Revolution, 1789–99
Napoleonic Wars in Europe, 1796–1815
Alois Senefelder perfects lithography technique, 1798
Camera lucida becomes aid to drawing, 1806
Biedermeier style of extreme naturalism in drawing, 1816–48
Joseph Nicéphore Niépce develops heliography, 1820s
In Brazil, Hercules Florence prints images using sunlight, 1832
William Henry Fox Talbot develops "photogenic drawing," 1834
Chartist Movement for political reform in Britain, 1836–48
François Arago presents photography to Academy of Science/Academy of Fine Arts, Paris, 1839
Louis-Jacques-Mandé Daguerre patents daguerreotype, 1839
John Herschel develops "photographic specimens," 1839

TIMELINE

1840–1850

Bayard, *Self-Portrait as a Drowned Man*, 1840 (1.14)
Cornelius (attrib?), *Seated Couple*, c. 1840 (2.47)
Ettingshausen, *Section of Climatis*, 1840 (2.11)
Maurisset, *La Daguerréotypomanie*, 1840 (2.1)
Morse, *Graduates of Yale*, 1840 (2.49)
Lerebours, *Portail de Notre Dame*, 1840–44 (2.35)
Horeau, *Medinet Habu*, 1841 (2.34)
Martin, *Vienna: Winter Landscape*, 1841 (2.2)
Talbot, *Hayrick with Porter*, 1841 (2.8)
Anon, *Ingres' Painting of Cherubini and Muse*, 1841–42 (2.68)
Biow, *Ruins of Hamburg Fire*, 1842 (2.25)
Cruikshank, *Photographic Phenomena*, 1842 (2.50)
Herschel, *Untitled*, 1842 (1.16)
Hill & Adamson, *Dr. Alexander Keith*, c. 1843 (2.63)
Talbot, *The Open Door*, 1844 (2.6)
Talbot, *Articles of China*, 1844–46 (2.7)
Anon, *Untitled* (Talbot's Reading establishment), c. 1845 (2.9)
Foucault, *Microscopic studies*, 1845 (2.12)
Hill & Adamson, *Newhaven Fishwives*, c. 1845 (2.64)
Thiésson, *Native Woman of Sofala*, 1845 (2.19)
Whipple, *Hypnotism*, c. 1845 (2.67)
Anon, *Death of Major Ringgold*, 1846 (2.31)
Martens, *Panorama of Paris*, c. 1846 (2.42)
Washington, *John Brown*, c. 1846–47 (2.57)
Ball, *Unidentified Man*, n.d. (2.58)
Anon, *Amputation*, 1847 (2.32)
Anon, *General Wool and Staff*, 1847 (2.30)
Anon, *Untitled* (Eye deformity), c. 1847 (2.23)
Easterly, *Keokuk*, 1847 (2.66)
Keith, "Zion will be plowed as a field," 1847 (2.38)
Oehme, *Group Portrait*, 1847 (2.52)
Southworth & Hawes, *Early Operation Using Ether*, 1847 (2.24)
Kilburn, *Chartist Meeting*, 1848 (2.29)
Langenheim (W. & F.), *African Youth*, 1848 (2.20)
Southworth, *Self-Portrait*, c. 1848 (2.62)

1840–1850

E. Thiésson produces first anthropological photographs, 1840s
Frederick von Martens invents rotating camera for panoramic views, 1840s
Expeditionary and travel photography becomes popular, 1840s
Barbizon school of naturalistic landscape painting, 1840s
Noël Marie Paymal Lerebours publishes *Excursions Daguerriennes*, 1840–44
Realist movement in art, 1840s–80s
William Henry Fox Talbot patents calotype, 1841
Richard Beard opens first daguerreotype studio in Britain, 1841
Robert Hunt publishes *Popular Treatise on the Art of Photography*, 1841
Dr. William Morton develops use of ether as anaesthetic, 1842
Opium War ends in China, allowing Europeans greater trade opportunities, 1842
Samuel Morse transmits first telegraph message, 1844
J.M.W. Turner paints *Rain, Steam, and Speed*, 1844
William Henry Fox Talbot publishes *The Pencil of Nature*, 1844–46
Edgar Allan Poe publishes "The Raven", 1845
Léon Foucault produces microscopic daguerreotypes, 1845
Léon Foucault and Hippolyte Fizeau photograph sunspots, 1845
Irish potato famine, 1845
Mexican-American War, 1846–48
Louis Desiré Blanquart-Evrard sets up photographic printing factory, 1847
Claude Félix Abel de St Victor Niépce devises albumen glass-plate negatives, 1847
Calotype Club founded in London, 1847
Charlotte Brontë publishes *Jane Eyre*; Emily Brontë, *Wuthering Heights*, 1847
Factory Act in Britain restricts women's and children's workday to ten hours, 1847
Revolution in Paris; Second French Republic declared, 1848
Karl Marx and Friedrich Engels publish *Communist Manifesto*, 1848
Dante Gabriel Rossetti and others form Pre-Raphaelite Brotherhood, 1848
Dr. David Livingstone crosses Africa, 1848
First Women's Rights Convention, Seneca Falls, NY, 1848
Armand Fizeau measures the velocity of light, 1849

1840–1850 continued

Thibault, *Revolution of 1848*, 1848 (2.27, 2.28)
Anon, *John C. Calhoun*, c. 1848–49 (3.13)
Anon, *Edgar Allan Poe*, 1849 (2.4)
Anon, *James Warner Woolsey*, 1849–50 (2.53)
Anon, *Daniel Webster Addressing the Senate*, 1850 (2.59)
Bayard, *Self-Portrait with Plaster Casts*, 1850 (2.10)
Du Camp, *Colossus of Memnon*, 1850 (2.40)
Prangey, *Dome of the Rock*, c. 1850 (2.39)
Southworth & Hawes, *Harriet Beecher Stowe*, c. 1850 (2.61)

1840–1850 continued

Gustave Le Gray introduces waxed paper process, 1849
David Brewster invents stereoscopic viewer, 1849
California gold rush, 1849
Mathew Brady publishes *Gallery of Illustrious Americans*, 1850
Taiping Rebellion in China, 1850–64

1851–1860

Frith, *First Pylon View of Great Temple*, 1850s (3.44)
Price, *Don Quixote in his Study*, 1850s (3.96)
Shadbolt, *Watching the Newts*, 1850s (2.16)
Zealy, *Jack*, 1850s (2.21, 2.22)
Murray, *West Face of Taj Mahal*, 1850s–1860s (3.30)
Baldus, *Cloister of Saint-Trophîme*, 1851 (2.43)
Bond & Whipple, *Moon*, c. 1851 (2.0)
Claudet, *The Geography Lesson*, 1851 (2.51)
Le Gray, *Forest of Fontainebleau*, c. 1851 (2.69)
Le Secq, *Tower of Kings*, 1851 (2.44)
Mayall, *Crystal Palace*, 1851 (2.5)
Nègre, *Chimney Sweeps Walking*, 1851 (2.46)
Anon, *Untitled* (Lottery announcement), 1852 (2.18)
Atkins, *Poppy*, c. 1852 (2.14)
Le Secq, *Farmyard Scene*, c. 1852 (2.45)
McCosh, *Artillery in Front of Stone Dragons*, 1852 (2.33)
Moulin, *Étude: Séduction*, c. 1852 (2.54)
Durheim, *Katharina Josephine Wächter*, 1852–53 (2.65)
Anon, "The Stranger," 1853 (1.20)
Barnard, *Burning of Oswego Mills*, 1853 (2.26)
Llewelyn, *Thereza*, c. 1853 (2.15)
Durieu, *Académie de l'Album Delacroix réunissant*, 1853–54 (2.55)
Fenton, *The Royal Family*, 1854 (3.7)
Greene, *Banks of the Nile*, 1854 (2.41)
Langenheim (W. & F.), *Eclipse of the Sun*, 1854 (2.13)
Nadar, *Panthéon Nadar*, 1854 (3.93)
Nadar, *Théophile Gautier*, 1854–55 (3.94)
Nadar & Tournachon, *Pierrot the Photographer*, 1854–55 (3.0)
Anon, "Well, Jack!...," *Punch*, 1855 (3.4)
Clausel, *Landscape near Troyes*, c. 1855 (2.3)
Diamond, *Seated Woman with Bird*, c. 1855 (2.17)
Fenton, *A Quiet Day at the Mortar Battery*, 1855 (3.6)
Fenton, *Valley of the Shadow of Death*, 1855 (3.5)
Hawes, *McKay's Shipyard*, c. 1855 (2.60)
Langlois, *Taking of Sebastopol*, 1855 (3.9)
Robertson, *Interior of the Redan*, 1855 (3.8)
Charnay, *Landscape with Tree Planted by Cortés*, 1856 (3.49)
Daumier, *Nouveau procédé*, c. 1856 (2.48)
Elliott, *Quite a Hopeless Case*, 1856 (3.99)
Mostyn, *Oak Tree in Eridge Park*, 1856 (3.101)
Le Gray, *Mediterranean Sea at Sète*, 1856–59 (2.70)
Beato, *Execution of Mutineers*, 1857 (3.29)
Rejlander, *The Two Ways of Life*, 1857 (3.97)
Robinson, *Fading Away*, 1858 (3.100)
Anon, *Die Kunst der Zukunft*, 1859 (3.108)
Carroll, *Alice Liddell as "The Beggar Maid,"* c. 1859 (3.106)
De Clercq, *Eighth Station of the Cross*, 1859–60 (3.47)
Carrick, *Fishmonger, St. Petersburg*, 1859–78 (3.86)
Beato, *Interior of North Fort*, 1860 (3.32)
Beato, *Panorama of Hong Kong*, 1860 (3.34)
Brady, *Abraham Lincoln*, 1860 (3.16)
Hawarden, *Girl in Fancy Dress*, c. 1860 (3.105)
Robinson, *Group with Recumbent Figure*, 1860 (3.98)
Anon, *Cutting on the 49th Parallel*, 1860–61 (3.51)
Gardner, "Westward, the Course of Empire...," n.d. (3.52)
Cook, *Major Robert Anderson*, 1860–65 (3.10)

1851–1860

Hugh Welch Diamond advocates using photographs as therapy for mental patients, 1850s
Stereographs become popular, 1850s
New York Times begins publication, 1851
William Henry Fox Talbot uses electric spark to provide light for photography, 1851
Edouard Baldus pioneers combination printing, 1851
Heliographic Society founded in France, 1851
Henry Hunt Snelling founds *The Photographic Art Journal*, 1851
Great Exhibition, Crystal Palace, London, 1851
Frederick Scott Archer publishes collodion process, 1851
Louis Napoleon becomes emperor of France (Napoleon III), 1852
Harriet Beecher Stowe publishes *Uncle Tom's Cabin*, 1852
Second Burma War, 1852–53
Baron Haussmann begins remodeling of Paris, 1853
The Photographic Society of London founded, 1853
Gadsden Purchase redefines Mexican-U.S border, 1853
Giuseppe Verdi's opera, *La Traviata*, first performed, 1853
Commodore Matthew Perry forces Japan to open its ports to the West, 1853–54
André Adolphe Eugène Disdéri patents *carte-de-visite*, 1854
Fratelli Alinari Fotografi Editori founded, 1854
William Holman Hunt publishes *The Light of the World*, 1854
Alfred Lord Tennyson publishes "The Charge of the Light Brigade", 1854
Florence Nightingale begins nursing in the Crimea, 1854
Photographic societies formed in India, 1854–56
Crimean War, 1854–56
French Photographic Society founded, 1855
Frank Leslie's Illustrated Newspaper begins publication, 1855
Walt Whitman publishes *Leaves of Grass*, 1855
Introduction of tintype, 1856
Second Opium War between Britain and China, 1856–60
Harper's Weekly begins publication, 1857
Charles Baudelaire publishes *Les Fleurs du Mal*, 1857
Gustave Flaubert publishes *Madame Bovary*, 1857
Indian Mutiny, 1857–58
49th Parallel Survey, 1857–61
William Lake Price publishes *A Manual of Photographic Manipulation*, 1858
Suez Canal Company is founded, 1858
Charles Darwin publishes *On the Origin of Species*, 1859
Richard Wagner's opera, *Tristan und Isolde*, first performed, 1859
French and British troops occupy Peking, 1860
Charles Dickens publishes *Great Expectations*, 1860

1861–1870

Anon, *Untitled* (Stereoscopes in use), c. 1860s **(3.1)**
Floyd, *Photographers' Studios*, 1860s–1870s **(3.33)**
Berghaus, *Brady's Photographic Gallery*, 1861 **(3.15)**
D'Avignon, *John C. Calhoun*, c. 1861 **(3.14)**
Leutze, *Westward the Course of Empire...*, 1861 **(3.53)**
Miller (M. M.), *Cantonese Mandarin and Wife*, 1861–64 **(3.36)**
Brady, *Soldiers on the Battlefield*, 1862 **(3.20)**
Carjat, *Charles Baudelaire*, c. 1862 **(3.92)**
Disdéri, *Princess Buonaparte Gabrielli*, c. 1862 **(3.3)**
Millet, *The Sower*, 1862 **(3.91)**
Anon, *John and Nicholas Marien*, c. 1862–64 **(3.12)**
Bergstresser brothers, *Bergstressers' Studio*, c. 1862–64 **(3.11)**
Anon, *Nagar Brahmin Women*, 1863 **(3.31)**
Charnay, *Mission in Madagascar*, 1863 **(3.50)**
Gardner, *Harvest of Death*, 1863 **(3.18)**
Gardner, *Home of a Rebel Sharpshooter*, 1863 **(3.21)**
Bourne, *Valley and Snowy Peaks*, 1863–66 **(3.28)**
Anon, *Frank Leslie's Illustrated Newspaper*, 1864 **(3.19)**
Barnard, *Sherman's Hairpins*, 1864 **(3.17)**
Filmer, *Untitled* (Collaged photographs), c. 1864 **(3.104)**
Nasmyth & Carpenter, *Back of Hand, Wrinkled Apple*, 1864 **(3.74)**
Nasmyth & Carpenter, *Moon, Crater of Vesuvius*, 1864 **(3.73)**
Nadar, *The Sewers of Paris*, 1864–65 **(3.95)**
Anon, *Untitled* (Corporal Samuel Thummam), 1865 **(3.70)**
Margaritis, *Untitled* (Acropolis), 1865 **(2.37)**
Gardner, *Execution of the Lincoln Conspirators*, 1865 **(3.22)**
Rutherfurd, *Moon*, 1865 **(3.72)**
Watkins (C. E.), *Mariposa Trail*, c. 1865–66 **(3.60)**
Anon, *Patronize the Disabled Soldier*, c. 1866 **(3.68)**
Brady, *Clara Barton*, c. 1866 **(3.69)**
Civiale, *Panorama from Bella Tolla*, 1866 **(3.76)**
García, *Trenches of Tuyuty*, 1866 **(3.23)**
Woolley, *Trucanini*, 1866 **(3.85)**
Anon, *Croat Couple*, 1867 **(3.80)**
Cameron, *Herschel*, 1867 **(3.102)**
Cameron, *Ophelia*, 1867 **(3.103)**
Watkins, *Cape Horn, near Celilo*, 1867 **(3.59)**
Annan (T.), *Close No. 37, High Street*, 1868 **(3.87)**
Marville, *Rue des Marmousets*, n.d. **(3.88)**
Anon, *Brinjara and Wife*, 1868 **(3.81)**
Anon, *Looking up Broadway*, 1868 **(3.2)**
Anon, *Maqdala*, 1868 **(3.46)**
Beato, *Beato's Artist*, c. 1868 **(3.41)**
Beato, *Mount Fuji*, 1868 **(3.40)**
Gardner, *Untitled* (Commissioners with Indians), 1868 **(3.66)**
Lamprey, *Malayan Male*, 1868–69 **(3.82)**
McDonald, *Jerbel Serbal*, 1868–69 **(3.48)**
O'Sullivan, *Miner in Comstock Mine*, 1868 **(3.56)**
Russell, *Meeting of the Rails*, 1869 **(3.54)**
Thomson, *Island Temple Foochow*, 1870–71 **(3.39)**
Anon, *Arab Woman and Turkish Woman*, 1870–80 **(3.83)**

1861–1870

Photographic Society founded in Vienna, 1861
Nadar takes photographs underground using artificial light, 1861
James Clerk Maxwell produces single color image using three lantern slides, 1861
Unification of Italy, 1861
Russian Emancipation Manifesto proposes to free serfs, 1861
Abraham Lincoln president of the United States, 1861–65
American Civil War, 1861–65
Guillaume Benjamin Duchenne de Boulogne publishes *Mécanisme de la physionomie humaine*, 1862
Victor Hugo publishes *Les Misérables*, 1862
Bismarck becomes Prussian Prime Minister, 1862
Proclamation for the Emancipation of Slaves in the U.S, 1863
Edouard Manet paints *Le Déjeuner sur l'herbe*, 1863
Leo Tolstoy publishes *War and Peace*, 1863–69
Karl Marx organizes First International in London, 1864
Lewis Carroll publishes *Alice's Adventures in Wonderland*, 1865
Alexander Gardner publishes *Gardner's Photographic Sketch Book of the Civil War*, 1865-66
War of the Triple Alliance, Paraguay, 1865–70
Walter E. Woodbury invents Woodburytype, 1866
George Barnard publishes *Photographic Views with Sherman's Campaigns*, 1866
U.S Army Medical Museum publishes *Photographs of Surgical Cases and Specimens*, 1866
Alfred Nobel invents dynamite, 1866
Intercolonial Exhibition, Melbourne, Australia, 1866
Maqdala Expedition to Ethiopia, 1867
Clarence King directs Rocky Mountains survey, 1867
U.S purchases Alaska from Russia, 1867
Imperial power restored in Japan; end of shogunate, 1867
Karl Marx publishes *Das Kapital*, 1867
Japanese art first appears in West, 1867
Moscow Ethnographic Exhibition, 1867
Fort Laramie Treaty between the U.S. and Native Americans, 1868
The People of India published, 1868–75
Henry Peach Robinson publishes *Pictorial Effect in Photography*, 1869
First U.S. transcontinental railway opened, 1869
The Suez Canal opens, 1869
Anthony's Photographic Journal begins publication, 1870
Darién Survey Expedition, 1870
Franco-Prussian War, 1870–71
Arts and Crafts movement, c. 1870–1900

1871–1880

Fisler, *Selling Pears*, 1870s **(3.35)**
Muybridge, *Ascending and Descending Stairs*, 1870s **(4.58)**
Anon, *Communards in their Coffins*, 1871 **(3.24)**
Anon, *Ruins of Paris*, 1871 **(3.26)**
Appert, *Assassination of Chaudey*, 1871 **(3.27)**
Braquehais, *Vendôme Column after Destruction*, 1871 **(3.25)**
Jackson (W. H.), *Mud Geyser in Action*, 1871 **(3.63)**
O'Sullivan, *The Nipsic in Limón Bay*, 1871 **(3.57)**
Thomson, *The Cangue*, 1871–72 **(3.37)**
Anon, *Stanley and Kululu*, c. 1872 **(4.64)**
De Boulogne, Anon, Rejlander, *Untitled*, pre-1872 **(3.78)**
Uchida, *The Emperor Meiji*, c. 1872 **(3.42)**
Uchida, *Haru-ko, Empress of Japan*, c. 1872 **(3.43)**
Muybridge, *Valley of the Yosemite*, c. 1872 **(3.61)**

1871–1880

U.S Geographical Survey (Wheeler Survey), 1871
Unification of Germany; Wilhelm I becomes first emperor, 1871
Paris Commune, 1871
Charles Darwin publishes *The Descent of Man*, 1871
Yellowstone designated a U.S National Park, 1872
Celluloid production begins in U.S, 1872
Claude Monet paints *Impression—Sunrise*, 1872
Celluloid production begins (later adapted by Kodak for photographic film), 1872
Modoc War, 1872–73
Eadweard Muybridge photographs horses in motion, 1872–87
Jules-Bernard Luys publishes *L'Iconographie photographique des centres nerveux*, 1873
Platinotype invented in Britain, 1873

1871–1880 continued

Muybridge, *Modoc Brave on the War Path*, 1872–73 **(3.65)**
Anon, *Frank Leslie's Illustrated Newspaper*, 1873 **(3.64)**
Luys, *Segments of Cerebellum*, c. 1873 **(3.71)**
O'Sullivan, *Ruins in the Cañon de Chelly*, 1873 **(3.58)**
Lai, *Wreck of the "Léonore" and "Albay" Steamers*, 1874 **(3.38)**
Illingsworth, *Indians' View of Custer Expedition*, 1874 **(3.67)**
Janssen, *Transit of Venus*, 1874 **(3.75)**
Anon, *Before and After: Young Boys*, c. 1875 **(3.90)**
Anon, *Attitudes Passionelles*, 1876 **(3.79)**
De Boulogne, "Electrical contraction...," 1876 **(3.77)**
Hooper, *Victims of the Madras Famine*, 1876–78 **(3.107)**
Jackson (W. H.), *Indians Building Houses*, 1877 **(3.62)**
Thomson, *The Crawlers*, 1877–78 **(3.89)**
Muybridge, *Untitled* (Trot and gallop), 1878 **(4.52)**
O'Sullivan, *Pyramid and Tufa Domes*, 1878 **(3.55)**
Sadiq, *The Holy City*, c. 1880 **(3.45)**

1871–1880 continued

Jules Verne publishes *Around the World in Eighty Days*, 1873
First exhibition of Impressionist paintings, Paris, 1874
Carl Dammann publishes *Ethnological Photographic Gallery of the Various Races of Man*, 1875
Thomas Eakins paints *The Gross Clinic*, 1875
Centennial Exhibition, Philadelphia, 1876
Peter Tchaikovsky's ballet *Swan Lake* first performed, 1876
Battle of Little Big Horn, 1876
Queen Victoria becomes Empress of India, 1876
Mark Twain publishes *The Adventures of Tom Sawyer*, 1876
"Custer's Last Stand," Sioux and Cheyenne defeat U.S Cavalry at Little Big Horn, 1876
Alexander Graham Bell invents the telephone, 1876
William Henry Jackson publishes *Descriptive Catalogue of Photographs of American Indians*, 1877
Reconstruction collapses in United States, 1877
Jean-Martin Charcot publishes *L'Iconographie photographique de La Salpêtrière*, 1877–80
Karl Klic develops photogravure process, 1879
U.S. Bureau of Ethnology established, 1879
Auguste Rodin casts *The Gates of Hell*, 1880
Post-Impressionist movement in art, 1880–1905

1881–1890

Galton, *Untitled* (from *Inquiries into Human Faculty*), 1883 **(4.71)**
Marey, *Joinville Soldier Walking*, 1883 **(4.53)**
Eakins, *The Pole Vaulter*, 1884–85 **(4.57)**
Kimbei, *Geisha Resting*, c. 1885 **(3.84)**
von Gloeden, *Nude Sicilian Youths*, c. 1885 **(4.27)**
Emerson, *Poling the Marsh-Hay*, 1886 **(4.5)**
Anon, *Untitled* (Picnic), c. 1888 **(4.2)**
Riis, *Bandits' Roost, New York*, 1888 **(4.46)**
Davison, *The Onion Field*, 1889 **(4.7)**
Stieglitz, *Sun's Rays—Paula, Berlin*, 1889 **(4.20)**
Degas, *Berthe Morisot's Salon*, c. 1890 **(4.38)**

1881–1890

Dry-plate process simplifies photography, 1880s
Pictorialist style flourishes in photography, mid-1880s–1920s
Symbolist movement in art, 1880s
Clara Barton founds American Red Cross, 1881
Henry James publishes *The Portrait of a Lady*, 1881
Photographic roll film invented in England and the U.S, 1881
Richard Wagner's last opera *Parsifal* first performed, 1883
Explosion of Krakatoa volcano creates massive dust cloud in the Far East, 1883
Francis Galton devises a system of fingerprinting, 1885
Frederick E. Ives develops half-tone engraving process, 1886
Statue of Liberty installed in New York harbor, 1886
Halftone engraving pioneered by Frederick Ives, leading to reproduction of photos in newspapers, 1886
American Federation of Labor (AFL) founded by Samuel Gompers, 1886
Eadweard Muybridge publishes *Animal Locomotion*, 1887
Queen Victoria celebrates her Golden Jubilee, 1887
Slaves freed in Brazil, 1887
Eastman Co. introduces No. 1 Kodak camera, 1888
Adding machine created by William Seward Burroughs, 1888
National Geographic Society founded in U.S, 1888
National Geographic begins publication, 1888
Wilhelm II becomes emperor (Kaiser) of Germany, 1888
Peter Henry Emerson publishes *Naturalistic Photography*, 1889
Vincent van Gogh paints *A Starry Night*, 1889
Worldwide influenza epidemic begins, 1889
Battle at Wounded Knee ends Native American resistance to development of western states, 1890
Jacob Riis publishes *How the Other Half Lives*, 1890
Sherman Anti-Trust Act passed by U.S Congress to break up business monopolies, 1890

1891–1900

Annan (J. C.), *Miss Janet Burnet*, 1893 **(4.15)**
Arnold, *Basin and Court of Honor*, 1893 **(4.51)**
Anon, *Marquis de La Fayette*, 1895 **(1.3)**
Davis, *Samoa Princess*, c. 1895 **(4.68)**
Martin, *Dancing to the Organ*, c. 1895 **(4.44)**
Richer, *Man Descending a Staircase*, 1895 **(4.54)**
Röntgen, *Frau Röntgen's Hand*, 1895 **(4.60)**
Austen, *Organ-Grinder Couple*, 1896 **(4.45)**
Day (F. H.), *Untitled* (Crucifix), 1896 **(4.17)**
Johnston, *Self-Portrait (as New Woman)*, c. 1896 **(4.0)**

1891–1900

Photographic postcards become popular, 1890s
Secessionist movement in art, 1890s
Wiener Kamera Klub formed in Austria, 1891
Henry Peach Robinson and others form Linked Ring in Britain, 1892
Ellis Island opened for processing of immigrants into U.S, 1892
Alphonse Bertillon publishes *Identification anthropométrique*, 1893
Independent Labour party founded in Britain, 1893
World's Columbian Exposition, Chicago, 1893
Edvard Munch paints *The Scream*, 1893
Thomas Edison introduces kinetoscope, 1894

1891–1900 continued

Valenta & Eder, *Aesculapian Snake*, 1896 (4.62)
Zola, *Denise Sitting*, 1897–1902 (4.37)
Riis, *Police Station Lodgers*, c. 1898 (4.47)
Käsebier, *Blessed Art Thou Among Women*, 1899 (4.32)
Lobovikov, *The Widow's Pillow*, c. 1900 (4.11)
Underwood & Underwood, *The Dying Bugler's Last Call*, 1900 (4.67)

1891–1900 continued

Photo-Club de Paris formed, 1894
Louis and Auguste Lumière invent motion pictures, 1895
Cuban War of Independence from Spain begins, 1895
Wilhelm Conrad Röntgen discovers X-ray, 1895
Spanish-American War, 1898
H.G. Wells publishes *The War of the Worlds*, 1898
Marie and Pierre Curie discover radium, 1898
Sigmund Freud publishes *The Interpretation of Dreams*, 1899
Boer War between British and Afrikaners in South Africa, 1899–1902
Eastman Co. produces "Brownie" camera, 1900

1901–1910

Käsebier, *Portrait—Miss N.*, 1902 (4.33)
Steichen, *Self-Portrait*, 1902 (4.22)
Evans (F. H.), *Steps to Chapter House*, 1903 (4.19)
Demachy, *Struggle*, 1904 (4.8)
Smith (C. S.), *Claude F. Hankins*, 1904 (4.70)
Lartigue, *My Cousin Bichonnade*, 1905 (4.39)
Anon, *Female Employees at AEG*, 1906 (4.50)
Curtis, "Vanishing Indian Types," 1906 (4.36)
Henneberg, *Villa Falconieri*, 1906 (4.13)
Howe, Front page of *New York American*, 1906 (4.1)
Watzek, *Sheep*, 1906 (4.12)
Day (F. H.), *Nude Youth*, c. 1907 (4.18)
Reece, *Poinsettia Girl*, 1907 (4.6)
Steichen, *Alfred Stieglitz*, 1907 (4.23)
Stieglitz, *The Steerage*, 1907 (4.21)
Anon, *Untitled* (Is your wife a Suffragette?), 1908 (4.29)
Anon, *Mrs. How Martyn Makes Jam*, n.d. (4.30)
Hine, *Child in a Carolina Cotton Mill*, 1908 (4.49)
White (C. H.), *Morning*, 1908 (4.16)
Boughton, *Nude*, 1909 (4.26)
Coburn, *Wapping*, 1909 (4.40)
Martin, *Taking our Geese to Market*, 1909 (4.4)
Puyo, *Puyo, Demachy and de Singly*, 1909 (4.14)
Underwood & Underwood, *Girls in an African Village*, 1909 (4.65)
Anon, *Sons of the Cannibals*, c. 1910 (4.66)
Anon, *Untitled* (Kodak Girl), c. 1910 (4.31)
Brigman, *The Heart of the Storm*, c. 1910 (4.28)
Dugmore, *The Author and His Camera*, 1910 (4.63)
Eugene, *Adam and Eve*, 1910 (4.10)
Fukuhara (S.), *Light with its Harmony 8: Pond*, c. 1910 (6.22)
Kühn, *On the Hillside*, 1910 (4.9)
Steichen, *Nocturne*, c. 1910 (4.24)

1901–1910

Charles H. Coffin publishes *Photography as a Fine Art*, 1901
Kodak Girl advertising image introduced, 1901
Guglielmo Marconi makes first radio transmission, 1901
Queen Victoria dies, 1901
Alfred Stieglitz founds Photo-Secession, 1902
Camera Work journal founded, 1903
Orville and Wilbur Wright achieve first powered flight, 1903
Suffragettes campaign in Britain for women's votes, 1903
Louis and Auguste Lumière develop autochrome process of color photography, 1904
St. Louis World's Fair, 1904
Anton Chekhov produces *The Cherry Orchard*, 1904
Russo-Japanese War, 1904–05
Little Galleries of the Photo-Secession ("291") opens, 1905
Fauve paintings exhibited in Paris, 1905
Albert Einstein publishes paper on theory of relativity, 1905
San Francisco earthquake and fire, 1906
British Labour Party founded, 1906
Pablo Picasso paints *Les Demoiselles d'Avignon*, 1907
Herman Minkowski introduces idea of time as a fourth dimension, 1907
Cubist paintings exhibited in Paris, 1907
Triple Entente (Britain, France, Russia) formed, 1907
Edward S. Curtis publishes *The North American Indian*, 1907–30
Ford Motor Co. introduces Model T, 1908
Emilio Filippo Marinetti publishes *Futurist Manifesto*, 1909
Mexican Revolution ignites a decade-long civil war, 1910

1911–1920

Hine, *Madonna of the Tenements*, c. 1911 (4.48)
Bragaglia, *Giacomo Balla*, 1912 (4.56)
Duchamp, *Nude Descending a Staircase # 2*, 1912 (4.55)
Hare, *Carrying out the Wounded, San Juan*, c. 1914 (4.72)
Anon, *Snapshots from Home*, 1915 (4.73)
Anon, *Untitled* (Soldiers in trenches), n.d. (4.74)
Fukuhara (R.), *Sangaatsudo*, c. 1915 (6.23)
Strand, *Abstractions, Porch Shadows*, 1915 (4.43)
Anon, *Demonstration by Revolutionary Democrats*, 1917 (4.76)
Boas & Hunt, *Untitled* (Kwakiutl woman), n.d. (4.77)
Coburn, *Vortograph*, 1917 (4.41)
Gilbreth, *Woman Staking Buttons*, 1917 (4.59)
Rider-Rider, *Untitled* (Passchendaele), 1917 (4.75)
Schamberg, *Untitled* (Cityscape), 1917 (5.19)
Strand, *Photograph—New York*, 1917 (4.42)
Anon, *Untitled* (Postcard), 1918 (4.3a, b)
Duchamp, *L.H.O.O.Q.*, 1919 (5.17)
Grosz & Heartfield, *Leben und Treiben*, 1919 (5.11)
Höch, *Schnitt mit dem Küchenmesser*, 1919 (5.10)
Ernst & Arp, *Physiomythological Diluvian Picture*, 1920 (5.18)
Hausmann, *Tatlin at Home*, 1920 (5.13)

1911–1920

Revolution in China ends imperial dynasty, 1911
Japan annexes Korea, 1911
Mexican Revolution, 1911–14
Carl Jung publishes *The Psychology of the Unconscious*, 1912
Sinking of the *Titanic*, 1912
Marcel Duchamp paints *Nude Descending a Staircase, no. 2*, 1912
African National Congress founded in South Africa, 1912
Niels Bohr presents theory of atomic structure, 1913
Armory Show of modern art, New York, 1913
Igor Stravinsky produces *The Rite of Spring*, 1913
Opening of Panama Canal, 1914
Margaret Sanger crusades for "birth control", 1914
World War I, 1914–18
D. W. Griffith produces *The Birth of a Nation*, 1915
Easter Rising in Ireland, 1916
First radio news broadcast, 1916
U.S enters World War I, 1917
Bolshevik Revolution in Russia, 1917
Christian Schad and Man Ray produce cameraless images, 1918
Tristan Tzara publishes *Dada Manifesto*, 1918
Woodrow Wilson proposes formation of a League of Nations, 1918

PHOTOGRAPHS AND RELATED WORKS	ARTISTIC, CULTURAL, AND POLITICAL DEVELOPMENTS

1911–1920 continued

Klucsis, *Electrification of the Entire Country*, 1920 **(5.6)**
Schad, *Schadograph 24b*, c. 1920 **(5.9)**

1911–1920 continued

Benito Mussolini starts first Italian Fascist organization, 1919
Walter Gropius founds Bauhaus in Germany, 1919
Prohibition era in U.S, 1920–33
Women granted right to vote in U.S, 1920

1921–1930

Watkins (M.), *Advertisement for Myer's Gloves*, 1920s **(5.34)**
Mobsby, *Untitled* (Arthur Conan Doyle), 1921 **(4.61)**
Ray, *Abstract Composition*, 1921–28 **(5.21)**
Outerbridge, *Ide Collar*, 1922 **(5.35)**
Rodchenko, *Untitled* ("Pro Ito"), 1923 **(5.7)**
Höch, *Denkmal I*, 1924 **(5.12)**
Lissitzky, *The Constructor*, 1924 **(5.5)**
Moholy-Nagy & Moholy, *Photogram*, 1924 **(5.14)**
Renger-Patzsch, *Fingerhut*, c. 1924 **(5.40)**
Atget, *Café*, 1924-25 **(5.65)**
Ulmann, *Mr. and Mrs. Anderson*, n.d. **(5.66)**
Anon, Advertisement for Pond's Cold Cream, 1925 **(4.34)**
Erfurth, *Käthe Kollwitz*, c. 1925 **(4.35)**
Moholy-Nagy, *Goerz*, 1925 **(5.36)**
Weston, *Excusado*, 1925 **(5.52)**
Modotti, *Workers, Mexico*, c. 1926–30 **(5.51)**
Bayer, Cover of *Bauhaus 1*, 1928 **(5.15)**
Cahun, *Self-Portrait*, 1928 **(5.27)**
Howard, *Dead!*, 1928 **(5.3)**
Kertész, *Meudon*, 1928 **(5.30)**
Krull, Cover of *Métal*, 1928 **(5.16)**
Rodchenko, *Untitled* (Walking figure), 1928 **(5.8)**
Cunningham, *Snake in a Bucket*, 1929 **(5.47)**
Munkacsi, *Berliner Illustrirte Zeitung*, 1929 **(5.1)**
Sander, *Boxers*, 1929 **(5.67)**
Thormann, Cover of *Der Arbeiter-Fotograf*, 1929 **(5.68)**
Tschichold, "Film und Foto" poster, 1929 **(5.33)**
Vertov, *Man with a Movie Camera*, 1929 **(5.32)**
Finsler, *Untitled* (Toothpaste and brush), c. 1930 **(5.38)**
Hoyningen-Huene, *Schiaparelli Beachwear*, 1930 **(5.43)**
Salomon, *Hague Conference*, 1930 **(5.2)**
Stieglitz, *Equivalent*, 1930 **(4.25)**
Tabard, *Publicité Dunhill*, 1930 **(5.37)**

1921–1930

Group f.64 formed in California, 1920s
Arbeiter Illustrierte Zeitung launched in Germany, 1921
Adolf Hitler becomes leader of German Nazi Party, 1921
Mao Zedong and others found Chinese Communist Party, 1921
Irish Civil War, 1921–23
Karel Teige creates *Foto-Kino-Film*, 1922
T.S. Eliot publishes *The Waste Land*, 1922
Wirephoto transmissions begin, 1923
Le Corbusier publishes *Towards a New Architecture*, 1923
Adolf Hitler writes first volume of *Mein Kampf*, 1923
J. Edgar Hoover becomes director of U.S Federal Bureau of Investigation, 1924
Leica compact camera introduced, 1924
André Breton publishes *Surrealist Manifesto*, 1924
Ernst Friedrich publishes *War against War!*, 1924
Flashbulb developed in Germany, 1925
László Moholy-Nagy produces *Malerei, Photographie, Film*, 1925
Sergei Eisenstein produces the film *Battleship Potemkin*, 1925
Robert Goddard launches first liquid-propelled rocket, 1926
Television demonstrated for the first time, 1927
First "talkie," the film *The Jazz Singer*, is screened, 1927
Charles Lindbergh makes first solo transatlantic flight, 1927
Joseph Stalin becomes ruler of Soviet Union, 1927
Eastman Kodak Co. introduces color film for 16-mm movie cameras, 1928
Vu journal launched in France, 1928
Alexander Fleming discovers penicillin, 1928
Geneva Convention convenes on treatment of prisoners of war, 1929
Film und Foto exhibition, Stuttgart, Germany, 1929
Wall Street Crash, 1929
Great Depression, 1929–33
Workers' Film and Photo League founded in New York, 1930
Das Lichtbild exhibition, Munich, Germany, 1930
Technicolor introduces full-color film, 1930
Frank Whittle patents jet engine, 1930

1931–1940

Welty, *Crossing the Pavement*, 1930s **(5.62)**
Albin-Guillot, *Diatom*, 1931 **(5.74)**
Foto ringl + pit, *Petrole Hahn Advertising*, 1931 **(5.39)**
Van Dyke, *Cement Works*, 1931 **(5.46)**
Anon, "Zwei Welten...," 1932 **(5.75)**
Cartier-Bresson, *Behind the Gare St. Lazare*, 1932 **(5.31)**
Sheeler, *Industry*, 1932 **(5.20)**
Van der Zee, *Couple in Raccoon Coats*, 1932 **(5.72)**
Brandt, *Parlormaid and Under-Parlormaid*, 1932–35 **(5.70)**
Adams (A.), *Valley View*, c. 1933 **(5.49)**
Brassaï, *"Bijou" of Montmartre*, c. 1933 **(5.28)**
Brassaï, *Sculpture involontaire*, 1933 **(5.22)**
Eisenstaedt, *Joseph Goebbels*, 1933 **(5.78)**
Heartfield, *Durch Licht zür Nacht*, 1933 **(5.80)**
Hiller, *Étienne Gourmelen*, c. 1933 **(5.45)**
Kertész, *Distortion # 2*, 1933 **(5.29)**
Liberman, "In Germany, toward a mass army," 1934 **(5.42)**
Weston, *Nude*, 1934 **(5.53)**
Bellmer, *Doll*, 1935 **(5.24)**
Bayer, *Deutschland Ausstellung* brochure, 1936 **(5.41)**
Bourke-White, Cover of *Life*, 1936 **(5.61)**
Capa, *Death of a Loyalist Soldier*, 1936 **(5.84)**
Edgerton, *Drop of Milk*, 1936 **(5.77)**
Evans (W.), *Allie Mae Burroughs*, 1936 **(5.0)**
Horst, *Untitled* (Fashion photograph), 1936 **(5.44)**

1931–1940

Exhibition of Foreign Advertising and Industrial Photography, New York, 1931
Salvador Dalí paints *The Persistence of Memory*, 1931
John Cockcroft and Ernest Walton split the atom, 1932
Brassaï publishes *Paris de nuit*, 1933
Die Kamera exhibition, Berlin, 1933
President Franklin D. Roosevelt launches New Deal, 1933
Adolf Hitler seizes power in Germany, 1933
Mao Zedong leads Long March in China, 1934–35
Frank Lloyd Wright builds "Fallingwater" house, Bear Run, PA, 1934–37
Associated Press Wirephoto division formed, 1935
Newsreels become regular feature of cinema programs, 1935
Resettlement Administration (later Farm Security Administration) set up, 1935
Works Progress Administration set up, 1935
Nuremberg Laws legalize anti-semitism in Germany, 1935
Stalinist purges begin in Soviet Union, 1935
Life magazine launched in U.S, 1936
Walter Benjamin publishes "The Work of Art in the Age of Mechanical Reproduction," 1936
Germany occupies Rhineland, 1936
Edward VIII of Britain abdicates; marries Wallis Simpson, 1936
Spanish Civil War, 1936–39
Pablo Picasso paints *Guernica*, 1937
Museum of Modern Art exhibition of photographic history, 1937
Japan invades China, 1937

1931–1940 continued

Lange, *Migrant Mother*, 1936 **(5.55)**
Maar, *Père Ubu*, 1936 **(5.26)**
Ray, *Untitled* (from *Minotaure*), 1936 **(5.23)**
Rothstein, *Fleeing a Dust Storm*, 1936 **(5.57)**
Van Vechten, *Georgia O'Keeffe*, 1936 **(5.73)**
Anon, *"Zeppelin Blast Kills Thirty-Five,"* 1937 **(5.4)**
Evans, *Untitled* (from *Land of the Free*), 1937 **(5.54)**
Spender, *Midway Clowns*, 1937 **(5.69)**
Vishniac, *Boy with Earlocks*, 1937 **(5.79)**
Siskind, *Reflection of a Man*, c. 1938 **(5.71)**
Ubac, *La Conciliabule*, 1938 **(5.25)**
Bravo, *La Buena Fama Durmiendo*, 1938–39 **(6.12)**
Abbott, *Daily News Building*, 1939 **(5.64)**
Lange, *Ma Burnham*, 1939 **(5.56)**
Levitt, *New York*, c. 1940 **(6.53)**

1931–1940 continued

Crash of *Hindenburg* airship, 1937
Walker Evans publishes *American Photographs*, 1938
Picture Post launched in Britain, 1938
Germany annexes Austria and Czech Sudetenland, 1938
John Steinbeck publishes *The Grapes of Wrath*, 1939
Germany and Soviet Union sign non-aggression pact, 1939
World War II, 1939–45
Department of Photography opens at Museum of Modern Art, 1940
Charlie Chaplin makes *The Great Dictator*, 1940

1941–1950

Mydans, *Back Yard Alley Dwelling*, 1941 **(5.63)**
Weegee, *Their First Murder*, 1941 **(6.44)**
Parks, *Ella Watson*, 1942 **(5.58)**
Bubley, *Listening to a Murder Mystery*, 1943 **(5.59)**
Sommer, *Arizona Landscape*, 1943 **(6.36)**
Capa, *Ed Regan, D-Day Landing*, 1944 **(5.85)**
Miyatake, *Chrysanthemum Specialist*, 1944 **(5.50)**
Smith (W. E.), *Marines with Dying Infant*, 1944 **(5.81)**
Bourke-White, *Sergeant Wilson and Private Derrickson*, 1944–45 **(5.60)**
Anon, *Untitled* (MacArthur and Hirohito), 1945 **(6.29)**
Cartier-Bresson, *Gestapo Informer*, 1945 **(5.83)**
Khaldei, *Reichstag*, 1945 **(5.87)**
Miller (L.), *Buchenwald*, 1945 **(5.82)**
Model, *Albert-Alberta*, c. 1945 **(6.47)**
Rosenthal, *Raising the Flag on Iwo Jima*, 1945 **(5.86)**
Anon, *Atomic Cloud*, 1946 **(6.30)**
Weston, *Waterfront, Monterey*, 1946 **(6.62)**
Callahan, *Eleanor*, 1947 **(6.41)**
Janah, *Untitled* (News of Gandhi's assassination), 1948 **(6.19)**
Paolozzi, *Meet the People*, 1948 **(6.80)**
DeCarava, *Graduation*, 1949 **(6.42)**
López, *Campesino*, 1949 **(6.8)**
Siskind, *Jerome, Arizona*, 1949 **(6.34)**
Anon, *Hombre*, c. 1950 **(7.81)**
Duncan, *Untitled* (cover of *Life*), 1950 **(6.33)**
Jacobi, *Photogenic*, c. 1950 **(6.35)**

1941–1950

Abstract Expressionism emerges in New York, late 1940s
Japan bombs Pearl Harbor; U.S enters World War II, 1941
Orson Welles makes *Citizen Kane*, 1941
Warsaw Ghetto uprising, 1943
Frank Lloyd Wright designs Guggenheim Museum, New York, 1943–52
Eastman Kodak Co. introduces Kodacolor, 1944
D-Day landings in Normandy begin liberation of Europe from Nazis, 1944
Atom bombs dropped on Hiroshima and Nagasaki, 1945
American occupation of Japan, 1945–52
United Nations founded, 1945
Atom bomb tested on Bikini Atoll, 1946
Nuremberg Trials of Nazi war criminals, 1946
Edwin Land invents Polaroid camera, 1947
Marshall Plan brings aid to war-torn Europe, 1947
George Orwell publishes *1984*, 1948
Universal Declaration of Human Rights, 1948
Partition of Berlin into East and West; Berlin Airlift, 1948
State of Israel founded, 1948
Statutory imposition of apartheid in South Africa, 1948
India gains independence from Britain, 1948
Assassination of Mahatma Gandhi, 1948
NATO founded, 1949
Chinese Communist Party takes control of China, 1949
Soviet Union develops atomic bomb, 1949
Senator Joseph McCarthy's anti-communist campaign in U.S, 1950–54
Korean War, 1950–53

1951–1960

Yamahata, *Boy with a Rice Ball*, 1952 **(6.24)**
Klein, *Swing and Boy and Girl*, 1954 **(6.43)**
Anon, *Family of Man* exhibition, 1955 **(6.1)**
Frank (R.), *Drug Store, Detroit*, 1955 **(6.39)**
Rauschenberg, *Untitled Combine*, 1955 **(6.82)**
Stern, *Martini and Pyramid*, 1955 **(6.59)**
Hamilton, *Just what is it that makes today's homes...?*, 1956 **(6.78)**
Henderson, *Head of a Man*, 1956 **(6.79)**
Domon, *Marriage of A-Bomb Victims*, 1957 **(6.25)**
Abbott, *Light Rays Through a Prism*, 1958 **(5.76)**
Keïta, *Two Women*, 1959 **(6.13)**
Muir, *My Brother Gary*, 1959 **(7.72)**
Noval, *Korda with Photos of Che Guevara*, 1960 **(6.2)**
Rangel, *Untitled* (from *Our Nightly Bread*), 1960 **(6.15)**
Shunk, *Yves Klein Leaping into the Void*, 1960 **(6.88)**

1951–1960

Festival of Britain, 1951
Nuclear weapons tests begin in Nevada desert, 1951
Color television launched in U.S, 1952
Hydrogen bomb tests begin in Pacific, 1952
U.S. Supreme Court bans racial segregation in schools, 1954
James Watson and Francis Crick discover DNA, 1954
Warsaw Pact establishes military alliance of Soviet-bloc countries, 1955
The Family of Man exhibition, New York, 1955
Soviet Union and Eastern European allies sign Warsaw Pact, 1955
Ingmar Bergman makes *The Seventh Seal*, 1956
Cuban Revolution begins, 1956
Jack Kerouac publishes *On the Road*, 1957
Jørn Utzon creates Sydney Opera House, Australia, 1957–73
Soviet Union launches first space satellite, Sputnik I, 1957
Pop Art movement begins, 1958
John Galbraith publishes *The Affluent Society*, 1958
Robert Frank publishes *The Americans*, 1958–59
Mao Zedong starts China's Great Leap Forward, 1958–1960
Fidel Castro establishes Communist government in Cuba, 1959
Xerox introduces the xerographic copier, 1959
Polaroid introduces high-speed film, 1960
Alfred Hitchcock makes *Psycho*, 1960

PHOTOGRAPHS AND RELATED WORKS	ARTISTIC, CULTURAL, AND POLITICAL DEVELOPMENTS
1961–1970	**1961–1970**
Callahan, *Chicago*, 1961 **(6.40)**	Mercury poisoning at Minamata, Japan, early 1960s
Tomatsu, *Time Stopped*, 1961 **(6.27)**	Op Art movement, 1960s
Ishimoto, *Chicago*, 1962 **(6.31)**	Minimalist movement in art, mid-1960s
Meatyard, *Romance (N)*, 1962 **(6.49)**	"Social landscape" photography becomes popular, mid-1960s
Warhol, *Marilyn Diptych*, 1962 **(6.81)**	Photorealist movement in art, late 1960s
White (M.), *Empty Head*, 1962 **(6.38)**	Conceptual movement in art, 1960s–70s
Porter (E.), *October 3, 1858*, 1962 **(6.61)**	First manned space flight launched by Soviet Union, 1961
Anon, *Roles Reserved for the Negro*, 1963 **(6.77)**	Berlin Wall erected, 1961
Hiro, *Tilly Tizzani*, 1963 **(6.0)**	U.S invades Cuba at Bay of Pigs, 1961
Jackson (B.), *Lee Harvey Oswald Shot*, 1963 **(6.103)**	Yuri Gagarin is first man in space, 1961
Moore, *Birmingham*, 1963 **(6.69)**	Cuban Missile Crisis, 1962
Bailey (D.), *Mick Jagger*, 1964 **(6.93)**	Eastman Kodak introduces Instamatic camera, 1962
Metzker, *Composites: Philadelphia*, 1964 **(6.100)**	Second Vatican Council begins reform of Roman Catholic Church, 1962–65
Winogrand, *American Legion Convention*, 1964 **(6.46)**	Society for Photographic Education formed, 1963
Anon, *Untitled* (Manakal's son), c. 1965 **(6.21)**	Betty Friedan publishes *The Feminine Mystique*, 1963
Avedon, Cover of *Harper's Bazaar*, 1965 **(6.58)**	Assassination of President John F. Kennedy, 1963
García, *Campesino Covered with a Leaf*, 1965 **(6.9)**	U.S military involvement in Vietnam begins, 1964
Heinecken, *Refractive Hexagon*, 1965 **(6.99)**	Civil Rights Act passed in U.S, 1964
Anon, Cover of *Life*, 1966 **(6.66)**	Civil Rights marches in Selma and Montgomery, Alabama, 1965
Burrows, *First-Aid Center*, 1966 **(6.70)**	John Szarkowski publishes *The Photographer's Eye*, 1966
Lyon, *Cal*, 1966 **(6.51)**	International protests against Vietnam War increase, 1966
Nauman, *Self-Portrait as a Fountain*, 1966 **(6.89)**	Cultural Revolution in China, 1966–76
Davidson, *Untitled* (from *East 100th Street*), 1966–68 **(6.50)**	*New Documents* exhibition, New York, 1967
Anon, *Death Picture of Che Guevara*, 1967 **(6.3)**	Marshall McLuhan publishes *The Medium is the Message*, 1967
ATS Satellite, *Earth*, 1967 **(6.67)**	Dr. Christian Barnard performs first heart transplant, 1967
Baldessari, *Untitled* (Parking lot), 1967 **(6.92)**	Death of Che Guevara in Bolivia, 1967
Cole, *Untitled* (from *House of Bondage*), 1967 **(6.17)**	Six-Day War between Israel and Arab nations, 1967
Griffiths, *Napalm Victim*, 1967 **(6.71)**	Stanley Kubrick makes *2001: A Space Odyssey*, 1968
Magubane, *Untitled* (Wenela Mine agency), 1967 **(6.16)**	Assassination of Martin Luther King, 1968
Rosler, from *Bringing Home the War*, c. 1967–72 **(7.31)**	"Prague Spring" ends with invasion of Czechoslovakia by Soviet Union, 1968
Friedlander, *New Orleans*, 1968 **(6.45)**	Civil Rights protests lead to violence in Northern Ireland, 1968
Hosoe, *Kamaitachi 31*, 1968 **(6.28)**	Year of student protests in Europe, 1968
McCullin, *Corpse of North Vietnamese Soldier*, 1968 **(6.102)**	Tet Offensive in Vietnam, 1968
Ruscha, *Nine Swimming Pools*, 1968 **(6.96)**	Woodstock Music Festival, New York, 1969
Withers, *Solidarity March*, 1968 **(6.68)**	Neil Armstrong is first man on moon, 1969
Adams (E.), *General Loan Executing Vietcong Suspect*, 1968 **(6.72)**	Students shot in Vietnam protest, Kent State University, Ohio, 1970
Close, *Self-Portrait*, 1968 **(6.84)**	
Adams (R.), *Newly Occupied Tract Houses*, 1969 **(6.56)**	
Apollo II, *Untitled* (Far side of the moon), 1969 **(6.65)**	
Smithson, *Seventh Mirror Displacement*, 1969 **(6.86)**	
Uelsmann, *Untitled* (Floating tree), 1969 **(6.37)**	
Eggleston, *Greenwood, Mississippi*, 1970 **(6.94)**	
Filo, *Untitled* (Kent State girl screaming), 1970 **(6.73)**	
Frank (S.), *Untitled* (Diane Arbus), 1970 **(6.48)**	
Haeberle & Brant, *And Babies?*, 1970 **(6.75)**	
Khanh, *U Minh Forest*, 1970 **(6.76)**	
1971–1980	**1971–1980**
Moriyama, *Stray Dog*, 1971 **(6.32)**	Greenpeace is founded, 1971
Clark, *Tulsa Portfolio*, 1972 **(6.52)**	"Bloody Sunday" shootings in Northern Ireland, 1972
Dater, *Maureen with Fan*, 1972 **(7.45)**	John Szarkowski publishes *Looking at Photographs*, 1973
Kuwabara, *Untitled* (from *Minamata Disease*), 1972 **(6.26)**	Judy Dater publishes *The Feminine Eye in Photography*, 1973
Owens, *Untitled* (from *Suburbia*), 1972 **(6.57)**	OPEC raises price of oil and precipitates oil crisis, 1973
Ut, *Children Fleeing a Napalm Strike*, 1972 **(6.74)**	Native American protestors occupy Wounded Knee, South Dakota, site of 1890 massacre, 1973
Michals, *The Bogeyman*, 1973 **(6.54)**	U.S. troops withdraw from Vietnam, 1974
Parker, *Young Indian Couple*, 1973 **(6.4)**	Watergate scandal leads to resignation of Richard Nixon, 1974
Samaras, *Untitled* (Polaroid manipulated), 1973 **(6.95)**	Augusto Pinochet seizes power in Chile, 1973
Evans (W.), *Untitled* (Crushed beer can), 1973–74 **(6.63)**	*New Topographics* exhibition, Rochester, N.Y, 1975
Amdursky, *Colorama*, n.d. **(6.64)**	U.S. Apollo and Soviet Soyuz spacecraft link up in space, 1975
Baltz, *Southwest Wall*, 1974 **(6.55)**	Helsinki Accords outline basic human rights, 1975
Broodthaers, *La Soupe de Daguerre*, 1974 **(6.90)**	Pol Pot and the Khmer Rouge carry out genocide in Cambodia, 1975–78
Cumming, *Academic Shading Exercise*, 1974 **(6.97, 6.98)**	Civil war in Nicaragua, 1976–79
Estes, *Woolworth's*, 1974 **(6.83)**	Susan Sontag publishes *On Photography*, 1977
Rosler, *The Bowery in Two Systems*, 1974–75 **(7.32)**	First manned flight of U.S space shuttle, 1977
Bakor, *Untitled* (Two young women), 1975 **(6.14)**	*Hecho in Latinoamérica* exhibition, Mexico City, 1978
Anon, *Untitled* (Cambodian prisoners), 1975–79 **(7.29)**	*Mirrors and Windows* exhibition, 1978
Cunningham, *Irene "Bobby" Libarry*, 1976 **(5.48)**	

1971–1980 continued

Facio & D'Amico, *Untitled* (from *Humanario*), 1976 **(6.7)**
Mapplethorpe, *Rosie*, 1976 **(7.83)**
Flack, *World War II (Vanitas)*, 1976–77 **(6.85)**
Pfahl, *Australian Pines*, 1977 **(7.86)**
Nomura, *'Moon' Score*, 1977–80 **(6.91)**
Faucon, *Les Papiers qui Volent*, 1977–95 **(7.66)**
Andujar, *Yanomami Youth*, 1978 **(6.6)**
Grobet, *Proposiciones*, 1978 **(6.10)**
Leeson & Dunn, *Health Cuts Can Kill*, 1978 **(7.33)**
Meyer, *Untitled* (Wealthy woman), 1978 **(6.5)**
Wegman, *Man Ray Contemplating the Bust of Man Ray*, 1978 **(6.101)**
Pierre et Gilles, *Le Cowboy—Victor*, 1978 **(8.1)**
Sherman, *Untitled Film Still*, 1978 **(7.35)**
Simmons, *Blonde/Red Dress/Kitchen*, 1978 **(7.56)**
Iturbide, *Woman Angel*, 1979 **(6.11)**
Sternfeld, *Beached Whales*, 1979 **(7.85)**
Peress, *Demonstration in Iran*, 1980 **(7.13)**
Welling, *August 16a*, 1980 **(7.39)**

1971–1980 continued

Karol Wojtyla becomes Pope John Paul II, 1978
Birth of first test-tube baby, 1978
Claudia Andujar publishes *Yanomami*, 1978
Francis Ford Coppola makes *Apocalypse Now*, 1979
Shah of Iran is deposed by Ayatollah Khomeini, 1979
Margaret Thatcher becomes British Prime Minister, 1979
Soviet Union invades Afghanistan, 1979
China introduces one-child policy to stem population growth, 1979
Roland Barthes publishes *Camera Lucida*, 1980
Voyager space probe photographs Saturn, 1980
Solidarity movement begins in Poland, 1980
Iran–Iraq War, 1980–88

1981–1990

Becher (B. & H.), *Gas Tower*, 1981 **(6.87)**
Mahler, *Untitled* (from *Living Together*), c. 1981 **(7.62)**
Meiselas, *Street Fighter in Managua*, 1981 **(7.12)**
Nachtwey, *Rioters in Belfast*, 1981 **(7.16)**
Skoglund, *Revenge of the Goldfish*, 1981 **(7.50)**
Turbeville, *Radio City Music Hall*, 1981 **(6.60)**
Polke, *Lager*, 1982 **(7.5)**
Goldin, *Nan and Brian in Bed*, 1983 **(7.69)**
Hockney, *Isherwood Talking to Holman*, 1983 **(7.6)**
Kruger, "We won't play nature...," 1983 **(7.47)**
Mark, *"Rat" and Mike with a Gun*, 1983 **(7.8)**
Singh, *Shiva Temple, Jahngira*, 1983 **(6.20)**
Burson, *Mankind*, 1983–84 **(8.23)**
Dittborn, *Commonplaces*, 1984 **(7.23)**
Boltanski, *Monuments*, 1985 **(7.27)**
Park, *Nightmare no. 3*, 1985 **(7.24)**
Fischli & Weiss, *Untitled* (from *Stiller Nachmittag*), 1985 **(7.51)**
Kuprejanov, "The lights of the day extinguished," 1985 **(7.22)**
Parr, *Tupperware Party*, 1985 **(7.10)**
Misrach, *Bomb Crater and Destroyed Convoy*, 1986 **(7.87)**
Spence, *Transformations*, 1986 **(7.61)**
Ess, *Untitled* (from *Food for the Moon*), 1986–87 **(7.40)**
Barney, *Marina's Room*, 1987 **(7.74)**
Dridi, *Mosque, Fes*, 1987 **(7.37)**
Head, *Toxic Lagoon*, 1987 **(7.60)**
Mofokeng, *Shebeen in White City*, c. 1987 **(7.30)**
Ruff, *Portrait*, 1987 **(7.25)**
Cohen, *Observation Room*, n.d. **(7.26)**
Serrano, *Piss Christ*, 1987 **(7.48)**
Witkin, *Las Meninas, New Mexico*, 1987 **(7.59)**
Casebere, *Chuck Wagon with Yucca*, 1988 **(7.52)**
Di Corcia, *Brian*, 1988 **(7.65)**
Gupta, *Lodhi Gardens*, 1988 **(7.89)**
Kiefer, *Siegfried's Difficult Way*, 1988 **(7.4)**
Richter, *Shot Down (1)*, 1988 **(7.38)**
Satoh, *Photorespiration*, 1988 **(7.57)**
Simpson, *Five-Day Forecast*, 1988 **(7.28)**
Boran, *Tony Potts*, 1989 **(7.55)**
Goldblatt, *Untitled* (from *The Transported*), 1989 **(6.18)**
Mann, *Naptime*, 1989 **(7.82)**
Ellis, *Untitled* (Grandfather), 1990 **(7.78)**
Fontcuberta, *Ich danke Ihnen*, 1990 **(7.42)**
Messager, *My Vows*, 1990 **(7.46)**
Piper, *Pretend no. 3*, 1990 **(7.3)**
Salgado, *Serra Pelada, Brazil*, 1990 **(7.18)**
Serrano, *Semen and Blood*, 1990 **(7.49)**
Sligh, *Untitled* (from *Reading Dick and Jane*), 1990 **(7.77)**

1981–1990

Neo-Expressionist movement in art, 1980s
IBM launches first personal computer, 1981
Attempted assassination of President Ronald Reagan, 1981
Marriage of Prince Charles and Lady Diana Spencer, 1981
Alice Walker publishes *The Color Purple*, 1982
Steven Spielberg makes *ET*, 1982
Introduction of compact disks, 1982
Soviet spacecraft takes first color photographs of Venus, 1982
Falklands War, 1982
Israel invades Lebanon, 1982
AIDS virus (HIV) identified, 1983
U.S invades Grenada, 1983
First compact discs marketed, 1983
President Reagan backs Contra rebels in Nicaragua, 1983
Apple launches Macintosh computer, 1984
Assassination of Indira Gandhi, 1984
Miners' strike in Britain, 1984–85
Mikhail Gorbachev becomes leader of Soviet Union, 1985
Antarctic survey team confirms hole in ozone layer, 1985
Space shuttle Challenger explodes, 1986
Nuclear accident at Chernobyl power station, Soviet Union, 1986
Libya bombed by U.S, 1986
"Irangate" scandal in U.S, 1986
U.S and Soviet Union sign INF Treaty, 1987
Single European Act, 1987
First portable computer sold, 1987
Salman Rushdie publishes *The Satanic Verses*, 1988
Soviet Union begins to withdraw from Afghanistan, 1988
Terrorists blow up Pan Am flight 103 over Lockerbie, Scotland, 1988
Adbusters magazine launched, 1989
Berlin Wall comes down, 1989
Communist regimes toppled in Eastern Europe, 1989
Tiananmen Square massacre, Beijing, 1989
Launch of Hubble space telescope, 1990
Reunification of Germany, 1990
Iraq invades Kuwait, 1990
Nelson Mandela released from prison in South Africa, 1990

PHOTOGRAPHS AND RELATED WORKS	ARTISTIC, CULTURAL, AND POLITICAL DEVELOPMENTS

1981–1990 continued

Somonte, *Woman with Rattlesnake Skin*, 1990 **(7.43)**
Sugimoto, *Aegean Sea, Pilion 1*, 1990 **(8.5)**

1991–present

Stanford Univ., from *The Visible Human Project*, 1990s **(8.10)**
Ferrato, from *Living with the Enemy*, 1991 **(7.15)**
Meyer, *Temptation of the Angel*, 1991 **(8.13)**
Opie, *Chicken*, 1991 **(7.91)**
Patiño, *Constant Navigation*, 1991–92 **(7.80)**
Wall, *Dead Troops Talk*, 1991–92 **(8.17)**
Fuss, *Wish*, 1992 **(7.41)**
Hevey, *Untitled* (from *Beyond the Barriers*), 1992 **(7.93)**
Kirby, *Untitled* (AIDS patient), 1992 **(7.97)**
Kim, *Distances*, 1992 **(7.2)**
Orozco, *Cats and Watermelons*, 1992 **(7.54)**
Sherman, *Untitled* (Plastic body parts), 1992 **(7.36)**
Sultan, *Untitled* (from *Pictures from Home*), 1992 **(7.73)**
Tillmans, *Lutz and Alex*, 1992 **(7.67)**
Weems, *Diana Portraits*, 1992 **(7.88)**
Zelck, *Untitled* (from *Familienbande*), 1992–96 **(7.64)**
Anon, *Time* cover, 1993 **(8.22)**
MANUAL (Bloom & Hill), from *The Constructed Forest*, 1993 **(8.12)**
Cottingham, *Untitled (Triple)*, 1993 **(8.0)**
Marie, *Learning to Count THREE*, 1993 **(8.14)**
Nagashima, "Self-Portrait," *Mother no. 2*, 1993 **(7.71)**
NASA, *View of Venus*, 1993 **(8.6)**
Prince, *Untitled* (Cowboys), 1993 **(7.34)**
Rickard, *Untitled* (from *Scientifically Unnatural*), 1993 **(7.17)**
Aziz & Cucher, *Dystopia*, 1994 **(8.24)**
Barth, *Ground # 42*, 1994 **(8.4)**
Billingham, *Untitled* (Family life), 1994 **(7.75)**
Richards, *Crack Plague in Red Hook*, 1994 **(7.11)**
Yashiro, *Yanaginoya Fukushima*, 1994 **(7.20)**
Chalmers, *Bug*, 1994–96 **(8.11)**
Amundson, *Dr. Kempf's Nightmare*, 1995 **(7.92)**
Chong, *Aunt Winnie*, 1995 **(7.79)**
Day (C.), *George on the Bed*, 1995 **(7.95)**
Porter (C. H.), *Fireman and Child*, 1995 **(7.14)**
Rogala, *Lover's Leap*, 1995 **(8.20)**
Underhill, *Untitled* (from *Returning the Gaze*), 1995 **(7.90)**
Trockel, *Beauty*, 1995–96 **(8.2)**
Chen, *Self-Destruction*, 1996 **(8.16)**
Johnston, *Landscape Specimen 004*, 1996 **(8.7)**
Morimura, *Self-Portrait (Actress)*, 1996 **(8.18)**
Parada, *Transplant*, 1996 **(8.21)**
Araki, *Untitled* (from *Desire and the Void*), 1996–97 **(7.70)**
Hui, *Commemorative Picture*, 1997 **(7.21)**
Hurn, *Seaside in Wales*, 1997 **(7.9)**
Parke-Harrison, *Patching the Sky*, 1997 **(7.84)**
Pierson, *Untitled* (from *Jack Pierson*), 1997 **(7.68)**
Schneider, *Ear*, 1997 **(8.8)**
Schneider, *Tumor Suppressor Genes*, 1997 **(8.9)**
Starn (M. & D.), *Mater Dolorosa*, 1997 **(7.94)**
Mori, *Pure Land*, 1997–98 **(8.19)**
Witteveen, *Jon*, 1997–98 **(7.19)**
Gursky, *Bundestag, Bonn*, 1998 **(7.1)**
Shonibare, *Diary of a Victorian Dandy*, 1998 **(7.58)**
Tsinhnahjinnie, *Damn!*, 1998 **(8.15)**
Jinsong, *Parents*, 1998 **(7.63)**
Bailey (R.), *Untitled* (Mixed media), 1999 **(7.76)**
Chao, *Member of KNLA*, 1999 **(7.0)**
Demand, *Copyshop*, 1999 **(7.53)**
Pollack, *Family of Men* installation, 1999 **(7.44)**
Anon, Cover of *Adbusters*, 2000 **(7.98)**
Dijkstra, *Tiergarten, Berlin*, 2000 **(8.3)**
Tillmans, *Victoria Line* and *Martha Osamor*, 2000 **(7.96)**
Orlan, *Omniprésence Vénus*, 2001 **(7.7)**

1991–present

Pleasures and Terrors of Domestic Comfort exhibition, New York, 1991
Regarding Beauty: A View of the Late Twentieth century exhibition, Washington, D.C, 1991
Soviet Union collapses, 1991
Gulf War, 1991
Earth summit in Rio de Janeiro sets protocols for environmental protection, 1992
Single European Market established, 1992
Yugoslavia breaks into several independent republics, 1992
Oslo Peace Accord signed by Israel and PLO, 1993
Jiang Zemin succeeds Deng Xioping as president of China, 1993
Steven Spielberg makes *Schindler's List*, 1994
Channel Tunnel connects England and France, 1994
First fully democratic elections in South Africa; Nelson Mandela becomes president, 1994
Russia invades Chechnya, 1994
Massacres in Rwanda, 1994
Federal building in Oklahoma City destroyed by terrorist bomb, 1995
Intergovernmental Panel on Climate Change offers strong evidence of global warming, 1995
Dayton Peace Accord ends civil war in Bosnia, 1995
Establishment of World Trade Organization, 1995
Assassination of Prime Minister Yitzhak Rabin of Israel, 1995
BSE ("mad cow disease") crisis in Britain, 1996
Taliban forces seize power in Afghanistan, 1996
Frank Gehry creates Guggenheim Museum, Bilbao, Spain, 1997
Kyoto Protocol proposes ways to minimise global climate change, 1997
Labour Party wins election in Britain, ending 18 years of Conservative government, 1997
Death of Mother Theresa, 1997
Diana, Princess of Wales, killed in crash in Paris, 1997
Hong Kong comes under political control of China, 1997
Good Friday Agreement in Northern Ireland, 1998
Conflict in Kosovo begins, 1998
India and Pakistan launch nuclear tests, 1998
Vladimir Putin becomes Russian prime minister, 1999
Deborah Willis publishes *Reflections in Black: A History of Black Photographers, 1840 to the Present*, 2000
Human DNA sequence established, 2000
North and South Korean presidents meet to attempt better relations, 2000
Mad cow disease spreads within Europe, 2001
World Trade Center destroyed by terrorists, 2001
"War against Terror" begins with bombing of Afghanistan, 2001
Death of Queen Elizabeth the Queen Mother at 101, 2002
Far-right National Front reaches final round of presidential election in France, 2002
India and Pakistan risk nuclear war over Kashmir, 2002

NOTES

Introduction

1 Allan Sekula, "Photography: Between Labour and Capital," in *Mining Photographs and Other Pictures, 1948–1968: A Selection from the Negative Archives of Shedden Studio, Glace Bay, Cape Breton, Photographs by Leslie Sheddon*, ed. Benjamin H. D. Buchloh and Robert Wilkie (The Press of the Nova Scotia College of Art and Design and The University College of Cape Breton Press, 1983), p. 201.
2 Lady Elizabeth Eastlake, [untitled review], *The Quarterly Review*, vol. 101 (April 1857), p. 465.
3 Henry James, "The Real Thing," in *The Short Stories of Henry James*, ed. Clifton Fadiman (New York: Random House, 1945), p.194.
4 Siegfried Kracauer, "Photography," in his *The Mass Ornament*, ed. and trans. by Thomas Y. Levin (Cambridge, MA: Harvard University Press, 1995), pp. 58–61. This essay and the others in *The Mass Ornament* were published in the newspaper *Die Frankfurter Zeitung*.
5 Daniel J. Boorstin, *The Image: A Guide to Pseudo-Events in America* (New York: Harper Colophon Books, 1961), p. 240.
6 Thomas Lawson, "Last Exit: Painting," *Artforum* (October 1981), p. 45.
7 John Berger, *Ways of Seeing* (London and Middlesex, England: Penguin Books and the British Broadcasting Corporation, 1972), p. 7.

CHAPTER ONE
The Origins of Photography (to 1839)

1 For more information, see J. L. Heilbron, *The Sun in the Church: Cathedrals as Solar Observatories* (Cambridge, MA: Harvard University Press, 1999).
2 Oliver Wendell Holmes, "The Stereoscope and the Stereograph," *Atlantic Monthly*, vol. 3 (June 1859), pp. 738–39.
3 Eric Hobsbawm, *The Age of Revolution, 1789–1848* (New York: Vintage Books, 1996), pp. 7–28.
4 Eric Hobsbawm, pp. 7–28. The role of realistic depiction in art and science in promoting the invention of photography is discussed in Heinrich Schwarz, *Art and Photography: Forerunners and Influences: Selected Essays by Heinrich Schwarz*, ed. William E. Parker (Layton: UT: Gibbs M. Smith and Peregrine Smith Books, 1985), and Peter Galassi, *Before Photography: Painting and the Invention of Photography* (New York: Museum of Modern Art, 1981).
5 For a review of perspective machines see Martin Kemp, *The Science of Art: Optical Themes in Western Art from Brunelleschi to Seurat* (New Haven: Yale University Press, 1990), pp. 163–257. My discussion of perspective and drawing machines is indebted to this excellent text.
6 Gisèle Freund, *Photography and Society* (Boston: David R. Godine, Publisher, 1980), p. 11.
7 Boris Kossoy, "Hercules Florence, Pioneer of Photography in Brazil," *Image*, vol. 20, no. 1 (March 1977), p. 17.
8 Kossoy, pp. 16–19.
9 For the circumstances of Florence's invention, I am indebted to Boris Kossoy's essay, "Photography in Nineteenth-Century Latin America: The European Experience and the Exotic Experience," in *Image and Memory: Photography from Latin America, 1866–1994*, ed. Wendy Watriss and Lois Parkinson Zamora (Austin, TX: University of Texas Press, 1998), pp. 21–25.
10 Quoted in Boris Kossoy, "Photography in Nineteenth-Century Latin America: The European Experience and the Exotic Experience," in *Image and Memory: Photography from Latin America, 1866–1994*, ed. Wendy Watriss and Lois Parkinson Zamora, p. 25.
11 In 1842, Talbot wrote to Herschel that "Science is now cultivated by so many, that it is impossible that cases of simultaneous invention should not frequently arise." Quoted in Larry J. Schaaf, *Out of the Shadows: Herschel, Talbot and the Invention of Photography* (New Haven, CT: Yale University Press, 1992), p. 126.
12 Thomas Wedgwood and Sir Humphry Davy, "An Account of a Method of Copying Paintings Upon Glass and of Making Profiles, by the Agency of Light upon Nitrate of Silver," reprinted in Beaumont Newhall, *Essays and Images* (New York: Museum of Modern Art, 1980), p. 16.
13 See a discussion of Niépce's processes in Helmut and Alison Gernsheim, *L. J. M. Daguerre: The History of the Diorama and the Daguerreotype*, 2nd, rev. ed. (New York: Dover Publications, Inc., 1968), pp. 51–64.
14 For a technical description of this process and many early photographic processes, see William Crawford, *The Keepers of Light: A History and Working Guide to Early Photographic Processes* (Dobbs Ferry, New York: Morgan & Morgan, 1979).
15 Quoted in Helmut and Alison Gernsheim, *L. J. M. Daguerre: The History of the Diorama and the Daguerreotype*, 2nd, rev. ed., pp. 80–81.
16 See Mary Warner Marien, *Photography and Its Critics: A Cultural History, 1839–1900* (New York: Cambridge University Press, 1997), pp. 32–33.
17 Arago's statement and Gaucheraud's newspaper article are excerpted in English in Helmut and Alison Gernsheim, *L. J. M. Daguerre: The History of the Diorama and the Daguerreotype*, 2nd, rev. ed., pp. 82–85.
18 See the discussion in Larry J. Schaaf, *Out of the Shadows: Herschel, Talbot and the Invention of Photography*, pp. 23–25.
19 See Pierre G. Harmant, "Anno Lucis 1839," a three-part article in *Camera* (May 1977, no. 5, pp. 39–43; August, no. 8, pp. 37–41; October, no. 10, pp. 40–44). Also Robert Meyer, "Hans Thøger Winther: A Norwegian Pioneer in Photography," in *Shadow and Substance: Essays on the History of Photography*, ed. Kathleen Collins (Bloomfield Hills, MI: The Amorphous Institute Press, 1990), pp. 39–48.
20 Bayard's note is reproduced in full in Michael Sapir, "The Impossible Photograph: Hippolyte Bayard's Self-Portrait as a Drowned Man," *Modern Fiction Studies*, vol. 40, no. 3 (Fall 1994), p. 623.
21 Quoted in Larry J. Schaaf, *Out of the Shadows: Herschel, Talbot and the Invention of Photography*, p. 49.
22 Schaaf, p. 130.
23 Letter by William Henry Fox Talbot, dated January 30, 1839, published in the *Literary Gazette*, February 2, 1839. Quoted in Gail Buckland, *Fox Talbot and the Invention of Photography* (Boston, MA: David R. Godine, Publisher, 1980), p. 43. It is unknown if Talbot was actually preparing a report, or whether his claim to be doing so was an attempt to respond to the announcement of the daguerreotype.
24 Gail Buckland, *Fox Talbot and the Invention of Photography*, p. 38.
25 William Henry Fox Talbot, *The Pencil of Nature* (London: Longman Brown, Green & Longmans, 1844–46), n.p. The book was reproduced in facsimile by Da Capo Press in 1969.
26 This experiment is described in Larry J. Schaaf, *Out of the Shadows: Herschel, Talbot and the Invention of Photography*, p. 40.
27 Quoted in Larry J. Schaaf, *Out of the Shadows: Herschel, Talbot and the Invention of Photography*, p. 42.
28 Quoted in Gail Buckland, *Fox Talbot and the Invention of Photography*, p. 39.
29 See Mary Warner Marien, *Photography and Its Critics: A Cultural History, 1839–1900*, pp. 6, 35.
30 Quoted in Larry J. Schaaf, *Out of the Shadows: Herschel, Talbot and the Invention of Photography*, p. 57.
31 Schaaf, p. 71.
32 Schaaf, p. 75.
33 See Mary Warner Marien, *Photography and Its Critics: A Cultural History, 1839–1900*, p. 17.
34 Quoted in Helmut and Alison Gernsheim, *L. J. M. Daguerre: The History of the Diorama and the Daguerreotype*, 2nd, rev. ed., pp. 101–2.
35 See Marien, *Photography and Its Critics*, p. 3, and the subsequent discussion.

CHAPTER TWO
The Second Invention of Photography (1839–1854)

1 "New Discovery in the Fine Arts," *The New Yorker* (April 13, 1839), excerpted in Merry Foresta and John Wood, *Secrets of the Dark Chamber: The Art of American Daguerreotype* (Washington, DC: Smithsonian Institution Press, 1995), p. 224.
2 "New Discovery in the Fine Arts," p. 223.
3 "Self-operating Processes of Fine Art: The Daguerotype [sic]," *The Museum of Foreign Literature, Science and Art*, 35, n.s. 7 (January–April, 1839), p. 341.
4 For a discussion of the range of these meanings applied to photography see Jens Jäger, "Discourses on Photography in Mid-Victorian Britain," *History of Photography*, vol. 19, no. 4 (1995), pp. 316–21.
5 Fritz Kempe, *Daguerreotypie in Deutschland: Vom Charme der frühen Fotografie* (Seebruck am Chiemsee: Heering Verlag, 1979), p. 62.
6 *The Athenaeum* (December 18, 1847), p. 1304, quoted in Jens Jäger, "Discourses on Photography in Mid-Victorian Britain," *History of Photography*, p. 317.
7 Francis Wey, "Exposé sommaire du but et des principaux éléments du journal," (1851), reprinted in Heinz Buddemeier, *Panorama, Diorama, Photographie* (Munich: Wilhelm Fink Verlag), pp. 253–54.
8 *Alexander's Weekly Messenger* (January 15, 1840), p. 38.
9 "Fine Arts," unsigned review of the Society of British Artists, *The Athenaeum* (April 17, 1847), p. 416.
10 "Self-operating Processes of Fine Art: The Daguerotype [sic]," p. 341.
11 Paul Greenhalgh, *Ephemeral Vistas: The Expositions universelles, Great Exhibitions and World's Fairs, 1851–1939* (Manchester: Manchester University Press, 1988), p. 145.
12 *The Golden Age of British Photography, 1839–1900*, ed. Mark Haworth-Booth (Millerton, NY: Aperture, 1984), p. 18.
13 William Henry Fox Talbot, *Some Account of the Art of Photogenic Drawing, or the Process by which Natural Objects May Be Made to Delineate Themselves without the Aid of the Artist's Pencil* (London: R. & J. S. Taylor, 1839), n.p.
14 Letter dated June 1839, quoted in Gail Buckland, *Fox Talbot and the Invention of Photography* (Boston, MA: David R. Godine, Publishers, 1980), p. 19.
15 William Henry Fox Talbot, *The Pencil of Nature* (1844–46; rpt New York: Da Capo Press, 1869), n.p.
16 Larry J. Schaaf, *The Photographic Art of William Henry Fox Talbot* (Princeton: Princeton University Press, 2000), p. 166.
17 Francis Wey, "Album de la Société héliographique," *La Lumière* (May 18, 1851), p. 58. Quoted in Andre Jammes and Eugenia Parry Janis, *The Art of the French Calotype* (Princeton, NJ: Princeton University Press, 1983), p. 4.
18 Sander Gilman, *Seeing the Insane* (New York: J. Wiley, 1982) p. 189.
19 Hugh W. Diamond, "On the Application of Photography to the Physiognomic and Mental Phenomena of Insanity" (read before the Royal Society, May 22, 1856), reprinted in *The Face of Madness: Hugh W. Diamond and the Origin of Psychiatric Photography*, ed. Sander L. Gilman (New York: Brunner/Mazell, Publishers, 1976), p. 19.
20 Diamond, p. 20.
21 Diamond, p. 24.
22 See Bates Lowry and Isabel Barrett Lowry, *The Silver Canvas: Daguerreotype Masterpieces from the J. Paul Getty Museum* (Los Angeles, CA: The J. Paul Getty Museum, 1998), p. 112.

23 Daniel M. Fox and Christopher Lawrence, *Photographing Medicine: Images and Power in Britain and America Since 1840* (New York: Greenwood Press, 1988), p. 24.

24 Brian Wallis, "Black Bodies, White Science: Louis Agassiz's Slave Daguerreotypes," *Art in America*, vol. 9, no. 2 (Summer 1995), p. 40.

25 Daniel M. Fox and Christopher Lawrence, *Photographing Medicine*, p. 25.

26 For further details, see the discussion in Bates Lowry and Isabel Barrett Lowry, *The Silver Canvas*, pp. 182–85.

27 See Olivier Debroise, *Mexican Suite: A History of Photography in Mexico*, trans. Stella de Sá Rego (Austin, TX: University of Texas Press, 2001), pp. 164–67.

28 Gina Rodriguez Hernandez, "Cerro Gordo, abril 18 de 1847," in *Alquimia*, vol. 1, no. 2 (April 1998), pp. 44–45.

29 See Olivier Debroise, *Mexican Suite: A History of Photography in Mexico*, p. 166.

30 Beaumont Newhall, *The Daguerreotype in America* (New York: Dover Publications, Inc., 1976, 3rd rev. ed.), p. 88.

31 James R. Ryan, *Picturing Empire: Photography and Visualization of the British Empire* (Chicago, IL: University of Chicago Press, 1997), p. 28.

32 Alkis X. Xanthakis, *History of Greek Photography, 1839–1960* (Athens: Hellenic Literary and Historical Archives Society, 1988) pp. 28–29.

33 Xanthakis, p. 30.

34 Yeshayahu Nir, *The Bible and the Image: The History of Photography in the Holy Land, 1839–1899* (Philadelphia: University of Pennsylvania Press, 1985), p. 35. I am indebted to Nir's discussion, and the work of Kathleen Stewart Howe in *Revealing the Holy Land: The Photographic Exploration of Palestine* (Santa Barbara, CA: Santa Barbara Museum of Art, 1997).

35 Quoted in Kathleen Stewart Howe, *Revealing the Holy Land*, p. 23. These daguerreotypes are now lost. Also see Robert Hershkowitz, *The British Photographer Abroad: The First Thirty Years* (London: Robert Hershkowitz Ltd., 1980), p. 80.

36 For a full discussion of the commission and its work, see Jammes and Janis, *The Art of the French Calotype*, especially pp. 52–66.

37 Malcolm Daniel, *The Photographs of Edouard Baldus* (New York: The Metropolitan Museum of Art, 1994), pp. 21–22.

38 Eugenia Parry Janis and Josiane Sartre, *Henri Le Secq: Photographe de 1850–1860* (Paris: Flammarion, 1986), p. 116.

39 This image is discussed in William Welling, *Photography in America: The Formative Years* (Albuquerque, NM: University of New Mexico Press, 1978), p. 28.

40 *Daguerrean Journal*, vol. 1, no. 4 (January 1, 1851), p. 117. Quoted in Michael L. Carlebach, *The Origins of Photojournalism in America* (Washington, DC: Smithsonian Institution Press, 1992), p. 27.

41 Janet E. Buerger, *French Daguerreotypes* (Chicago, IL: University of Chicago Press, 1989), p. 28.

42 See *Photography in Russia, 1840–1940*, ed. David Elliott (London: Thames and Hudson, 1992), p. 28.

43 *Photography in Russia*, p. 27.

44 Francis Wey, "Du Naturalisme dans l'art de don principe et ses conséquences," (*La Lumière*, vol. 1, 1851), reproduced in Heinz Buddemeier, *Panorama, Diorama, Photographie*, p. 281 The quotation reads "et leurs portraits ne ressemblent point, comme certaines épreuves daguerriennes, des merlans frits collés sur un plat d'argent."

45 Elizabeth Anne McCauley, *Industrial Madness: Commercial Photography in Paris, 1848–1871* (New Haven, CT: Yale University Press, 1994), p. 154.

46 T. S. Arthur, *Godey's Lady's Book*, 1849. Quoted in Floyd Rinhart and Marion Rinhart, *The American Daguerreotype* (Athens, GA: University of Georgia Press, 1981), pp. 113–14.

47 Quoted in Robert Taft, *Photography and the American Scene* (1938; rpt New York: Dover Publications, 1964), p. 76.

48 Alan Trachtenberg, *Reading American Photographs: Images as History, Mathew Brady to Walker Evans* (New York: Hill and Wang, 1989), p. 26.

49 Deborah Willis, *Reflections in Black: A History of Black Photographers, 1840 to the Present* (New York: W. W. Norton & Co., 2000), p. 4.

50 Michael L. Carlebach, *The Origins of Photojournalism in America*, pp. 22–23.

51 Matthew R. Isenburg, "Southworth and Hawes: The Artists," in John Woods, *The Daguerreotype: A Sesquicentennial Celebration* (Iowa City, IA: University of Iowa Press, 1989), p. 75.

52 Albert Sands Southworth, "The Early History of Photography in the United States," in *Photography: Essays and Images*, Beaumont Newhall, ed. (New York: Museum of Modern Art, 1980), p. 41.

53 Sara Stevenson, "David Octavius Hill and Robert Adamson," in *British Photography in the Nineteenth Century: The Fine Art Tradition* (New York: Cambridge University Press, 1989), p. 53.

54 Talbot quoted in Larry J. Schaaf, *The Photographic Art of William Henry Fox Talbot* (Princeton, NJ: Princeton University Press, 2000), pp. 19, 59.

55 Letter from Hill to Mr. Bicknell, dated January 17, 1848, quoted in Colin Ford and Roy Strong, eds, *An Early Victorian Album: The Photographic Masterpieces (1843–1847) of David Octavius Hill and Robert Adamson* (New York: Alfred A. Knopf, 1976), p. 321.

56 Sara Stevenson, "David Octavius Hill and Robert Adamson," p. 43.

57 See discussion in Richard Rudisill, *Mirror Image: The Influence of the Daguerreotype on American Society* (Albuquerque, NM: University of New Mexico Press, 1971), pp. 218–19.

58 Sir Francis Palgrave, "The Fine Arts of Florence," *Quarterly Review*, vol. 66 (1840), p. 326.

59 "Photogenic Drawing, or Drawing by Agency of Light," *Edinburgh Review*, vol. 154 (January 1843), pp. 160–61, 169.

60 John Ruskin, *The Works of John Ruskin*, ed. E. T. Cook and A. Wedderburn (London: G. Allen, 1903–1912), vol. 33, p. 304.

61 "Otkrytie Dagera," in *Khudozhestvennaia gazeta*, no. 2 (January 15, 1840), pp. 11–12, quoted in *Photography in Russia*, p. 26.

62 Eugène Delacroix, "Le dessin sans maître, par Mme Elisabeth Cavé," *Revue des Deux Mondes*, vol. 3 (September 15, 1850), pp. 1144–45.

63 Gustave Flaubert, *Correspondance (1850–1854)* (Paris: Louis Conard, 1910), p. 427 and C. A. Sainte-Beuve, "De la littérature industrielle," *Portraits Contemporains*, vol. 2 (Paris: Michel Lévy Frère, 1889), p. 434. The comments appeared in September 1839.

64 Enne. Jn. Delécluze, "Exposition de 1850," *Journal des Débats* (March 21, 1851), n.p.

65 For a fuller discussion of photography's critics, see Mary Warner Marien, *Photography and Its Critics: A Cultural History, 1839–1900* (New York: Cambridge University Press, 1997), pp. 64–73.

66 For Francis Wey's discussion, see "Du Naturalisme dans l'art de don principe et ses conséquences," (*La Lumière*, vol. 1, 1851), reproduced in Heinz Buddemeier, *Panorama, Diorama, Photographie* (Munich: Wilhelm Fink Verlag, 1970), pp. 267–84.

67 See William Newton's address to the Photographic Society of London, printed in the *Journal of the Photographic Society*, vol. 1 (March 3, 1853), p. 6.

68 Gustave Le Gray, *Photographie: traité nouveau théorique et practique des procédés et manipulations sur papier ... et sur verre* (Paris: Lerebours et Secretan [1852]), p. 1. See also p. 3.

69 Michel Foucault, *Discipline and Punishment: The Birth of the Prison*, trans. Alan Sheridan (New York: Vintage Books, 1979), p. 187.

CHAPTER THREE
The Expanding Domain (1854–1880)

1 [Lady Elizabeth Eastlake], (Untitled Book Review) *Quarterly Review* 101 (January–April 1857), pp. 442–43.

2 Keith F. Davis, "'A Terrible Distinctness': Photography and the Civil War Era," in *Photography in Nineteenth-Century America*, ed. Martha A. Sandweiss (New York: Harry N. Abrams, Inc., 1991), p. 137.

3 See the contemporary description from *New York Review*, reproduced in William Welling, *Photography in America: The Formative Years, 1839–1900* (Albuquerque, NM: University of New Mexico Press, 1978), p. 265.

4 Oliver Wendell Holmes, "The Stereoscope and the Stereograph," *Atlantic Monthly*, vol. 3 (June 1859), p. 744.

5 Oliver Wendell Holmes, "Sun-Painting and Sun-Sculpture," *Atlantic Monthly*, vol. 8 (July 1861), pp. 14–15.

6 Oliver Wendell Holmes, "The Stereoscope and the Stereograph," p. 747.

7 "Stereoscope: or Travel Made Easy," *Athenaeum*, no. 1586 (March 20, 1858), p. 371.

8 *Revue Photographique* (1862), p. 151, quoted in André Rouillé, "The Great Photography Debate," *Impact of Science on Society*, vol. 42, no. 4 (no. 168), p. 292.

9 Elizabeth Anne McCauley, *A. A. E. Disdéri and the Carte de Visite Portrait Photograph* (New Haven, CT: Yale University Press, 1985), p. 220.

10 For information on photographic journals in the United States, see William and Estelle Marder, "Nineteenth-century American Photographic Journals: A Chronological List," *History of Photography*, vol. 17, no. 1 (Spring 1993), pp. 95–100.

11 Oliver Wendell Holmes, "The Stereoscope and the Stereograph," p. 748.

12 [John W. Draper], "Editorial Miscellany," *American Journal of Photography*, vol. 3 (1861) p. 320.

13 Callwell's *Small Wars: Their Principles and Purpose* was published in 1899. See the discussion in James R. Ryan, *Picturing Empire: Photography and the Visualization of the British Empire* (Chicago, IL: University of Chicago Press, 1997), p. 73. Also of related interest is André Rouillé, *L'Empire de la Photographie, 1839–1870* (Paris: Le Sycomore, 1982).

14 James R. Ryan, p. 73.

15 [Eugéne Durieu], "Rapport," *Bulletin de la Société Française de photographie* (February 1856), p. 50.

16 Donald E. English, *Political Uses of Photography in the Third French Republic, 1871–1914* (Ann Arbor, MI: University of Michigan Research Press, 1984), p. 8.

17 Helmut and Alison Gernsheim, *Roger Fenton: Photographer of the Crimean War* (London: Secker & Warburg, 1954), pp. 12–13.

18 See the discussion in Mike Weaver, "Le Gray—Fenton—Watkins," in *The Art of Photography, 1839–1989*, ed. Mike Weaver (New Haven, CT: Yale University Press, 1989), p. 96. Indeed, it may not have been the actual spot where the tragic military offensive took place. See Jennifer Green-Lewis, *Framing the Victorians: Photography and the Culture of Realism* (Ithaca, NY: Cornell University Press, 1996), p. 126.

19 *Photographic Journal*, vol. 2 (1855), p. 221.

20 Fenton may not have been the first to offer photographic instruction to Queen Victoria and Prince Albert. They may have been taught by Dr. Ernst Becker, who was appointed librarian to Prince Albert and an assistant tutor to the princes. See Francis Dimond and Roger Taylor, *Crown and Country; The Royal Family and Photography, 1842–1910* (New York: Viking, 1987), p. 14.

21 For a study of his work and reprints of his letters from the Crimea, see *Jean-Charles Langlois: La Photographie, La Peinture, La Guerre. Correspondence Inédite de Crimée (1855–1856)*, ed. François Robichon and André Rouillé (Nîmes: Éditions Jacqueline Chambon, 1992).

22 See *New York Times* (July 26, 1864), p. 4.

23 Cook's life and work are recounted in Jack C. Ramsay, Jr., *Photographer Under Fire: The Story of George S. Cook, 1819–1902* (Green Bay, WI: Historical Resources Press, 1994).

24 Quoted in Josephine Cobb, "Photographers of the Civil War," *Military Affairs*, vol. 26, no. 2 (Fall 1962), p. 128.

25 Mary Panzer, *Mathew Brady and the Image of War* (Washington, DC: Smithsonian Institution Press, 1997), p. 103.

26 Vicki Goldberg, *The Power of Photography* (New York: Abbeville Publishing Group, 1991), p. 77.

27 Geo. Alfred Townsend ("Gath"), "The *New York World* Interview with Mathew Brady," in Vicki Goldberg, *Photography in Print* (New York: Simon and Schuster, 1981), p. 204.

28 *New York Times* (Monday, July 21, 1862), p. 5.

29 Described in Jack C. Ramsay, *Photographer Under Fire*, p. 71.

30 Alexander Gardner, *Gardner's Sketchbook of the Civil War* (1865–66; rpt. New York, Dover, 1959), p. 36.

31 Kathleen Collins, "Living Skeletons; *Carte-de-visite* Propaganda in the American Civil War," *History of Photography*, vol. 12, no. 2 (April–June 1988), p. 104.

32 Collins, pp. 103–20. A *carte de visite* in the William C. Darrah collection shows the Elmira prison as neat and orderly rows of white tents. See his *Cartes de Visite in Nineteenth Century Photography* (Gettysburg, PA: W. C. Darrah, Publisher, 1981), p. 83, p. 189.

33 *New York Times* (Monday, October 20, 1862), p. 5.

34 Oliver Wendell Holmes, "Doings of the Sunbeam," *Atlantic Monthly*, vol. 12 (July 1863), pp. 11–12.

35 At one point, the photograph was credited to Timothy O'Sullivan by Gardner.

36 Wendy Watriss and Lois Parkinson Zamora, *Image and Memory: Photography from Latin America, 1866–1994* (Austin, TX: University of Texas Press, 1998) pp. 7, 411.

37 For this information, and a comprehensive discussion of photography during the French Commune, I am indebted to Donald E. English, in his book, *Political Uses of Photography in the Third French Republic, 1871–1914*, for my discussion of the French Commune.

38 Albert Boime, *Art and the French Commune* (Princeton: Princeton University Press, 1995), p. 5. Boime's book is a lucid account of the reaction of artists to the events of the Paris Commune.

39 Quoted in Boime, p. 194.

40 For more discussion of this print, see English, p. 24.

41 "Photographs from the Philippine Islands," *Photographic News*, no. 61 (November 4, 1859), p. 99.

42 S. Bourne, "Narratives of a Photographical Trip to Kashmir and Adjacent Districts," *British Journal of Photography* (November 23–28, 1866), pp. 559–60.

43 *The Golden Age of British Photography, 1839–1900*, ed. Mark Haworth-Booth (Millerton, New York: Aperture, 1984), p. 104.

44 B. A. and H. K. Henisch, "James Robertson of Constantinople: A Chronology," *History of Photography*, vol. 14, no. 1 (January–March 1990), pp. 30–31.

45 Mark Haworth-Booth, ed., *The Golden Age of British Photography*, p.104, and "Photographieren auf Forschungsreisen: Robert Schlagintweit und seine Brüder erforschen die Alpen, Indien und Hochasien (1850–1857), in *Silber und Salz: Zur Frühzeit der Photographie im deutschen Sprachenraum, 1839–1860*, ed. Bodo von Dewitz and Einhard Matz, (Cologne and Heidelberg: Edition Braus, 1989), pp. 310–33.

46 Clark Worswich and Ainslie Embree, *The Last Empire: Photography in British India, 1855–1911* (Millerton, NY: Aperture, 1976), pp. 4–5. I am indebted to this book for information on the history of photography in India, as well as to Christopher Pinney's *Camera Indica: The Social Life of Indian Photography* (Chicago, IL: University of Chicago Press, 1997).

47 Vidya Dehejia, *India Through the Lens, 1840–1911* (Washington, DC: Freer Gallery of Art and Arthur M. Sackler Gallery, Smithsonian Institution, 2000), p. 17.

48 See Roberta Wue, "Picturing Hong Kong: Photography Through Practice and Function," in *Picturing Hong Kong* (New York: Asia Society Galleries and George Braziller, 1997), p. 28, n. 5. I am indebted to Wue for her insightful essay on early Hong Kong photography.

49 John Thomson, quoted in Roberta Wue, "Picturing Hong Kong," p. 38. For all his years in Asia, Thomson had two assistants, Akum and Ahong, the latter of whose name resembles A-Hung and Afong. For Ahong, see Stephen White, *John Thompson: A Window to the Orient* (New York: Thames and Hudson, 1985), p. 10.

50 John Thomson, quoted in Roberta Wue, "Picturing Hong Kong," p. 37. Afong was active from about 1859 to 1900.

51 Clark Worswick, *Japan: Photographs, 1854–1905* (New York: A Pennwick/Alfred A. Knopf, 1979), p. 30. Also see Terry Bennett, *Early Japanese Images* (Rutland, VT: Charles E. Tuttle Company, 1996), pp. 31–32. I am indebted to Worswick and Bennett for information on Japanese photography. Long considered lost, some of the Eliphalet Brown daguerreotypes may be held in Japanese museums. See Bennett, above, pp. 30–31 and Hugh Cortazzi and Terry Bennett, *Japan: Caught in Time* (New York: Weatherhill, 1995) p. 31.

52 Julia Meech, "Woodblock Prints and Photographs: Two Views of Nineteenth-Century Japan," *Asian Arts* (Summer 1990), p. 56.

53 Clark Worswick, *Japan*, p. 136, and Terry Bennett, *Early Japanese Images*, p. 144.

54 Bill Jay, *Victorian Cameraman: Francis Frith's Views of Rural England, 1850–1898* (Newton Abbot, Devon: David & Charles, 1973).

55 Richard Parkhurst and Denis Gérard, *Ethiopia Photographed* (London: Kegan Paul International, 1996), p. 20.

56 Kathleen Stewart Howe maintains that De Clercq's religious photographs are unusual among French photographs of the Holy Land. She suggests that, unlike English religious education, which stressed Bible reading and a sense of historical place, French religious study emphasized Catholic creed. See *Revealing the Holy Land: The Photographic Exploration of Palestine*, essay by Kathleen Stewart Howe (Santa Barbara, CA: Santa Barbara Museum of Art, 1997), p. 28. The relationship between surveys and photography is also discussed in Nissan N. Perez, *Focus East: Early Photography in the Near East, (1839–1885)* (New York: Harry N. Abrams, Inc., 1988), pp. 77–80.

57 See Elizabeth Anne McCauley, *Industrial Madness*, p. 306, and Keith B. Davis, *Désiré Charnay, Expeditionary Photographer* (Albuquerque, NM: The University of New Mexico Press, 1981), p. 19.

58 Keith David, *Désiré Charnay*, p. 21.

59 Quoted in Mark Haworth-Booth, ed., *The Golden Age of British Photography*, p. 114.

60 William Goetzmann, *Army Exploration in the American West, 1803–1863* (New Haven, CT: Yale University Press, 1959), p. 427–29. The border survey was not the first time that a photographer accompanied a survey team in Canada. The Assiniboine and Saskatchewan topographical and geological survey of 1858 was photographed by an engineer-photographer, Humphrey Lloyd Hime. See Richard J. Huyda, *Camera in the Interior: 1858, H. L. Hime, Photographer: The Assiniboine and Saskatchewan Exploring Expedition* (Toronto: The Coach House Press, 1975).

61 William H. Goetzmann, *Exploration and Empire: The Explorer and the Scientist in the Winning of the American West* (New York: Alfred A. Knopf, 1967), p. 231.

62 William H.Goetzmann, *Army Exploration in the American West*, p. 5.

63 William H.Goetzmann, *Exploration and Empire*, p. 303–04.

64 Gardner was not alone in associating the Leutze mural with the railroad. The artist Fanny Palmer used the title in a 1868 lithograph showing the railroad crossing the west, and painter Andrew Melrose painted *Westward the Star of Empire*, a strange view in which the train glows in a way reminiscent of J. M. W. Turner's rendering of the train as sublime in *Rain, Steam, and Speed*. For more on Leutze and on art and the railroad, see *The West as America: Reinterpreting Images of the Frontier, 1820–1920*, ed. William Truettner, (Washington, DC: Smithsonian Institution Press, 1991).

65 *New York Times* (May 8, 1867), p. 8.

66 James D. Horan, *Timothy O'Sullivan: America's Forgotten Photographer* (New York: Doubleday & Co., 1966), pp. 217–18.

67 Horan, p. 221.

68 Peter Bacon Hales, *William Henry Jackson and the Transformation of the American Landscape* (Philadelphia, PA: Temple University Press, 1988), p. 95. I am indebted to Hales's work for my understanding of Jackson.

69 Hales, p. 96.

70 Robert Bartless Haas, *Muybridge, Man in Motion* (Berkeley, CA: University of California Press, 1976), p. 51.

71 For more information on Modoc war photography, see Peter Palmquist, "Imagemakers of the Modoc War: Louis Heller and Eadweard Muybridge," *Journal of California Anthropology* (Winter 1977), pp. 206–41.

72 Alan Axelrod, *Chronicle of the Indian Wars: From Colonial Times to Wounded Knee* (New York: Prentice Hall General Reference, 1993), pp. 208–09.

73 Axelrod, p. 203.

74 James D. Horan, *Timothy O'Sullivan*, p. 285.

75 Robert M. Utley and Wilcomb E. Washburn, *The American Heritage: History of the Indian Wars* (New York: American Heritage Publishing Company, 1977), p. 266.

76 Oliver Wendell Holmes, *Atlantic Monthly*, vol. 10 (May 1863).

77 It exists today as the Armed Forces Institute of Pathology. For more information on medicine during the American Civil War, see Stanley B. Burns, *Early Medical Photography in America* (New York: The Burns Archive, 1983), pp. 1444–69, which is a reprint of the August 1980 issue of *New York State Journal of Medicine*.

78 See *Confederate States Medical and Surgical Journal* (rpt. Metuchen, N.J.: The Scarecrow Press: 1976), p. 25.

79 Ann Thomas, "The Search for Pattern," in *Beauty of Another Order: Photography in Science*, ed. Ann Thomas (New Haven, CT: Yale University Press, 1997), p. 99.

80 Quoted in Ann Thomas, "The Search for Pattern," p. 100.

81 Frederic Luther, *Microfilm: A History, 1839–1900* (Annapolis, MD: The National Microfilm Association, 1959), pp. 23–46.

82 For a discussion of this book, and nineteenth-century photographically illustrated books, see Carol Armstrong, *Scenes in a Library: Reading the Photograph in the Book, 1843–1875* (Cambridge, MA: The MIT Press, 1998).

83 This event is extensively described in Ann Thomas, "Capturing Light: Photographing the Universe," in Ann Thomas, ed., *Beauty of Another Order: Photography in Science*, pp. 191–93.

84 For a full discussion, see Ann Thomas, "The Search for Pattern," pp. 86–88.

85 Oliver Wendell Holmes, "Doings of the Sunbeam," p. 15.

86 Quoted in Nancy Ann Roth, "Electrical Expressions: The Photographs of Duchenne de Boulogne," *Multiple Views*, ed. Daniel P. Younger (Albuquerque, NM: University of New Mexico Press, 1991), p. 116.

87 Paul Ekman, "Introduction," Charles Darwin, *The Expression of the Emotions in Man and Animals* (New York: Oxford University Press, 1998), p. xiii. I am indebted to Ekman's research on Darwin and his use of photography, which appears throughout his edition of the 1872 book.

88 John O'Neill, "The Question of an Introduction: Understanding and the Passion of Ignorance," in *Freud and the Passions*, ed. John O'Neill (University Park, PA: The Pennsylvania State University Press, 1966), p. 10.

89 Joan Copjec, "*Flavit et Dissipati Sunt*," in *October: The First Decade, 1976–1986*, ed. Annette Michelson, Rosalind Krauss, Douglas Crimp, and Jon Copjec (Cambridge, MA: The MIT Press, 1987), p. 300.

90 Quoted in Sigrid Schade, "Charcot and the Spectacle of the Hysterical Body: The 'Pathos Formula' as an Aesthetic Staging of Psychiatric Discourse — A Blind Spot in the Reception of Warburg," *Art History*, vol. 18, no. 4 (December 1995), p. 510.

91 Roslyn Poignant, "Surveying the Field of View: The Making of the RAI Photographic collection," in *Anthropology and Photography, 1860–1920*, ed. Elizabeth Edwards (New Haven, CT: Yale University Press, 1992), p. 51.

92 "Elena Barkhatova, "Realism and Document: Photography as Fact," in *Photography in Russia, 1840–1940*, ed. David Elliott (London: Thames and Hudson, 1992), p. 42. I am indebted to the essays in Elliott's book for an understanding of Russian photography.

93 Roslyn Poignant, "Surveying the Field of View, pp. 47–48. Edwards's book is a fine source for information on nineteenth- and early twentieth-century anthropological photography.

94 See Bernard S. Cohn, "Representing Authority in Victorian India," in *The Invention of Tradition*, ed. Eric Hobsbawm and Terence Ranger (New York: Cambridge University Press, 1983), pp. 167, 183).

95 Edward Said, *Orientalism* (London: Routledge & Kegan Paul, 1978). The application of the term Orientalism to Asia has been much criticized in recent years. But in its loosest meanings, the word has come to signal illicit looking.

96 Clark Worswick, *The Last Empire: Photography in British India, 1855–1911* (Millerton, NY: Aperture, 1976), p. 9, and Robert A. Sobieszek and Carney E. S. Gavin, *Remembrance of the Near East: The Photographs of Bonfils, 1867–1907* (Rochester, NY: International Museum of Photography at George Eastman House, 1980), n.p.

97 Vidya Dehejia, *India Through the Lens, 1840–1911*, p. 19.

98 Todd D. Smith, "Gay Male Pornography and the East: Re-orienting the Orient," *History of Photography*, 18 (Spring 1994), p. 17.

99 For a discussion of pornography, see Elizabeth Anne McCauley, *Industrial Madness, 1848–1871*.

100 Roslyn Poignant, "Surveying the Field of View," p. 45.

101 The name was later changed to the Bureau of American Ethnology (BAE).

102 For information on the American West and photography, see *Native Nations: Journeys in American Photography* (London: Barbican Art Gallery, 1998); Merry A. Foresta, *American Photographs: The First Century* (Washington, DC: Smithsonian Institution Press, 1996) and *The West as America: Reinterpreting*

Images of the Frontier, 1820–1920, ed. William Truettner (Washington, DC: Smithsonian Institution Press, 1991).

103 Wendy Watriss and Lois Parkinson Zamora, *Image and Memory*, p. 43.

104 See Felicity Ashbee, "William Carrick: A Scots Photographer in St. Petersburg (1827–1878)," *History of Photography*, vol. 2, no. 3 (July 1978), p. 211.

105 Mary Bennett and Paul C. Juhl, *Iowa Stereographs: Three-dimensional Visions of the Past* (Iowa City, IA: University of Iowa Press, 1997).

106 *Art Journal* (1860), p. 221, from frontispiece of Richard J. Huyda, *Camera in the Interior: 1858, H. L. Hime, Photographer: The Assiniboine and Saskatchewan Exploring Expedition* (Toronto: The Coach House Press, 1975).

107 Andre Jammes and Eugenia Parry Jani, *The Art of the French Calotype* (Princeton, NJ: Princeton University Press, 1983), pp. 162, 185.

108 Francis Frith, "The Art of Photography," *Art Journal*, 5 (1859), pp. 71–72 (emphases Frith).

109 C. Jabez Hughes, "On Art Photography," *American Journal of Photography*, 3 (1861), p. 261.

110 Christopher Date and Anthony Hamber, "The Origins of Photography at the British Museum," *History of Photography*, vol. 14, no. 4 (1990), p. 316.

111 Valerie Lloyd, *Roger Fenton: Photographer of the 1850s* (London: South Bank Board, 1988), p. 11.

112 Abigail Solomon-Godeau, *Photography at the Dock: Essays on Photographic History, Institutions, and Practices* (Minneapolis, MN: University of Minnesota Press, 1991), pp. 158–59.

113 See Howard B. Leighton, "The Lantern Slide and Art," *History of Photography*, vol. 8, no. 2 (1984), pp. 107–18.

114 Marcus Aurelius Root, *The Camera and the Pencil* (1864; rpt. Pawlet, VT: Helios, 1971), p. 28.

115 "Stereoscopes for Amateurs—Process of Producing Stereoscopic Photographs," *Scientific American*, 2 (June 2, 1860) p. 361. For a discussion of art reproduction and visual literacy, see Mary Warner Marien, *Photography and Its Critics* (New York: Cambridge University Press, 1997).

116 "Fine Arts: New Publications" [review of the exhibition "Gems of Art Treasures"], *Athenaeum*, 1549 (July 4, 1857), p. 856.

117 Rembrandt Peale, "Portraiture," *Crayon*, 4, Parat II (February 1857), p. 44 (emphasis Peale).

118 Charles Baudelaire, "Salon of 1859," in *Art in Paris*, p. 154.

119 Rembrandt Peale, loc. cit.

120 Eugène Delacroix, "Le dessin sans maître, par Mme. Elisabeth Cavé," *Revue des Deux Mondes*, 3 (September 15, 1850), pp. 1144–45.

121 For an international discussion of the painters who might have been influenced by photography see Nissan N. Perez, *Focus East: Early Photography in the Near East, 1839–1885* (New York: Harry N. Abrams, 1988), pp. 66–67.

122 A later version (1858) included drawing derived from photographs taken by Nadar.

123 Plate note, in Maria Morris Hambourg, Françoise Heilbrun, and Philippe Néagu, *Nadar* (New York: The Metropolitan Museum of Art, 1995), p. 114.

124 Quoted in Maria Morris Hambourg, "A Portrait of Nadar," in Maria Morris Hambourg, Françoise Heilbrun, and Philippe Néagu, *Nadar*, p. 25.

125 See Elizabeth Anne McCauley, *Industrial Madness*, p. 124.

126 Maria Morris Hambourg, plate note, in Maria Morris Hambourg, Françoise Heilbrun, and Philippe Néagu, *Nadar*, p. 113.

127 For a history of the *tableau vivant*, see Heinz K. Henisch and Bridget A. Henisch, *The Photographic Experience, 1839–1914* (University Park, PA: The Pennsylvania State University Press, 1994), pp. 70–75.

128 Mark Haworth-Booth, ed., *The Golden Age of British Photography, 1839–1900*, p. 94.

129 For more information on Madame Warton's programs see Jack W. McCullough, *Living Pictures on the New York Stage* (Ann Arbor, MI: UMI Research Press, 1983), pp. 38–47.

130 William Crawford, *The Keepers of Light* (Dobbs Ferry, N.Y.: Morgan & Morgan, 1979), p. 55. This book contains a useful key to the allegorical significance of the figures in *The Two Ways of Life*.

131 Anne Anninger and Julie Mellby, *Salts of Silver, Toned with Gold: The Harrison D. Horblit Collection of Early Photography* (Cambridge, MA: The Houghton Library, Harvard University, 1999), p. 116.

132 Grace Seiberling, *Amateurs, Photography, and the Mid-Victorian Imagination* (Chicago, IL: University of Chicago Press, 1986), p. 139.

133 From a letter to John Herschel reproduced in Helmut Gernsheim, *Julia Margaret Cameron: Her Life and Photographic Work* (Millerton, NY: Aperture, 1975), p. 14.

134 Julia Margaret Cameron, "The Annals of My Glass House," in Beaumont Newhall, ed., *Photography: Essays and Images* (New York: Museum of Modern Art, 1980), p. 137.

135 See Mike Weaver, *Julia Margaret Cameron, 1815–1879* (Boston, MA: New York Graphic Society/Little Brown Company, 1984), p. 138.

136 Naomi Rosenblum, *A History of Women Photographers* (New York: Abbeville Press, 1994), p. 302.

137 Virginia Dodier, "Clementina, Viscountess Hawarden," in Mike Weaver, *British Photography in the Nineteenth Century: The Fine Art Tradition* (New York: Cambridge University Press, 1989), p. 145.

138 William Culp Darrah, "Nineteenth-Century Women Photographers," *Shadow and Substance: Essays on the History of Photography*, ed. Kathleen Collins (Bloomfield Hills, MI: The Amorphous Institute Press, 1990) p. 89.

139 Jabez Hughes, "Photography as an Industrial Occupation for Women," *British Journal of Photography* (May 9, 1873), p. 223.

140 William Culp Darrah, "Nineteenth-Century Women Photographers," p. 89.

141 [Robert Cecil] Unsigned, untitled review, *Quarterly Review*, vol. 116, no. 232 (July and October 1864), p. 498.

142 Cecil, p. 499.

143 Thomas Thurston, "Hearsay of the Sun: Photography, Identity and the Law of Evidence in Nineteenth-Century American Courts," http://chmn.gmu.aq/photos/essay/intro.htm (February 1, 1999).

144 *The American Law Register* 1 (January, 1869) hyper-text project http://chmn.gmu.aq/photos/text/17ALR1.htm

145 Maria Morris Hambourg, Pierre Apraxine, Malcolm Daneil, Jeff L. Rosenheim, and Virginia Heckert, *The Waking Dream: Photography's First Century, Selections from the Gilman Paper Company Collection* (New York: The Metropolitan Museum of Art, 1993), p. 275.

146 Carol Mavor, *Pleasures Taken: Performances of Sexuality and Loss in Victorian Photographs* (Durham, NC: Duke University Press, 1995), and Susan H. Edwards, "Pretty Babies: Art Erotica or Kiddie Porn?" *History of Photography*, vol. 18, no. 1 (Spring 1994) pp. 38–46.

147 An exception is Captain W. W. Hooper's photographs of the Madras famine, 1876–77.

148 Quoted in John Falconer, "Willoughby Wallace Hooper: 'a craze about photography,'" *Photographic Collector*, vol. 4, no. 3 (Winter 1983), p. 259.

149 For photographs of the Suez Canal, see Nissan N. Perez, *Focus East: Early Photography in the Near East, 1839–1885* (New York: Harry N. Abrams, 1988).

150 See William Newton's address to the Photographic Society of London, printed in *Journal of the Photographic Society*, 1 (March 3, 1853), p. 6.

151 John Ruskin, *The Works of John Ruskin*, ed. E. T. Cook and A. Wedderburn (London: G. Allen, 1903–1912), vol. 11, p. 212.

152 Ruskin, *Works*, vol. 20, pp. 96–97.

153 Henri de la Blanchère, *L'Art du photographe* (Paris: Amyot Editeur, 1859), p. 3.

CHAPTER FOUR

Photography in the Modern Age (1880–1918)

1 Keith F. Davis, *An American Century of Photography: From Dry-Plate to Digital*, 2nd ed. (Kansas City, MO: Hallmark Cards, Inc., 1999), p. 16.

2 Margarett (sic) Loke, ed., *The World as it Was, 1865–1921: A Photographic Portrait from the Keystone-Mast Collection* (New York: Summit Books, 1980), p. 12.

3 Loke, ed., p.16.

4 Ulrich Keller, "Photojournalism Around 1900: The Institutionalization of a Mass Medium," in *Shadow and Substance: Essays on the History of Photography*, ed. Kathleen Collins (Bloomfield Hills, MI: The Amorphous Institute Press, 1990), pp. 293–94.

5 James Lawrence Breese, "The Relations of Photography to Art," *Cosmopolitan*, vol. 18, no. 2 (December 1894), p. 140.

6 See Malek Alloula, *The Colonial Harem* (Minneapolis, MN: University of Minnesota Press, 1986).

7 Michael Lesy, *Dreamland: America at the Dawn of the Twentieth Century* (New York: The New Press, 1997), pp. xi–xii.

8 H. Roger Grant, *Railroad Postcards in the Age of Steam* (Iowa City, IA: University of Iowa Press, 1994), p. 4.

9 J. Wells Champney, "Fifty Years of Photography," *Harper's New Monthly Magazine*, vol. 79, no. 471 (August 1889), p. 366.

10 Emile Zola, *Le Roman expérimental* (Paris: Bernouard, 1982), p. 52.

11 Peter Henry Emerson, "Photography: A Pictorial Art," in *Amateur Photographer*, no. 3 (March 19, 1886), p. 138.

12 Peter Henry Emerson, *Naturalistic Photography for Students of the Art*, 1st ed. (1889; rpt New York: Arno Press, 1972), p. 21, and Peter Henry Emerson, "Photography: A Pictorial Art," p. 138.

13 Peter Henry Emerson, "Photography: A Pictorial Art," p. 139.

14 J. C. Strauss, quoted in Christian A. Peterson, "The Photograph Beautiful 1895–1915," *History of Photography*, vol. 16, no. 3 (Autumn 1992), p. 192.

15 Charles H. Caffin, *Photography as a Fine Art* (New York: Doubleday, Page & Co., 1901), pp. vii, 24.

16 Jain Kelly, "Jane Reece," in Naomi Rosenblum, *A History of Women Photographers* (New York: Abbeville Press, 1994), p. 318.

17 For James Craig Annan, I am indebted to the essay, "James Craig Annan: Brave Days in Glasgow," by William Buchanan, in *The Golden Age of British Photography, 1839–1900*, ed. Mark Haworth-Booth (Millerton, NY: Aperture, 1984), pp. 170–73.

18 Frederick H. Evans, "Opening Address," *Photographic Journal*, vol. 59 (April 30, 1900), p. 238.

19 Sadakichi Hartmann, "A Plea for Straight Photography," reproduced in Beaumont Newhall, *Photography: Essays and Images* (New York: Museum of Modern Art, 1980), pp. 185–88.

20 *Photo-Secession*, no. 1 (December, 1902), quoted in William Innes Homer, *Alfred Stieglitz and the Photo-Secession* (Boston, MA: Little, Brown, and Co., 1983), p. 56.

21 For information on the pictorial photographic societies, see William Innes Homer, *Alfred Stieglitz and the Photo-Secession* and Margaret Harker, *The Linked Ring: The Secession Movement in Photography in Britain* (London: Heinemann, 1979).

22 Alfred Stieglitz, "The Photo-Secession," reproduced in Beaumont Newhall, *Photography*, p. 167.

23 Richard Whelan, *Alfred Stieglitz: A Biography* (Boston, MA: Little, Brown, and Co., 1995), p. 236.

24 Quoted in Whelan, p. 224.

25 Robert A. Sobieszek, *The Art of Persuasion: A History of Advertising Photography* (New York: Harry N. Abrams, 1988), p. 22, and Douglas Collins, *The Story of Kodak* (New York: Harry N. Abrams, 1990), p. 157.

26 For Käsebier, I have relied on Barbara L. Michael's monograph *Gertrude Käsebier: The Photographer and Her Photographs* (New York: Harry N. Abrams, Inc, 1992).

27 See the discussions throughout Patricia Johnston, *Real Fantasies: Edward Steichen's Advertising Photography* (Berkeley, CA: University of California Press, 1997).

28 Christian A. Peterson, "The Photograph Beautiful 1895–1915," *History of Photography*, vol. 16, no. 3 (Autumn 1992), p. 199.

29 Charles L. Mitchell, *American Amateur Photographer*, vol. 12 (December 1900), p. 567, quoted in Keith F. Davis, *An American Century of Photography: From Dry-Plate to Digital*, p. 51.

30 Quoted in Malcolm Daniel, *Edgar Degas, Photographer* (New York: The Metropolitan Museum of Art, 1998), p. 24.

31 For a description of Strindberg's photography, see Linda Haverty Rugg, *Picturing Ourselves: Photography and Autobiography* (Chicago, IL: University of Chicago Press, 1997), pp. 81–131.

32 *Bernard Shaw on Photography*, ed. Bill Jay and Margaret Moore (Salt Lake City, UT: Peregrine Smith Books, 1989) p. 90.

33 Robert Doty, *Photo-Secession: Stieglitz and the Fine-Art Movement in Photography* (New York: Dover Publications, Inc., 1978), p. 51.

34 Doty, p. 34.

35 Ulrich F. Keller, "The Myth of Art Photography: An Iconographic Analysis," *History of Photography*, vol. 9, no. 1 (January–March 1985), p. 10.

36 Ulrich F. Keller, "The Myth of Art Photography: A Sociological Analysis," *History of Photography*, vol. 8, no. 4 (October–December 1984), p. 253.

37 Keller, p. 260.

38 Alfred Stieglitz, "Pictorial Photography," *Scribner's*, vol. 26, no. 5 (November 1899), p. 528.

39 Paul Strand, "Photography," *Seven Arts*, 2 (August 1917), p. 524.

40 Alfred Stieglitz, "Our Illustrations," *Camera Work*, no. 49/50 (June 1917), p. 36.

41 Paul Strand, "Photography," p. 524.

42 Strand, p. 524.

43 Peter Bacon Hales, *Silver Cities: The Photography of American Urbanization, 1839–1915* (Philadelphia, PA: Temple University Press, 1983), pp. 243–60. I am indebted to Hales for his discussion of photography and urban reform.

44 Jacob Riis, "Flashes from the Slums: Pictures Taken in Dark Places by the Lightning Process," *Sun* [New York] (February 12, 1888), reprinted in Beaumont Newhall, ed., *Essays and Images*, p. 156.

45 Riis, p. 156.

46 For an insightful critique of Riis, see Sally Stein, "Making Connections with the Camera: Photography and Social Mobility in the Career of Jacob Riis," *Afterimage*, vol. 10, no. 10 (May 1983), pp. 9–16.

47 Quoted in *Photo Story: Selected Letters and Photographs of Lewis W. Hine*, ed. Daile Kaplan (Washington, DC: Smithsonian Institution Press, 1992), p. xxvii.

48 *Photo Story*, p. xxv.

49 Daile Kaplan, "'The Fetish of Having a Unified Thread,': Lewis W. Hine's Reaction to the Use of the Photo Story in *Life* Magazine," *exposure*, vol. 27, no. 2 (1989), p. 10.

50 Larry Peterson, "Producing Visual Traditions among Workers: The Uses of Photography at Pullman, 1880–1980," *Afterimage*, vol. 13, no. 2 (Spring 1992), p. 7.

51 Peterson, p. 5.

52 Wolfgang Ruppert, "Images of the Kaiserreich: the Social and Political Import of Photographs," in *German Photography, 1870–1970: Power of a Medium*, ed. Klaus Honnef, Rolf Sachsse, and Karin Thomas (Cologne: DuMont Buchverlad, 1997), p. 25.

53 Kevin Boyle and Victoria Getis, *Muddy Books and Ragged Aprons: Images of Working-Class Detroit, 1900–1930* (Detroit, MI: Wayne State University Press, 1997), p. 40.

54 David E. Nye, *Image Worlds: Corporate Identities at General Electric, 1890–1930* (Cambridge, MA: The MIT Press, 1985), p. 81.

55 Peter Bacon Hales, *Silver Cities: The Photography of American Urbanization, 1839–1915* (Philadelphia, PA: Temple University Press, 1983), pp. 138–39.

56 Hales, p. 143.

57 Quoted in Melissa Banta and Curtis M. Hinsley, *From Site to Sight: Anthropology, Photography, and the Power of Imagery* (Cambridge, MA: Peabody Museum Press, 1986), p. 61.

58 Linda Dalrymple Henderson's article, "X Rays and the Quest for Invisible Reality in the Art of Kupka, Duchamp, and the Cubists," *Art Journal*, 47 (Winter 1988), p. 331, and Marta Braun, *Picturing Time: The Work of Etienne-Jules Marey (1830–1904)* (Chicago, IL: University of Chicago Press, 1992), p. 291.

59 Quoted in Elizabeth Johns, "An Avowal of Artistic Community: Nudity and Fantasy in Thomas Eakins's Photographs," in *Eakins and the Photograph* (Washington, DC: Smithsonian Institution Press, for the Pennsylvania Academy of Fine Art, 1994), p. 84.

60 Quoted in Marta Braun, *Picturing Time*, p. 296.

61 Marta Braun, "The Expanding Present: Photographing Movement," in *Beauty of Another Order*, ed. Ann Thomas, p. 172.

62 Marta Braun, *Picturing Time*, pp. 237–38.

63 For a discussion of the Gilbreths's work in the context of scientific management, see Martha Banta, *Taylored Lives: Narrative Productions in the Age of Taylor, Veblen, and Ford* (Chicago, IL: University of Chicago Press, 1992), pp. 160–61.

64 Michael O'Malley, *Keeping Watch: A History of American Time* (Washington, DC: Smithsonian Institution Press, 1996), p. 233.

65 Peter E. Palmquist, *Elizabeth Fleischmann: Pioneer X-Ray Photographer* (Berkeley, CA: Judah L. Magnes Museum, 1990), and Bettyann Holtzmann Kevles, *Naked to the Bone: Medical Imaging in the Twentieth Century* (Reading, MA: Addison-Wesley, 1998), p. 125.

66 Joseph J. Corn, ed., *Imagining Tomorrow: History, Technology, and the American Future* (Cambridge, MA: The MIT Press, 1986), p. 14.

67 The importance of the notion of a fourth dimension is exhaustively presented in Linda Dalrymple Henderson's *The Fourth Dimension and Non-Euclidean Geometry in Modern Art* (Princeton, NJ: Princeton University Press, 1983).

68 Giovanni Lista, "Futurist Photography," *Art Journal*, vol. 41, no. 4 (Winter 1981), p. 358.

69 Bettyann Holtzmann Kevles, *Naked to the Bone*, p. 53. My discussion of the X-ray owes to Kevles's research and writing as well as to Linda Dalrymple Henderson's articles, "X Rays and the Quest for Invisible Reality in the Art of Kupka, Duchamp, and the Cubists," *Art Journal*, 47 (Winter 1988), pp. 323–40, and her "Francis Picabia, Radiometers, and X-Rays in 1913," *Art Bulletin*, vol. 71, no. 1 (March 1989), pp. 114–23.

70 Umberto Boccioni, "Futurist Painting: Technical Manifesto," quoted in Stephen Kern, *The Culture of Time and Space, 1880–1918* (Cambridge, MA: Harvard University Press, 1983), p. 185.

71 Christian Brinton, "Evolution Not Revolution in Art," *International Studio*, vol. 69 (April 1913), p. 35.

72 Cosmo Burton, "The Whole Duty of the Photographer," *British Journal of Photography*, vol. 36 (1889), p. 668 [emphases Burton].

73 E. F. im Thurn, "Anthropological Uses of the Camera," *Journal of the Anthropological Institute*, vol. 22 (1893), p. 184.

74 John Thomson, "Exploring with the Camera," *British Journal of Photography*, vol. 32 (1885), p. 373, quoted in James R. Ryan, *Picturing Empire: Photography and the Visualization of the British Empire* (Chicago, IL: University of Chicago Press, 1997), p. 43.

75 See the discussion in James R. Ryan, *Picturing Empire: Photography and the Visualization of the British Empire*, pp. 131–35.

76 Quoted in Ryan, *Picturing Empire*, p. 31.

77 For an extensive discussion of these photographs, see James R. Ryan, *Picturing Empire*, pp. 30–44.

78 The saga of Stanley, Livingstone, and the images their encounter generated can see seen in *David Livingstone and the Victorian Encounter with Africa* (London: National Portrait Gallery, 1996). For Kalulu, see pp. 132–33.

79 Nicholas Monti, *Africa Then: Photographs, 1840–1918* (New York: Alfred A. Knopf, 1987), p. 9.

80 Quoted in Catherine A. Lutz and Jane L. Collins, *Reading the National Geographic* (Chicago, IL: University of Chicago Press, 1993), pp. 26–27. I have used this account to describe the Society's founding.

81 For a discussion of the importation of European ways in Africa, see Terence Ranger, "The Invention of Tradition in Colonial Africa," in *The Invention of Tradition*, ed. Eric Hobsbawm and Terence Ranger (New York: Cambridge University Press, 1983), pp. 211–62.

82 See Anne Baldasarri, *Picasso and Photography* (Paris: Flammarion, 1997). Fortier is discussed throughout *Delivering Views: Distant Cultures in Early Postcards*, ed. Christraud M. Geary and Virginia-Lee Webb (Washington, DC: Smithsonian Institution Press, 1998).

83 Quoted in Nicholas Monti, *Africa Then: Photographs, 1840–1918*, p. 10.

84 Jorge Lewinski, *The Camera at War* (New York: Simon and Schuster, 1978), p. 56.

85 Roy Flukinger, *The Formative Decades: Photography in Great Britain, 1839–1920* (Austin, TX: University of Texas Press, 1985), p. 141.

86 Quoted in Alison Devine Nordström, "Photography of Samoa: Production, Dissemination, and Use," in *Picturing Samoa: Colonial Photography of Samoa, 1875–1925* (Daytona Beach, FL: Southeast Museum of Photography, 1996), p. 14. I am indebted to this work for information on Samoan photography.

87 Alison Devine Nordström, "Photography of Samoa," p. 15.

88 For a discussion of tattoos and exotic Pacific island life, see Harriet Guest, "The Great Distinction: Figures of the Exotic in the Work of William Hodges," in *New Feminist Discourses*, ed. Isobel Armstrong (London: Routledge, 1992), pp. 296–341.

89 Allan Sekula, "The Body and the Archive," in *The Contest of Meaning*, ed. Richard Bolton (Cambridge, MA: The MIT Press, 1989), p. 351. For more information on the use of photography in police work, see Sandra S. Phillips, Mark Haworth-Booth, and Carol Squiers, *Police Pictures: The Photograph as Evidence* (San Francisco: San Francisco Museum of Modern Art and Chronicle Books, 1997).

90 Eugene S. Talbot, *Degeneracy: Its Causes, Signs, and Results* (London: Walter Scott, 1901), p. 18.

91 For a history of finger-printing, see the inventor William J. Hershel's *The Origin of Finger-Printing by Sir William J. Hershel* (1916, rpt. New York: AMS Press, 1974).

92 My discussion of Clara Sheldon Smith owes to the research and writing of photographer Arne Svenson in his book *Prisoners* (New York: Blast Books, 1997).

93 Francis Galton, "Eugenics: Its Definition, Scope, and Aims," *The American Journal of Sociology*, vol. 10, no. 1 (July 1904), p. 1.

94 Galton, p. 3.

95 Francis Galton, "Photographic Chronicles from Childhood to Age," *Fortnightly Review* (new series; vol. 31, January 1–June 1, 1882), p. 26.

96 Francis Galton, *Inquiries into Human Faculty and Its Development*, pp. 6, 222.

97 Susan D. Moeller, *Shooting War: Photography and the American Experience of Combat* (New York: Basic Books, 1989), p. 25. My discussion of the Spanish–American War owes to her analysis.

98 Margarett (sic) Loke, ed., *The World as it Was, 1865–1921: A Photographic Portrait from the Keystone-Mast Collection*, pp. 15–16.

99 Quoted in Lewis L. Gould and Richard Greffe, *Photojournalist: The Career of Jimmy Hare* (Austin, TX: University of Texas Press, 1977), p. 75. I have relied on this work for information on Jimmy Hare.

100 Gould and Greffe, p. 33.

101 For this dimension of the War, and for information on the British homefront see John Taylor, *War Photography: Realism in the British Press* (London: Routledge, 1991), p. 20.

102 Peter Robertson, "Canadian Photojournalism during the First World War," *History of Photography*, pp. 39, 42–43.

103 Quoted in Bernd Weise, "Photojournalism from the First World War to the Weimar Republic," in *German Photography, 1870–1970: Power of a Medium*, ed. Klaus Honnef, Rolf Sachsse, and Karin Thomas (Cologne: DuMont Buchverlag, 1997), p. 54.

104 Nevertheless, photographs of World War I corpses were made, both by professional photographers and by amateurs with small cameras. Generally, they would not be shown until after the war.

105 Allyson Booth, *Postcards from the Trenches: Negotiating the Space Betweeen Modernism and the First World War* (New York: Oxford University Press, 1996), p. 21.

106 Quoted in Jane Carmichael, *First World War Photographers* (London: Routledge, 1989), pp. 34–35. I rely on Carmichael for her account of photography during the war.

107 The story of Canadian photographer Ivor Castle's fabricated "over the top" photographs is told in Michael L. Carlebach, *American Photojournalism Comes of Age* (Washington, DC: Smithsonian Institution Press, 1997), p. 91, and Peter Robertson, "Canadian Photojournalism during the First World War," *History of Photography*, vol. 2, no. 1 (January 1978), p. 44. Castle was not the only photographer to fake war photographs. Jean-Baptiste Tournassou, Chief of the Photography and Cinematography Organization for the French Army, also staged photographs of soldiers.

108 Quoted in Miles Hudson and John Stanier, *War and the Media: A Random Searchlight* (New York: New York University Press, 1998), p. 40.

109 Bernd Weise, "Photojournalism from the First World War to the Weimar Republic," p. 53.

110 "The Real Thing," in *The Short Stories of Henry James*, ed. Clifton Fadiman (New York: Modern Library, n.d. c.1945.), p. 196.

111 Thomas Thurston, "Hearsay of the Sun: Photography, Identity and the Law of Evidence in Nineteenth-Century American Courts" [http://chnm.gmu.aq/photos/essay/intro.htm] (February 1, 1999).

112 Lewis Hine, "How the Camera May Help in Social

Uplift," quoted in Maren Stange, *Symbols of Ideal Life: Social Documentary Photography in America, 1890–1950* (New York: Cambridge University Press, 1989), p. 86.
113 James Lawrence Breese, "The Relations of Photography to Art," *Cosmopolitan*, vol. 18, no. 2 (December 1894), p. 140.
114 Lewis Hine, "How the Camera May Help in Social Uplift," quoted in George Dimock, "Children of the Mills: Rereading Lewis Hine's Child-Labour Photographs," *Oxford Art Journal*, vol. 16, no. 2 (1993), p. 39.

CHAPTER FIVE
A New Vision (1918–1945)

1 Anton Kaes, Martin Jay, Edward Dimendberg, ed. *The Weimar Republic Sourcebook* (Berkeley, CA: University of California Press, 1994), p. 641.
2 Colin Osman and Sandra S. Phillips, "European Visions: Magazine Photography in Europe between the Wars," in Marianne Fulton, *Eyes of Time: Photojournalism in America* (Boston, MA: New York Graphic Society/Little, Brown and Company, 1988), p. 76. The word "*Illustrirte*" in *Berliner Illustrirte Zeitung* was idiosyncratically spelled. More correctly, it would have been *Illustrierte*.
3 Willi Münzenberg's life and career are discussed in Helmut Gruber's "Willi Münzenberg's German Communist Propaganda Empire, 1921–1933," *Journal of Modern History*, vol. 38, no. 3 (Sept. 1966), pp. 278–97.
4 Colin Osman and Sandra S. Phillips, "European Visions," p. 76.
5 Osman and Phillips, p. 78.
6 Michael L. Carlebach, *American Photojournalism Comes of Age* (Washington, DC: The Smithsonian Institution Press, 1997), p. 145.
7 Richard Guy Wilson, "America and the Machine Age," in *The Machine Age in America, 1918–1941*, ed. Richard Guy Wilson (Brooklyn, NY: The Brooklyn Museum, 1986), p. 26.
8 William Stott, *Documentary Expression and Thirties America* (New York: Oxford University Press, 1973), pp. 80–81.
9 Kurt Schwitters, translated and quoted in Maud Lavin, "Advertising Utopia: Schwitters as Commercial Designer," *Art in America* (October 1985), p. 137.
10 Edlef Köppen, "The Magazine as a Sign of the Times," in *The Weimar Republic Sourcebook*, ed. Anton Kaes, Martin Jay, and Edward Dimendberg, p. 644.
11 Christopher Phillips, "Resurrecting Vision: European Photography between the World Wars," in *The New Vision: Photography between the World Wars* (New York: The Metropolitan Museum of Art, 1989), p. 73. I am indebted to Phillips for my understanding of this period.
12 Hannes Meyer, "The New World," in *The Weimar Republic Sourcebook*, ed. Anton Kaes, Martin Jay, and Edward Dimendberg, pp. 445–46.
13 Quoted in Peter Galassi, "Rodchenko and Photography's Revolution," in Magdalena Dabrowski, Leah Dickerman, and Peter Galassi, *Alexsandr Rodchenko* (New York: Museum of Modern Art, 1998), p. 104.
14 See the extended discussion in Margarita Tupitsyn, *El Lissitzky: Beyond the Abstract Cabinet* (New Haven, CT: Yale University Press, 1999), pp. 20–21.
15 Quoted in Margarita Tupitsyn, *The Soviet Photograph, 1924–1937* (New Haven, CT: Yale University Press, 1966), p. 11.
16 Quoted in Christopher Phillips, "Resurrecting Vision," p. 84.
17 For a discussion of the history of the idea of "making strange," see Simon Watney, "Making Strange: The Shattered Mirror," in *Thinking Photography*, ed., Victor Burgin (London, Macmillan, 1982), pp. 154–76.
18 Tristan Tzara, "Dada Manifesto 1918," in *Art in Theory, 1900–1990: An Anthology of Changing Ideas* (Oxford: Blackwell, 1992), p. 252.
19 Richard Hülsenbeck, "First German Dada Manifesto," in *Art in Theory, 1900–1990: An Anthology of Changing Ideas* (Oxford: Blackwell, 1992), p. 253.
20 The most comprehensive book on women photographers in Germany and their connection to the new woman motif has yet to be translated into English. See *Fotografieren hiess Teilnehman: Photografinnen der Weimarer Republik*, ed. Ute Eskilden (Düsseldorf: Richter Verlag, 1994).
21 Quoted in Dawn Ades, *Photomontage* (rev. ed.) (London: Thames and Hudson, Ltd., 1986), p. 12.

22 Maud Lavin, *Cut with the Kitchen Knife: The Weimar Photomontages of Hannah Höch* (New Haven, CT: Yale University Press, 1993), p. 23. I owe my understanding of Höch to Lavin's scholarship.
23 Dawn Ades, *Photomontage*, p. 28.
24 László Moholy-Nagy, "Unprecedented Photography," in *Photography in the Modern Era: European Documents and Critical Writings, 1913–1940*, ed. Christopher Phillips (New York: The Metropolitan Museum of Art/Aperture, 1989), p. 84.
25 Moholy-Nagy, p. 85.
26 László Moholy-Nagy, "Photography in Advertising," in *Photography in the Modern Era*, ed. Christopher Phillips, p. 90.
27 Johannes Molzahn, "Stop Reading! Look!" in *The Weimar Republic Sourcebook*, ed. Anton Kaes, Martin Jay, and Edward Dimendberg, p. 648.
28 Quoted in Kim Sichel, *Germaine Krull: Photographer of Modernity* (Cambridge, MA: The MIT Press, 1999), p. 77. I am indebted to Sichel for my understanding of Krull.
29 "Les intellectuels allemands ne peuvent pas faire caca ni pipi sans des idéologies." Quoted in Dawn Ades, *Photomontage*, p. 114.
30 Ades, p. 115.
31 Francis Naumann, "The New York Dada Movement: Better Late Than Never," *Arts* (February 1980), p. 143.
32 Maria Morris Hambourg, "From 291 to the Museum of Modern Art: Photography in New York, 1910–37," in Maria Morris Hambourg and Christopher Phillips, *The New Vision: Photography Between the World Wars*, pp. 15–16.
33 Quoted in Theodore E. Stebbins, Jr. and Norman Keyes, Jr., *Charles Sheeler: The Photographs* (Boston: Museum of Fine Arts, 1987), p. 17.
34 Stebbins and Keyes, p. 25.
35 Stebbins and Keyes, p. 27.
36 See Sue Taylor, *Hans Bellmer: The Anatomy of Anxiety* (Cambridge, MA: The MIT Press, 2000), and Therese Lichtenstein, *Behind Closed Doors: The Art of Hans Bellmer* (Berkeley, CA: University of California Press, 2001).
37 Kim Sichel, *Germaine Krull: Photographer of Modernity*, p. 106.
38 Quoted in Peter Galassi, *Henri Cartier-Bresson: The Early Work* p. 39
39 Henri Cartier-Bresson, *The Decisive Moment* (New York: Simon & Schuster, 1952), n.p.
40 Peter Galassi, *Henri Cartier-Bresson: The Early Work*, p. 29.
41 Dziga Vertov, "The Council of Three," in *Kino-Eye: the Writings of Dziga Vertov*, ed. Annette Michelson, trans. Kevin O'Brien (Berkeley, CA: University of California Press, 1984), p. 17.
42 James Curtis, *Mind's Eye, Mind's Truth: FSA Photography Reconsidered*, pp. 77–78.
43 Quoted in Victor Margolin, *The Struggle for Utopia: Rodchenko, Lissitzky, Moholy-Nagy, 1917–1946* (Chicago, IL: University of Chicago Press, 1997), p. 113.
44 Eleanor M. Hight, *Picturing Modernism: Moholy-Nagy and Photography in Weimar Germany*, p. 209.
45 Willi Warstat, "Photography in Advertising," in *The Weimar Republic Sourcebook*, ed. Anton Kaes, Martin Jay, and Edward Dimendberg, p. 651.
46 Eleanor M. Hight, *Picturing Modernism*, p. 203.
47 Karel Teige, "The Tasks of Modern Photography," in *Photography in the Modern Era*, p. 319.
48 Teige, pp. 318, 319. Teige's art and his theoretical writings are reviewed in Eric Dluhosch and Rostislav Suácha, *Karel Teige, 1900–1951: L'enfant terrible of the Czech Modernist Avant-Garde* (Cambridge, MA: The MIT Press, 1999).
49 Walter Benjamin, "A Small History of Photography," in his *One-Way Street and Other Writings*, trans. Edmund Jephcott and Kingsley Shorter (London: NLB: 1979), p. 255.
50 Benjamin, p. 254.
51 Quoted in Melissa A. McEuen, *Seeing America: Women Photographers between the Wars* (Lexington, KY: University Press of Kentucky, 2000), p. 37.
52 Margarita Tupitsyn, *El Lissitzky: Beyond the Abstract Cabinet*, p. 61.
53 See Christopher Phillips, "Resurrecting Vision," p. 95 and Benjamin H. D. Buchloh, "From Faktura to Factography," in *The Contest of Meaning: Critical Histories of Photography*, ed. Richard Bolton (Cambridge, MA: The MIT Press, 1989), pp. 76–77.
54 Raoul Hausmann, "Photomontage," in *The Weimar*

Republic Sourcebook, ed. Anton Kaes, Martin Jay, and Edward Dimendberg, p. 652.
55 Robert A. Sobieszek, *The Art of Persuasion: A History of Advertising Photography* (New York: Harry N. Abrams, 1988), p. 66.
56 Quoted in Therese Thau Heyman, "Modernist Photography and the Group f.64," in *On the Edge of America: California Modernist Art, 1900–1950*, ed. Paul J. Karlstrom (Berkeley, CA: University of California Press, 1996), p. 252.
57 Heyman, p. 256.
58 Quoted in Michel Oren, "On the 'Impurity' of Group f/64 Photography," *History of Photography*, vol. 15, no. 2 (Summer 1991), p. 122.
59 Weston's statement for the *Film und Foto* exhibition, quoted in David Travis, "Ephemeral Truths," in Sarah Greenough, Joel Snyder, David Travis, and Colin Westerbeck, *On the Art of Fixing a Shadow: One Hundred and Fifty Years of Photography* (Washington, DC: National Gallery of Art, 1989), p. 243.
60 Leah Ollman, "The Worker Photography Movement: Camera as Weapon," in *Multiple Views: Logan Grant Essays on Photography, 1983–89*, ed. Daniel P. Younger (Albuquerque, NM: University of New Mexico Press, 1991), p. 235.
61 Forrest McDonald, *The American Presidency: An Intellectual History* (Lawrence, KS: University of Kansas Press, 1994), pp. 441–42.
62 See the extensive discussions of these media throughout William Stott, *Documentary Expression and Thirties America* (New York: Oxford University Press, 1973).
63 John Grierson, "First Principles of Documentary" (1934–36), in *Imagining Reality: The Faber Book of Documentary*, ed. Kevin Macdonald and Mark Cousins (London: Faber and Faber, 1996), p. 101.
64 John Grierson, "The Documentary Idea: 1942," in *Grierson on Documentary*, ed. Forsyth Hardy (Berkeley, CA: University of California Press, 1966), p. 249.
65 Adams was addressing Roy Stryker, head of the Farm Security Section that produced photographs. See Roy E. Stryker and Nancy Wood, *In This Proud Land: America 1935–1943 as Seen in the FSA Photographs* (Greenwich, CT: New York Graphic Society, 1973), p. 8.
66 See Leah Bendavid-Val, *Propaganda & Dreams: Photographing the 1930s in the USSR and US* (New York: Edition Stemle, 1999).
67 William Stott, *Documentary Expression and Thirties America*, p. 26.
68 Maren Stange, "'The Record Itself': Farm Security Photography and the Transformation of Rural Life," in Pete Daniel, Merry A. Foresta, Maren Stange, and Sally Stein, *Official Images: New Deal Photography* (Washington, DC: Smithsonian Institution Press, 1987), p. 1.
69 Maren Stange, *Symbols of Ideal Life: Social Documentary Photography in America, 1890–1950* (New York: Cambridge University Press, 1989), p. 111.
70 Quoted in Lawrence W. Levine, "The Historian and the Icon: Photography and the History of the American People in the 1930s and 1940s in *Documenting America, 1935–1943*, ed. Carl Fleishhauer and Beverly W. Brannan (Berkeley, CA: University of California Press, 1988), p. 39.
71 See Keith F. Davis's discussion in his *An American Century of Photography: From Dry-Plate to Digital*, 2nd, rev. ed. (Kansas City, MO and New York: Hallmark Cards, Inc., in association with Harry N. Abrams, 1999), p. 165.
72 Quoted in Maria Morris Hambourg, "A Portrait of the Artist," in Maria Morris Hambourg, Jeff L. Rosenheim, Douglas Eklund, and Mia Fineman, *Walker Evans* (New York: The Metropolitan Museum of Art, 2000), pp. 21–22.
73 Quoted in Belinda Rathbone, *Walker Evans: A Biography* (New York: Houghton Mifflin, 1995), p. 70. The original appeared in a book review by Evans titled "The Reappearance of Photography," in *Hound and Horn*, vol. 5, no. 1 (October–December 1931), p. 127.
74 Maria Morris Hambourg, "A Portrait of the Artist," in *Walker Evans*, Maria Morris Hambourg et al, p. 9.
75 James Agee and Walker Evans, *Let Us Now Praise Famous Men* (1941; rpt; Boston, MA: Houghton Mifflin Co., 1988), p. xlvii.
76 Quoted in Sally Stein, "Peculiar Grace: Dorothea Lange and the Testimony of the Body," in *Dorothea Lange: A Visual Life*, ed. Elizabeth Partridge

(Washington, DC: Smithsonian Institution Press, 1994), p. 59.

77 James Curtis, *Mind's Eye, Mind's Truth: FSA Photography Reconsidered* (Philadelphia, PA: Temple University Press, 1989), pp. 75–76.

78 Jefferson Hunter, *Image and Word: The Interaction of Twentieth-Century Photographs and Texts* (Cambridge, MA: Harvard University Press, 1987), p. 97.

79 Keith F. Davis's discussion in his *An American Century of Photography*, p. 165.

80 Quoted in Vicki Goldberg, *Margaret Bourke-White: A Biography* (New York: Harper & Row, 1986), p. 115.

81 *Documenting America, 1935–1943*, ed. Carl Fleishhauer and Beverly W. Brannan; essays by Lawrence W. Levine and Alan Trachtenberg, p. 314.

82 Jefferson Hunter, *Image and Word*, pp. 14–15. In *Documentary Expression and Thirties America*, William Stott voices much the same opinion.

83 *August Sander: Citizens of the Twentieth Century*, ed. Gunther Sander, text, Ulrich Keller, trans. Linda Keller (Cambridge, MA: The MIT Press, 1986), pp. 8–9. I am indebted to this publication for my analysis of Sander.

84 *August Sander*, p. 19.

85 Melissa A. McEuen, *Seeing America: Women Photographers between the Wars*, pp. 58–59.

86 See Leah Ollman, "The Worker Photography Movement: Camera as Weapon," in *Multiple Views: Logan Grant Essays on Photography, 1983–89*, p. 226. Most articles on Worker Photography have not been translated from German.

87 Leah Ollman, "The Worker Photography Movement," pp. 230–31.

88 See the discussion in Ute Eskilden, "The A-I-Z and the Arbeiter Fotograf: Working Class Photographers in Weimar," *Image*, vol. 23, no. 2 (December 1980), p. 7.

89 See Terry Dennett, "The British Film and Photo League," in *Creative Camera*, nos. 197–98, (May/June 1981), p. 91. The entire issue is devoted to worker photography. Also see Hanno Hardt and Karin B. Ohrn, "The Eyes of the Proletariat: The Worker-Photography Movement in Weimar Germany," *Studies in Visual Communications*, vol. 7, no. 3 (Summer 1981), pp. 46–57.

90 Leah Ollman, "The Worker Photography Movement," p. 233.

91 See the discussion throughout Maud Lavin, "Montage, Mass Culture, and Modernity: Utopianism in the Circle of New Advertising Designers," in Matthew Teitelbaum, ed., *Montage and Modern Life, 1919–1942* (Cambridge, MA: The MIT Press, 1992), pp. 37–59.

92 Deborah Frizzell, *Humphrey Spender's Humanist Landscapes: Photo-Documents, 1932–1942* (New Haven, CT: Yale Center for British Art, 1997), p. 24.

93 Erik Barnouw, *Documentary: A History of the Non-Fiction Film*, 2nd rev. ed. (New York: Oxford University Press, 1993), pp. 111–12.

94 For more information on the Photo League, see Anne Tucker, "A History of the Photo League: The Members Speak," *History of Photography*, vol. 18, no. 2 (Summer 1994), pp. 174–84. Also see her "Aaron Siskind and the Photo League: A Partial History," *Afterimage*, vol. 9, no. 10 (May 1982), pp. 4–5.

95 Ute Eskilden, "Innovative Photography in Germany Between the Wars," in *Avant-Garde Photography in Germany, 1919–1939* (San Francisco, CA: San Francisco Museum of Modern Art, 1980), p. 35.

96 Ann Thomas, "The Search for Pattern," in *Beauty of Another Order: Photography in Science*, ed. Ann Thomas (New Haven, CT: Yale University Press, 1997) p. 110.

97 Peter Reichel, "Images of the National Socialist State," in Klaus Honnef, Rolf Sachsse, and Karen Thomas, eds., *German Photography, 1870–1970: Power of a Medium* (Cologne: DuMont Buchverlag, 1997), p. 72.

98 Quoted in Rolf Sachsse, "Photography as NS State Design Power's Abuse of a Medium," in *German Photography, 1870–1970*, p. 92.

99 Phillip Knightley, *The First Casuality: From the Crimea to Vietnam—The War Correspondent as Hero, Propagandist, and Myth Maker* (New York: Harcourt Brace Jovanovich, 1975), pp. 220–21.

100 Susan Moeller, *Shooting War: Photography and the American Experience of Combat* (New York: Basic Books, 1989), p. 192.

101 Mary Anne Staniszewski, *The Power of Display: A History of Exhibition Installations at the Museum of Modern Art* (Cambridge, MA: The MIT Press, 1998), p. 215.

102 Staniszewski, p. 215.

103 Staniszewski, p. 224.

104 Walter Benjamin, "The Work of Art in the Age of Mechanical Reproduction," in Walter Benjamin, *Illuminations*, ed. Hannah Arendt (New York: Schocken Books, 1969), p. 223.

105 Maud Lavin, "Montage, Mass Culture, and Modernity: Utopianism in the Circle of New Advertising Designers," in Matthew Teitelbaum, ed., *Montage and Modern Life, 1919–1942*, p. 59.

106 Phillip Knightley, *The First Casuality: From the Crimea to Vietnam*, pp. 210–12. For a recent continuation of the story, see Caroline Brothers, *War and Photography: A Cultural History* (London: Routledge, 1997), pp. 179–81.

107 See the discussion of the photograph in Vicki Goldberg, *The Power of Photography* (New York: Abbeville Press, 1993), pp. 142–47.

CHAPTER SIX
Through the Lens of Culture
(1945–1975)

1 Edward Steichen, *The Family of Man* (New York: Simon and Schuster, 1955), pp. 4–5.

2 Christopher Phillips, "The Judgment Seat of Photography," in Richard Bolton, *The Contest of Meaning: Critical Histories of Photography* (Cambridge, MA: The MIT Press, 1989), p. 28.

3 Quoted in Aline B. Saarinen, "The Camera Versus the Artist," compiled in "The Controversial Family of Man," *Aperture*, no. 3 (1955), p. 11.

4 Jacob Deschin, "Panoramic Show at the Museum of Modern Art," compiled in "The Controversial Family of Man," *Aperture*, no. 3 (1955), p. 8.

5 Barbara Morgan, "The Theme Show: A Contemporary Exhibition Technique," compiled in "The Controversial Family of Man," *Aperture*, no. 3 (1955), p. 24.

6 William Manchester, *In Our Time: The World as Seen by Magnum Photographers* (New York: The American Federation of Arts and W. W. Norton & Co., 1989), pp. 423, 430.

7 Eric J. Sandeen, *Picturing an Exhibition: The Family of Man and 1950s America* (Albuquerque, NM: University of New Mexico Press, 1995), pp. 43–49. I am indebted to Sandeen's writing for information on the exhibit.

8 Phoebe Lou Adams, "Through a Lens Darkly," *Atlantic Monthly*, no. 195 (April 1955), p. 72.

9 Roland Barthes, "The Great Family of Man," in his *Mythologies*, trans. Annette Lavers (New York: Hill and Wang, 1972), pp. 100–01.

10 The Universal Declaration of Human Rights is available on the United Nations website. See http://www.un.org/Overview/rights.html

11 Eric J. Sandeen, *Picturing an Exhibition*, p. 27.

12 Melville J. Herskovits, *Cultural Relativism: Perspectives in Cultural Pluralism*, ed. Frances Herskovits (New York: Random House, 1972), p. 8.

13 For the history of the Che Guevera photograph, see Fernando Castro, "Crossover Dreams: Remarks on Contemporary Latin American Photography," in Wendy Watriss and Lois Parkinson Zamora, *Image and Memory: Photography from Latin America, 1866–1994* (Austin, TX: University of Texas Press, 1998), pp. 57–61, and Vicki Goldberg, *The Power of Photography* (New York: Abbeville Publishing Group, 1991), pp. 156–61.

14 The now-classic study is Eva Cockcroft, "Abstract Expressionism, Weapon of the Cold War," *Pollock and After: The Critical Debate*, ed. Francis Frascina (New York: Harper and Row, 1985), pp. 125–32.

15 Fernando Castro, "Crossover Dreams: Remarks on Contemporary Latin American Photography," in Wendy Watriss and Lois Parkinson Zamora, *Image and Memory*, p. 61. Castro's article is one of the few in English to recount the relationship of politics and photography in Latin America.

16 John Mraz, "Cuban Photography: Context and Meaning," *History of Photography*, vol. 18, no. 1 (Spring 1994), p. 88.

17 For the late survival of itinerant photography in Latin America see Ann Parker and Avon Neal, *Los Ambulantes: The Itinerant Photographers of Guatemala* (Cambridge, MA: The MIT Press, 1982).

18 Raquel Tibol, [no title], in *Hecho en Latinoamérica* (Mexico City: Consejo Mexicano de Fotografía, 1978), p. 25.

19 Tibol, p. 28.

20 Maria Eugenia Haya (Marucha), "Photography in Latin America," *Aperture*, no. 109 (1987), pp. 68–69.

21 For a discussion of the work of Latin American women making anthropological photographs, see Naomi Rosenblum, *A History of Women Photographers*, p. 196.

22 John Mraz, "Nacho Lopez, Photojournalist of the 1950s," *History of Photography*, vol. 20, no. 3 (Autumn 1996), p. 210.

23 Quoted in Olivier Debroise, *Mexican Suite: A History of Photography in Mexico*, trans. Stella de Sá Rego (Austin, TX: University of Texas, 2001), p. 197.

24 John Mraz, "Foto Hermanos Mayo: A Mexican Collective," *History of Photography*, vol. 17, no. 1 (Spring 1993), p. 88, n. 1.

25 The literature on Álvarez Bravo is replete with references to his surrealism. An example is Charles Hagen's review of an exhibition: "A Mexican Master Surveys the Past," *New York Times* (Sunday, March 22, 1992), H 37.

26 Paul Hill and Thomas Cooper, "Manuel Alvarez Bravo," in their *Dialogue with Photography* (New York: Farrar/Straus/Giroux; 1979), p. 231.

27 Hill and Cooper, p. 226.

28 Quoted in Jane Livingston, *Manuel Alvarez Bravo* (Boston, MA: David R. Godine, Publisher, 1978), p. ix.

29 Paul Hill and Thomas Cooper, "Manuel Alvarez Bravo," p. 233.

30 I am indebted to Nissan N. Perez for this interpretation, which appeared in "Visions of the Imaginary: Dreams of the Intangible," in *Revelaciones: The Art of Manual Alvarez Bravo* (Albuquerque, NM: University of New Mexico Press, 1990), p. 18.

31 Heike Behrend, "A Short History of Photography in Kenya," in *Anthology of African and Indian Ocean Photography* (Paris, Review Noire, 1999), p. 161. I am indebted to this book and to *In/Sight: African Photographs, 1940 to the Present* (New York: Guggenheim Museum, 1996) for my understanding of African photography.

32 PMSL & JLP, [untitled section introduction] in *Anthology of African and Indian Ocean Photography* (Paris, Review Noire, 1999), p. 197.

33 Stephen F. Sprague, "Yoruba Photography: How the Yoruba See Themselves," *African Arts*, vol. 12, no. 1 (1978), pp. 52–59. I am indebted to this now classic article for my understanding of the subject.

34 Joanna C. Scherer, "The Photographic Document: Photographs as Primary Data in Anthropological Enquiry," in *Anthropology and Photography, 1860–1920* (New Haven, CT: Yale University Press, 1992), p. 37.

35 G. Thomas, *History of Photography in India, 1840–1980* (N.P.: Anhandra Pradesh State Akademi of Photography, 1981), p. 45. A comprehensive history of photography in India, especially in the years immediately preceding independence to the present, is sorely lacking.

36 Thomas, pp. 5, 49, 51.

37 P. C. Smith, "The Colors of India: Raghubir Singh," *Art in America*, vol. 88, no. 3 (March 2000), p. 99.

38 For this discussion, I relied on the research and analyses by Christopher Pinney in his *Camera Indica: The Social Life of Indian Photographs* (Chicago, IL: University of Chicago Press, 1997).

39 Pinney, p. 149.

40 Vinay Lal, "Reading between the Frames: Burden (and Freedom) of Photography," *Economic and Political Weekly*, vol. 35, no. 14 (April 1–7, 2000), p. 1170.

41 For a discussion of Japanese aesthetics and the camera see Robert Stearns, *Photography and Beyond in Japan* (Tokyo: Hara Museum of Contemporary Art, 1995).

42 Yosuke Yamahata, *Nagasaki Journey: The Photographs of Yosuke Yamahata, August 10, 1945*, ed. Rupert Jenkins (San Francisco, CA: Pomegranate Artbooks, 1995), p. 19.

43 Mark Holborn, "Introduction," in *Eikoh Hosoe* (New York: Aperture, 1999), p. 5.

44 Shoji Yamagishi, "Introduction," in *New Japanese Photography*, ed. John Szarkowski and Shoju Yamagishi (New York: Museum of Modern Art, 1974), p. 11.

45 Mark Holborn, *Black Sun: The Eyes of Four—Roots and Innovation in Japanese Photography* (New York: Aperture, 1986), p. 10.

46 Holborn, p. 14.
47 Shomei Tomatsu, *Nagasaki, 11:02, August 9, 1945* (Tokyo: Shinchosa, 1995).
48 Edward Putzar, *Japanese Photography, 1945–1985* (Tucson, AZ: Pacific West, Inc., 1987), p. 6.
49 For this and other aspects of the postwar Japanese experience, see John W. Dower, *Embracing Defeat: Japan in the Wake of World War II* (New York: W.W. Norton & Co./The New Press, 1999), p. 293.
50 John W. Dower, *Embracing Defeat*, p. 293.
51 Quoted in Fuminori Yokoe, "The Call of the Ocean of Memory," in Colin Westerbeck, *Yasuhiro Ishimoto: A Tale of Two Cities* (Chicago, IL: The Art Institute of Chicago, 1999), p. 103.
52 Quoted in Spencer R. Weart, *Nuclear Fear: A History of Images* (Cambridge, MA: Harvard University Press, 1988), p. 110.
53 I depended on the following sources for this discussion: Peter B. Hales, "The Atomic Sublime," *American Studies*, vol. 32 (Spring 1991), pp. 5–31; Vince Leo, "The Mushroon Cloud Photograph: From Fact to Symbol," *Afterimage*, vol. 13, nos. 1 and 2 (Summer 1985), pp. 6–12; and Spencer R. Weart's study, *Nuclear Fear*.
54 Leo Rubinfien, "Investigations of a Dog," *Art in America* (October 1999), p. 134.
55 Rubinfien, p. 134.
56 Rubinfien, p. 135.
57 Rubinfien, p. 136.
58 Quoted in Helen Gee, *Photography of the Fifties: An American Perspective* (Tucson, AZ: Center for Creative Photography, 1983), p. 4.
59 Tom Engelhardt, *The End of Victory Culture: Cold War America and the Disillusioning of a Generation* (New York: Basic Books, 1995), p. 10.
60 David Riesman, with Nathan Glazer and Reuel Denny, *The Lonely Crowd: A Study of the Changing American Character* (abridged by the authors) (New York: Doubleday & Co., Inc., 1953).
61 Quoted in Lili Corbus Bezner, *Photography and Politics in America: From the New Deal into the Cold War* (Baltimore, MD: The Johns Hopkins University Press, 1999), p. 14.
62 Aaron Siskind, "The Drama of Objects," in *Aaron Siskind, Pleasures and Terrors*, ed. Carl Chiarenza (Boston, MA: Little, Brown and Co., 1982), pp. 65–66.
63 See the discussion in Daniel Belgrad, *The Culture of Spontaneity: Improvisation and the Arts in Postwar America* (Chicago, IL: University of Chicago Press, 1998), pp. 49–56.
64 Sheryl Conkelton, "Seeing and Knowing the Order of Things," in *Frederick Sommer: Selected Texts and Bibliography*, ed. Sheryl Conkelton (New York: G. K. Hall & Co., 1995), p. 11.
65 Jerry Uelsmann, "Preface," *Photo Synthesis* (Gainesville, FL: University Press of Florida, 1992).
66 Quoted in Peter C. Bunnell, *Minor White: The Eye that Shapes* (Princeton, NJ: The Art Museum, Princeton University, 1989), p. 17.
67 Quoted in Bunnell, *Minor White*, pp. 15–16.
68 Allan Sekula, "On the Invention of Photographic Meaning," in *Thinking Photography*, ed. Victor Burgin (London: Macmillan, 1982), p. 102.
69 Peter C. Mazio, "Introduction," *Robert Frank: New York to Nova Scotia* (Houston, TX: Museum of Fine Arts, 1986), p. 6.
70 Quoted in "History—His Story," in *The Pictures are a Necessity: Robert Frank in Rochester, NY, November 1988*. Occasional Papers no. 2, Rochester Film and Photo Consortium (Rochester, NY: University Educational Services at George Eastman House, 1989), p. 43.
71 Andy Grundberg, "Harry Callahan, Cool Master of the Commonplace, Dies at 86," *New York Times* (Thursday, March 18, 1999), B9.
72 Maren Stange, "'Illusion Complete within Itself': Roy DeCarava's Photography," *Yale Journal of Criticism*, vol. 9, no. 1 (1996), pp. 63–92.
73 Quoted in Keith F. Davis, *An American Century of Photography, From Dry-Plate to Digital*, 2nd, rev. ed. (Kansas City, MO and New York: Hallmark Cards, Inc., in association with Harry N. Abrams, 1999), p. 288.
74 For a comparison of *film noir* and tabloid photography, see William Hannigan, *New York Noir: Crime Photos from the Daily News Archive* (New York: Rizzoli, 1999), especially pp. 20–22.
75 The textual source, if there is one, is not mentioned. See Jonathan Green, *American Photography*, p. 99.
76 Green, p. 106.

77 Bruce Davidson, *Bruce Davidson: Photographs* (New York: Agrinde/Summit Books, 1978), p. 10.
78 Jonathan Green, *American Photography*, p. 119.
79 Joseph Marshall, "The Moral Issue of a Pregnant Woman Shooting Up," *Photo Review*, vol. 16, no. 1 (Winter 1993), p. 5.
80 Quoted in David Halberstam, [Introduction] in Bill Owens, *Suburbia*, ed. Robert Harshorn Shimshak (New York: Fotofolio, 1999), n.p. (p. 5).
81 Jeffrey Kastner, "A Vision of Suburban Bliss Edged with Irony," *New York Times* (Sunday, March 19, 2000), AR 36.
82 Quoted in Douglas Collins, *The Story of Kodak* (New York: Harry N. Abrams, 1990), p. 261.
83 Quoted in Maria Morris Hambourg, Jeff L. Rosenheim, Douglas Eklund, and Mia Fineman, *Walker Evans* (New York: The Metropolitan Museum of Art, 2000), p. 137.
84 Quoted in Beaumont Newhall, *Supreme Instants: The Photography of Edward Weston* (Boston, MA: Little, Brown and Company, 1986), p. 43.
85 Douglas Collins, *The Story of Kodak*, p. 289.
86 For a full discussion of the impact of space photography, see Vicki Goldberg, *The Power of Photography*, pp. 52–57.
87 Marianne Fulton, "Changing Focus: The 1950s to the 1980s," in Marianne Fulton, *Eyes of Time: Photojournalism in America* (Boston: Little, Brown and Company, 1988), p. 217.
88 David Robbins, *The Independent Group: Postwar Britain and the Aesthetics of Plenty* (Cambridge, MA: The MIT Press, 1990), p. 55.
89 Robbins, p. 69.
90 Robert Smithson, "Art Through the Camera's Eye," quoted in Robert Sobieszek, *Robert Smithson: Photo Works* (Albuquerque, NM: University of New Mexico Press, 1993), p. 32.
91 It is interesting to note that both Bill Brandt and Nigel Henderson photographed at Bethnal Green, a lower-class area of London, yet both also moved outside social documentary to more experimental forms of photography.
92 Quoted in Tony Godfrey, *Conceptual Art* (London: Phaidon Press Limited, 1998), p. 203.
93 Quoted in Michael Compton, *Marcel Broodthaers* (London: Tate Gallery, 1980), p. 13.
94 Robert Stearns, *Photography and Beyond in Japan* (Tokyo: Hara Museum of Contemporary Art, 1995), pp. 59–60.
95 Quoted in Reiko Tomii, "Concerning the Institution of Art: Conceptualism in Japan," in *Global Conceptualism: Points of Origin* (New York: Queens Museum of Art, 1999), p. 26.
96 John Szarkowski, *Looking at Photographs: 100 Pictures from the Collection of the Museum of Modern Art* (New York: Museum of Modern Art, 1973), p. 120.
97 John Szarkowski, *A Photographer's Eye* (New York: Museum of Modern Art, 1966), n.p.
98 See, for instance, John Szarkowski, *Looking at Photographs*, p. 10.
99 John Szarkowski, *From the Picture Press* (New York: Museum of Modern Art, 1973), p. 6.
100 Kubler—and before him, the art historians Heinrich Wölfflin (1864–1945) and Alois Riegl (1858–1905)—insisted on a large time frame, not a decade.
101 John Szarkowski, *Looking at Photographs*.
102 John Szarkowski, *A Photographer's Eye*.
103 Quoted in Jonathan Green, *American Photography: A Critical History 1945 to the Present*, p. 187.
104 John Szarkowski, *William Eggleston's Guide* (New York: Museum of Modern Art, 1976), pp. 6–8.
105 John Szarkowski, *Mirrors and Windows: American Photography since 1960* (New York: Museum of Modern Art, 1978), p. 11.
106 Szarkowski, p. 18.
107 Szarkowski, p. 13.
108 Szarkowski, p. 14.

CHAPTER SEVEN
Convergences (1975–Present)

1 Cristina Vives Gutiérrez, "About the Idea, the Negative and Negation," in *Conceptual Art in Cuba* (Minneapolis: Parts, n.d. [2000]), n.p.
2 See Thomas McEvilley, "Toward a Creative Reversal," *Art in America* (January 2001), p. 41.
3 Young Kim, [untitled artist's statement] in Andy Grundberg, Rebecca Solnit, and Ronald Takaki,

Tracing Cultures (San Francisco, CA: The Friends of Photography, 1995), p. 40.
4 Weston Naef and Sebastião Salgado quoted in Matthew L. Wald, "The Eye of the Photojournalist," *New York Times Magazine* (June 9, 1991), p. 58.
5 Vicki Goldberg, "Art, Facts, and Artifacts," *American Photographer* (March 1988), p. 26.
6 Susan Kismaric, *British Photography from the Thatcher Years* (New York: Museum of Modern Art, 1990), p. 12.
7 Eugene Richards, quoted in Eric Pooley, "The Trouble He's Seen," *American Photographer* (November 1989), p. 40.
8 Cornell Capa, quoted in Pooley, p. 40.
9 See, for example, John Worden, "Gimme Shelter," *Afterimage*, vol. 15, no. 10 (May 1988), p. 19.
10 Gilles Peress, *Telex Iran: In the Name of Revolution* (Zurich and New York: Scalo, 1997).
11 David Perlmutter, "The Vision of War in High School Social Science Textbooks," *Communication*, vol. 13, no. 2 (1992), pp. 143–60.
12 Donna Ferrato, *Living with the Enemy* (New York: Aperture, 1991), n.p.
13 Quoted in a 1987 interview with Marianne Fulton, in her "Changing Focus: The 1950s to the 1980s," in Marianne Fulton, *Eyes of Time: Photojournalism in America* (Boston, MA: Little, Brown and Company, 1988), p. 248.
14 Vicki Goldberg, "The Heroism of Anonymous Men and Women," *New York Times* (June 13, 1993), H35.
15 See, for example, *Anthropology and Photography, 1860–1920*, ed. Elizabeth Edwards (New Haven, CT: Yale University Press, 1992); and James Clifford, *The Predicament of Culture: Twentieth-Century Ethnography, Literature, and Art* (Cambridge, MA: Harvard University Press, 1988).
16 Allan Sekula, "Dismantling Modernism, Reinventing Documentary (Notes on the Politics of Representation)," in *Photography: Current Perspectives*, ed. Jerome Liebling (Rochester, NY: Light Impressions Corporation, 1978), p. 232.
17 Jolene Rickard, quoted in Theresa Harlan, "As in Her Vision: Native American Women Photographers," in *Reframing: New American Feminist Photographies*, ed. Diane Neumaier (Philadelphia, PA: Temple University Press, 1995), p. 115.
18 Rickard, quoted in Harlan, p. 115.
19 Michael Kimmelman, "Can Suffering Be Too Beautiful?" *New York Times* (July 13, 2001), Section E, Part 2, 27.
20 David Byrne, "Foreword," in Lynne Cohen, *Occupied Territory* (New York: Aperture, 1987), p. 15.
21 J. M. Roberts, *Twentieth Century: The History of the World, 1901–2000* (New York, Viking, 1999), p. 613, n. 1. The Cambodian Genocide Program at Yale University can be accessed at www.yale.edu/cgp
22 Santu Mofokeng, "Trajectory of a street-photographer," in *Anthology of African and Indian Ocean Photography* (Paris: Review Noire, 1999), p. 269.
23 Walter Benjamin, "A Short History of Photography," in *One-Way Street and Other Writings*, trans. Edmund Jephcott and Kingsley Shorter (London: NLB, 1979), p. 255.
24 Martha Rosler, *Positions in the Life World*, ed. Catherine de Zegher (Cambridge, MA: The MIT Press, 1998), pp. 32–33. For a discerning analysis of the new social documentary, see Grant H. Kester, "Toward a New Social Documentary," *Afterimage*, vol. 14, no. 8 (March 1987), pp. 10–14.
25 Rosler, *Positions in the Life World*, p. 33.
26 Abigail Solomon-Godeau, "Who is speaking thus? Some questions about documentary photography," from *Photography at the Dock* (Minneapolis, MN: University of Minnesota Press, 1991), p. 183.
27 The poster/essay for *The Health and Safety Game* was written by Allan Sekula.
28 Fred Lonidier, "Working with Unions," in *Cultures in Contention*, ed. Douglas Kahn and Diane Neumaier (Seattle, WA: The Real Comet Press, 1985), p. 103.
29 Martha Rosler, "In, around, and afterthoughts (on documentary photography)" in *The Contest of Meaning: Critical Histories of Photography*, ed. Richard Bolton (Cambridge, MA: The MIT Press, 1989), p. 322.
30 Martha Rosler, *Positions in the Life World*, p. 44.
31 Martha Rosler, "In, around, and afterthoughts (on documentary photography)," pp. 307–25.
32 Andy Grundberg, "Two Camps Battle Over the Nature of the Medium," *New York Times* (Sunday, August 14, 1983), H 24.

33 Allan Sekula, "The Traffic in Photographs," *Art Journal*, vol. 41, no. 1 (Spring 1981), p. 20.

34 Allan Sekula, "The Body and the Archive," in *The Contest of Meaning: Critical Histories of Photography*, ed. Richard Bolton (Cambridge, MA: The MIT Press, 1989), pp. 342–89.

35 Allan Sekula, "On the Invention of Photographic Meaning," in *Thinking Photography*, ed. Victor Burgin (London: Macmillan, 1982), p. 102.

36 Sekula, p. 109.

37 Allan Sekula, "Dismantling Modernism, Reinventing Documentary (Notes on the Politics of Representation)," in *Photography: Current Perspectives*, ed. Jerome Liebling (Rochester, NY: Light Impressions Corporation, 1978), p. 231.

38 Sekula, p. 239.

39 Sekula, p. 251.

40 Allan Sekula, "The Body and the Archive," p. 379.

41 Sekula, p. 249.

42 Alan Trachtenberg, quoted in Naomi Rosenblum, "Jerome Liebling," *Contemporary Photographers* (New York: St. Martin's Press, 1982), p. 455.

43 Roland Barthes, *Camera Lucida: Reflections on Photography* (New York: Hill and Wang, 1981), p. 73.

44 Douglas Crimp, *Pictures* (New York: Artists Space; Committee for the Visual Arts, 1977), p. 3. Another Crimp article, also titled "Pictures," was published in *October*, vol. 8 (Spring 1978), pp. 75–88. It expanded on the first article and brought the ideas to bear on artists not included in the original show, most notably Cindy Sherman.

45 Thomas Lawson, "Last Exit: Painting," *Artforum* (October, 1981), p. 45.

46 Sontag's book was compiled from essays she wrote in 1973, 1974, and 1977 for the *New York Review of Books*.

47 Abigail Solomon-Godeau, "Conventional Pictures," *The Print Collector's Newsletter*, vol. 12, no. 5 (November–December 1981), p. 138.

48 See, for example, the discussion in Abigail Solomon-Godeau, "Photography After Art Photography," in her *Photography at the Dock: Essays on Photographic History, Institutions, and Practices* (Minneapolis, MN: University of Minnesota Press, 1991), pp. 113–14.

49 David Rimanelli, [untitled review] *Artforum* (December 2000), p. 120.

50 See the discussion of this picture in Brandon Taylor, *The Art of Today* (London: Everyman Art Library, 1995), p. 53.

51 Craig Owens, "The Discourse of Others: Feminists and Postmodernism," in Hal Foster, *The Anti-Aesthetic: Essays on Postmodern Culture* (Port Townsend, WA: Bay Press, 1983), p. 59.

52 Owens, p. 68.

53 See Griselda Pollock, "What's wrong with images of women," *Screen Education*, no. 24 (October 1977), pp. 25–31, and Janet Wolff, *Feminine Sentences: Essays on Women & Culture* (Berkeley, CA: University of California Press, 1990).

54 Deborah Bright, "Of Mother Nature and Marlboro Men: An Inquiry into the Cultural Meanings of Landscape Photography," in *The Contest of Meaning: Critical Histories of Photography*, ed. Richard Bolton (Cambridge, MA: The MIT Press, 1989), p. 139.

55 For a more complete discussion of the controversy see Steven C. Dubin, *Arresting Images: Impolitic Art and Uncivil Actions* (New York: Routledge, 1992).

56 Dubin, p. 100.

57 A. D. Coleman, "The Directorial Mode: Notes Toward a Definition," in his *Light Readings: A Photography Critic's Writings, 1968–1978* (Albuquerque, NM: University of New Mexico Press, 1998), pp. 250–54.

58 See David Mellor, "Romances of Decay, Elegies for the Future," in Mark Haworth-Booth, et al., *British Photography: Towards a Bigger Picture* (New York: Aperture, 1988), p. 52.

59 Quoted in Gary Boas, "New Image Art," in *Artforum* (December 2000), p. 152.

60 Walker, Ursitti, and McGinniss, *Photo Manifesto: Contemporary Photography in the USSR* (New York: Stewart, Tabori & Chang, 1991), p. 63.

61 Ulf Erdmann Ziegler, "Preface" to *Contemporary German Photography* (Cologne: Taschen Verlag, 1997), n.p.

62 Göran Gnaudschun [artist's statement], in *Contemporary German Photography*, n.p.

63 Quoted in Jennifer Blessing, *Rrose is a Rrose is a Rrose: Gender Performance in Photography* (New York: Guggenheim Museum, 1997), p. 208.

64 Quoted in Peter Weiermair, "Photography as Fiction," in *Jack Pierson: The Lonely Life*, ed. Gérard A. Goodrow and Peter Weiermair (Zurich: Editions Stemmle, 1997), n.p.

65 See Peter Weiermair, *Japanese Photography: Desire and Void* (Zurich: Edition Stemmle, 1997), p. 12.

66 Noriko Fuku, "I am a Photographer," in *An Incomplete History: Women Photographers from Japan, 1864–1997* (Rochester, NY: The Visual Studies Workshop, 1998), p. 11.

67 Noriko Fuku, "I am a Photographer," p. 5.

68 Larry Sulton, *Pictures from Home* (New York: Harry N. Abrams, 1992), p. 114.

69 I am grateful to Elizabeth Ferrer's interpretation in *A Shadow Born of Earth: New Photography in Mexico* (New York: The American Federation of Arts, 1993), p. 85.

70 See Robert Shlaer, *Sights Once Seen: Daguerreotyping Frémont's Last Expedition through the Rockies* (Albuquerque, NM: Museum of New Mexico, 2000).

71 For an overview, see Laura U. Marks, "Minor Infractions: Child Pornography and the Legislation of Morality," *Afterimage*, vol. 18, no. 4 (November 1990), pp. 12–14.

72 See, for example, Carol Mavor, *Pleasures Taken: Performance of Sexuality and Loss in Victorian Photographs* (Durham, NC: Duke University Press, 1995) and Anne Higonnet, *Pictures of Innocence: The History and Crisis of Ideal Childhood* (London: Thames and Hudson, 1998).

73 For a comprehensive history of political debates involving images, see Steven C. Dubin, *Arresting Images: Impolitic Art and Uncivil Actions* (New York: Routledge, 1992).

74 See, for example, Bill McKibben, "The Problem with Wildlife Photography," *Doubletake* (Fall 1997), pp. 50–56.

75 Robert Adams, *Beauty in Photography: Essays in Defense of Traditional Values* (New York: Aperture, 1981), p. 13.

76 Marusia Bociurkiw, "The Transgressive Camera," *Afterimage*, vol. 16, no. 6, (January 1989), p. 18.

77 From the ACT UP flyer handed out at Nixon's 1988 show at the Museum of Modern Art, quoted in its entirety in Jan Zita Grover, "Visible Lesions: Images of the PWA," *Afterimage* (Summer 1989), p. 14.

78 Interview with David Hevey titled "A Radical Creature" [no author] *Creative Camera* (February–March 1992), pp. 28–30.

79 Joyce Kozloff [interview with Barbara Pollack] [www.jca-online.com/pollack.html].

80 Andy Grundberg, *Mike and Doug Starn* (New York: Abrams, 1990), p. 35.

81 Grundberg, pp. 43–44.

82 Grundberg, p. 46.

83 See Abigail Solomon-Godeau, "Living with Contradictions: Critical Practices in the Age of Supply-Side Aesthetics," in her *Photography at the Dock*, pp. 134–48.

84 See *Fashion: Photography of the Nineties*, ed. by Camilla Nickerson and Neville Wakefield (Zurich: Scalo, 1998).

85 Adam Lammiman, "Whose reality is it anyway?", *Adbusters*, no. 30 (June/July 2000), p. 18.

EPILOGUE
On Beauty, Science, and Nature

1 Allan Sekula, "On the Invention of Photographic Meaning," in *Thinking Photography*, ed. Victor Burgin (London: Macmillan, 1982), p. 102.

2 Walter Benjamin, "The Work of Art in the Age of Mechanical Reproduction," in Walter Benjamin, *Illuminations*, ed. Hannah Arendt (New York: Schocken Books, 1969), p. 241.

3 Hal Foster, "Postmodernism: A Preface," in *The Anti-Aesthetic: Essays on Postmodern Culture*, ed. Hal Foster (Port Townsend, WA: Bay Press, 1983), p. xv.

4 See Neal Benezra "The Misadventures of Beauty," in Neal Benezra and Olga M. Viso, *Regarding Beauty: A View of the Late Twentieth Century* (Washington, DC: Smithsonian Institution Press, 1999), p. 12.

5 Peter Schjedahl, "Beauty is Back," *New York Times Magazine* (September 29, 1996), p. 161.

6 Schjedahl, p. 161.

7 For Hillman's ideas, see James Hillman, "The Practice of Beauty," in *Uncontrollable Beauty: Toward a New Aesthetics* (New York: Allworth Press, 1998), pp. 261–74.

8 Ann Thomas, "The Portrait in the Age of Genetic Mapping," in Gary Schneider, *Genetic Self-Portrait* (Syracuse, NY: Light Work, 1999).

9 Thomas, p. 32.

10 For a discussion of Delaroche's legendary comment, see Mary Warner Marien, *Photography and Its Critics* (New York: Cambridge University Press, 1997), pp. 55–57.

11 Nicholas Mirzoeff, *An Introduction to Visual Culture* (London: Routledge, 1999), p. 88.

12 William J. Mitchell, *The Reconfigured Eye: Visual Truth in the Post-Photograpy Era* (Cambridge, MA: The MIT Press, 1992), bookjacket. A similar, but less forceful, statement occurs in the text on p. 20.

13 Joan Fontcuberta, "Introduction," in Pedro Meyer, *Truths and Fictions: A Journey from Documentary to Digital Photography* (New York: Aperture Foundation, 1995), p. 9.

14 Fontcuberta, p. 10.

15 Fontcuberta, p. 12.

16 See David King, *The Commissar Vanishes: The Falsification of Photographs and Art in Stalin's Russia* (New York: Metropolitan Books, 1997).

17 For analyses of the Gulf War see Douglas Keller, *The Persian Gulf TV War* (Boulder, CO: Westview Press, 1992), and Michael Griffin and Jongsoo Lee, "Picturing the Gulf War: Constructing an Image of War in *Time*, *Newsweek*, and *U.S. News and World Report*," *Journalism & Mass Communication Quarterly*, vol. 72, no. 4 (Winter 1995), pp. 813–25.

18 Katy Siegel, "Consuming Vision," *Artforum* (January 2001), p. 106.

19 Keith Cottingham, "Fictional Portraits," in *Photography after Photography: Memory and Representation in the Digital Age* (Amsterdam and Munich: OPA and Siemens Kulturprogramm, 1996), p. 162.

20 Lynne Warren, "Miroslaw Rogala," in *Photography after Photography*, p. 52.

21 "Blood and Oil," *The Economist* (March 4, 2000), p. 68.

22 See the discussion in Victor Burgin, "The Image in Pieces: Digital Photography and the Location of Cultural Experience," in *Photography after Photography*, p. 32.

23 Joan Fontcuberta, "Introduction," in Meyer, *Truths and Fictions*, p. 11.

24 Anthony Aziz and Sammy Cucher, "Notes from Dystopia," in *Photography after Photography*, pp. 126–28.

25 Aziz and Cucher, pp. 126–28.

BIBLIOGRAPHY

Many excellent books on individual photographers and movements have been published in recent years. This bibliography emphasizes English-language general histories, rather than monographs.

GENERAL HISTORIES OF PHOTOGRAPHY

Braive, Michel F. *The Photograph: A Social History*, trans. David Britt (New York: McGraw-Hill Book Company, 1966). Idiosyncratic, historically outdated, yet delightful array of European vernacular photography.

Daval, Jean-Luc. *Photography: History of an Art* (New York: Rizzoli, 1982). Oversize and beautifully printed review emphasizing European photography. Daval concentrates on the interaction of photography and other art media.

Eder, Josef Maria. *History of Photography*, trans. Edward Epstean (New York: Dover Publications, Inc., 1978). Eder's influence on the history of photography, through his chronological organization of the medium's technical developments in Europe (first translated in 1945), is still felt. No illustrations.

Freund, Gisèle. *Photography and Society* (Boston, MA: David R. Godine, 1980). Originally published in France. Freund's insistence on seeing European photography, especially French photography, in the context of political and social events, helped to shift scholarly focus from photography as art to the cultural history of photography.

Frizot, Michel, ed. *A New History of Photography* (Cologne: Könemann, 1998). Lavishly illustrated history, with articles primarily on photography in the United States and Europe. This book incorporated new directions in the field, such as research on the development of mass-media networks, fashion photography, and the use of photography in the development of ethnic stereotypes. Flawed by the excessive use of sepia in the reproductions.

Gernsheim, Helmut, with Alison Gernsheim. *The History of Photography from the Camera Obscura to the Beginning of the Modern Era*, 2nd ed. (New York: McGraw-Hill, 1969). With Beaumont Newhall (see below), the Gernsheims shaped the field of photographic history. The Gernsheim collection, now in the Harry Ransom Research Center at the University of Texas at Austin, is one of the few large private collections to remain intact.

Kevles, Bettyann Holtzmann. *Naked to the Bone: Medical Imaging in the Twentieth Century* (New Brunswick, NJ: Rutgers University Press, 1997). From X-rays to PET scans, Kevles provides an informative reflection on society's reaction to imaging the body, and frequently notes the uses to which artists put medical imaging.

Kosinski, Dorothy. *The Artist and the Camera: Degas to Picasso* (Dallas, TX: Dallas Museum of Art, 1999). Kosinski and others examine the sometimes hidden history of photography's impact on modern art. Well-researched and lavishly illustrated.

LeMagny, Jean-Claude and André Rouillé, eds. *A History of Photography*, trans. Janet Lloyd (New York: Cambridge University Press, 1987). Individual articles mostly on European photographic history, written by leading historians and curators.

Newhall, Beaumont. *The History of Photography* (New York: The Museum of Modern Art, 1982). Newhall's preference for so-called straight photography, whether in art, documentary, or photojournalism, was apparent from his first catalog, published in 1937, to this last edition. The influential historian and curator shaped the prominent collections at the Museum of Modern Art in New York City and George Eastman House in Rochester, New York.

Rosenblum, Naomi. *A World History of Photography*, 3rd ed. (New York: Abbeville Press, 1997).

Rosenblum led the way to the current rewriting of photographic history. Her book included long-overlooked women photographers, and reached out to report on photography in the non-Western world.

Scharf, Aaron. *Art and Photography* (Harmondsworth, Middlesex: Penguin, 1974). One of the first books to investigate interactions between the fine arts and photography. Contains a useful bibliography of primary sources.

Thomas, Ann. *Beauty of Another Order: Photography in Science* (New Haven, CT: Yale University Press, 1997). Highly informative articles by Thomas and others in a catalog to the important exhibition of the same name at the National Gallery of Canada in Ottawa.

NINETEENTH-CENTURY PHOTOGRAPHY

Bartram, Michael. *The Pre-Raphaelite Camera* (New York: New York Graphic Society, 1985). Painstaking and convincing look at the shared themes and visual techniques of painting and photography.

Batchen, Geoffrey. *Burning with Desire: The Conception of Photography* (Cambridge, MA: MIT Press, 1997). A critical, philosophically aware review of the formal, cultural, and political definitions of photography in its early decades.

Buerger, Janet E. *French Daguerreotypes* (Chicago, IL: University of Chicago Press, 1989). Largely based on the Cromer collection at George Eastman House in Rochester, New York, this book elucidates the multiple directions taken by the daguerreotype in mid-nineteenth-century France.

Carlebach, Michael L. *The Origins of Photojournalism in America* (Washington, DC, Smithsonian Institution Press, 1992). An introduction to the integration of photographically-based images into nineteenth-century newspapers.

Crawford, William. *The Keepers of Light* (Dobbs Ferry, New York: Morgan & Morgan, 1979). In his mixture of history and how-to-do-it, Crawford guides novice photographers through the chemistry and techniques of early photographic processes. This book is still sought-after for its clear instructions.

Edwards, Elizabeth, ed. *Anthropology and Photography, 1860–1920* (New Haven, CT: Yale University Press, 1992). Seldom-seen images and insightful essays track the intertwined development of photographic practice and the science of anthropology.

Flukinger, Roy. *The Formative Decades: Photography in Great Britain, 1839–1920* (Austin, TX: University of Texas Press, 1985). Showcases the wealth of nineteenth-century photography housed in the libraries at the University of Texas at Austin. Accompanied by helpful notes on the works and photographers.

Foresta, Merry and John Wood. *Secrets of the Dark Chamber: The Art of the American Daguerreotype* (Washington, DC: National Museum of American Art and Smithsonian Institution Press, 1995). Daguerreotypes from an exhibition at the National Museum of American Art in Washington, DC, accompanied by writings on the medium produced by critics and photographers throughout the nineteenth century.

Galassi, Peter. *Before Photography: Painting and the Invention of Photography* (New York: Museum of Modern Art, 1981). Like Schwarz (below), Galassi speculated on the aesthetic forebears of photography. A still controversial early essay by the director of the photography department at the Museum of Modern Art.

Hambourg, Maria Morris, Pierre Apraxine, Malcolm Daniel, Jeff L. Rosenheim, and Virginia Heckert. *The Waking Dream: Photography's First Century: Selections from the Gilman Paper Company Collection* (New York: The Metropolitan Museum of Art, 1993). Richly illustrated review, augmented with extensive, succinct descriptions of individual works.

Henisch, Heinz Z., and Bridget A. Henisch. *The Photographic Experience, 1839–1914: Images and Attitudes* (University Park, PA: Pennsylvania State University Press, 1994) and *The Painted Photograph, 1839–1914: Origins, Techniques, Aspirations* (University Park, PA: Pennsylvania State University Press, 1996). Drawn mostly from a collection of vernacular photography started by Henisch and Henisch before studies of the photography of everyday life became popular in the late twentieth century.

Jammes, Andre, and Eugenia Parry Janis, *The Art of the French Calotype* (Princeton, NJ: Princeton University Press, 1983). Photographic history's debt to collectors is evidenced in the images from the Jammes collection of French photography. Janis's attentive history serves not only to underscore the depth of the collection, but also its loss to scholars and the public when it was dispersed by auction at Sotheby's in 1999.

Kemp, Martin. *The Science of Art: Optical Themes in Western Art from Brunelleschi to Seurat* (New Haven, CT: Yale University Press, 1989). Lavishly illustrated, Kemp's book incorporates detailed histories and technical data for optical instruments, such as the camera obscura, which preceded the invention of the photographic camera.

Marien, Mary Warner. *Photography and Its Critics: A Cultural History, 1839–1900* (New York: Cambridge University Press, 1997). An analysis of U.S. and European critical writing on the medium.

McCauley, Elizabeth Anne. *Industrial Madness: Commercial Photography in Paris, 1848–1871* (New Haven, CT: Yale University Press, 1994). A comprehensive look at commercial photography and its consumers.

Rudisill, Richard. *Mirror Image: The Influence of the Daguerreotype on American Society* (Albuquerque, NM: University of New Mexico Press, 1971). Difficult-to-find social history of early photography that has survived the test of time.

Sandweiss, Martha A., ed. *Photography in Nineteenth-Century America* (Fort Worth, TX: Amon Carter Museum, and New York: Harry N. Abrams, 1991). Richly illustrated. Six scholarly essays trace the social interactions of photography. The first entry, Alan Trachtenberg's "Photography: the emergence of a keyword," is an invaluable introduction to the intricate interplay of photographic practice and cultural values.

Schwarz, Heinrich. *Art and Photography: Forerunners and Influences: Selected Essays by Heinrich Schwarz*, ed. William E. Parker (Layton, UT: Peregrine Smith Books, 1985). Essays by the distinguished Czech museum curator, whose examination of the social and cultural forces that encouraged the invention of photography has been widely influential in photographic studies.

Seiberling, Grace. *Amateurs, Photography, and the Mid-Victorian Imagination* (Chicago, IL: University of Chicago Press, 1986). Intelligent analysis of the role that photography played in defining social class among British middle- and upper-class amateurs.

Thomas, Alan. *Time in a Frame: Photography and the 19th-Century Mind* (New York: Schocken Books, 1977). An early attempt to conceive photography as the history of an idea.

PHOTOGRAPHY SINCE 1900

Amelunxen, Hubertus van, Stefan Iglhaut, and Florian Rötzer, eds. *Photography after Photography: Memory and Representation in the Digital Age* ([Amsterdam?]: G+B Arts, 1996). Individual essays elucidate suites of images by contemporary artists whose images depend on computer assistance.

Blessing, Jennifer. *Rrose is a Rrose is a Rrose: Gender Performance in Photography* (New York: Guggenheim

Museum, 1997). Blessing and others underscore the philosophical unity linking early twentieth-century photographers such as Claude Cahun with contemporary artists such as Cindy Sherman.

Constructed Realities: The Art of Staged Photography (Zurich: Edition Stemmle, 1989/1995). Attempts to define the staged photograph through a broad survey of work by American and European artists.

Doswald, Christoph, ed. *Missing Link: The Image of Man in Contemporary Photography* (Zurich: Edition Stemmle, 2000). Unfortunately titled, wide-ranging survey of the overwhelming presence of the human form in contemporary art photography.

Enwezor, Okwui, ed. *The Short Century: Independence and Liberation Movements in Africa, 1945–1994* (Munich: Prestel, 2001). Enwezor and a group of scholars examine popular imagery in post-World War II liberation movements. Lavish illustrations show, among other things, the centrality of photographic practice.

Global Conceptualism: Points of Origin, 1950s–1980s (New York: Queens Museum of Art, 1999). Not primarily about photography, but demonstrates the extent to which photography became a major medium in North American, South American, European, African, and Asian art.

Graham-Brown, Sarah. *Images of Women: The Portrayal of Women in Photography of the Middle East, 1860–1950* (New York: Columbia University Press, 1988). Comprehensive, undervalued study of stereotypes, and also the role of women as photographers.

In/sight: African Photographers, 1940 to the Present (New York: Guggenheim Museum, 1996). Scholars such as Okwui Enwezor and Olu Oguibe bring critical insights to the practice of post-war photography in Africa.

Janus, Elizabeth, ed. *Veronica's Revenge: Contemporary Perspectives on Photography* (Zurich: Scalo, 1998). Janus and others explore the scope of Marion Lambert's perceptive collection of American and European photographers and artists who use photography in their work.

Kemper, Sarah. *Virtual Anxiety: Photography, New Technologies, and Subjectivity* (Manchester: Manchester University Press, 1998). A reflection on the possible impacts of digitalization on photography.

Lahs-Gonzales, Olivia, and Lucy Lippard. *Women Photographers of the 20th Century* (St. Louis, MO: St. Louis Art Museum, 1997). International in scope and taking account of recent theoretical approaches, this book contains essays introducing the often-overlooked collection of Helen Kornblum.

McEuen, Melissa A. *Seeing America: Women Photographers between the Wars* (Lexington, KY: University Press of Kentucky, 2000). Engaging text on such photographers as Margaret Bourke-White, whose images responded to and shaped American social policy.

Mitchell, William J. *The Reconfigured Eye: Visual Truth in the Post-Photographic Era* (Cambridge, MA: MIT Press, 1992). Merges a technical account, now largely out-of-date, with the philosophical issues raised by digital imaging.

Phillips, Christopher, ed. *Photography in the Modern Era: European Documents and Critical Writings, 1913–1940* (New York: Metropolitan Museum of Art, 1989). Valuable resource for understanding photography between the world wars, with important articles by Gustav Klucis, Ossip Brik, and Karel Tiege.

Pultz, John. *The Body and the Lens: Photography 1839 to the Present* (New York: Harry N. Abrams, 1995). A compact introduction to late twentieth-century concerns with the body as the primary site of human identity.

Reframings: New American Feminist Photographies (Philadelphia, PA: Temple University Press, 1995). Essays and images that underscore the diversity of women's photographic practice.

Rosenblum, Naomi. *A History of Women Photographers* (New York: Abbeville Press, 1994). An encyclopedic account that has had a lasting impact on photographic studies. Especially strong on mid-twentieth-century figures.

Tupitsyn, Margarita. *The Soviet Photograph, 1924–1937* (New Haven, CT: Yale University Press, 1996). Compact look at interrelated political and aesthetic issues from the death of Lenin to the pre-war period under Stalin.

HISTORIES OF ETHNIC, REGIONAL, AND NATIONAL PHOTOGRAPHY

Alibhai-Brown, Yasmin, *Imaging the New Britain* (London: Routledge, 2001). Although not a photography book, this is a perceptive and wide-ranging analysis of contemporary multicultural Britain in the shadow of the royal family and Shakespeare. Provides useful background to contemporary British photographic practice.

Alison, Jane, ed. *Native Nations: Journeys in American Photography* (London: Barbican Art Gallery, 1998). Comprehensive look at photography of and by Native Americans, with text by many of the artists represented in the book.

Anthology of African and Indian Ocean Photography (Paris: Éditions Revue Noire, 1999). Beautifully printed images in a huge compilation devoted to recent historical scholarship, including that of the black diaspora from the point of view of Africans.

Badger, Gerry, and John Benton-Harris. *Through the Looking Glass: Photographic Art in Britain, 1945–1989* (London: Barbican Art Gallery, 1989).

Bezner, Lili Corbus, *Photography and Politics in America: From the New Deal to the Cold War* (Baltimore, MD: The Johns Hopkins Press, 1999). Bezner shows that American documentary photography cannot be separated from political reform movements and official reactions.

Billeter, Erika. *A Song to Reality: Latin-American Photography, 1860–1993* (Barcelona: Lunwerg Editores, 1998). Strong on documentary photography, and the continuing iconographic themes that inform Latin-American photography.

Daniel, Pete, Merry A. Foresta, Maren Stange, and Sally Stein. *Official Images: New Deal Photography* (Washington, DC: Smithsonian Institution Press, 1987). A close examination of the politics behind the public idealism of photographic projects such as those carried out by the Farm Security Administration.

Davis, Keith F. *An American Century of Photography, From Dry-Plate to Digital: The Hallmark Photographic Collection*, 2nd ed., rev. (Kansas City, MO and New York: Hallmark Cards, Inc. in association with Harry N. Abrams, Inc., 1999). A clearly written, well-illustrated review of photography, with an emphasis on photography as art.

Debroise, Olivier. *Mexican Suite: A History of Photography in Mexico*, trans. and rev. by Stella de Sá Rego (Austin, TX: University of Texas Press, 2001). Covers twentieth-century photography by Mexicans and non-Mexicans. Canonical works, such as those of Manuel Álvarez Bravo, are accompanied by new research, especially into the vernacular uses of photography.

Dehejia, Vidya. *India: Through the Lens, Photography 1840–1911* (Washington, DC, Smithsonian Institution, 2000). Lavishly illustrated account of colonial photography with historical essays by scholars including John Falconer, curator of photographs for the outstanding Oriental and India Office Collections at the British Library in London.

Elliott, David, ed. *Photography in Russia, 1840–1940* (London: Thames and Hudson, 1992). Russian scholars and curators discuss major developments. Experimental movements in the 1920s are well-known outside of Russia, but equal space is given to early efforts.

Ferrer, Elizabeth. *A Shadow Born of Earth: New Photography in Mexico* (New York: Universe Publishing, 1993). An eye-opening review of contemporary documentary as well as art photography.

Gao Minglu ed. *Inside Out: New Chinese Art* (Berkeley, CA: University of California Press, 1998). Gao brings together Western and Chinese scholars to review recent developments in contemporary Chinese art, which is frequently photo-based. (The history of photography in China has yet to be written.)

Green, Jonathan. *American Photography: A Critical History, 1945 to the Present* (New York, Harry N. Abrams, 1984). Still influential for its taxonomy of post-war photography, as well as the publications and the institutions that promoted the medium.

Gupta, Sunil, ed. *An Economy of Signs: Contemporary Indian Photographs* (London: Rivers Oram Press, 1990). Especially interesting for an essay by Saleem Kidwai on the relationship of photography to traditional Indian arts, and for its account of feminist photographic practice.

Hales, Peter Bacon. *Silver Cities: The Photography of American Urbanization, 1839–1915* (Philadelphia, PA: Temple University Press, 1983). Explores the use of photography in creating both visual histories of American cities and so-called 'booster books' to promote commerce.

Holborn, Mark. *Black Sun: The Eyes of Four: Roots and Innovation in Japanese Photography*. Concentrates on the influential post-war images of Hosoe, Tomatsu, Fukase, and Moriyama.

Honnef, Klaus, Rolf Sachsse, and Karin Thomas, eds. *German Photography 1870–1970: Power of a Medium* (Cologne: DuMont Buchverlag, 1997). Strongest in its account of photography and the rise of National Socialism, and the aftermath of World War II.

India: A Celebration of Independence, 1947 to 1997 (New York: Aperture, 1997). Reviews the work of Indian photographers such as Sunil Janah, and Western photographers such as Mary Ellen Mark, who have worked in India. (A comprehensive account of colonial and post-colonial photography in India is long overdue.)

Kuehn, Karl Gernot. *Caught: The Art of Photography in the German Democratic Republic* (Berkeley, CA: University of California Press, 1997). Against the odds, some photographers countered photo-based propaganda with scenes of the harshness of everyday life and lyrical personal diaries that experimented with form.

Out of India: Contemporary Art of the South Asian Diaspora (New York: Queens Museum of Art, 1998). Many photo-based works by artists of Indian descent living around the world.

Pinney, Christopher. *Camera Indica: The Social Life of Indian Photographs* (Chicago, IL: University of Chicago Press, 1997). Acknowledging his debt to French theorist Roland Barthes's influential book *Camera Lucida* (see below), Pinney examines the ways in which Indian photographers broke from colonial modes of representation and invented unique forms of photographic practice.

Stange, Maren. *Symbols of Ideal Life: Social Documentary Photography in America, 1890–1950* (New York: Cambridge University Press, 1986). An in-depth examination of the documentary practice of Jacob Riis and Lewis Hine, as well as others who developed the notion of documentary photography.

Stathatos, John. *Image and Icon: The New Greek Photography, 1975–1995* (Athens: Hellenic Ministry of Culture, 1997). With Aris Georgiou, whose work is included in this survey, Stathatos has worked tirelessly to make Greek photographic practice better known, primarily through the yearly international festival of photography held in Thessaloniki. The most lavishly illustrated of his recent publications, this text uses a broad definition of landscape to encompass recent mixed-media work.

Stearns, Robert. *Photography and Beyond in Japan: Space, Time and Memory* (Tokyo: Hara Museum of Contemporary Art, 1995). A brief history of enduring themes in Japanese image-making. The last section concentrates on international figures such as Yasumasa Morimura and Nobuyoshi Araki.

Stott, William. *Documentary Expression and Thirties America* (New York: Oxford University Press, 1973). Reviews the definitions of documentary that influenced government-sponsored photographic projects, such the Farm Security Administration's work, as well as social science.

Taft, Robert. *Photography and the American Scene: A Social History, 1839–1889* (New York: Dover Publications, Inc., 1964). First published in 1938, Taft's extensive archival research and collection of anecdotes set the stage for the study of photography in the United States.

Trachtenberg, Alan. *Reading American Photographs: Images as History, Mathew Brady to Walker Evans* (New York: Hill and Wang, 1989). An insightful look at the impact of political and cultural developments on photography from the Civil War to the Depression years. Trachtenberg pioneered the inclusion of photographic history in American Studies.

Walker, Ursitti and McGinniss. *Photo Manifesto: Contemporary Photography in the USSR* (New York: Stewart, Tabori & Chang, 1991). Profusely illustrated, with solid analytic text describing the lively con-

dition of photography during the dissolution of the Soviet Union.

Watriss, Wendy, and Lois Parkinson Zamora, eds. *Image and Memory: Photography from Latin America, 1866–1994* (Austin, TX: University of Texas Press, 1998). Large, well-illustrated catalog for an exhibition surveying historical and contemporary work in more than a dozen countries.

Weiermair, Peter, and Gerald Matt, eds. *Japanese Photography: Desire and Void* (Zurich: Edition Stemmle, 1997). Well-illustrated account of contemporary Japanese photography, especially those figures who have acquired international reputations.

Welling, William. *Photography in America: The Formative Years, 1839–1900* (New York: Thomas Y. Crowell, 1978). What began as a compendium of nineteenth-century writings on photography was illustrated with carefully selected images, many from private or seldom-seen collections.

Willis, Deborah. *Reflections in Black: A History of Black Photographers 1840 to the Present* (New York: W.W. Norton, 2000). An extensive look at African-Americans who practiced photography by a scholar who has spent her career researching the topic. Some reproductions, especially in the first third of the book, are inexplicably blurry, but the remainder are sharp and fresh.

Wride, Tim B. *Shifting Tides: Cuban Photography after the Revolution* (Los Angeles, CA: Los Angeles County Museum of Art, 2001). Cuban photographers did not shed their experimental tendencies, but participated in the international trend toward personal photography, with diary-like images that confound the better-known revolutionary propaganda photographs.

Xanthakis, Alkis X. *History of Greek Photography, 1839–1960*, trans. John Solman and Geoffrey Cox (Athens: Hellenic Literary and Historical Archives Society, 1988). Primarily Greek photographers, with many images of classical architecture, as well as vernacular photography.

PHOTOGRAPHIC THEORY AND CRITICISM

Barthes, Roland. *Camera Lucida: Reflections on Photography*, trans. Richard Howard (New York: Hill and Wang, 1981). Barthes's meditation on a photograph of his mother as a child has become a standard reference in photographic studies, much as Proust's madeleine has come to signal the 'remembrance of things past.'

Berger, John. *Ways of Seeing* (London: British Broadcasting Corporation and Penguin Books, 1972). Influential essay, based on a BBC television series, which discusses the impact of pictures, regardless of medium or context – for example,

Ingres's Odalisque is paired with a bare-bosomed figure that illustrated a girlie magazine.

Bolton, Richard, ed. *The Contest of Meaning: Critical Histories of Photography* (Cambridge, MA: MIT Press, 1989). Thoughtful anthology of writings by such critics as Allan Sekula and Rosalind Krauss, selected to demonstrate the breadth of postmodern theory.

Bourdieu, Pierre. *Photography: A Middle Brow Art*, trans. Shaun Whiteside (Stanford, CA: Stanford University Press, 1990). First published in 1965, this book is a cross between anthropology and speculative criticism, in which the author stresses the relationship between taste, photographic practice, and social class.

Burgin, Victor, ed. *Thinking Photography* (London: Macmillan, 1982). With *The Contest of Meaning* (above), a compendium of influential critical writing, including essays by Walter Benjamin and Umberto Eco, as well as articles by Burgin.

Solomon-Godeau, Abigail. *Photography at the Dock: Essays on Photographic History, Institutions, and Practices* (Minneapolis, MN: University of Minnesota Press, 1991). A collection of writings by one of the most incisive and persuasive contemporary critics of photographic practice.

Sontag, Susan. *On Photography* (New York: Farrar, Straus and Giroux, 1973). Contains six of Sontag's seven short essays on photography that first appeared in the New York Review of Books. Widely analyzed and discussed when they were published, the essays introduced ideas about mass media that are still prevalent.

Wells, Liz, ed. *Photography: A Critical Introduction*, 2nd ed. (London: Routledge, 2000). A largely successful attempt to integrate contemporary photographic theory with a history of twentieth-century photographic practice.

WEBSITES

Websites are making historical and contemporary photography widely available. Search engines can be used to pursue the names of individual photographers as well as ethnic and national collections. The few listed below only hint at the growing richness of the World Wide Web as a resource for photographic history.

Prominent among the general websites is the well-maintained site for George Eastman House, www.geh.org, which offers a time-line of photography, and is constantly enriched with new material. The United States Library of Congress, www.loc.gov, has a rich assortment of photographs displayed in its American Memory section, and frequently directs viewers to other themed sites where photographs

can be found. Likewise, many museums, such as the Smithsonian Institution http://www.si.edu/; the Getty Museum www.getty.edu; The Museum of Contemporary Photography, http://www.mocp.org/; and the Museum für Kunst und Gewerbe in Hamburg, Germany http://www.mkg-hamburg.de/; have samples of their collection and exhibits on line. The American Museum of Photography is a museum without walls at http://www.photographymuseum.com/.

Major journals devoted to photography often have on-line exhibits and articles. See, for example, *Camera Austria*, http://www.camera-austria.at/, and the *British Journal of Photography*, http://www.bjphoto.co.uk/.

Some sites, such as http://www.lightwork.org/lw.html; http://www.bjphoto.co.uk/, and www.spelthorne.ac.uk/pm/sites.htm, collect and post links to a variety of websites devoted to historic and contemporary photography. The International Directory of Photography Historians lists the interests of more than a thousand specialists: http://www.rit.edu/~andpph/hpg.html; and The Women in Photography archive can be found at http://www.sla. purdue.edu/WAAW/Palmquist/. Autograph: The Association of Black Photographers has changing exhibitions on-line at http://www.autograph-abp.co.uk/.

Websites of special interest to photohistorians include the images and related materials about the French Commune available at www.library. nwu.edu/spec/siege. Increasingly, specialized archives are being put on-line. For example, the United States Steel Gary [Indiana] Works are being digitized by Indiana University. See www.dlib.indiana.edu/collections/ steel/steel.html.

Various historical photographic techniques also have websites, for example the Daguerrian Society at http://www.daguerre.org/. Craig's Daguerrian Registry is primarily a source for collectors but also supports a list of daguerreotypists: see www.daguerreotype.com. Those interested in contemporary and former uses of the cyanotype can visit www.cyanotypes.com. The Stereoscopic Association can be found at http://www.stereoscopicsociety.org.uk/. One of the largest websites showing postcards can be found at http://www.lcfpd.org/teich_archives. Similarly, sites for persons interested in area studies or historical period have also been founded. See, for example http://interart.co.il/photography/, which is devoted to photography in the Near East. The Latin American photographic archive at Tulane University at http://www.tulane.edu/~latinlib/lalphoto. html contains fifty major collections.

INDEX

524
INDEX

528

INDEX